modern art

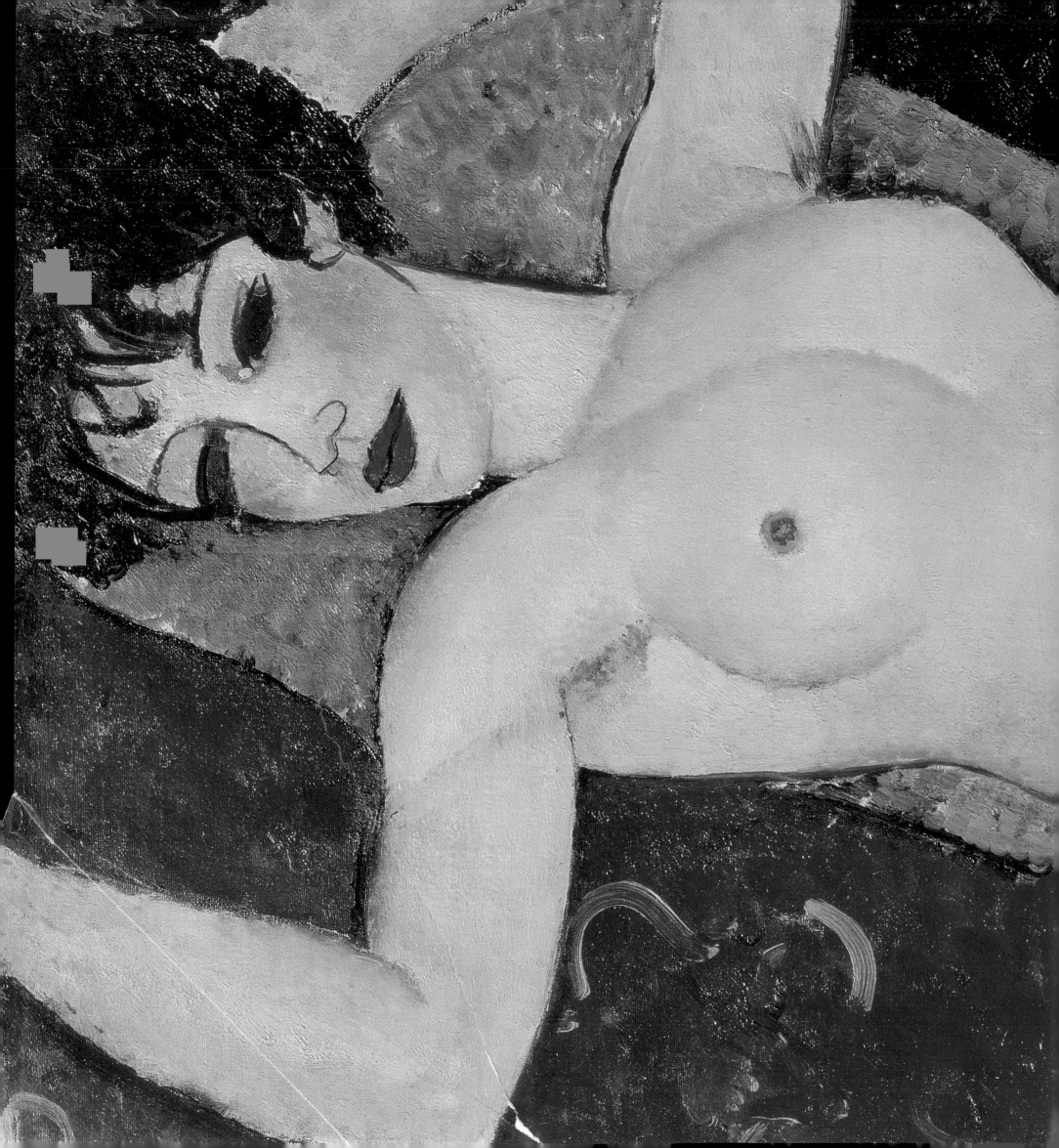

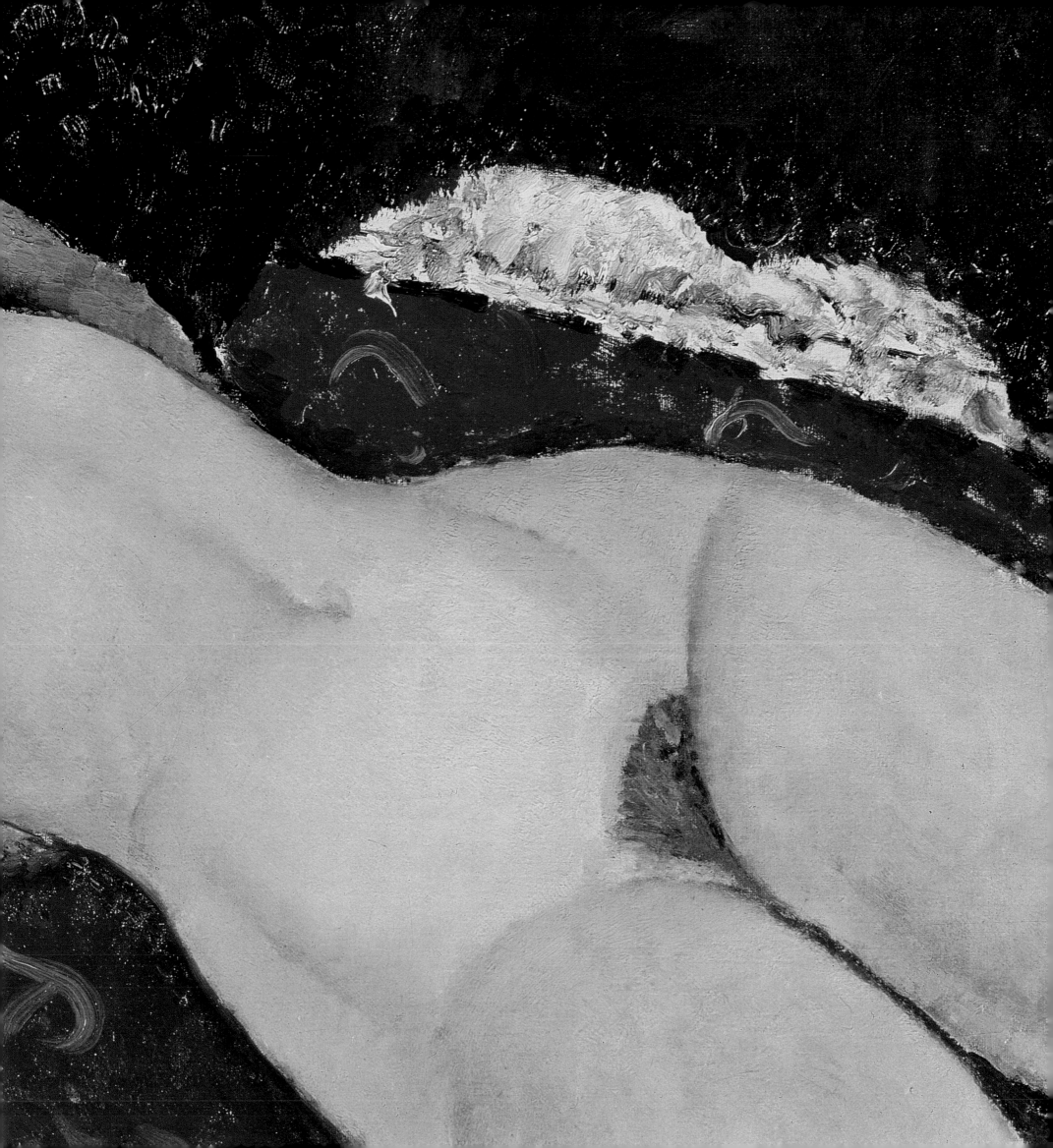

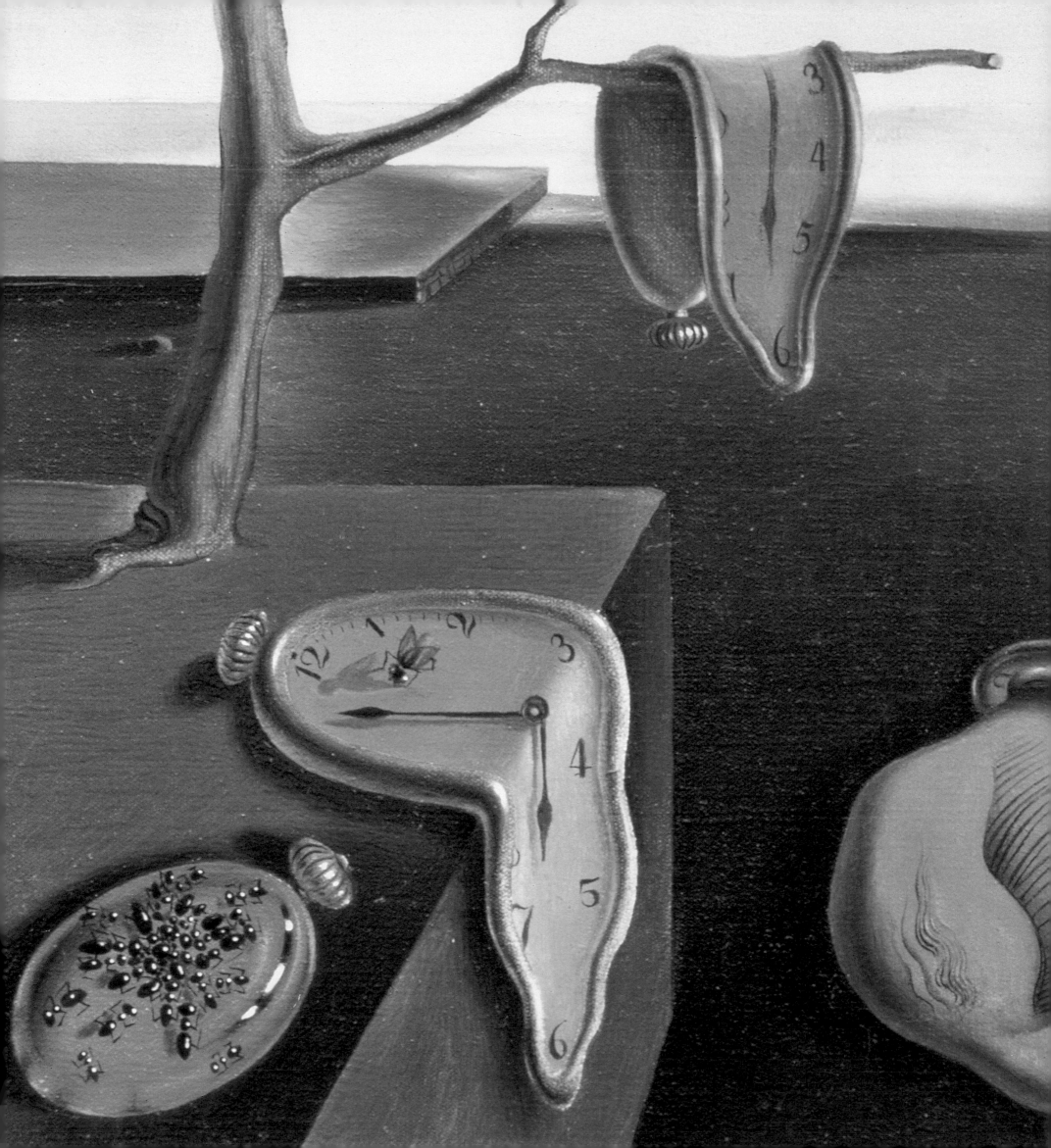

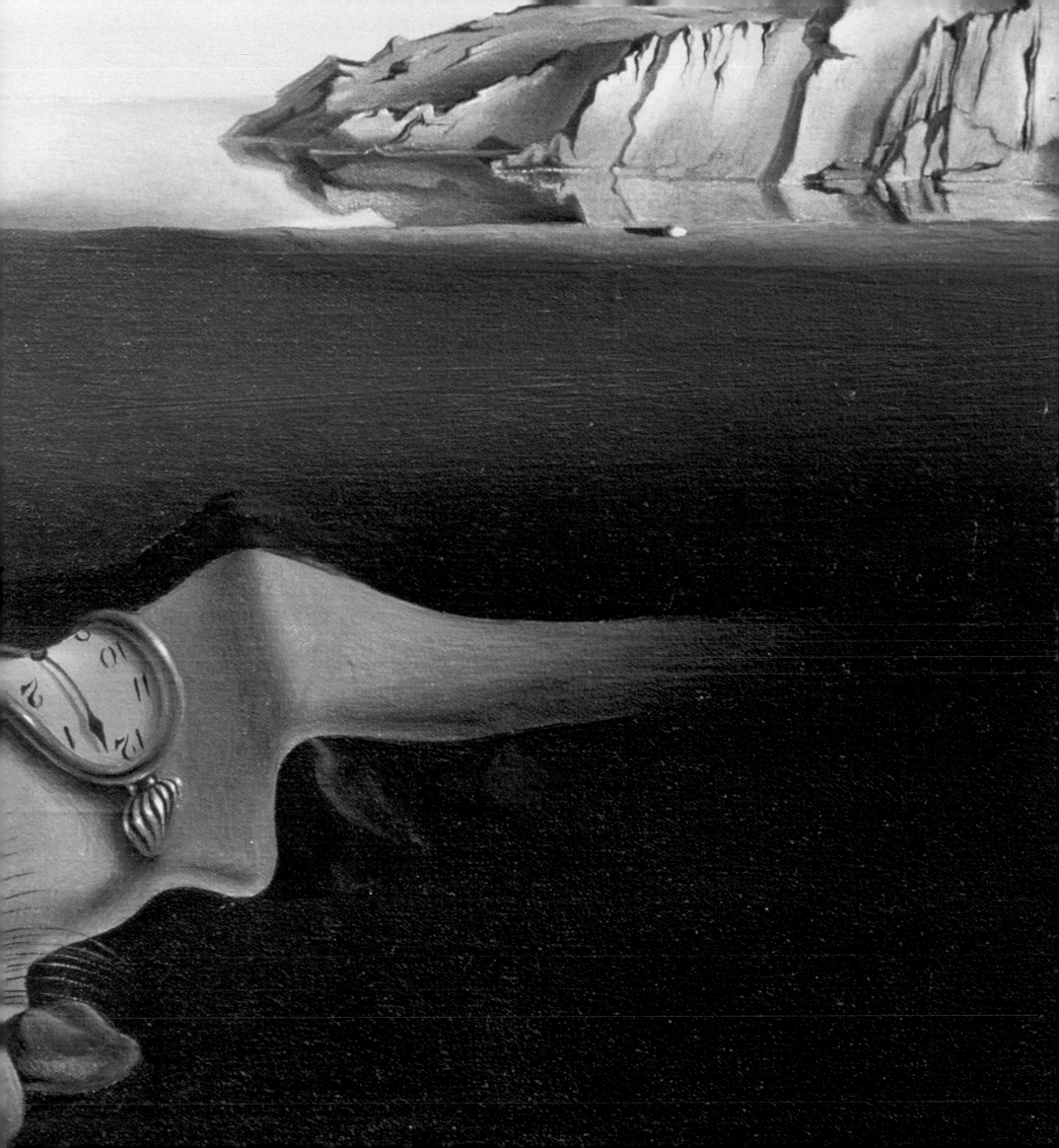

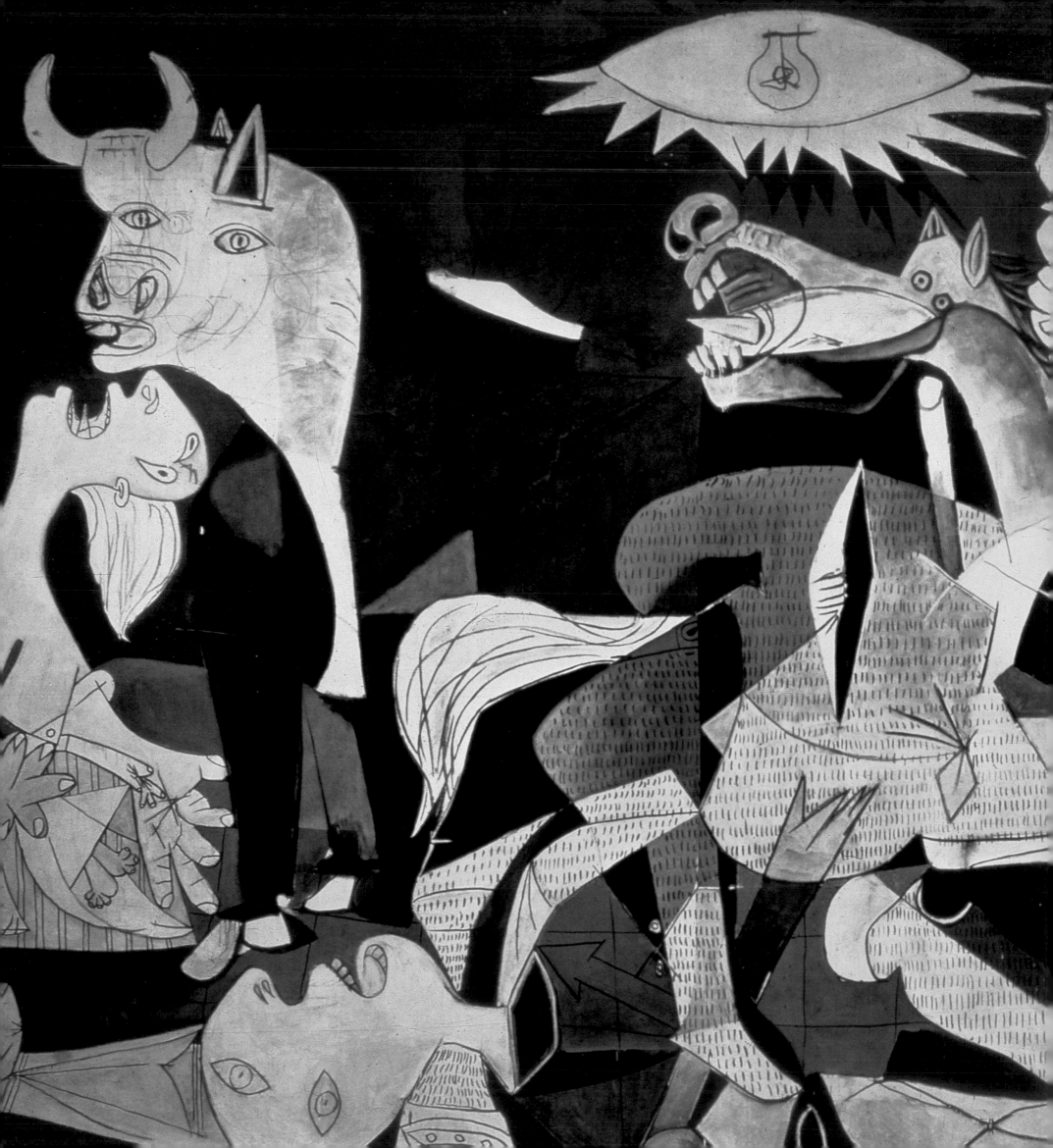

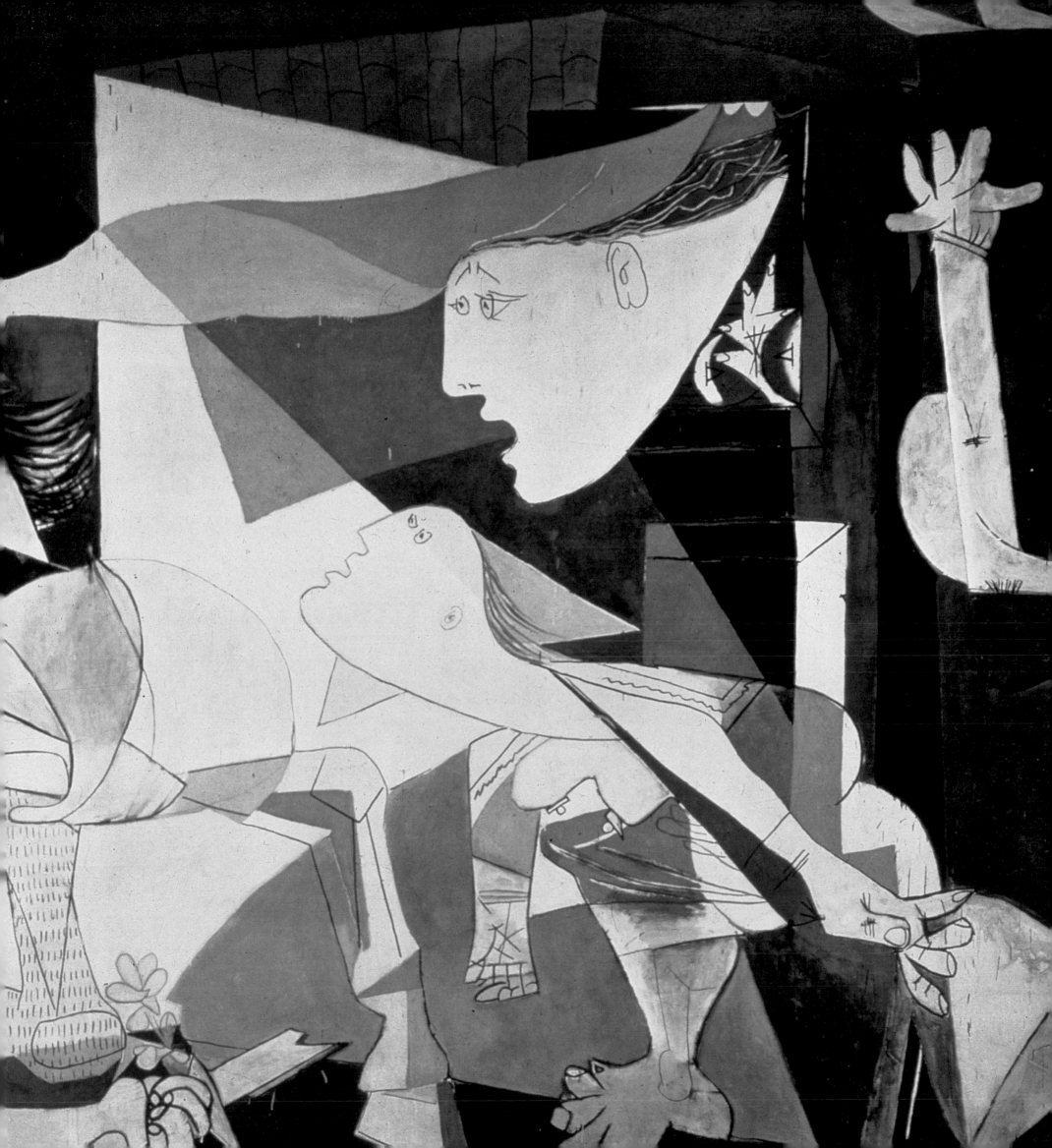

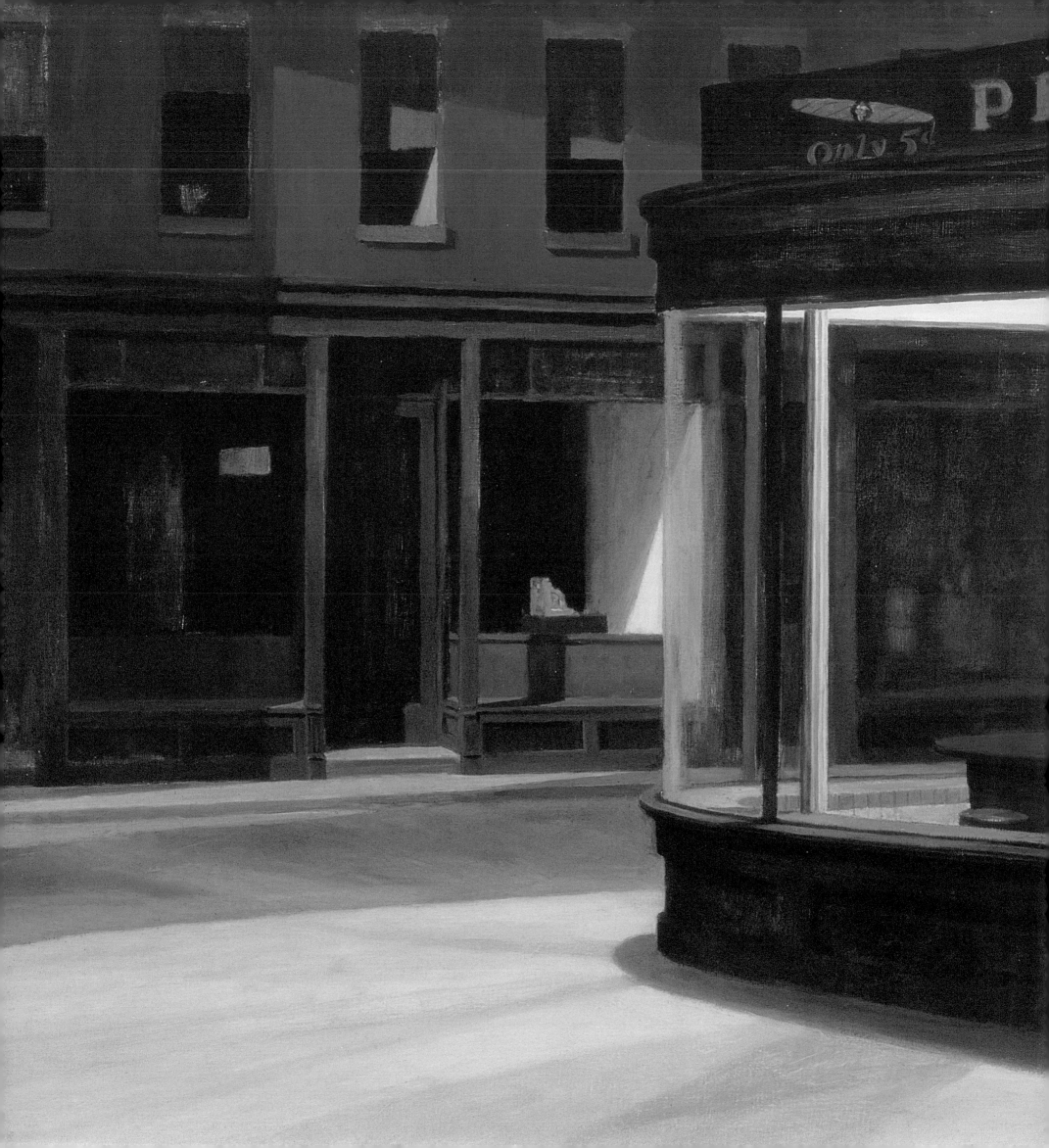

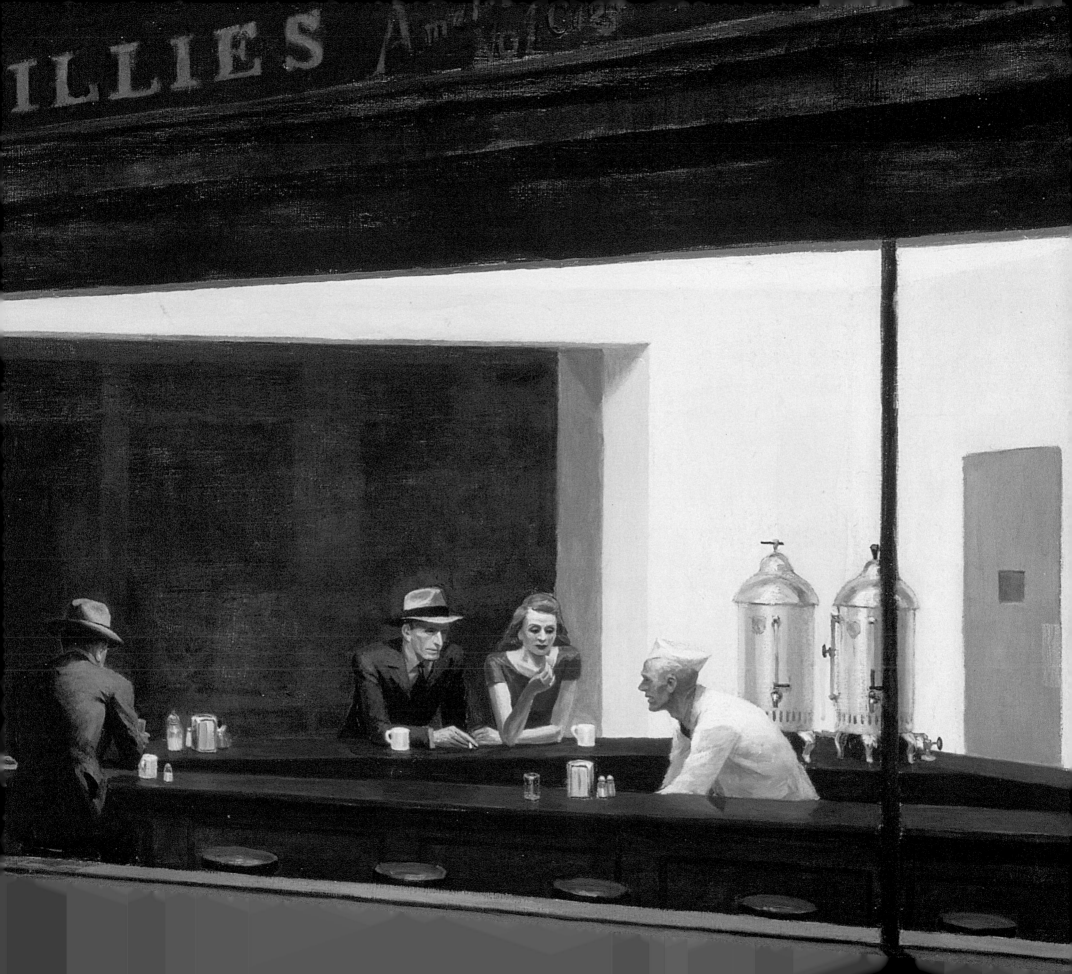

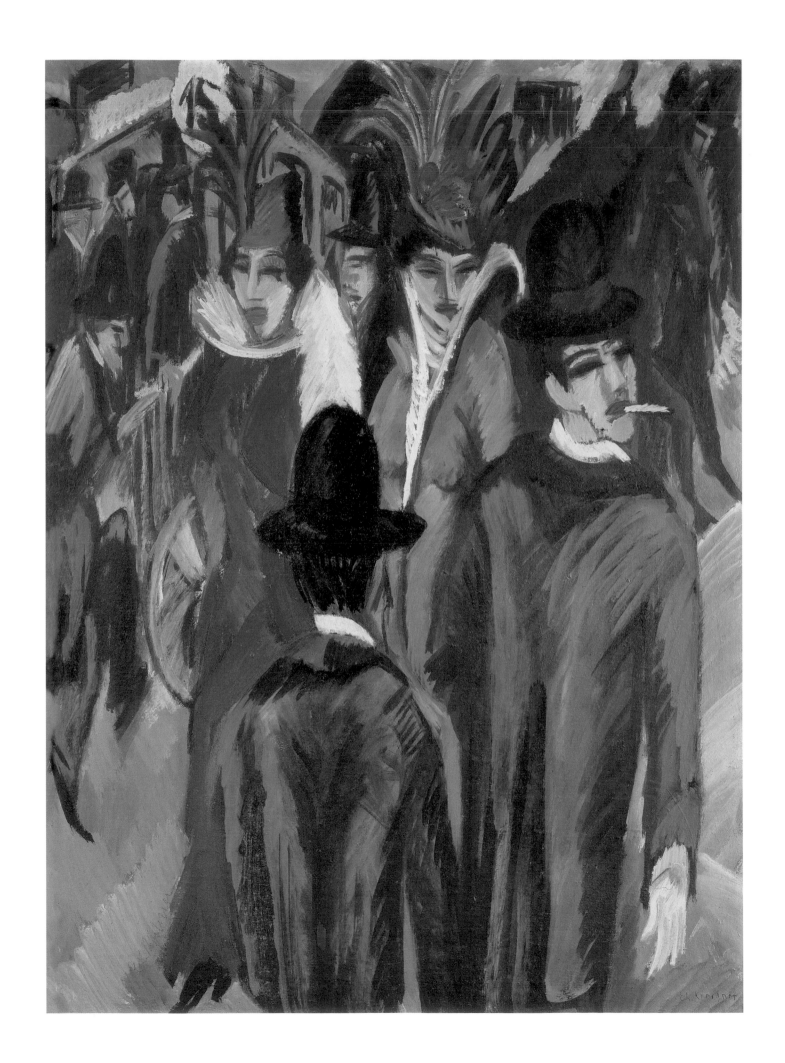

UMBERTO BOCCIONI

MARC CHAGALL

SALVADOR DALÍ

GIORGIO DE CHIRICO

OTTO DIX

MARCEL DUCHAMP

EDWARD HOPPER

WASSILY KANDINSKY

ERNST LUDWIG KIRCHNER

PAUL KLEE

Gabriele Crepaldi

modern art
1900-45: THE AGE OF AVANT-GARDES

RENÉ MAGRITTE

KAZIMIR MALEVICH

HENRI MATISSE

JOAN MIRÓ

AMEDEO MODIGLIANI

PIET MONDRIAN

PABLO PICASSO

DIEGO RIVERA

Collins

ART DIRECTOR
Giorgio Seppi

MANAGING EDITOR
Lidia Maurizi

PICTURE RESEARCH
Simona Bartolena

PRODUCTION
Elastico, Milan
Micaela Arlati (text)
Luna Faleschini (layout)

ENGLISH TRANSLATION
Jay Hyams

TYPESETTING
Michael Shaw

Published in the UK in 2007 by
Collins, an imprint of
HarperCollins*Publishers*
77-85 Fulham Palace Road
Hammersmith
London W6 8JB

First published in Italy, in 2005, as *arte moderna* by
Mondadori Electa S.p.A., Milan

The Collins website address is **www.collins.co.uk**

Collins is a registered trademark of HarperCollins Publishers limited.

10 09 08 07

6 5 4 3 2 1

© 2005 Mondadori Electa S.p.A., Milan
English translation © 2007, Mondadori Electa S.p.A.

A catalogue record for this book is available from the British Library

ISBN 978-0-00-726142-0

Printed by Artes Graficas Toledo, S.A.U, Spain

To Dad and Mom, for their fifty years of marriage

Captions for the preceding pages

Pages 2–3: Wassily Kandinsky, *Picture with a Black Arch* (detail), 1912; Musée National d'Art Moderne, Centre Georges Pompidou, Paris
Pages 4–5: Amedeo Modigliani, *Red Nude (Reclining Nude with Open Arms)* (detail), 1917; private collection
Pages 6–7: Salvador Dalí, *The Persistence of Memory* (detail), 1931; Museum of Modern Art, New York
Pages 8–9: Pablo Picasso, *Guernica* (detail), 1937; Museo Reina Sofia, Madrid
Pages 10–11: Edward Hopper, *Nighthawks* (detail), 1942; Art Institute of Chicago
Page 12: Ernst Ludwig Kirchner, *Berlin Street Scene*, 1913; Brücke Museum, Berlin

Note to the reader

In the chapter introductions, page references are given for works of art (in parenthesis) only for works that do not appear in the chapter itself.

Contents

16 Introduction

22 Art Nouveau

32 Klimt, Schiele, and Kokoschka

44 Picasso, the blue and rose periods

56 Matisse and the Fauves

72 Cubism

86 Futurism

102 Avant-garde movements in Russia

116 Modigliani in Paris

128 Primitivism

138 Die Brücke and the birth of Expressionism

154 Der Blaue Reiter

168 Abstractionism

184 Metaphysical art

194 Dada

206 Surrealism

224 Art in Italy between the World Wars

238 Art in Germany between the World Wars

254 Art in Europe between the World Wars

266 Art in the United States

284 The artists of Latin America

296 Sculpture

310 Art prints

322 Architecture

338 Design and the applied arts

350 Photography

358 Motion pictures

366 1900–45: Events, artists, works

368 *References*

369 *Biographies*

393 *Bibliography*

395 *Index of names and places*

399 *Photographic sources*

The history of the first half of the 20th century was profoundly marked by the two World Wars. The wars caused incalculable loss of human life, both directly, in battles, prison camps, or bombardments, and indirectly, through the terrible suffering caused, the deprivations, scarcity of food, and diseases, beginning with the so-called Spanish flu pandemic that struck immediately after the Great War. The two conflicts also caused profound economic, social, and political upheavals: the first war marked the demise of four empires (German, Austrian, Russian, Ottoman); the second saw the fall of the Nazi and Fascist dictatorships and relocated world leadership from Europe to the United States and, until recently, the Soviet Union. These events had a profound impact on humanity's vision of the world, on culture in all its manifestations, and in particular on art. Art historians and critics usually refer to the first half of the 20th century as the "age of avant-gardes." Every century has had artists who rebelled against tradition. Not satisfied with the version of art they had been taught, they sought to change the style and subject matter of their discipline. Never before, however, had there been such a large-scale and radical challenge to tradition, calling into question the very principles on which the

misunderstood, derided or denigrated, rejected outright or cast into half-hidden corners. This began to change during the second half of the 19th century, by which time industrial and commercial development had created a middle class that could afford to acquire works of art for their homes. At the same time during this period, the church was greatly reducing its involvement and presence in the field. Between 1850 and 1950 what we would today call the art market came into being, with all its laws and characteristic traits. With the exception of certain rare cases, the artist no longer worked in direct contact with a patron. Artists found themselves facing an increasingly vast and numerous public composed of buyers and collectors. Thus, they needed a structure to help them in the work of informing the public and promoting their works. So it was that the figure of the art dealer came to assume increasing importance as the person who promotes his clients and makes them and their work known to potential buyers by mounting group or one-person shows. These events are publicized and made known to potential buyers by art critics, who publish their reviews and comments in the press, both specialized and not. The main concern of the artist (and of the gallery owner sponsoring the artist) became that of

Introduction

Umberto Boccioni,
Riot in the Galleria,
1910, oil on canvas,
76 x 64 cm;
Pinacoteca di Brera,
Milan

creation and use of art were based. This phenomenon can be explained at least partially as a result of societal changes. In the past, artistic activity had been subordinate to the desires of patrons: the nobility for their palaces and castles, the clergy for their churches and monasteries. They imposed not only the subjects and iconography, but also the style, which had to reflect the dominant culture of the period and suit the personal taste of the buyer. There are many famous examples of great artists who had to face tremendous struggles to have their works accepted. Works that are today unanimously embraced as absolute, towering masterpieces were

creating works that would stand out from the many thousands of similar works being shown throughout the world. Doing so meant gaining the attention of critics and thus attracting public attention and convincing collectors of the value of investing in his or her work. Faith in the traditional canons of Western art, in the styles and examples of masters of the past, was thus replaced by the pressing demand to be original and personal, to create something new that would be easily recognizable and identifiable to the point of being admired, appreciated, and desired. A second factor that contributes to explaining the major changes set in motion at the beginning of the 20th century concerns the training of artists and their relationship with traditional teaching. The new century opened under the influence of the Impressionists, who, beginning in the last decades of the 19th century, were leaders of a radical challenge of the official art of the Salon and the academies. Immediately

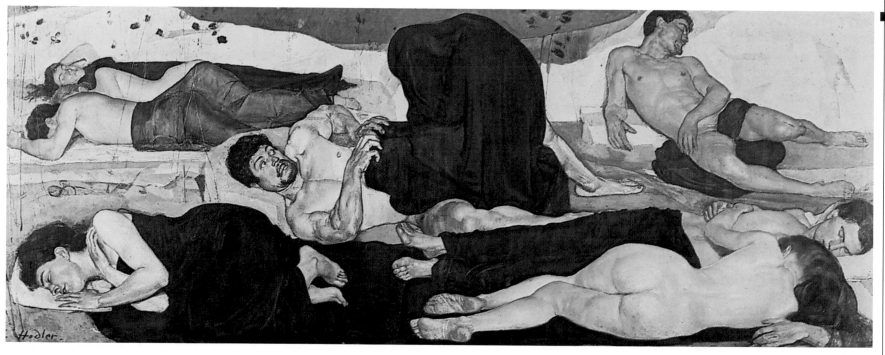

Ferdinand Hodler,
Night, 1980,
oil on canvas,
116 x 299 cm;
Kunstmuseum, Bern

after the Franco-Prussian War of 1870, they followed the example of Courbet and the suggestions of the Goncourt brothers and left behind museum galleries, ateliers, and scholastic halls to draw inspiration from contemporary life, painting landscapes, portraits, still lifes, and scenes of urban or country life, very often doing so from life, *en plein air*. They also adopted a style that involved methods and approaches different from those of their teachers. They showed a preference for color over design; used dense and wide brushstrokes, leaving outlines undefined and shaded; distributed shadows in a different way, using the colors themselves instead of black. They organized space in a new way, closer to the two-dimensional universe of Japanese prints than to the strict rules of perspective dating back to the Renaissance. After being derided, rejected, and insulted for more than a decade, they had been generally accepted by the time of the Universal Exposition of 1889, and the 1900 Exposition marked their triumphant victory. With the exception of Edouard Manet, who died in 1883, the leaders of the Impressionist movement were active into the opening years of the 20th century and exercised great influence on new generations. Different contributions were made by Camille Pissarro (who died in 1903), Paul Cézanne (1906), Edgar Degas (1917), Pierre-Auguste Renoir (1919), and Claude Monet, who died in 1926 at the age of eighty-six. Their legacy can be seen in the series of movements usually referred to as Post-Impressionism; for example, the Pointillists and Nabis at the end of the 19th century, and Fauvism in the early years of the 20th. At the same time,

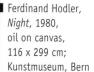

various art movements arose in Europe that sought to alter the definition and role of art in light of new discoveries of science and technology that came with the industrial growth of the times. In general this new attitude can be subsumed under the heading Art Nouveau, which spread—with different names and different characteristic traits—all across Europe.

As had been the case throughout the 19th century, in the first decades of the 20th the Western world's cultural center was Paris, with its theaters and night spots, art galleries and museums, editors and collectors. The city was the focal point for artists, intellectuals, musicians, men of letters, critics, and philosophers, who discussed, debated, and dictated what became the new trends in dominant taste. They created new groups and movements, some with brief, turbulent lives, others destined to leave indelible signs of their passing. Paris was the proving ground on which an unknown aspirant from the provinces could find fame and fortune. Most Western artists either went to Paris or dreamt of going. Some had short stays, some stayed entire lives, and they arrived from all over, from the Spaniard Salvador Dalí to Italian Futurists, from members of the Russian avant-gardes to the Mexican Diego Rivera, from the Romanian Constantin Brancusi to the Pole Tamara de Lempicka. Few had the good fortune to encounter immediate favor from critics and collectors. It could happen, of course, as in the famous example of Giovanni Boldini who, after signing a favorable contract with the publisher Goupil, capitalized on his talent to become the official portraitist of the Belle Epoque, desired and courted by the richest

Lyonel Feininger,
The White Man, 1907,
oil on canvas,
68 x 53.3 cm;
Museo Thyssen-
Bornemisza, Madrid

17

Kazimir Malevich,
*Suprematist
Composition*, 1915,
oil on canvas,
70 x 48 cm;
Fine Arts Museum,
Tula

and most fascinating women. Most artists, however, struggled through years of obscurity before finding a gallery willing to display their works, not to mention a buyer willing to pay money for them. Many were the cases of artists like the Italian Amedeo Modigliani, who spent his life in poverty and misery, almost completely unknown, and died at a young age only to be discovered and adored in later decades.

Standing out over all these artists is the figure of Pablo Picasso, gifted with a strong personality and exceptional charisma and determined to study and assimilate the novelties of the present and unite them with the teachings of the masters of the past. The unchallenged leader for more than fifty years, a prolific and tireless genius, the Spanish painter was always able to remain faithful to himself even while continuously changing subjects and style. He did so from the blue period to the rose, from Cubism to Surrealism, from the "return to order" following World War I to the period of political engagement in the 1930s and the final daring formal experiments of his last decades. Picasso's main competitor was Henri Matisse, known for his proud and passionate spirit. Matisse's art is characterized by the search for a perfect balance between design and color so as to create a light and graceful dance, a hymn to the joy of life.

This contrast between instinct and reason, rhythm and harmony, straight lines and curved lines, order and chaos—a contrast that sometimes shows up in works by the same artist—animated much of the artistic avant-garde of the beginning of the century: from Futurism, which made dynamism an absolute value, to Cubism, which fragmented and refashioned

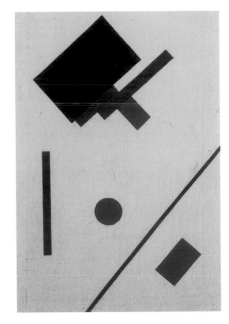

reality in an apparently arbitrary way. Even the various currents of abstract art can be divided into two dominant trends. One trend is composed of those artists who carried out increasingly radical geometric simplifications, leading, for example, to Malevich's *Black Square* or Mondrian's yellow, red, and blue boxes; the other trend is composed of those who created abstract biomorphic forms with flowing and shaded contours, shapes that are irregular and asymmetrical.

During the same first decades of the 20th century, while this artistic activity was taking place in France, Germany and Austria were also home to artists with strong personalities and temperaments. Critics most often group them under the general term Expressionism. They too assimilated and interpreted the style of the Impressionists, most especially the use of color in the works of Paul Gauguin and Vincent van Gogh. They adopted sharp tonal contrasts, creating highly dramatic effects, and limited shading to emphasize the line, accentuating angles and sharply defined shapes and making use of colors that were hardly realistic to create strong visual impact and give their compositions a more dynamic and accelerated rhythm. The style was first used by the Austrian painters Klimt, Schiele, and Kokoschka; its leading exponents were then the painters of the Die Brücke and Der Blaue Reiter groups.

Another phenomenon that assumed great importance early on in the new century was the relationship between European art and the art from non-European countries, in particular so-called primitive art. Even earlier, at the end of the 19th century, many European painters and sculptors had begun to reject the idea that artistic training had to consist of the passive copying of classical works, and to seek inspiration from outside Europe. This was facilitated by the intensification of commercial exchanges with Europe's colonies, which provided Europeans with not only raw materials but also craft products and artworks. Such works of art were exhibited in the leading international shows (such as the universal exhibitions in Paris and London) and were also displayed in the growing numbers of private art galleries. Following the example of Paul Gauguin, many artists set off on trips to Africa, Asia, or Occania and encountered many sources of inspiration. The encounter with African and Asian art, as well as with the art of the populations of the various islands of the Pacific, helped European artists create new images and new forms, in a personal and original synthesis.

Wassily Kandinsky,
Several Circles, 1926,
oil on canvas,
140 x 140 cm;
Solomon R.
Guggenheim Museum,
New York

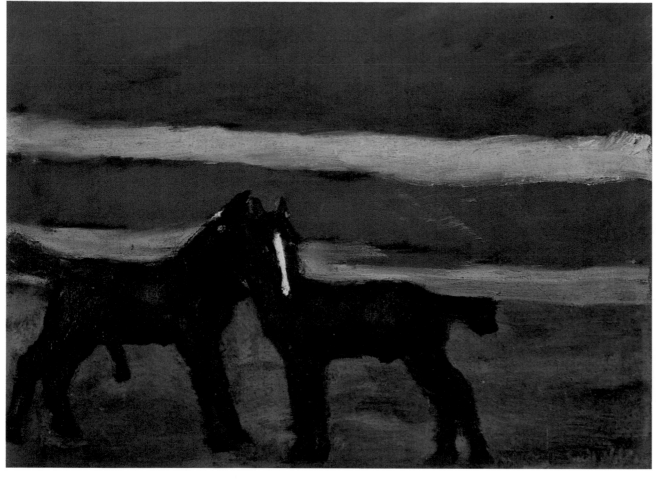

Emil Nolde, *Young Horses*, 1916, oil on canvas, 73 x 100 cm; Museum Am Ostwall, Dortmund

which the artist decides to grant artistic dignity. Surrealism and Dada, which proposed an art that was as lighthearted as it was irrational and irreverent, present one of the attitudes taken by artists in response to World War I. The other response was the call for a "return to order," a deliberate return to representational art and the styles of the masters of the past, meaning art expressed following solid rational values, both in technique and content. Examples of this movement are numerous, most especially in Italy and Germany, but in general throughout Europe, from the so-called classical period of Picasso to the members of Italy's Novecento movement and Socialist Realism in the Soviet Union. This rational approach to art can also

World War I marked a clear break in the life and creativity of many artists and caused two antithetical attitudes. The first reflected the climate of destruction and upheaval that accompanied the collapse of political and social realities that had once seemed indestructible and unchangeable. This attitude made its way into artistic disciplines, creating in them the desire to flee from a reality so depressing and unpromising to take shelter in new fantasy worlds. The outstanding examples of this are: Metaphysical art, which interpreted reality through allegory and symbolism; Surrealism, which led artists to flee the real and rational to explore the realm of the subconscious, dreams, and madness; and, most of all, Dada, which took certain notions from Futurist artists to their extreme conclusions, glorifying the spontaneous expression, the impulsive gesture, the most absurd and paradoxical combination, free of logic, intention, or meaning. The symbol par excellence of Dada is one of Duchamp's readymades, destined to have a profound influence on the artistic expression of the second half of the century. The readymades cancelled out all of the physical work of art, putting the emphasis on the artist's intuition: the artist does not make anything but only selects objects already made and at the most assembles them or intervenes in some other limited way. These works erased all the classical divisions among the various disciplines (painting, sculpture, design, graphics, photography) and paid no attention to traditional techniques (oils, tempera, watercolor), since they can be constructed with any material to

be made to include the Bauhaus School, in which Gropius and the other teachers eliminated every decorative and superfluous element and simplified forms to achieve an essential linearity. Their objective was the creation of a "total" work of art, one that would blend painting, sculpture, the decorative arts, and architecture. The emblem of this was the Gothic cathedral, the construction of which had required exactly this kind of cooperation among the many artistic disciplines.

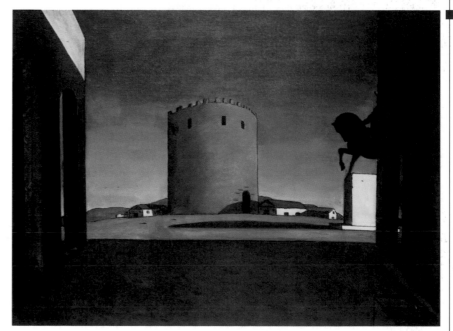

Giorgio de Chirico, *The Red Tower*, 1913, oil on canvas, 73.5 x 100.5 cm; Peggy Guggenheim Collection, Venice

The European art of the first half of the 20th century influenced the style of many American artists, both in the United States and in the countries of Latin America. This connection had already existed in the second half of the 19th century. A famous example is the exhibit of Impressionist works mounted by the French art dealer Durand-Ruel in the United States; there are then such artists as John Singer Sargent, James Abbott McNeill Whistler, and Mary Cassatt who traveled to Europe, where they visited museums, studied in art schools, and associated with the exponents of the major art currents of the end of the century, from the Macchiaioli in Italy to the Pre-Raphaelites in England and the Impressionists in France. These cultural exchanges between the Old World and the New intensified in the first decades of the 20th century. So it was that Diego Rivera made friends with Modigliani and Picasso in Paris, Tina Modotti spent part of her life in Mexico, and Man Ray performed a fundamental role in the spread of Surrealism. Among the many other examples that could be cited is the Armory Show held in New York from February 17 to March 15, 1913, in which about 1,250 paintings by three hundred artists were shown, offering

a comparison between the art of Europe and that of the United States. The show was a crucial event for many reasons, making way as it did for a series of fundamental and illuminating encounters. Aside from the excitement and interest awakened by the event and amplified by the critics and mass media, it drew the attention of American collectors to this new art. This had important results, including some economic. The many artists active in the Americas can be roughly divided into those who sought a return to indigenous roots and those whose attention was drawn to the ideas of avant-garde movements. Standing out among the artists in the United States were the members of the Eight (so-called from the show held in 1908 at the Macbeth Gallery in New York). There was also Edward Hopper, who presented his own view of life in the Unites States with its energy, its hopes, its dreams, but also its fears and loneliness and lack of communication: and, in Mexico, the three great "muralists," Siqueiros, Orozco, and Rivera, as well as Rivera's wife Frida Kahlo.

The first half of the century saw important developments in other artistic disciplines, beginning with sculpture and art prints. The important changes in both of these disciplines involved new techniques and new materials, but also new subjects, from scenes of daily life to abstract compositions, geometric and informal. The fields of architecture and design underwent a stylistic and conceptual evolution

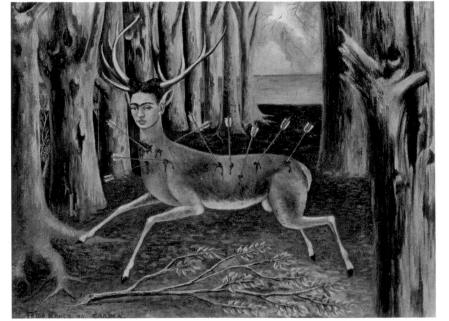

directed at the creation of a new way of living and new way of inhabiting public and private spaces, most especially large cities. The field of design was still the subject of a lively debate—one that dates back to the middle of the 19th century—on the possibility of increasing the value of objects that are mass produced by giving them aesthetic value. The period covered by this book also involves the growth of new forms of artistic expression: photography and the motion picture. From the first photographic experiments of Daguerre early in the 19th century, painters and sculptors looked upon this new discovery with great interest, and many made use of it in order to better perceive aspects of reality that are not immediately visible, such as human motion. The fact that the first Impressionist show, held in Paris in 1874, was set up in the studio of a photographer, Nadar, is emblematic of photography's importance, as is the fact that the sequence photographs by Muybridge showing the movements of humans and animals were used by many painters, from Degas to Duchamp. Over the span of fifty years photography replaced painting as the primary means for documenting and representing reality. Painters were stimulated by this shift to redefine their role, their function, and their goals; as for the photographers, they came to realize that their device was not as impersonal and neutral as might have been thought, but that it could be used to create works of art expressing emotions and sentiments.

The same discussion can be

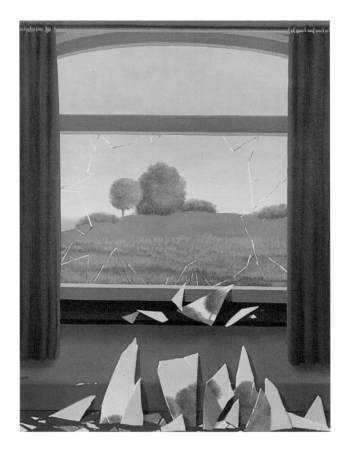

applied to the cinema, which went through an astonishing evolution over the span of a few decades, an evolution in terms not only of technique (from black and white to color, from silent to sound) but of language. Film's evolution made possible its vast diffusion, and its extraordinary impact on the whole world. During the first decades of film's history the French school led the way, followed by the Italian and the German, but by the 1920s the great Hollywood film industry had come into being, and it soon attracted the best minds from throughout the world and came to monopolize much of the production and distribution of films worldwide.

All in all, this volume illustrates the creations of the leading figures of an extraordinary historical and cultural period, showing both their most important and best-known masterpieces and lesser-known works that are of equal importance. Because of space limitations the coverage cannot claim to be either complete or exhaustive, but it is hoped that the presentation and explanation of this period of art history will serve as the stimulus for further study and that it will make a visit to a museum or gallery of modern art a more satisfying and enjoyable experience.

■ René Magritte, *The Key of the Fields (La Clef des Champs)*, 1936, oil on canvas, 86 x 60 cm; Museo Thyssen-Bornemisza, Madrid

■ Pablo Picasso, *On the Beach (La Baignade)*, 1937, crayon and chalk on canvas, 130 x 195 cm; Peggy Guggenheim Collection, Venice

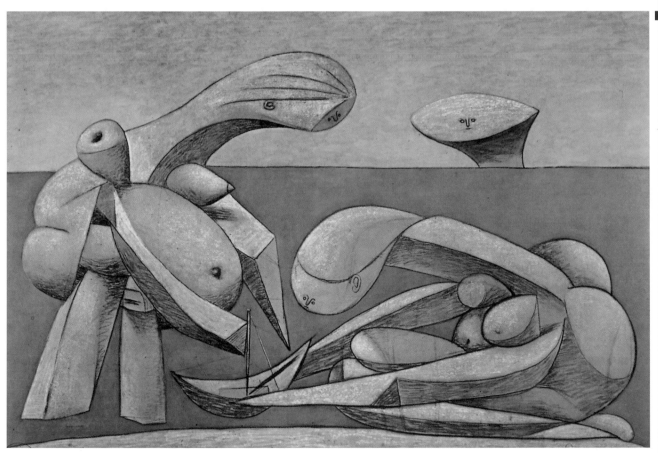

The 1900s opened with the Universal Exhibition of Paris, which ran from April 15 to November 12, 1900. The last such exposition to be called "universal," it was grander and more impressive than the 1889 exhibition, which had been dedicated to the centennial of the French Revolution. The theme in 1900 was the "balance of a century," meaning a celebration of the progress made in the fields of science, art, and culture in the 19th century, as well as an anticipation of the progress to come in the century just beginning. Under the direction of the general commissioner Alfred Picart, enormous pavilions were set up occupying an area of 112 hectares (an entire section of Paris). Nearly 83,000 exhibitors from around the world participated, and more than 50 million people are believed to have visited the show. Among the most popular exhibits were the demonstrations of new applications of electricity, which had ceased to be merely experimental and had begun to make its way into daily life. Visitors were astonished by the progress made in the field of photography, but even more amazing were the first motion-picture projections on a large screen by the Lumière brothers. The Petit Palais and the Grand Palais, built for the occasion, presented two painting exhibitions, one dedicated to the art of the 19th century in general, the other to works of the last decade, with paintings by the Impressionists much in evidence, a reflection of their final triumph on the artistic scene during those years. Also participating were many young artists, exponents of Art Nouveau.

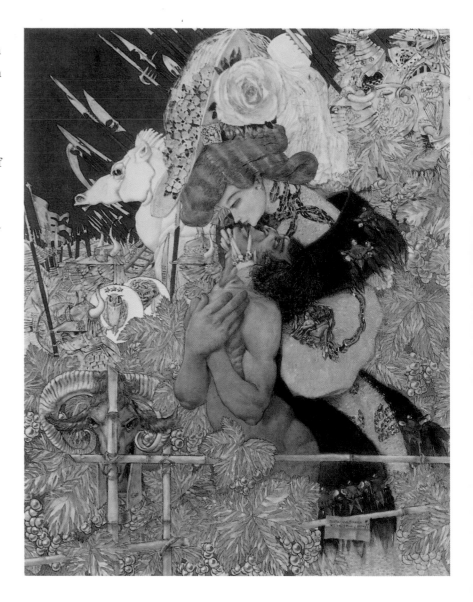

The name *Art Nouveau* is derived from the Maison de l'Art Nouveau, an art gallery specializing in interior design that S. Bing (1838–1905) opened in December 1895 in Rue de Provence. Rather than a true art movement, Art Nouveau refers to an attitude, a state of mind shared by artists who were otherwise quite different in terms of sensibility, cultural training, and interests. These artists were active in many disciplines, from painting to architecture, from the decorative arts to literature. Art Nouveau assumed different names in the various European countries in which it developed. In Austria it was called Sezessionstil because of its derivation from the Secession, and its most representative and authoritative exponent was Gustav Klimt; in Germany it was known as Jugendstil, from the magazine *Jugend* ("Youth"), founded in Munich in 1896, and its diffusion was favored by the birth of the Vereinigte Werkstätten für Kunst und Handwerk ("United Workshops for Art and Craftwork"), active in Munich and Dresden beginning in 1897, which primarily involved architects and designers. In Italy, Art Nouveau was known as the Stile Floreale, for the preference it gave botanical subjects, or the Stile Liberty, named for the emporium opened in London in 1875 by Arthur Lasenby Liberty (1843–1917). In Scotland it found expression primarily through the Glasgow School of Art, dominated by the figure of Charles Rennie Mackintosh; in Britain it was called the Modern style and continued the work of the Pre-Raphaelites, in particular William Morris and the Arts and Crafts Movement. In Spain it was baptized Modernismo and Barcelona was its leading center, where Ramon Casas, Santiago Rusiñol, Isidre Nonell, and Joaquim Mir were active.

Gustave-Adolphe Mossa, *The Kiss of Helen*, circa 1904, oil on canvas, 92.1 x 73 cm; private collection

Friedrich König, *The Muse of Music*, circa 1900, watercolor and gouache on panel, 129.5 x 52 cm; private collection

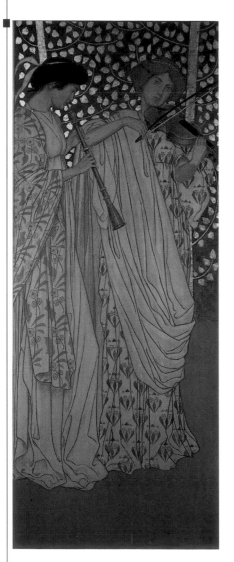

The driving force behind most of Art Nouveau was a reaction against the concept of art as an imitation and repetition of the styles and models of classical art, which is exactly how art had been codified and taught for decades in Europe's art academies. In the past, an art student had spent years working in a master's studio so as to assimilate the master's technique and style; or the student spent most of his apprenticeship copying the classical works displayed in public institutions and private collections. During the 19th century, beginning with Romanticism, the criteria followed in the training and selection of young students were called into question, with a turn in favor of artistic creation over mere imitative ability. By the time the 19th century was nearing its close, this new sensibility was being reinforced by the widespread application of industrial processes, which radically changed not only the economy and societal

and tradition, the industrial mentality looked elsewhere: at progress and the continuous innovations and improvements that science and technology brought to work and everyday life. At the same time, young artists—sometimes out of utopian optimism, sometimes ingenuously—proclaimed the superiority of the new, presenting newness and originality as objective values toward which every work of art must aspire. The most obvious effects of this new concept showed up in architecture and the applied arts, but there was no lack of important examples among the painters who anticipated and laid the basis for the avant-garde experiments of the opening decades of the 20th century.

Of course, not all artists shared the same attitude to industrial production. Along with those who enthusiastically embraced the discoveries of modern technology there were artists who denounced

Art Nouveau

relationships but even more the way in which life and the world were judged and evaluated. While a society based on cattle breeding or agriculture might well attribute fundamental importance to experience

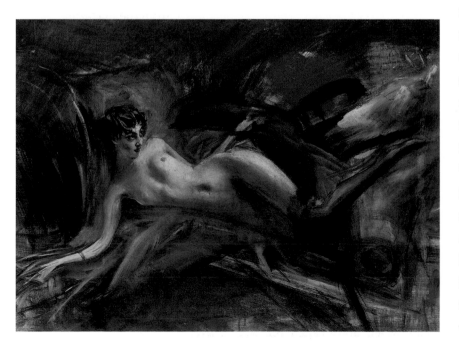

the leveling of standards wrought by mass production and valued instead the quality of uniqueness in artistic creation. Similar contrasts can be found between those artists who adhered to positivism and those who followed the spiritualist movements; between those who were drawn to humanitarian socialism and those who maintained an aristocratic outlook; between those who sought to achieve a detailed, almost scientific realism and those who followed the simplification of forms to the outer borders of abstraction. Because of its anti-academic stance and its yearning to break free of the limitations of what had been produced in the past, by continuously seeking new solutions and new subjects, the "modernist" aesthetic cannot be readily codified and must be seen instead as the expression of a wide range of innovative figures who rarely painted in groups and most often preferred to express their creativity on an individual basis. Traits shared by almost all these artists, however, include an increased attention to decorative aspects, often inspired by Japanese prints—at the time widespread and popular—and to symbolic themes, reworked in personal and original ways with a great variety of subjects.

FERNAND KHNOPFF
The Caress
(The Sphinx)
1896, oil on canvas
50.5 x 151 cm
Musée Royaux des
Beaux-Arts, Brussels

Two very different
female types appear
in the works of this
Belgian painter.
There is the angel-
woman, symbolic
of purity and
spirituality, and
there is also, as
in this work, the
sphinx-woman,
imbued with a
certain mysterious,
feline sensuality
that fascinates but
that can also lead its
victims to perdition.

JAN TOOROP
Fatality
1893, watercolor
and pen on paper
60 x 75 cm
Rijksmuseum Kröller-
Müller, Otterlo

In 1892 Toorop
exhibited at the
Salon de la Rose +
Croix in Paris—a
cultural association
of Symbolist
inspiration with an
irrational and esoteric
vision of art—and
over the following
months he made
various works,
including this one.
In this painting he
reworked various
themes from the
culture of Java,
where he was born,
blending them with
ideas drawn form
the works of Odilon
Redon, Fernand
Khnopff, and the
Pre-Raphaelites.
He thus abandoned
the realism of his
youthful landscapes
to paint complex
allegorical scenes
with elaborate
layouts.

EDGAR MAXENCE
Woman with an Orchid
1900, oil on panel
58 x 44 cm
Musée d'Orsay, Paris

Student of Jules-Elie Delaunay and Gustave Moreau, one of the leading representatives of French Symbolism, Maxence began exhibiting at the Paris Salon in 1894 and took part in various shows at the Salon de la Rose + Croix. So closely did he study the works of the Pre-Raphaelites that he came to be called the "Breton Burne-Jones." From them he learned to paint half-bust female portraits such as this one, characterized by an ethereal, languid, and dreamy beauty, perhaps a little affected and artificial. The woman depicted directs her serene and tranquil gaze at the viewer, almost as though expecting the viewer to begin a conversation with her or to invite her to take a stroll in the woods that appear behind her. The image is clear and precise, with attention given the smallest detail, and it is embellished by the careful application of light, which delicately caresses the colors to create an atmosphere suspended between reality and a dream.

Idleness
1900, oil on canvas
99.1 x 58.4 cm
Private collection

John William Godward
is among the best-
known members of
the pictorial genre
called the "Victorians
in toga," paintings
showing scenes of
domestic life, almost
always languidly
sentimental, set in
ancient Greece, Rome,
or Egypt; it was a
type of work much
loved by Godward's
compatriots, who saw
themselves in the
figures portrayed. This
is the second version,
more refined in detail
and more attentive to
the emotional and
psychological aspects,
of a painting that
Godward had made in
1891 called *Pastime*,
today in a private
collection. In both
works a young girl,
clearly bored, is
seated on a marble
seat overlooking the
sea, using a long
peacock feather to
tease her kitten,
which is attracted
and at the same time
frightened by the
mysterious object.
The girl wears an
elegant yellow tunic
with a purple stole
that brings out the
pallor of her skin, one
of the admired traits
of female beauty in
ancient Rome.

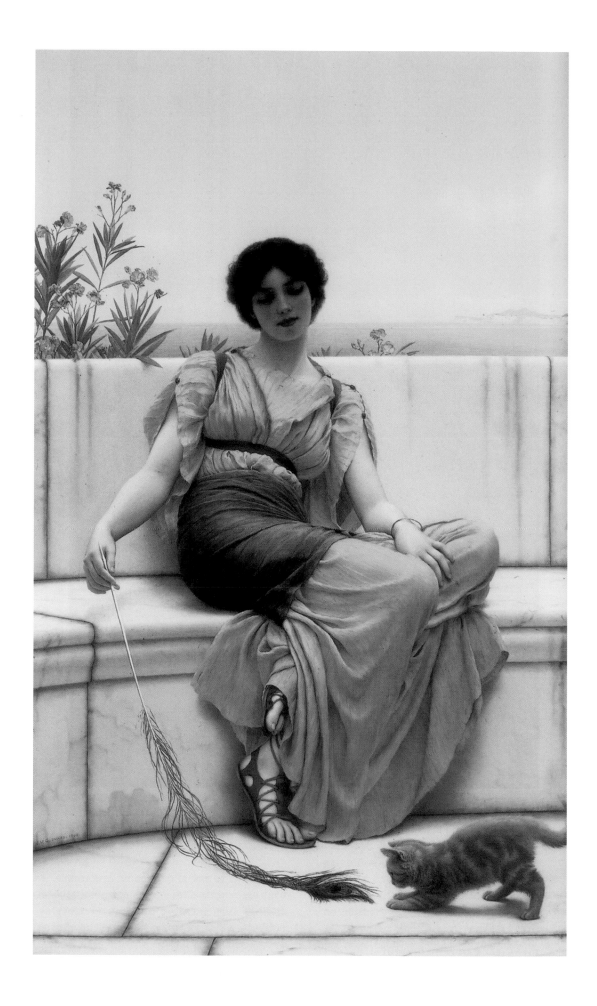

■ WILHELM LIST
**Night Rises
from the Sea**
1904, tempera and
silver on canvas
158 x 64.5 cm
Private collection

List drew inspiration
for this painting
from *Pallas Athene*
(Historisches Museum,
Vienna), an 1898
work by Klimt; it
also shows many
stylistic affinities
with *The Three Brides*
by Jan Toorop
(Rijksmuseum Kröller-
Müller, Otterlo),
which was in the
seventh Secession
show, in March-June
1900, and with the
central figure in
Ferdinand Hodler's
painting *The Truth II*
(Kunsthaus, Zurich),
displayed at the
nineteenth Secession
show, in January-
March 1904.

■ GEORGES DE FEURE
The Art of Glass
1900, oil on canvas
280 x 103 cm
Private collection

This is one of seven
large canvases that
de Feure made for the
northern façade of
the Art Nouveau
pavilion at the
Universal Exposition
in Paris in 1900. The
cycle was based on
the theme of the
applied arts; in each
panel de Feure
painted a female
figure meant to be
an allegory to the
discipline
represented—
Architecture,
Sculpture, Ironwork,
Jewelry, Ceramics,
Brass, and the Art
of Glass.

FERDINAND HODLER
The Sacred Hour
circa 1910,
oil on canvas
175 x 77 cm
Aargauer Kunsthaus,
Aarau

In 1905 Hodler went
to Italy and was
finally able to see
works he had studied
through photographic
reproductions; in
particular he was
struck by the
powerful, energetic
figures sculpted by
Michelangelo for the
Medici tombs in the
church of San
Lorenzo, Florence.
This painting is one
of the best examples
of his work from later
years in which he
sought to translate in
paint the expressive
force of
Michelangelo's
sculpture. To do so
he employed a
meticulously accurate
line to create the
woman's long,
graceful figure, her
almost theatrically
posed gesture, and
the firm and resolved
expression on her
face, which conveys
an indication of the
inner tension of her
soul. The intense
colors that Hodler
used, which place the
composition in the
sphere of the epic
and heroic, were to
have a strong
influence on the style
of the Expressionists.

■ GIOVANNI BOLDINI
Marchesa Luisa Casati
1914, oil on canvas
136 x 176 cm
Galleria Nazionale
d'Arte Moderna, Rome

Luisa Amman was born in 1881 into a rich family of textile industrialists; when very young she married the marchese Camillo Casati Stampa and died in 1957. Learned and refined, extravagant and enchanting, eccentric in dress, a collector of exotic animals and organizer of magnificent parties, she loved the company of artists and intellectuals. She was the inspirational muse, patron, friend, and sometimes lover to artists such as D'Annunzio, Cocteau, Marinetti, Kerouac, van Dongen, Balla, Alberto Martini, Man Ray, and Cecil Beaton. Boldini had already made a portrait of her, around 1908, that received much positive response at the 1909 Salon. In this second work he presents her in a more daring and unconventional pose. Boldini shows all his talent in his rapid and incisive style, which bordered on the virtuosic with hints of narcissistic self-satisfaction, thus a style perfectly in tune with the noblewoman's character.

SANTIAGO RUSIÑOL
View of Cuenca from the Júcar River
1916, oil on canvas
100 x 130 cm
Private collection

Rusiñol was the charismatic leader of Catalán Modernismo. The term *modernismo* appeared for the first time in Spain in 1884 in the magazine *L'Avenç,* which in the two following decades became the principal expression of the various innovative trends that animated the Iberian culture of the time (in particular the Catalan) and helped in the formation of personalities such as Pablo Picasso, Joan Miró, and Salvador Dalí. Rusiñol was also one of the principal animators of the café known as Els Quatre Gats ("The Four Cats"), which performed a role similar to that of the Café Guerbois and La Nouvelle Athènes for the French Impressionists. This work was presented for the first time at the Sala Parés in Barcelona, where the Modernists began exhibiting in 1890. Although these exhibits received a negative response from critics, still entrenched in academic positions, they gave the artists the opportunity to present to the public their new methods and themes, some of which were similar to the Symbolist current in the rest of Europe.

Girl with Loose Hair and Tulips
1920, oil on canvas
76.8 x 66.9 cm
Mucha Foundation, Prague

Mucha was among the most important Art Nouveau artists, famous for his alluring female figures: their long hair moved by the wind, their diaphanous classical-style clothes, and their thoughtful, moody expressions. His preferred technique was lithography, but he also worked in painting, sculpture, photography, and the decorative arts. Between 1910 and 1920, in his studio in the castle of Zbiroh in Bohemia, he painted twenty large scenes based on the history of the Slavic people, various portraits, and several fantasy visions. Here Mucha uses a highly restricted range of colors, made even paler and more evanescent by a cold, dull light that he applies with refined skill to create an atmosphere packed with emotional tension. The viewer's attention is drawn to the expression of the girl; mysteriously she almost loses her individual identity and becomes a symbolic figure: a modern Mary Magdalene; an allegory of faith and hope.

he outstanding feature of Vienna's cultural life during the closing years of the 19th century was the Secession; these shows attracted the participation of all artists who saw the teaching of art academies as obsolete and hoped to radically change the style and content of their art. In March 1900, at the seventh show of the Vienna Secession, Gustav Klimt presented his not yet finished *Philosophy*, freely inspired by the *Gates of Hell* (see page 298) by Auguste Rodin. This was the first of three canvases that the Austrian ministry of culture and education had commissioned him to make in 1893 for the ceiling of the Great Hall in the University of Vienna. The composition caused a sensation, awakening loud and angry controversy. Although it went on to win the award for best foreign work at the Universal Exposition in Paris that year, it was harshly criticized by the press and was rejected by the official authorities, who had expected something altogether different: not just more solemn,

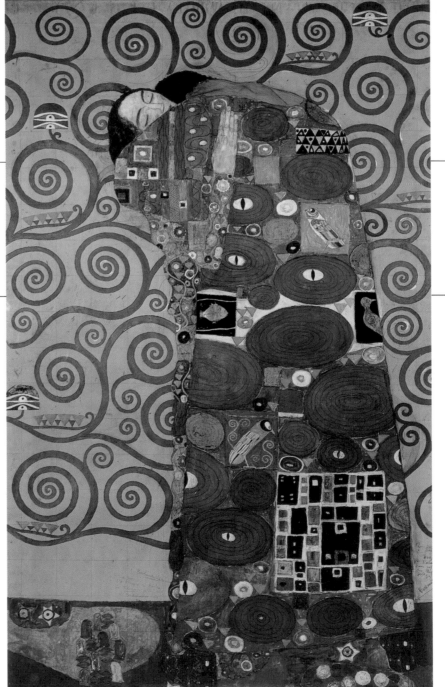

but most of all more optimistic and reassuring. The debate raged on, growing only more bitter a few months later when the other two allegories, *Jurisprudence* and *Medicine*, were shown. The deputy Alfred von Steine together with twenty-one colleagues asked the ministry of education to have the canvases destroyed, awakening a heated public debate on the state's view of the freedom of artistic expression. These works—which later became part of the Lederer Collection and were lost in 1945 in the fire in Immendorf Castle—

fully expressed Klimt's new aesthetic endeavor, destined to influence much of modern art.

Klimt's artistic training, which eventually led him to create these controversial works, began in his childhood, when his father, Ernst, a skilled engraver and goldsmith, taught him the application of dense design, richly elaborate and extending to the smallest space. The lessons he took at the School of Applied Arts, which he attended from 1876 to 1883, endowed him with great confidence and skill in the organization of masses and the use of color. These skills enabled him, working together with his brother Ernst and school friend Franz Matsch, to obtain prestigious commissions, including the decoration for the National Theater of Bucharest and the Burgtheater in Vienna. For Klimt, 1897 was a year of fundamental importance, marking as it did the beginning of new artistic efforts. On April 3 the Vereinigung Bildender Künstler Österreichs ("Union of Austrian Visual Artists"), known as the

Klimt,

Vienna Secession, was officially instituted. The forty founders elected Rudolf Alt honorary president and Gustav Klimt acting president. Klimt was involved in intense activity over the next two years. He oversaw publication of the magazine *Ver Sacrum*, official organ of the Secession, to which he contributed drawings and critical essays; he took part in the organization of exhibits in the organization's headquarters—the Secession Building by Joseph Maria Olbrich; and he painted portraits and landscapes. In 1902, on the occasion of the fourteenth

Secession show, on the invitation of architect Josef Hoffmann, he made the *Beethoven Frieze* to decorate the hall in which a polychrome sculpture of Beethoven by Max Klinger was placed. The frieze is composed of seven panels, more than two meters high and twenty-four meters long, that present symbolic images of the Ninth Symphony. In the spring of 1903 Klimt went to Venice and Ravenna and was greatly impressed by the Byzantine mosaics he saw: their formal simplifications; the reduction of space to two dimensions; the rarefied and unreal atmospheres; the noble majesty of the figures; and the richly decorated backgrounds, especially those

the many young Austrian artists who attended it was Egon Schiele, then seventeen. Klimt recognized his precocious talent and encouraged him to continue his artistic studies. When Schiele was forced to abandon his studies at the Vienna Academy by the rigid and intransigent attitude of his professors, Klimt obtained various commissions for him from the Weiner Werkstätte, invited him to exhibit in the Kunstschau shows, and introduced him to important collectors, among them August Lederer. Finally, in 1913, Schiele was accepted into the Bund Österreichischer Künstler ("League of Austrian Artists"), of which Klimt was president. Oksar

■ Egon Schiele,
Self-portrait with Black Vase and Spread Fingers,
1911, oil on panel,
27.5 x 34 cm;
Historisches Museum,
Vienna

Schiele, and Kokoschka

done in gold. The result was some of his best-known masterpieces, those of his so-called gold period. In 1904 he received another important commission from Josef Hoffmann, busy with the construction of a home for Adolf Stoclet in Brussels (see page 329). For the dining room of the rich industrialist Klimt designed three large mosaic panels made in the workshops of the Wiener Werkstätte ("Viennese Workshop") between 1905 and 1911. With their great force and beauty, these images anticipate many stylistic techniques used by the Expressionists and in abstract art.

The debates and arguments over Klimt's work and personality did not abate, and eventually caused an internal schism in the Vienna Secession. In 1906 Klimt founded a new group, known variously as the Kunstschau ("Art Show") and the "Klimt group," because of his dominant role. Standing out among

Kokoschka was another Austrian painter who got his training under Klimt's guidance. As a student at the school of decorative arts in Vienna, he contributed to the Wiener Werkstätte and the Kunstschau, for which he made a poster in 1908. In 1916 Klimt, Schiele, and Kokoschka took part in an exhibit of Austrian artists in the Secession of Berlin; this proved to be the swan song of the Vienna Secession. By then World War I, which eventually led to the dissolution of the Austro-Hungarian Empire, was in its second year. Klimt died on February 6, 1918, Schiele on October 31 of the same year. Kokoschka survived to develop his own Expressionist style, which he learned through association with the members of Die Brücke ("The Bridge") and Der Blaue Reiter ("The Blue Rider") groups and which he refined during his years teaching in Dresden.

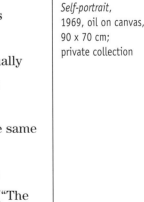

■ Oskar Kokoschka,
Self-portrait,
1969, oil on canvas,
90 x 70 cm;
private collection

GUSTAV KLIMT
Judith I
1901, oil on canvas
84 x 42 cm
Österreichische
Galerie, Vienna

This painting, also
known by the title
Salome, anticipates
Klimt's gold period
in its rich decoration,
the semitransparent
dress, the precious
collar, and the
background, which
recalls an Assyrian
bas-relief of the 7th
century BC from the
palaces of Nineveh
preserved in the
Louvre. In this canvas
Klimt emphasizes the
contrast between the
sensual, almost
ecstatic pose of the
woman and the
decapitated head
of Holophernes.

GUSTAV KLIMT
Hope I
1903, oil on canvas
181 x 67 cm
National Gallery of
Canada, Ottawa

Klimt here reworks
and elaborates a
group of figures
previously depicted
in the upper right of
Medicine, painted for
the University of
Vienna. This work
was the subject of
scandal because of
its presentation of
a naked pregnant
woman near a
skeleton and other
disturbing figures;
there were critics
who interpreted the
composition as the
image of a satanic
birth. The canvas
was supposed to be
publicly exhibited in
1903, but the minister
of education, von
Hartel, intervened,
and the work was
not displayed.

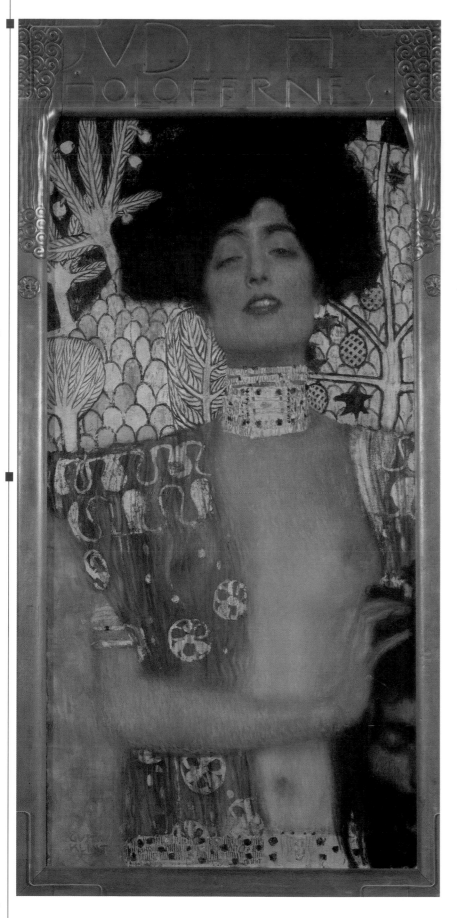

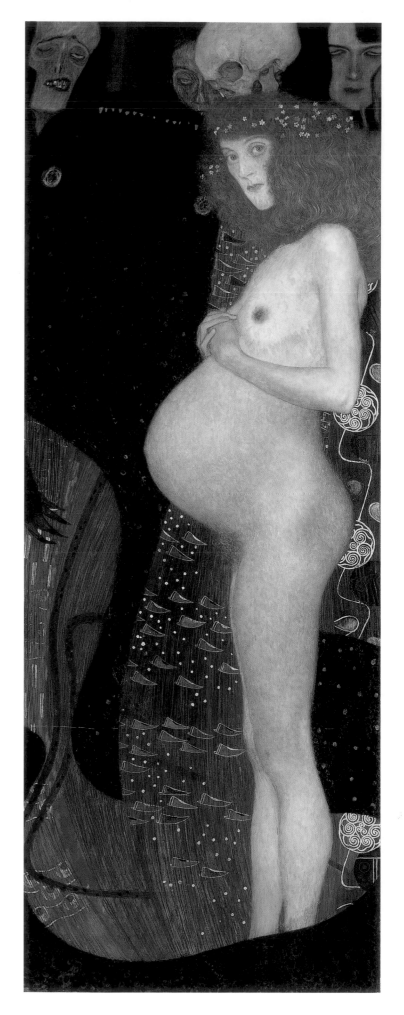

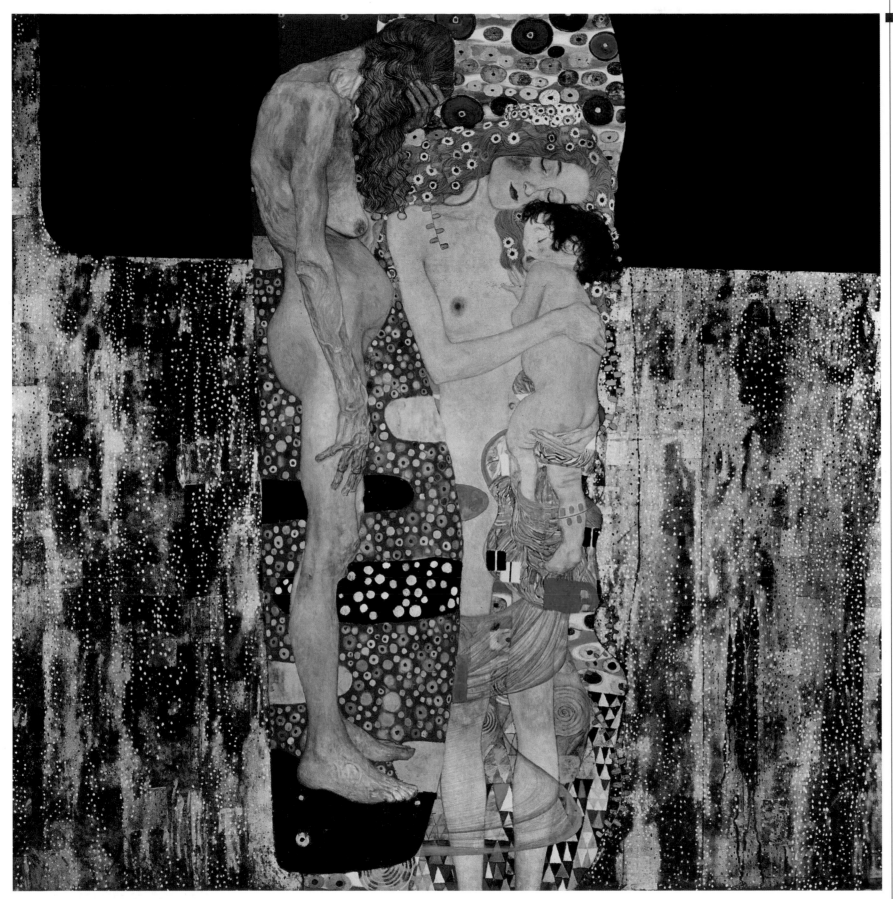

■ GUSTAV KLIMT
**The Three Ages
of Woman**
1905, oil on canvas
180 x 180 cm
Galleria Nazionale
d'Arte Moderna, Rome

This work was first
exhibited in the
second show of the
Deutscher
Künstlerbund
("League of German
Artists") at Berlin in
1905. It was later
presented, not
without criticism and
debate, at Mannheim
and then Vienna in
1907, and won a gold
medal at the
international
exhibition of art in
Rome in 1911. The
abstract background,
partially decorated
with geometric
motifs, locates the
figures in an
allegorical dimension,
symbolic of the cycle
of human existence.
In the foreground
Klimt locates a
delicate scene of
maternity, presented
in pale colors and soft
shades. The baby
sleeps serenely in the
arms of her mother;
the mother too is
depicted with eyes
closed and an
expression of intense
inner happiness. The
third figure,
representing old age,
appears in shadow,
her body marked by
her years and posed
in a position of
discomfort, almost of
surrender in the face
of the inescapable
approach of death.

Adele Bloch-Bauer
1907, oil on canvas
138 x 138 cm
Österreichische
Galerie, Vienna

Adele Bloch-Bauer, the subject of this work, was the daughter of a rich banker and the wife of the owner of a sugar refinery. One of Klimt's most beautiful portraits, this work is a splendid example of his gold period. The woman is literally absorbed by the decorative background, made with an abundant wealth of gold and silver leaf that creates a complex two-dimensional geometric motif. The woman's pale, ethereal face is in sharp contrast with the dark mass of her hair. There is a certain fascination in her languid and pained expression, while her hands, nervously joined and bent in an almost unnatural way, give a sense of profound agitation. The complex relationships between Klimt and his models inspired the Viennese dramatist Arthur Schnitzler to create the character of the painter Gysar in his *Comedy of Seduction*, a play set in 1914 and published in 1924.

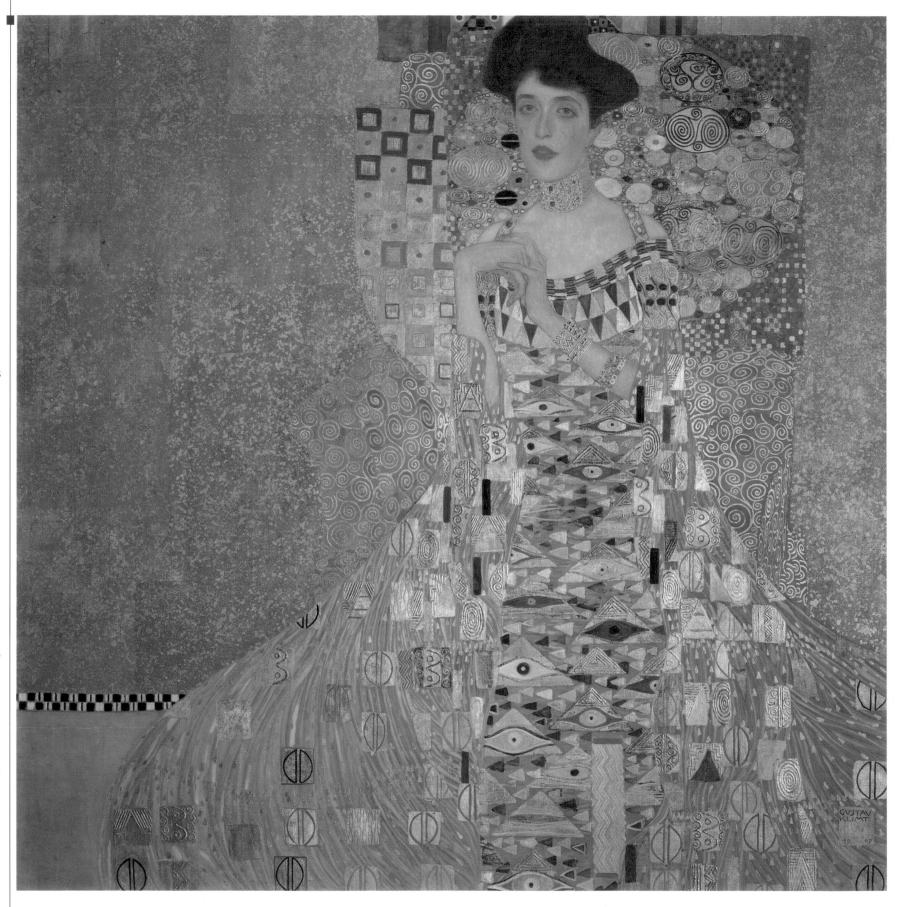

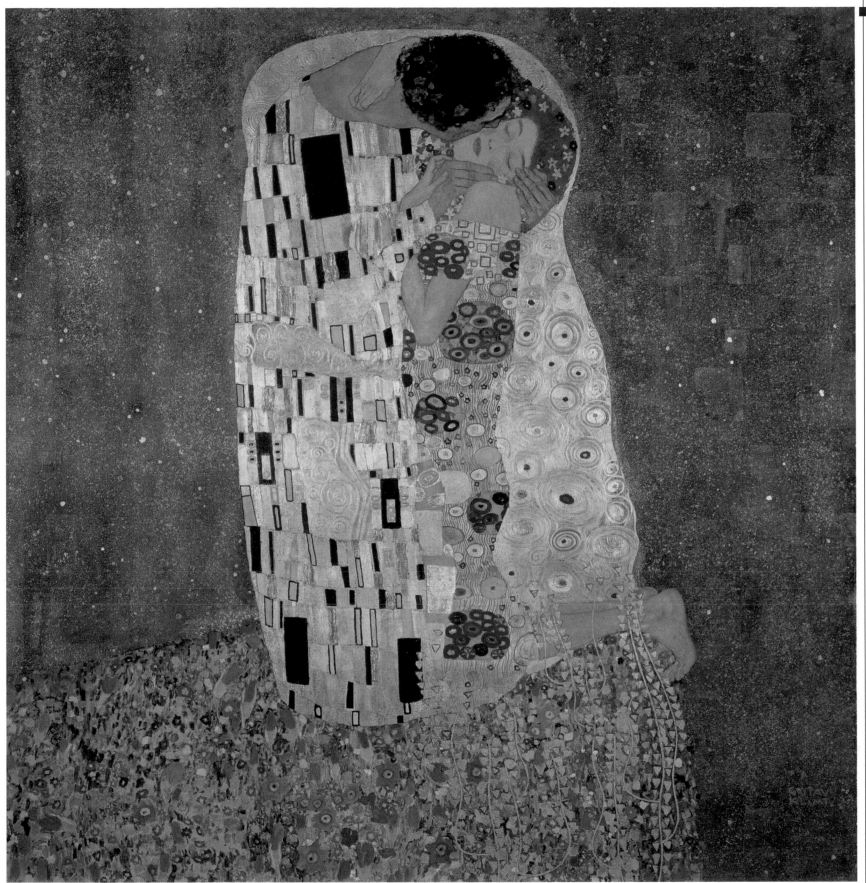

■ GUSTAV KLIMT
The Kiss
1907–08,
oil on canvas
180 x 180 cm
Österreichische
Galerie, Vienna

Klimt's best-known and most popular work, this is considered the masterpiece of his gold period and a perfect synthesis of his art. Klimt had already depicted lovers embracing in his *Beethoven Frieze* of 1902 as well as in the decorations he made for the Palais Stoclet in Brussels between 1905 and 1911. He also made use of rich floral backgrounds and complex gold and silver decorations in other works of this period. Thus, no new elements appear in this canvas; even so, it is endowed with a greater sense of harmony than those works, and its perfect balance and felicitous inspiration make the viewer identify with the two figures, so totally enrapt by the magical force of their love. The work had a great influence not only on the exponents of Art Nouveau but on many Expressionist painters, and it was of primary importance to the later efforts of abstract painters.

GUSTAV KLIMT
Judith II
1909, oil on canvas
178 x 46 cm
Galleria
Internazionale d'Arte
Moderna di Ca' Pesaro,
Venice

In this canvas Klimt
repeated the theme
of 1901 (see page
34), but with a
different stylistic
arrangement. He
eliminated the gold
and accentuated the
emotional quality of
the colors, thus
approaching the
powerful chromatics
of the Fauves and the
Expressionists. The
sensual and seductive
woman reveals her
inner tension in the
position of her
spasmodically
clenched hands.
This painting was
exhibited at the 1910
Venice Biennale,
where it was acquired
by that city's gallery
of modern art.

GUSTAV KLIMT
Adam and Eve
1917–18,
oil on canvas
173 x 60 cm
Österreichische
Galerie, Vienna

One of Klimt's last
works, this painting
was left unfinished.
Eve's pose and
expression recall
one of the figures
in the allegory of
Jurisprudence painted
for the University of
Vienna. The
decorative elements,
such as the flowers
in the lower area,
are reduced to a
minimum to give
space to the two
figures, symbolic
of eternal love.

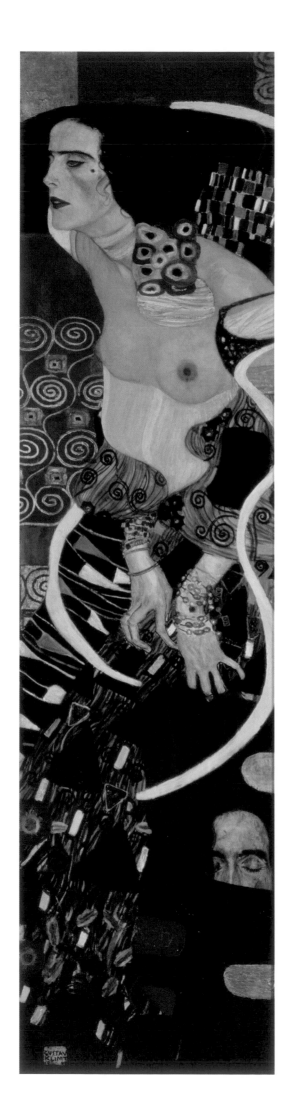

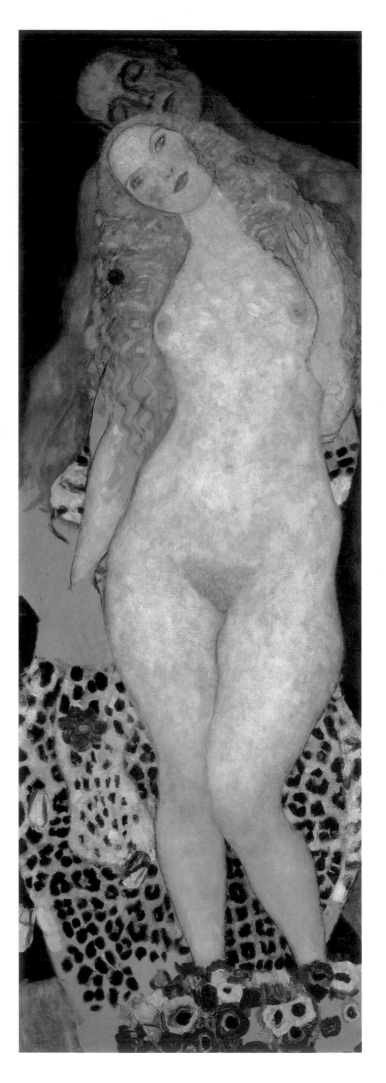

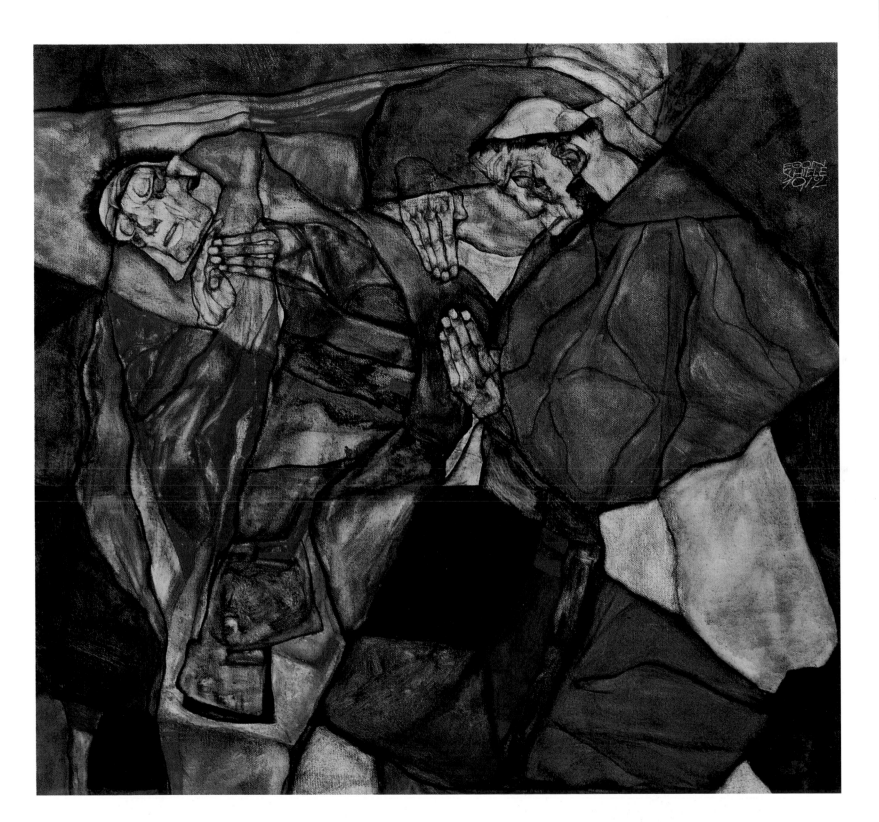

■ EGON SCHIELE
Agony
1912, oil on canvas
70 x 80 cm
Neue Pinakothek,
Munich

This scene, with its strong emotional and dramatic impact, shows a Franciscan monk at the sick bed of a man whose empty and reddish eye sockets indicate the approach of death. Schiele decomposes the planes of the scene and presents them from different perspectives in much the same way as the Cubist artists active in those same years. The viewer sees the dying man from above, almost crushed beneath the weight of pain and suffering, while the monk is shown in profile, his expression one of profound empathy. Schiele also applies the Cloisonnism painting style, used several years earlier by Paul Gauguin: he divides the space into colored sections separated by black contours that imitate the stained glass of Gothic cathedrals. The design, highly simplified, yet particularly incisive in the delineation of the faces and hands, shows the teaching of Klimt while also paralleling the works of the Expressionists.

EGON SCHIELE
**Death and
the Maiden**
1915, oil on canvas
150.5 x 180 cm
Österreichische
Galerie, Vienna

Love and death form
an inseparable pair
in the life and art
of Schiele; they are
a constant presence
that he looks upon at
times with an attitude
of courageous
rebellion but at other
times with a sense of
disenchanted
resignation. Painted
early in World War I,
this canvas is marked
by the heavy losses
suffered by the
Austrian army on the
Russian front; it was
perhaps because of
those losses or
because of Italy's
entrance in the
conflict, a former ally
of the Central Powers,
that Schiele, who a
year earlier had been
excused from service
for reasons of health,
was called back for a
new medical exam
and was drafted. In
this painting the male
figure, an allegory of
death, stands out
sharply against the
white cloth, symbolic
of the pale winding
sheets used in
ancient burials. His
clawlike left hand
clings to the girl's
reddish hair. As
model for the girl
Schiele used Wally
Neuzil, his model and
companion from 1911
until his marriage to
Edith Harms, on June
17, 1915.

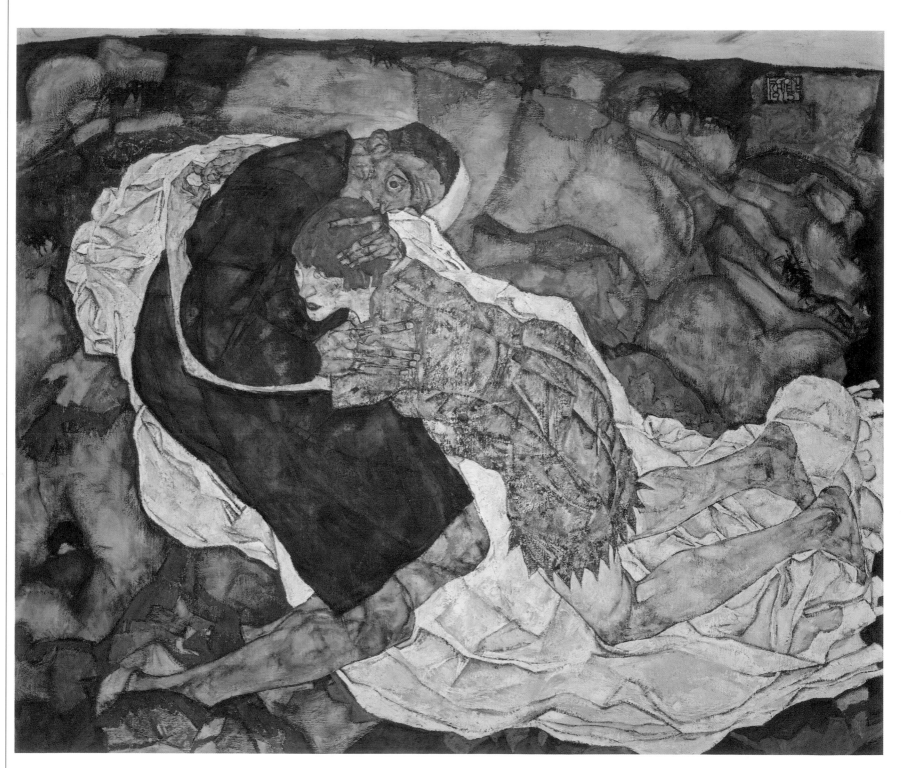

■ EGON SCHIELE
Gertrude Schiele
1909, oil on canvas
100 x 99.8 cm
Georg Waechter
Memorial Foundation,
Switzerland

This painting
depicts Schiele's
younger sister, born
in 1894 and
eventually the wife
of Schiele's friend
Anton Peschka.
Certain elements of
the painting reveal
the influence of
Klimt, such as the
contorted position
of the hands, the
elaborate geometric
decoration of the
clothing, and the
expression on the
face. In fact, Schiele
originally painted the
background in gold
and silver but then
later softened and
lightened it by the
addition of pale gray.

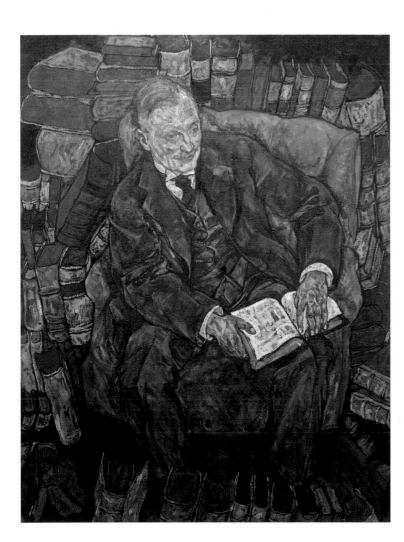

■ EGON SCHIELE
Hugo Koller
1918, oil on canvas
140.3 x 109.6 cm
Österreichische
Galerie, Vienna

Hugo Koller
(1867–1942),
industrialist and art
patron, is depicted
in his library. Rather
than looking toward
the viewer, he seems
instead to be turned
toward an unseen
guest with whom
he is engaged in
conversation. The
existential anguish
of Schiele's youthful
portraits seems to
have subsided,
replaced by a greater
sense of harmony, as
indicated by the
bright colors and the
sitter's more relaxed
expression.

**Duke Joseph de
Montesquiou-
Fezensac**
1910, oil on canvas
80 x 63 cm
Moderna Museet,
Stockholm

At the end of 1909,
Kokoschka, together
with the architect
Adolf Loos, took a
trip to Leysin,
Switzerland, near the
Lake of Geneva. While
there Kokoschka
painted a portrait of
Loos's companion,
Bessie Bruce, along
with several works
that reveal the style
of Edward Munch and
Vincent van Gogh.
Among these are two
portraits, one of
Duchess Victoire de
Montesquiou-Fezensac
(Cincinnati Art
Museum), the other
of her husband (first
exhibited in the
Cassirer Gallery,
Berlin). The nervous
and contracted lines
reveal the character
of the man but do so
without troubling to
embellish him, the
only concern being
that of revealing his
innermost hidden
feelings, his true
personality. The
jacket is sketched in
with rapid, disorderly
brushstrokes. The
indefinite background
is neutral in color,
giving even greater
contrast to the figure
in the foreground,
who seems on the
point of stepping
out of the canvas
and approaching
the viewer.

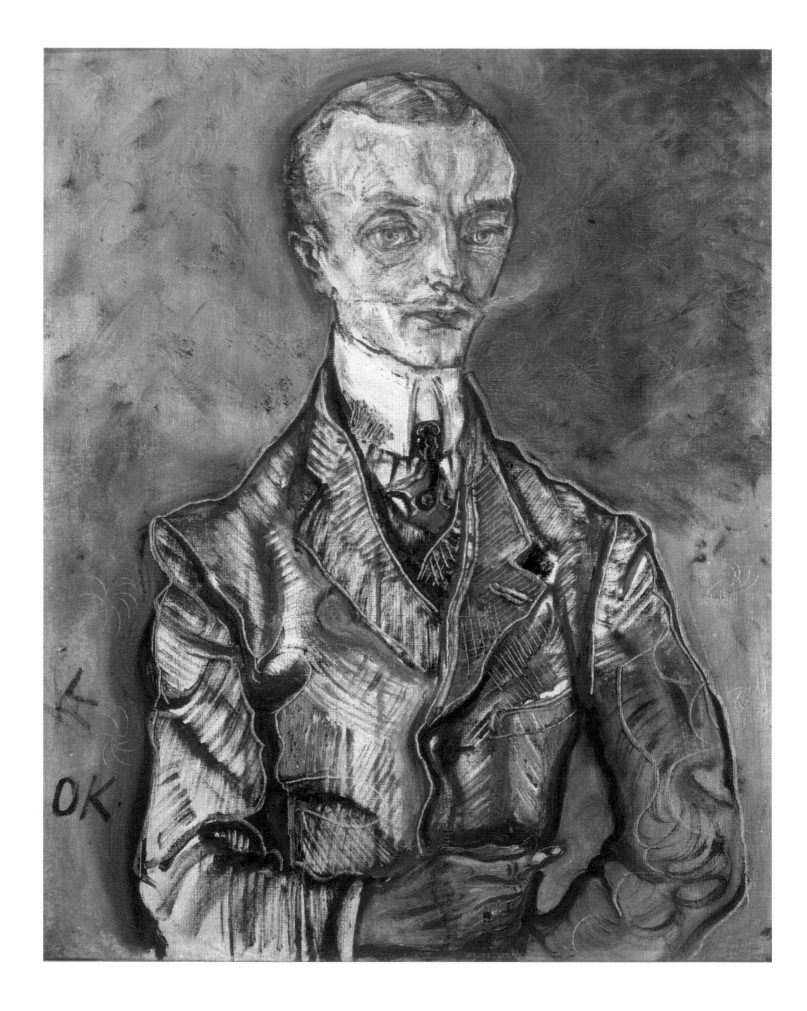

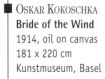

■ OSKAR KOKOSCHKA
Bride of the Wind
1914, oil on canvas
181 x 220 cm
Kunstmuseum, Basel

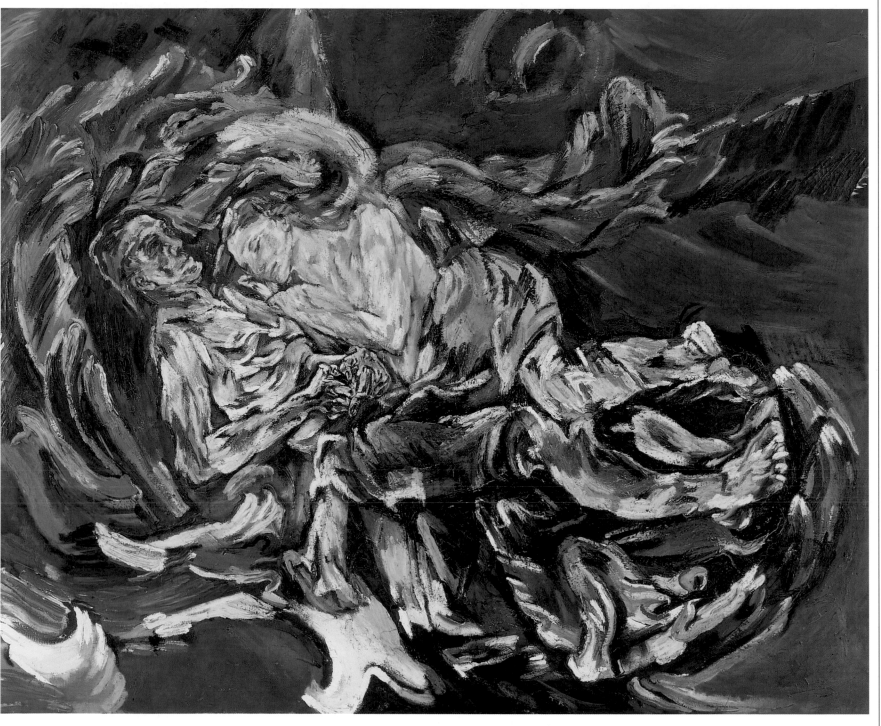

Kokoschka here depicts his stormy relationship with Alma Schindler, widow of the composer Gustav Mahler. A storm of brushstrokes of dark, cold colors dominated by gray and blue tones swirls around the two lovers, threatening their idyll and apparently on the verge of overwhelming them. In fact the painting was made in 1914, on the eve of World War I, a "storm" that overwhelmed not only the lives of the two figures but the entire continent. The face of the man seems passive, almost serene, but the position of his hands with their contracted fingers gives a sense of worry and anxiety. The woman abandons herself in his arms, seeking protection and shelter. A learned and fascinating woman with a strong and willful character, Alma (1879–1964) had a special fondness for artists and intellectuals and later was married to the architect Walter Gropius and the poet and novelist Franz Werfel.

icasso first visited Paris near the end of October 1900, arriving in the company of Charles Casagemas and Manuel Pallarés. He had only recently completed his artistic training, at the La Guarda school of La Coruña, the La Lonja Escuela de Bellas Artes in Barcelona, and at Madrid's Academia Real de San Fernando. Throughout his education, he demonstrated precocious talent and proved himself a quick learner. He had visited the Prado several times, studying the masterpieces by the Old Masters, and had assiduously visited the gathering places of Spanish artists and intellectuals, eager to pick upon the novelties of the Catalan Modernismo movement. In particular, Picasso was one of the leading figures in the meetings in the café Els Quatre Gats, the famous artistic-literary tavern located in the Casa Martí, the Neo-Gothic palace designed by Josep Puig i Cadafalch on the corner of the Carrer de Montsió and Calle Patriarca in Barcelona.

In 1898, together with Pallarés, Picasso went to Horta de Ebro, a small town in the province of Tarragona, where he began to paint and draw from life. He later affirmed, *"Todo lo que sé, lo he aprendido en*

Pablo Picasso, *Scene at Café-concert*, 1902, pastel on paper, 30.5 x 38.5 cm; Staatliche Museen, Museum Berggruen, Berlin

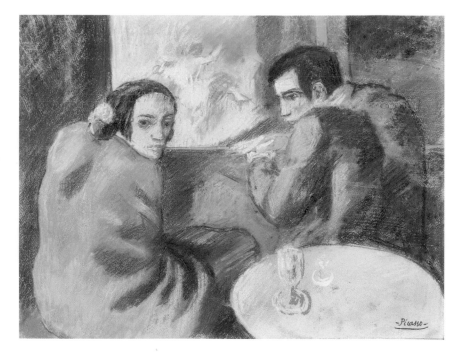

La Revue Blanche, Félicien Fagus wrote of an *"invasion espagnole"* ("Spanish invasion") and compared Picasso to Goya.

Picasso, the blue

Horta de Ebro" ("Everything I know I learned at Horta de Ebro"). In Paris he was the guest of the Barcelonan painter Isidre Nonell in his studio at 49 Rue Gabrielle, and while there he made his first contact with the Parisian cultural world. He saw the works of the Impressionists and their heirs, commonly grouped under the generic name Post-Impressionists. On December 24 he returned to Spain, stopping at Barcelona, Malaga, and Madrid. In the middle of June 1901 he took his second trip to Paris, this time with Jaume Andreu Bonsons; this time he met a Catalan industrialist, Pedro Mañach, who offered him a monthly contract of 150 francs, found him a studio at 130ter, Boulevard de Cliché, and exhibited seventy-four of his works, including drawings and oils, at Ambroise Vollard's gallery. Max Jacob visited the exhibit, later becoming one of Picasso's closest friends, and the show received favorable reviews. In one, published in the magazine

Pablo Picasso, *Boy with a Dog*, 1905, gouache on cardboard, 57 x 41 cm; Hermitage, St. Petersburg

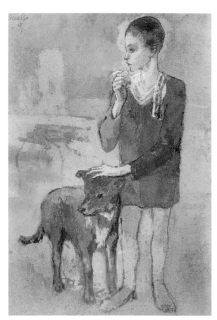

In October 1901 Picasso was joined in Paris by the poet Jaime Sabartés, who remained close to him for the rest of his life. It was now that he began the so-called blue period of his production, which ended in the spring of 1904. In January 1902 he returned to Barcelona where, with his friend Ángel Fernández de Soto, he rented a studio at 6, Calle del Conde del Asalto. He continued to associate with the artists and intellectuals at Els Quatre Gats and met the tailor Benet Soler, who provided him with clothing in exchange for drawings and paintings. In October of that year he made his third trip to Paris, together with Sebastián Junyer Vidal. Despite the recognition and esteem he was receiving from colleagues and various critics, his works failed to find buyers, and this was a period of true poverty for Picasso. He shared a miserable room with Max Jacob, taking turns sleeping in the only bed and struggling to scrape together enough money for food. Legend has

it that Picasso was forced to burn most of his drawings that winter to keep warm. At the end of January he returned to Barcelona, to the home of his parents, and stayed there for more than a year, developing and intensifying the themes of his blue period. In April 1904, still with Sebastián Junyer Vidal, he again returned to Paris, finding a place to stay in a squalid tenement house on Montmartre where he lived until October 1909. This was the famous Bateau Lavoir ("Laundry Boat"), as it was to be nicknamed by Max Jacob, a creative forge in which Picasso studied and worked in close contact with many other artists, writers, and intellectuals, among them Amedeo Modigliani, André Salmon, and Pierre Mac Orlan. For a short time he

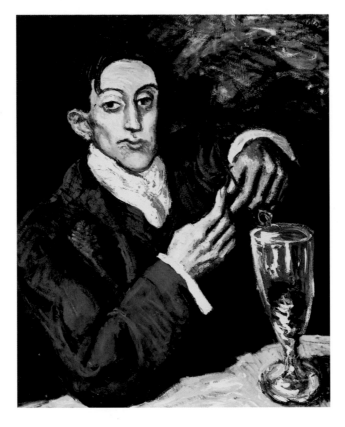

Americans Leo and Gertrude Stein, among the first to perceive his talent. Picasso made etchings and dry-point engravings, including the series of fifteen prints of *Saltimbanques*, published by Delâtre between 1904 and 1905 and presented again by Vollard in 1913. At the same time he lost no opportunity to visit the Louvre, where he sought to understand the secrets of painting and drawing of the Old Masters; he had studied them in Spain but looked at them now with different eyes. Gradually the suffering humanity and the cold tonalities of his blue period gave way to a more fluid line, in compositions with a lighter palette and more colors; at the beginning of 1905 Picasso began what critics call his rose period, which includes

■ Pablo Picasso, *Portrait of Ángel Fernández de Soto*, 1903, oil on canvas, 69.5 x 55.2 cm; private collection

and rose periods

allowed himself to be influenced by his friends' vices and experimented with opium, but he soon gave it up, greatly affected by the suicide of German painter Karl Wilhelm Wiegels, which brought back to him the anguish he had felt at the loss of his friend Charles Casagemas, who died tragically in the winter of 1901. He met Fernande Olivier, his model and inspiring muse, remaining emotionally tied to her until 1912. He associated with Kees van Dongen and Henri Matisse, with whom he had lengthy artistic discussions. By way of the Nabis group he rediscovered the works of Paul Gauguin and fell in love with primitive art. His friendship with the poets Max Jacob and Guillaume Apollinaire stimulated him to enrich the themes of his paintings, moving closer to Symbolism. Gallery owners, including Ambroise Vollard and Daniel-Henry Kahnweiler, became aware of him and his still unexpressed potential, as did various art collectors, such as the

about 130 to 150 works, among them several masterpieces. From February 25 to March 6, 1905, Picasso exhibited several of his most recent works at the Serrurier gallery in Paris, receiving praise from critics, including two reviews by Guillaume Apollinaire in *La Revue Immoraliste* and *La Plume*. In the summer of that year he went to Holland. Between May and August 1906 he was in Barcelona with Fernande Olivier to present her to his parents. They then got married at Gosol, a medieval village at 1,500 meters of altitude, in the Valleys of Andorra in the Pyrenees. While there Picasso painted and drew with renewed vigor, seeking new subjects and different expressive models. His return to Paris in the fall of 1906 is seen as the end of the rose period. A novel published that year, *Sandricourt*, by Eugène Marsan, includes a fleeting reference to Picasso as a reasonably well-known artist who seemed destined for a brilliant career.

■ Pablo Picasso, *Nude Boy*, 1905–06, gouache on cardboard, 68 x 52 cm; Hermitage, St. Petersburg

Figures seated in a Parisian café is a subject that appears in several famous Impressionist works, most especially *In a Café (The Absinthe Drinker)* made by Edgar Degas in 1876 (Musée d'Orsay, Paris), to which this painting makes explicit reference. The figure dressed as Harlequin also recalls Paul Cézanne's *Mardi Gras* (Pushkin Museum, Moscow). Despite the way they are dressed, which makes one think of a masked ball, the two figures in Picasso's painting do not seem to be enjoying themselves. The way they look in different directions creates a sense of loneliness, boredom, and lack of communication. The melancholy expressions on the pained faces is emphasized by the nervous and awkward positions of the arms and hands, exterior signs of interior anguish. This work was acquired by the art dealer Ambroise Vollard, who then sold it to the Russian collector Ivan Morozov.

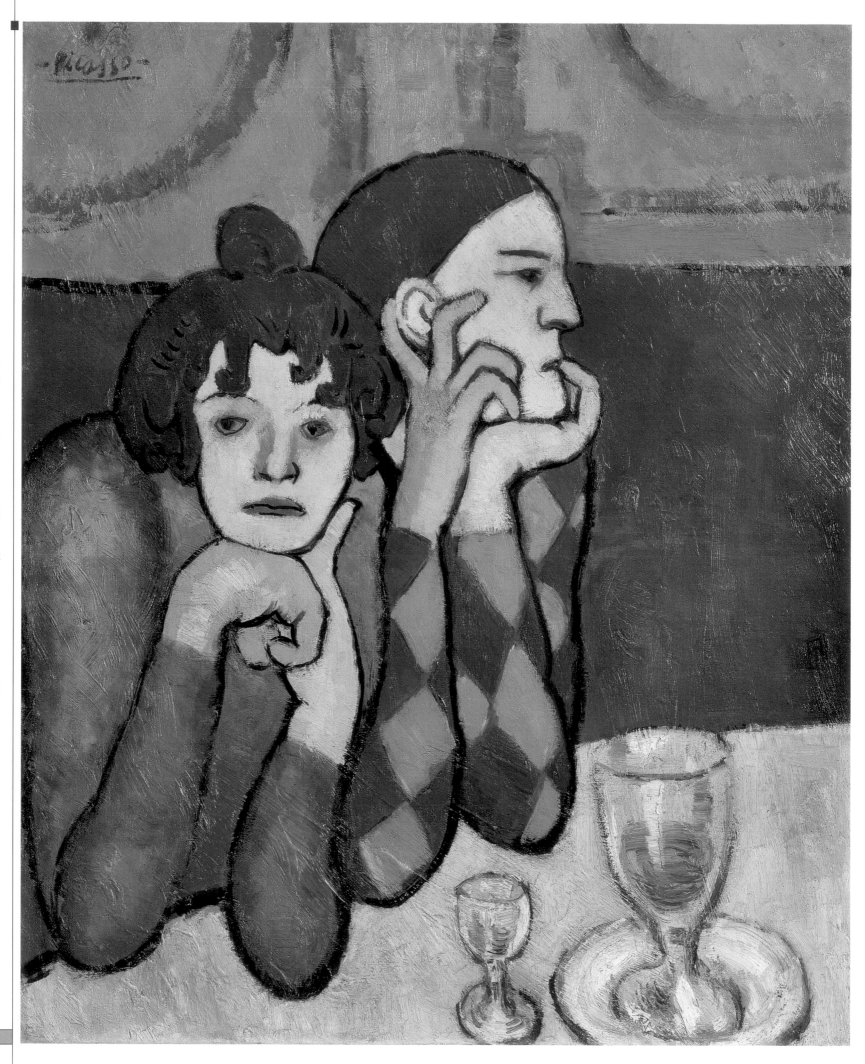

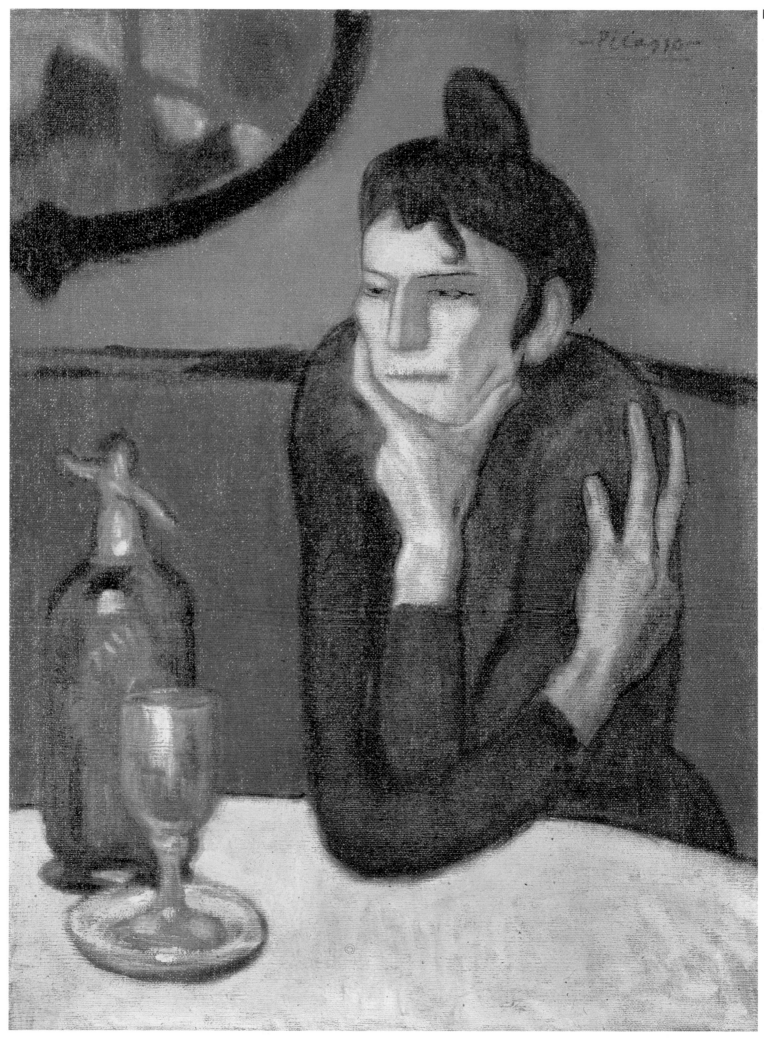

■ PABLO PICASSO
The Absinthe Drinker
1901, oil on canvas
73 x 54 cm
Hermitage,
St. Petersburg

From his first visit to Paris, Picasso was drawn to that city's nocturnal life, its innumerable cafés, bursting with life and entertainment. At the same time, however, he was unable to integrate himself, and felt marginalized and excluded, a penniless foreigner in the capital of the Belle Époque, with its exultation of luxury and wealth. This state of mind, in solidarity with the excluded, the disinherited, and the afflicted, put him on the same artistic wavelength as Henri de Toulouse-Lautrec, who was also fascinated by dancehalls, theaters, and café-concerts but felt himself distanced and pitied because of his physical deformity. This canvas bears clear stylistic and thematic affinities with the works of Toulouse-Lautrec: the same simplified line, the same cold tones, the same sad and melancholy atmosphere legible in the eyes and gestures of the woman, who vainly seeks friendship, understanding, protection.

PABLO PICASSO
Woman with Crossed Arms
1901–02,
oil on canvas
81.3 x 58.4 cm
Private collection

Picasso's blue period is named for its chief stylistic characteristic, the preponderance of a single color, a cold and impersonal blue. Picasso pushed the tones of this blue to their limits, driven by the desire to understand how far his art could reach. He behaved much like an archer on the eve of an important contest who practices stringing his bow with all his strength, trying to find the point of greatest tension, the level just before the string breaks. A second element of this period, equally evident in this canvas, is the mood of the works, intimate and introspective, reflecting Picasso's personal psychological situation, tormented by financial problems, uncertainty about the future, and disturbed by the suicide of his friend Charles Casagemas, which had occurred a few months earlier. Gertrude Stein was this painting's first buyer. Since then it has passed through various collections and was sold at auction at Christie's in New York on November 8, 2000, for $55 million.

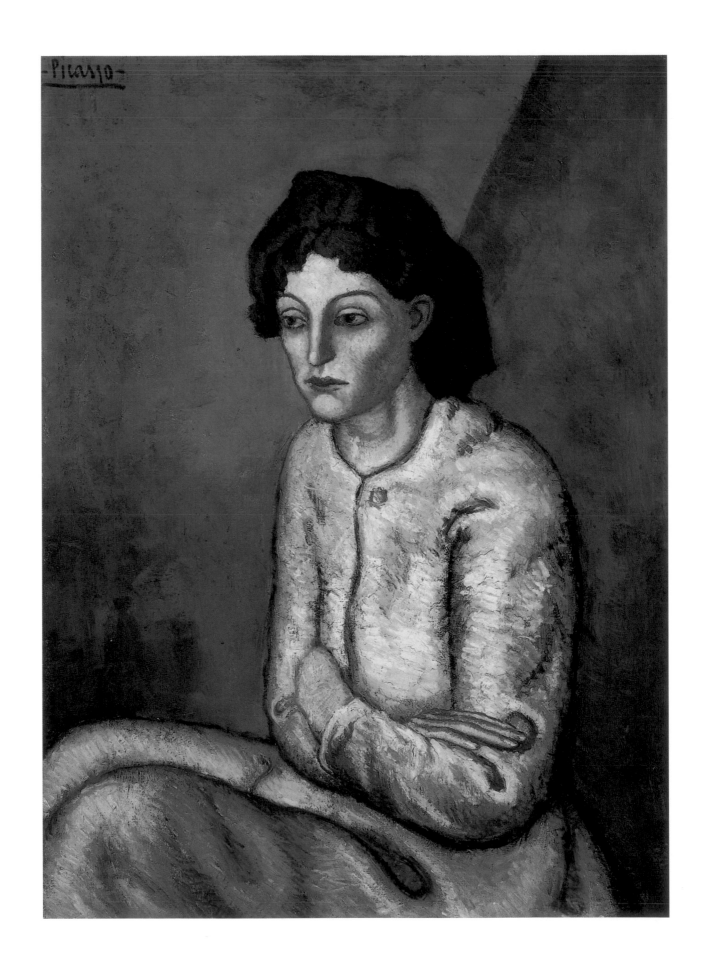

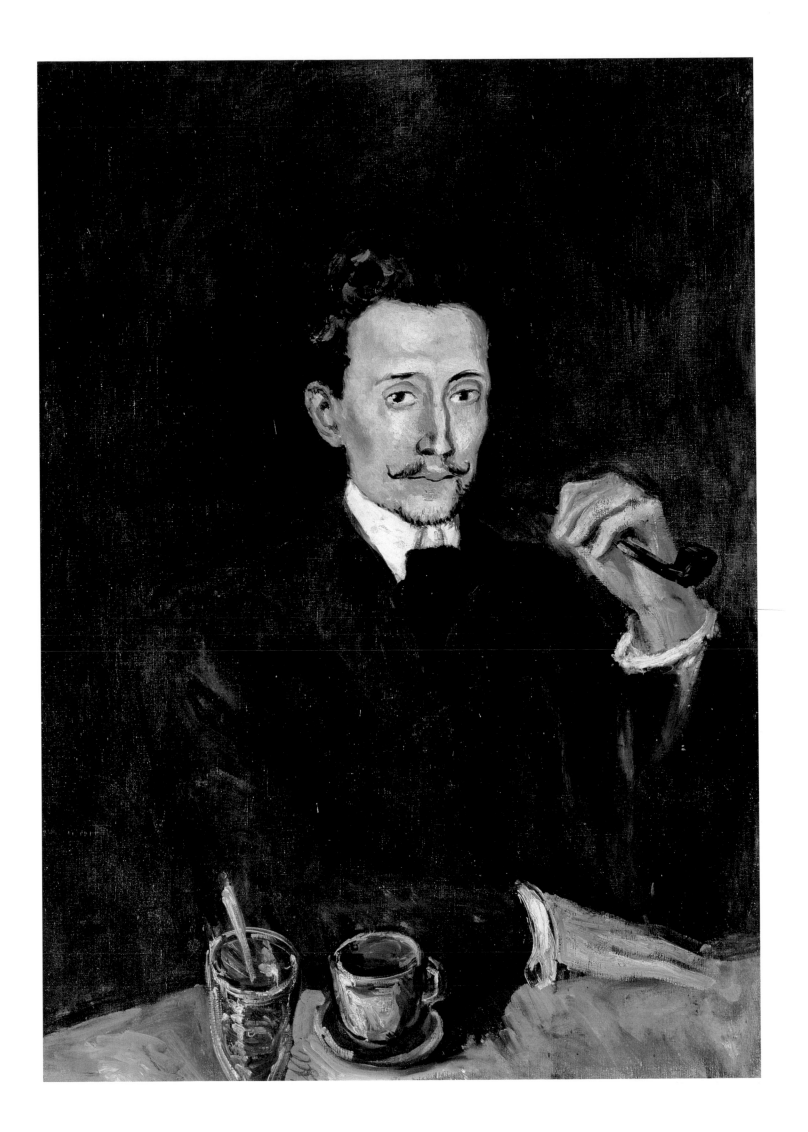

PABLO PICASSO
**The Tailor
Benet Soler**
1903, oil on canvas
100 x 70 cm
Hermitage,
St. Petersburg

In the spring of 1903, while in Barcelona following his second trip to Paris, Picasso made friends with the tailor M. Benet Soler (1874–1945), who had a shop in Plaza Santa María. Soler was a regular at the café Els Quatre Gats and had become the patron of several artists and men of letters, often inviting them to lunch in his home and giving them financial support. Picasso, who was greatly concerned with his personal appearance despite his straitened circumstances, profited from Soler's generosity, making paintings for him in exchange for clothes. This canvas originally constituted one side of a triptych, the other two works being a portrait of the tailor's wife, Montserrat Soler (Neue Pinakothek, Munich), and a composition depicting the couple together with their four children—Mercé, Antoñita, Carles, and Montserrat—during a picnic following a hunt (Musée des Beaux-Arts, Liège).

PABLO PICASSO
La Vie (Life)
1903, oil on canvas
197 x 127.5 cm
Cleveland Museum
of Art, Cleveland

In this canvas Picasso reveals his awareness of the creations of the Symbolists; in fact, the work includes many allegorical allusions, some clear, others quite obscure. To the left are two lovers who face toward a woman holding a child, symbolic of love and life. At the same time, the two drawings on the wall behind them, which dominate the center of the composition, suggest the presence of pain and solitude in human life. There is also an autobiographical reference that must be added to these elements, something which many critics see as an explanation for the sorrow and melancholy of many works of the blue period. In a preparatory drawing for this large canvas Picasso presented himself as the male figure, but in the final version he used his friend Charles Casagemas, who on February 17, 1901, killed himself in the Parisian café L'Hippodrome, following an unhappy love affair with the model Laure Gargallo.

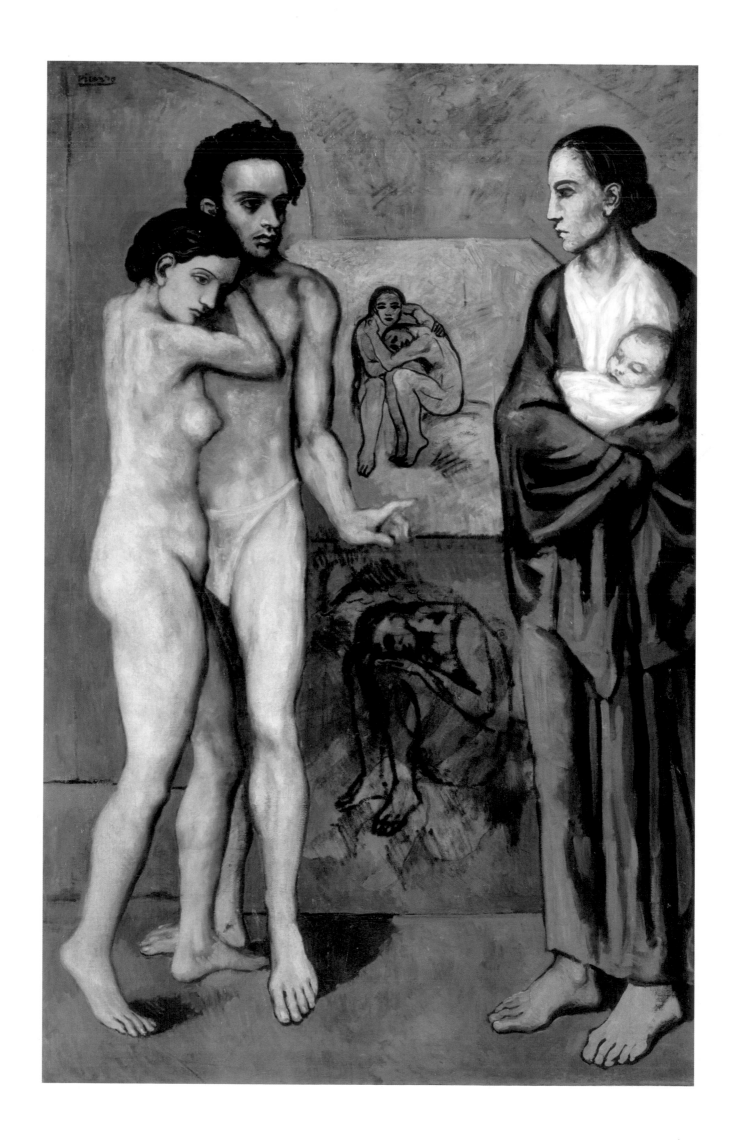

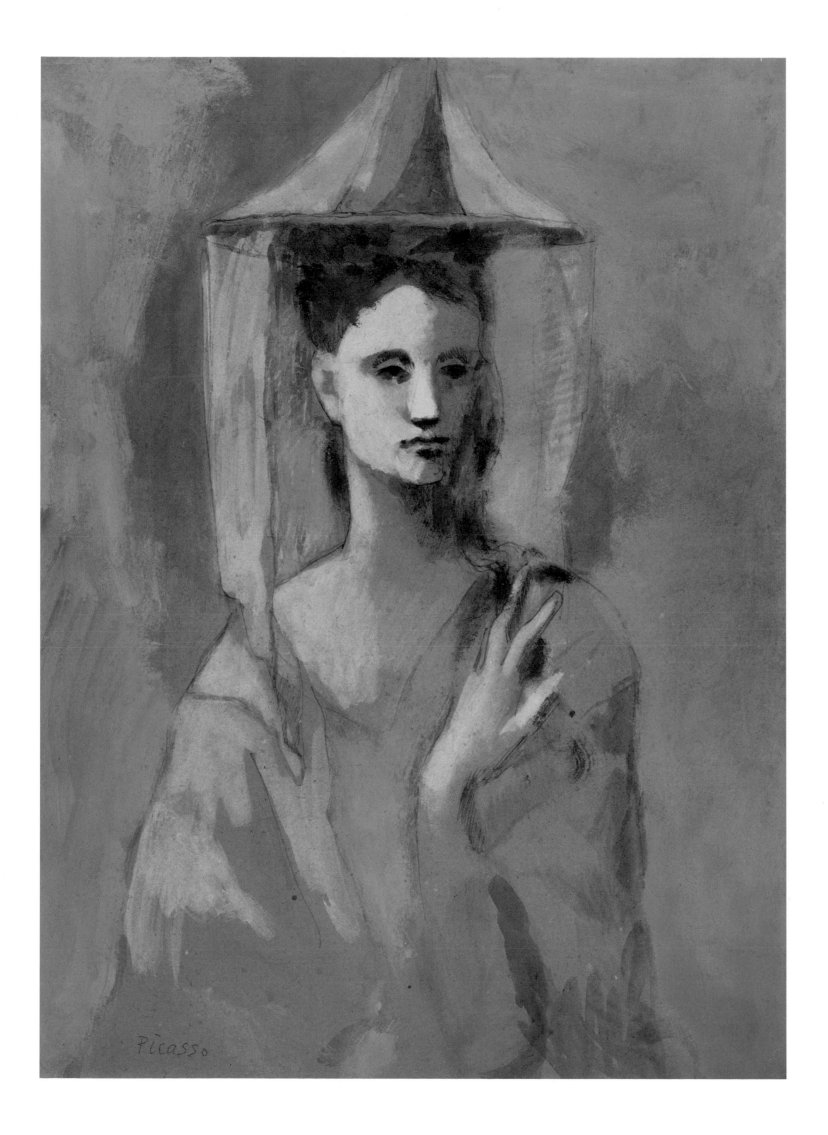

Picasso

PABLO PICASSO
Girl of Majorca
1905,
gouache on paper
67 x 51 cm
Pushkin Museum,
Moscow

This is one of the preparatory studies for the female figure seated to the right in the large painting *Family of Saltimbanques* (see page 52). It testifies to the passage from the blue period to the rose, which began with *The Actor* (Metropolitan Museum, New York) and the *Acrobat and Young Harlequin* (Guggenheim Museum, New York), painted in the winter between 1904 and 1905. The rough, angular lines, austere tonalities, and bleak melancholy of the earlier compositions gave way to a softer line, a warmer luminosity, and a basic serenity that gave the figures an increased self-awareness and a more optimistic view of life. In the final painting Picasso simplified the shape of the hat, which has a more refined appearance here and gives the woman a noble and dignified expression not unlike that of a Renaissance princess. This painting was bought by the Russian collector Sergei Shchukin, who had fifty-one works by Picasso in his collection.

PABLO PICASSO
**Family of
Saltimbanques**
1905, oil on canvas
213 x 229.5 cm
National Gallery of
Art, Washington, D.C.

For several months in 1905 Picasso, along with Kees van Dongen, attended performances of the Cirque Medrano, which was set up a short distance from the Bateau Lavoir. Picasso often stayed behind after the shows to chat with the acrobats, saltimbanques, and circus staff. He also invited them to his studio, where he enjoyed making portraits of them, sometimes without their knowing it. The many drawings and paintings he made of them came to constitute the principal nucleus of his rose period. In 1923, the German poet Rainer Maria Rilke published his *Duino Elegies*, the fifth of which is dedicated to Hertha Koenig, at the time the owner of this painting. Picasso's work inspired the following verses from the poet: "But tell me, who *are* they, these travellers, even a little more fleeting than we ourselves . . . as though from an oily, smoother air, they come down on the threadbare carpet, thinned by their everlasting upspringing, this carpet forlornly lost in the cosmos."

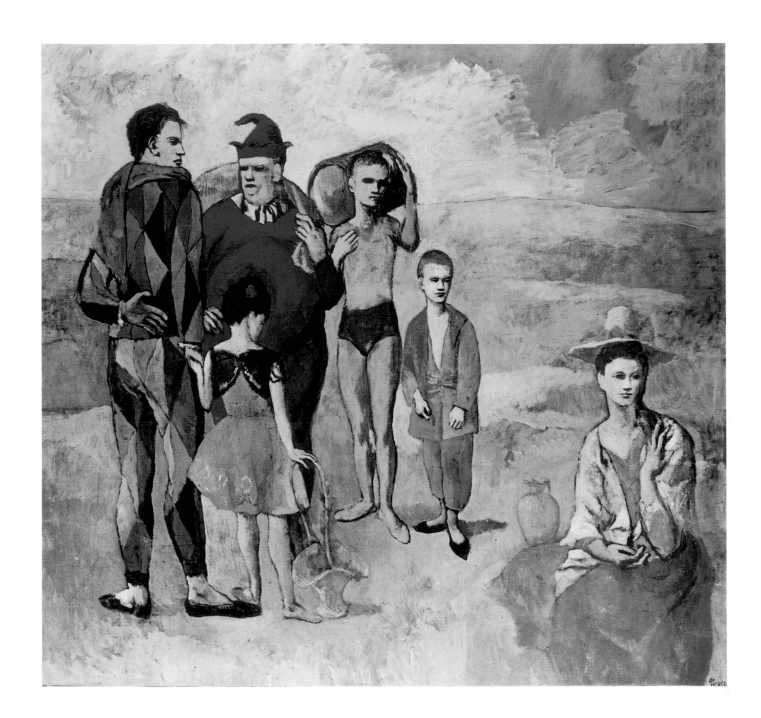

Picasso, the blue and rose periods

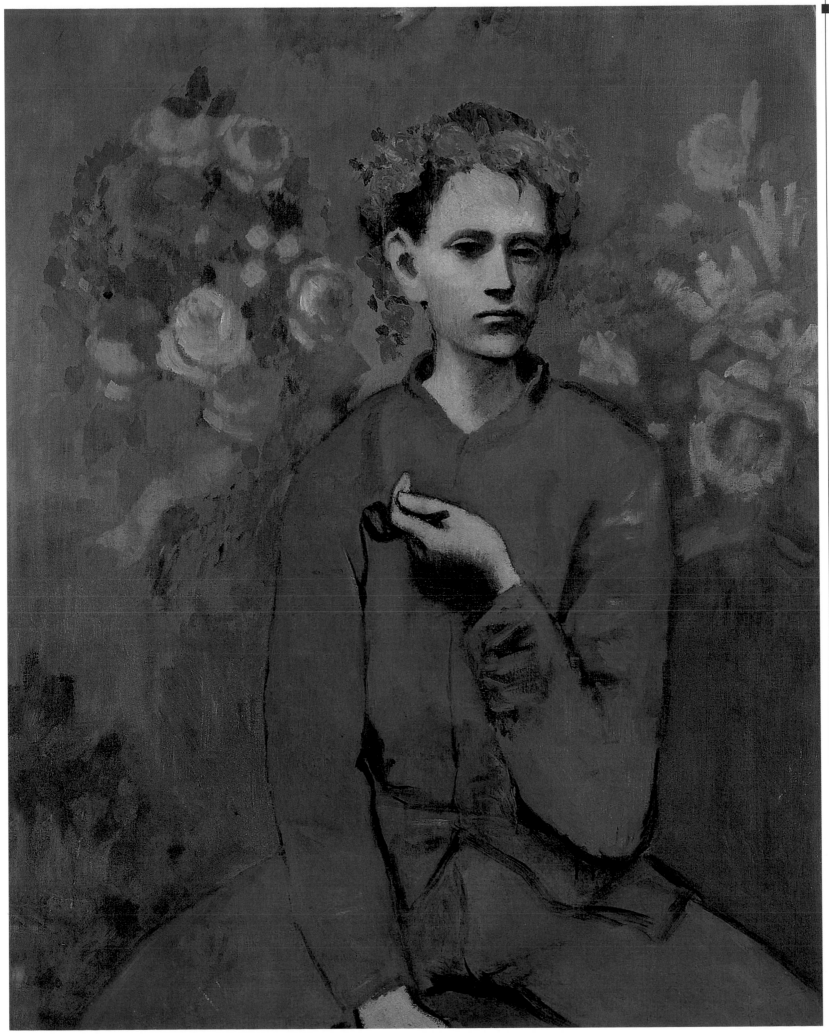

PABLO PICASSO
Boy with Pipe
1905, oil on canvas
100 x 81 cm
Private collection

This portrait, which recalls some of Odilon Redon's last Symbolist compositions, is one of the most beautiful and intense of the rose period, particularly evocative for its melancholy grace and the wealth of its lyrical shading. The floral background with its soft and delicate colors, recalls the boy's crown of roses and gives the painting a deliberately mysterious and ambiguous atmosphere. Nothing is known about the identity of the sitter or his profession. His blue work clothes suggest he was a laborer, but he may have been an actor. There is also the possibility that he is an adolescent named Louis who often visited Picasso's studio at the Bateau Lavoir. The painting, which was part of the famous collection of the Whitneys, John Hay and Betsey Cushing, was sold at auction at Sotheby's New York on May 5, 2004, for the record price of $104,168,000, the proceeds going to the philanthropic work of the Greentree Foundation.

Seminude with Pitchers
1906, oil on canvas
100 x 81 cm
Private collection

This painting is one of a series of nudes that Picasso painted at Gosol in the summer of 1906. During this crucial moment in his artistic career, Picasso concentrated his attention on the human figure, and it was in these works that he began moving in the direction of the Cubist experiments in the *Demoiselles d'Avignon* (see page 74). By then Picasso had assimilated the paintings of nude women by Edgar Degas—women bathing, washing or drying themselves, combing their hair or having it combed—along with the Bathers by Paul Cézanne and the girls in brothels by Henri de Toulouse-Lautrec. The outlines of this female figure are clearly indicated, but the colors—primarily pale red, terracotta, and a faded pink—are not applied in a uniform manner, most of all in the background, which is left unfinished. Critics have noticed a certain stylistic resemblance to the Greek sculptures that Picasso had studied in the Louvre and documented in preparatory drawings he made.

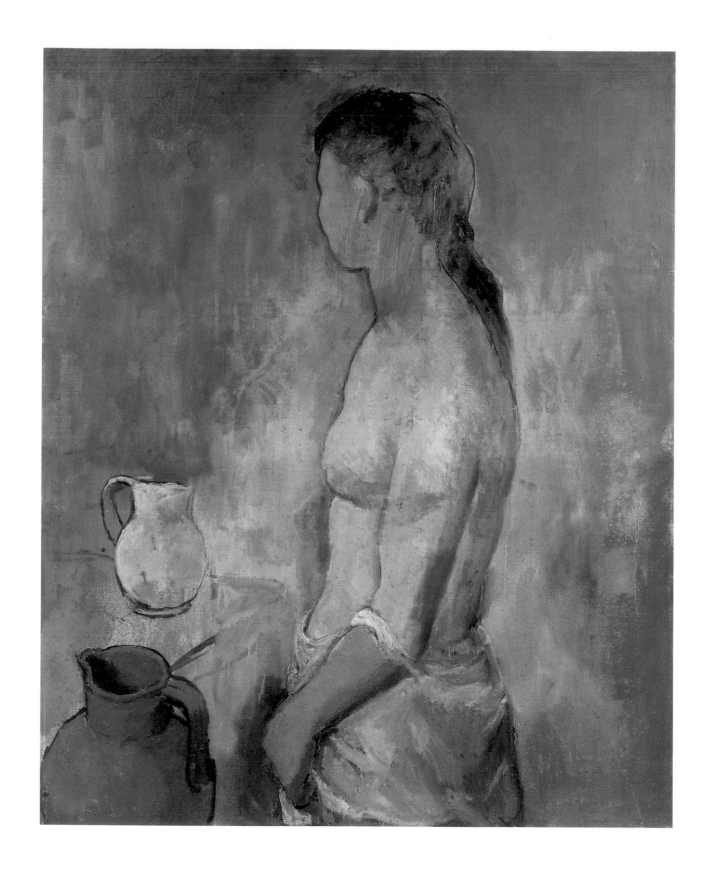

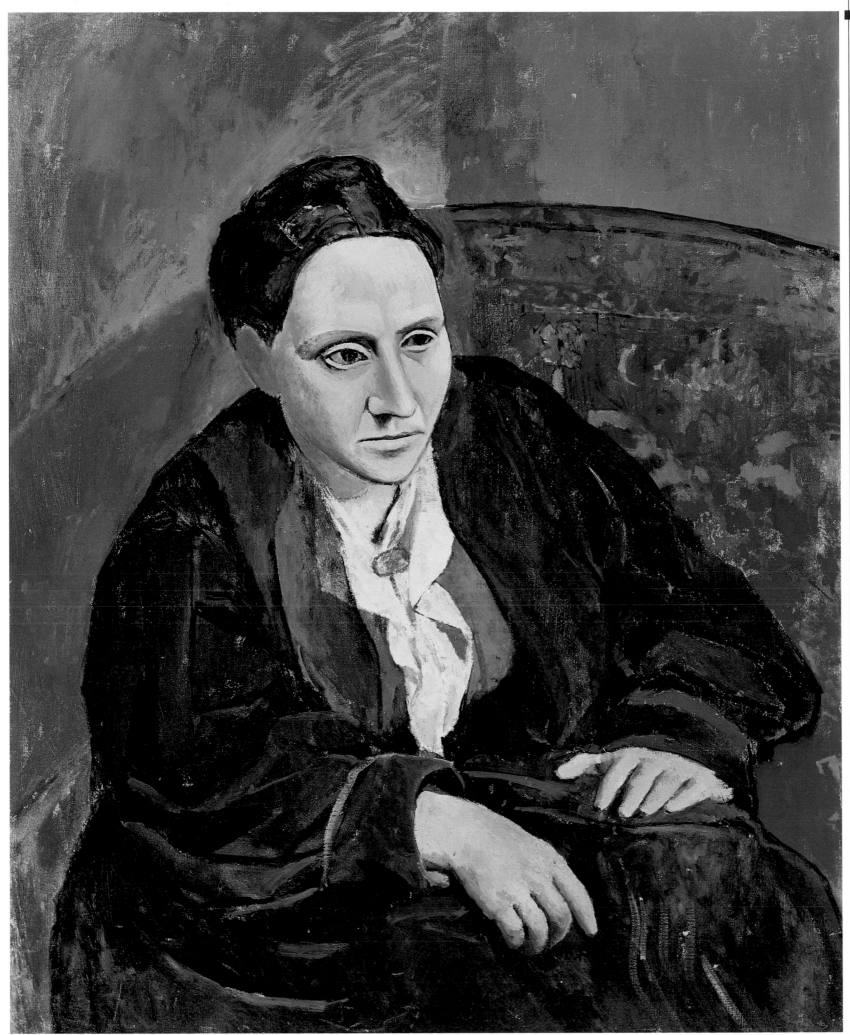

■ PABLO PICASSO
Gertrude Stein
1906, oil on canvas
110 x 81 cm
Metropolitan Museum
of Art, New York

Gertrude Stein was
born into a Jewish
family of German
origin on February 3,
1874, in Allegheny,
PA (today part of
Pittsburgh); she died
in Paris on July 27,
1946. She moved to
Paris with her brother
Leo near the end of
1902, setting herself
up in a large
apartment at 27, Rue
de Fleurus, which
became a cultural
salon visited by
writers, intellectuals,
and artists, of whom
she became both
friend and patron. As
a literary critic she
was esteemed (and
feared) and as a
writer she enjoyed
success in both
poetry and prose.
This portrait had a
long and difficult
gestation. Picasso
began working on
it in the winter
between 1905 and
1906 and it came to
require a great
number of sittings
(more than eighty).
In the spring, still
not satisfied with the
result, Picasso erased
the head, and in the
fall of that year, after
a stay at Gosol, he
repainted it from
memory, giving it its
masklike appearance,
without requiring
another sitting from
Stein, who was
nevertheless
completely happy
with the result.

he organizers of the 1905 Salon d'Automne in Paris decided to exhibit the works of Charles Camoin, André Derain, Othon Friesz, Henri Manguin, Albert Marquet, Henri Matisse, Jean Puy, Louis Valtat, Kees van Dongen, and Maurice de Vlaminck. Critics and the public alike were amazed and perplexed by the works on display with their use of violent color contrasts, so deliberately strident and far removed from reality. The magazine *L'Illustration* dedicated an entire page to these artists in its November 4 edition, with photographs of seven paintings and numerous critical comments expressing open condemnation of a style considered eccentric and outrageous. Standing at the center of the hall where the paintings were exhibited was a small bronze bust by Albert Marquet depicting a child, a work vaguely inspired by 15th-century Tuscan art. Louis Vauxcelles, art critic for the magazine *Gil Blas*, playing on what he saw as the ironic contrast between the classical piece and the new artistic manner, unintentionally gave the style its name: *"Donatello parmi les Fauves"* ("Donatello in the middle of wild beasts"). Within a few months this pejorative definition was being used by the artists themselves, and by the Salon des Indépendants of the following year everyone was calling them *Fauves* ("wild beasts"). On the basis of stylistic affinity, several other painters can be added to the list of those whose works were exhibited at the Salon d'Automne, such as Raoul Dufy and Georges Braque, and, at least marginally, Georges Rouault, Wassily Kandinsky, Alexei Jawlensky, and Aristide Maillol.

André Derain,
Waterloo Bridge,
1906, oil on canvas,
80.5 x 101 cm;
Museo Thyssen-
Bornemisza, Madrid

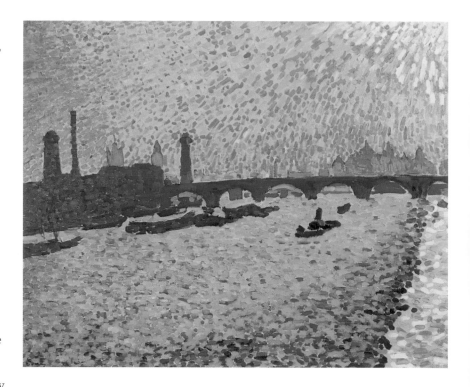

Henri Manguin,
The Prints,
1905, oil on canvas,
81 x 100 cm;
Museo Thyssen-
Bornemisza, Madrid

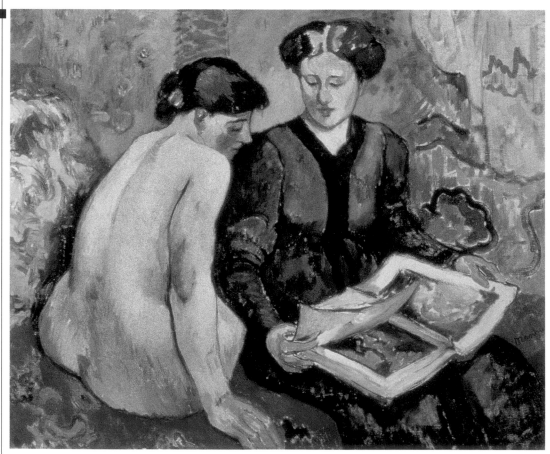

The Fauves did not constitute a unitary movement, nor did they follow a predetermined program. Each artist followed his own route of personal interest. Even so, they had certain points in common and shared certain influences. Camoin, Manguin, Marquet, Matisse, and Valtat were all students of Gustave Moreau at the École des Beaux-Arts in Paris, and they often discussed their master's teachings, which stimulated them to give more weight to color and to explore its expressive potentials. Another thing they had in common was the gallery of Ambroise Vollard, which in 1900 began giving regular exhibitions of the works of Valtat, Derain, and Matisse. Between 1900 and 1901 Matisse studied at the academy of Eugène Carrière, together with Puy and Derain, who introduced him to Vlaminck, with whom he rented a studio at Chatou. Between 1903 and 1905 many of the Fauves, in particular Matisse, Derain, and Marquet, associated with Paul Signac and experimented with his Pointillist style, which involved breaking up the pictorial surface into small, uniform, separate points of pure color, arranged in a regular manner to create new visual effects. In the summer of 1905 Matisse, together with his wife, Amélie, and daughter Marguerite, went to Collioure, on the southern coast of France, a few kilometers from the Spanish border; on June 28 they were joined by Derain. This proved an important stay for both artists, bringing them to a new concept of light and color, luminous and with strongly contrasting

Matisse and the Fauves

tones, so much so as to almost completely annul design and shading. Many of the Fauves were drawn to music—some played instruments—and they lost no opportunity to explain how they wanted to use colors in their paintings like musical notes to obtain the same effects, no longer descriptive but rather narrative and emotive.

The 1905 show at the Salon d'Automne marked the conclusive moment of a long period of effort and made the works of the Fauves known to critics and collectors who, as mentioned, greeted them with disdain and derision. The pitiless reviews took particular aim at Matisse's paintings, and against his will he found himself referred to as the group's leader as well as its primary example. In fact Matisse was showing greater sureness in the distribution of color and a greater awareness of the new role he was giving color, so much so that he was nicknamed the "professor." He taught his colleagues how to use large and luminous fields of color, to distribute colors in thick, sinuous strokes, to align planes, indicating contours with black or, on the contrary, blending the surfaces of objects into a single, indistinct whole.

For nearly all the artists, the Fauvist period did not mark an arrival in their careers but only a passage toward new experiences and further

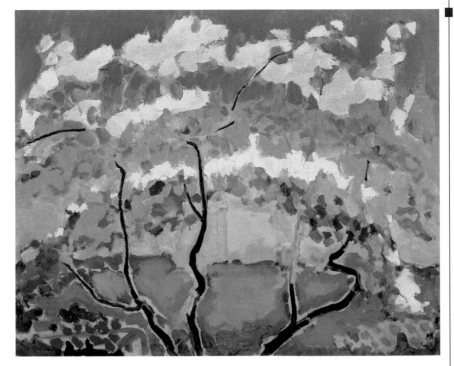

Kees van Dongen, *Spring*, 1908, oil on canvas, 81 x 100.5 cm; Hermitage, St. Petersburg

years working in a law office in Saint-Quentin. From the moment of their meeting their artistic careers ran along parallel tracks. Matisse introduced

Matisse and the Fauves

work, carried on parallel to the rise and spread of the Expressionist movement and the revolution caused by Cubism and abstract art. The Matisse paintings exhibited at the 1905 Salon d'Automne included *Woman with the Hat* (Museum of Modern Art, San Francisco). The work received highly negative reviews from critics, who reproached Matisse for an unnatural use of colors, taking him to task in particular for the green and blue brushstrokes on the sitter's face. Leo and Gertrude Stein, on the other hand, were quite pleased with the portrait, which they bought, becoming not just Matisse's friends but the first collectors of his works. In 1906 they introduced him to the young Pablo Picasso, who had finally moved definitively to Paris from Spain. Picasso was a dozen years younger than Matisse, but was precociously talented, whereas Matisse had discovered his artistic calling when already in his twenties, after studying law and spending several

Picasso to African sculpture, gave him technical advice as a sculptor and engraver, and introduced him to several important collectors, including the brothers Sergei and Andrei Shchukin and Ivan Morozov. In subsequent years, the two artists had various occasions to meet, maintaining a close friendship despite the attempts by various critics and journalists to create a rivalry between them. In fact Matisse and Picasso can be taken as emblematic of the two antithetical souls of their century. Adapting an idea from the German philosopher Nietzsche, the spirit of Matisse can be seen as Apollonian, meaning a serene representation of grace and reason, whereas Picasso's soul was Dionysian, ruled by a dynamic incarnation of uncontrolled energy. The first, calm and reflective, sought to please the viewer with his sweetly sensual line; the second, rash and impetuous, wanted to startle and provoke the viewer with a severe and angular style.

Maurice de Vlaminck, *Self-portrait*, 1911, oil on canvas, 73.3 x 60 cm; Musée National d'Art Moderne, Centre Georges Pompidou, Paris

Landscape
1905, oil on canvas
73 x 60 cm
Private collection

Together with Dufy and Braque, Friesz formed the so-called Le Havre group, even though in reality he had little in common with the other two artists. Together they attended the local school of fine arts and painted landscapes at Trouville and Honfleur. At first, they based their style on that of the Impressionists, but after seeing Matisse's *Luxe, Calme et Volupté* (see page 64) they joined the Fauvist group. Beginning in 1905 Friesz made a series of landscapes set on the Mediterranean coast, characterized by the use of large areas of pure color, bright and vivid, embellished by a solar luminosity. In this canvas the houses are reduced to elementary geometric forms and seem completely absorbed by nature, which expresses all its energetic vitality in the tree in the foreground. Friesz's adhesion to the Fauvist style diminished in later decades as he rediscovered a vision of nature similar to Cézanne's, accentuating the realistic and naturalistic characteristics in his works.

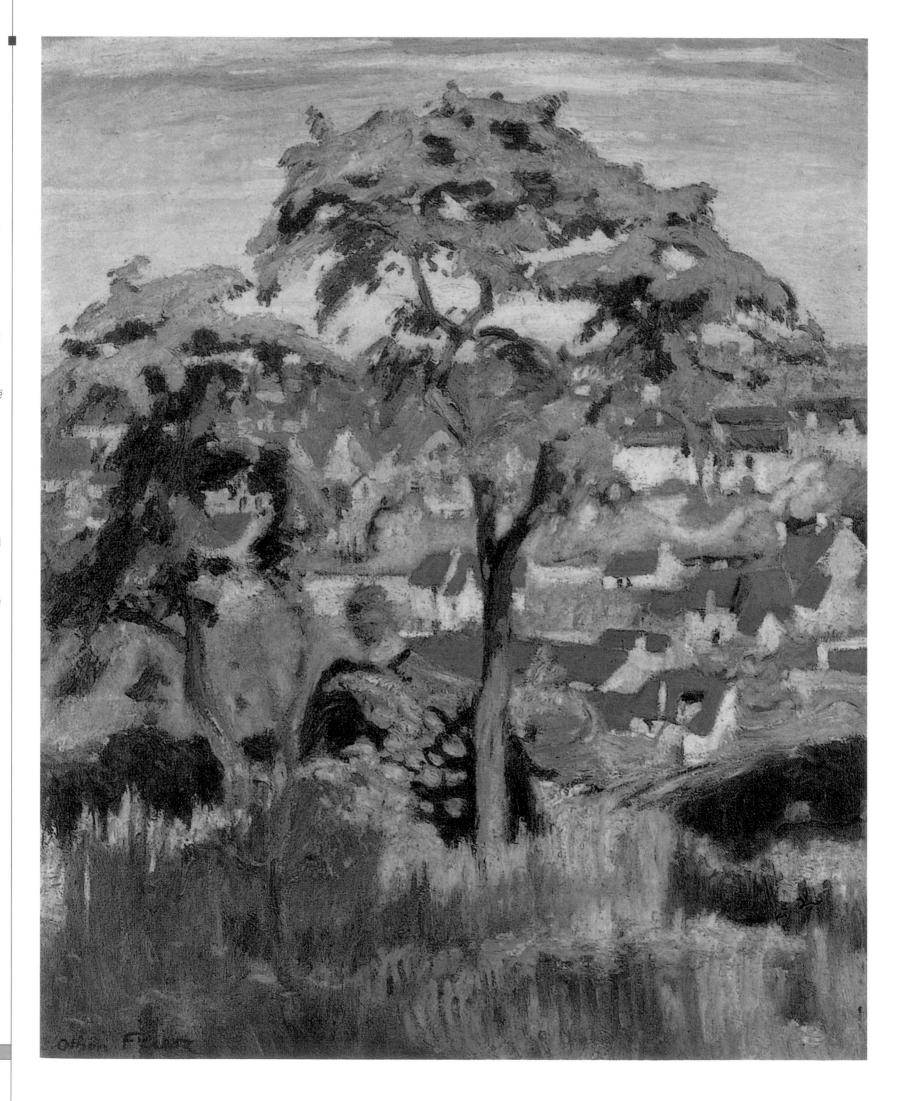

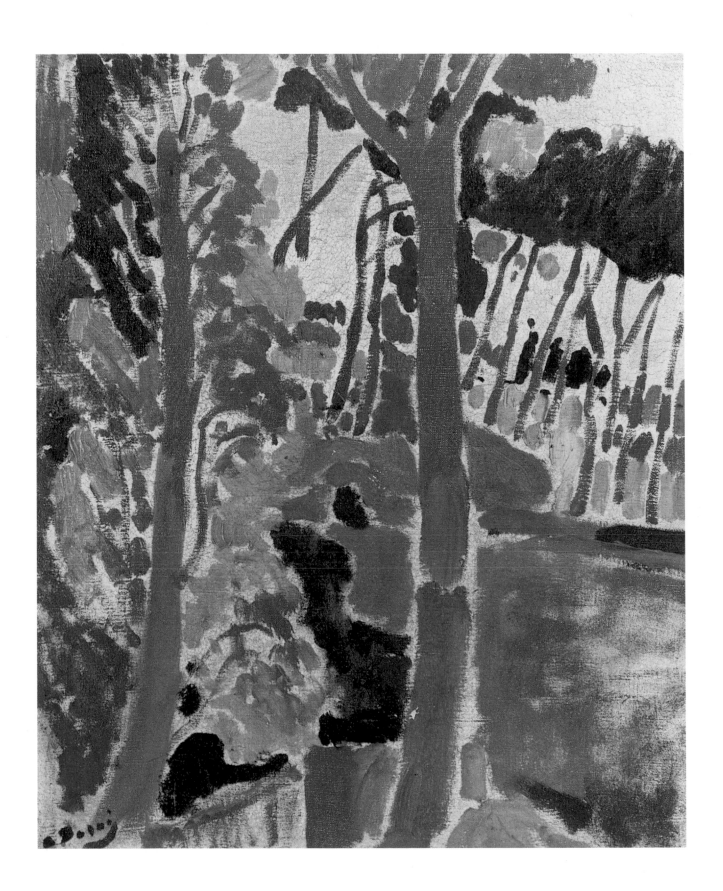

■ ANDRÉ DERAIN
Trees at L'Estaque
1906, oil on canvas
46 x 38 cm
Private collection

Derain made this painting at L'Estaque, a small town on the Mediterranean coast where he spent the summer of 1906. In the many landscapes he painted there he deepened and further explored the ideas he had developed the preceding year at Collioure together with Matisse, with whom he had given life to the Fauvist style. This canvas also shows the influence of the paintings Gauguin made in Tahiti, both in terms of the bright, vivid colors and in the wild and primitive atmosphere that pervades the entire composition, giving it a sense of the exotic. Making use of only a few clearly defined brushstrokes, Derain gives the scene an uncommon rhythm and a vivacity, as though he had made it in a single burst following a flash of inspiration. The Fauvist period was only a brief experience for Derain; after World War I he went to Italy. Study of the great masters of the past gave his works a renewed sense of rigorous design.

HENRI MANGUIN
The Bather
1906, oil on canvas
61 x 49 cm
Pushkin Museum,
Moscow

In 1905, the year
in which he took
part in the historic
exhibit at the Salon
d'Automne—the
famous *cage aux
fauves* ("cage of wild
beasts")—where he
showed five works,
Manguin spent several
months at Saint-
Tropez. While there
he met Paul Signac,
who taught him the
Pointillist style.
Fascinated by the
area, he bought a
home, called
L'Oustalet, that
remained his frequent
abode until his death.
This painting was
presented at the 1906
Salon d'Automne in
Paris and was bought
by Ivan Morozov.
Although the
Pointillist technique
is not applied in a
rigorous manner,
one can see the
decomposition of the
pictorial surface of
the sea in numerous
small touches of
bright color that
communicate the idea
of the movement of
the waves and the
reflections of light
on the water. The
body of the girl in
the foreground is
delineated by means
of large, fluid
brushstrokes that
sweetly caress her
body, giving it a
powerful charge
of sensuality.

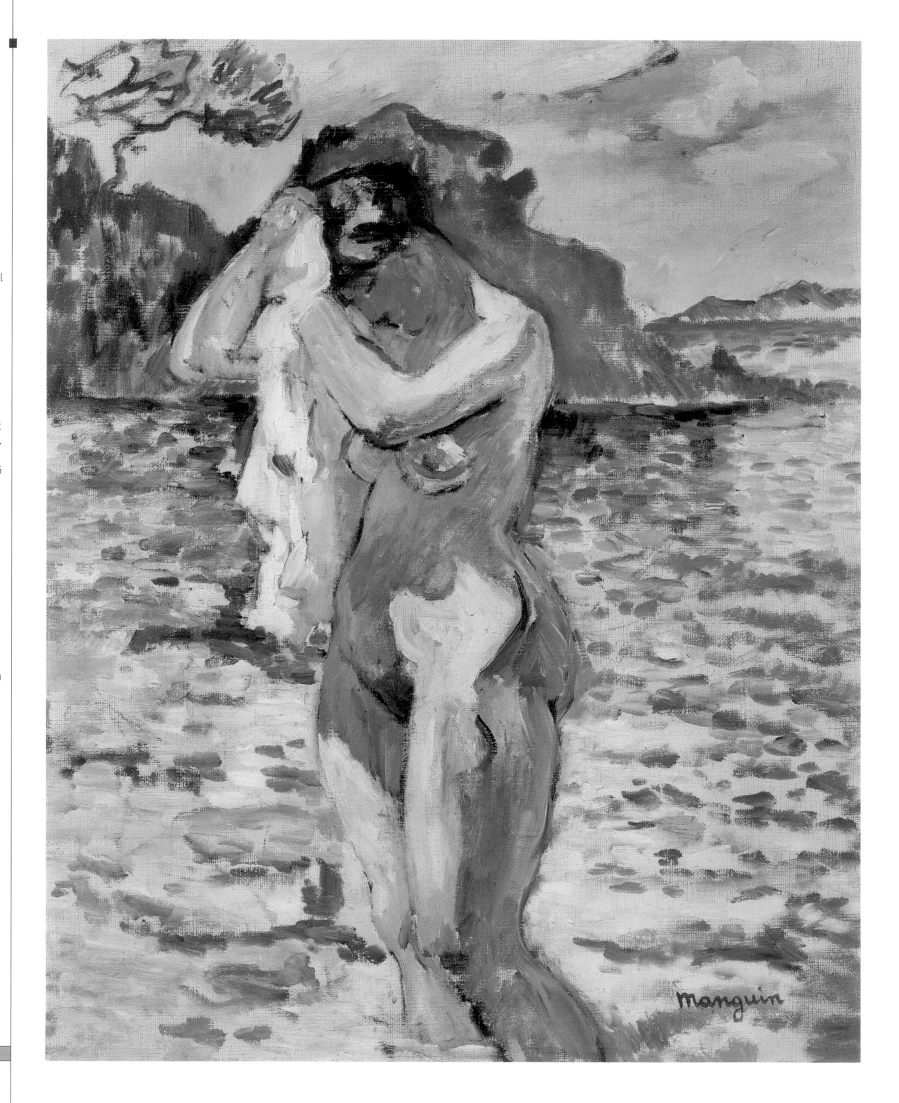

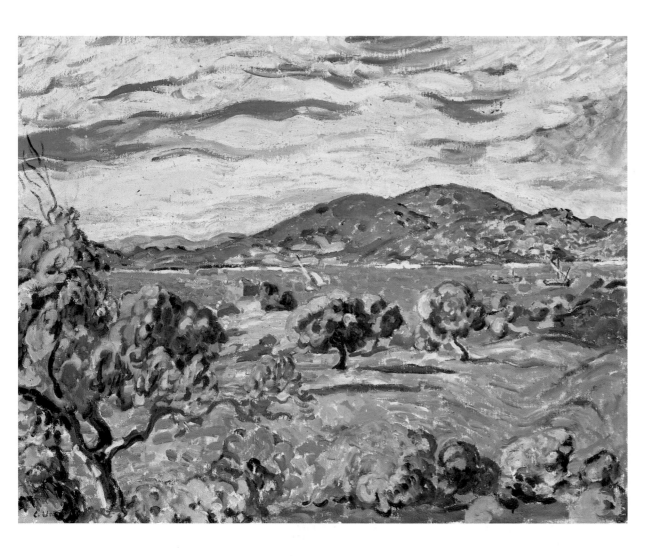

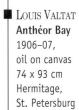 LOUIS VALTAT
Anthéor Bay
1906–07,
oil on canvas
74 x 93 cm
Hermitage,
St. Petersburg

Valtat was considered a precursor of the Fauves because he began using strong, bright tints during the first years of the 20th century, in contact with the Nabis painters. Between 1899 and 1913 he divided his time between Paris and Anthéor on the Côte d'Azur, where he made numerous landscapes. As in this canvas, he loved broad sunny spaces that permitted him to use bright, luminous colors capable of communicating a sense of serenity and peace.

GEORGES BRAQUE
Port Miou
1907, oil on canvas
49 x 60 cm
Civico Museo d'Arte
Contemporanea, Milan

In October 1906 Braque went to L'Estaque, near Marseilles, remaining there until February of the next year. In the landscapes he made during those months, depicting the town's small port and the area around it, he used the same intense colors as the Fauves. He deliberately ignored the traditional rules of perspective so as to have greater freedom in arranging masses and to put greater stress on the rhythm of the colors.

KEES VAN DONGEN
**Woman with
Blue Eyes**
1908, oil on canvas
27 x 22 cm
Private collection

In 1907 van Dongen
signed an important
contract with the
gallery owner Daniel-
Henry Kahnweiler;
the next year he
exhibited in the
Parisian gallery of
Bernheim-Jeune,
receiving flattering
reviews from critics.
The works he made
in those years, which
mark the beginning
of a long and
fortunate career,
were characterized
by bright colors and
highly expressive
design, which
attracted the
attention of the
members of Die
Brücke, with whom
van Dongen
participated in
several collective
shows. The extremely
close-up point of
view used in this
portrait reveals the
basic features of the
girl, in particular her
long-lashed big blue
eyes with which she
stares directly at the
viewer, as though
seeking to enchant or
hypnotize. After
World War I
van Dongen became
a portraitist of the
bel monde between
Paris and the Côte
d'Azur, enriching his
palette with new
tints, far more
delicate and shaded.

■ MAURICE
DE VLAMINCK
Town
1908–09,
oil on canvas
73.4 x 92.3 cm
Hermitage,
St. Petersburg

The years between
1906 and 1910 were
particularly intense
for Vlaminck, both
for the many shows
in which he
participated—
including his own
one-man show
arranged by Vollard
in Paris—and for
the many paintings
he made, which
testify to his efforts
to achieve greater
compositional rigor
and to his more
meditated use of
lines and colors.
One notes here the
decomposition of
the planes into
elementary geometric
forms, a method
destined to have a
powerful influence
on the Cubists.

■ RAOUL DUFY
Port
1908,
watercolor on paper
65 x 80 cm
Alte Nationalgalerie,
Berlin

Dufy's works are
characterized by
a minute and
descriptive design,
almost anecdotal,
that demonstrates
his acute talents as
an observer. Using
only a limited number
of elements he
creates a serene and
tranquil atmosphere,
such as this port view
in which figures stroll
along the dock and
look out over the
water at the slow
progress of a sailboat.

HENRI MATISSE
**Luxe, Calme
et Volupté**
1904, oil on canvas
99 x 118 cm
Musée d'Orsay, Paris

The title of this painting is from a couplet by Charles Baudelaire in *Invitation to the Voyage: "Là, tout n'est qu'ordre et beauté/Luxe, calme et volupté"* ("There all is order and beauty/Luxury, peace, and pleasure"). Presented at the Salon des Indépendants in the spring of 1905, the canvas received a positive response from critics and drew particular admiration from Paul Signac, who saw it as an excellent application of his Pointillist style and who in the month of September bought it to display in the dining room of the villa La Haune at Saint-Tropez. Matisse applied the Pointillist technique, making use of small dots of pure color arranged next to one another, but he did not apply it in the rigorous and systematic manner established in the rules codified by Georges Seurat. A second source of inspiration was the Bathers by Paul Cézanne, to whom Matisse refers most of all in the soft and seductive lines of the women's bodies, a virtual hymn to sensuality and the joy of life.

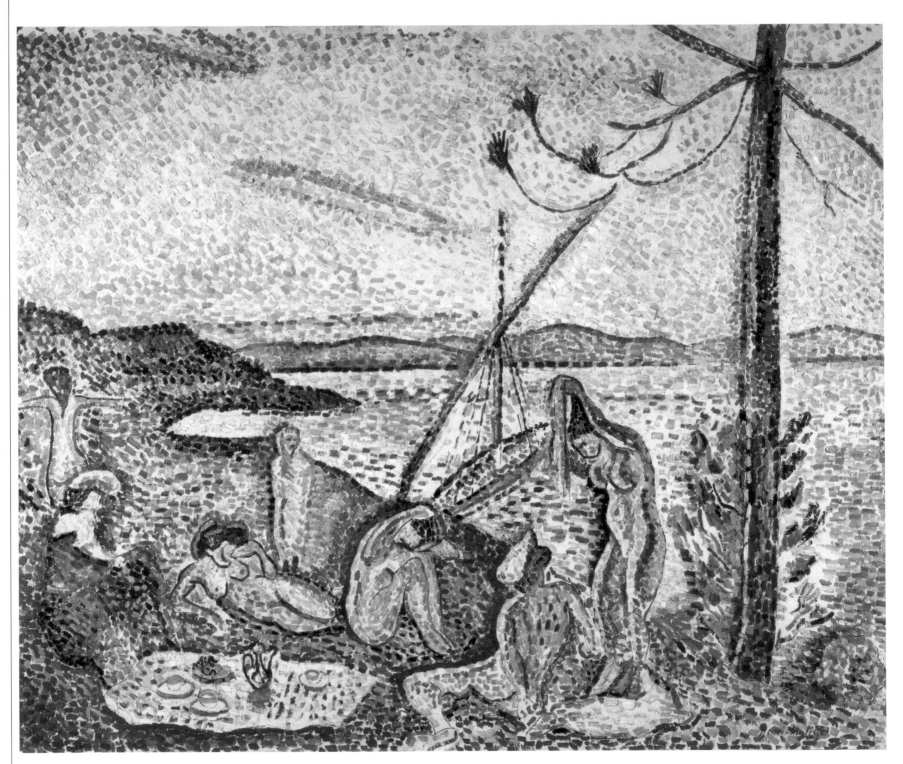

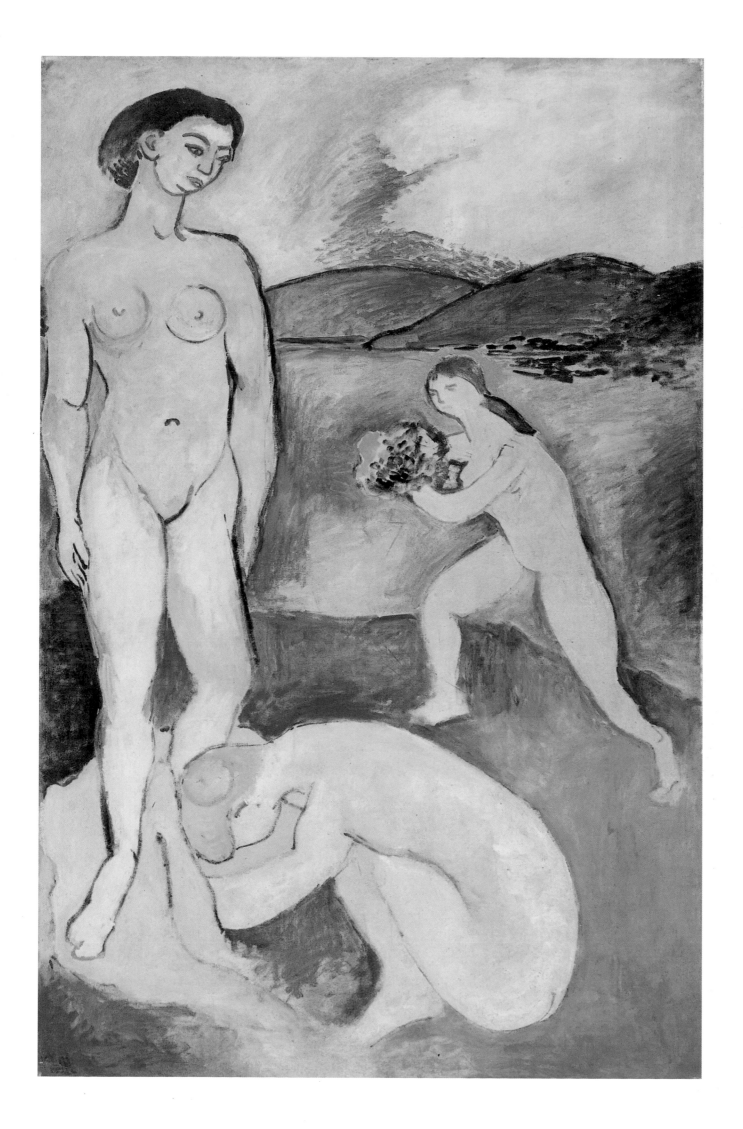

■ Henri Matisse
Luxury I
1907, oil on canvas
210 x 138 cm
Musée National d'Art
Moderne, Centre
Georges Pompidou,
Paris

In 1907 Matisse made two paintings depicting three women on the beach, this work and *Luxury II* (Statens Museum for Kunst, Copenhagen). In both works Matisse repeated the theme of the Bathers by Paul Cézanne, but he had definitively abandoned the Pointillist style. The three figures and the background landscape are delineated with a simplified design using clear outlines that create large two-dimensional surfaces enlivened by the sharp chromatic contrasts that are typical of Fauvist painting. The colors are not applied in a uniform way but give life to a particularly evocative rhythm of empty and full spaces. The two women in the foreground are presented in a static, almost sculptural pose, also without depth, but the third is caught in the act of running toward them. Her body perfectly expresses the idea of agile and harmonious movement that shows up in many of the works Matisse made in later decades.

HENRI MATISSE
**The Red Room
(Harmony in Red)**
1908–09,
oil on canvas
180 x 220 cm
Hermitage,
St. Petersburg

Since green was the
predominant color in
his first version of
this painting, Matisse
planned to call it
Green Harmony. A
few months later,
however, he became
dissatisfied with the
work as it was and
repainted it in blue.
He exhibited it at the
1908 Salon d'Automne
with the title *Blue
Harmony* and
promised it to Sergei
Shchukin, one of the
first buyers of his
works. Before handing
the large canvas over
to the Russian
collector, Matisse
changed his mind
again, and in the
spring of 1909 he
repainted it in a
bright and lively
red, giving it its final
appearance and final
title. The intense
colors are typical of
the Fauvist style, and
there is the addition
of the decorative
elements that would
become fundamental
characteristics in the
second part of his
career. There is a
clear lack of depth,
most of all on the
table that the
woman is setting
and in the garden
visible through the
open window.

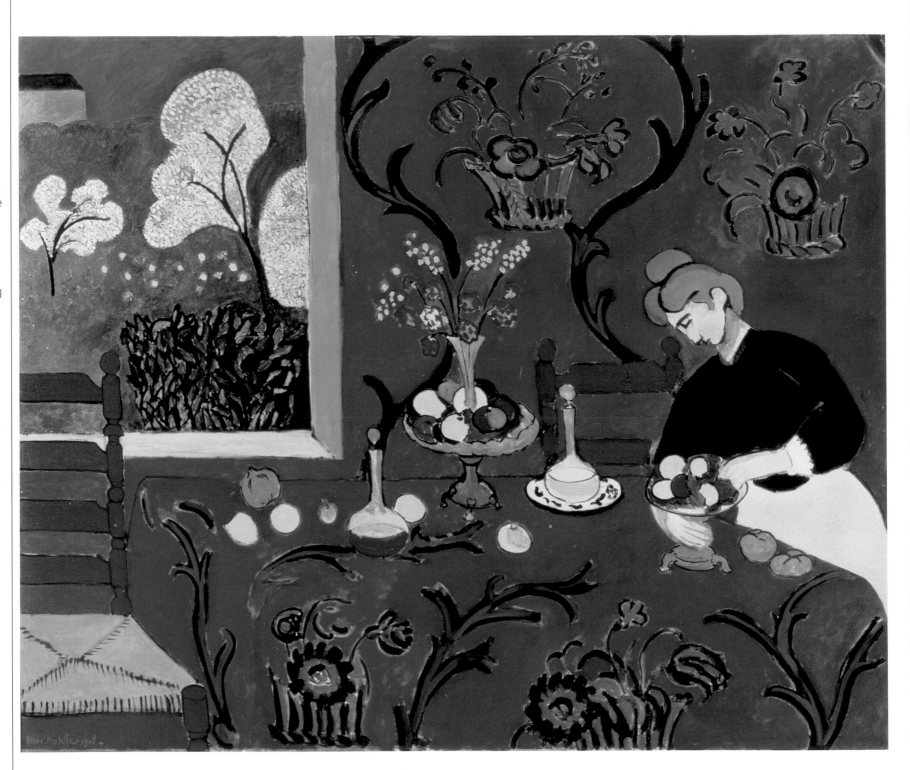

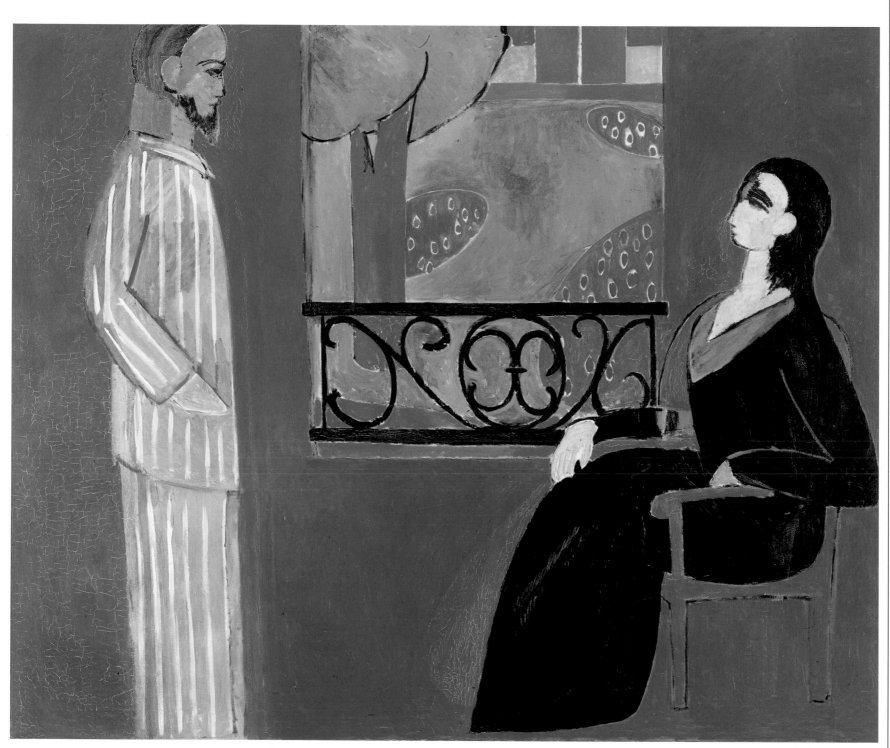

■ HENRI MATISSE
Conversation
1908–12,
oil on canvas
177 x 217 cm
Hermitage,
St. Petersburg

The subject of the painting, which Sergei Shchukin bought in the summer of 1912, is apparently quite simple: We see the artist, dressed in pajamas, giving a morning greeting to his wife, Amélie Parayre, whom he married on January 8, 1898. Even so, from its first public appearance, at the Post-Impressionist show mounted by Roger Fry at the Grafton Galleries in London and running from October 5, to December 31, 1912, the canvas has been the subject of many interpretations and readings, including those psychoanalytic, on the complex relationships between the two figures. Matisse drew inspiration for the painting from a Cassite stele from 1200 BC preserved in the Louvre, in which a king presents his daughter to the goddess Nana. The choice of colors—black, blue, green, and red—seems based on several Byzantine enamels that Matisse was able to see at the Louvre and in the collection of Shchukin's uncle in Moscow during a trip there in 1911.

HENRI MATISSE
Dance
1909–10,
oil on canvas
260 x 389
Hermitage,
St. Petersburg

On March 31, 1909,
Sergei Shchukin
commissioned Matisse
to make two large
decorative panels
for the walls of the
stairway in his
Moscow home. For
the first, dedicated
to music, Matisse
expanded upon a
drawing made at
Collioure in 1907.
Matisse was highly
knowledgeable about
music, kept a small
harmonium in his
atelier, and was a
reasonably good
violinist, even playing
several times together
with professional
musicians. The second
painting, dedicated
to dance, repeated
and developed a
group of six dancers
that appear in the
background of
Joy of Life from
1905–06 (Barnes
Foundation, Merion,
Pennsylvania). In
order to adapt the
composition to the
long, narrow,
rectangular shape of
the panel, Matisse
eliminated one figure
and emphasized the
tension in the bodies,
which open outward
in a way that releases
an extraordinary
sense of vital energy.
A characteristic
aspect of both
compositions is the
particular use of

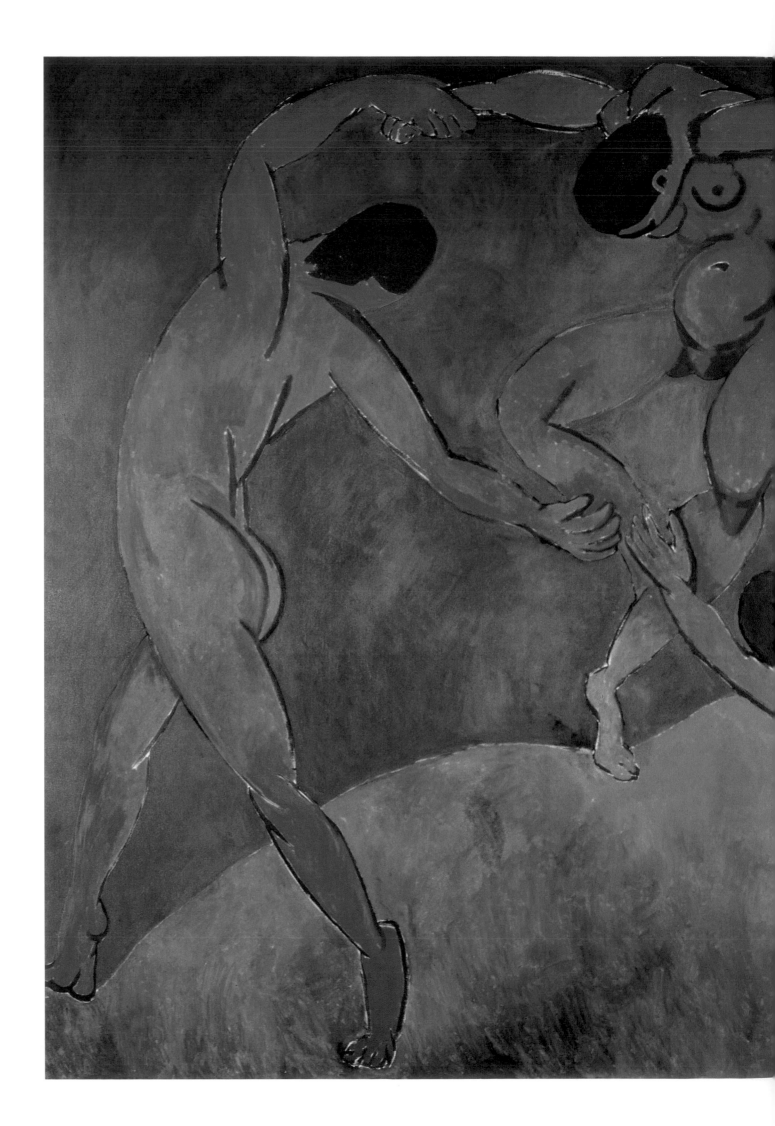

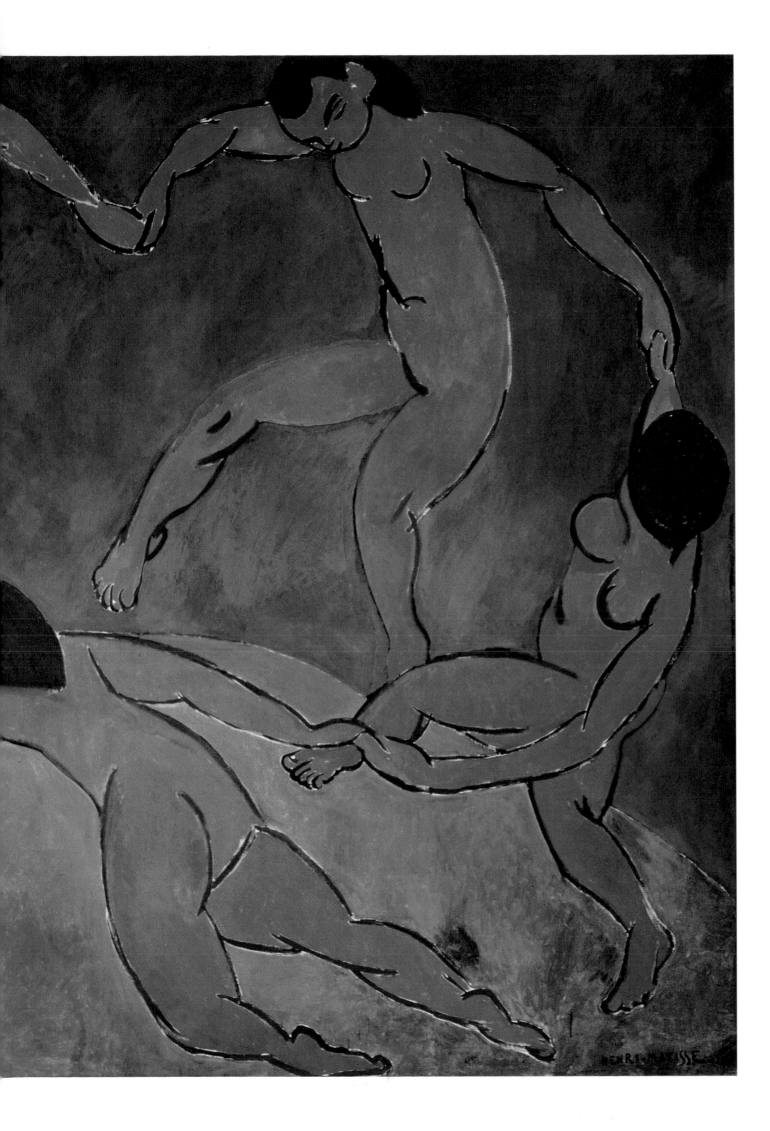

colors: With their bright skin and brown hair, the figures stand out sharply against the background, which is painted a uniform green and blue with very sharp and strong tonalities. The space is completely without depth, and the figures seem almost immaterial, light and insubstantial. These stylistic decisions categorically ruled out any naturalist definition and locate the scene in a timeless dimension, purely abstract and decorative. The two works were exhibited at the Salon d'Automne in Paris in October-November 1910, but received negative criticism. Even Shchukin was unhappy with the two paintings, worried about the presence of so many nudes, and he asked Matisse to clothe them. Disappointed and offended, Matisse refused to do so and took off for Spain. When Matisse returned to France in 1911 the Russian collector changed his mind and decided to keep the two panels.

HENRI MATISSE
The Goldfish
1911, oil on canvas
146 x 97 cm
Pushkin Museum,
Moscow

Matisse was
fascinated by goldfish
and presented them
several times over
the years in different
stylistic settings. This
composition is based
on curving lines,
those of the various
sizes and types of
leaves, those of the
flowers, depicted with
a few touches of soft
color, those of the
extremely simplified
table, and those of
the large cylindrical
bowl in the
foreground. The
bright red of the
fish is reflected and
multiplied on the
surface of the water
and gives the
composition vivacity
and dynamism.
Matisse wanted to
transfer to canvas
the emotions he
experienced in
contact with nature;
he wanted to give
the viewer the
impression of sensing
a silent dialogue
between the world
animated by the fish
and the equally lively
world of the plants.
In his *Souvenirs*, the
painter Jean Puy
compared Matisse to
a goldfish who sees
the world filtered
and deformed by
the liquid mirage
of his bowl.

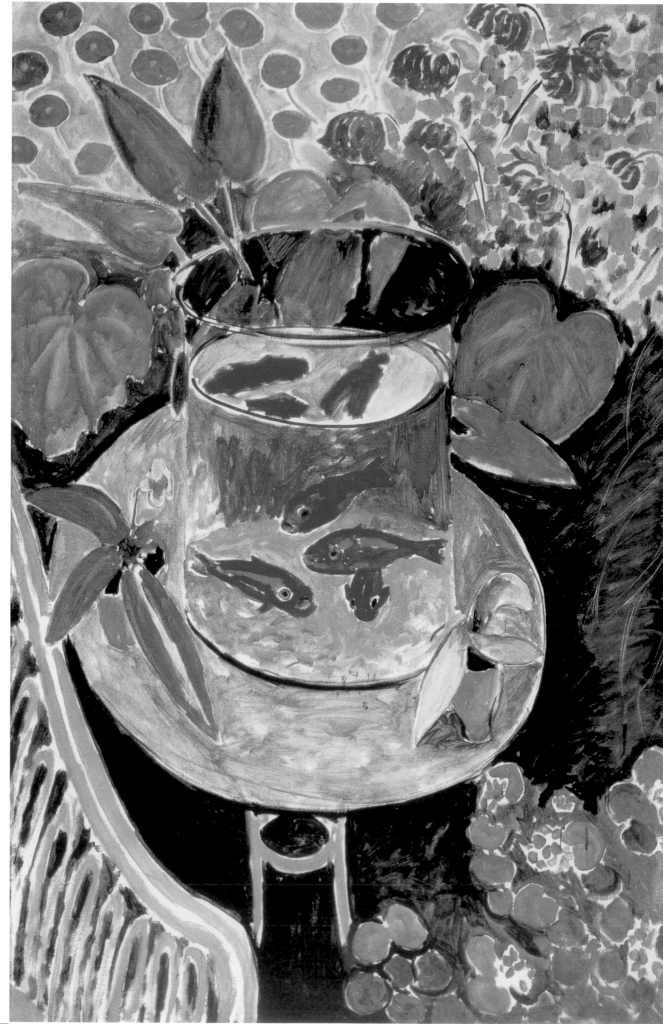

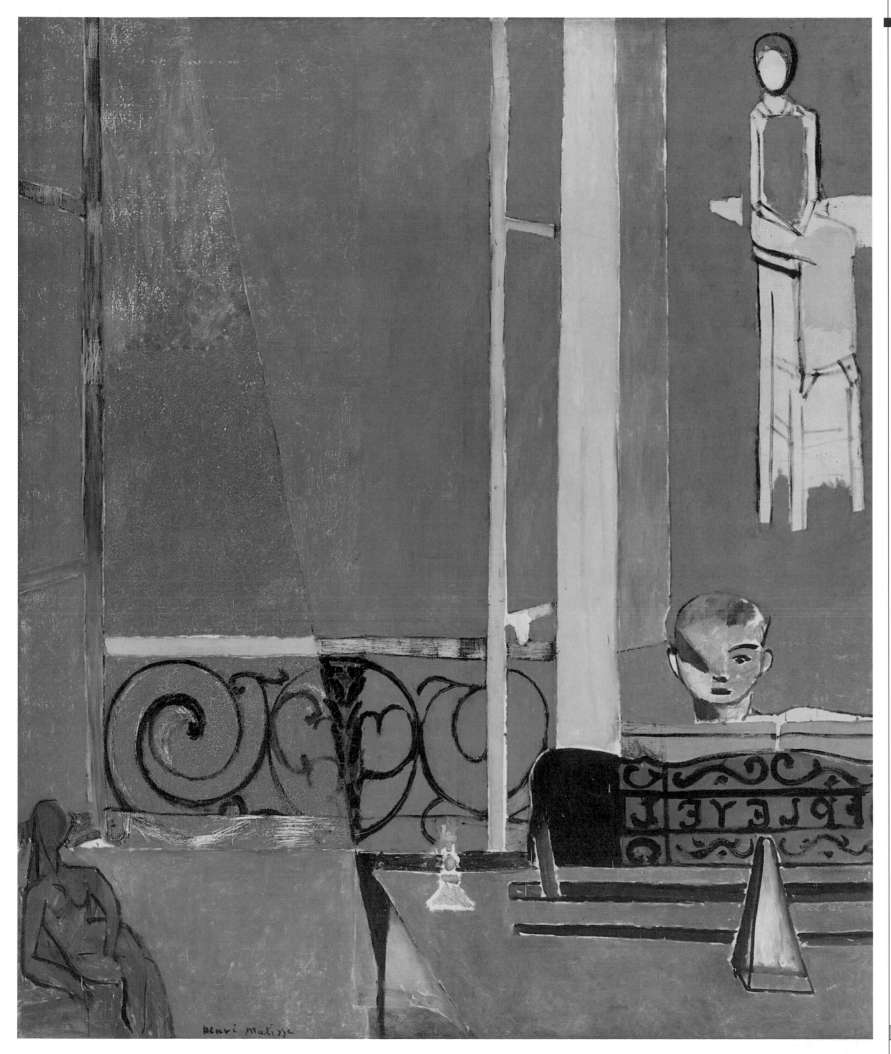

Henri Matisse

HENRI MATISSE
The Piano Lesson
1916, oil on canvas
245 x 212 cm
Metropolitan Museum
of Art, New York

At the outbreak of
the World War I
Matisse withdrew to
Collioure, where he
met Juan Gris, Albert
Gleizes, and Jean
Metzinger and moved
his style toward that
of the Cubists. The
boy in this painting
is Matisse's son,
Pierre, shown intent
on playing a Pleyel
piano. He was sixteen
at the time, although
he seems much
younger; the shadow
that covers his eye
recalls the triangular
shape of the green
drape to the left and
the shape of the
metronome atop the
piano. The female in
the background
repeats, with forms
more simplified, a
Matisse painting of
1914, *Woman on a
High Stool* (Museum
of Modern Art, New
York), one of his first
compositions with a
Cubist inspiration. As
model for the female
figure Matisse used
Germaine, wife of the
critic Maurice Raynal
(of whom Juan Gris
had made a portrait
a year earlier). In
the lower left is a
sculpture entitled
Decorative Figure
(private collection),
which Matisse made
in 1908.

eeking to identify the origin of Cubism, art historians usually select the 1907 Salon d'Automne with its retrospective show dedicated to Paul Cézanne. It was then that Picasso, Matisse, Braque, Léger, and other artists discovered the fruit of the years of study and work that Cézanne had conducted at Aix-en-Provence, where he went disappointed and embittered by the ferocious criticism that his paintings had received in the first Impressionist exhibits. His last works constituted a true revolution, for the rejection of the traditional rules of perspective, the reduction of space to only two dimensions, and the simplification of objects to pure geometric forms. No less important for the birth of Cubism was the influence of art from outside Europe, which offered artists new stimuli and alternatives to the classical models of ancient art. In particular, the Cubist style is often associated with the taste for African sculpture, which the artists encountered by way of the Fauves: Derain, Vlaminck, and Braque collected African art, buying it between 1903 and 1907; Max Jacob and Gertrude Stein mention that

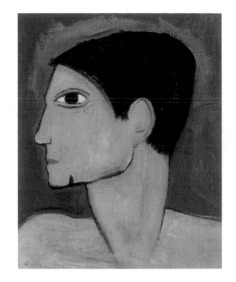

Matisse had a collection of around twenty pieces; Matisse in turn showed these works to Picasso, transmitting to him his passion for that art. Picasso often visited the ethnographic collections in the Trocadéro, and as early as 1907, while painting *Les Demoiselles d'Avignon*, he had African masks and sculptures in his studio.

The "official" birth of Cubism is usually dated to the end of 1907, when Guillaume Apollinaire presented Picasso to Braque, thus beginning a long and profitable collaboration between the two artists. Braque was literally astonished by the *Demoiselles d'Avignon*, which he analyzed in depth, seeking to understand its every secret in a series of drawings and studies that he then used for making his *Large Nude*, which he began work on in December 1907 and exhibited at the Salon des Indépendants in 1908. In the same year Braque continued his work on a series of paintings he made at

L'Estaque; he hoped to exhibit them at the Salon d'Automne, but the jury rejected them. Braque had the good fortune to meet a young German gallery owner, Daniel-Henry Kahnweiler, who would perform a decisive role in the history of Cubism. Kahnweiler had recently opened a small gallery in Paris at 28, Rue Vignon, and he organized an exhibit of Braque's works that ran from November 9 to 28, 1908. Apollinaire wrote the introduction to the catalogue, later expanding it into his fundamental critical essay *Les Peintres Cubistes*, in which he identified and explained the fundamental aspects of the new artistic movement. Most of the reviews of the exhibit were negative, such as that of Charles Morice in the *Mercure de France* of December 16, and, in particular, the review by Louis Vauxcelles in *Gil Blas* of November 14, which includes this brief phrase: *"Il méprise la forme, reduit tout, sites et figures et maisons, à des cubes"* ("He disdains forms, reducing everything, places, figures, and buildings, to cubes"). This is the first text in which the term *cube* is associated with the new style. Thus, after having "baptized" the Fauves, the French critic Vauxcelles—born in 1870—made himself godfather to the Cubists. There is another story of the birth of the term *cubism*, one reported by Apollinaire in the *Mercure de France* of October 16, 1911, and repeated in his *Les Peintres Cubistes*. According to this version, while the jury of the 1908 Salon was examining Braque's paintings, Matisse, who was a member of the jury, exclaimed,

Marie Laurencin,
Portrait of Pablo Picasso, 1908,
oil on canvas,
41.3 x 33 cm;
private collection

Georges Braque,
Large Nude, 1907–08,
oil on canvas,
140 x 100 cm;
Collection Alex Maguy, Paris

"Toujours les cubes!" ("Always cubes!"). The magazine *L'Art Libre* of November 1910 included a piece about that year's Salon d'Automne by the poet and essayist Roger Allard, destined to become one of the primary supporters of Cubism. Writing about a nude by Jean Metzinger, one of the first artists to follow the example of Braque and Picasso, Allard referred to the artist's analysis of the relationships between the objects and to the synthesis that he was seeking to accomplish. These two terms, *analytical* and *synthetic*, were later used by Kahnweiler in his book *Der Weg zum Kubismus* ("The Way of Cubism"), written between 1915 and 1918, and the terms were then adopted by critics as names for the movement's two phases.

The official consecration of Cubism took place at the two salons of 1911. In Hall XLI of the Salon des Indépendants works by Albert Gleizes, Henri Le Fauconnier, Fernand Léger, Robert Delaunay, and

Cubism) or, even worse, would veer into abstraction, which was something they rejected. The second danger was that colors would lose their sense. To avoid these possible problems they retained chromatic values and the necessary relationship to reality by inserting newspaper clippings, playing cards, bits of wood, words, or numbers, thus creating the collages and *papiers collés* ("pasted papers") that were to have an important impact on the artistic movements of later decades, from Dadaism to pop art. After 1912 Cubism spread throughout Europe (for example, Alexandre Mercereau introduced

Pablo Picasso, *House and Trees*, 1908, oil on canvas, 98 x 73 cm; Pushkin Museum, Moscow

Cubism

Jean Metzinger were exhibited; Hall VIII of the Salon d'Automne presented paintings by Fernand Léger, André Lhote, Jacques Villon, Luc-Albert Moreau, Marcel Duchamp, Jean Metzinger, Roger de La Fresnaye, Henri Le Fauconnier, Albert Gleizes, and André Dunoyer de Segonzac. In his book *Souvenirs-Le Cubisme, 1908–1914*, published in Paris in 1957, Gleizes recalls how on both occasions large crowds filled the rooms in which the works were displayed, leading to loud and heated discussions between supporters and detractors, all of it reported and exaggerated in the reviews, where the critics themselves took positions either openly in favor or strongly against this type of art.

The passage from Analytical to Synthetic Cubism took place between 1911 and 1912. In that period Picasso and Braque no longer limited themselves to the fragmentation of planes and simple objects but sought to organize more articulated and complex compositions. In doing so, however, they became aware of two dangers. The first was that of making the relationship to reality so feeble that their works would be either incomprehensible (leading to discussion of "hermetic"

it to Prague, Budapest, and Moscow), and various subgroups came into being. Among these were Orphism, the term Apollinaire used for the work of Robert and Sonia Delaunay, because of its subtle analogies with music and poetry, and the Section d'Or ("Golden Section"), so named after the exhibition in October 1912 at the Galerie la Boëtie in Paris, in which about thirty artists interested in geometric and mathematical problems took part. Cubism reached its period of greatest development between 1912 and 1915; after World War I the individual artists followed separate routes that took them in different directions.

Pablo Picasso, *Portrait of Daniel-Henry Kahnweiler*, 1910, oil on canvas, 101 x 73 cm; Art Institute of Chicago

PABLO PICASSO
**Les Demoiselles
d'Avignon**
1907, oil on canvas
244 x 233 cm
Metropolitan Museum
of Art, New York

The many preparatory
drawings that
preceded this
painting varied widely
in both content and
style, revealing how
Picasso began with
an initial, somewhat
vague idea and
successively removed
or added various
elements on the
route to achieving
the final result. In
its first phase, the
canvas was going to
present five women
and two men (a sailor
and a student holding
a skull) in a brothel in
Calle de Avinyó in
Barcelona, with large
drapes and still lifes
of flowers and fruit.
The men and flowers
were later eliminated,
leaving only the fruit
in the foreground and
some drapery in the
back. The three
figures to the left
recall Cézanne's
Bathers; the figure
at far right (in the
background) shows
the influence of
African masks; the
seated woman at
lower right is the
most "Cubist" of all.
The way she presents
her back to the
viewer is an early
attempt at
"simultaneous"
painting, showing
reality from different
points of view.

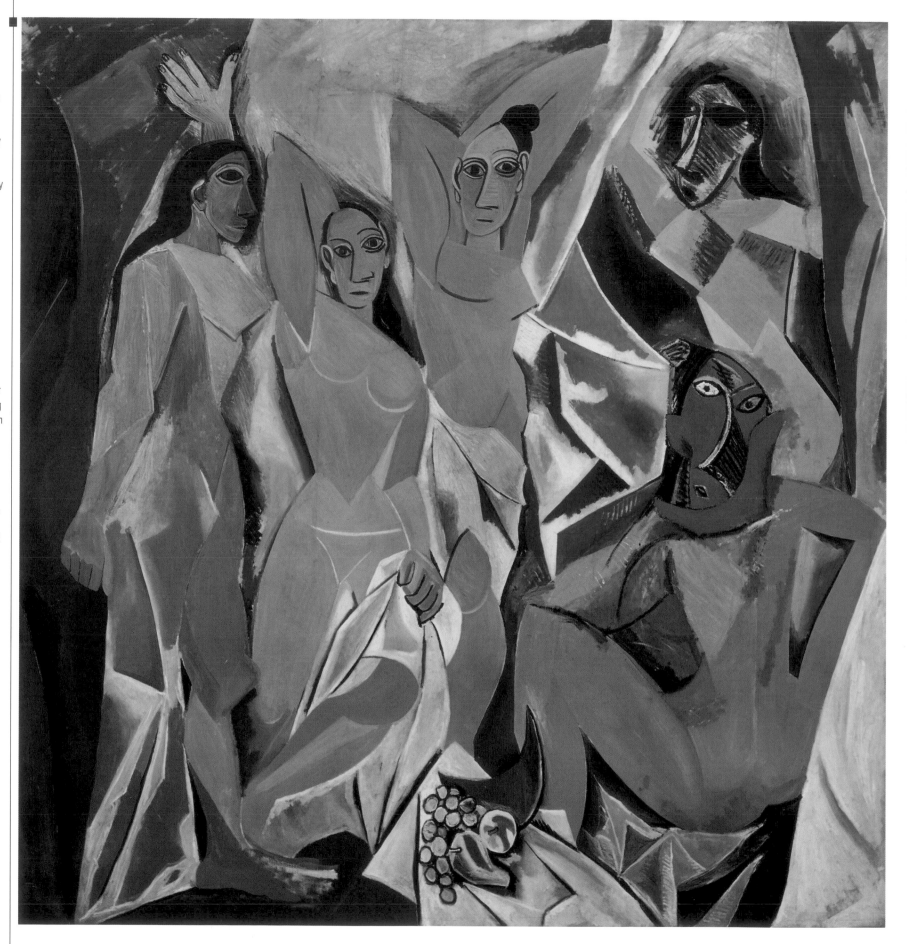

Cubism

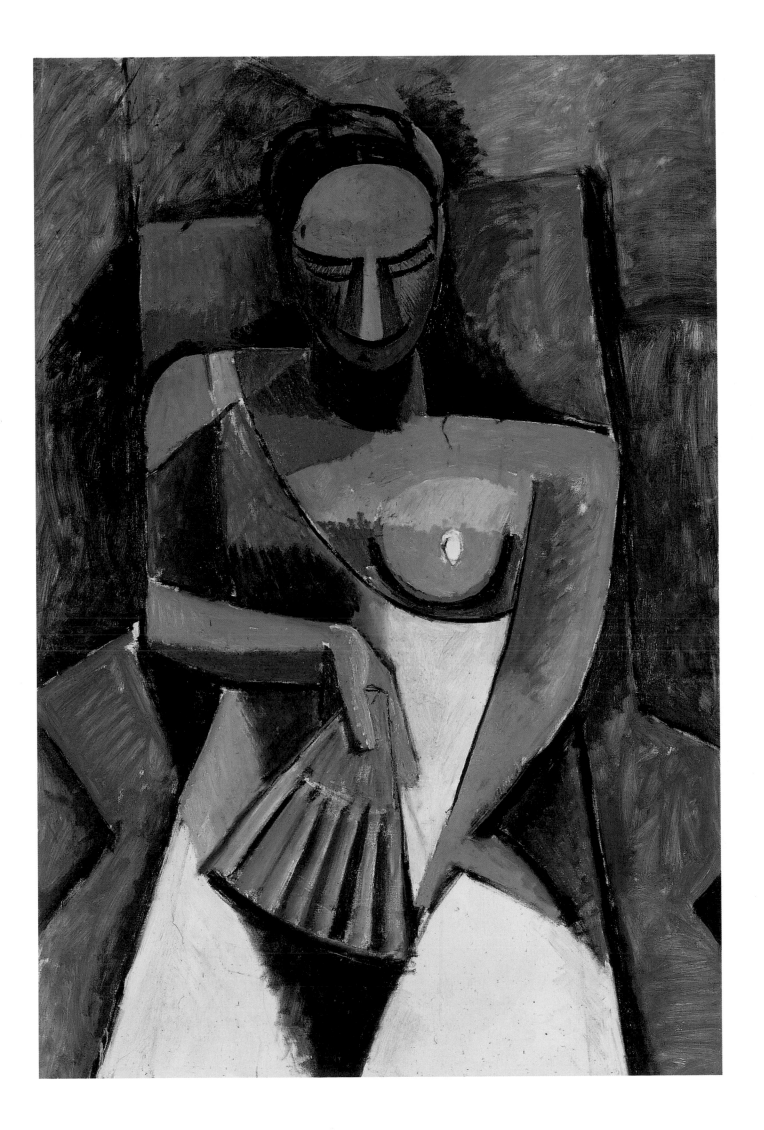

■ PABLO PICASSO
Woman with a Fan
1907–08,
oil on canvas
152 x 101 cm
Hermitage,
St. Petersburg

This work is one of fifty paintings that the Russian collector Sergei Shchukin bought from Picasso, to whom he had been introduced by Henri Matisse. The painting is an important document in the stylistic route that led to Cubism and also reveals much about Picasso's working methods. X-ray analysis has revealed that Picasso initially portrayed his companion Fernande Olivier in a traditional and realistic way. He later made changes to the drawing, and using only a limited number of colors— most of all gray, white, and ocher— he progressively modified and simplified the work, finally bringing it close to elementary geometric figures. The fragmentation of forms is most clear in the chair, while the figure of the woman, although without depth, still presents naturalistic aspects. For this reason, works made between 1907 and 1909 belong to an experimental phase called pre-Cubism.

PABLO PICASSO
**Brick Factory
at Tortosa**
1909, oil on canvas
53 x 60 cm
Hermitage,
St. Petersburg

In the summer of
1909 Picasso and
Fernande Olivier
went to Horta de
Ebro, a village in
Spain's Terragona
province. Thanks to
help from Kahnweiler,
Picasso was in far
better financial shape
and could dedicate
himself to painting
without worries about
the future. He made
several portraits of
Fernande along with
landscapes in which
he explored the ideas
he had begun in
Paris, thereby
creating what critics
have come to call
Analytical Cubism.
Influenced by similar
efforts undertaken by
Braque (for example,
Houses at L'Estaque;
see page 78), Picasso
divided space into
large shadowed
facets, reducing the
buildings to an
assembly of geometric
solids seen from a
variety of
perspectives. Even
the trunks of the
palm trees are
presented as simple
cylinders; only the
thick foliage
maintains a vague
sense of realistic
nature. The colors,
reduced to a limited
spectrum, contribute
to the creation of a
cold, unnatural
atmosphere.

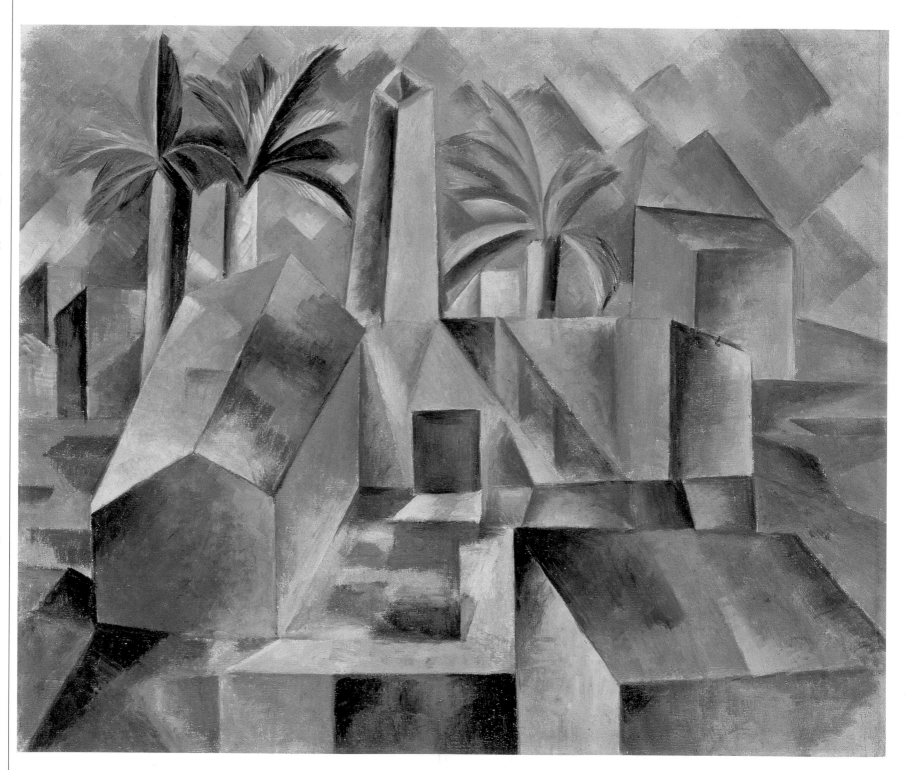

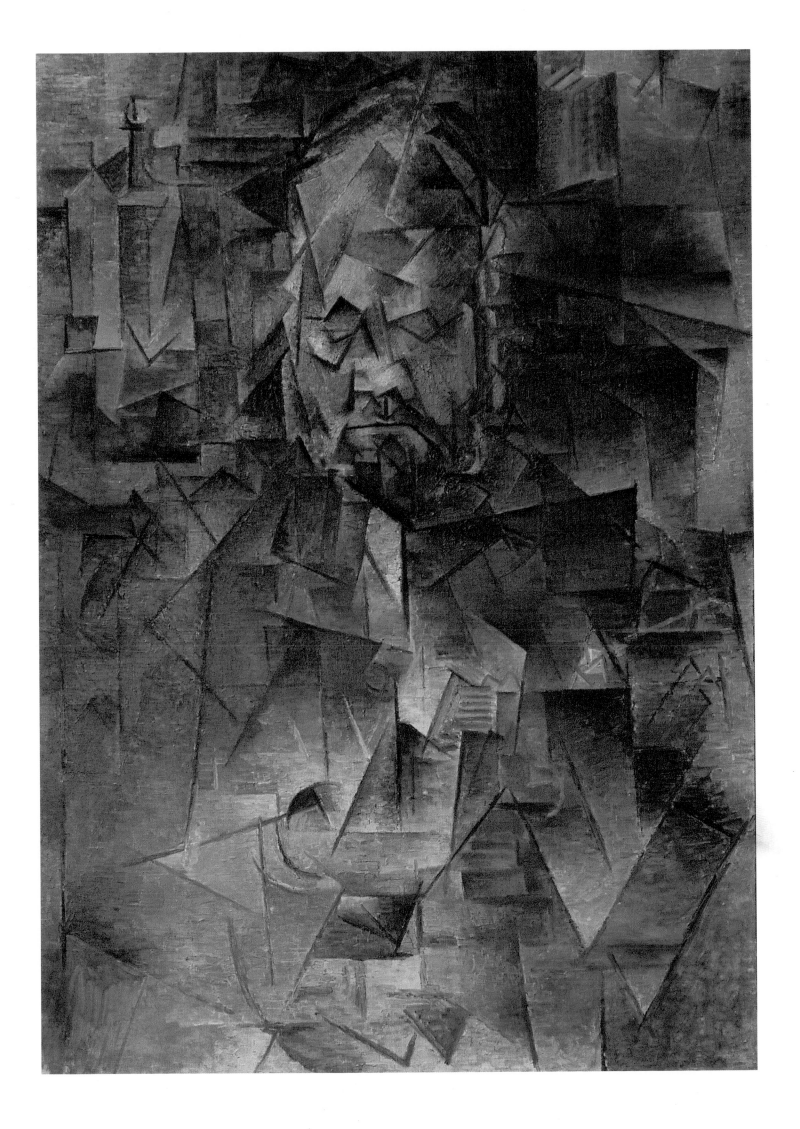

■ PABLO PICASSO
Ambroise Vollard
1909–10,
oil on canvas
92 x 65 cm
Pushkin Museum,
Moscow

This portrait, along
with those of Wilhelm
Uhde and Kahnweiler
from the same period,
is one of the
outstanding examples
of Analytical Cubism,
characterized by a
radical fragmentation
of forms that so
thoroughly cancels
their material
substance that the
style is also called
"hermetic." Vollard
is seated frontally
at the center of the
painting; behind
him can be seen (or
imagined) a table,
with a bottle and
book located
vertically. The art
dealer was not
completely happy
with Picasso's Cubist
works, in part because
they differed so
greatly from his
personal taste and
in part because he
feared they could
have a negative effect
on the prices of works
from the blue and
rose periods still in
his possession. For
this reason, although
he recognized himself
in this portrait and
understood its
excellent
psychological
characterization,
he did not keep it
and instead sold it
in 1913 to the
Russian collector
Ivan Morovoz for
3,000 francs.

GEORGES BRAQUE
Houses at L'Estaque
1908, oil on canvas,
73 x 60 cm
Kunstmuseum, Bern

This painting marked Braque's passage from the Fauvist style, to which he had adhered for several years, to Cubism. It also testifies to Braque's indebtedness to Cézanne's landscapes, with their decompositions and simplifications. The houses are reduced to elementary geometric forms, while the trees in the foreground have lost almost all sense of naturalism. Braque and Picasso worked in close contact during these years, and both affirmed that their interest was not directed at a faithful depiction of reality so much as at its intellectual perception, so as to create not a simple visual correspondence to realty but a more complex spiritual tie. This attitude, which was further developed by conceptual artists in the coming decades, perplexed and disoriented critics and the public alike, as the criteria by which they had understood and judged works of art were being eliminated.

Cubism

■ GEORGES BRAQUE
**Mandolin
and Glass**
1911, oil on canvas
40.6 x 33 cm
Private collection

The painting at far
left belongs to the
final phase of
Analytical Cubism.
Rather than
presenting objects
simultaneously from
different points of
view, Braque presents
the viewer with the
presence of the
objects or parts of
them in relation to
the surrounding
space. One can
identify the handle
and the strings of a
musical instrument
and part of a glass,
but the forms of the
two objects are so
thoroughly
disassembled that
the composition
approaches the
abstract.

■ GEORGES BRAQUE
Violin and Palette
1910, oil on canvas
91.7 x 42.8 cm
Solomon R.
Guggenheim Museum,
New York

In his Analytical-
period paintings
Braque gradually
replaced planes
with volumes and
took objects apart,
presenting them to
the viewer from
different points of
view. This radical
decomposition of
forms makes it very
difficult to identify
objects, as in this
painting, in which the
palette (near the top
of the canvas) and
violin (below) are
difficult to recognize.

ALBERT GLEIZES
Landscape at Meudon
1911, oil on canvas
146.4 x 114.4 cm
Private collection

This painting was first exhibited at the Salon des Indépendants, from April to June 1911; it was then exhibited in Brussels and Barcelona, where it was bought by Alphonse Kann, one of the first collectors of Cubist works. During the German occupation of France in World War II, part of Kann's prestigious collection was seized by the Nazis. In 1949 this painting was returned and deposited at the Musée National d'Art Moderne in Paris, but in July 1997 it was given to Kann's heirs, who then sold it to another collector. In this work Gleizes scrupulously followed the decompositions of Analytical Cubism, but at the same time he remained faithful to a sense of perspective, respecting the sense of proportion between the human figure in the foreground and the houses in the background, with the exception of the two trees at the center of the work, which are far higher and seem to soar.

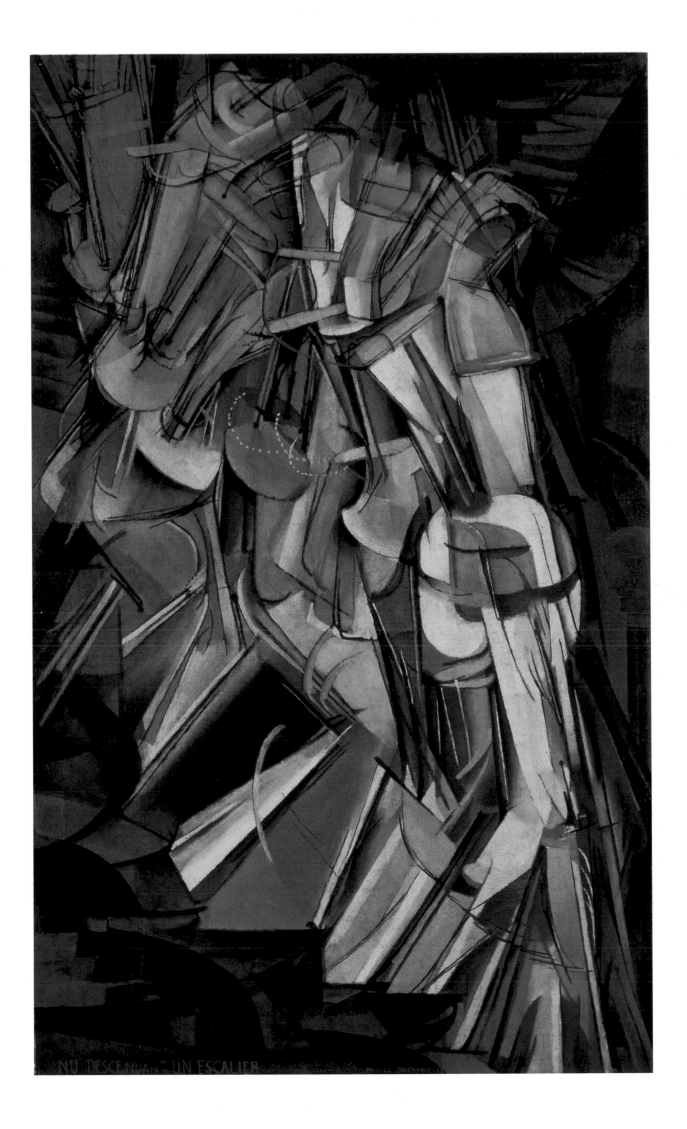

■ MARCEL DUCHAMP
**Nude Descending
a Staircase No. 2**
1912, oil on canvas
148 x 89 cm
Philadelphia Museum
of Art, Philadelphia

The first version of
this painting was a
preliminary study in
oil on cardboard
made in December
1911; the work here
is the second version,
painted on canvas the
following January.
Rejected by the jury
of the Salon des
Indépendants in
Paris, the painting
was exhibited in the
Dalmau gallery in
Barcelona; in February
1913, it was part of
the Armory Show in
New York, where it
caused a sensation.
The influences of
Analytical Cubism are
clear in the geometric
decomposition of the
forms and the limited
chromatic range.
Duchamp claimed
that he had been
inspired by the first
chronophotographies
by Etienne-Jules
Marey and by the
human-motion
photographs by
Eadweard Muybridge,
which inspired him
to study objects and
people in movement.
On the other hand,
he denied all contact
with the Futurists,
whose works he would
have been able to see
firsthand only in
February of 1912, at
the Bernheim-Jeune
gallery in Paris, by
which time this
painting was
already finished.

FERNAND LÉGER
The Stairway
1914, oil on canvas
144.5 x 93.5 cm
Moderna Museet,
Stockholm

This painting repeats,
with only a few
variations, a
composition Léger
made in the same
year entitled *Exit the
Ballets Russes*
(Museum of Modern
Art, New York).
Between 1911 and
1914 Léger worked on
the decomposition of
reality into geometric
elements, keeping in
mind both the work
of the Futurists—
primarily Boccioni
and Severini—and
those of the Cubists,
in particular Picasso
and Braque. He
concentrated
intensively on the
depiction of people in
movement; with that
cnd in mind he made
a series of paintings
called *Contrasts of
Forms*, in which he
distributes an orderly
series of lines and
geometric figures
across the pictorial
surface so as to
accentuate their
dynamic function. He
performes a similar
process of progressive
simplification in his
choice of colors, and
ends up using only
primary colors.

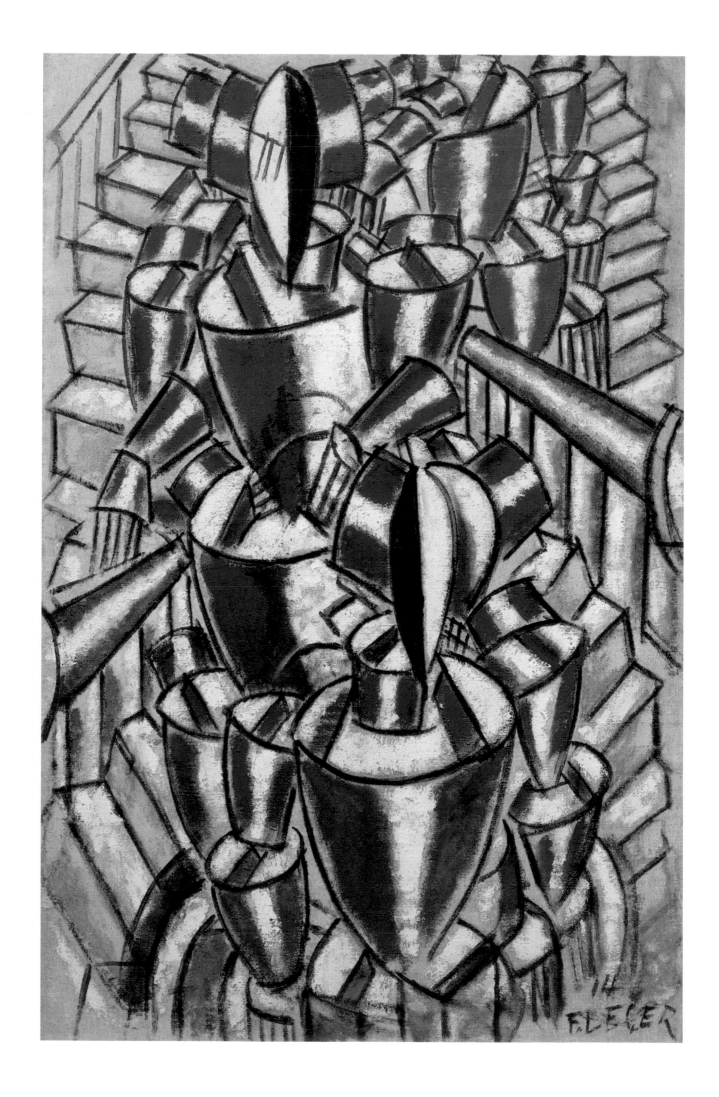

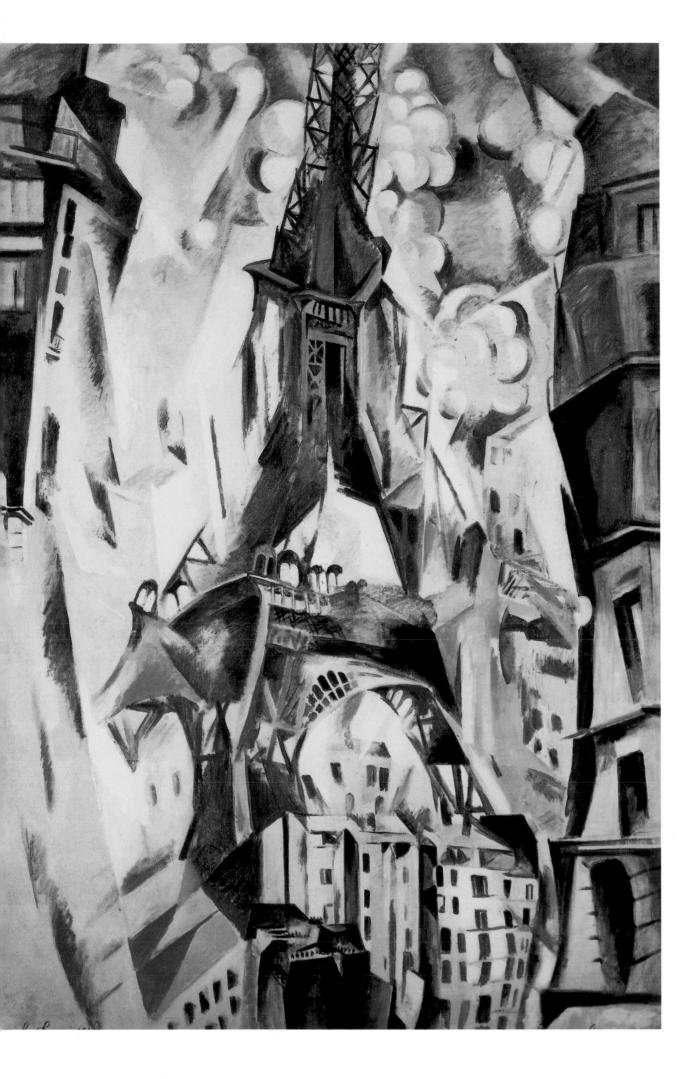

ROBERT DELAUNAY
The Eiffel Tower
1911, oil on canvas
202 x 138.4 cm
Solomon R.
Guggenheim Museum,
New York

Delaunay was quite
fond of the Eiffel
Tower as a subject
for paintings and
repeated it several
times over his career,
adopting different
stylistic approaches.
Here he decomposes
the giant metallic
structure and
recomposes it from a
daring perspective; he
applies the principles
of Cubism in a
dynamic spatial way,
giving preference to
chromatic values
with an intense
overall luminosity.

SONIA DELAUNAY-
TERK
**Illustration for the
Trans-Siberian
Express
(La Prose du
Transsiberien et de
la Petite Jehanne
de France) by Blaise
Cendrars**
1913, oil and
tempera on paper
193.5 x 18.5 cm
Hermitage,
St. Petersburg

In this work the
French writer Cendrars
and Ukrainian painter
Delaunay-Terk blended
their personal
experiences in stories
about train trips,
sometimes quite
exciting, heard in
popular Parisian
nightspots. Their goal
was the creation of a
"simultaneous book"
in which the words
and colors would
perfectly match and in
which different points
of view would be
presented at the same
time and in relation
to one another.

JUAN GRIS
**The Package
of Tobacco**
1916, oil on canvas
46 x 38 cm
John Berggruen
Gallery, San Francisco

In 1906 Gris moved
from Madrid to Paris,
where he worked with
Picasso and Braque.
In 1908 he met
Daniel-Henry
Kahnweiler, who
became his friend as
well as his favorite art
dealer, and in 1913
he met Josette, his
future wife. At the
outbreak of World War
I, in 1914, he moved
to Collioure, near the
Spanish border. There
he met Matisse, with
whom he had long
discussions on the
subject of art. In
particular Gris
explored the style
of Synthetic Cubism,
of which this
painting is one of
the first examples.
Gris presents
superimposed
intersecting planes,
playing with angles
and color contrasts.
While the background
is dominated by
darker, opaque tones,
the foreground, with
a glass and the
package of tobacco
that gives the work
its title, is enlivened
by paler tones. In
the works he made
immediately after
this Gris gave his
compositions further
movement through
the technique
of collage.

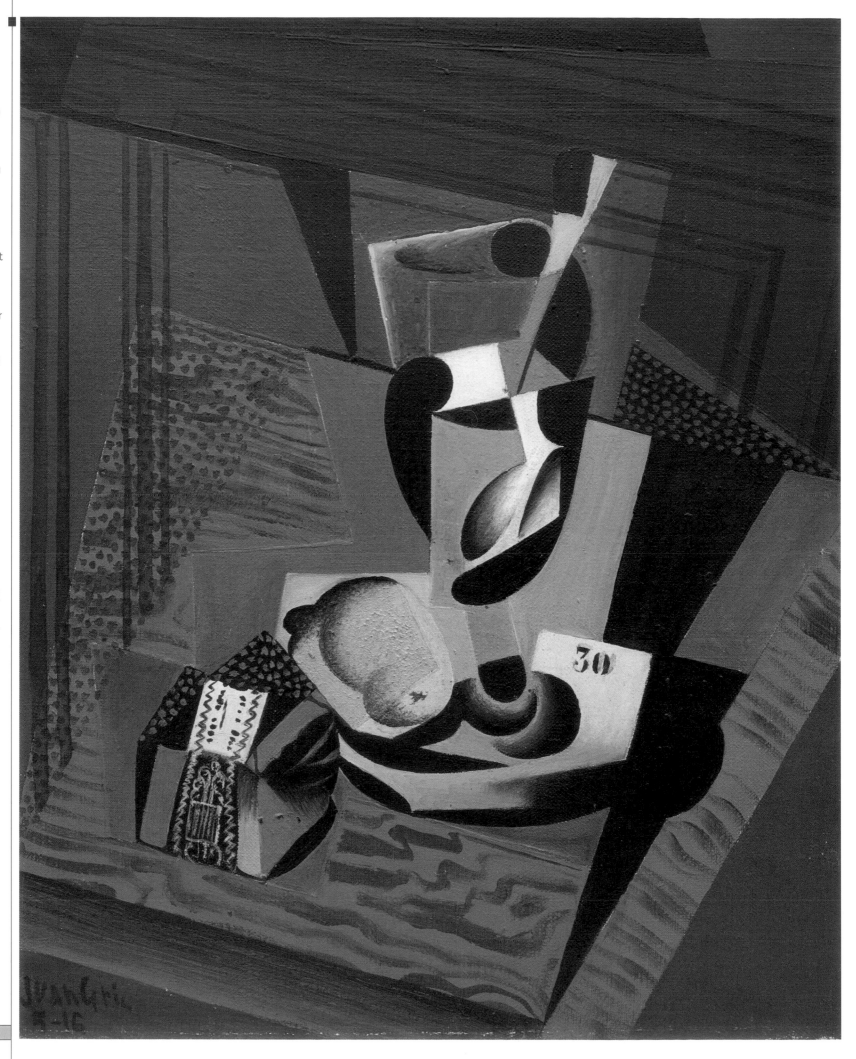

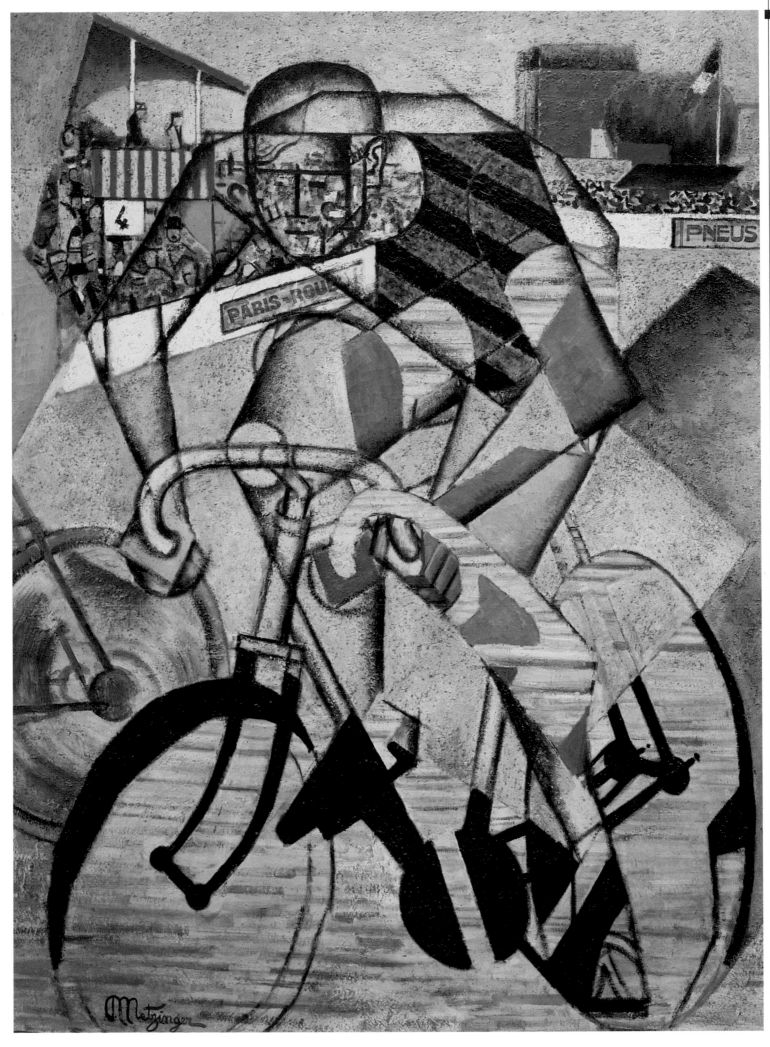

**At the Cycle-
Race Track
(Au Vélodrome)**
1911–14,
oil and collage
on canvas
130.4 x 97.1 cm
Peggy Guggenheim
Collection, Venice

Early in 1912
Metzinger and Albert
Gleizes published a
long essay entitled
Du Cubisme in which
they explained why
they had joined the
movement and the
rational and
intentions of their
art. Metzinger, who
said he had been
inspired by the works
Gustave Courbet and
Paul Cézanne, was
among the first to
reveal the
relationships
between his spatial
decompositions and
non-Euclidian
geometry. This
painting is an
excellent example
of Metzinger's artistic
maturity. It makes
clear use of
fragmented planes
and differing points
of view, typical
aspects of Cubism
emphasized by the
sharp contrasts
between the colors
and accentuated by
the addition of
granular surfaces
and collages.
Metzinger blends
the body of the
cyclist, reduced to
its essential lines
and rendered almost
transparent, with
the stands in the
background crowded
with viewers,
depicted as small
touches of pure
color in a single
dynamic whole.

At the beginning of the 20th century Milan was going through a period of great economic growth, as indicated by the World Exposition of 1906, designed as a large-scale celebration of industrial expansion, as well as by the construction of the Simplon Tunnel, which opened on June 1 of that year. It was in this climate of enthusiastic faith in scientific discoveries and their technological applications—destined, or so it was believed, to resolve most of humanity's problems and provide a serene future—that Futurism

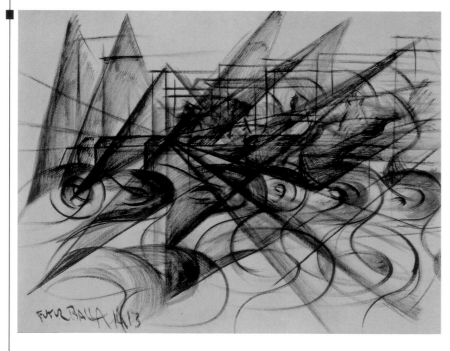

came into being. The history of the Futurist movement is composed in large part of a series of manifestos, conferences, events, debates, and performances in which the leading exponents of the movement loudly and categorically proclaimed their political ideals and their aesthetic ideas as applicable to almost all fields of knowledge, not only in literature, painting, sculpture, and architecture, but also music, films, the theater, and even fashion and cooking. Many Futurists were influenced by the personality and works of Gabriele D'Annunzio, but they rejected his refined narcissistic aesthetics in favor of a more dynamic vision of life and art.

The Futurist movement's official birthday is February 20, 1909,

when Filippo Tommaso Marinetti published, on the pages of *Le Figaro*, "The Founding and Manifesto of Futurism." As clearly indicated by the name *Futurist*, Marinetti wanted to exalt everything that represented the future and innovation, as opposed to every "passéist" cult of tradition: "Admiring an old painting is the same as pouring our sensibility into a funerary urn instead of hurling it far off in violent spasms of action and creation We want no part of it, the past, we the young and strong Futurists!" A second fundamental theme was the desire to celebrate movement, speed, and everything represented by power and dynamism: "We intend to exalt aggressive action, a feverish insomnia, the racer's stride, the mortal peal, the punch and the slap. We affirm that the world's magnificence has been enriched by a new beauty: the beauty of speed." The symbol par excellence of this new vision of the world and of art was the race car, considered "more beautiful than the Victory of Samothrace." These themes were repeated in the "Manifesto of Futurist Painters," dated February 11, 1910, signed by Giacomo Balla, Umberto Boccioni, Carlo Carrà, Luigi Russolo, and Gino Severini, and read publicly by Boccioni on March 8, 1910, at the Chiarella Theater in Turin. Next came the "Technical Manifesto of Futurist Painting," published April 11, 1910, and the "Technical Manifesto of Futurist Sculpture" of April 11, 1912.

Stylistically the Futurist painters began their career with an approach to Divisionism; in particular they admired the landscapes by Giovanni Segantini and Gaetano Previati, from which they learned to decompose colored surfaces into small brushstrokes of pure color. They were also interested in the works of European Symbolist painters, who did not stop at realism or naturalism but enriched their compositions with multiple allegorical meanings. The philosophy of Henri Bergson and non-Euclidian geometry were direct infuences as well, opening new perspectives on the concepts of space and time. Futurist painters first made contact with the public when they took part, with fifty works, in the Exposizione d'Arte Libera, which opened at the Ricordi Pavilion in Milan on April 30, 1911. The primary objective of these artists was to make movement visible in their

paintings. The "Technical Manifesto" of April 11, 1910, affirms that "All things move, all things run, all things are rapidly changing. A profile is never motionless before our eyes, but it constantly appears and disappears The construction of pictures has hitherto been foolishly traditional. Painters have shown us the objects and the people placed before us. We shall henceforward put the spectator in the center of the picture." To do this they turned first to photography, which since its invention, in the middle of the 19th century, sought to capture images of objects and people in movement, from the first *chronophotographies* of Etienne-Jules Marey, such as *Marching Soldier* of 1882, to the human-motion photographs by Eadweard Muybridge, already used by Edgar Degas to study the movements of jockeys and race horses.

Anton Giulio Bragaglia performed an important role in Futurism. Since 1910 he had been involved in experimental photography—which he called photodynamism—and was one of the pioneers of Italian moviemaking. In 1918, together with his brother Carlo Ludovico, he founded the Casa d'Arte Bragaglia, where the leading Italian artists

Russolo, Carrà, Marinetti, Boccioni, and Severini (from left to right), photographed in Paris in 1912.

were mounted in London during those years, including one at the Sackville Gallery in 1912; a one-man show dedicated to Gino Severini

Futurism

of the 20th century met and exhibited their works. Artists of the Futurist movement had close relationships with exponents of the other leading avant-garde movements in Europe. In France Gino Severini and Ardengo Soffici were in contact with the Fauves and the Cubists; there was even a show of thirty-four Futurist works held in February 1912 at the Bernheim-Jeune gallery in Paris. In 1913 Felix Delmarle published in the *Paris-Journal* the "Manifeste Futuriste contre Montmartre." In 1910 Marinetti presented the movement's ideas at a conference at the Lyceum Club in London. Many exhibits of Futurist works

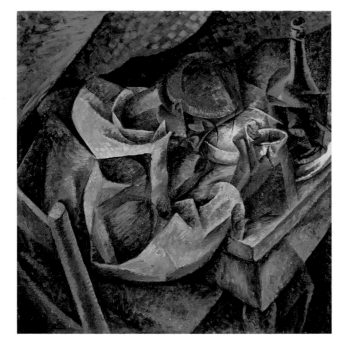

in 1913 at the Marlborough Gallery; and the show at the Doré Galleries in 1914 that influenced the work of Christopher Nevinson, Edward Wadsworth, and Wyndham Lewis. In 1914 Marinetti went to Russia, where he inspired the work of numerous writers and artists, among them Vladimir Mayakovsky, Vladimir Tatlin, Mikhail Larionov, Natalia Goncharova, and the members of "Cubo-Futurism," led by David Burlyuk. Many German Expressionists came in contact with Futurist works and their creators in a reciprocal exchange of ideas and stylistic advice. There were distant echoes of Futurism in Spain (Rafael Barradas), Sweden (Gösta Adrian-Nilsson), and even in Japan, thanks to an exchange of letters between Marinetti and several Japanese intellectuals. During the Paris show of 1912 Carrà and Severini met Joseph Stella, Italian by birth but American by adoption, who introduced Futurism to the United States.

Umberto Boccioni, *The Drinker*, 1914, oil on canvas, 86 x 87 cm; Civico Museo d'Arte Contemporanea, Collection Riccardo Jucker, Milan

UMBERTO BOCCIONI
Simultaneous Visions
1911, oil on canvas
70 x 75 cm
Von der Heydt
Museum, Wuppertal

The "simultaneous
visions" referred to
in the title of this
Futurist work have
much in common
with those presented
by the Cubists during
the same years.
They refer to the
contemporary
presence of different
points of view. The
colors are bright and
lively, to the point
of surreality, and
increase the
expressive force
of the entire
composition. The
objects presented
are simplified and
deformed almost to
abstraction. The
supple and animated
line sometimes
follows a swirling
movement similar
to a vortex, meant
to render the idea
of movement. The
large face and
reflection in the
foreground overlap
and blend. In their
works the Futurists
exalted large cities
for being dynamic
and active, symbolic
of progress; they
loved crowded
streets, full of stores
and nightspots
where work and
entertainment take
place incessantly.

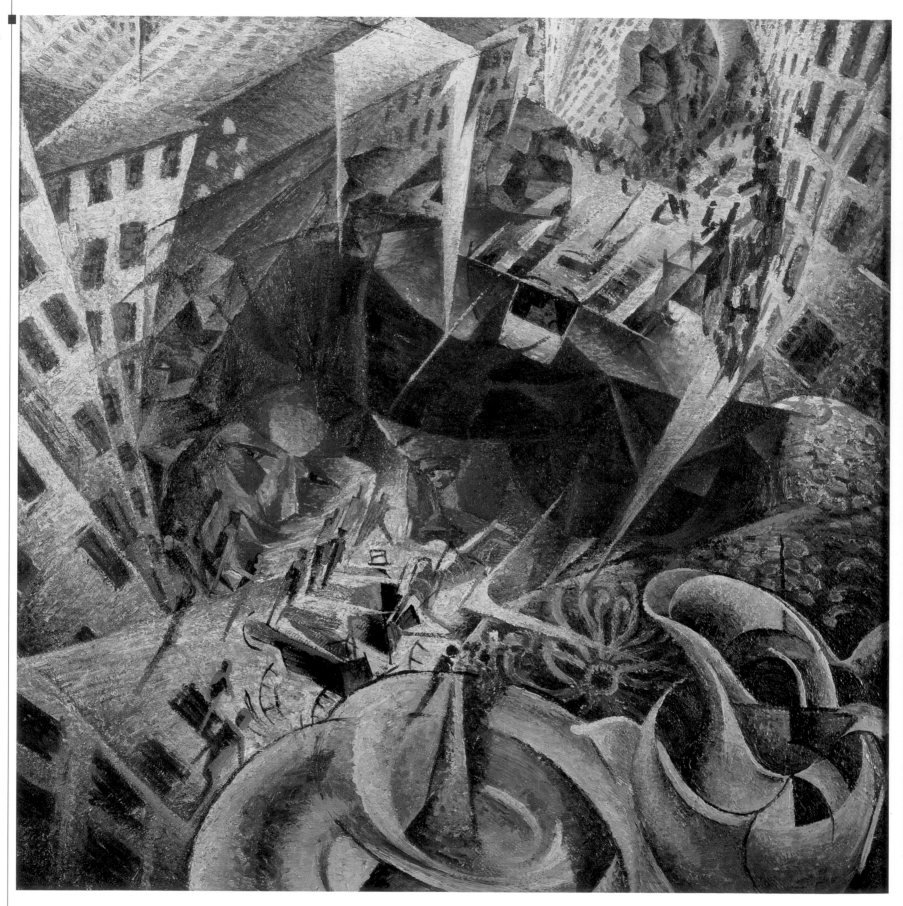

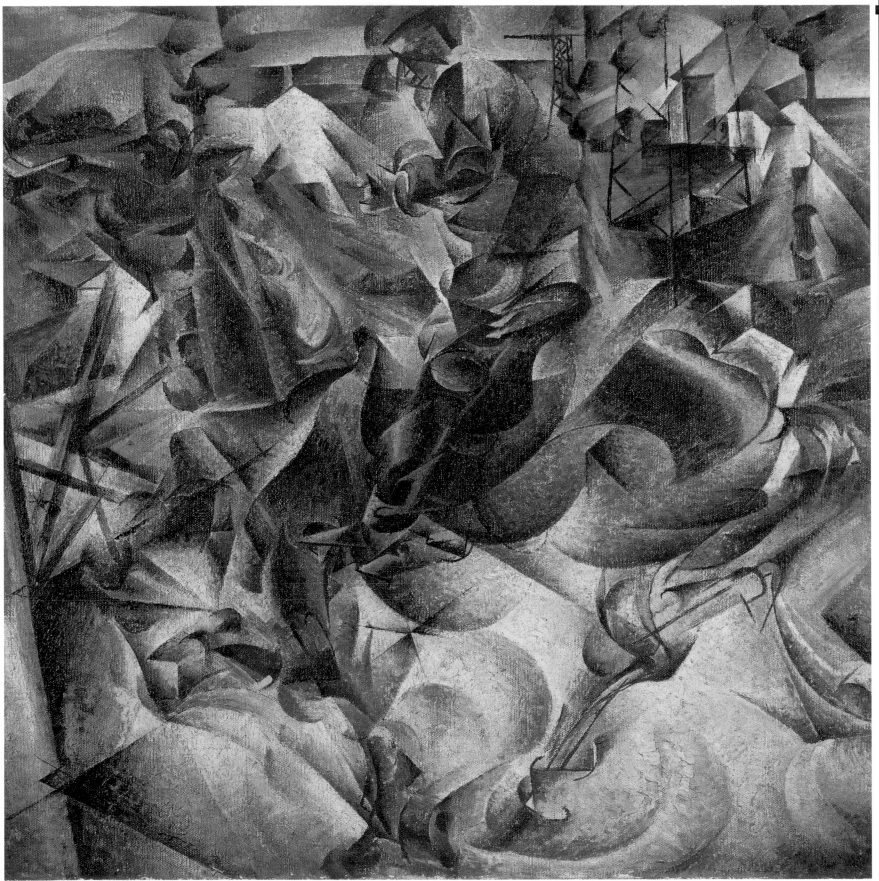

■ UMBERTO BOCCIONI
Elasticity
1912, oil on canvas
100 x 100 cm
Civico Museo d'Arte
Contemporanea,
Collection Riccardo
Jucker, Milan

This canvas can be
seen as a synthesis
of the efforts
Boccioni made
beginning in 1910
with *The City Rises*
(Museum of Modern
Art, New York) and
later developed in
the triptych *States
of Mind* of 1911
(Civico Museo d'Arte
Contemporanea,
Milan). Like Degas,
Boccioni loved horses
and saw them as the
prefect expression of
power and agility.
Here he fragments
and multiplies the
anatomical details
of the animal and
rider and does the
same with the
urban-landscape
background, thus
suggesting the
visual illusion of
speed and movement.
Perspective is
completely absent,
and the borders
between several
areas are deliberately
vague, creating a
fusion among the
various parts of the
painting, which is
given a two-
dimensional aspect
without depth. A
careful balance of
straight lines and
curving lines gives
the composition
its rhythm.

UMBERTO BOCCIONI
Materia
1912–13,
oil on canvas
226 x 150 cm
Gianni Mattioli
Collection (on hold
with the Peggy
Guggenheim
Collection, Venice)

In this painting
Boccioni presents
his mother, Cecilia
Forlani (1852–1927),
who played a defining
role not only in his
life but also in his
art. Boccioni here
transfigures her into
a universal symbol
of maternity and the
vital and creative
energy of *materia*.
Comparison of this
work with Picasso's
portrait of Vollard
(see page 77) reveals
the many affinities
but also the
differences between
Cubism and Futurism.
Boccioni is less
rigorous in the
decomposition of
forms and gives more
space to movement
and color. Begun in
1912, the painting
was exhibited in
February of the
following year at the
Futurist show in the
foyer of the Costanzi
Theater in Rome. At
the end of the
exhibit, however,
Boccioni was still not
completely satisfied
with the work and
made changes, most
of all in the lower
part, making the
whole more
homogeneous and
in keeping with the
aesthetic vision
of Futurism.

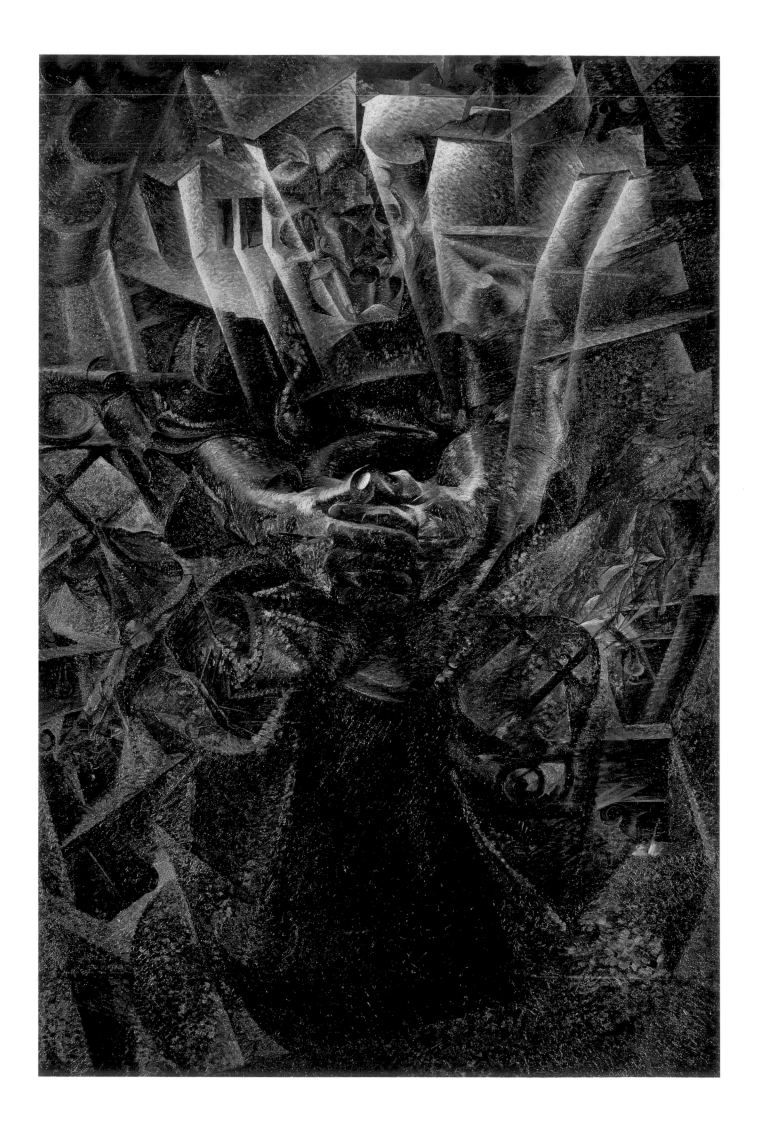

■ GIACOMO BALLA
**Girl Running
on a Balcony**
1912, oil on canvas
125 x 125 cm
Civica Galleria d'Arte
Moderna, Milan

This painting was
made in 1912, after
Balla's first two visits
to Düsseldorf, where
he was employed as
decorator for the
home of Margherita
Speyr and Arthur
Löwenstein. Presented
at the 1913 Futurist
show at the
Kunstkring in
Rotterdam, the work
is an example of the
Futurists' many
attempts to visually
depict physical
movement. The artist
drew inspiration from
the motion
photographs taken by
Marey and Muybridge
and in making the
painting followed a
procedure not unlike
that behind
filmmaking, then
in its infancy. He
divided the route
of the girl on the
balcony into a series
of small photograms
and then arranged
them across the
canvas in such a way
that the human eye
can reconstruct the
scene in its entirety.
The composition's
dynamism is increased
by the division of the
pictorial space into
small dots of pure
color arranged in an
almost geometric
manner, a method
taken from the style
of Divisionism.

GIACOMO BALLA
**Spazzolridente
(Brush Smile)**
1918, oil on canvas
70 x 100 cm
Civico Museo d'Arte
Contemporanea,
Collection Riccardo
Jucker, Milan

After World War I the original nucleus of Futurism fell apart: Boccioni died in 1916, Russolo turned almost exclusively to music, Carrà and Severini were seeking new expressive forms. Only Balla remained as leader of what came to be called Second Futurism, the theories of which he presented together with Depero in "The Futurist Reconstruction of the Universe" in 1915. In October 1918 Balla held his first one-man show in Rome, at the Casa d'Arte Bragaglia, where he exhibited forty works made for the most part during the war. In this canvas he used lighthearted, humoristic tones, clear in the grotesque figure on the right with the exaggeratedly broad smile, which recalls the brush moving across the foreground. Aside from the usual decompositions of forms, there is the attentive study of the effects of light on colors, with which Balla had already experimented in the series of *Iridescent Interpenetrations*.

■ GIACOMO BALLA
Marombra
1919, oil on canvas
72 x 108 cm
Private collection

During the summer of 1919 Balla was at Viareggio, where he made a series of about twenty canvases entitled *Force-Lines of the Sea*. In these works he takes traditional marine scenes and applies to them the experiments he had made in his early years on landscapes, concentrating his attention on the effects of light on the movement of waves and boats. In particular he sought a balance between the faithful representation of reality and the abstract geometries of his *Iridescent Interpenetrations*. In each painting of the series he tried to change the arrangement of the elements, their forms, and their colors; here he experiments with a nocturnal view, as made clear in the broad fields of different tonalities of dark blue. There is then the shaped frame, which Balla himself painted, which extends the waving movement beyond the surface of the canvas, increasing the work's dynamic and decorative appeal.

CARLO CARRÀ
**The Funeral of the
Anarchist Galli**
1911, oil on canvas
185 x 260 cm
Museum of Modern
Art, New York

In the summer of
1910 the Futurists
came up with the
idea that each of
them should paint
a large horizontal
canvas to present
their aesthetic vision
in a collective show
that was to be held
in April 1911 at the
Ricordi Pavilion in
Milan before moving
on to Paris, Berlin,
London, and
Brussels. Boccioni
painted *The City Rises*
(Museum of Modern
Art, New York),
Severini *Pan-Pan at
the Monico*, destroyed
in a fire and redone
by the artist in 1959
(Musée National
d'Art Moderne,
Paris). Russolo
made *Rebellion*
(Gemeentemuseum,
The Hague), and
Carrà painted this
work, *The Funeral of
the Anarchist Galli*, in
which he expressed
his social concerns
and his libertarian
aspirations. This is a
work of great visual
impact, full of
emotional tension,
with bright and dark
colors applied in a
Divisionist style
with a taut and
fragmentary Futurist
line. As he wrote in
his 1913 manifesto
entitled "The Painting
of Sounds, Noises,
and Smells," Carrà
intended to give life
to "boiling swirling
forms with resounding
light, noisy and
odorous."

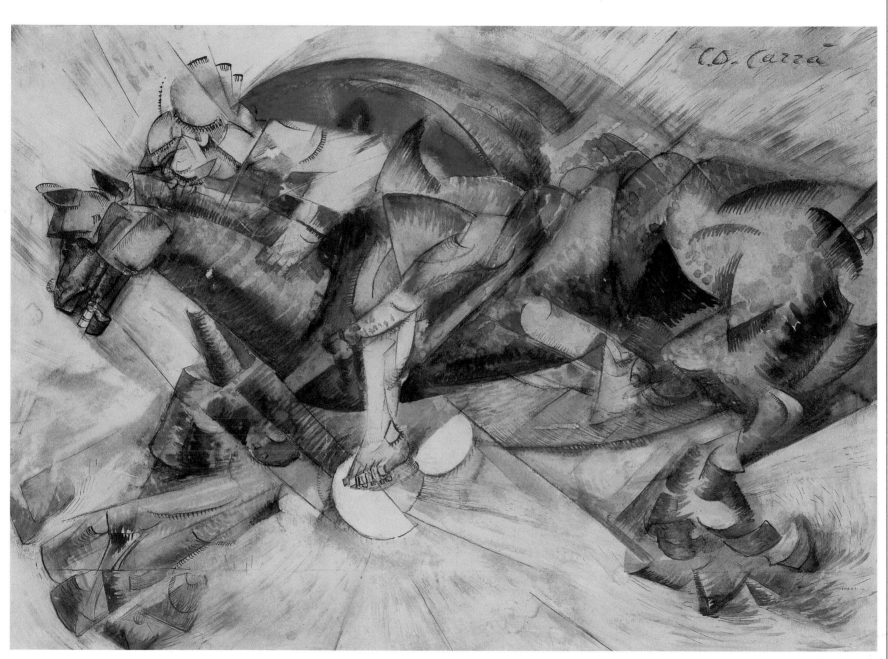

■ CARLO CARRÀ
Red Horseman
1913, tempera and
ink on paper
26 x 36 cm
Civico Museo d'Arte
Contemporanea,
Collection Riccardo
Jucker, Milan

At the end of the
summer of 1912
Severini, who had
moved to Paris in
1906, returned to
Italy for a short time
and while there told
Carrà about recent
avant-garde events in
France. Hearing about
the violent, bright
colors used by the
Fauves and the
fragmentation of
forms of Analytical
Cubists led Carrà to
partially change his
style. This painting,
made while Boccioni
completed a painting
with the same
subject—a running
horse—in *Elasticity*
(see page 89)
indicates the shift.
All of the viewer's
attention is
concentrated on the
horse, colored a
bright red to make
it stand out against
the pale background,
while the lines
arranged in rays
around the animal
suggest that the
animal's speed and
force are making the
surrounding air
vibrate. The body
of the rider seems
almost diaphanous,
dematerialized,
intentionally unified
with the force of
the charger.

Luigi Russolo
**Dynamism of
an Automobile**
1912–13,
oil on canvas
104 x 140 cm
Musée National d'Art
Moderne, Centre
Georges Pompidou,
Paris

Together with the
train and airplane,
the automobile
represented one
of the "myths" of
Futurism, seen as the
fruit of the progress
of technology and
symbolic of power
and speed. In his
1909 manifesto
Filippo Tommaso
Marinetti wrote, "We
want to hymn the
man at the wheel,
who hurls the lance
of his spirit across
the Earth, along the
circle of its orbit."
The attempt to
visually present the
movement of the car,
an aesthetic desire of
all Futurist painters,
is here resolved
through the use of
angular lines similar
to arrows that spread
across the entire
composition and that
the artist himself
called "force-lines." A
second characteristic
element is the
strident clash of the
dark blue of the
vehicle with the
bright red of much
of the background,
which in the mind of
the artist represents
the bursts of flame
given off by the
power of the internal-
combustion engine.

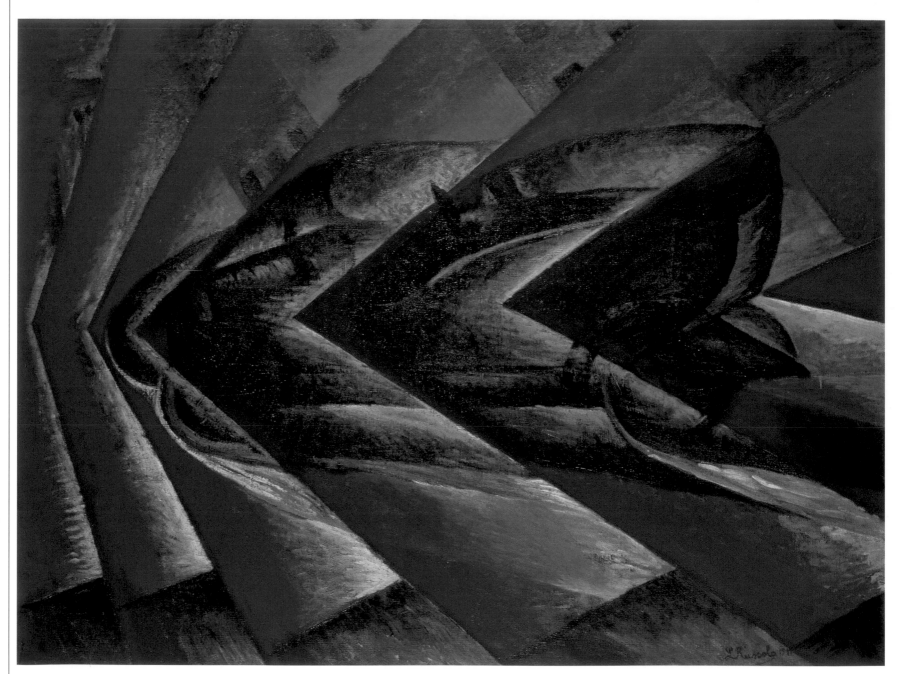

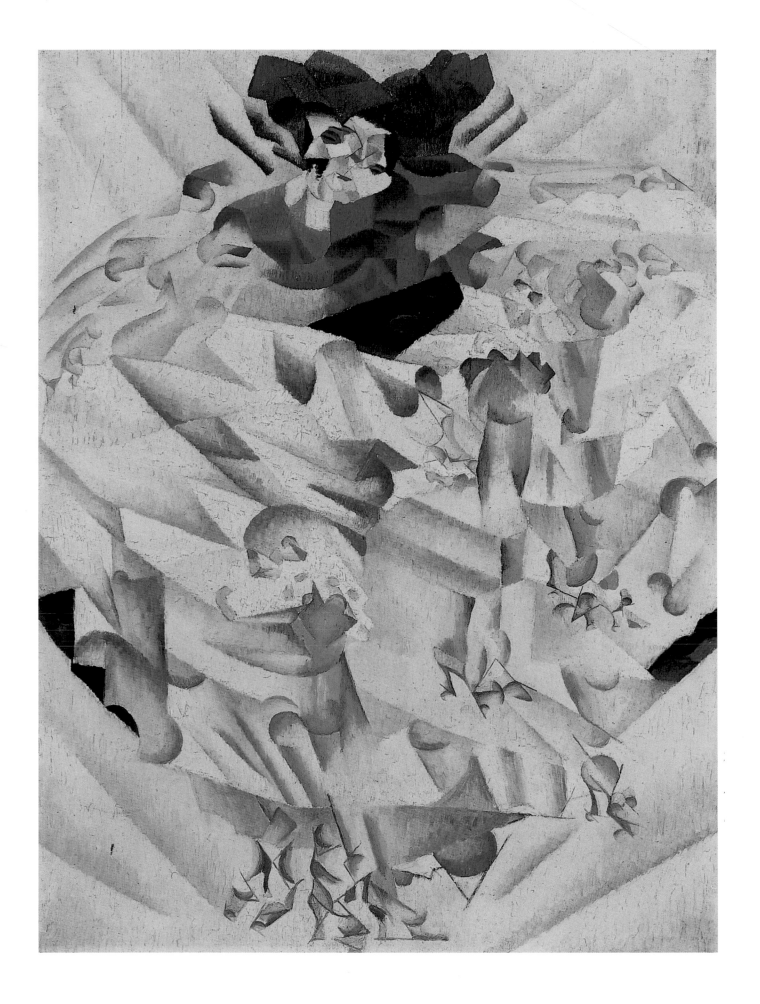

■ GINO SEVERINI
**La Chahuteuse
(Dynamism of
a Dancer)**
1912, oil on canvas
60 x 45 cm
Civico Museo d'Arte
Contemporanea,
Collection Riccardo
Jucker, Milan

The subjects of the
theater and dance
often appear in the
works of Futurist
painters, as they offer
the opportunity to
depict one or more
figures in movement.
This canvas makes
clear Severini's ties
to Cubism, from which
he learned to divide
space into elementary
geometric forms and
to recompose the
forms in accordance
with a delicate
rhythmic balance.
A large area of the
painting is occupied
by the swirling
movement of the
dancer's legs; she
herself cannot be
seen as a whole but
only imagined from
the positions of her
shoes. The upper part
of her body seems
compressed and
flattened, although
her open arms give
her graceful agility.
The main point of
view, from below
looking upward,
coincides with that
of a member of the
audience seated in a
theater, looking up
at the performance.
The colors are used
sparingly, but the
selection proves
both effective
and attractive.

ARDENGO SOFFICI
**Still Life
(Low Velocity)**
1913, oil, tempera,
and collage on
paperboard
67 x 50 cm
Civico Museo d'Arte
Contemporanea,
Collection Riccardo
Jucker, Milan

On January 1, 1913,
Soffici was among
the founders of the
magazine *Lacerba*,
sixty-nine issues of
which were published
(running to May 22,
1915); these provide
fundamental
documentation of
Futurism. During that
same period Soffici
began including
newspaper clippings,
labels, and other
objects in his still
lifes, using the
technique of collage,
which he had learned
in Paris through
association with
Apollinaire and study
of the works of
Synthetic Cubism.
This composition
includes a train
ticket, three clippings
from French
newspapers—one
from *Le Monde*—and
a clipping from the
financial pages of an
Italian paper, an
association that the
artist saw as
emblematic of the
close ties between
France and Italy,
Cubism and Futurism.
The large letters in
the upper area, the
glass, and the two
bottles in the
foreground were
painted by means
of a stencil applied
to the surface of
the work.

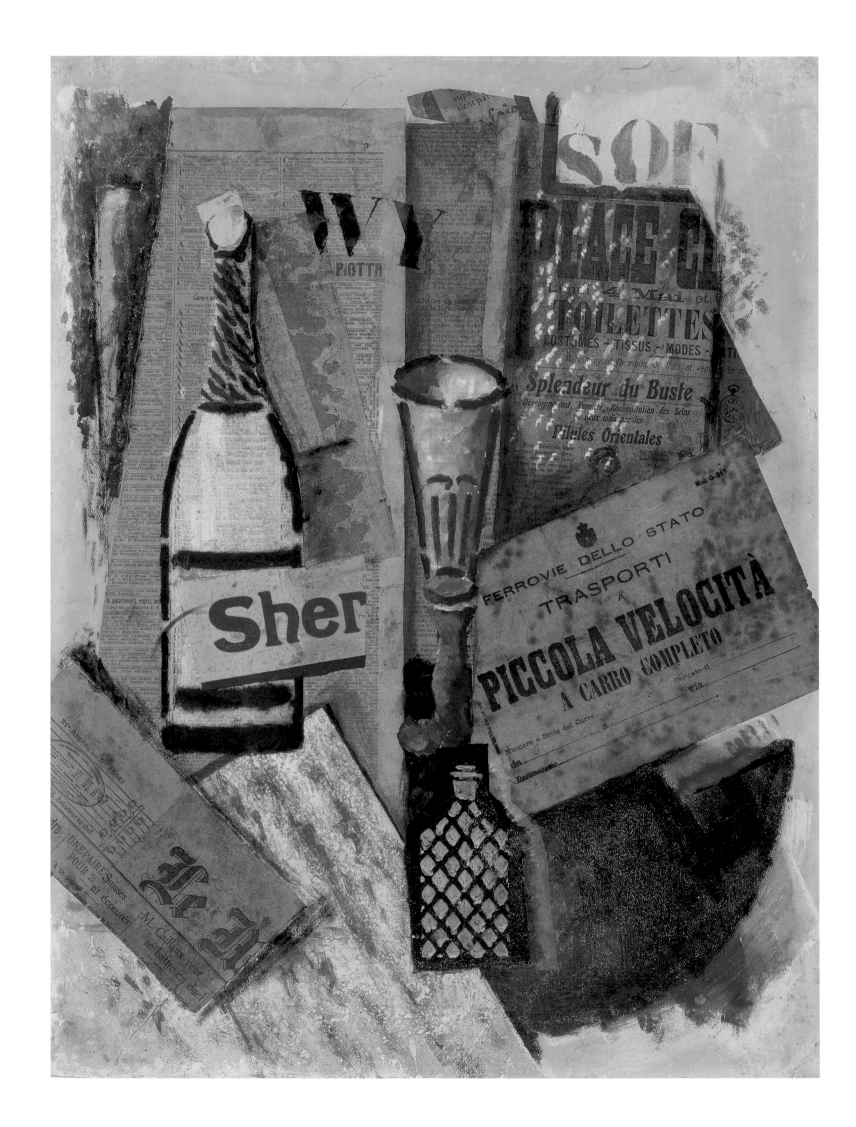

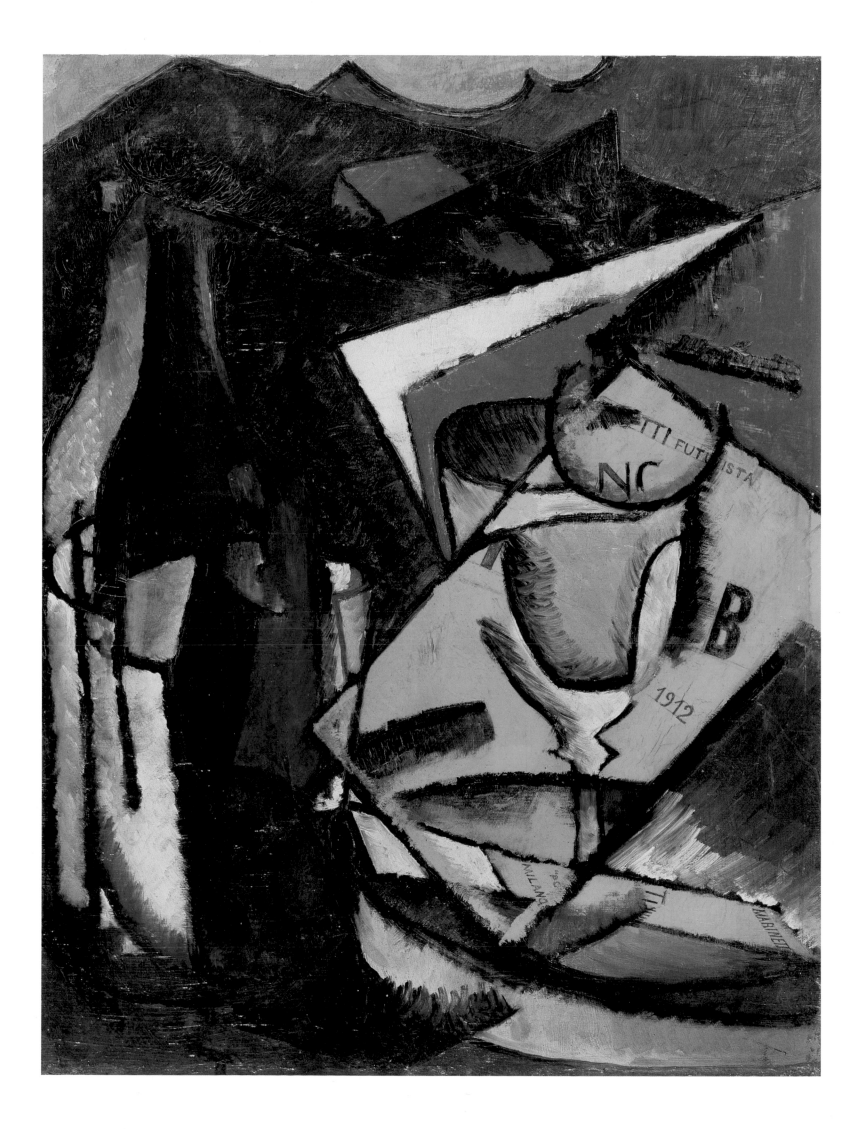

■ OTTONE ROSAI
Zang Tumb Tumb
1913–14,
oil on canvas
44.5 x 34.5 cm
Civico Museo d'Arte
Contemporanea,
Collection Riccardo
Jucker, Milan

In 1913 Rosai
exhibited in Florence
in Via Cavour, a short
distance from the
Lacerba show. Several
Futurist painters
admired his paintings
and invited him to
join their movement;
from April 13 to May
25, 1914, Rosai took
part in the
Esposizione Libera
Futurista at the
Sprovieri gallery in
Rome, and on April 1
he began making
regular contributions
to the magazine
Lacerba. He was also
the guest of Ardengo
Soffici at Poggio a
Caiano, and Soffici
brought him up to
date on events in
Paris and introduced
him to the works of
Cézanne and the
Cubists, as reflected
in this canvas in its
choice of colors and
the fragmentation of
the planes. The
painting is dedicated
to *Zang Tumb Tumb*,
the most famous
"words-in-freedom"
novel by Marinetti, in
which he applied the
principles he himself
had formulated in the
"Manifesto of Futurist
Literature" in 1910
and the "Technical
Manifesto of Futurist
Literature" in 1912.

FORTUNATO DEPERO
My "Balletti Plastici"
1921, oil on canvas
189 x 180 cm
Private collection

Depero was one of
the leading members
of Second Futurism.
Gifted with fertile
creativity and
outstanding
versatility, he
founded the Casa
d'Arte Depero in
Rovereto, also called
the Casa del Mago
(see page 234), with
the goal of making
real "The Futurist
Reconstruction of the
Universe." Depero
adopted the principles
of the movement not
only in painting but
also in the applied
arts, industrial
design, fashion, and
advertising. He was
also highly active in
the theater, and
following a brief
collaboration with
Serge Diaghilev he
created the *Balletti
Plastici* together
with the composer
Gianfrancesco
Malipiero and Alfredo
Casella. The show,
presented at Rome's
Teatro dei Piccoli in
1918, impressed the
spectators with its
scenery in bright,
gaudy colors, its
bizarre costumes and
strange figures,
marionettes and
mechanical puppets,
all of which
transported them
to a fantastic and
surreal world.

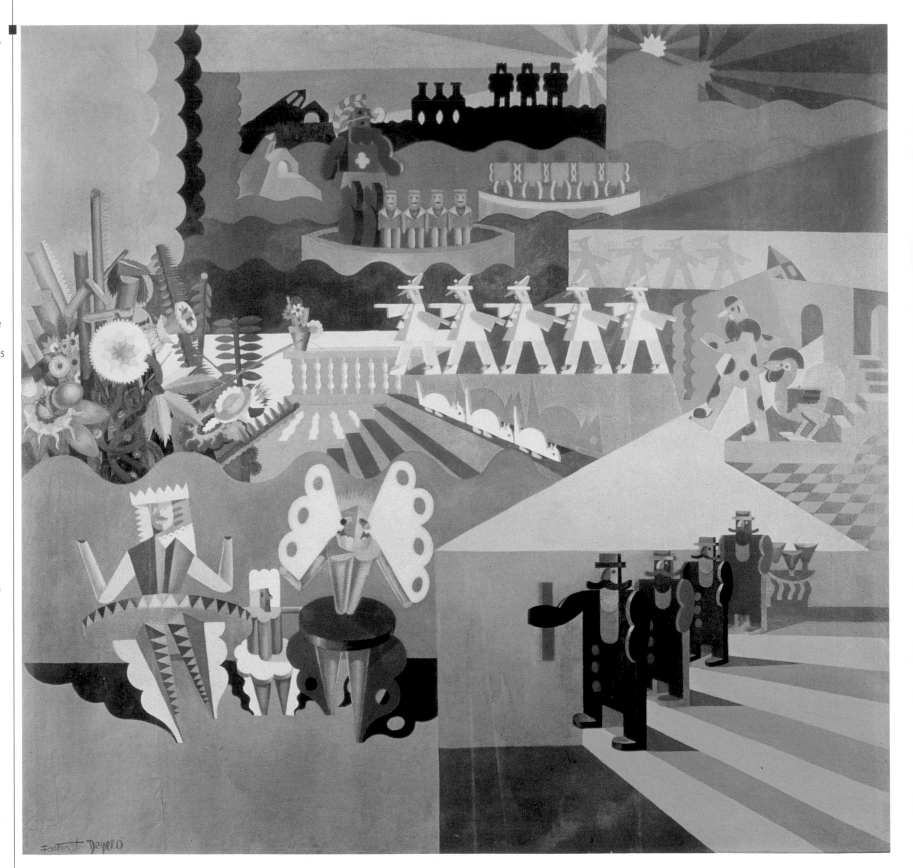

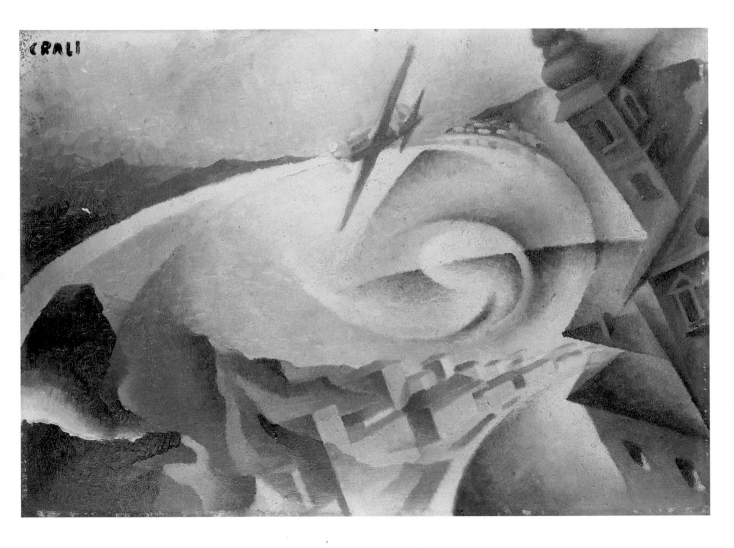

The first issue of the magazine *Mir Iskusstva* ("The World of Art") came out in October 1898. It was written by young artists attracted to the painting of the Symbolists and the Post-Impressionists, in particular the Nabis; they were also drawn to the ideas expressed by the exponents of Art Nouveau. Among the leading contributors were Serge Diaghilev, one of the founders of the Ballets Russes, Alexandre Benois, Léon Bakst, Mikhail Vrubel, Valentin Serov, and Viktor Borisov-Musatov, associated with the Blue Rose group. They mounted several exhibitions, the last of which, in 1906, was also presented at the Salon d'Automne in Paris, testifying to their close contacts with the intellectuals and painters active in France. No less important was the stimulus given by various wealthy Russian collectors, most especially Ivan Morozov and Sergei Shchukin, who brought back to Russia many important works by Matisse, Picasso, and other artists, thus providing young Russian artists

Guro, and Velimir Khlebnikov. Two exhibits were organized in St. Petersburg in 1910, the first by the Union of Youth group, the second by the Jack of Diamonds group, which for several years performed the important role of keeping the Russian artists active in Moscow and St. Petersburg in connection with artists in the principal European capitals. In fact, many Russian painters spent time in France, Italy, Austria, and Germany, where they played an active role in the artistic and cultural life. For example, Wassily Kandinsky and Alexei Jawlensky were among the founders of the Neue Künstlervereinigung ("New Artists' Association") in Munich in 1909. Two years later, along with the Burlyuk brothers, Natalia Goncharova, and Kazmir Malevich, they were among the leading exponents of Der Blaue Reiter ("The Blue Rider"). March 11, 1912, marked the inauguration of a show in Moscow by a group calling itself the Donkey's Tail and including, among others, Malevich, Tatlin,

Avant-garde

with a sense of the progress and evolution of contemporary art. *Mir Iskusstva* ceased publication in 1904, but was replaced by other magazines, such as *Scales*, *The New Way*, *Apollon*, and *The Golden Fleece*, which organized three important shows in Moscow: one in 1908 with 282 canvases and three sculptures; one in January 1909; and a third at the end of 1909. The last show was dedicated entirely to paintings by Mikhail Larionov and Natalia Goncharova, initiators of a primitive style that drew on popular Russian traditions—icons, Siberian embroidery—and popular prints. In 1909 the "Founding and Manifesto of Futurism," published by Filippo Tommaso Marinetti in the pages of *Le Figaro*, was translated in Russian. This proclamation caused a sensation in Russia, favoring the birth of a similar movement, active in both painting and literature, with the brothers David and Vladimir Burlyuk, Vladimir Mayakovsky, Alexei Kruchonykh, Yelena

Goncharova, Chagall, and Larionov. Larionov claimed the group had taken its unusual name from a newspaper anecdote about a group of French artists who had tied a paintbrush to the tail of a donkey, positioned the animal near a canvas, and included the resulting work in an exhibition, thus poking fun at the patrons and critics of the event. Between 1910 and 1913 Larionov and Goncharova developed a new style, called Rayism, a synthesis between Futurism, Cubism, and Orphism: like the Cubists they decomposed space into elementary geometric shapes, and like the Futurists they sought to depict immaterial entities, such as energy, movement, and light. To achieve these ends they made use of more or less heavy lines of color to create a network of rays, arranged in accordance with carefully established criteria. Their aim was still figurative, but the result was much closer to abstract art and had a strong influence on the pictorial formation of

Malevich. Malevich was the founder of Suprematism, which he presented in a manifesto written in 1915 together with Mayakovsky and in the essay *Suprematism, or the World of the Nonobjective,* published in 1920. According to Malevich the purpose of Suprematism was "to liberate art from the ballast of the representational world," meaning the bonds of the representation of reality, and thus to express the "supremacy" of pure emotions and abstract sensations. The clearest expressions of these visions are *Black Square, Black Cross,* and *Black Circle* (State Russian

The outbreak of World War I brought an almost complete end to communication between Russian artists and artists in European capitals, but at the same time it multiplied cultural changes within Russia itself. The Russian Revolution of October 1917 marked the end of the power of the czar. The artists welcomed this with enthusiasm, convinced they would be able to make contributions to the establishment of a new society. They organized theatrical performances, poetry and literary meetings, art exhibits, and art schools, all celebrating the new revolutionary regime. In 1918

■ Natalia Goncharova, *Washerwomen,* 1910, oil on canvas, 105 x 117 cm; Tretyakov Gallery, Moscow

movements in Russia

Museum, St. Petersburg), dated 1913 by Malevich but likely made between 1915 and 1920.

Constructivism came into being at the same time as Suprematism. The term *constructivism* was first used, in 1913, by the critic Nikolay Punin to define the series of *Pictorial Reliefs* by Vladimir Tatlin. These artists "constructed" their works using almost exclusively elementary geometric figures and drawing inspiration from the world of machines and technology. The leading members of this style were Naum Gabo, Antoine Pevsner, Alexander Vesnin, Liubov Popova, Alexandra Exter, Alexander Rodchenko, and Varvara Stepanova.

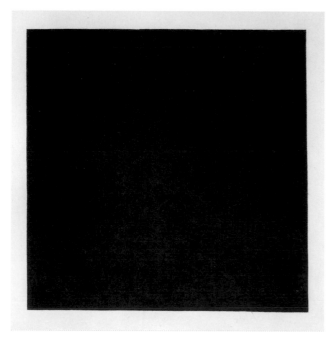

an institute of fine arts was created, entrusted with organizing the country's artistic life. In 1920 Inkhuk (an acronym for the Institute of Artistic Culture), was created with the specific aim of training and educating the young. With the rise to power of Stalin, named general secretary of the Communist party in April 1922, artistic creativity found itself increasingly subject to political aims, and eventually became completely suffocated through control. The Russian Association of Proletarian Artists ruled that it was the duty of artists to serve the ideology of the party, and in 1934 "Socialist Realism" was imposed on all the arts. In order to join the artists' union and thus have permission to paint, an artist had to celebrate the values of socialism through a rigorously figurative and realist style. In 1930 Mayakovsky committed suicide; many intellectuals and artists took refuge outside Russia to be free to express their art.

■ Kazimir Malevich, *Black Square,* circa 1920, oil on canvas, 106 x 106 cm; State Russian Museum, St. Petersburg

NATALIA
GONCHAROVA
Spring in the City
1911, oil on canvas
70 x 91 cm
Abram Filippovic
Cudnovskij Collection,
Moscow

This painting
testifies to
Goncharova's
relationship with
the members of the
Blaue Reiter group,
a relationship that
lasted several
months. Goncharova
met Kandinsky in
1910, during the
first show of the
Union of Youth, and
he put her in contact
with the German
Expressionists in
Munich, from whom
she assimilated the
use of a simplified
line and sharply
contrasting colors.

NATALIA
GONCHAROVA
The Cyclist
1913, oil on canvas
79 x 105 cm
State Russian
Museum, St.
Petersburg

The development of
Rayism, from 1910
to 1914, marked an
important period
for Goncharova.
This painting is
highly reminiscent
of Italian Futurism
in its attempt to
depict speed by
fragmenting and
multiplying certain
elements of the
bicycle and its rider.
The insertion of
advertising phrases
and Cyrillic letters
relates to the works
of Synthetic Cubism.

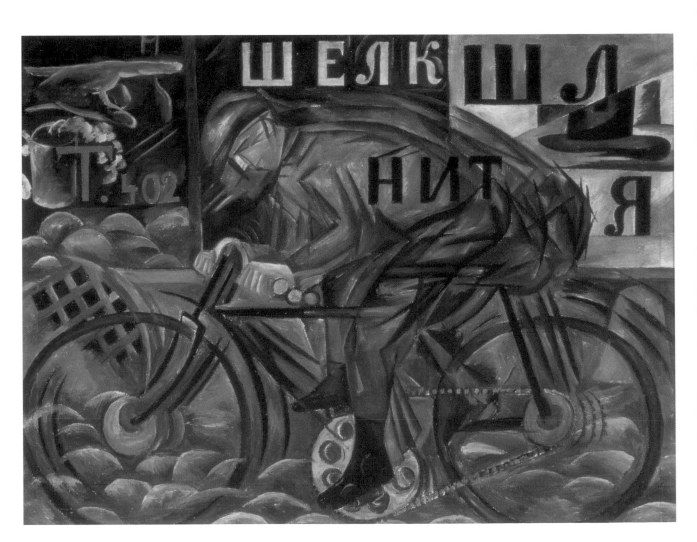

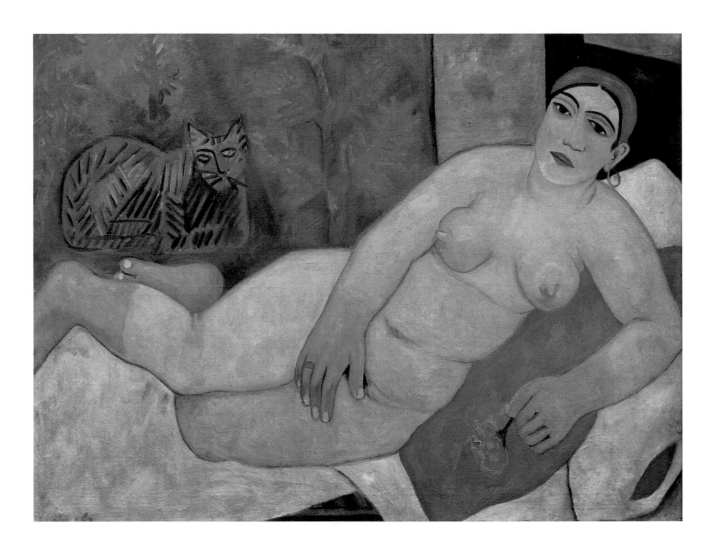

■ MIKHAIL LARIONOV
Katsap Venus
1912, oil on canvas
99.5 x 129.5 cm
State Museum of Art,
Novgorod

In the works of his
so-called primitive
period Larionov
sought to reconcile
the elements of
classical painting,
which he had studied
during a trip to Paris,
with popular Russian
tradition. This
painting was
certainly inspired
by classical works,
but the features and
body of the woman
belong more closely
to a Russian peasant
than to the goddess
of beauty. The trees
and the strange
feline in the
background are of
Rayist derivation.

■ MIKHAIL LARIONOV
Rayist Composition
1912–13,
oil on canvas
49 x 40 cm
Private collection

This is one of the
first works in which
Larionov made use
of the Rayist style,
a style he had
officially presented
to critics and the
public in an article
entitled "Rayists
and Futurists,"
published 1913 in
Donkey's Tail and
Target, the almanac
that reproduced the
works of the
Donkey's Tail group.
The dense network
of lines, which
represent the "rays"
emanating from
objects, almost
cancels all sense
of reality and
approaches the
works of abstract art.

KAZIMIR MALEVICH
The Aviator
1914, oil on canvas
126 x 85 cm
State Russian
Museum,
St. Petersburg

This work marks
the high point of
Malevich's Futurist
activity, originally
stimulated by a trip
to Russia by Marinetti
in 1914. In this
painting and in
another very similar
work entitled *An
Englishman in Moscow*
(Stedelijk Museum,
Amsterdam), Malevich
also shows the
influence of Synthetic
Cubism, as in the
enormous Cyrillic
letters in the upper
part of the painting.
Objects appear in this
canvas without
apparent justification
and without any
logical relationship to
the title (a fork, an
ace of clubs, a
stylized fish, the
blade of a saw). Nor
can the viewer hope
to discern a meaning
to the arrangement
of the objects, which
in fact may be
entirely accidental,
in keeping with a
procedure drawn
from several Russian
Futurist poets that
was later embraced
methodically by the
Dadaists and
Surrealists.
Recognizable in
the background are
several geometric
forms that Malevich
was to later insert
in his Suprematist
works.

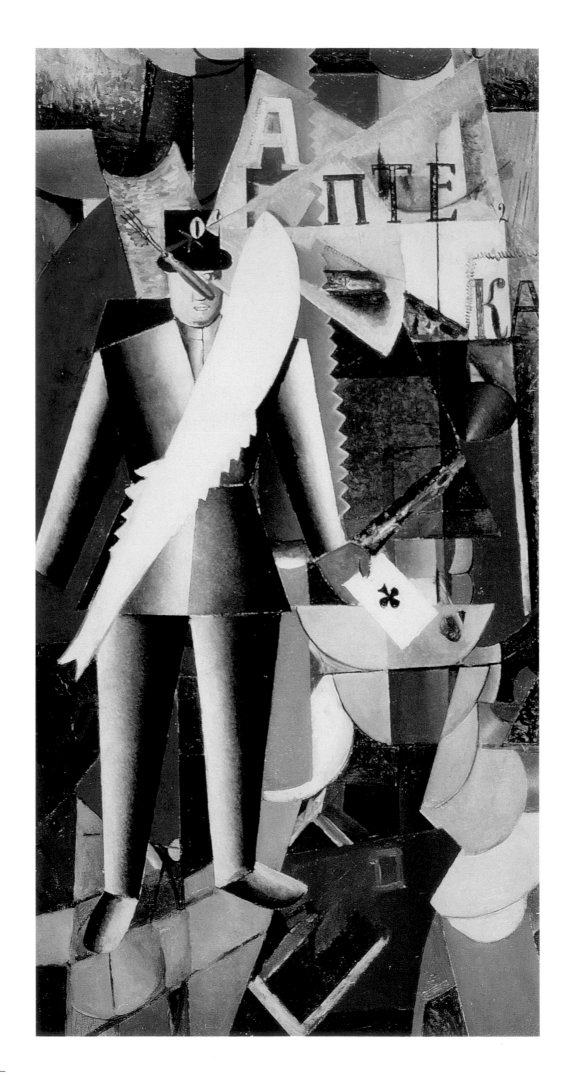

Avant-garde movements in Russia

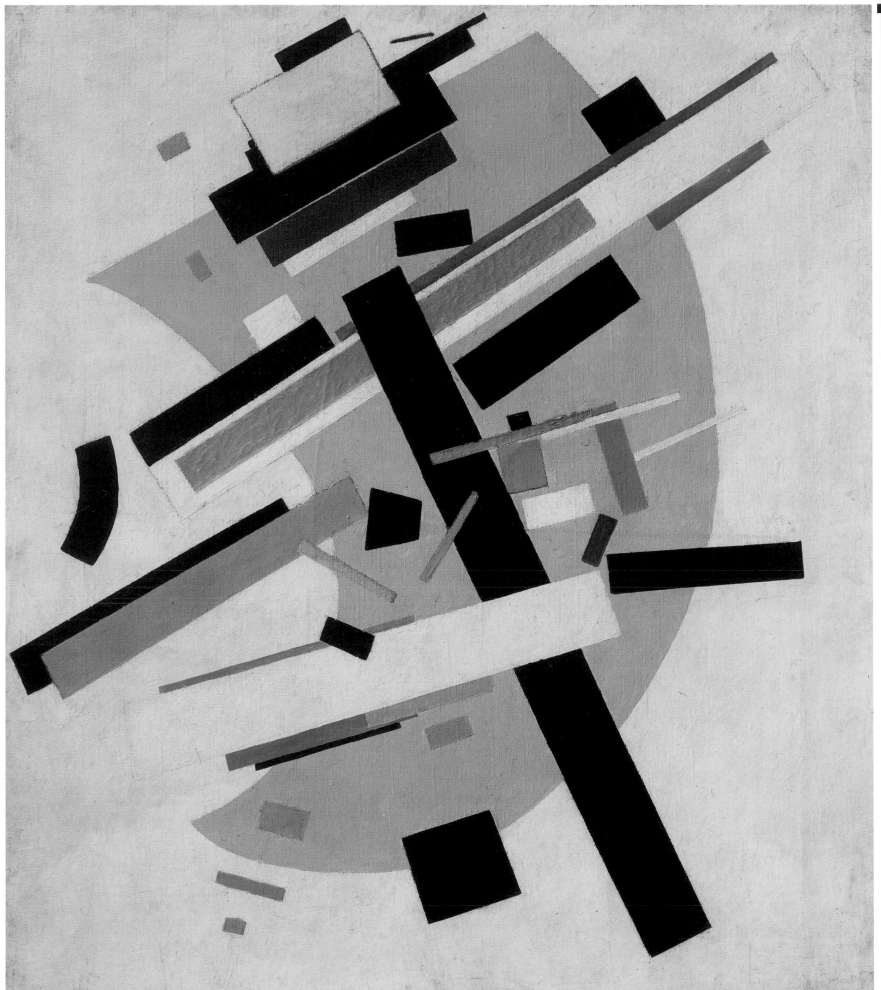

■ KAZIMIR MALEVICH
**Suprematism
(Abstract
Composition)**
1916, oil on canvas
79.5 x 70.5 cm
State Russian
Museum,
St. Petersburg

In his Suprematist
compositions
Malevich abandoned
both the direct
and indirect
representation of
reality in the name
of the "supremacy"
of abstract
compositions. With a
destructive and
iconoclastic spirit,
similar to the one
that animated the
Dadaists during the
same period, Malevich
sought to knock down
the age-old figurative
pictorial tradition so
as to reach what he
called the "absolute
zero" of forms, their
representation in the
pure and elementary
state. Against a white
gray background that
locates the painting
outside time and
space, Malevich
arranges colored
geometric figures,
flat and smooth,
showing no concern
for the classical
rules of perspective,
symmetry, or the
balance of masses.
The work is given
rhythm by the even
distribution of color,
which Malevich
used with a greater
vivacity and variety
here than in his
first Suprematist
compositions.

MARC CHAGALL
**Jew at Prayer
(The Rabbi of
Vitebsk)**
1914, oil on canvas
104 x 84 cm
Galleria
Internazionale
d'Arte Moderna di
Ca' Pesaro, Venice

This painting is
one in a series of
portraits that Chagall
made between 1914
and 1916 of the
inhabitants of
Vitebsk; the series
includes *The
Newspaper Seller*
(private collection)
and *The Jew in Red*
(State Russian
Museum, St.
Petersburg). The
subject is dressed in
the ritual clothing
worn by Orthodox
Jews during morning
prayer or to go to
synagogue; draped
over his head and
shoulders is a tallit
(a white fringed
prayer shawl) and he
wears tefilin, small
boxes containing
scriptural passages.
Chagall used a limited
number of colors
and heightened the
contrast between
the white and black
areas. The indefinite
background presents
several geometric
simplifications that
demonstrate
Chagall's awareness
of Suprematism
and Constructivist
works. The intense
expression on the
face of the old rabbi
is emphasized by the
careful distribution of
light, creating a sense
of solemn spirituality.

Avant-garde movements in Russia

■ MARC CHAGALL
The Mirror
1915, oil on
cardboard
100 x 81 cm
State Russian
Museum,
St. Petersburg

During his stay in Paris between 1910 and 1914 and on his return to Russia, Chagall kept in touch with members of the pictorial avant-gardes, drawing inspiration for the works he presented in Moscow at the show entitled "The Year 1915." In this painting, made a few months later, he completely overturns the size and scale of objects. The pictorial space is taken up almost entirely by a giant mirror with an elaborate wooden frame that reflects an enormous oil lamp. Visible in the lower left corner is a minuscule female figure asleep on a chair, resting her head atop the table, both pieces of furniture far larger than she is. The viewer does not know the reasons for this particular setting, and the evident disproportion between the figure and the objects creates a mysterious, disturbing atmosphere, emphasized by the brilliant and nearly surrealistic use of colors.

MARC CHAGALL
The Promenade
1917–18,
oil on canvas
170 x 163.5 cm
State Russian
Museum,
St. Petersburg

In this famous
painting Chagall
united the two great
loves of his life:
Vitebsk, the city of
his birth, and Bella,
his wife. He depicts
the wooden houses in
a schematic, almost
Cubist way, along
with the high
stockade of the small
town in Byelorussia,
and poetically
transforms the colors
to locate the scene in
a dreamy dimension:
blue leaves, a pink
church, green houses
and fields against
which the multicolor
tablecloth stands out
sharply. The painter is
at the center of the
canvas, with an
expression of happy
pleasure. In his right
hand he holds a small
bird while with his
left he holds onto his
wife, who floats in
the sky, a symbol of
the happiness of
conjugal love.
Daughter of a rich
jeweler of Vitebsk,
Bella Rosenfeld
married Chagall on
July 25, 1915, and in
the spring of 1916
gave birth to their
daughter Ida. She
was Chagall's steady
companion and
inspirational muse
until her death, on
September 2, 1944.

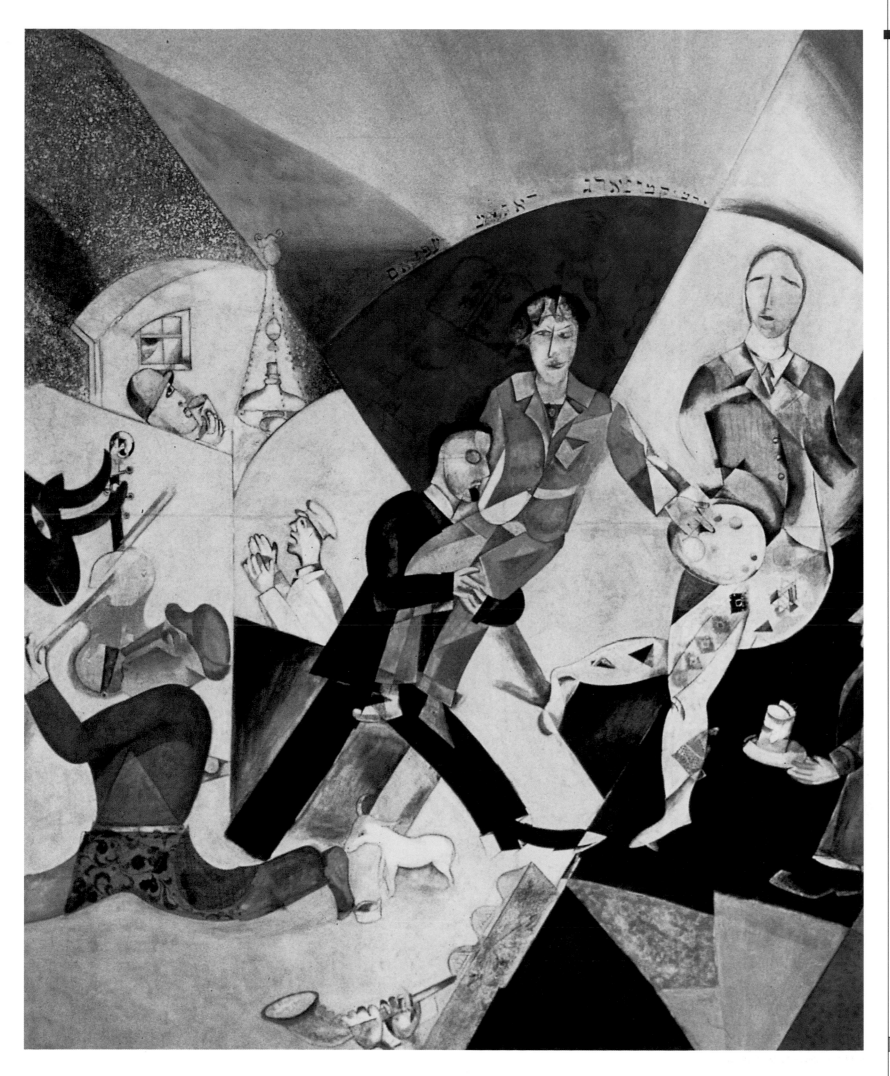

■ MARC CHAGALL
Introduction to the Jewish Theater
(detail)
1920, tempera and kaolin on canvas
Tretyakov Gallery, Moscow

On November 20, 1920, on the invitation of the art critic Abram Efros, Chagall began the decorations for the Jewish Chamber Theater of Moscow. In less than two months he painted the curtain, *Lovers in Flight* on the ceiling (lost), and seven panels: along the long blind wall, *Introduction to the Jewish Theater;* opposite it, between the windows, four allegories of *Music, Dance, Drama,* and *Literature;* above the windows the long narrow frieze of the *Wedding Table;* and on the wall of the foyer to the small theater, *Love on the Stage.* He also designed the costumes and scenery for three plays by Sholom Aleichem: *Mazeltov, Agents,* and *The Ruined Passover.* In this detail of the larger panel Chagall presents himself with his palette held up by Abram Efros, who is presenting him to the director of the Jewish theater, Alexei Granovsky, performing a dance step.

ALEXANDRA EXTER
**Costume for
"Romeo and Juliet"**
1920–21,
oil, gouache, and
pen on cardboard
48 x 35 cm
Private collection

This is one of the
drawings Exter made
for the costumes of
the ballet *Romeo and
Juliet*, produced by
Alexander Tairov and
performed for the first
time at the Kamerny
Theater in Moscow on
May 17, 1921. In
collaboration with
Tairov, Exter designed
a "synthetic theater"
in which all the
elements—scenery,
costumes,
performance, and
music—blended in
a dynamic whole.

LÉON BAKST
The Indian Groom
1922, watercolor,
pen, and gouache
on paper
67.3 x 48.8 cm
Private collection

This watercolor is
based on one of the
costumes designed by
Bakst for the ballet
The Sleeping Princess,
with music by Peter
Ilyich Tchaikovsky,
choreographed by
Marius Petipa. Bakst
did the scenography
in addition to the
costumes. The first
performance, given
by the Ballets Russes
of Serge Diaghilev,
took place on
November 2, 1921,
at the Alhambra
Theatre in London
with orchestration
by Igor Stravinsky.

Avant-garde movements in Russia

■ ALEXANDER
RODCHENKO
Abstraction
1920, oil on canvas
136 x 141.1 cm
Private collection

Alexander Rodchenko
was first influenced
by the Cubists and
the Futurists. He
then moved on to
the Suprematism
of Malevich and the
Constructivism of
Tatlin. Early in the
1920s he went
through a period
of artistic crisis
during which he
experimented with
a variety of very
difficult styles in
search of a language
capable of faithfully
expressing his
thoughts. In this
canvas Rodchenko
takes leave of forms
and lines in an
attempt to grasp
true painting. To
achieve this end he
distributes the
brushstrokes following
criteria very similar
to those employed
by the Abstract
Expressionists. The
intense light seems
to melt and dilute
the colors, canceling
the material
substance of the
paint. Beginning with
the "5 x 5 = 25" show
held in September
1921, Rodchenko
progressively
abandoned his
activity as a painter
to dedicate himself
to design and
photography.

IVAN KLYUN
Spherical
Construction
circa 1921,
oil on paper mounted
on canvas
72.5 x 44.5 cm
Private collection

At the beginning of
his career Klyun drew
inspiration from the
paintings of Gauguin,
Matisse, and members
of the Symbolist
movement; in 1907
he made friends with
Kazimir Malevich, who
taught him the
fundamental
principles of
Suprematism. He
began distancing
himself from
Malevich's style in
1919, saw the works
of Kandinsky and
Tatlin, and sought
new, more original
expressive forms. In
this painting, for
example, he seeks to
achieve a synthesis
between Suprematism
and Constructivism,
intersecting
transparent and
opaque geometric
forms set against a
neutral background,
so as to multiply the
effects of light and
create a greater
number of
combinations.
Another technique
that he adopted in
his works made during
the 1920s is shading,
whereby he lightened
the outlines of figures
to make the passage
from one to another
less clear, thus
creating a vaguer,
more indeterminate
atmosphere.

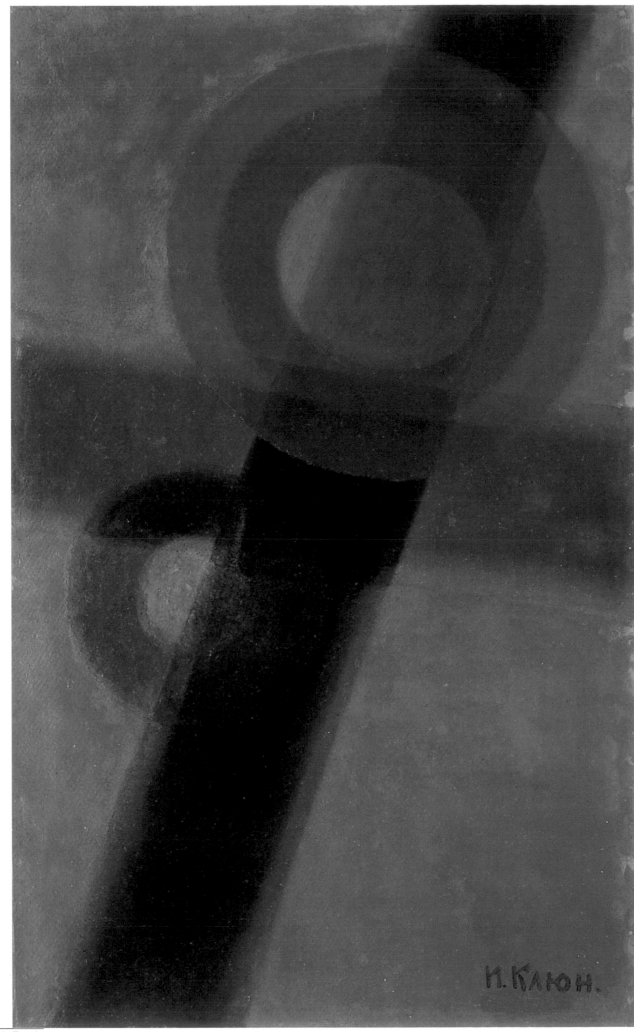

LIUBOV POPOVA
**Spatial Force
Construction**
1921, oil, pen, and
marble powder on
plywood
71 x 63.9 cm
Private collection

In 1910 Popova
traveled to Italy and
two years later went
to Paris, where she
studied with the
Cubists Henri Le
Fauconnier and Jean
Metzinger. On her
return to Russia in
1913 she worked in
Tatlin's studio, then
contributed to
Malevich's magazine
Supremus together
with Ivan Klyun, Olga
Rozanova, Nadezhda
Udal'tsova, and
Alexandra Exter. By
the end of the early
1920s she had
developed her own
personal style, a
geometric
abstractionism of
great expressive force
that she also adopted
in the applied arts.
The composition
shown here is closely
tied to the linoleum
etching that she
presented together
with four paintings at
the "5 x 5 = 25" show
held in Moscow in
September 1921. In
this work she very
carefully constructs a
pictorial space marked
off by the irregular
rhythm of the pale
bands variously
superimposed, while
the black areas
against the brown
background suggest
the idea of movement
and depth.

Modigliani was born in Livorno, Italy on July 12, 1884. He was given the first name Amedeo but was known as Dedo by his family and Modi by his friends, and he received his first drawing lessons at fourteen, attending the studio of Guglielmo Micheli, a former student of Giovanni Fattori. His companions in these studies included Benvenuto Benvenuti, Gino Romiti, Llewelyn Lloyd, Renato Natali, and Oscar Ghiglia (who was his closest friend in those years). Struck by tuberculosis, he took a long trip with his mother to Naples, Rome, Florence, and Venice, visiting museums and art galleries. On May 7, 1902, he enrolled in the Scuola Libera di Nudo in Florence and after a short stay at Pietrasanto, where he studied sculpture, he entered the Scuola Libera di Nudo of the Institute of Fine Arts in Venice. In January 1906 Modigliani moved to Paris, where he became a part of an extremely lively and creative cultural setting. At first, thanks to money from his mother, he was able to stay in a hotel near the Church of the Madeleine and enrolled in the Académie Colarossi. He rented a studio in Rue Caulaincout and began visiting the nocturnal cafés of Montparnasse and Montmartre, where he came to know Picasso, Derain, Vlaminck, van Dongen, Picabia, Apollinaire, and the members of the Italian colony in Paris, including Gino Severini and Anselmo Bucci. In 1907 he changed studios, moving to 7, Place Jean-Baptiste Clément: he drew, painted, and sculpted a great deal; in October he exhibited two oil paintings and five watercolors at the Salon d'Automne, but despite his many efforts to have his work seen and judged by gallery owners and private collectors he failed to find buyers, putting him in a difficult financial situation. Disappointed and frustrated by the lack of tangible recognition for his work, he began to abuse alcohol and drugs, further undermining his fragile constitution. These experiences of dissolute and precarious living, together with his numerous love affairs, were later emphasized by critics and biographers, who saw him as the

Amadeo Modigliani, *Caryatid*, circa 1916, colored pencil and ink on paper; Musée d'Art Moderne de la Ville de Paris, Paris

Amedeo Modigliani, *Max Jacob*, 1916, oil on canvas, 73 x 60 cm; Kunstsammlung Nordrhein-Westfalen, Düsseldorf

stereotypical starving artist, the *maudit* ("cursed") artist (it helped that his nickname Modi rhymed with *maudit*). In November of 1907 he had one of the fundamental encounters of his life: He met Paul Alexandre, a young doctor at the Lariboisière hospital, and his brother Jean, a dentist. Although not particularly rich, the two brothers were passionate about art, driven by the desire to help talented but indigent young artists. To this end they rented a tumbledown building at 7, Rue du Delta and made it available to artists, supporting them financially and buying their work. They periodically organized evenings dedicated to theater and poetry to stimulate creativity and the exchange of ideas. They also hired two professional artists, Maurice Drouard and Henri Doucet, to select new recruits and instruct, guide, and council them. For about seven years Paul Alexandre was the patron and friend of Modigliani. Not only did he give him material support, but he also went with him to visit churches, museums, shows, and other sites of art and culture in Paris; and they had long conversations about art. On the advice of Paul Alexandre, Modigliani presented six works in the 1908 Salon des Indépendants, and six in 1910, including *Beggar of Livorno* (private collection), inspired by Cézanne, which he had painted during a short stay in Italy during the preceding summer. In that period he also met the Romanian Constantin Brancusi and exhibited eight stone statues at the 1912 Salon d'Automne. Sculpture was his true passion, and only his weak health prevented him from

practicing it the way he would have liked. Meanwhile he continued to associate with other artists, including Picasso and the Cubists, Matisse, the Fauves, Severini and the Futurists. He learned something from each of these encounters, but his distant and independent character prevented him from joining any of the movements or from fitting his style to any one idea. With the outbreak of World War I Paul Alexandre was drafted; his place in the artist's life was taken by the art dealer Paul Guillaume, who met Modigliani thanks to a meeting organized by Max Jacob, one of the first to appreciate and value Modigliani's works. In those months Modigliani made friends with the Mexican painter Diego Rivera, with whom he shared a studio for a while. He also began an intense and troubled love affair with Beatrice

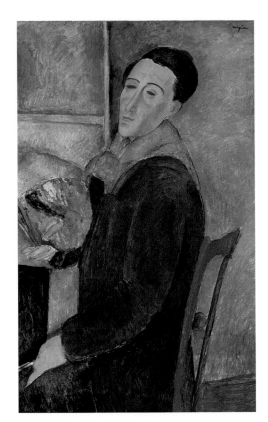

In 1918 Modigliani and Jeanne went to Cagnes-sur-Mer and Nice; on November 29 a daughter was born, named Jeanne. Modigliani spent the first months of 1919 at Nice, where he made portraits of children and his only four landscapes. On May 31 he returned to Paris alone, hoping to obtain a better financial relationship with Zborowski, who had him included in a collective show in London where he achieved discreet success. In the fall his health deteriorated, in part because he still had not overcome his problem with alcohol. On January 22, 1920, he was taken, unconscious, to the Hôpital de la Charité, the clinic for the poor, and he died there on January 24. The next day Jeanne Hébuterne, once again pregnant and staying with her parents, escaped their watchfulness and committed suicide, throwing herself from a fifth-floor window.

■ Amedeo Modigliani, *Self-portrait*, 1919, oil on canvas, 100 x 65 cm; Museu de Arte Contemporañea da Universidade de São Paulo, São Paulo

Modigliani in Paris

Hastings. In June 1916, through Fernande Barrey, first wife of Tsuguharu Foujita (a Japanese artist in Paris) Modigliani met Léopold Zborowski, who became his admirer, protector, patron, dealer, and friend. After signing a contract that guaranteed him a monthly stipend in exchange for paintings, Modigliani moved to 13, Place Emile Goudeau and participated in a collective exhibit at the atelier of Emile Lejeune. In the spring of 1917, during a carnival celebration, he met nineteen-year-old Jeanne Hébuterne, a student at the Académie Colarossi and the Ecole Nationale des Arts Décoratifs. She was from a middle-class family that did everything to prevent her relationship with a man fourteen years her senior, a man who could not provide her with a dignified life, most of all a man known for his excesses and his problematic health. Despite all this, Jeanne and Modigliani lived together in an old condominium at 8, Rue de la Grande Chaumière. A few months later, Léopold Zborowski organized the first one-man show of Modigliani in the Parisian gallery of Berthe Weill, at 50, Rue Taitbout, with a touching and inspired preface by Blaise Cendrars. But the outcome was negative: only two drawings sold, for 30 francs each.

■ Modigliani, Picasso, and the writer André Salmon in Montparnasse in a photo of 1916

AMEDEO MODIGLIANI
Paul Alexandre in Front of a Window
1913, oil on canvas
81 x 45.6 cm
Musée des Beaux-Arts, Rouen

In April 1909 Paul Alexandre introduced Modigliani to his family and commissioned four portraits from him: two of himself, one of his father (the pharmacist Jean-Baptiste) and one of his brother Jean. This painting—made four years later on the basis of drawings, without having his friend pose—is one of the first in which Modigliani began to deform the features of figures. Here he elongated the features of the face, almost certainly inspired by the carved-stone heads he was making during the same years. Another characteristic that was to become typical of his portraits is the absence of pupils, which gives his figures a particular expressiveness. The pose is traditional, but the use of color reveals new elements that recall Cézanne and Toulouse-Lautrec. During the seven years in which he was Modigliani's patron, Paul Alexandre bought twenty-five portraits and dozens of drawings, works that testify to the painter's artistic formation and evolution during his first years in Paris.

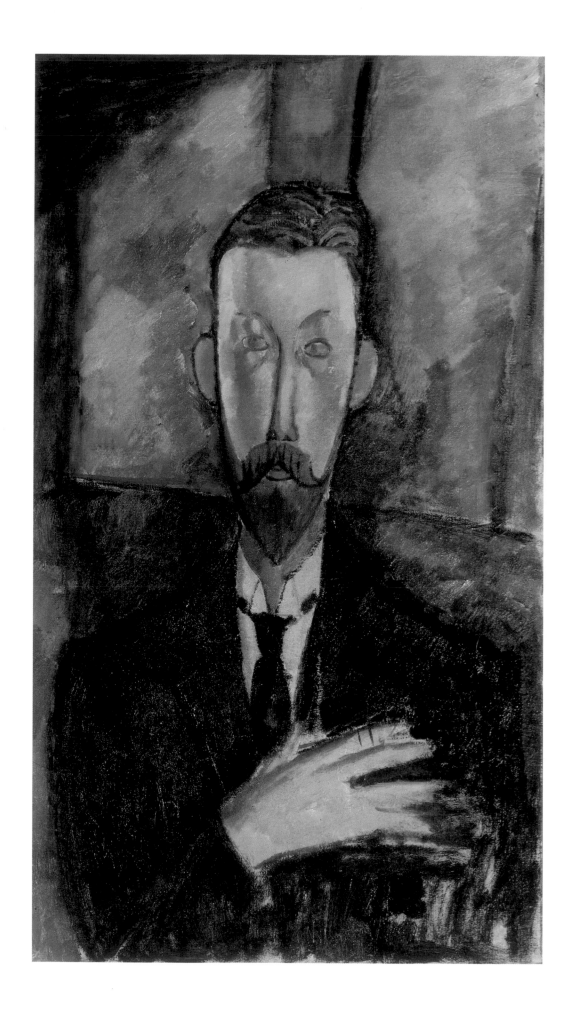

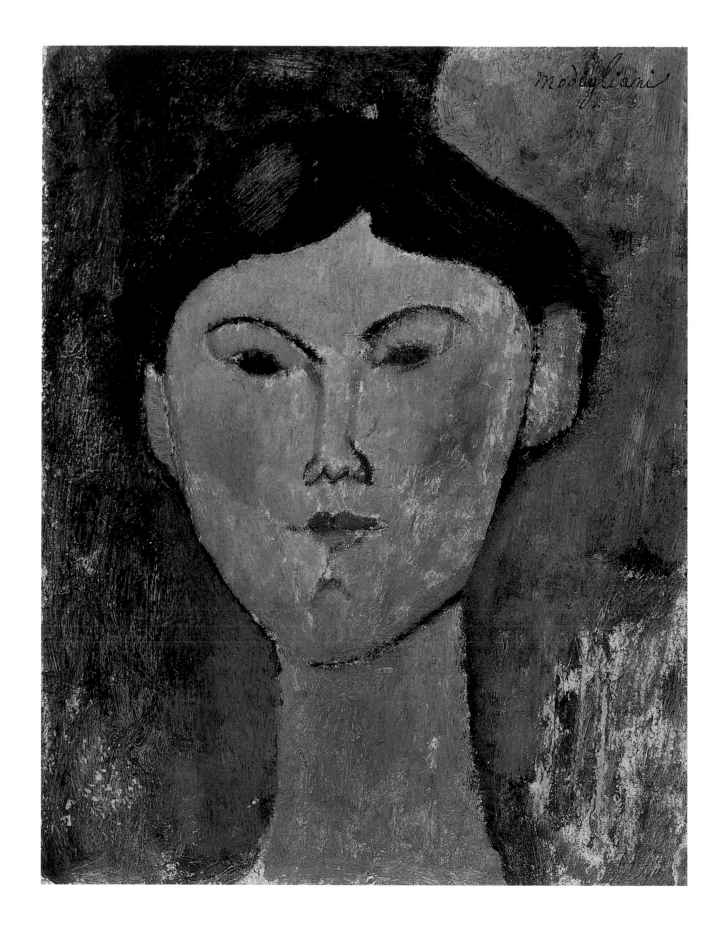

AMEDEO MODIGLIANI
Beatrice Hastings
1915, oil on canvas
35 x 27 cm
Civico Museo d'Arte
Contemporanea,
Collection Riccardo
Jucker, Milan

English journalist
and poet, born in
South Africa in 1879,
Hastings arrived in
Paris in 1914 as
correspondent for the
magazine *New Age*.
Five years older than
Modigliani, she met
him at the café La
Rotonde; at first they
lived together at 53,
Rue Montparnasse,
later moving to
Montmartre. A
learned and sensual
woman with a strong
personality, she
exercised a great
influence on
Modigliani for almost
two years, even if
their relationship
was marked by
frequent quarrels,
the result of their
unstable characters
and shared abuse of
alcohol and drugs.
The portraits
Modigliani made
of her are among
his most beautiful,
with an acute
psychological
penetration. These
portraits also present
some of the new
methods that were
later to characterize
his style, in part a
result of his long
conversations with
his friend Constantin
Brancusi. After
leaving Modigliani,
Hastings married a
boxer and committed
suicide in 1943.

AMEDEO MODIGLIANI
Moïse Kisling
1915, oil on canvas
37 x 28 cm
Pinacoteca di Brera,
formerly Collezione
Jesi, Milan

Moïse Kisling was
born in Kracòw in
1891 and died in
1953. He moved to
Paris in 1910, where
he began associating
with the Cubist
painters and became
one of Modigliani's
closest friends. In
this canvas Modigliani
can be seen to have
deformed the features
of the Polish painter;
in particular, the neck
is widened, giving the
face a heftier, more
determined look. He
was also beginning to
make facial features
slightly asymmetrical,
with crossed eyes and
uneven lips,
cheekbones, and chin.

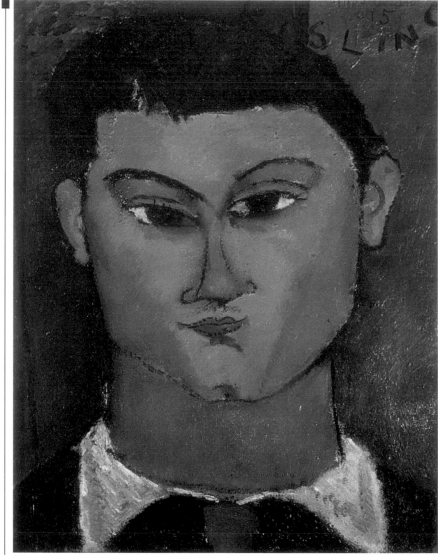

MOÏSE KISLING
Kiki of Montparnasse
1927, oil on canvas
100 x 81 cm
Musée du Petit
Palais, Geneva

Kiki was the *nom d'art*
of Alice Ernestine Prin
(1901–1953), a
nightclub singer and
actress, model and
painter, one of the
icons of the
Bohemian world of
Paris, so much so
that she was
nicknamed the Queen
of Montparnasse. The
artists who used her
as a model include
Man Ray (see page
354), Chaïm Soutine,
and Tsuguharu
Fuujila. Kiki was also
friends with Jean
Cocteau, Max Ernst,
and Ernest
Hemingway.

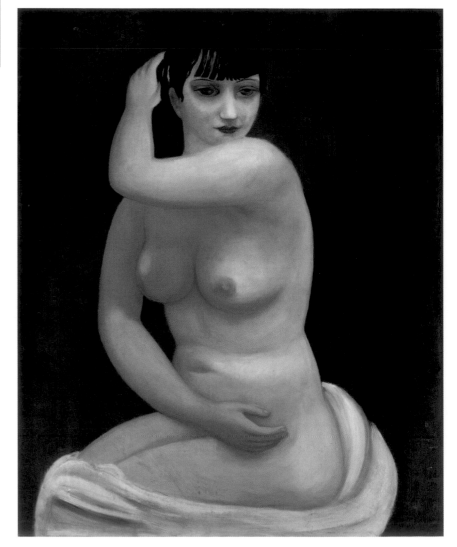

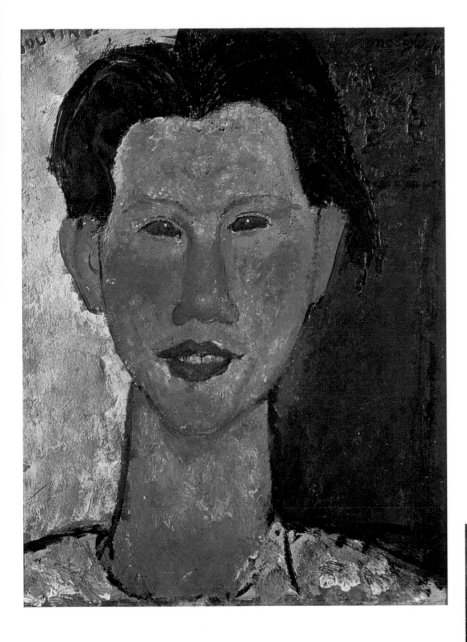

■ AMEDEO MODIGLIANI
Chaïm Soutine
1915, oil on panel
36 x 27.5 cm
Staatsgalerie,
Stockholm

Chaïm Soutine was
born at Smilovitchi,
near Minsk, in 1894
and died in 1943. In
1911 he arrived in
Paris, where he met
Marc Chagall and
Jacques Lipchitz,
who presented him
to Modigliani. Ten
years older than
Soutine, Modigliani
treated him like a
younger brother. He
tried to correct his
sloppy and awkward
appearance and
taught him the rules
of polite society so
he could cut a better
figure in the cultural
settings of Paris. He
also gave him lessons
in drawing and
painting and got
Zborowski to take
care of him.

■ CHAÏM SOUTINE
Hotel Busboy
circa 1925,
oil on canvas
98.1 x 80.5 cm
Musée National d'Art
Moderne, Centre
Georges Pompidou,
Paris

Soutine's style
certainly showed
the influence of
Modigliani, but
from his first years
it stood apart for
its more nervous
and concise line
and for its strongly
contrasting tonalities
of color, similar to
the style of the
Expressionists.
Thanks to help from
Zborowski, Soutine
encountered several
influential collectors
and after the war
his works earned
him a certain amount
of financial success.

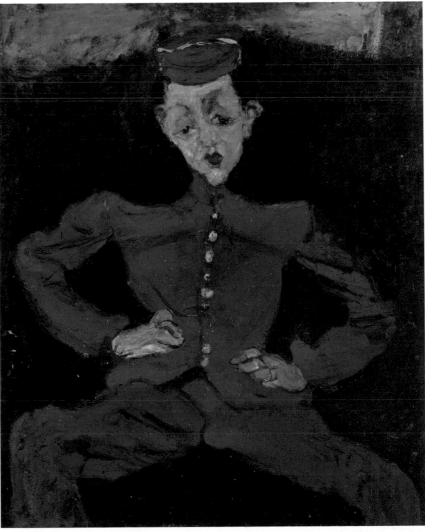

AMEDEO MODIGLIANI
**Red Nude
(Reclining Nude
with Open Arms)**
1917, oil on canvas
60 x 92 cm
Private collection

From his arrival in
Paris Modigliani made
various drawings with
studies of nudes, but
he began to paint
canvases of nudes
only at the end of
1916, in the
apartment of Léopold
Zborowski at number
3, Rue Joseph Barra.
In 1917 he made a
series of about
thirteen nudes in a
horizontal format,
with models lying
down, seen from
slightly above, with
their arms in various
positions but usually
behind the head. The
most immediate
reference is the
odalisque, a theme
that had been popular
in European art for at
least a century, but
Modigliani treated the
form and colors of the
subject in a way that
differed completely
with all versions of
the past. The model
in the painting shown
here offers herself to
the eyes of the viewer
without inhibition or
fear; she presents the
shape of her body and
her beauty in a
thoroughly explicit
pose, full of powerful
and instinctive
eroticism. Her thick,
intensely red lips are
emphasized by the
repetition of that
color in much of the
background, which

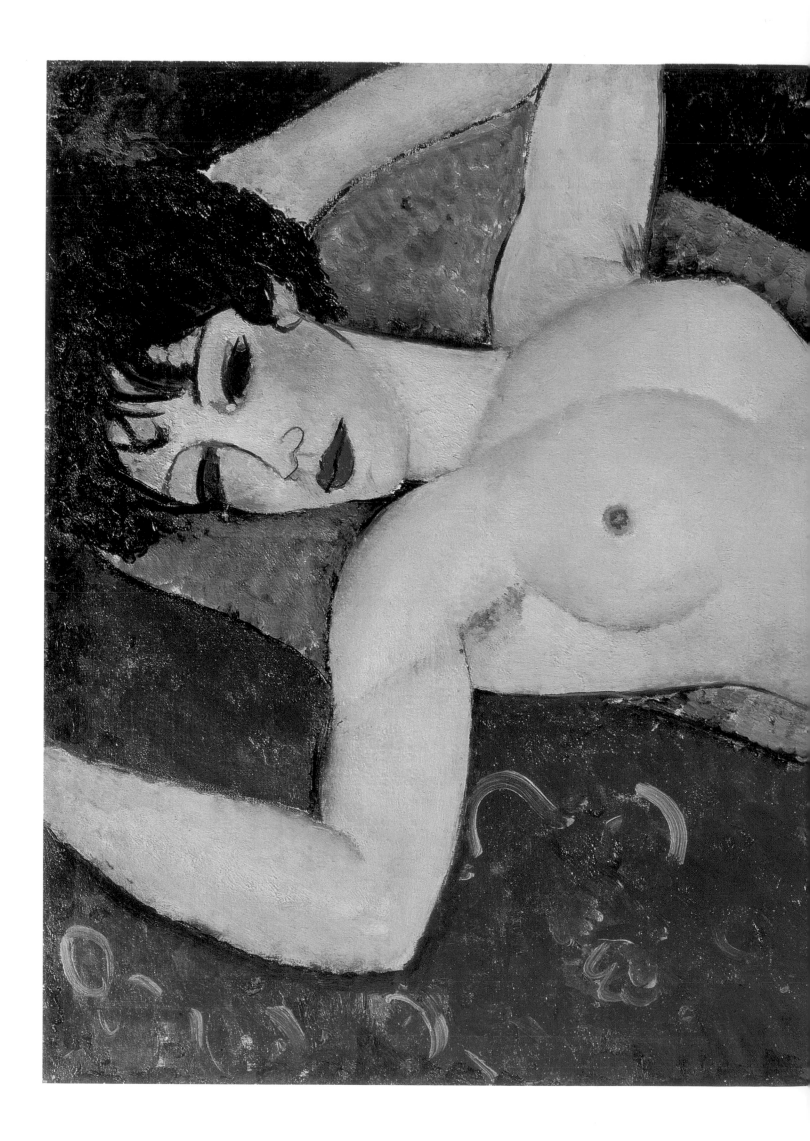

amplifies the passionate charge of the entire composition. The woman's attitude is immediate and direct: Modigliani does nothing to veil or sublimate the scene with learned allegorical or mythological references, as had been common in the traditional paintings of the period. This is why, unlike the dozens of paintings depicting Venus, Diana, nymphs, or the chaste Susanna at her bath, happily tolerated by the most conservative and moralistic members of the public, the nudes by Modigliani provoked scandal and outcry. Such was the response to his first one-man show, held at the gallery of Berthe Weill. The show was supposed to run from December 3 to December 30, 1917, but from its opening it was plagued by interventions of the police, who ordered the removal, "for offense to public decency," of several of the thirty-two works on display, especially the nudes shown in the window.

**Paul Guillaume
Seated**
1916, oil on canvas
81 x 54 cm
Civico Museo d'Arte
Contemporanea, Milan

Paul Guillaume, who
began his career as
an agent for an
insurance company,
opened an art gallery
in Rue Miromesnil
in 1913. He came
in contact with
Apollinaire, who
communicated to
him his passion for
African art, and with
Montmartre artists,
including Kisling and
Modigliani. Between
1914 and 1916 he
was Modigliani's
principal buyer and
patron. As Modigliani
himself wrote in 1915
on a portrait of
Guillaume, he was his
"new pilot." In 1917
Guillaume moved his
gallery to 100, Rue
Faubourg St. Honoré,
where he exhibited
paintings by De
Chirico, Severini, and
Derain, among others.
In 1923 Guillaume
sold various canvases
by Modigliani and
Soutine to the rich
American collector
Albert C. Barnes,
whom he also
introduced to Henri
Matisse. After
Guillaume's death, in
1932, at the age of
forty-one, his widow
donated part of his
important collection
to the Louvre.

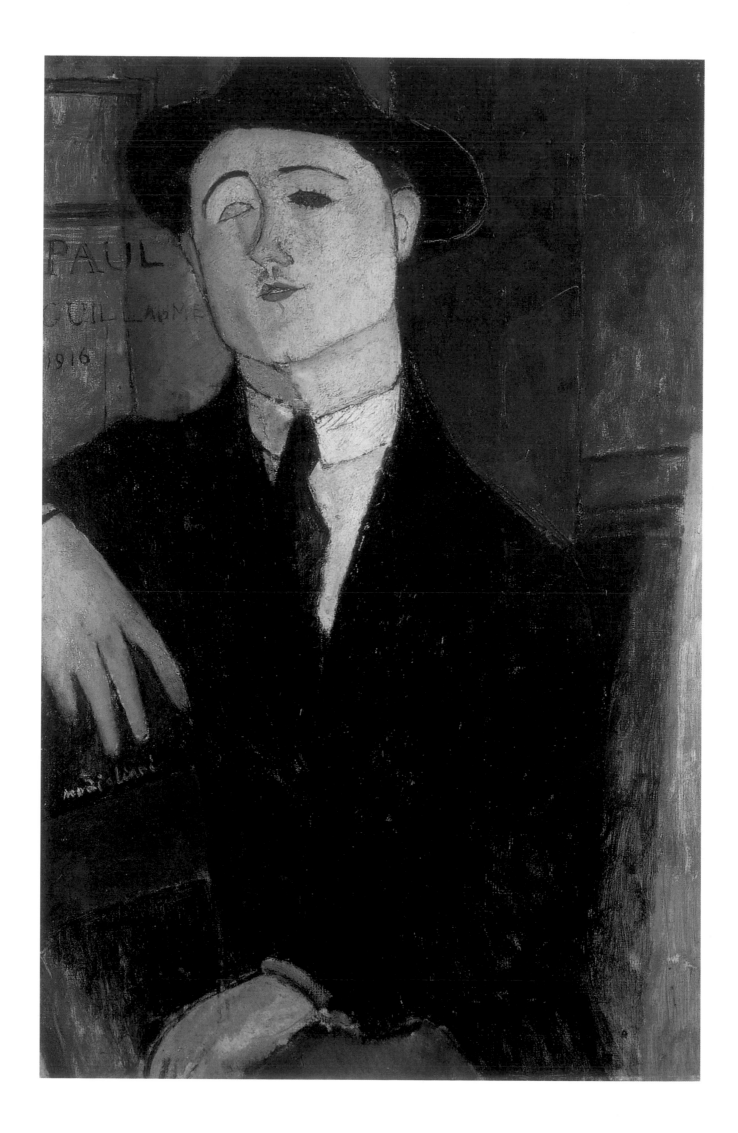

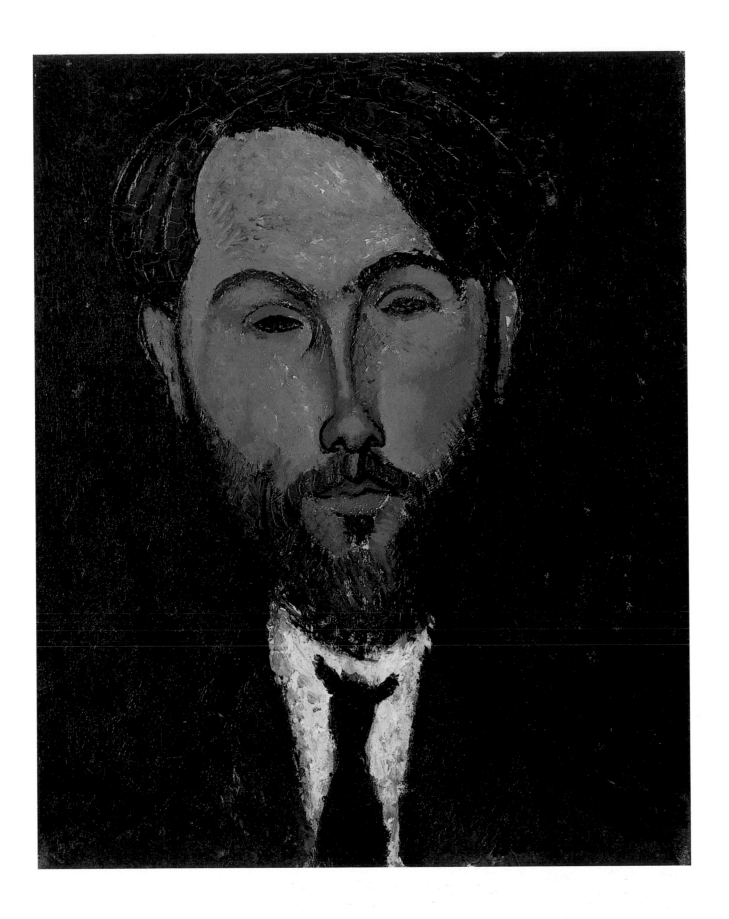

■ AMEDEO MODIGLIANI
Léopold Zborowski
1917, oil on canvas
40 x 32 cm
Private collection

This painting is one of many portraits that Modigliani made of his patron, Léopold Zborowski, and his wife, Anna. Born in 1889 in the Polish village of Zaleschiki, Zborowski got a degree in literature from the University of Kracōw. In 1913 he moved to Paris to study French culture at the Sorbonne, but at the outbreak of World War I he abandoned books to dedicate himself to the art market. A fine connoisseur, he frequented the meeting places of artists, offering himself as intermediary and agent. In 1916 he met Modigliani and had him sign an exclusive contract, in return for which he helped him in his most difficult moments, most of all after the birth of his daughter, Jeanne. In 1927 Zborowski opened his own gallery, but the financial crisis at the end of the 1920s brought an end to his hoped-for success. He died nearly penniless in 1932, and his widow, in order to survive, was forced to sell his prestigious collection.

AMEDEO MODIGLIANI
**Jeanne Hébuterne
with Yellow Sweater**
1918–19,
oil on canvas
100 x 64.7 cm
Solomon R.
Guggenheim Museum,
New York

Jeanne Hébuterne
was the inspirational
muse and faithful
companion of the
last three years of
Modigliani's life.
Modigliani made many
portraits of her, in
different poses and
attitudes, fascinated
as he was by her
beauty, which was not
necessarily striking
but seemed to fit his
female ideal. The
"distinctive signs"
that Modigliani
adopted in his
portraits and that
have made him
popular are quite clear
in this work: the long
neck, the tilt of the
head, the stylized,
enlarged nose, the
imperceptible
asymmetries in the
face, and the
particular way he
painted eyes, with
the pupils just barely
indicated or, in some
cases, completely
absent. Among
Modigliani's numerous
"debts" to Cézanne
there is also, as here,
the position of the
hands and the
indistinct background,
created with shaded
neutral colors to
make the figure in
the foreground stand
out even more.

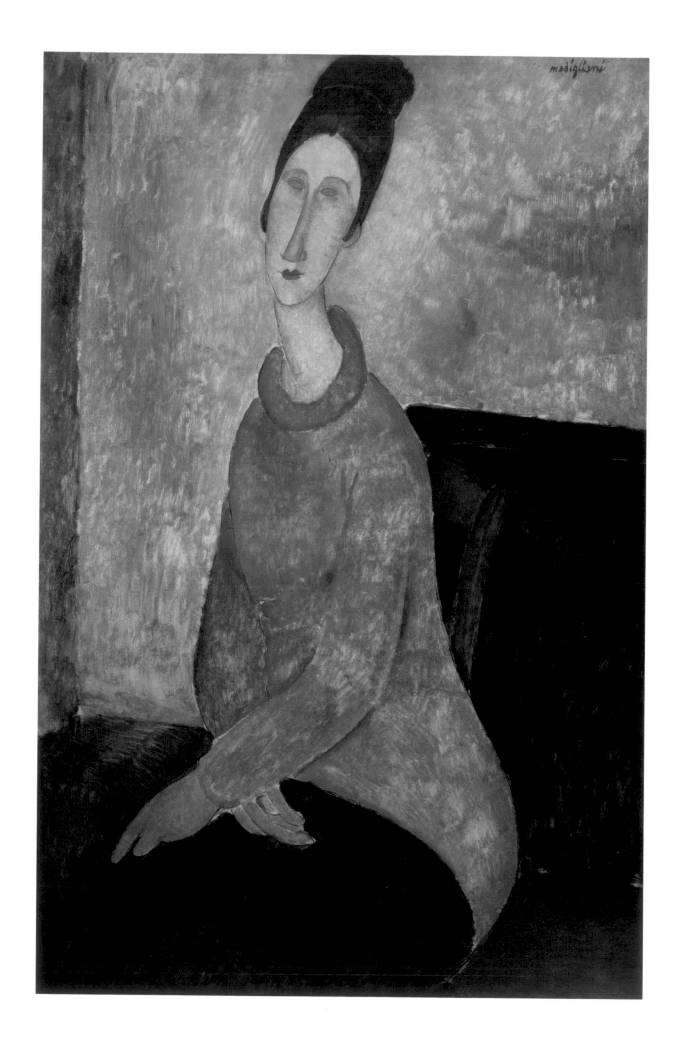

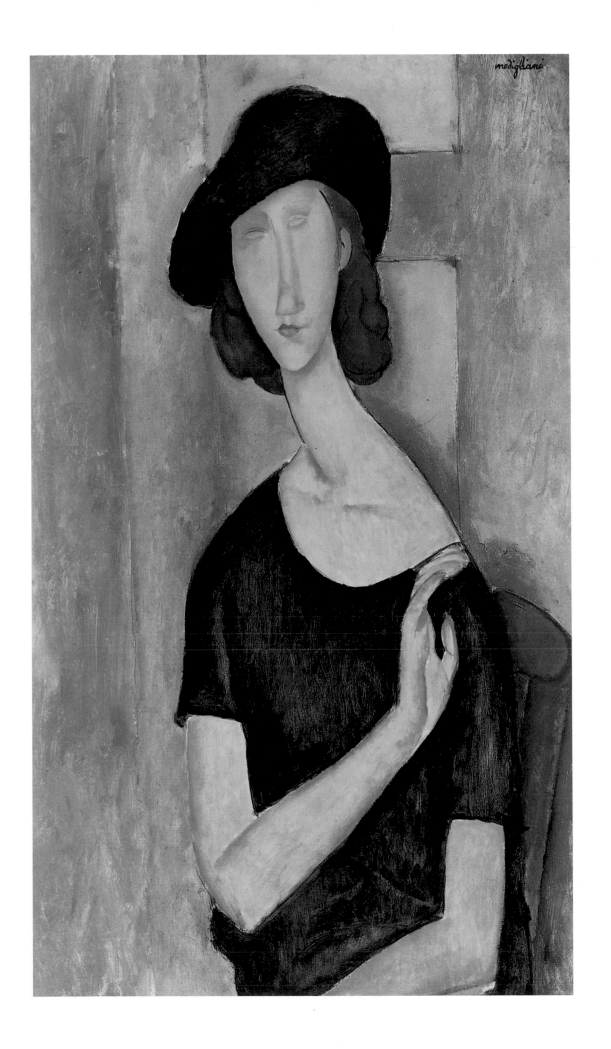

■ AMEDEO MODIGLIANI
**Jeanne Hébuterne
in Hat**
circa 1919,
oil on canvas
93 x 53 cm
Private collection

This work is one of
the last that
Modigliani made and
dedicated to his
adored companion,
presented here with
a thoughtful and
melancholy expression
in an austere and
noble attitude, similar
to that of a
Renaissance princess.
In particular in this
canvas, with its
refined and rarefied
atmosphere, the
young woman seems
to lose all material
consistency to
become an icon of
female grace and
love. As Osvaldo
Patani wrote in 1988
in the catalog
accompanying a
retrospective exhibit
of Modigliani's works
at the Galleria d'Arte
Moderna in Verona,
Modigliani
"in his brief meteoric
passage was an
instinctive, acute,
and inventive
chronicler whose
lucid hands took
as subjects figure-
friends, famous or
not, consenting and
seduced by his bitter
human art, and put
them in the
untouchable and
unreachable world
of the youthful years
so important to the
poetry of art."

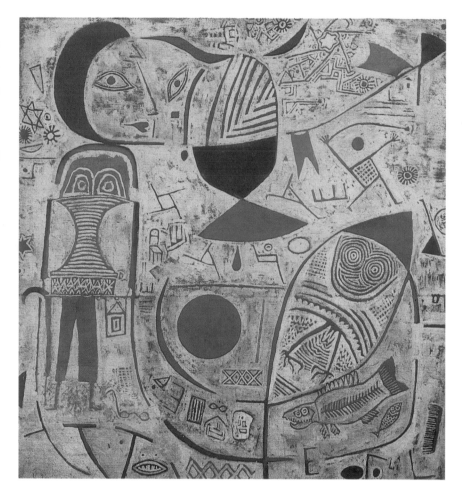

Primitivism is only one aspect of the wider European interest in non-European cultures in the late 19th and early 20th century, that also included Orientalism (seen in works ranging from the *Women of Algiers* of Eugène Delacroix, today in the Louvre in Paris, to the Odalisques by Henri Matisse) and Japanisme (such as Vincent van Gogh's imitation of models drawn from Hiroshige and Ikeda Eisen). These interests can be seen as an aspect of European colonialism. Between 1815 and 1915 Britain, France, and to a lesser degree the other nations of Europe extended their economic and political control over much of the rest of the world. During this period, European control extended from 35 to 85 percent of the earth's dry land. The European nations had colonies all over the world. Raw materials, breeding stock, and agricultural products were not the only imports to reach Europe from these colonies; artisan products and works of art came as well. These were first looked upon with suspicion, but this soon changed to curiosity and a growing interest. Specialized galleries were opened for this new art; museums set aside special halls; increasingly knowledgeable shows were held; and the number of collectors grew each year. In 1855 the Musée Permanent des Colonies opened in Paris, with works of art from the Orient, by Native Americans and Africans, and from Oceania; in 1865 Henry Christy donated his collection of such objects to the British Museum in London; in 1876 the scholar Luigi Pigorini (1842–1925) expanded and organized

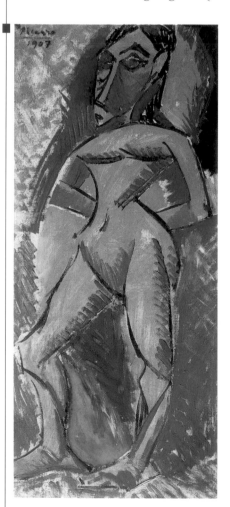

part of the collection that had formerly belonged to the Museum Kircherianum of the College of Rome, founded in the 17th century by the German Jesuit and scientist Athanasius Kircher, and gave life in Rome to the Museo Nazionale Preistorico ed Etnografico. The Ethnographic Museum of Paris opened a section dedicated to African art in 1878, and the Universal Exposition held in Paris in 1889 included several villages of indigenous peoples set up on the Champ-de-Mars. As time passed these objects were discovered and studied by the intellectuals and younger members of avant-garde art movements. Tired of the traditional teachings of art academies, they were in search of new aesthetic and cultural models.

The term *primitivism* made its first appearance in a French dictionary in the *Nouveau Larousse Illustré*, published between 1897 and 1904. The definition given was quite simple: *imitation des primitifs* (imitation of primitives) without however clarifying the concept of "primitive." Prior to this, in fact, the word *primitive* had been applied to the art of various Italian and Dutch schools of the 14th and 15th centuries; it had then been extended to the artists of the Romanesque and Byzantine periods. Only later, with the advent of colonialism, was the word applied to art from non-European cultures, from the Native American and pre-Columbian to Asiatic, African, and Oceanic cultures. The first art critics to use the words *primitive* and *primitivism* in this sense used it with a negative and derogatory meaning since they considered these products coarse, lacking the requisite technical and stylistic qualities. In the beginning, very few European critics discerned positive values in the art of non-European populations, but soon European artists saw these works as expressions of free spirits, authentic and original works of art not repressed or conditioned (as they saw it) by any rules or disciplines, as was instead the case in Europe. They discovered and imitated so-called primitives with the desire to return art to its infancy, to the spontaneous soul of children, and they sometimes reached this conclusion in a superficial manner, seeing a kind of original purity in all non-European art, and assuming that it had been made in a setting that

maintained a direct and untainted relationship with reality, with its true nature, and thus able to express the mystery and magic of life.

In considering the art of such "primitive" cultures, Western artists thought in terms of both content and form. As for content, they tended to see positive values in the simple, elementary way of life of these populations, so different from that of Western civilization. Their world was seen as happy and uncontaminated, not yet corrupted by technology, machines, and the thirst for power and wealth of modern Western humanity. An emblematic example is that of Paul Gauguin. Disappointed and embittered not only with Paris but with the small towns of Normandy and Provence, the inhabitants of which he saw as miserly and small-minded, he spent the last years of his life in the islands of the Pacific in search of an uncontaminated Earthly Paradise. Other artists sought instead to reclaim the vision of art as a

gardes, the Futurists, and even more the Expressionists, both the members of Die Brücke ("The Bridge") and those of Der Blaue Reiter ("The Blue Rider"). Even the Dadaists found inspirational motifs in primitive art, beginning with the writings of André Breton, who exalted the wild eye that looks at a world freed from the control of reason. In 1915 the critic Carl Einstein published *Negerplastik* ("Black Sculpture"), and in 1917 Paul Guillaume mounted a large show in Paris dedicated to African art. In the 1920s there was talk of an artistic movement called Art Nègre, that was expressed in painting, sculpture, and literature, while the 1922 Venice Biennale included a large selection of African sculpture. In the United States and Latin America many artists turned to their cultural roots, from Wifredo Lam to Sebastian Matta, from Jackson Pollock to Mark Rothko and Barnett Newman. Far more examples could be cited—from Joan Miró to Paul Klee, from André Derain to Fernand Léger—and they

Primitivism

tool for communicating spiritual values different from those transmitted by Christianity. Therefore they labored to understand the religious concepts of those distant populations, most of which, they found, were tied to the primordial forces of nature and a magical and sacred interpretation of natural events.

The second aspect of the relationship with non-European cultures came to involve a greater number of artists and involved the effort to create a new style of art in contrast to the rigid rules of the classical tradition, which imposed a rigid respect for perspective, proportions, symmetry, and verisimilitude and gave primacy to design over color and harmony over rhythm. From Cézanne on, European painters sought to free themselves from this "shell," which they felt was too heavy and unwieldy, in the name of a progressive formal simplification that would have as its result abstract art and, several decades later, minimalism. Matisse, Picasso, Modigliani, Brancusi, and many others drew inspiration from African masks to make rigorously elemental works, of a stylized design, and with great expressive force. Their influence spread throughout Europe and shows up in the works of the Russian avant-

increased in the period following World War II through a process of interpenetration and assimilation that led to increasingly wider diffusion.

Hermaphrodite
1910–11,
pencil on paper
43 x 26 cm
Private collection

Meeting Constantin
Brancusi proved to
be of central
importance to
Modigliani's artistic
development. The
Romanian sculptor
showed the Italian
artist new stylistic
techiques and helped
him understand the
secrets of African
sculpture, which
Modigliani had seen
only superficially in
museums and art
galleries with Paul
Alexandre, as well as
in private collections,
such as that of Frank
Burty Haviland.
Between 1909 and
1911 Modigliani made
several sculptures,
preceded by numerous
preparatory drawings,
such as this one, in
which the effort to
adopt the expressive
style of African
cultures is clear.
Modigliani was
searching for new
rhythms, a new way
of expressing lines
and volumes; in
African statues he
found the same
formal simplifications
that he had admired
in Gothic sculpture,
and he used it to
create works that
are refined and
silent, imbued with
a melancholy
expressiveness.

■ CARLO CARRÀ
Composition with Female Figure
1915, tempera on cardboard
41 x 31 cm
Pushkin Museum, Moscow

The Futurists came in contact with "primitive" art in Paris, by way of intellectuals and other artists in the French capital, in particular Picasso and the Cubists. Carrà visited Paris several times, in 1899, 1911, and again between 1912 and 1914. He wrote various essays against Cubism, separating his art from what he saw as a "negrism" that he judged to have "no aesthetic importance." In reality, however, he was influenced by the art of non-European cultures, as indicated by several drawings and paintings he made during those years. In this composition, for example, the central figure has clear points in common with a small ivory statue made by the Lega people (Zaïre) that was in the collection of Paul Guillaume, whom Carrà met in Paris. The Lega statue has the same oval-shaped head, eyes, and mouth, and the neck is squared, as in this work.

Masks
1911, oil on canvas
73 x 77.5 cm
Nelson-Atkins Museum
of Art, Kansas City

In 1911 Nolde went
to Ostend to visit the
Belgian painter James
Ensor, who shared his
passion for masks.
Nolde went on to
make a series of still
lifes, beginning with
this work. The mask in
profile at the far left
is based on the prow
decoration of a canoe
from Vella Lavella
(Solomon Islands in
the Pacific) preserved
in Berlin's Museum of
Ethnology. The mask
at lower right was
inspired by a
shrunken head
originally from Brazil
and on display in the
same Berlin museum
(of which Nolde made
a preparatory
drawing). The second
mask from the left
(upside down) and
the third seem to be
carnival masks, while
the last, at above
right, has much in
common with several
sculptures from the
Ijo tribe of Nigeria,
which Nolde could
have seen in the
museums of Leiden
or Hamburg.

Shrunken head
(Yoruna Indian, from
the Mundurucu people
of Brazil)
human head, cotton,
and fabric
height 16 cm
Staatliche Museen,
Ethnologisches
Museum, Berlin

EMIL NOLDE
Missionary
1912, oil on canvas
79 x 65.5 cm
Berthold Glauerdt
Collection, Solingen

This canvas is an example of how Nolde united elements from very different traditions in the same composition. The mother and child are from images of the Yoruba culture of Nigeria, and the mask at the center is also African, from the Sudan: Nolde saw it and copied it at Berlin's Ethnographic Museum. That same museum held the model for the large idol that Nolde used as the model for the figure of the missionary, the bearer of a culture and a civilization distant from those of the woman kneeling at his feet. In fact, the idol is from Korea and is of a type usually located along a roadway. The figures are depicted in an ironic manner that approaches caricature; the summary design, almost two-dimensional, the bright colors, and the monochromatic background locate the scene in an unreal dimension with a symbolic value.

Statue of divinity
(Korea)
painted wood
height 291 cm
Staatliche Museen,
Ethnologisches
Museum, Berlin

Bongo mask
(Sudan)
wood and teeth
height 30 cm
Staatliche Museen,
Ethnologisches
Museum, Berlin

MAX PECHSTEIN
Palau Family
1917, oil on canvas
53.5 x 51 cm
Private collection

Pechstein's interest
in primitive art
dated back to the
first decade of the
20th century, when
he visited the
anthropological and
ethnological museums
of Dresden and
Berlin. In 1910 he
made paintings and
engravings in which
he depicted dances
and tribal scenes. In
1914, following the
example of Paul
Gauguin, he set off
on a long trip to the
Pacific, in particular
the German colony
of Palau in the South
Seas. This journey led
to a famous series of
canvases, including
the one shown here.

MAX PECHSTEIN
**Wooden African
Sculptures**
1919, oil on canvas
80.5 x 69.8 cm
Private collection

After World War I
Pechstein collected
artifacts and works of
primitive art, which
he used as models in
a series of wood
sculptures and for
several paintings, all
of which testify to his
interest in African
culture. The German
artist was fascinated
by stylized lines that
deform the features
and exaggerate facial
expressions. The use
of bright contrasting
color is typical of the
style of the
Expressionists.

■ PAUL KLEE
Ventriloquist
1923, watercolor
on paper
39 x 28.9 cm
Staatliche Museen,
Museum Berggruen,
Berlin

In 1914 Klee took a trip to Tunisia. The experience not only enabled him to lighten and enrich his palette, but also provided him with many sources of inspiration, drawn from primitive cultures. In the following years, most of all after he joined the Weimar Bauhaus in 1920, where he worked in close contact with Kandinsky, Klee developed and enlarged his repertory, blending quite disparate elements, as seen in this watercolor. On a background of squares in an unreal space-time, an almost human figure appears, similar to those drawn by children. The head is vaguely based on ritual masks used in Guinea and in Sierra Leone. The deformed body is occupied by strange transparent forms inside, which are five fantasy animals that recall recurrent motifs from the aboriginal peoples of Australia and Africa.

MARSDEN HARTLEY
Indian Fantasy
1914, oil on canvas
119.4 x 100.3 cm
North Carolina
Museum of Art,
Raleigh

During the second
decade of the 20th
century primitivism
spread from Europe
to the United States,
where it assumed
somewhat different
traits. Some
American artists
drew inspiration
from African art or
from that of Japan,
but most looked
instead to the
original cultures of
America. In January
1913 Marsden Hartley
went to Munich to
directly study the
works of Kandinsky
and the other
members of Der
Blaue Reiter. He
discovered that the
painters of the group
were very interested
in the art of Native
Americans; August
Macke in particular
made several canvases
based on the subject.
On his return to New
York in 1914, Hartley
made a series of
works in which he
united the
Expressionistic style
with "primitive"
subjects, giving these
works the German
title *Amerika*. In this
canvas, for example,
he blends various
decorative motifs
from Bavarian vases
with others from
Native American
cultures, such as the
colors: red, yellow,
and green tones on a
black background.

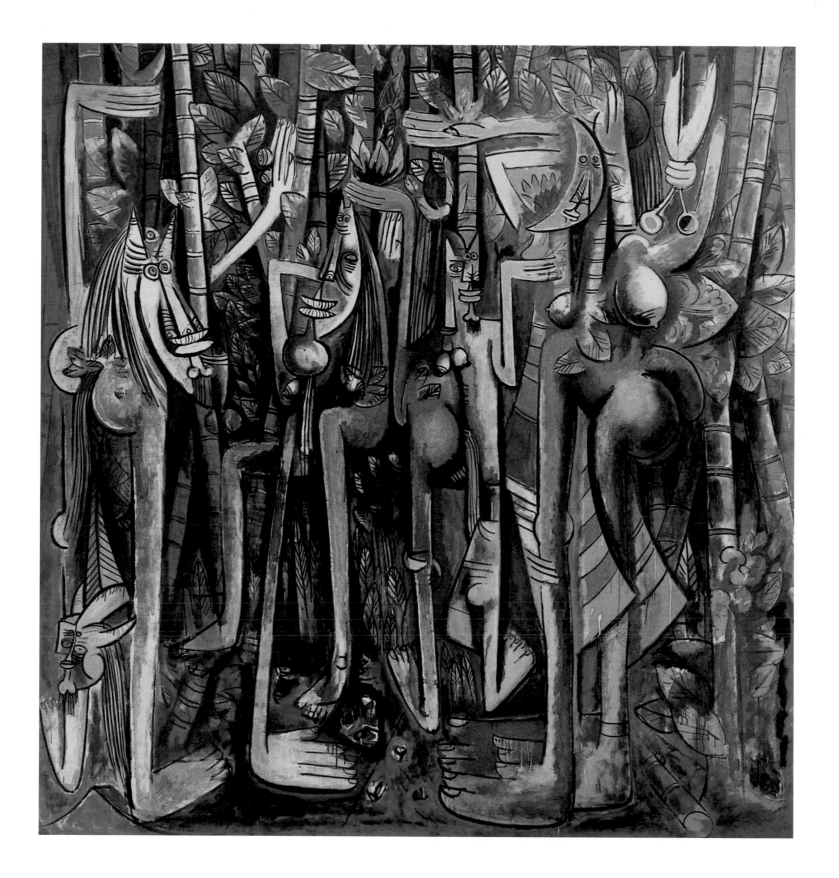

WIFREDO LAM
The Jungle
1943, gouache
on paper mounted
on canvas
239.4 x 229.9 cm
Museum of Modern
Art, New York

In 1941 Lam
returned to Cuba,
his birthplace, after
a long stay in
Madrid, Barcelona,
and Paris, where he
had met, among
others, André Breton,
Max Ernst, and the
anthropologist Claude
Lévi-Strauss. Thanks
to his encounter with
the Surrealists, he
was able to give
expression to his
imagination,
elaborating an
imaginary universe
in which he
reinterpreted the
popular myths and
legends of the
Antilles Islands. To
Lam, these myths
embodied a pure and
original creativity
and at the same time
possessed a strong
magical and spiritual
charge that Lam
sought to transmit
in his paintings. His
jungle is populated
by strange and bizarre
spirits with vaguely
anthropomorphic
forms, enormous feet,
strangely shaped body
parts, and faces like
tribal masks. Even the
colors are unnatural,
indicating that this is
not a depiction from
life but rather the
report of a dream or
hallucination.

In 1901 Ernst Ludwig Kirchner took a series of courses at the Dresden Polytechnic; the following year he became friends with Fritz Bleyl. Between 1903 and 1904 Kirchner spent two semesters in Munich at the art school of Wilhelm von Debschitz and Hermann Obrist; he also visited the sites of the Secession, which disappointed him; visited the exhibit of Belgian and French Post-Impressionists mounted in December 1903 by the Phalanx exhibiting society, led by Kandinsky; and closely studied Jugendstil. In 1904, after taking his final examinations at Chemnitz, Erich Heckel moved to Dresden to study architecture, and there he met

the suggestion of Schmidt-Rottluff, they gave the group the smbolic name Die Brücke ("The Bridge"). Emil Nolde joined the group in 1916; two years later Otto Mueller joined. Among the other artists who participated in the activities of Die Brücke were the Swiss Cuno Amiet, the Finn Akseli Gallen-Kallela, the Dutch Kees van Dongen and Lambertus Zijl, the Czech Bohumil Kubista, and the German Franz Nölken. They drew their primary inspiration from the masters of Romanticism, who had battled against rationalism, equalitarianism, and enlightened realism in the name of the free expression of the feelings of the individual. Like the Romantics, they dreamed of a total interdisciplinary art that would involve in a single vital and dynamic form both the figurative arts (drawing, graphics, painting, and sculpture) as well as architecture, literature, music, the theater, photography, and the nascent cinema. A second point of reference were the Secessions,

Die Brücke and the

both Kirchner and Bleyl; a few months later the three were joined by Max Pechstein and Karl Schmidt-Rottluff, school friends of Heckel at Chemnitz. In 1905 Kirchner and Bleyl took their final exams at the Dresden Polytechnic and decided to dedicate themselves full-time to art. On June 7, 1905, the five young friends (the oldest was twenty-five, the youngest twenty-two) founded a new painting group, the principal aim of which was to coordinate the many efforts of the artistic avant-gardes and to favor the awareness and comparison of such groups both within Germany and in other nations. For this reason, and at

Ernst Ludwig Kirchner, *A Community of Artists: Karl Schmidt-Rottluff, Erich Heckel, Ernst Ludwig Kirchner, and Otto Mueller,* 1925, oil on canvas, 167 x 125 cm; Museum Ludwig, Cologne

the artist associations that had been formed at the end of the 19th century in Dresden, Berlin, Vienna, and Munich, opposed to authoritarian methods and to the old-style academic teaching of the arts and in favor of a new understanding of art. Magazines were of fundamental importance in the formation of Die Brücke, among them *Jugend, Simplicissimus, Pan, Insel,* and the English-language *The Studio.* Of equal importance was the encounter with the works of certain members of Post-Impressionistic movements, from van Gogh to Gauguin, from Ensor to Munch, considered true spiritual fathers of the group, along with Matisse and the Fauves. Like the Fauves, the members of Die Brücke attributed little importance to design, which they simplified and reduced to its essential elements, and put all their efforts and energy instead into the communicative power of colors, sharply contrasting and packed with an intense, almost violent light. Like the Impressionists, they sought to portray real life and nature in all its forms; but while the vision of the Impressionists was reassuring and untroubled, basically optimistic about life, the

members of Die Brücke were restless, tormented, distressed. They read Nietzsche and Kierkegaard, Wedekind and Freud, Ibsen and Strindberg. They did not share the values or ethics of the middle class, did not believe in positivistic optimism, nor in the illusion of a world of continuous progress thanks to the discoveries of science and technology. Instead, they affirmed the subjective and irrational values of art. They were convinced that human life was characterized by its emotional dimension and that the role of the artist was to express in images what could not be understood by means of concepts and words. They visited Dresden's art museum to study the works of the masters of the past, and also visited the city's print department, the director of which, aware of contemporary art, acquired and exhibited works by such modern artists as Henri de Toulouse-Lautrec, from whom the artists of the group learned to appreciate Japanese prints. It was from Japanese prints that they derived their passion for woodcuts, a technique they exploited for all its expressive potential. To maintain close ties to art collectors and their supporters, the "active" members of Die Brücke—the artists—created the figure of the "passive member." In exchange for annual

Max Pechstein, *Reclining Nude*, 1911, oil on canvas, 100 x 100 cm; Leopold-Hoesch Museum, Düren

birth of Expressionism

dues, such members were kept informed of meetings, gatherings, and the roughly sixty group exhibitions. They also received the yearly *Brücke Mappen*, reports of the union's activities, including a limited-print-run album of works. While maintaining their individual identities, the members of Die Brücke often worked together; for example, in the summer of 1910, Pechstein, Heckel, and Kirchner went to Moritzburg, near Dresden, to paint nudes and landscapes. An exhibit was given in Dresden's Arnold gallery from September 1 to 30, 1910, in which eighty-seven works by six artists were displayed; the artists being

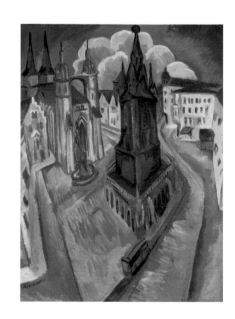

Heckel, Kirchner, Schmidt-Rottluff, Mueller, Amiet, and Pechstein. It was during that period that art critics began using the term *expressionism*, although how it came into use is unclear. Various explanations attribute it to the painter Julien-Auguste Hervé, the critic Louis Vauxcelles, the art dealer Paul Cassirer, among others. The definition was first applied to certain French painters, then to German-speaking artists, but in a generic and vague way, indicating a state of mind more than a cultural movement. In 1911 the members of the group moved to Berlin in search of new stimuli, but by then the first disagreements over point of view were surfacing. The highpoint of their group activity also proved to be their swan song: the international art show of the Sonderbund, held in Cologne from May 25 to September 30, 1912, which included works by members of Die Brücke, the Blaue Reiter, and other European artistic groups. In May 1913 the "passive members" received word of the official dissolution of the union. From then on, each artist was left to follow his own independent career.

Ernst Ludwig Kirchner, *The Red Belltower of Halle*, 1915, oil on canvas, 120 x 90 cm; Museum Folkwang, Essen

ERNST LUDWIG
KIRCHNER
Nude (Dodo)
1909, oil on canvas
75.5 x 67.5 cm
Private collection

Kirchner's female
nudes are almost
always jarring and
rough; the women
presented, often
prostitutes, possess
neither grace nor
sweetness and strike
the viewer with a
charge of ambiguity,
which renders them
malicious and
disturbing. Kirchner's
eroticism seems
tormented and deeply
felt, a conflict of
opposing desires. The
sitter for this canvas
was Doris Grosse
(circa 1884–1936),
nicknamed Dodo,
milliner, model, and
lover of the artist,
for whom she posed
between 1908 and
1911. As with many
other Kirchner works
of those years, this
painting received
scant praise and was
instead criticized for
its unrealistic use of
color, in particular
the red and green
brushstrokes on the
woman's body. Her
heavily made-up face
was thought to lack
expression, and the
violently colored
background was
accused of having
no depth and of
immersing the scene
in an unreal
atmosphere.

Die Brücke and the birth of Expressionism

ERNST LUDWIG
KIRCHNER
**Fränzi in Front of a
Carved Chair**
1910, oil on canvas
71 x 49.5 cm
Museo Thyssen-
Bornemisza, Madrid

Between 1905 and 1915 Kirchner worked intensely, making many drawings, paintings, and engravings characterized by vivid and bright colors applied to the canvas with explosive force, as if his hand were guided by an inner fury comparable to that of van Gogh or Munch. Some of these works are dedicated to the women Kirchner knew, such as Dodo, the ballerina Mimi, or Fränzi and Marcella, two sisters in Dresden who posed as models for other painters of the Brücke group, usually together, nude or dressed, outdoors or inside. Here Kirchner presents the young woman's face in the near foreground, against the background of a carved chair with a strange anthropomorphic shape that constitutes a disturbing and threatening presence behind her. The viewer is struck and at the same time disoriented by the features of the girl's face, tense and exaggerated, and most of all by the surrealistic colors.

Die Brücke and the birth of Expressionism

Ernst Ludwig
Kirchner

Berlin Street Scene
1913, oil on canvas
121 x 95 cm
Brücke Museum,
Berlin

Between 1913 and
1915, after Die Brücke
moved to Berlin,
Kirchner painted a
dozen oils showing
street scenes, with
groups of men and
women in the
foreground. These
paintings, like all
of the artist's Berlin
production, are
characterized by
elongated and
stylized figures, a
predominance of
oblique lines, and
sharp chromatic
contrasts. Unlike the
Parisian views made
by the Impressionists,
which transmit a
sense of pleasant
gaiety, the painting
shown here implies a
subject frightened by
the streets full of
crowds in constant
movement. The faces
of the figures turned
toward the viewer
seem empty and
expressionless, not
unlike those of
mannequins, and
represent what
Kirchner saw as
the anonymous
impersonal mass that
populated the large
German city.

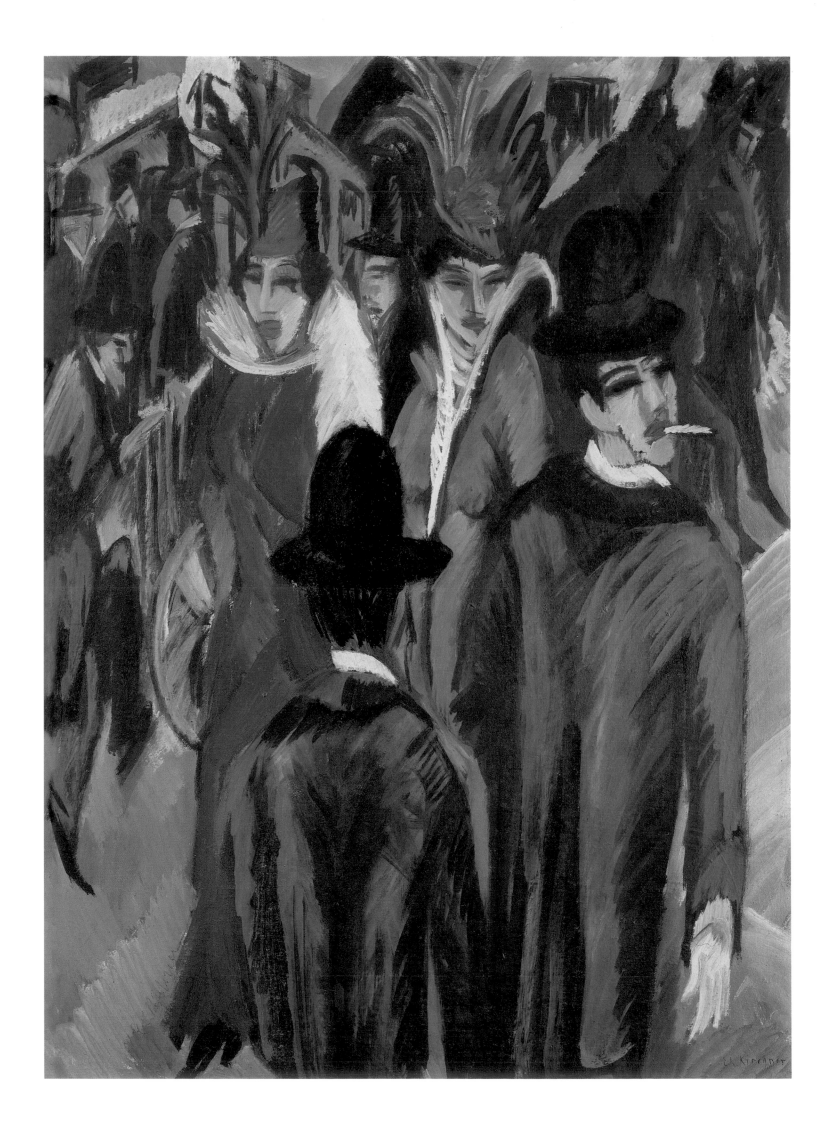

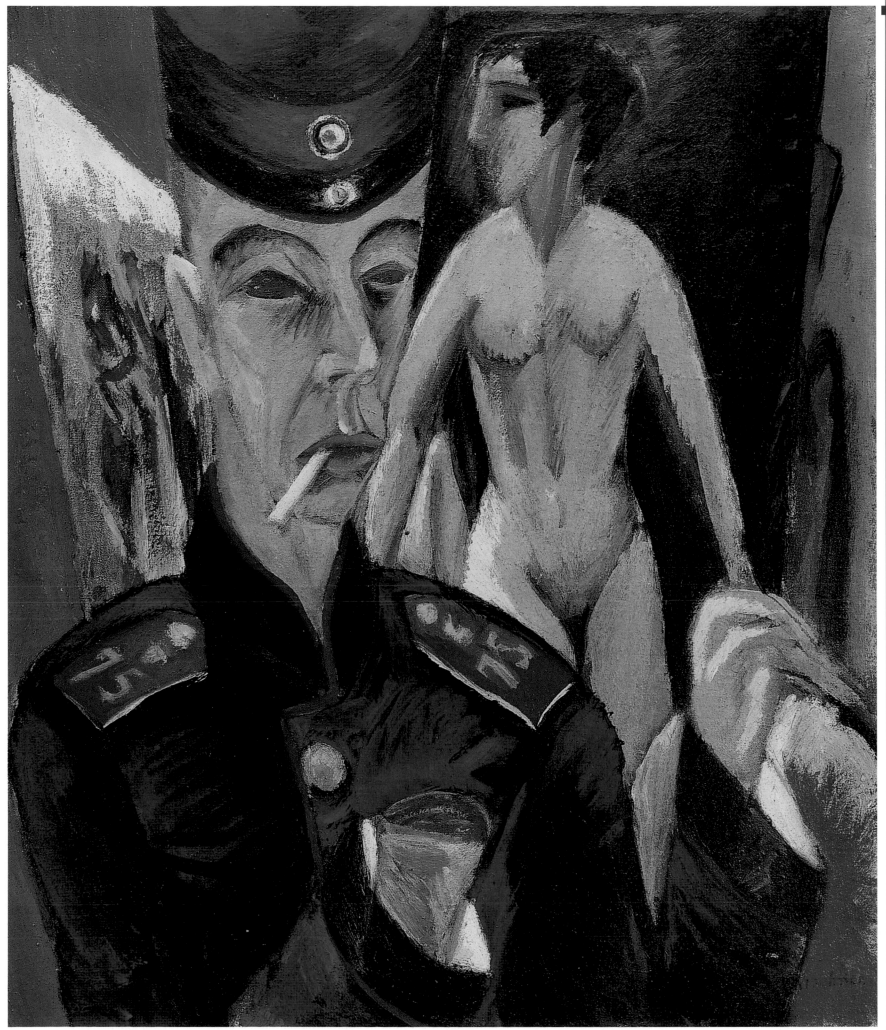

**Self-portrait as
a Soldier**
1915, oil on canvas
69 x 61 cm
Allen Memorial Art
Museum, Oberlin,
Ohio

Kirchner's portraits
often display the
same rigid features
and the same raw and
pitiless vision that
characterizes part of
the German artistic
tradition, from Dürer
to Grünewald to
Cranach. In this
canvas Kirchner
presents himself in
front of several of
his paintings dressed
as a soldier, a direct
reference to the
traumatic experience
that left an indelible
wound on his psyche;
in the spring of 1915,
he was put in the
75th Artillery
regiment at Halle. By
October he had been
released because of
medical and
emotional problems,
and in the middle of
December he was
hospitalized in a
sanatorium for mental
patients in the
Tanusuper region.
Kirchner's internal
suffering appears in
this work not only in
the features of his
face but most of all
in the sliced-off right
hand (a symbolic
wound), by which
Kirchner meant to
express the
impossibility of
continuing his work
as a painter.

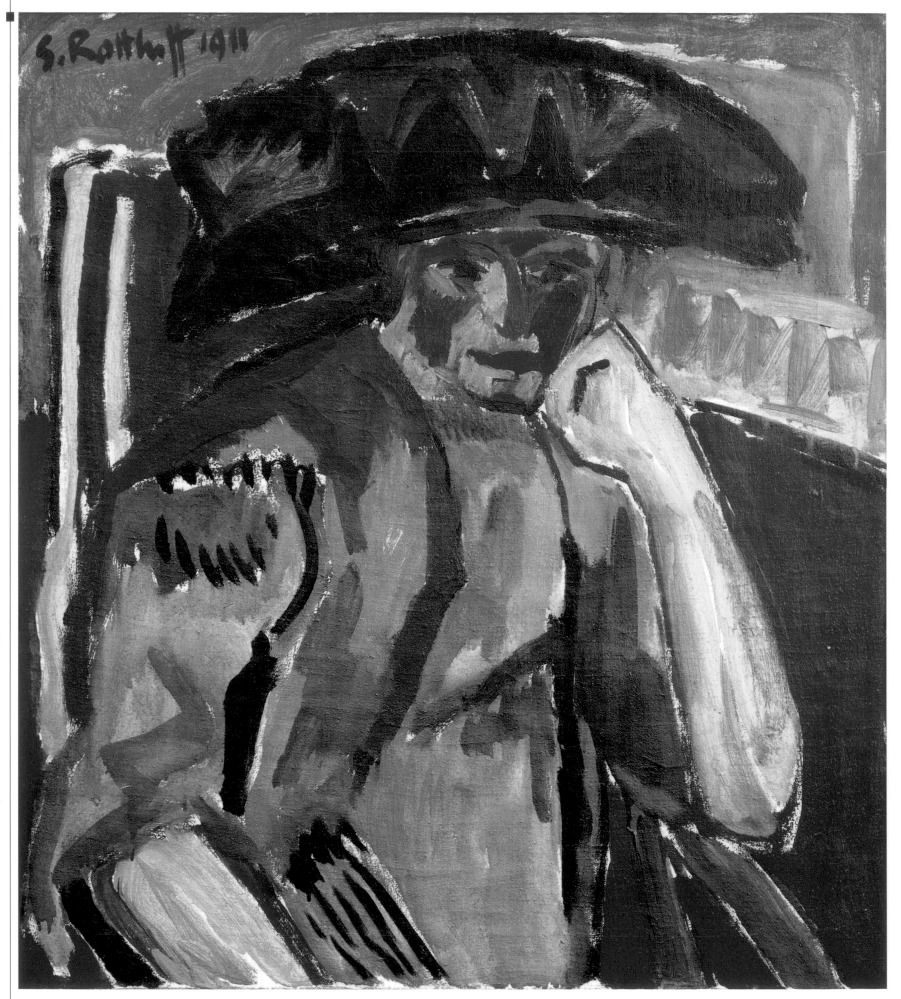

KARL
SCHMIDT-ROTTLUFF
Rosa Schapire
1911, oil on canvas
84 x 76 cm
Brücke Museum,
Berlin

This canvas shows the
clear influence of the
works of Vincent van
Gogh, Henri Matisse,
and Emil Nolde, with
whom Schmidt-
Rottluff spent the
summer of 1906 on
the island of Alsen in
the Baltic. Beginning
the following year,
and until 1912,
Schmidt-Rottluff went
to Dangast several
times, where he
painted landscapes
and still lifes, often
in the company of
Heckel. Here one can
see how he used very
bright colors, which
he applied directly to
the canvas by means
of a spatula. Rosa
Schapire (1874–1954)
was a friend of
Schmidt-Rottluff and
edited the catalogue
raisonné of his
engravings; she was
a well known art
historian and among
the first critics to
appreciate the works
of the members of Die
Brücke. Learned and
refined, she and the
critic Wilhelm
Niemeyer published
an art magazine
called *Kundung: Eine
Zeitschrift fur Kunst*
("Notice: A Magazine
of Art"), to which
Schmidt-Rottluff
contributed woodcuts.

Die Brücke and the birth of Expressionism

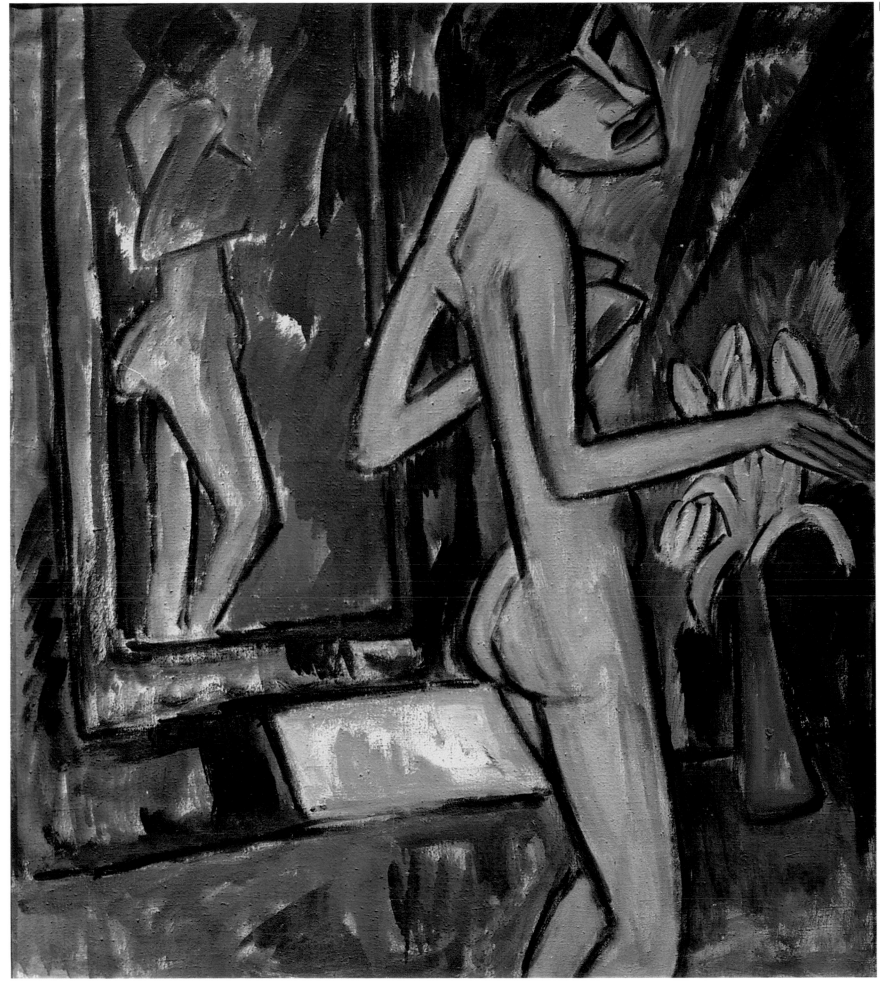

■ KARL
SCHMIDT-ROTTLUFF
Girl at the Mirror
1915, oil on canvas
101 x 87 cm
Staatliche Museen,
Neue Nationalgalerie,
Berlin

Schmidt-Rottluff
made this painting
shortly before being
called to arms, in May
1915. His state of
mind, greatly troubled
by the outbreak of
war, is clear in his use
of cold colors, tones
of green, yellow, and
blue. Also the line has
become angular and
nervous: the subject
has lost the softness
and warm sensuality
of his bathers of the
preceding years;
instead, her face
expresses sorrow and
melancholy. Her
extremely thin body
resembles the wooden
sculptures from Africa
and the Pacific that
Schmidt-Rottluff had
already used as
models in several
woodcuts in 1914.
During the coming
years, up to his
discharge in 1918,
he quit painting and
produced only a few
sculptures and
woodcuts, most of
them with religious
themes, such as his
nine engravings
dedicated to the
life of Christ.

ERICH HECKEL
Brickyard
1907, oil on canvas
68 x 86 cm
Museo Thyssen-
Bornemisza, Madrid

During the summer
of 1907 Heckel made
his first trip to
Dangast, on the coast
of the North Sea,
where he was the
guest of Schmidt-
Rottluff. The quiet
and severe simplicity
of those natural
settings reinvigorated
him and led to some
of his most beautiful
paintings. In this
canvas the
dramatization of the
landscape is clear not
only in the choice of
a very angled
perspective but most
of all in the extremely
nervous line and the
sharp and aggressive
chromatics. The dense
and pasty
brushstrokes are
arranged in an
irregular manner,
recalling the
paintings from van
Gogh's last years;
but unlike the works
of the Dutch artist,
there are no symbolic
references here, only
a spontaneous and
immediate expression
of nature. The field
and the sky seem to
blend into a single
living, dynamic
mass that wraps
and crushes the
buildings of the
brickyard, squeezing
them outward.

Die Brücke and the birth of Expressionism

On the Beach at Osterholz
1913, oil on canvas
79.8 x 70 cm
Städtisches Museum Abteiberg, Mönchengladbach

The protagonist of this composition is Siddi, whom Heckel married in 1915. The artist met the young dancer in 1910 at Dresden, and several times over the following years invited her to the coast of Schleswig-Holstein so she could serve as his model. In the middle of June 1913, after spending a few days at Mellingstedt (near Hamburg), the guest of Gustav Schiefler—a collector and art dealer of the Die Brücke group—Heckel went with Siddi to the port of Flensburg, near the island of Alsen. During a boat trip in the fiord of Flensburg, he spotted a beach near Osterholz that he thought would make a perfect background for a series of nudes on the shore. He rented an old house to use as a studio from a carpenter of the area, a certain Peter Hansen; in 1918 he bought the house. In 1913 Heckel presented these paintings to the public in a one-person show at the Gurlitt gallery in Berlin.

MAX PECHSTEIN
Dance
1909, oil on canvas
95 x 120 cm
Brücke Museum,
Berlin

Pechstein is the
only one of the five
founders of Die
Brücke to attend an
art academy; in 1906
he won the Rome
Prize, which enabled
him to spend a year
in Italy. The next year
he spent six months
in Paris, where he
came in contact with
many painters and
intellectuals, in
particular Henri
Matisse and Kees van
Dongen. In this work,
the simplified design,
broad, apparently
disorderly
brushstrokes, use of
intense and lively
tones with a clear
prevalence given
primary colors, the
accentuated
dynamism, and the
odd framing of the
composition all show
clear points of
contact with the style
of Expressionism and
that of the Fauves.
This canvas also
reflects Pechstein's
passion for the world
of the theater, but
at the same time it
clearly shows the
enormous difference
between the
atmosphere of
Expressionism
and that of
Impressionism, as
in the quiet and
delicate tones of
the ballerinas by
Edgar Degas.

Die Brücke and the birth of Expressionism

■ MAX PECHSTEIN
Fishing Boat
1913, oil on canvas
190 x 96 cm
Brücke Museum,
Berlin

Pechstein went to
Italy with his friend
Alexander Gerbig in
the summer of 1913
and stayed at
Monterosso al Mare
in the La Spezia
province of Liguria.
This canvas, painted
in the winter of that
year, shows his ability
to make works with
great visual impact.
Pechstein accentuates
the diagonal lines and
chooses a very close-
up point of view to
give the viewer a
sense of dramatic
excitement. While
the sky and sea in
the background
threaten an imminent
storm, the sailors look
to the right of the
painting. The viewer
cannot see why: are
they looking at a
reef? Another boat?
The concentrated and
worried look on their
faces expresses
tension, and the
viewer has the sense
of experiencing their
concern. The use of
cold, dark colors
emphasizes the
drama of this
particular moment.

EMIL NOLDE
Crucifixion
1911–12,
oil on canvas
220.5 x 193.5 cm
Ada und Emil Nodle
Stiftung, Seebüll

This is the central
part of a triptych
dedicated to the life
of Christ. Each of the
two side panels is
divided into four
square compartments.
Those to the left
present the Nativity,
Circumcision, Jesus
with the Doctors in
the Temple, and the
Mount of Olives, while
to the right are the
episodes of Christ
with the Adulterer,
Christ in Prayer, the
Resurrection, and
the Incredulity of
Thomas. In this cycle
Nolde reworks in a
personal way the
sacred compositions
of German art, from
Martin Schongauer to
Matthias Grünewald.
The use of bold
colors, typical
of Expressionism,
recalls the work of
van Gogh, and in the
case of this dramatic
*Crucifixion, The Yellow
Christ* by Gauguin
(Albright-Knox Art
Gallery, Buffalo, New
York). This and the
other paintings of
the triptych were
exhibited in 1912 at
the Folkwang Museum
in Hagen; they were
supposed to be
exhibited at the
World Exposition in
Brussels, but were
withdrawn following
strong opposition
from the local church.

Die Brücke and the birth of Expressionism

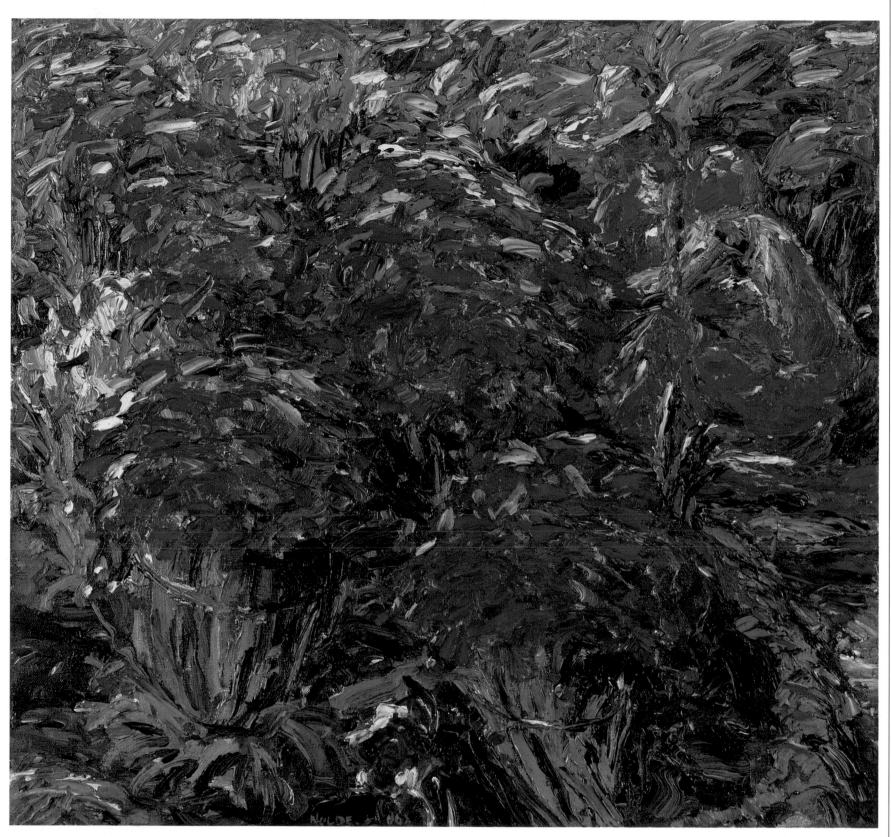

■ EMIL NOLDE
Red Flowers
1906, oil on canvas
52.4 x 55.8 cm
Museo Thyssen-
Bornemisza, Madrid

Nolde was quite fond of compositions with flowers and returned to the subject many times during his career. In his memoirs he explained that as a child he had been fascinated by the intense colors and scents of the flowers his mother grew and that every time he put flowers in a drawing, painting, or engraving, he had the sense of reliving that happy and carefree period of his childhood. He himself had flower gardens at all the homes he lived in, at Alsen, Utenwarf, and Seebüll. The editor Gustav Schiefler, who in 1910 and 1925 published the two volumes of the catalogue raisonné of Nolde's art, recalled having spent many afternoons as the guest of the painter and his wife, sitting in their garden in the midst of a profusion of flowers of all colors.

OTTO MUELLER
Lovers
1919, tempera on
hemp canvas
106.5 x 80 cm
Museum der
Bildenden Künste,
Leipzig

Mueller drew his
figures with a refined
delicacy, with agile
lines and the careful
application of light.
In the choice of
colors he reworked
the Expressionist
style in a personal
way that contributed
to the creation of
atmospheres of a rare
poetic sensibility. The
woodland background
indicates a desire for
an open and honest
relationship between
humans and nature.
The pair of lovers in
the immediate
foreground seem
happy and carefree.
It is as though
Mueller were trying to
escape the tensions
that Germany was
experiencing in the
period following
World War I by
taking shelter in an
enchanted realm in
which love triumphs
over all ills. This
canvas is stylistically
similar to the series
of particularly
felicitous oils and
engravings that
Mueller made of
Gypsies, works in
which he expressed
his admiration for
their carefree and
independent spirit,
their fierce pride,
and, as he saw it
their poor but
dignified lives.

Die Brücke and the birth of Expressionism

Otto Mueller
Bathers
1920, oil on jute
canvas
110 x 91 cm
Aargauer Kunsthaus,
Aarau

Nude human figures
in a landscape were
among Mueller's
favorite subjects. He
began painting such
works between 1909
and 1911 in the
company of Ernst
Ludwig Kircher and
Erich Heckel on the
Baltic coast and in
the countryside near
Berlin. Mueller's
nudes are neither
sensual nor
provocative. Instead,
they are presented
with immediate
simplicity and
naturalness: They
evoke the pure and
uncorrupted origins
of humanity and
seem to express
nostalgia for a lost
paradise in which
humans lived in a
close and authentic
relationship with
nature. In this work
the bodies stand
out against the
vegetation and
assume agile and
dynamic poses.
The landscape does
not offer precise
geographical
characteristic, nor
does it give any
indication of time.
Instead, it presents
a fantasy locale, a
dreamscape in which
the painter locates
his ideal of humanity.

Die Brücke and the birth of Expressionism

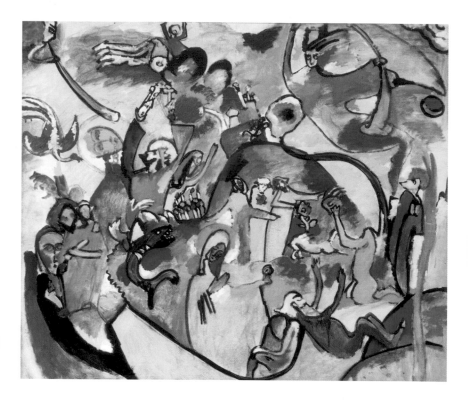

any artists during the first decade of the 20th century were dissatisfied with the teachings of art academies and wanted to be among the leaders of a radical change in the style and subjects of art. On January 22, 1909, the Neue Künstlervereinigung München ("New Artists' Association of Munich") was created in Munich, founded by Alexei Jawlensky, Alexander Kanoldt, Adolph Erbslöh, Marianne Werefkin, Wassily Kandinsky, and Gabriele Münter, Kandinsky's student and companion. The painters hoped to have Hermann Schlittgen as their president, but he refused to join the group, so they settled on Kandinsky. Other artists later joined the group, among them Paul Baum, Karl Hofer, Vladimir von Bechtejeff, Erma Bossi, Moisey Kogan, Pierre Girieud, Henri Le Fauconnier, and Alfred Kubin. The members of the group held their first public exhibit at the Tannhäuser gallery in Munich, and in other German cities, beginning on November 8, 1909. On March 3, 1910, Herwarth Walden founded the magazine *Der Sturm*, which followed the activity of avant-garde groups, both German and foreign. The second exhibit of the Neue Künstlervereinigung was also held in the Tannhäuser gallery in Munich and opened on November 14, 1910; among the other artists invited to join in the exhibition were Georges Braque, Pablo Picasso, Georges Rouault, André Derain, Maurice de Vlaminck, and Kees van Dongen. In January 1911, Kandinsky resigned as president and was replaced by Adolf Erbslöh; in February Franz Marc joined the group, and a few months later became its third president. On December 2, 1911, during the third exhibit of the Neue Künstlervereinigung München, Kandinsky presented a painting, *Composition V*, that was rejected by the association's jury; the Russian artist then left the association and together with Franz Marc and Gabriele Münter formed a new group, which came to be called Der Blaue Reiter ("The Blue Rider"). On December 8, 1911, they had their first exhibit, in the Tannhäuser gallery and at the same time as the show of the Neue Künstlervereinigung München. Forty-three works were exhibited by various painters, among them Henri Rousseau, Albert Bloch, the brothers David and Vladimir

Burliuk, Heinrich Campendonk, Robert Delaunay, Wassily Kandinsky, August Macke, Gabriele Münter, Franz Marc, and the musician Arnold Schoenberg. The show remained open until January 1, 1912; it then moved on to Cologne, in the Gereon Club, thanks to the efforts of Emmy Worringer; and then to Berlin, where it remained from March 12 to April 10, in Herwarth Walden's Der Sturm Gallery, only recently opened. From February 12 to April 2 the members of the Blue Rider held their second show, with 315 works on paper, in the library and art showroom of Hans Goltz in Munich; although the show was entitled "Black White," many of these compositions were in color. In April of that year the magazine *Der Sturm* published a piece by Kandinsky, "The Language of Forms and Colors"; in May, Piper-Verlag published an almanac called *Der Blaue Reiter*, a large-format volume with many color illustrations and critical essays on contemporary painting and music.

Marc and Kandinsky chose the name Blaue Reiter to poetically express two themes important to them. First, "blue": the importance of color over design, a stylistic decision that placed them within the Expressionist group, although they differed in several ways from the contemporary Die Brücke group. The second element—the rider—was very dear to Kandinsky, who in those days in 1912 published his fundamental aesthetic work, *Concerning the Spiritual in Art*. For him

the rider was symbolic of the contemporary artist who sees an ethical and spiritual role for his art, a mission that consists in defending and spreading the values of beauty and truth. Other important artists collaborated with Kandinsky and Marc on a more or less regular basis. These included August Macke, Gabriele Münter, Alfred Kubin, Heinrich Campendonk, Henri Le Fauconnier, Marianne Werefkin, Alexei Jawlensky, Paul Klee, and almost all the members of the Brücke group; the comparison of all their different ideas stimulated the exploration of new expressive forms. Several musicians participated in their meetings, in particular Arnold Schoenberg (whose 12-tone "serial" technique was to revolutionize modern music), a reflection of the close ties between the two disciplines and their common search for new expressive forms. Indeed, the painters of the Blue Rider often used the term *vibration* to indicate the visual effect awakened by colors,

most authentic and faithful realism or the purest abstraction, it must be without compromises or mediations. Equal dignity was given to European culture and non-European, to the civilizations of the past, to the lower class, and to the artistic expression of children no less than to that of adults. The goal, inherited from Romanticism, was the total work of art, a perfect synthesis of all disciplines. Over the next two years the artists of the Blaue Reiter produced numerous works, some realist, some abstract, full of symbolic figures and intense, bright colors. In 1913 Kandinsky and Marc began work on the second volume of the almanac of the Blaue Reiter, in collaboration with Mikhail Larionov, Karl Wolfskehl, and other artists, but the project was never completed. In 1914 the *Almanac of the Blue Rider* was reprinted, and in April the last show of the Blue Rider took place in the Der Sturm Gallery in Berlin. World War I marked the end of the group.

Der Blaue Reiter

which they thought could imitate the emotional effects of sounds. In 1904, exponents of theosophy Annie Besant and Charles Leadbeater published the book *Thought-forms*, in which they cited abstract images capable of expressing the same sensations and the same states of mind as those experienced listening to music. The Blaue Reiter group had close ties to theosophy, the system of thought blending many doctrines and philosophies that was given new life at the end of the 19th century by the Theosophical Society, founded in New York in 1875 by Helena Petrovna Blavatsky. A fundamental belief of the Blaue Reiter was that all doctrines and privileges of authority should be abolished; they wanted to claim total freedom of expression for the individual to give voice to his interior being. Whether such expression takes the form of the

WASSILY KANDINSKY
The Blue Rider
1903, oil on canvas
52 x 55 cm
Bührle Collection,
Zurich

Kandinsky was the
unquestioned leader
and theorist of the
Blaue Reiter. In 1896
he left Moscow, where
he had studied law,
and moved to Munich
to attend that city's
art academy in the
class of Franz von
Stuck. He spent time
in Paris and Berlin
and performed an
important role in the
spread of Post-
Impressionist art in
Germany through the
shows organized
between 1901 and
1904 by the Phalanx
group, which he
directed. This
painting, the title of
which is an accidental
premonition of
the art group to
come, reveals an
"Impressionistic"
use of colors, in
particular in the
golden reflections
on the leaves of the
trees and the small
brushstrokes with
which Kandinsky
rendered the
horseman and the
horse, to better
suggest the idea of
movement. A second
characteristic similar
to the style of
Impressionism is the
two-dimensional
structure of the
space, which the
Impressionists in
turn took from
Japanese prints.

■ WASSILY KANDINSKY
**Murnau—View with
Railroad and Castle**
1909, oil on
cardboard
36 x 49 cm
Städtische Galerie im
Lenbachhaus, Munich

Kandinsky's stay in
Murnau, a small town
in upper Bavaria,
represents a
fundamental step in
his stylistic evolution.
During that period he
was paying close
attention to the
works of Henri
Matisse and the other
exponents of the
Fauvist movement.
From them he learned
to use strong colors
with bright tints and
sharp contrasts. This
painting shows the
view from the window
of the house at 36,
Ainmillerstrasse,
where Kandinsky lived
with his companion,
Gabriele Münter. The
fast-moving black
mass of the train
crosses a landscape
dominated by green
and yellow tones,
broken up by the
white puffs of steam
from the locomotive
and the white clouds.
The unreal colors
emphasize the fact
that this is not a
naturalistic depiction
but rather an inner,
spiritual vision.
There are places in
the work where the
brushstrokes take
the upper hand over
the underlying
design, a style
approaching
abstraction.

WASSILY KANDINSKY
St. George II
1911, oil on canvas
107 x 95 cm
State Russian
Museum, St.
Petersburg

St. George occupied a
special place among
the many horsemen
that populate
Kandinsky's paintings.
In 1911, impressed
by *Still Life with St.
George* by Gabriele
Münter (Gabriele
Münter Collection,
Munich), Kandinsky
dedicated two
canvases to the
warrior saint as well
as two paintings on
glass and a woodcut.
This composition
comes close to
abstract art; unlike
the first version on
canvas (private
collection, Zurich)
here the landscape is
extremely simplified,
so much that the
viewer's attention is
drawn completely to
the figures, presented
in the culminating
moment of the event.
To the left can be
seen the tied-up,
defenseless girl; at
the center is St.
George on the horse,
driving his long lance
through the throat of
the dragon, crushed
in the lower right
corner. Kandinsky
gave the painting a
spiritual meaning:
St. George is the
symbol of Good
struggling against
Evil, represented by
the dragon.

Der Blaue Reiter

■ WASSILY KANDINSKY
All Saints I
1911, oil and gouache
on cardboard
50 x 64.8 cm
Städtische Galerie im
Lenbachhaus, Munich

Every figurative
element in this work
has lost definition so
that the entire work
approaches the
pure expression
of sensation and
emotion that
Kandinsky theorized
in those months in
his work *Concerning
the Spiritual in Art*.
More than seeing
them, the viewer
imagines the presence
of the saints at the
center, one of whom,
on horseback, could
be St. George, already
the protagonist of
other works made in
1911; angels
sounding trumpets
are visible in the
corners. These
elements led
Kandinsky to give
the painting other
titles, such as *The
End of the World,
Last Judgment, The
Horsemen of the
Apocalypse*, and
Resurrection. Here
Kandinsky repeats
and reworks in a
modern style certain
elements of popular
Russian culture that
he learned during
his childhood in
Moscow and that
he considered the
genuine and sincere
expression of human
spirituality.

FRANZ MARC
Small Blue Horses
1911, oil on canvas
61 x 101 cm
Staatsgalerie,
Stuttgart

The subject repeated
most often in Marc's
paintings is animals
in a landscape, and
horses were his
favorite animals,
whether alone or, as
in this work, in small
herds. Marc had been
greatly impressed by
the Orphism of Robert
Delaunay, which he
saw in Paris, and by
theosophy, which he
learned about from
the poet Else Lasker-
Schüller. Marc clearly
stands apart from the
naturalism and
realism that were
widespread at the
end of the 19th
century and gives
his compositions a
poetic and symbolic
meaning, as is clear
in his choice of
unnatural colors. The
background in this
work has much in
common with the
abstract creations by
Kandinsky, while the
blue of the horses
makes them similar
to mythical,
supernatural beings.
Curving lines prevail
in this painting, with
a particularly
harmonious rhythm
that reflects Marc's
delicacy of design and
his passion for music.

■ FRANZ MARC
The Dream
1912, oil on canvas
100.5 x 135.5 cm
Museo Thyssen-
Bornemisza, Madrid

In January 1912 Marc went to Berlin, where he met the exponents of the Brücke group— Erich Heckel, Max Pechstein, and Ernst Ludwig Kirchner— from whom he learned to give a greater narrative breadth to his works. This canvas is probably the best synthesis of the many themes presented in his paintings. Marc created a world of idyllic purity, an Earthly Paradise not yet corrupted and spoiled by evil in which humans and animals live in perfect harmony with nature. The figure at the center, colored pink and surrounded by his beloved horses is presented as if in a dream (as indicated by the title of the work). To the left Marc locates an improbable yellow lion that vainly attempts to frighten the viewer with its roar. Its presence accentuates and repeats the imaginary and fabulous nature of the scene.

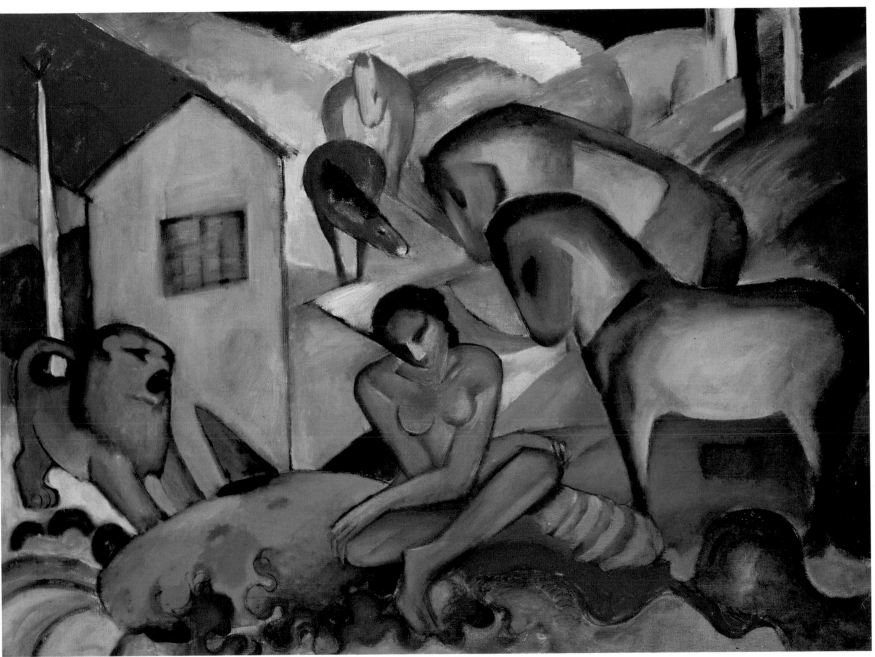

AUGUST MACKE
Landscape with Stream
1912, oil on canvas
51 x 51 cm
Saarland Museum,
Saarbrücken

Born in 1887, Macke was the youngest member of the Blaue Reiter; after studies in Germany he moved to Paris, where he was influenced by the work of Paul Cézanne, the Nabis, and the Fauves. The highly simplified design and incisive use of colors in this landscape create a particularly evocative and lyrical atmosphere. Macke presents no persons or animals; the protagonists of the work are the three trees on the bank of the stream; their vertical thrust compensates for the horizontal lines of the hills in the background. Unlike the other members of the group, Macke remained faithful to the representation of reality and showed less interest in symbolic meanings or more or less veiled allusions to magic or the world of dreams. His objective is that of creating a poetic atmosphere and of visually representing the same sensations as music, his second great passion after painting.

Der Blaue Reiter

AUGUST MACKE
The Walk
1914, oil on canvas
56 x 33 cm
Museo Thyssen-
Bornemisza, Madrid

Macke began painting in close contact with Marc, Klee, and Kandinsky in 1912; thanks to their example, he achieved full expressive maturity and made several urban views with groups of people, presented in the streets of the city or, as in this painting, while strolling in a park. These paintings are stylistically similar to Kirchner's works, but while Kirchner was biting and sarcastic, leaning heavily on caricature and grotesque aspects and denouncing the problems in German society during those years, Macke included no moralistic elements in his works and made no social or political statements. There is only his penchant for narrative description. His figures, such as these three seen from behind, recall instead the vacationing Parisians in *Sunday Afternoon on the Island of the Grand Jatte* by Georges-Pierre Seurat (Chicago Art Institute) or the elongated silhouettes in the illustrations so dear to the Jugendstil.

Boating
1910, oil on canvas
122.5 x 72.5 cm
Milwaukee Art
Museum, Milwaukee

Münter studied art
in Düsseldorf and
Munich and later
(1902) enrolled in
the art school
recently established
by the Phalanx group.
There she met
Kandinsky, of whom
she was first student
and then companion.
Together they made
numerous trips
(Holland, Tunisia,
Dresden, Rapallo,
Sèvres); in 1908
they stayed at
Murnau, together
with Jawlensky and
his companion,
Marianne Werefkin,
also a painter. The
period spent at
Murnau was
particularly rich and
productive; Münter
painted numerous
portraits and
landscapes in which
she revealed a skilled
creative vein, a
notable control of
design, and an
uncommon sense
of color. Here she
presents herself from
behind, at the oars
of a small boat on
Lake Staffelsee in
the company of
Marianne Werefkin,
seated beside her
youngest son,
Andrea. At the center
of the canvas she
portrays Kandinsky,
standing, looking at
her with a sweet and
affectionate gaze.

■ PAUL KLEE
**Saint-Germain
near Tunis**
1914, watercolor
on paper
21.8 x 31.5 cm
Musée National
d'Art Moderne,
Centre Georges
Pompidou, Paris

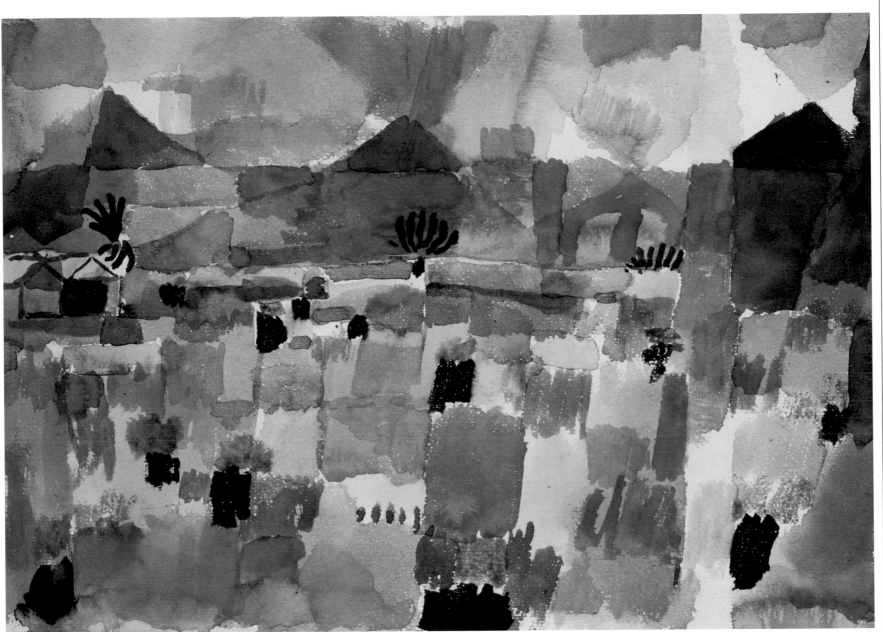

During his youth Klee dedicated himself to music and poetry, only later discovering his calling as a painter. His artistic maturity is marked by two trips, the first of which, in 1901, took him to Italy, where he was fascinated by classical art. In 1912 he read with great attention Robert Delaunay's essay "Light" and translated it into German for the magazine *Der Sturm*. In 1914, together with August Macke and Louis Moilliet, he went to Tunisia: as had happened several decades earlier to Eugène Delacroix, he was struck by the light and the colors and as a result lightened his palette and flooded his works with an intense, warm luminosity. This shift in style gradually began to dissolve the design, and although Klee's paintings always maintained a tenuous tie to reality, they came to approach the abstract, as can be seen in this watercolor, in which the natural elements are blended with those geometric in a delicate poetic balance.

ALEXEI JAWLENSKY
Head of Woman
1912, oil on
cardboard
61 x 51 cm
Staatliche Museen,
Neue Nationalgalerie,
Berlin

From the beginning
of his career,
Jawlensky specialized
in portraits of women,
in which he
demonstrated his
skill and an
uncommon poetic
sensibility. After
meeting Kandinsky,
Jawlensky abandoned
the influences of the
Jugendstil and Art
Nouveau, which had
characterized his early
works, and in 1912 he
joined the style and
sensibility of the
Blaue Reiter. In the
choice of lively and
gaudy colors he
reveals his debt to
Henri Matisse and the
other Fauve painters,
whom he had met
during a stay in Paris.
The sharp design,
presented using thick
black contours, gives
greater force to the
short, agile, and
nervous brushstrokes.
The features of the
woman's face are
typical of the people
in Jawlensky's mature,
fully Expressionist
style: big, wide-open
eyes with a magnetic
appeal, heavy
eyebrows, simplified
nose, almost
sculptural, sensual
lips, and proud and
spirited expression.

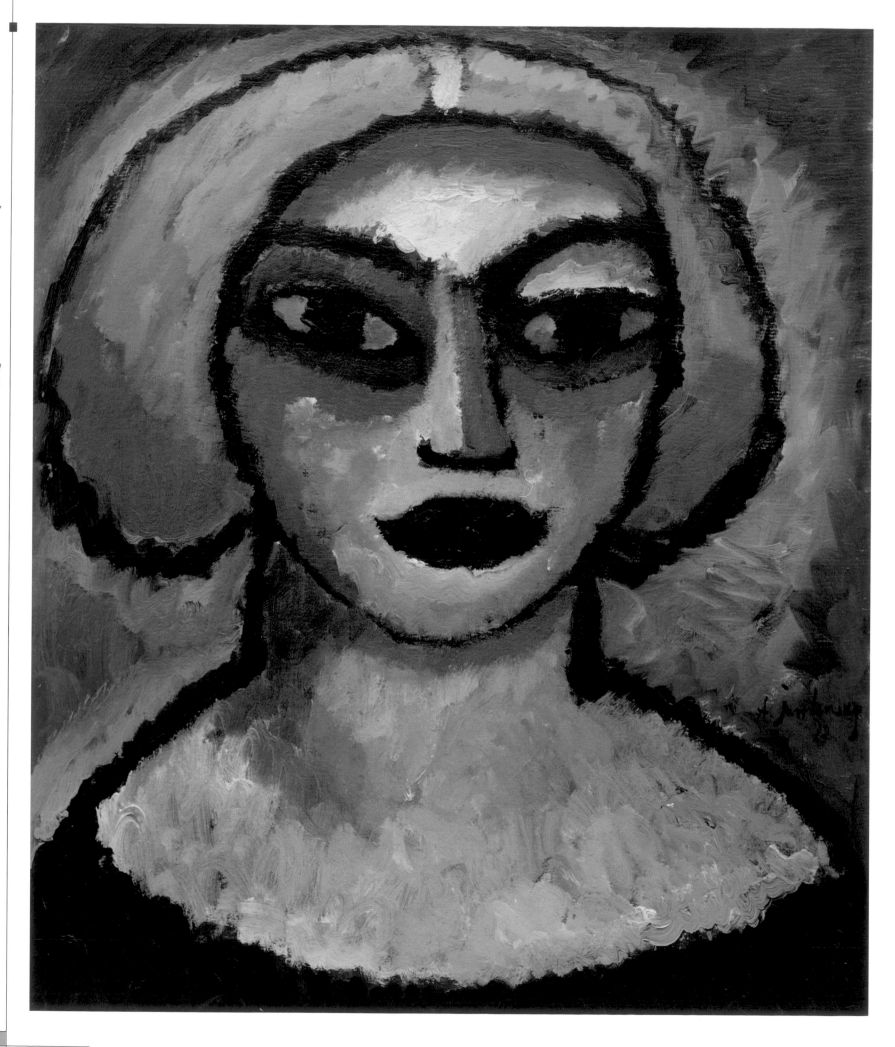

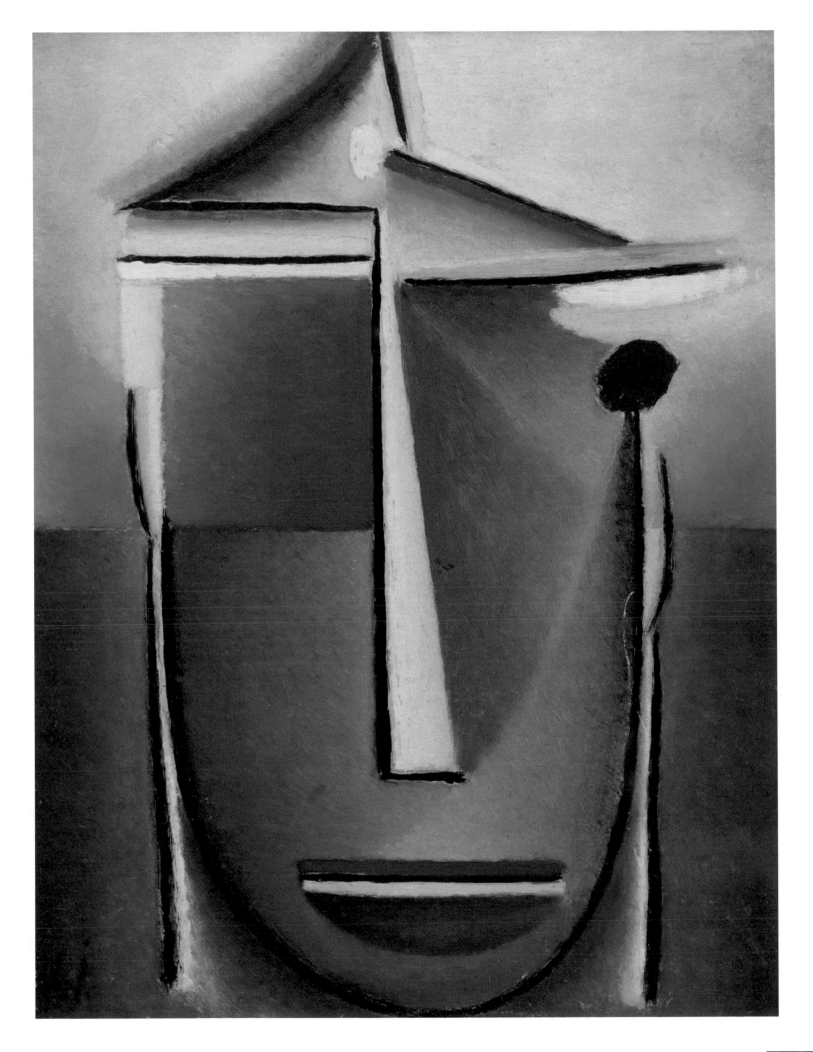

■ ALEXEI JAWLENSKY
Abstract Head
1921, oil on
cardboard
42.8 x 32.7 cm
Norton Simon
Foundation, Pasadena

At the outbreak of World War I, Jawlensky, who was a Russian citizen, left Germany and went to Switzerland, where he continued to paint portraits, gradually simplifying the features of his faces in a movement toward Cubism. He returned to Germany when the war ended and began a highly successful series of female heads, of which this painting is one of the best examples. The pictorial space is reduced to two-dimensional geometric planes by warm, intense colors; he no longer makes use of small overlapping brushstrokes but divides the surface in large uniform fields. Any realistic or naturalistic elements of the figure have disappeared; what the viewer sees is a symbolic representation, faithful to a spiritual concept of art. This new sensibility led Jawlensky to join in 1924 the group of the Blue Four (Blaue Vier), with Feininger, Klee, and Kandinsky, who convinced him to continue this kind of geometric abstraction and to push it farther.

In painting, the move toward abstraction was part of a far larger debate that called into question some of the basic principles on which Western culture had been based for centuries. This radical transformation was tied to the discoveries of chemistry and physics, which changed traditional ways of conceiving the world; it was related to the ideas of philosophers on the irrational aspects of existence (Bergson, Nietzsche, Kierkegaard); and it reflected the research of psychologists into the mechanisms of the human psyche and the perception of reality. Similar attitudes show up during the same period in poetry, from Symbolism to Hermetism, and the "words-in-freedom" of the Futurists and the "automatic writing" of the Surrealists can be considered attempts at abstract literature. No less important were the experiments in the field of music—from Claude Debussy to the 12-tone works by Arnold Schoenberg—which abandoned the rules of classical harmony.

Abstractionism was not a unitary movement. Instead, it developed in a multiplicity of directions. For the sake of convenience, critics often divide it into two large "families," or types—geometric and informal—although there is nothing strict about the borders between the two. The origins of the movement date to the third quarter of the 19th century, when Impressionist and Post-Impressionist painters began rebelling against the traditional teaching given in art academies, which gave great importance to design. These artists instead emphasized color, which they wanted to use to fully and freely express their emotions and sensations. In some areas of their canvases, the colors were applied with such expressive force that almost all of the drawing was canceled, diminishing the work's relationship to reality. This can be seen to have happened in many of the canvases that Paul Gauguin made during his voluntary exile to the islands of the Pacific, in the series of *Water Lilies* by Claude Monet, and in the last compositions by Paul Cézanne, most especially the landscapes of Aix-en-Provence, dominated by Mont Sainte-Victoire with its characteristic pyramidal shape.

The artistic avant-gardes of the opening decades of the 20th century called into question even more the norms and rules that had controlled the activity of artists for centuries, beginning with the concept of painting as

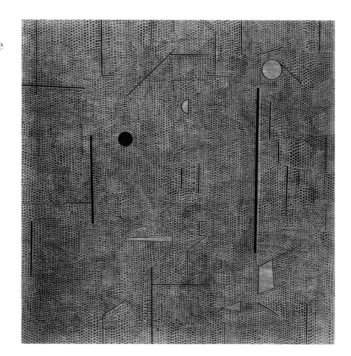

the imitation of nature. Reality was variously deformed, manipulated, twisted, and decomposed in its colors, shapes, and proportions by Pointillists, the Nabis, the Fauves, the Cubists, the Futurists, as well as the exponents of Art Nouveau, all of whom emphasized symbolic and decorative aspects and put adherence to reality in second place. The decisive step to the definitive emancipation was taken by Wassily Kandinsky; in 1906, after spending the first months at Rapallo, he moved with Gabriele Münter to Paris, where he approached the style of Paul Gauguin and the Fauves. On his return to Munich in 1908 he began a series of paintings that he called *Improvisations* in which the colors gradually got the upper hand over the representation of reality. Kandinsky recalled that one evening, entering his studio, his attention had been drawn to a painting half-hidden in an area of shadow. Going closer to get a better look, he realized the canvas was upside down. What had impressed him was not the scene depicted but the arrangement of the colors and the lines and their relationships. At that moment he decided to totally eliminate every reference to reality and painted his first abstract watercolors. In 1910 he began writing *Concerning the Spiritual in Art*, published in 1912 and considered the fundamental text for understanding the birth and the

Piet Mondrian,
*Large Composition A,
with Black, Red,
Yellow, and Blue,*
1919, oil on canvas,
91.5 x 92 cm;
Galleria Nazionale
d'Arte Moderna, Rome

Paul Klee,
The Light and Other,
1931, watercolor and
varnish on canvas,
95 x 97 cm;
private collection

Abstractionism

characteristics of abstract painting. In the coming decades Kandinsky increased his efforts in various directions and exercised a great influence on many artists.

At almost the same time another Russian painter, Kazimir Malevich, adapted the Rayism of Larionov and Goncharova to create Suprematism, an artistic movement that proclaimed "the supremacy of sensibility." He did not accept the notion of painting as only an imitation of nature but believed in its ability to create and transmit pure abstract emotions, using only lines and colors. Another artist to make a major contribution to the birth of abstractionism was the Dutch artist Piet Mondrian. In 1917,

Robert and Sonia Delaunay, who took certain Cubist intuitions to their extreme conclusions, called "Orphic" by Apollinaire; Francis Picabia, divided among Cubism, abstract art, Dadaism, and Surrealism; and Giacomo Balla with his *Iridescent Interpenetrations*, which sought a synthesis between Futurism and abstract art. There were also the interdisciplinary experiments of the Bauhaus, where Kandinsky founded the Blue Four (Blaue Vier) group together with Paul Klee, Alexei Jawlensky, and Lyonel Feininger. In 1938 Mondrian moved first to London and then, in October 1940, to New York, where he joined the group of the American Abstract Artists. Early in the 1950s, not only in Europe but also in the United

■ Wassily Kandinsky, *First Abstract Watercolor*, 1910, watercolor and ink on paper, 49.6 x 64.8 cm; Musée National d'Art Moderne, Centre Georges Pompidou, Paris

Abstractionism

together with Theo van Doesburg, Bart van der Leck, and Georges Vantongerloo, he founded in Leiden the group and magazine called *De Stijl* ("The Style"), which extended the principles of abstraction to painting and sculpture, architecture, graphics, and industrial design. In 1918 the founders of the magazine published the first manifesto of Neo-Plasticism, followed by a second proclamation, in 1920, in which they presented a theory of art based on the construction of space by means of simple geometric elements (straight lines and squares) and the use of primary colors. In 1929 Mondrian and Vantongerloo encouraged the birth in Paris of the Cercle et Carré ("Circle and Square") group, which attracted several artists and intellectuals, including Michel Seuphor and Joaquín Torres García. In 1930 van Doesburg founded the group and magazine called *Art Concret*, with Leon Tutundjian, Jean Hélion, and Otto G. Carlsund; the next year the Abstraction-Création group came into being, active in Paris until 1936, to which more than four hundred artists collaborated more or less regularly. There were many other artists who also approached the experiments of abstract art, such as

States and Japan, abstractionism received new impulses following the birth of the informal movement, which branched into many different forms, some of which are still practiced with success.

■ Wassily Kandinsky, *Composition*, 1916, watercolor and pencil on paper, 22.4 x 33.7 cm; Civico Museo d'Arte Contemporanea, Collection Riccardo Jucker, Milan

WASSILY KANDINSKY
**Impression III
(Concert)**
1911, oil on canvas
77.5 x 100 cm
Städtische Galerie im
Lenbachhaus, Munich

On January 1, 1911, Kandinsky attended a concert in Munich in which compositions by Arnold Schoenberg were performed, including the Quartet for Strings, Opus 10, and Three Small Pieces for Piano, Opus 11. Kandinsky was enormously impressed by this music, which he felt was much like his painting: Both sought not to describe reality but to express the inner life of humans and their most intimate emotions. This painting was made soon after the concert. It still includes representations of reality, such as the recognizable audience in the foreground and the black mass of the piano at the center, but such forms were gradually giving way to the free movement of lines and colors. During the coming years Kandinsky and Schoenberg met and became friends; their friendship was to play an important role in the personal and professional growth of each of them.

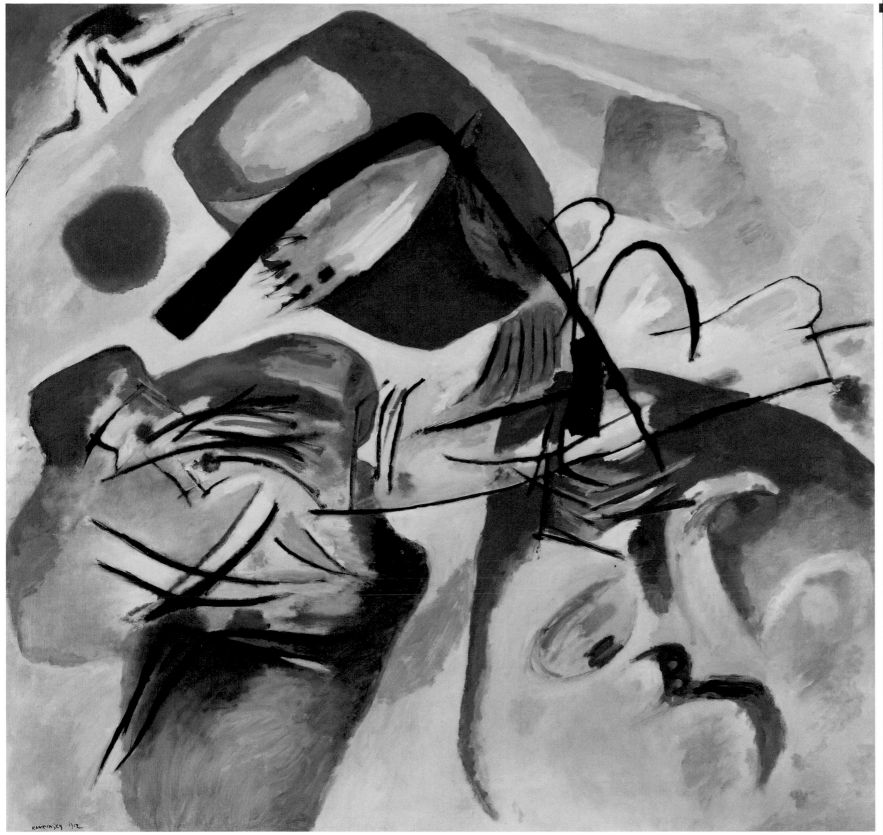

■ WASSILY KANDINSKY
**Picture with a
Black Arch**
1912, oil on canvas
188 x 196 cm
Musée National d'Art
Moderne, Centre
Georges Pompidou,
Paris

In this canvas the
Russian painter
translated in images
several of the
concepts he
expressed in his
fundamental work
*Concerning the
Spiritual in Art*,
published in the same
year. For Kandinsky,
painting must
abandon the function
of imitating reality
to become an
instrument with
which the artist
gives voice to his
soul and inner being.
The painter thus
arranges lines and
masses so that these
become a material
representation of
the spiritual realm.
They no longer
indicate objects
or people but channel
light and vital energy,
feelings and
emotions. In the
same way a musician
makes use of notes,
Kandinsky frees the
expressive power in
colors. No longer
caged and confined
by the limits of form
and design, the colors
can surge across an
unreal space and
take their own
forms, heedless of
order, proportion,
or the principles
of symmetry so
important to
traditional art.

Wassily Kandinsky
**Landscape
(Dünaberg)**
1913, oil on canvas
88 x 100 cm
Hermitage,
St. Petersburg

The year 1913 proved crucial in Kandinsky's career, as it was then that he reached full awareness of the expressive power of abstract painting. In this canvas he repeated and reworked a painting he had made in 1910 (today in a private collection in Switzerland) depicting a view of Dünaberg, a village nor far from Murnau. In this composition, pleasing for its freshness and the spontaneity of its execution, one can still identify the hill in the left foreground as well as houses and trees, but the ties to reality are becoming increasingly weak, with spaces that spread outward or contract in accordance with an almost musical rhythm. Even the alternation of full and empty spaces, together with the irregular movement of the vertical black lines, confers vivacity and movement on the scene, which appears to the eyes of the viewer as a universe in expansion, alive and pulsating.

**Painting with
Red Spot**
1914, oil on canvas
130 x 130 cm
Musée National
d'Art Moderne,
Centre Georges
Pompidou, Paris

Kandinsky completed
this painting on
February 25, 1914,
shortly before leaving
Paris for Russia,
where he remained
until 1921. In this
work he continued his
investigation of the
potentials of abstract
painting and his
attempts to create a
living work in which
the lines and colors
would have an
autonomous life,
free of the ties of
objective reality.
Other canvases made
during the same
period still include
vague references to
the objects, figures,
and situations of
everyday life, but
here we find a fantasy
world composed of
pure emotion. The
Russian painter chose
a square format to
immerse the viewer in
a vortex of light with
more or less solid
colored masses that
depart from the
center to spread in
an irregular manner
in all directions; the
eye is thus free to
move across the
entire surface of the
painting without
limits or obligatory
references imposed
by the artist.

FRANTIŠEK KUPKA
**Piano Keys
(The Lake)**
1909, oil on canvas
79 x 72 cm
Národni Gallery,
Prague

The Czech painter
Kupka, one of the
pioneers of
abstractionism,
began to experiment
with the effects of
light in 1906 in his
studio at Puteaux,
near Paris. Between
1908 and 1909 he
tried various methods
of making the colors
play a predominant
role in works in
which reality
gradually comes
apart, losing its
solidity and identity.
Here Kupka unites
two very different
figural elements,
the keyboard of a
piano and, in the
backqround, the
view of a lake. He
playfully disorients
the viewer, blending
the white and black
keys with the
reflections on
the water and
transforming the
figures in the small
boat into areas of
indistinct color. The
entire composition
is characterized by
an uncommon sense
of rhythm and by a
profound interior
harmony, suggesting
the hypothesis that
the artist drew
inspiration from
the stained-glass
windows of medieval
cathedrals, the colors
of which reflect and
amplify light.

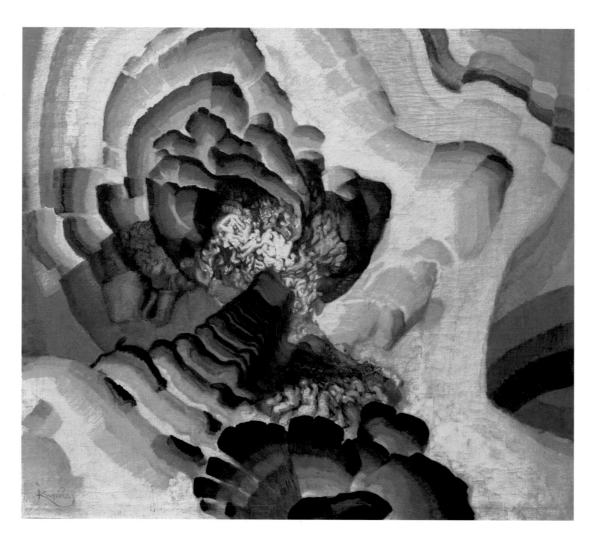

FRANTIŠEK KUPKA
**A Story of Pistils
and Stamens**
1919–20,
oil on canvas
80 x 90 cm
Wilhelm-Hack Museum,
Ludwigshafen am
Rhein

FRANTIŠEK KUPKA
**A Story of Pistils
and Stamens**
1919–20,
oil on canvas
110 x 92 cm
Národni Gallery,
Prague

Discharged from the
army in 1919, Kupka
went to Paris and
returned to painting
with renewed
enthusiasm. These
two canvases are part
of a series of three
works (there may
have been a fourth,
today lost) that he
painted between 1919
and 1920 and
exhibited in the 1920
Salon d'Automne and
in 1924 at the Galerie
la Boëtie in Paris (the
third work is today in
the Musée National
d'Art Moderne, Paris).
The artist presents
poetically the
fecundity of flowers,
symbolic of the vital
force of the universe
and an allegory of
artistic creation. He
seeks to use colors in
the same way in
which a musician uses
notes, giving them an
autonomous rhythm
and expressive force,
creating a true vortex
of color that spreads
outward from the
center of the
painting.

ALBERTO MAGNELLI
**Lyrical Explosion
No. 4**
1918, oil on canvas
120 x 120 cm
Private collection

After associating
with the Futurist
group in Florence,
Magnelli moved to
Paris in 1914, where
he made friends with
Apollinaire, Matisse,
Picasso, and other
artists, both Fauves
and Cubists. He
returned to Italy
during the war and
in 1918 made his
Lyrical Explosion
series of about
eighteen canvases,
including this one,
which mark an
important stage in his
career as well as in
the spread of abstract
art to Italy. Magnelli
demonstrated a
notable sureness in
his application of
brushstrokes that
transmitted a vigor
and energy to his
work along with an
uncommon sense of
rhythm. In this
composition he
reveals a solid
knowledge of the
works of the Blaue
Reiter group
(Kandinsky, but most
of all Marc), which
he had seen by way
of Apollinaire, but
at the same time he
was seeking his own
expressive form, to
which he returned
with even greater
awareness in his
second nonfigurative
period, after 1934.

Moholy-Nagy made
this painting in the
same year in which
he became a
professor at the
Bauhaus, and it
marks one of the
most intense and
representative
moments of his
abstractionism,
during which he
freed himself from
all ties to Russian
Constructivism to
achieve complete
expressive
independence. In this
work the geometric
forms are not
isolated, as in the
Suprematist paintings
by Malevich, and
instead form a
homogenous whole
by means of which
Moholy-Nagy
communicates a
sense of calm,
harmony, and order
that can be
interpreted as a
hymn to mechanical
precision. The
Hungarian painter
shows great skill in
rendering the slight
transparencies of the
colors, illuminated
in different ways to
give the entire
composition a
dynamic rhythm;
he also closely
controls the
distribution of the
masses to achieve
a perfect balance
among the forms,
colors, and the
illusion of space,
elements that were
to have a powerful
influence in the
birth of pop art in
the 1950s.

Between 1918 and
1925 Mondrian
abandoned the
traditional format
of his paintings and
made the famous
series of lozenges
(also called
diamonds), probably
in response to
compositions made
during the same
period by Theo van
Doesburg. The
lozenges are based
on a regular
geometric division—
a "grid"—composed
of triangles,
rectangles, and
squares of various
size arranged in an
asymmetric and
irregular manner.
Mondrian began this
painting in 1921 but
completed it only in
1925, when he
thickened the
horizontal and
vertical black lines.
The canvas belonged
to the dancer Gret
Palucca, pseudonym
of Margarethe Paluka,
born in Munich in
1902 and wife of
Fritz Bienert. She
was associated with
the Bauhaus and
was friends with
Feininger, Klee, and
Kandinsky and died
in Dresden in 1993.
Later the work passed
into the collection of
Herbert and Nannette
Rothschild, who gave
it to the National
Gallery.

PIET MONDRIAN
Broadway Boogie Woogie
1942–43, oil on canvas
127 x 127 cm
Museum of Modern Art, New York

In 1940, following the bombardments of London, Mondrian moved to the United States, arriving in New York on October 3. Thanks to help from Harry Holtzman and Fritz Glarner he found a room on East Fifty-Sixth Street and began a new series of abstract paintings depicting the large metropolis, the frenetic pace and the hyperactive life that admired. In these paintings he abandoned the use of black lines, turning instead to yellow stripes, crossed by gray, red, and blue squares that resemble the gridlike pattern of a Manhattan street map. As is clear, Mondrian also avoided every sense of symmetry, which in his opinion would have made the composition static and predictable. On the contrary, he gave it the rhythm and vivacity indicated by the title, a joyous homage to the dance of the famous street, site of some of the most famous theaters in the world.

PAUL KLEE
Rhythm of the Trees
circa 1914,
watercolor and
gouache on cardboard
19 x 21 cm
Musée d'Art et
d'Histoire, Centre
B. Luzzato, Geneva

In April 1914 Klee
went to Tunisia
together with Louis
Moilliet and August
Macke. The intense
light of the
Mediterranean
coast represented
a fundamental
experience for him,
thanks to which he
reached full
expressive maturity.
In the paintings he
made over the
coming months he
demonstrated a
perfect control of
line and color; he
divided the space
into numerous
elementary geometric
forms, usually without
outlines, sometimes
overlapping,
sometimes shaded.
It is unclear whether
Klee drew inspiration
from the formal
simplifications of
the Cubists or
whether he arrived
at abstractionism
following his own
route. In any case
he arranged the
various elements
across the pictorial
surface, alternating
the pale and dark
areas so as to suggest
a sense of movement,
accompanied by a
rhythmic scansion—
as indicated by the
title—that he
learned from his
musician father.

Abstractionism

■ PAUL KLEE
Separation of Evening
1929,
watercolor on paper
33.5 x 23.5 cm
Felix Klee Collection,
Bern

In 1924 Klee formed the Blue Four (Blaue Vier) group together with Kandinsky, Feininger, and Jawlensky. His association with the other three painters and the experience of teaching at the Bauhaus led Klee to make a series of works in which he attempted to reconcile the poetic-lyrical aspects with a strict scientific attitude. In particular, he further explored his efforts to achieve rhythm, translating into painting the experiments performed by avant-garde music, design, and advertising. The result is a series of force-lines of Futurist inspiration that generate two opposing arrows. The title provides a temporal location, but more than a realistic definition it relates to an emotion and a state of inner being. The pictorial space is divided in parallel bands of color in a uniform manner that suggests the point of separation between the sky and the ground.

THEO VAN DOESBURG
**Counter-Composition
XIII**
1925–26,
oil on canvas
49.5 x 50 cm
Peggy Guggenheim
Collection, Venice

After his brief debut
with the Fauves, van
Doesburg was among
the founders of the
De Stijl group and
magazine, the
official organ of
Neo-Plasticism.
Like Mondrian, he
fragmented pictorial
space into straight
and perpendicular
lines and elementary
geometric figures—
rectangles and
squares—arranged
on the canvas
asymmetrically. He
performed a similar
radical simplification
in his choice of
colors, using only
the three primary
colors, red, blue,
and yellow and the
three "noncolors,"
white, black, and
gray. After remaining
faithful to the
principles of Neo-
Plasticism, between
1925, the year in
which he began this
painting, and 1927
he developed a new
style that he called
"Elementarism" or
"Concretism," in
which he inserted
inclined planes and
diagonal lines to
awaken a sense of
instability and
surprise in the viewer.
In 1930 he became
involved in yet
another pictorial
group, again based
on an abstract
inspiration, called
Art Concret.

Abstractionism

1 Minute Zeit

Mühe, die anhängende

F. Vordemberge '23

■ FRIEDRICH
VORDEMBERGE-
GILDEWART
1 Minute Zeit
1923, watercolor,
pencil, and collage on
paper
27.7 x 18.3 cm
Private collection

After studying
sculpture and
architecture at
Hanover,
Vordemberge-
Gildewart began
painting abstract
art, making him
among the first
artists to begin with
abstract art instead
of arriving at it. This
painting is one of the
first of his artistic
career, and in it he
gives a demonstration
of what he considered
"absolute art,"
meaning free from
the influence of
reality and unbound
by the requirement to
represent an object.
In particular, he
worked a felicitous
synthesis between
the principles of
the Neo-Plasticism
of Piet Mondrian
and Russian
Constructivism,
following which the
artistic object par
excellence comes
from the relationship
among colors, shapes,
and spatial contrasts.
To this end he
simplified reality and
decomposed it into a
series of flat
geometric figures
of various shapes
and sizes, in an
apparently disorderly
way that instead
responds to a logical
criteria closely
followed by the
artist. There is then
the addition of a
piece of collage,
which recalls the
compositions made
several years earlier
by the Futurists and
the Cubists.

M etaphysical art came into being in Ferrara, Italy, between 1917 and 1918, as a result of the encounter between Giorgio de Chirico and Carlo Carrà, two artists with very different artistic and cultural backgrounds. De Chirico was born in 1888 in Greece to Italian parents; in 1906, after the death of his father, he moved to Munich, where he encountered the works of the Romantics and the Symbolists, from Caspar David Friedrich to Arnold Böcklin and Max Klinger. In 1911 he moved to Paris, where he became friends with Guillaume Apollinaire and painted his first Italian town squares, unreal locations with statues and odd figures. These works offer an explanation of the meaning of the term *metaphysical*, which is used to gesture at something located beyond the phenomenological appearance of reality and its general characteristics. By 1914 de Chirico was enriching his compositions with the apparently arbitrary addition of classical and fantasy motifs, symbolic elements, and objects from daily life, often those associated with the psychoanalytical interpretation of dreams. At the outbreak of World War I de Chirico and his brother Andrea, best known by his pseudonym, Alberto Savinio, were conscripted. At first they were stationed in the area of Florence but soon enough found themselves transferred to the Pollastrini barracks at Ferrara and the paymaster's office of the 27th Infantry; their mother soon joined them there. At the end of 1916 they met Filippo De Pisis, writer and painter, whose sister, Ernesta Tibertelli, had introduced him in those years to esoteric and magical culture and to the philosophy of Schopenhauer and Nietzsche. Several months later, by way of Ardengo Soffici and Giovanni Papini, the two artists met Carlo Carrà in the military hospital of Villa del Seminario (which de Chirico baptized the "villa of enigmas"). Carrà had attended Milan's Brera Academy, where he studied the late Lombard tradition and Romanticism and Divisionism, but at the same time had been open to

Carlo Carrà, *The Oval of Apparitions*, 1918, oil on canvas, 92 x 60 cm; Galleria Nazionale d'Arte Moderna, Rome

Carlo Carrà, *Still life with Square*, 1917, oil on canvas, 46 x 61 cm; Civico Museo d'Arte Contemporanea, Collection Riccardo Jucker, Milan

new English and French ideas, from Constable to Turner, Courbet, and the Impressionists. In 1910 he had been among the founders and promoters of Futurism, but by 1915 he had begun to distance himself from the group's style in search of new expressive forms. He painted several canvases inspired by primitivism and elaborated the poetics of the *antigrazioso* ("antipretty") against the traditional canons of aesthetics. Conscripted and sent to the 27th Infantry at Pieve di Cento, he fell ill and was moved to the military hospital at Ferrara, where he met the de Chirico brothers, de Pisis, and the poets Corrado Govoni and Giuseppe Ravegnani. These months of forced inactivity were troubled by the reality of the war and the chilling reports from soldiers at the front, but at the same time they provided the opportunity for long discussions and exchanges of ideas that contributed to the cultural formation of the young artists, opening them to new horizons. At the end of 1917 Carrà exhibited thirty paintings and forty-three drawings at the Galleria Chini in Milan. Early in 1918 the Bolognese writer Giuseppe Raimondi published a work on Carrà. Giorgio Morandi was especially struck by this work; having been a student at the Bologna Academy from 1907 to 1913, he had been strongly influenced by the way Cézanne's paintings decomposed reality into simple elements and by the relationships between light and color. In July 1918 Carrà and de Chirico exhibited at the gallery of the newspaper *L'Epoca* in Rome in an art show—to benefit the Red Cross—designed to compare the Futurists with emerging art

Metaphysical art

currents, including Metaphysical art. While in Rome the two artists met Morandi, who in those months was directing his work toward the sensibility and style of Metaphysical painting. In February 1919 de Chirico had his first one-man show at the Galleria Bragaglia in Rome; the paintings were accompanied by his *Noi Metafisici*, considered his manifesto. Only one painting sold during the period of the show, and the show itself received only one positive review, an article by Filippo De Pisis. All the other critics were dismissive of the show, including Roberto Longhi in an article entitled "To the Orthopedic God." In the brief text "On Metaphysical Art," published in the magazine *Valori Plastici*, in April–May 1919, de Chirico explicated the genesis and sense

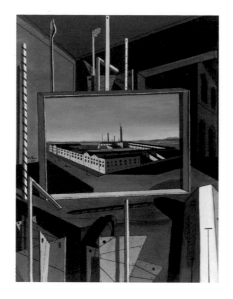

what terror, and perhaps even what pleasure and consolation I might view the scene. The scene would not have changed, but I would be seeing it from another angle. Which brings us to the metaphysical appearance of things."

In the same way Carlo Carrà expressed his aesthetic vision and the relationships between his painting and the artists of the past and present in the book *Pittura Metafisica*, published by Vallecchi in Florence in 1919. There was then also the contribution of Alberto Savinio, another solider at Ferrara, at the time a writer and musician and not yet a painter, an activity in which he became involved beginning in 1926 at the suggestion of Paul Guillaume and Jean Castel. In a pamphlet of July–August 1914 in the magazine *Les Soirées de Paris*, edited by Apollinaire, Savinio published the dramatic poem *Le Chants de la Mi-mort* ("The Songs of the Half-dead"), in which the enigmatic figure of the man "without voice, without eyes, without face" makes his first appearance. This is the figure from which de Chirico would draw inspiration for his neutral and impersonal mannequins, the protagonists of many Metaphysical paintings. The bonds joining these

Giorgio de Chirico, *Metaphysical Interior (with Large Factory)*, 1916, oil on canvas, 96.3 x 73.8 cm; Staatsgalerie, Stuttgart

Metaphysical art

of his painting: "Let's take an example: I enter a room, I see a man sitting in an armchair, I note a birdcage with a canary hanging from the ceiling, I spot some paintings on the wall, a bookcase with a few books. All this makes an impression on me because the threads of memories that tie these things together explain the logic of what I see. But let's suppose for a moment that for inexplicable reasons beyond my control the threads of memory were broken. Who knows how I might then see the seated man, the birdcage, the paintings, the bookcase; who knows with what astonishment,

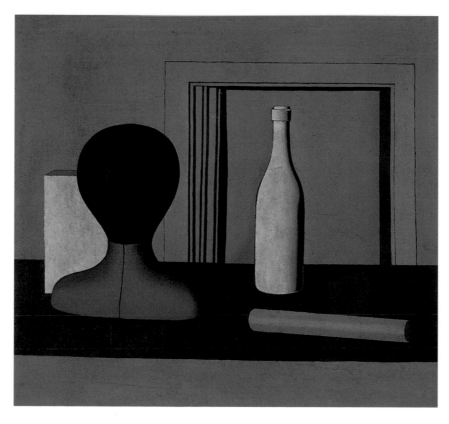

painters were extremely loose. For various reasons, but first of all differences of character, they did not form a movement but only a brief collaboration that resulted from the accidental coincidence of their styles and subjects. By the early years of the 1930s each was following his own artistic route in an autonomous manner. Even so, their paintings had an important influence on other artists, both in and out of Italy, most of all the Dadaists in Zurich and Paris, the exponents of Surrealism in France, and the followers of New Objectivity in Germany.

Giorgio Morandi, *Still life*, 1918, oil on canvas, 68.5 x 72 cm; Pinacoteca di Brera, Collezione Jesi, Milan

GIORGIO DE CHIRICO
The Scholar's Playthings
(Les Jeux du Savant)
1917, oil on canvas
89.5 x 51.4 cm
Minneapolis Institute of Arts, Minneapolis

In 1917 de Chirico made twenty-odd drawings and a dozen "Metaphysical" paintings, including this work, painted in April and May, immediately after his stay in the military hospital for nervous disorders at Villa del Seminario, Ferrara. This canvas was bought by Mario Broglio, who gave it to Paul Guillaume, who exhibited it in Paris in 1926; the work later passed to Pierre Matisse and to various American collectors until 1975, when Samuel H. Maslon gave it to the Minneapolis museum. In the background of the painting can be seen a door that opens onto a dark hall, at the end of which is a view of green sky. In the foreground the artist has placed several parallelepipeds (on which are presented two anatomical studies, two squares, and a factory) together with other objects, including a box painted with colored triangles, very similar to the box that appears in *Disquieting Muses*, made the following year (see page 188).

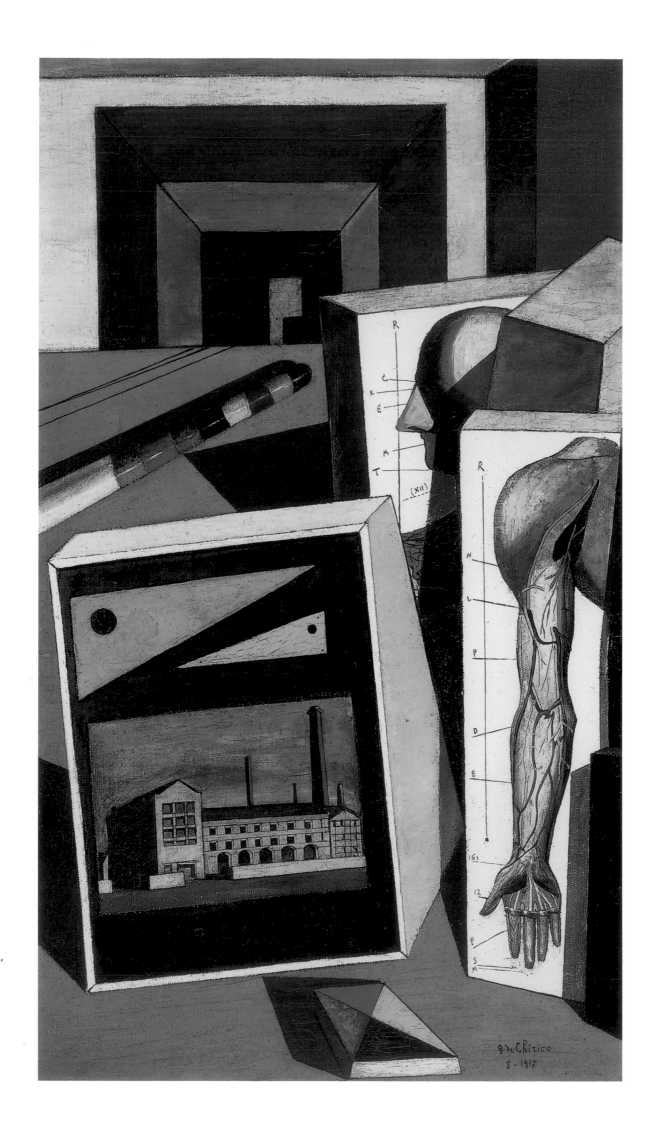

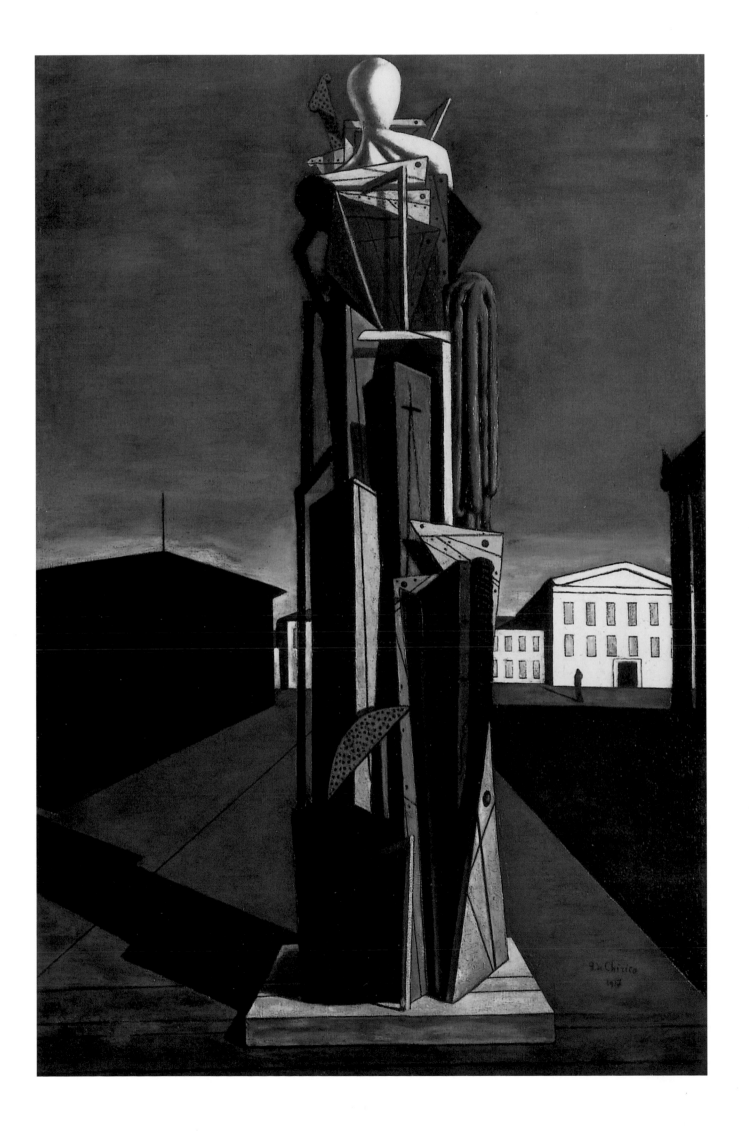

GIORGIO DE CHIRICO
The Great Metaphysician
1917, oil on canvas
104.5 x 69.8 cm
Private collection

In August 1917, having been released from Villa del Seminario, de Chirico spent a month on leave at Ferrara, where he made the canvas shown here early in the fall. The setting is an empty square, the colors are intense and unreal. Dominating the composition is the complex figure in the foreground, which de Chirico created by assembling various elements of the Metaphysical works he made during those months, from the mannequin to the squares. In his eyes this figure represents the man of the future, freely inspired by the Superman of Nietzsche and the man of iron described by Alberto Savinio in *La Realtà Dorata* ("Gilt Reality"). The painting's first owner was Mario Broglio; in 1924 it was given to Albert C. Barnes and later to other American collectors. In 1958 Philip L. Goodwin donated it to the Museum of Modern Art in New York, which sold it at auction at Christie's, New York, on May 4, 2004, fetching the sum of $7,175,500.

The Disquieting Muses

1918, oil on canvas
97 x 66 cm
Private collection

In the background of this painting, to the left, is a factory, the smokestacks of which, in form and color, recall the towers of the castle opposite it; this castle is similar to that of Ferrara, the city where Metaphysical painting had its birth and reached its apex. The central area of the painting is occupied by a theatrical stage, slightly inclined, on which stand three mannequin statues that the artist initially called "the disquieting virgins." Beside these de Chirico placed other objects that are not easy to identify, and their obscure significance contributes to making the entire composition even more enigmatic and mysterious. The presence of long shadows clearly indicates a source of light, but it is not possible to determine if this light is natural or artificial. The colors too, luminous but cold, contribute to creating an atmosphere of motionless silence, full of tension and expectation.

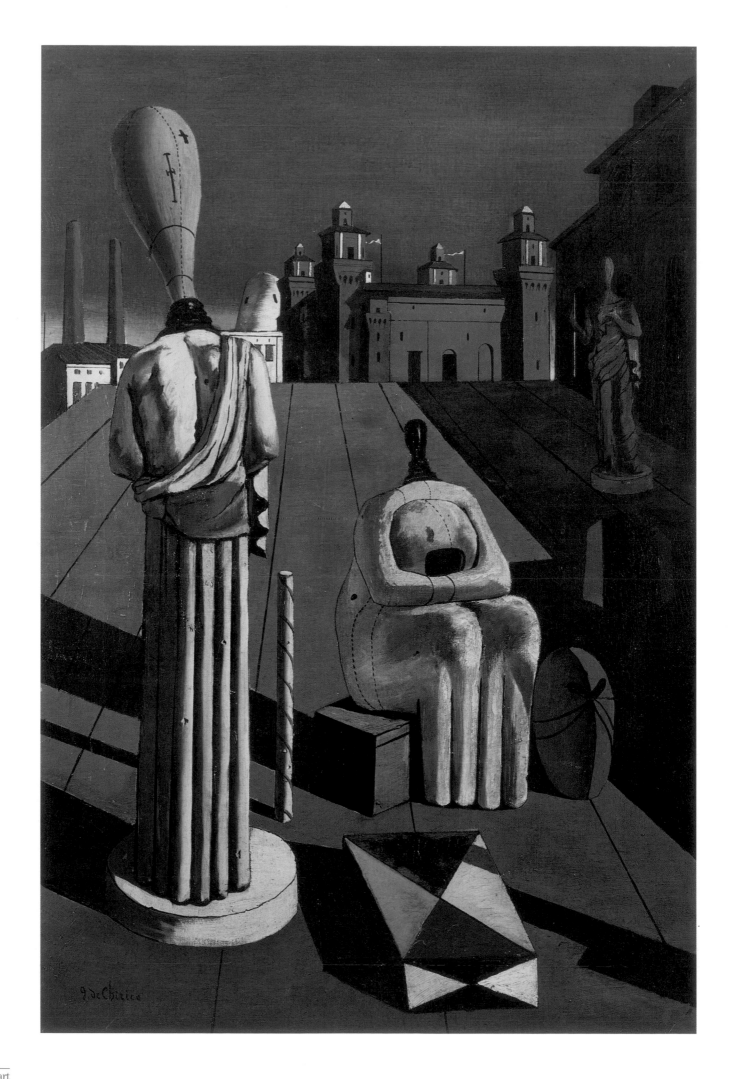

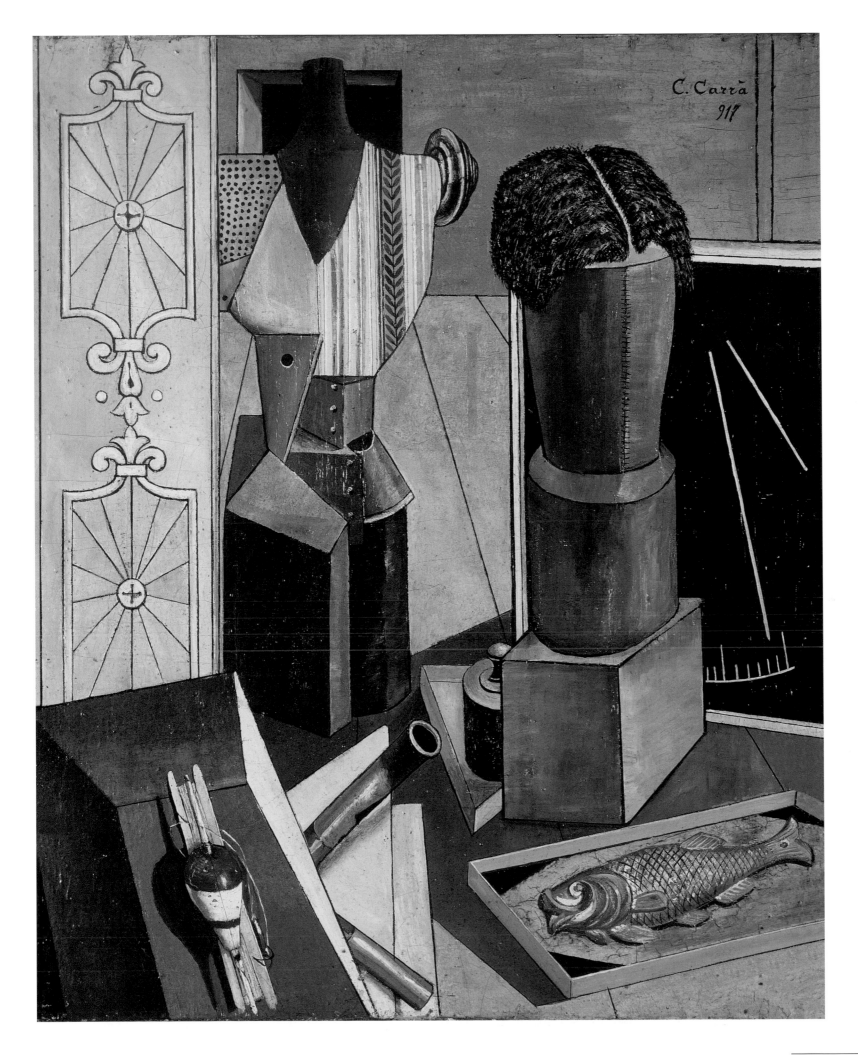

■ CARLO CARRÀ
The Enchanted Room
1917, oil on canvas
65 x 52 cm
Pinacoteca di Brera,
Collezione Jesi, Milan

This painting, made
in the hospital of
Villa del Seminario at
Ferrara, repeats many
objects found in the
world of de Chirico,
such as the fish in
the lower right
corner. On a postcard
of June 5, 1917,
sent to Ardengo
Soffici, Carrà wrote,
"I talk and paint
new realities with
de Chirico. He's a
good friend; that's
all I feel that
new doors have
opened for me and
that I will be able
to make new works."
This canvas was the
subject of numerous
reworkings, Carrà
covering it with
successive layers of
paint in search of a
perfect chromatic
agreement. The
arrangement of the
disparate objects
might give a viewer
the sense of a rebus
or puzzle with a
logical interpretation
to be worked out.
However, it seems
the painter has done
nothing to help
understand the
sense of the work
and instead seems
to intentionally
confuse and mislead
the viewer.

CARLO CARRÀ
The Metaphysical Muse
1917, oil on canvas
90 x 66 cm
Pinacoteca di Brera,
Collezione Jesi, Milan

The map in this painting is of Istria, an explicit reference to World War I and the historical climate in which the painting was made. The mannequin resembles those used by de Chirico yet also differs from them; its modern tennis outfit gives it an almost human appearance and brings it closer to reality. There is also, however, the detail of the row of little headstones marked with crosses running across the mannequin's chest, another reference to the war then raging that casts a troubling shadow over the entire composition. As for the mannequins, Carrà recalled, "One night in 1917 I found myself wandering the streets of Ferrara and happened to see some mannequins, and there and then I made a pencil drawing of one of those mannequins . . . that is the genesis of the mannequin that appears in my paintings of the period known as Metaphysical."

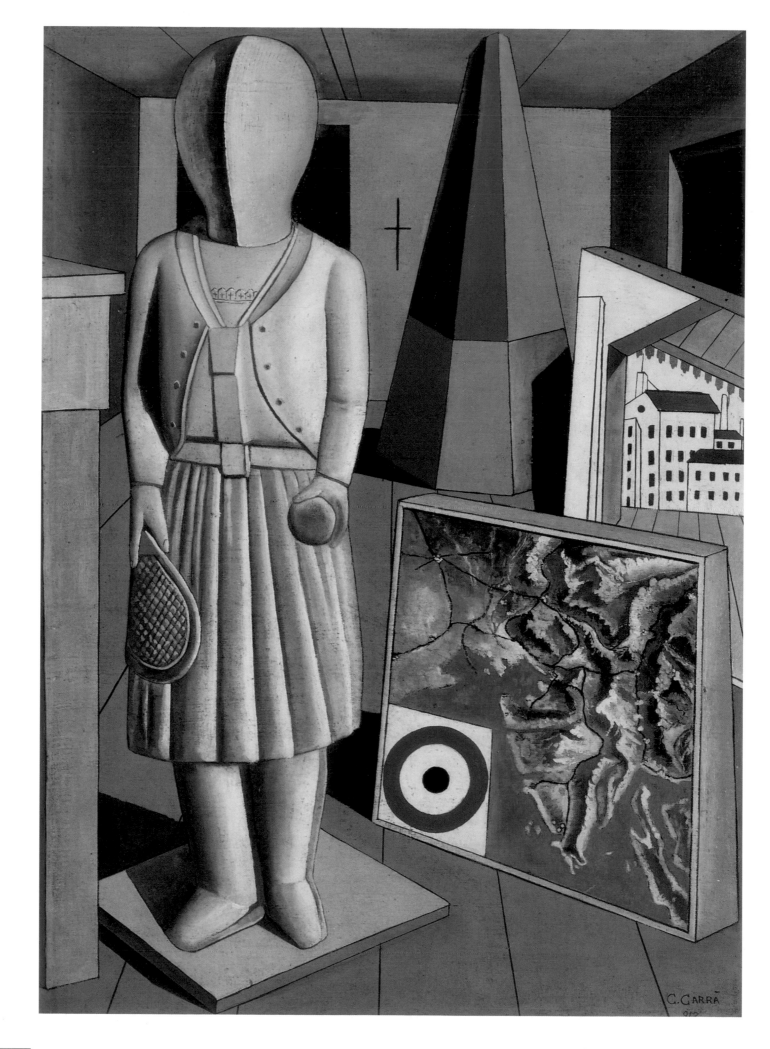

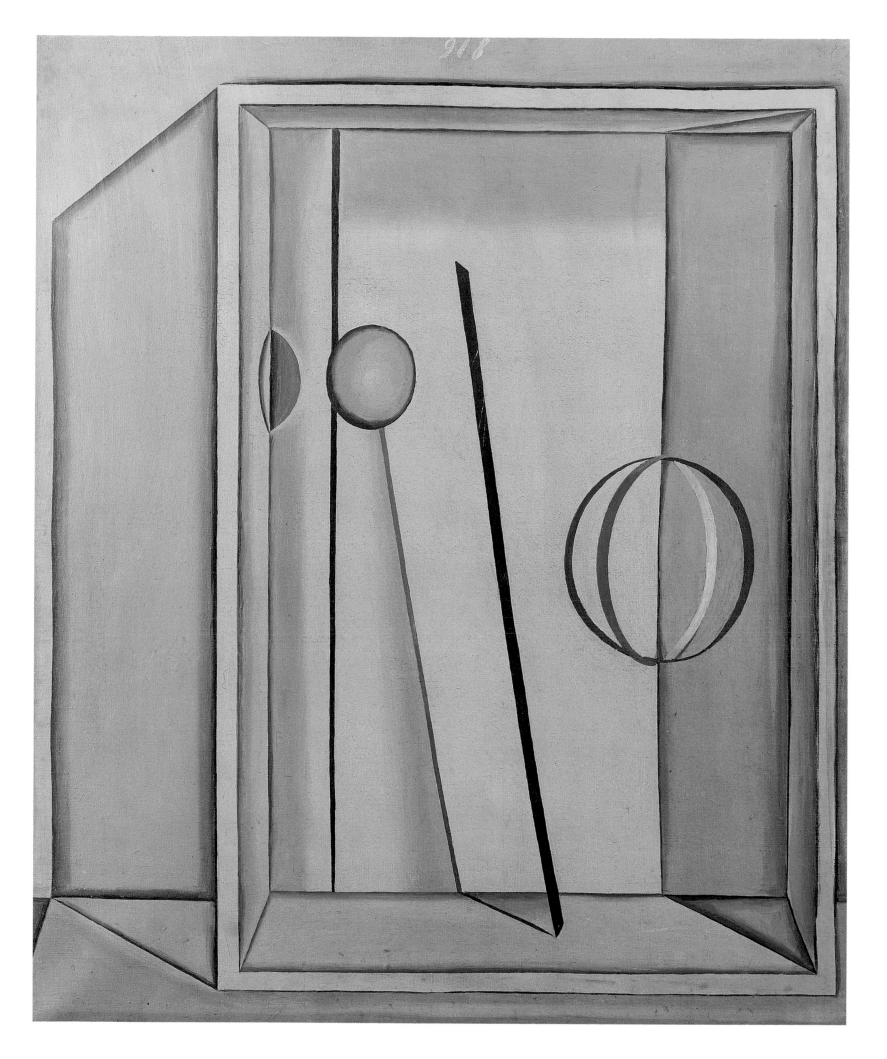

■ GIORGIO MORANDI
Still Life with Ball
1918, oil on canvas
65 x 55 cm
Civico Museo d'Arte
Contemporanea,
Collection Riccardo
Jucker, Milan

In 1918 Morandi
contributed to the
magazine *La Raccolta*,
directed by Giuseppe
Raimondi, who
introduced him to
Metaphysical
painting, to which
he then dedicated
several months. This
canvas has the kind
of rarefied
atmosphere typical
of Metaphysical
works. The apparently
casual arrangement
of unrelated objects
seem to float freely in
an unreal space. In
the catalog to the
exhibit "La Fiorentina
Primaverile" of 1922
de Chirico commented
on the Metaphysical
works by Morandi:
"He looks with the
eyes of a man who
believes, and the
intimate skeleton of
these things, which
are dead to us
because they are
motionless, appears
to him in its most
consoling aspect.
In that way he
participates in the
great lyricism created
by the final depth of
European art: the
metaphysics of
ordinary objects.
Meaning those
objects that habit
has made so familiar
to us that we, as
cunning as we are
with the mysteries of
appearances, often
see with the eye of a
man who looks but
does not understand."

GIORGIO MORANDI
Still Life with Mannequin
1918, oil on canvas
47 x 58 cm
Civico Museo d'Arte
Contemporanea,
Collection Riccardo
Jucker, Milan

Participation in
Metaphysical art
represented an
important step in
Morandi's stylistic
formation. He was
not drawn to the
magical aspects or
psychoanalytical
interpretations of
Metaphysical
paintings as much
as he was to the
atmosphere of
meditation, of
contemplative
silence, and even
more to the formal
rigor that infused
even the simplest
and most banal
object with a quiet,
austere solemnity.

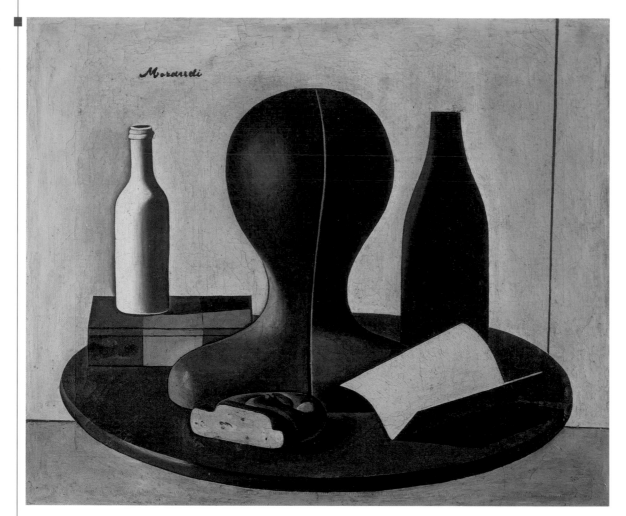

FILIPPO DE PISIS
Sacred Fish
1925, oil on canvas
55 x 62.5 cm
Pinacoteca di Brera,
Collezione Jesi, Milan

De Pisis met de
Chirico in 1916
and was influenced
by his paintings. The
title of this canvas
is the same as that of
a Metaphysical work
that de Chirico made
between December
1918 and January
1919. The large eye
at the center of the
composition, which
both painters took
as symbolic of the
ability to see beyond
material reality,
recalls three
paintings by de
Chirico: *Greetings from
a Distant Friend, The
Jewish Angel,* and *The
Corsair,* all from 1916.

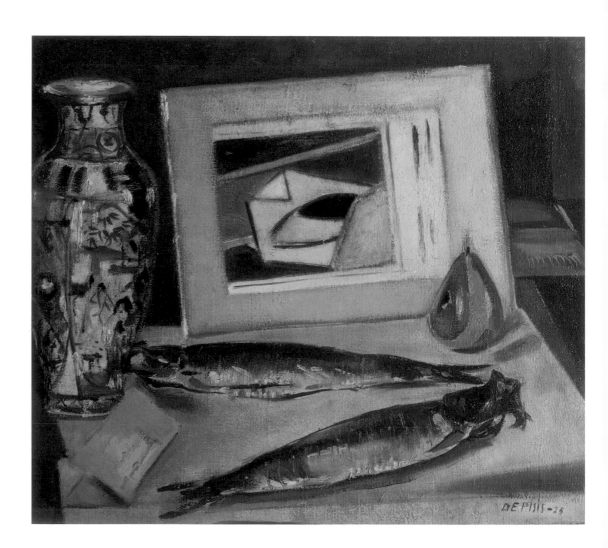

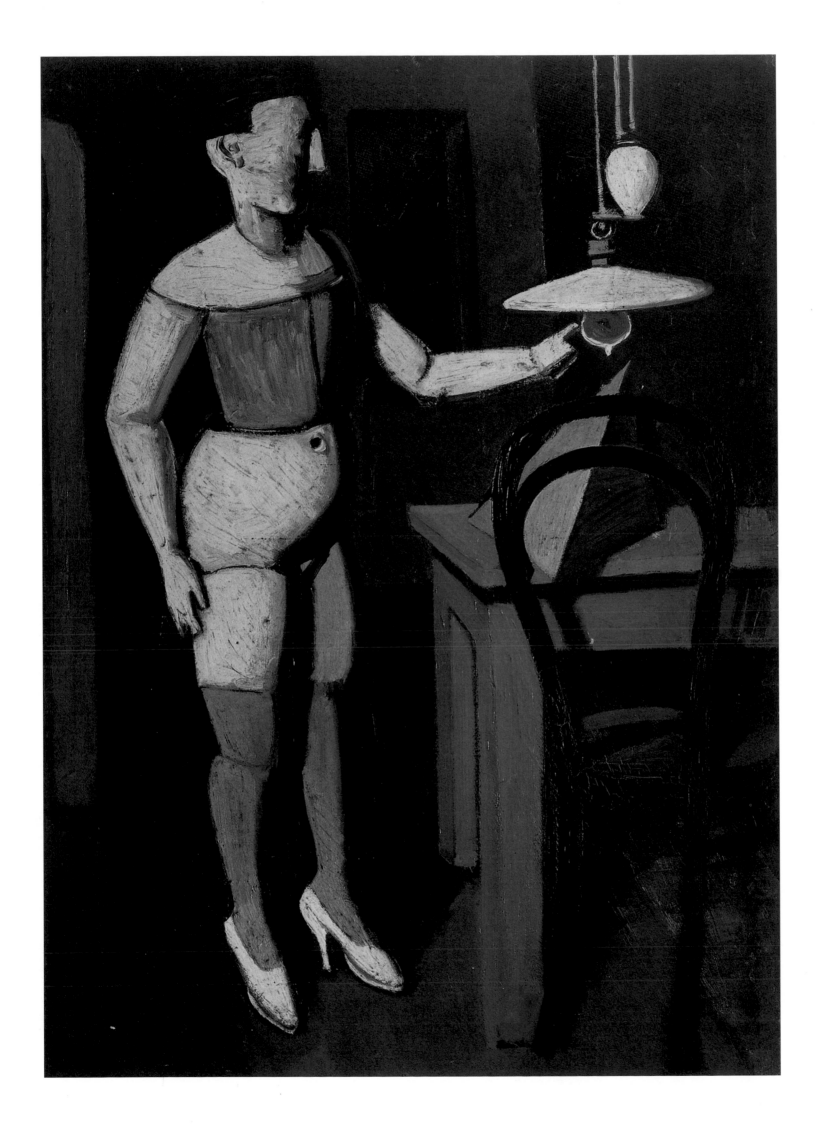

■ MARIO SIRONI
The Lamp
1919, oil on paper
78 x 56 cm
Pinacoteca di Brera,
Collezione Jesi, Milan

Sironi joined Futurism
during the second
half of 1913 and
actively participated
in the movement's
exhibits and events.
During the closing
months of 1919 he
made his first urban
landscapes and two
paintings—the one
shown here and
Venus of the Ports
(Civiche Raccolte
d'Arte, Milan)—in
which he made a
personal use of
mannequins, the
objects usually
associated with
Metaphysical art.
In works by de
Chirico and Carrà
the mannequins
tend to be static
and immobile;
here, instead, the
mannequin is in
movement and
almost humanized.
It is also true that
while the two
Metaphysical artists
accentuated their
dreamy, unreal
settings, in
anticipation of the
works of the
Surrealists, Sironi
leaves plenty of
space for elements
of daily life, such as
the table and chair
and the lamp that
gives the work its
title. Aside from the
mannequin, the only
extraneous and
incongruous element
is the irregular
pyramid set on the
table. This painting
is also notable for its
cold, leaden colors,
typical of many of
Sironi's works in the
coming decades.

The official birthdate of Dada was February 5, 1916, the day on which the German theatrical director, writer, and philosopher Hugo Ball founded the Cabaret Voltaire in Zurich at 1, Spiegelgasse, inside a former brewery. Here were mounted exhibits with works by Cubist, Futurist, and Expressionist artists, as well as literary recitals with pieces by Max Jacob, Guillaume Apollinaire, and Blaise Cendrars. With Europe in the throes of World War I, artists and intellectuals of every nation took refuge in neutral Switzerland: the Romanians Tristan Tzara and Marcel Janco, the Alsatian Jean Arp, the Germans Richard Hülsenbeck and Hans Richter. In a climate of violence and death destined to terminate a political order that Europeans had once thought eternal, with the collapse of four mighty empires (the Russian, German, Austro-Hungarian, and Ottoman), a cultural movement came into being that was equally destructive and nihilistic. Irrational and absurdist, Dada preached the overturning of every cultural tradition of the past. Over the coming years the exponents of the movement clarified their vision of the world and art. They did so in the *Dada Manifeste* and in "Dada evenings," chaotic and polemical meetings that resembled the events staged by the Futurists; there were exhibits in the Dada gallery in Zurich as well as the pages of the magazines *Cabaret Voltaire* and *Dada*. Like the Futurists, they ranged across almost all the artistic disciplines—literature, painting, theater, music (in particular Erik Satie)—and were among the first to make methodical use of the new techniques of photography and the cinema. The choice of the group's name is emblematic of their disillusionment and their attitude, deliberately shorn of values and logical references. In fact, the name *dada* means nothing: it was chosen by flipping through a French dictionary; *dada* is babytalk, a term used to indicate a rocking horse. The term "*dada*" may have been chosen intentionally to inform critics and the public that the movement's intellectual and artistic activity was merely a "game" and should not be taken too seriously.

At almost the same time a group of artists was forming in New York with the aim of using irony to demolish the rules and habits of tradition. This was the Society of Independent Artists, founded in 1916 and including such outstanding members as Marcel Duchamp, considered the group's creative leader; Francis Picabia; the photographer and gallery owner Alfred Stieglitz; and Man Ray. In 1917 Richard Hülsenbeck returned to Berlin to found a particularly active and combative Dada group; in 1918, at the Saal der Neuen Sezession he read the *Dada Manifeste*, joined by many other artists and intellectuals, including Raoul Hausmann, George Grosz, and Otto Dix, who contributed to the magazine *Der Dada*. Over the two next years the Berlin Dadaists held numerous conferences in Dresden, Hamburg, Leipzig, and Prague. In 1919 a Dada section was created in Cologne that made itself known with the magazine *Der Ventilator*. The leaders of this group were Jean Arp, Max Ernst (who developed the technique of photomontage), and the painter-poet Johannes Theodor Baargeld, who expressed himself by means of collages. Beginning in 1918 Kurt Schwitters, almost completely alone and isolated, began his activity in Hanover, making his work public through the magazine *Merz* (which he founded), published from 1923 to 1932. Between 1919 and 1920 many exponents of Dadaism came into contact with French intellectuals, in particular with Guillaume Apollinaire, always on the lookout for new artistic and cultural expressions. In 1919 Picabia exhibited at the Salon

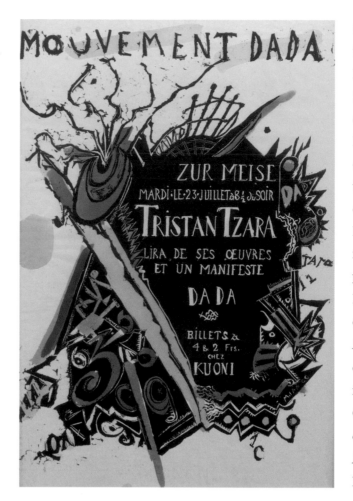

Marcel Janco, poster for a Dada performance held by Tristan Tzara in Zurich, July 23, 1918, 1918, 46.8 x 32.2 cm; private collection

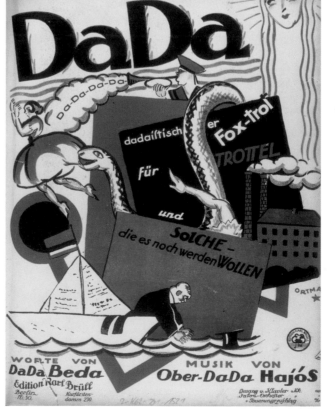

Frontispiece from a Dada musical work, Berlin, Edition Karl Brüll, 1921; Archiv für Kunst & Geschichte, Berlin

Dada

d'Automne; the next year Dada works caused a stir at the Salon des Indépendants and in other exhibits. The year 1922 saw the first fractures within the Dada group, with rivalry between Tristan Tzara and André Breton leading the latter to found the Surrealist movement.

Two fundamental aspects of Dada were destined to have wide-reaching influences on art during the second half of the 20th century. The first is the scarce consideration given to technique and the manual labor performed by artists. Perhaps the outstanding example of this is Duchamp's so-called readymades. In February 1917 he sent the Society of Independent Artists in New York an upside-down urinal entitled *Fountain*, signing it

proposed other canons, destined to meet varying degrees of success. The Dadaists did not limit themselves to this: they developed the Futurist theme of the *antigrazioso* ("antipretty") and called into discussion the notion according to which the goal of art is the expression of a value called "beauty." According to them, art should express sentiments and emotions that the artist finds inside himself, but the resulting work need not be judged beautiful by its maker or by those who see it. The artist has every right to make ugly works, as Jean Dubuffet was to theorize after 1945 with his Art Brut.

Based on the negation of all logic and meaning, and incapable of

■ Man Ray, *The Rope Dancer Accompanies Herself with Her Shadows*, 1916, oil on canvas, 132 x 184.4 cm; Museum of Modern Art, New York

Dada

with the pseudonym R. Mutt. In response to the inevitable outcry, Duchamp several times explained that, in his view, it was not important for the artist himself to actually make the work of art. What was important was the fact that the artist had chosen the object and had given it a role and a significance different from those for which it was originally made. Duchamp later did the same thing with a bottlerack, which he bought in a bazaar and exhibited exactly as he had found it; several years later he threw it away (to the great consternation of art collectors and museum curators), demonstrating his indifference to what he considered the fetishistic treatment of works of art.

Dada's second important contribution was the rejection of the identity between art and beauty. Many artists before Dada had called into question the aesthetic canons of their contemporaries and had

proposing new values and new languages, Dada soon exhausted its propulsive energy, and over the course of the 1930s many of its members turned to other expressive forms, such as Max Ernst, Francis Picabia, and Man Ray, who switched to Surrealism. During the second half of the 1950s Dada was rediscovered and reintroduced by various artists, generically grouped under the term New Dada or Neo-Dada. These include Robert Rauschenberg and Jasper Johns in the United States; Arman, Christo, and Daniel Spoerri in France; and Enrico Baj and Mimmo Rotella in Italy.

■ Marcel Duchamp, *Bottlerack*, 1913 (replica from 1964), readymade, iron, height 63 cm, diameter 37 cm; Staatsgalerie, Stuttgart

MARCEL DUCHAMP
**Chocolate Grinder
No. 2**
1914, oil, graphite,
and thread on canvas
65 x 54 cm
Philadelphia Museum
of Art, Philadelphia

Duchamp was
fascinated by
machines, by their
gears and complex
functions, to which
he attributed
mysterious and
arcane symbolism.
A chocolate grinder
he spotted in the
window of a shop in
Rouen ended up in
two of his paintings.
In this, the second
version, he further
simplified the forms
and indicated the
volumes of the
cylinders not with
gradations of color
but with lengths of
thread. Several years
later he inserted the
same grinder in the
lower part of the
Bride Stripped Bare
(see page 198). With
the same procedure
used for readymades,
Duchamp took an
ordinary object and
deprived it of all
practical function,
taking interest only
in its form, its colors,
and its visual impact
on the viewer. The
use of a neutral
background
eliminates every
spatial and temporal
reference and thus
accentuates the sense
of impersonality and
extraneousness,
qualities Duchamp
saw as essential in
a work of art.

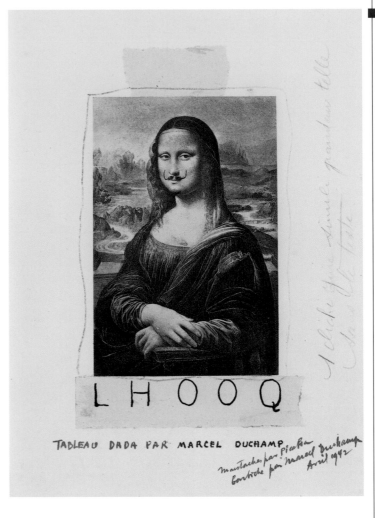

MARCEL DUCHAMP
L.H.O.O.Q.
1920, pencil and pen
on an engraving
23.8 x 17.8 cm
Private collection

This work is one of
the symbols of the
iconoclastic spirit of
Dadaism; Duchamp
took an engraving
with a reproduction
of the *Mona Lisa* by
Leonardo da Vinci,
the most famous
work of Renaissance
art, and in an act
of irreverence and
profanation added
a mustache and
goatee to the
woman's face. In
addition there are
the letters written
below the image,
which when read in
French sound like a
humorous but also
slightly vulgar
phrase, a further
sneer at the
sacredness of a
great masterpiece.

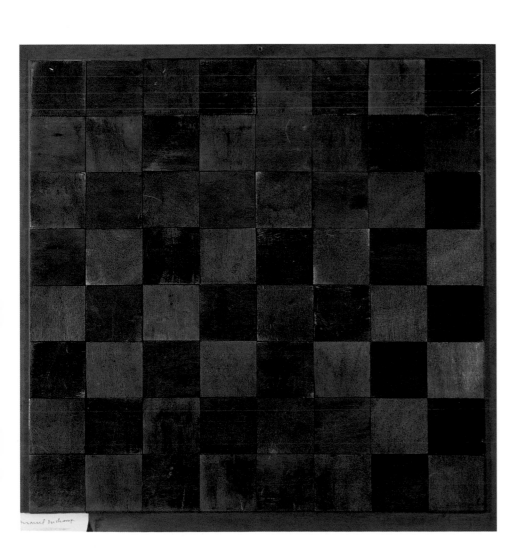

■ MARCEL DUCHAMP
Chessboard
1937,
readymade, wood
70 x 70 cm
Private collection

Duchamp was thirteen
when he learned to
play chess, and from
then on chessboards
occupied an
important place in
his life and art. In
1910 he painted a
canvas entitled *The
Game of Chess*
(Museum of Art,
Philadelphia), in
which he presented
his brothers, Raymond
and Jacques. In 1911
he made another two
paintings with the
same subject but in
a Cubist style (Musée
National d'Art
Moderne, Paris, and
Museum of Art,
Philadelphia).

MARCEL DUCHAMP
**The Bride Stripped
Bare by Her
Bachelors, Even
(The Large Glass)**
1915–23,
oil on glass
267 x 170 cm
Philadelphia Museum
of Art, Philadelphia

This extremely
complex work,
deliberately obscure
and ambiguous, is
open to a great many
possible readings.
Duchamp began
making preparatory
drawings in 1915
and continued for
several years, with
continuous
reworkings and
changes; in 1923
he abandoned the
work and almost
completely quit
painting to dedicate
himself to being a
professional chess
player. In 1926,
while it was being
transported after a
show in New York,
the glass broke;
Duchamp repaired
it ten years later,
adding the horizontal
bar that separates
the two parts. The
work is divided in
two sections. At the
bottom left are the
nine "bachelors"
joined to a sled,
along with a watermill
and other improbable
machines, among
which can be
recognized the
chocolate grinder
(see page 196). All
these machines
absorb the energy
produced by the
nine bachelors
and transfer it to
the upper part; there,
at the center, is the
Milky Way, forming
the veil and halo of
the bride to the left.

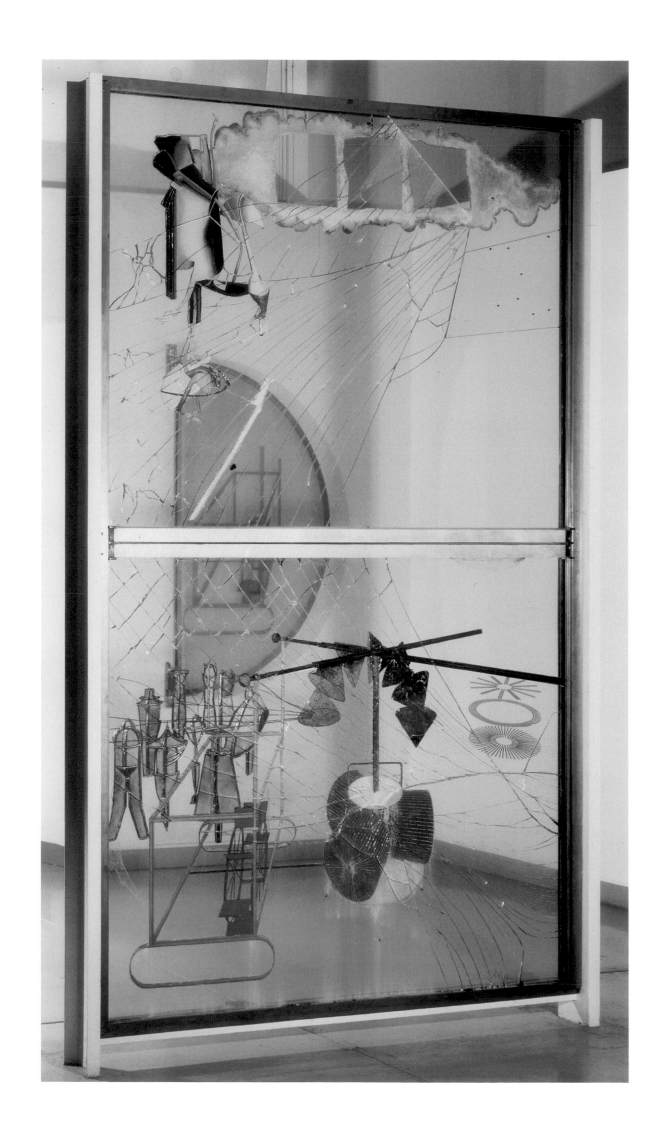

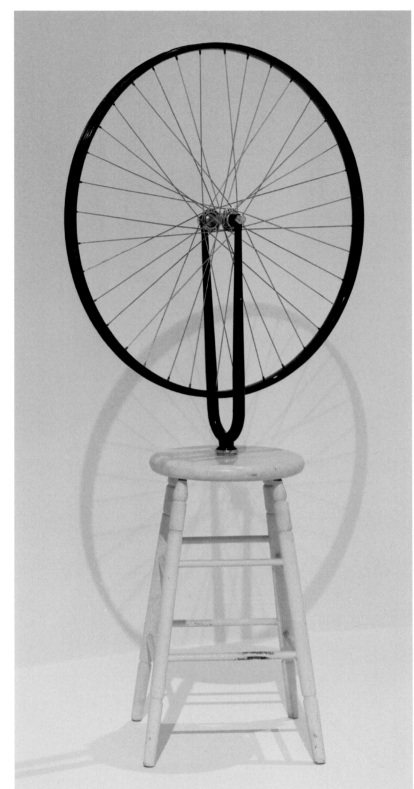

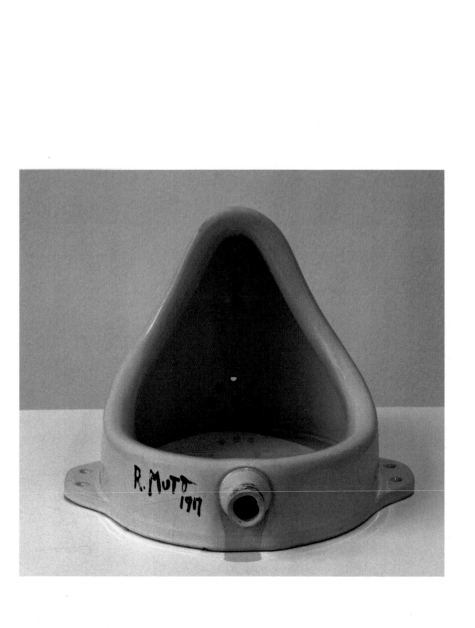

■ MARCEL DUCHAMP
Bicycle Wheel
1913 (replica from
1964), readymade,
wood and metal
128 x 64 x 33 cm
Hessisches
Landesmuseum,
Darmstadt

Duchamp's
readymades
represented a
radical revolution
in the concept of
art. By making art
out of already
"made" objects (in
this case a stool and
a bicycle wheel) he
almost entirely
eliminated the
manual-practical
aspect of being an
artist, giving
importance only to
the creative act of
intuition and design.

■ MARCEL DUCHAMP
Fountain
1917 (replica from
1964), readymade,
ceramic
33 x 42 x 52 cm
Moderna Museet,
Stockholm

In 1917 the Society
of Independent
Artists was formed
in the United States.
Duchamp, one of the
leaders of the group,
presented a ceramic
urinal to the jury,
signing it with the
pseudonym R. Mutt.
When the jury
refused to exhibit
it, Duchamp published
a photograph of it in
the magazine *The
Blind Man*,
accompanied by a
text in which he
defended the work's
symbolic value. The
original was lost
during the show,
and only in 1964
did Duchamp
authorize replicas.

**Music Is Like
Painting**
1917, oil on canvas
120 x 67 cm
Private collection

In 1913 Picabia
spent six months in
New York and took
part in the Armory
Show; two years later
he left Paris and
moved to New York
for several months.
Alfred Stieglitz
mounted a show of
Picabia's abstract
watercolors in his
gallery and introduced
him to Marcel
Duchamp and Man
Ray, with whom
Picabia organized
various Dada events.
This painting testifies
to Picabia's efforts to
overcome the
figurative tradition
in search of new
expressive forms.
Painting, like music,
must not remain tied
to the imitation of
reality but must
express sentiments
and emotions through
the free play of lines
and colors. The black
background further
contrasts with the
pale lines arranged
with an excellent
sense of rhythm and
proportion. Picabia
returned to Europe
in 1918 and together
with Tristan Tzara
became one of the
leading animators
of Dada activity in
Zurich and Paris.

The Cacodylic Eye (L'Oeil Cacodylate)
1921, oil, photography, and collage on canvas
148.6 x 117.4 cm
Musée National d'Art Moderne, Centre Georges Pompidou, Paris

This work resulted from an eye disease that struck Picabia for which he was put on a cure based on cacodyl. Picabia painted a large eye in the lower part of this canvas then threw a party on December 21, 1921, which he called the *Réveillon Cacodylate*, during which he asked his friends to write a message on the canvas and sign it. In this way Picabia emphasized in an ironic and subtly polemical way the excessive importance that some critics and collectors attributed to a "signature," sometimes putting the work of art in second place. The painting was seen as scandalous at the Salon d'Automne and was bought by Louis Moyses, who hung it in his Parisian cabaret, Le Boeuf sur le Toit, famous at the time for the American and Brazilian musicians who played there. The cabaret— its name from the title of a ballet designed in 1920 by Jean Cocteau, with music by Darius Milhaud—was often visited by Dada and Surrealist artists.

MAX ERNST
Dada
circa 1922
43.2 x 31.5 cm
Museo Thyssen-
Bornemisza, Madrid

One of the methods
typical of Dada
painting, and later
repeated and widely
used by Surrealists,
was the casual and
arbitrary assembly of
disparate objects and
figures. Doing so, the
artist confuses and
disorients the viewer,
who, depived of
habitual references,
is unable to attribute
meaning to what he
or she sees. The effect
is increased when the
painter, as in this
case, purposely
provokes the viewer
by inserting
incomprehensible
forms and figures
into his composition,
painting ordinary
objects out of context
and wildly out of
proportion, or
presenting bizarre
mechanisms that
appear to be
senseless. In the
canvas shown here
the viewer is naturally
drawn to identify
with the figure seen
from behind, but
has no hope of
understanding where
the figure is or what
he's doing.

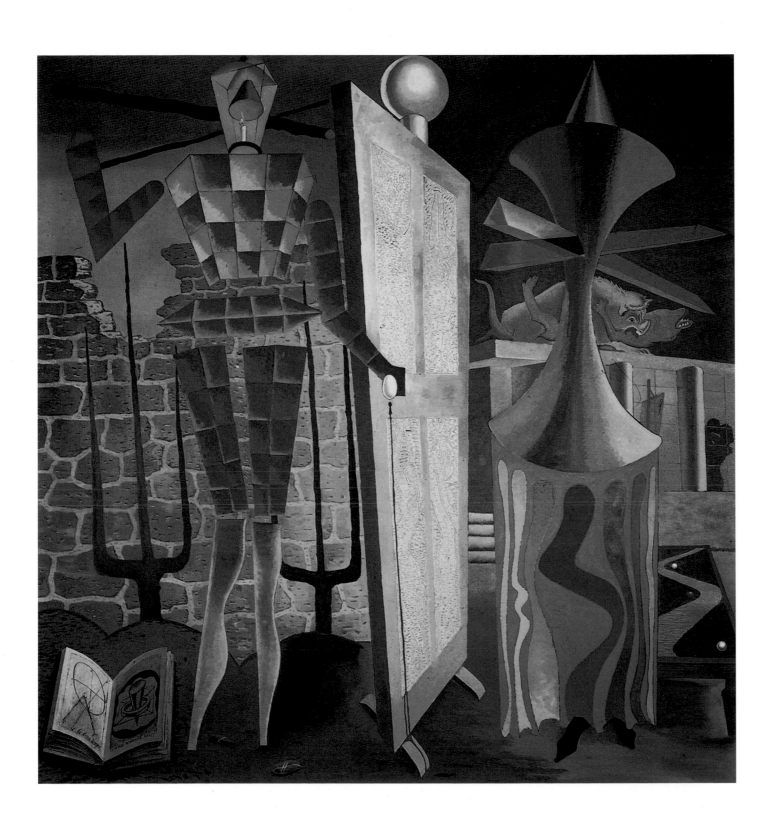

This painting is one of the last Man Ray made in Paris before leaving to spend nearly a decade in the United States. His works during the 1930s followed the Dada style but presented many Surrealist elements. In this enigmatically titled canvas, May Ray assembled strange and bizarre objects in a deliberately chaotic way, almost as though challenging the viewer to find a solution to the enigma. Is there some link between the couple seen embracing through the window on the right and the two monsters locked in mortal combat on the roof of the same building? And what is the meaning of the disturbing stream of blood coming out the keyhole in the door at the center; or the large book open to the left, or the pair of large forks placed near an improbable mannequin whose head is composed of a lantern illuminated by a candle.

RAOUL HAUSMANN
Dada siegt
(Dada Wins)
1920,
collage on paper
59.8 x 42.5 cm
Private collection

Hausmann joined
the Dada group in
1918, thanks to his
friendship with the
German poet Richard
Hülsenbeck. In this
composition the
Austrian artist
followed neither
order nor logic in
assembling objects
and figures without
the smallest common
denominator, his
sole purpose being
the amazement and
confounding of the
viewer, thereby
forcing him to look
at a work of art with
different eyes. Among
the many images one
can recognize is the
artist himself, dressed
in hat, elegant coat,
and gloves, standing
in front of an easel on
which is propped up
a photograph of a
street in Berlin. The
number 391, visible
on a building to the
left in the
photograph, refers
to the title of the
Dada magazine
founded by Picabia.
The man to the right
points to a map with
the capitals of Dada:
Paris, Prague, Zurich,
and Berlin. The ball
is a reference to the
Dada magazine
Jedermann seine
eigener Fussball ("To
Each His Football").
Hülsenbeck is in the
foreground in profile,
with his cranium
"uncovered."

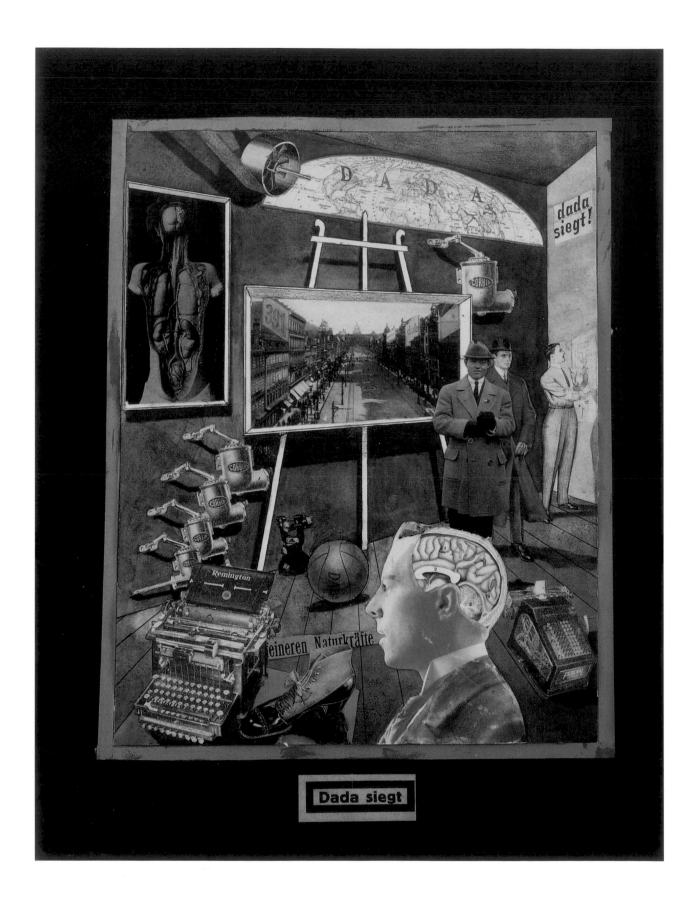

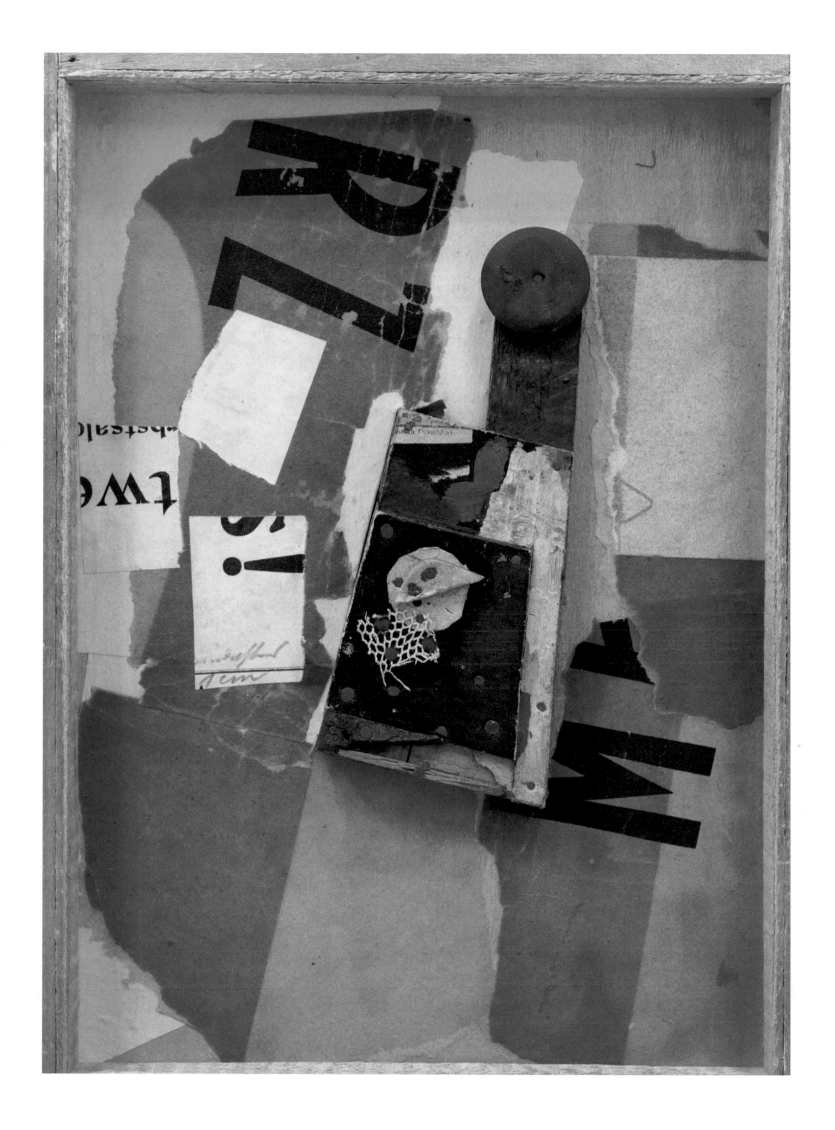

■ KURT SCHWITTERS
Untitled (Merz)
1919–23,
mixed media
28.1 x 20.1 cm
Fondazione
Marguerite Arp,
Locarno

At the end of World
War I, Schwitters
moved to Hanover
and began making
a series of works
entitled *Merz*, from
the fragment of the
word *Kommerz*
("commerce"),
which appeared in
a newspaper clipping
used in a collage.
The *Merzbilder* were
created primarily from
the assemblage of
pieces of wood, bare
or painted, fragments
of newspapers,
tickets, stamps,
labels, and other
disparate materials.
During the same years
Schwitters made
Merzzeichnungen
("Merz drawings"),
Merzplastiken ("Merz
sculpture"), and
Merzbau ("Merz
building"), an
installation composed
of a large quantity
of objects that
Schwitters had
accumulated in his
home. Following
the same principle,
Schwitters composed
literary texts by
putting together
fragments of words
and phrases taken
from the language of
daily life, such as *Die
Sonate in Urlauten*
("Sonata of Various
Primordial Sounds"), a
phonetic poem begun
in 1923 and published
in the magazine *Merz*
in 1932.

he term *surrealism* appeared for the first time in 1917, when Guillaume Apollinaire presented a two-act comic opera entitled *Les Mamelles de Tirésias* ("The Breasts of Tiresias"), calling it a "surrealist drama." The word caught on and was often repeated, sometimes seriously, sometimes ironically, in literary and artistic settings. Between 1919 and 1924 a group of poets and writers, among them Louis Aragon, André Breton, Joan Miró, and Philippe Soupault, founded the magazine *Littérature*. They shared Dada's distrust of rationalism as well as its stance against formal conventions, and they anticipated many of the ideas of Surrealism. In 1922 Breton and Soupault wrote *Les Champs Magnétiques* in which they explored the world of the unconscious and dreams. In 1924 Breton, who was quite familiar

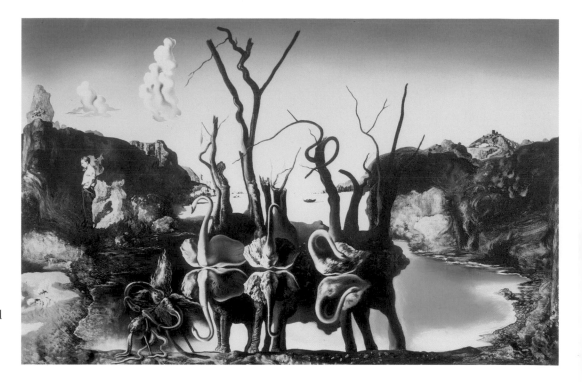

Salvador Dalí,
*Swans Reflecting
Elephants*,1937,
oil on canvas,
51 x 77 cm;
Cavalieri Holding
Co., Geneva

with the psychoanalytic theories of Sigmund Freud, published the "Manifeste du Surréalisme," in which he gave the following definition of Surrealism: "Psychic automatism in its pure state, by which one proposes to express—verbally, by means of the written word, or in any other manner—the actual functioning of thought. It is dictated by thought in the absence of any control being exercised by reason and is exempt from any aesthetic or moral concern."

Various writers, intellectuals, and artists joined the group, including Max Ernst, Yves Tanguy, and André Masson. In November 1925 the Surrealists mounted their first collective show at the Galerie Pierre in Paris, assembled by Pierre Loeb; in the same year a Bureau of Surrealist Research was set up, with headquarters at 15, Rue de

Max Ernst,
Castor and Pollux,
1923, oil on canvas,
73 x 100 cm;
private collection

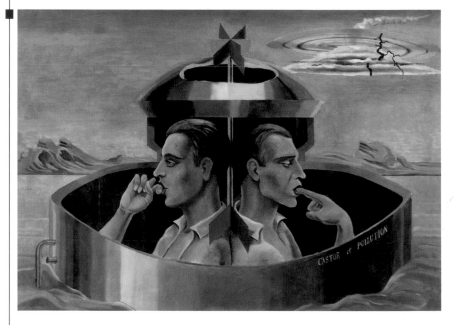

Grenelle, which concerned itself with the publication of the magazine *La Révolution Surréaliste*, the official organ of the movement until 1929. On March 26, 1926, the Galerie Surréaliste opened in Rue Jacques Callot, with an exhibit of sixty works of "primitive" Oceanic art and twenty-four creations by Man Ray. In 1928 Breton published the essay-manifesto *Surrealism and Painting*. Both writers and painters established the basic method of Surrealism: the unconscious procedure of "automatic writing," in which the irrational element dominates the rational, and expresses itself in daring comparisons and paradoxical allegories where apparently irreconcilable realities are joined. The Surrealists adopted a particular technique for the collective creation of poems or paintings called *cadavre exquis* ("exquisite corpse"), on the suggestion of André Breton, and based on an opening line conceived in 1925: *"Le cadavre exquis boira le vin nouveau"* ("The exquisite corpse will drink the new wine"). A member of the group wrote a phrase or made part of a design on a page, folded it to cover the first part of what he had made, and passed it to the next member, who continued the phrase or design without knowing what came before, and so on to all the participants in a game as bizarre as it was irrational. This juxtaposition of very different realities was of essential importance to the Surrealists, who gave it a definition by citing one of their favorite poets, Isidore Ducasse, alias Comte de Lautréamont (1846–1870), who in the sixth of his *Chants des Maldoror* wrote *"Il est beau . . . comme la rencontre fortuite sur un table de dissection d'une machine à coudre et d'un parapluie"* ("It is as beautiful . . . as the fortuitous encounter of an umbrella and a sewing machine on a dissecting table").

The interests of the Surrealists ranged across all artistic and literary disciplines, from poetry to painting to theater to film (examples of Surrealist cinema include *Un Chien Andalou/An Andalusian Dog* of 1929 and *L'Age d'Or/The Golden Age* of 1930, both from the collaboration of Salvador Dalí and Luis Buñuel). They inherited the rebellious and disenchanted spirit of the Dadaists: their aim was to provoke, disorient, and surprise the viewer with a series of images that puts his certainties and habits in crisis and forces him to look at the work of art with a different attitude. Given its anti-logical and irrational character, contrary to all codification and hostile to rules and hierarchies, the Surrealist movement had no homogeneous or unitary structure; it can be said there were as many Surrealisms as there were artists who, to a greater or lesser degree, made Surrealist art. Many were politically active: André Breton, Paul

life of the group was marked by angry arguments, furious battles, and traumatic separations or expulsions, such as that of Dalí in 1940, accused of betraying the revolutionary ideals of the movement and of having "sold out" to art dealers (Breton anagrammed Dalí's name "Avida Dollars").

Among the most important Surrealist exhibits in the 1930s were that of June 1933 at the Pierre Colle gallery in Paris; that of May 22–29, 1936, at the Charles Ratton gallery in Paris; that in the summer of 1936 mounted by Roland Penrose at the New Burlington Galleries in London; that of December 7, 1936, to January 17, 1937, at the Museum of Modern Art, New York—which marked the beginning of

René Magritte, *Pleasure*, 1927, oil on canvas, 74 x 98 cm; Kunstammlung Nordrhein-Westfalen, Düsseldorf

Surrealism

Eluard, Louis Aragon, and Benjamin Péret were members of the Communist party and in December 1929 presented their political ideas in a second Surrealist manifesto, followed by the publication of the magazine *Le Surréalisme au Service de la Révolution*, which was printed until 1933. In 1935 the pamphlet *Political Position of Surrealism* was printed, followed in 1938 by *For an Independent Revolutionary Art*, signed in Mexico City by Breton and Leon Trotsky.

The leading figures in the movement often found themselves in open conflict, whether for stylistic reasons or divergent political opinions; the

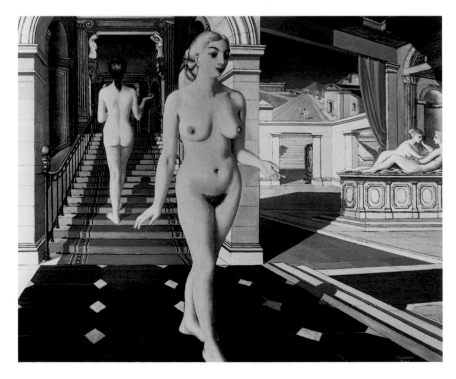

the movement's popularity and commercial fortune in the United States—and that of 1938 at the Galerie des Beaux-Arts in Paris. In October 1942 two events awakened particular interest: the show "First Papers of Surrealism" at the Whitelaw Reid Mansion in New York, organized by Breton on the invitation of Elsa Schiaparelli and mounted by Marcel Duchamp, and "Art of This Century" at Peggy Guggenheim's Art of New York Gallery, with its unusual presentation designed by Frederick Kiesler. There were also two particularly important magazines: *Monotaure*, from 1933 on, and *VVV*, printed in the United States beginning in 1942.

Paul Delvaux, *The Stairs (Nude at the Stairs)*, 1912–46, oil on panel, 122 x 152 cm; Museum voor Schone Kunsten, Ghent

MAX ERNST
**Long Live Love
(Pays Charmant)**
1923, oil on canvas
131.5 x 98 cm
Saint Louis Art
Museum, Saint Louis

Early in the 1920s
Ernst studied the
Metaphysical art of
Giorgio de Chirico and
translated in his own
painting his youthful
studies of philosophy,
art history, and
psychiatry at the
University of Bonn,
to which he added his
direct experience of
psychiatric hospitals.
He visited Paris for
the first time in 1920
and moved there in
1922. Nineteen
twenty-three proved a
crucial year in Ernst's
art, marking his
passage from Dadaism
to Surrealism thanks
to his friendship with
Breton and Eluard,
who inspired him
to insert themes
drawn from dreams
and from the
unconscious in his
compositions. There
are clear symbolic
references in this
canvas and more or
less veiled allusions
to Freud's theories
on sexuality,
unconscious desires,
and hidden drives.
There is also the
typical Surrealist
procedure of
locating a situation
involving thoroughly
imaginary figures in
a real context, in
this case a field
under a clear sky.

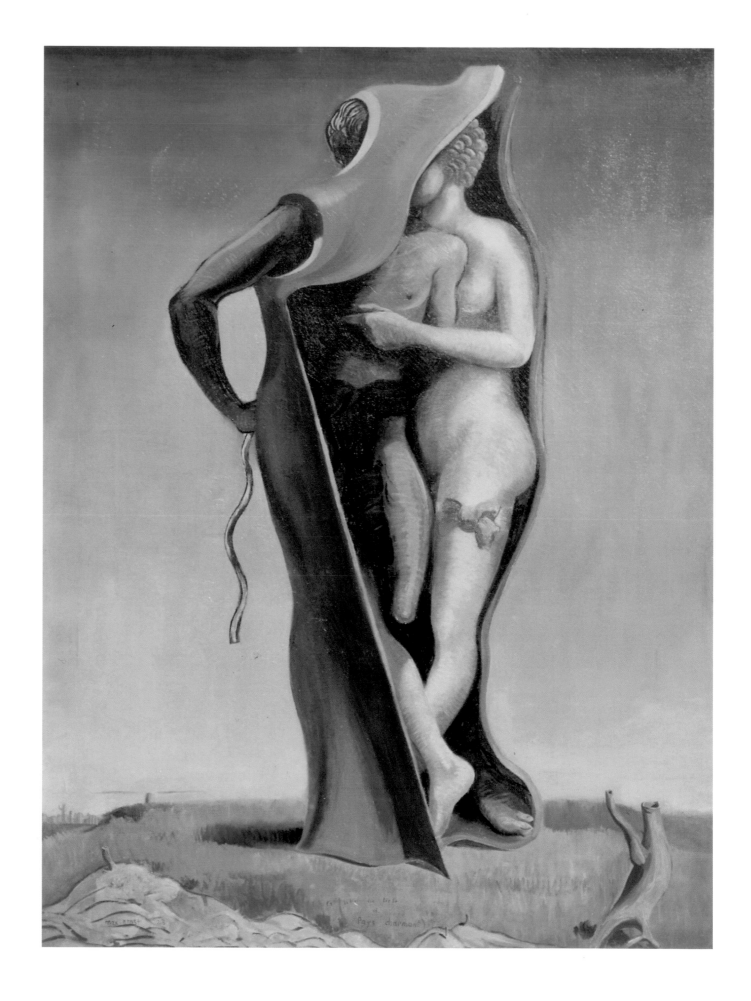

Surrealism

■ MAX ERNST
The Couple
(The Embrace)
1924, oil on canvas
73 x 54 cm
Private collection

After experimenting in various techniques, in particular collage and frottage—rubbing materials like wire, leaves, lead, or charcoal over paper laid on an irregular surface to obtain colors, texture or images—Ernst returned to the classic technique of oil paints on canvas, in articulated and complex compositions, works at once complex, evocative, and fantastic. In this work he disorients the viewer by transforming a quite ordinary situation, the embrace of a man and woman, into an irrational depiction, both ambiguous and enigmatic. The bodies and clothing of the two figures seem to be fused in a single monstrous organism, with outsized arms and hands, in a precarious figurative and chromatic balance. Their faces have undergone a metamorphosis similar to that in the Cubist portraits by Picasso, and even the setting contributes to giving the impression of a spectral vision or nightmare.

RENÉ MAGRITTE
Age of Wonder
1926, oil on canvas
120.6 x 80 cm
Sammlung Würth,
Künzelsau

This painting was
exhibited at the
personal show that
Magritte held from
April 23 to May 3,
1927, at the Le
Centaure gallery in
Brussels, where he
presented forty-nine
Surrealist canvases.
Critics were struck
by his unreal
and irrational
atmospheres, and
at the same time
intrigued by his
imagination and
inventive abilities.
The setting of this
canvas recalls several
Metaphysical scenes
by de Chirico, while
the insertion of
mechanical parts in
the body of the young
girl in the foreground
was inspired by the
creations of Max Ernst
and Francis Picabia.
The landscape painted
on an easel is a
theme that Magritte
would repeat with
numerous variants in
the coming years. The
work's title seems to
be a programmatic
declaration, since it
expresses the
painter's desire not
to depict actual
situations but to
create fantastic
settings able to
astonish and amaze
the viewer.

■ René Magritte
Black Magic
1936, oil on canvas
73 x 54 cm
Galerie Brusberg,
Berlin

Magritte worked in two types of Surrealism, visual and conceptual. He enjoyed amazing the viewer by showing him paradoxical situations such as a tuba in flames or a house immersed in the black of night beneath a pale sky. He played with forms and colors, creating surprising visual illusions. For example in the painting *The Red Model II* (Edward James Foundation, Chichester), he depicts two boots, the lower parts of which become human feet. At the same time Magritte sought to awaken reflection on the meaning of art and its role. In the painting *Ceci n'est pas une pipe* (Los Angeles County Museum of Art, Los Angeles), he painted a pipe and added the phrase that gives the work its title ("This is not a pipe"), raising serious questions about the relationship between painting and reality. Magritte applied to painting the theories of the poet Pierre Reverdy, according to whom a poetic image arises from the matching of extraneous, apparently irreconcilable elements. The greater the distance between the two realities, the stronger and more incisive will be their lyrical union.

SALVADOR DALÍ
**The Persistence
of Memory**
1931, oil on canvas
24 x 33 cm
Museum of Modern
Art, New York

Dalí's relationship with Gala, wife of Eluard, led to the final break between Dalí and his father. No longer willing to go to his father's home at Cadaqués, the two lovers bought a fisherman's house at Port Lligat. There Dalí made this famous painting, which he exhibited with another twenty-three works at the Pierre Colle gallery in Paris in June 1933, and the next year at the large Surrealist retrospective in New York. Dalí sets the scene in a landscape at sunset near Port Lligat and places his own enormously deformed self-portrait at the center, making clear the oneiric setting of the work. The famous limp watches, a result of Dalí's observation of melting Camembert cheese, are emblematic of what he called his "paranoiac-critical" method: In his eyes they are symbolic of how time devours everything and is then in turn corroded and consumed by reality, represented by the ants.

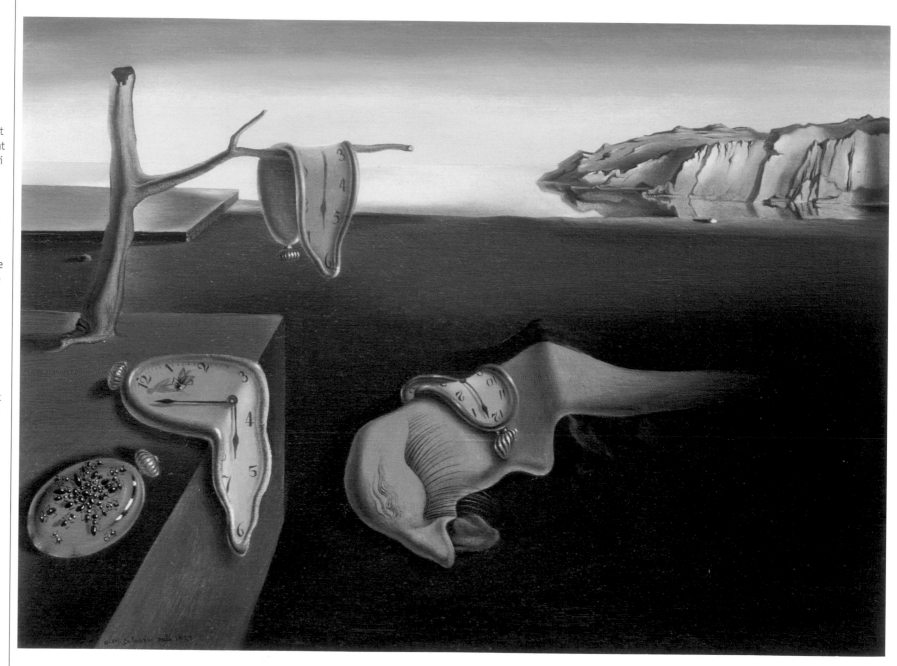

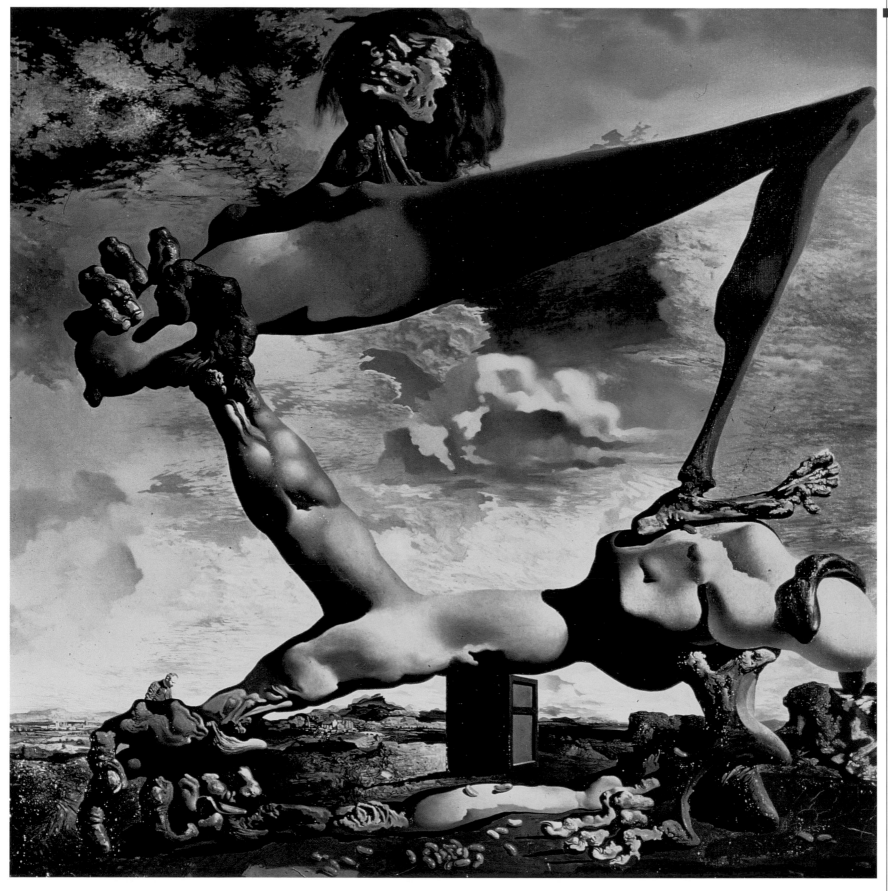

Despite the example
of his father, a
freethinker and
supporter of Catalan
federalism, Dalí
was not politically
active. In fact, his
detachment from the
social questions of
the time was one of
the principal sources
of friction between
him and Breton and
the other Surrealists
and was decisive in
causing his expulsion
from the movement.
In 1936, at the
outbreak of the
Spanish civil war,
Dalí was working on
a canvas called *Soft
Construction with
Boiled Beans*. Worried
about the threatening
events, he partially
reworked the subject
and transformed it
into a sad and tragic
vision in which an
enormous human
body, monstrously
deformed, becomes
a symbol of the
gratuitous and
irrational violence of
war with which
humanity tears itself
apart. The vivid colors
and the cold light
that illuminates the
deserted landscape
accentuate the
sensation of delirious
and anguished
desperation.

SALVADOR DALÍ
**The Family of the
Marsupial Centaurs**
1940, oil on canvas
35.6 x 31 cm
Private collection

Following the
outbreak of World
War II Dalí went to
the United States,
staying there from
1940 to 1948, during
which time he made
this painting. Dalí
conceived it as an
homage to Otto
Rank, the Viennese
psychoanalyst and
student of Freud who
died in New York,
in 1939. Dalí likely
drew inspiration from
Rank's book *The
Trauma of Birth*,
published in 1929,
which includes many
references to the
myths of ancient
Greece, and in
particular to half-
human and half-
animal beings, such
as the sphinx and
the centaurs,
presented here. The
organization of the
masses recalls Dalí's
discussions with
Matila Ghyka,
professor of
aesthetics at the
University of
Southern California
and author of two
essays, *The Geometry
of Art and Life* and
The Golden Number.
Here one can note
that the bodies of
the centaurs (for
example, one of
the rear legs) are
arranged along the
two diagonals of
the painting. With
this method, amply
explained by Ghyka,
Dalí accentuated the
dynamic rhythm of
the entire
composition.

■ SALVADOR DALÍ
Dream Caused by the Flight of a Bee around a Pomegranate a Second before Waking Up
1944, oil on canvas
51 x 41 cm
Museo Thyssen-Bornemisza, Madrid

At the center of this composition Dalí presents his wife, Gala, supine atop one of the reefs of Port Lligat in a position that recalls that of the *Birth of Venus* by Alexandre Cabanel (Musée d'Orsay, Paris). Beneath her are a pomegranate and a bee, the buzzing of which she hears while unconscious. The sound sets off a sequence of dream responses in her mind, including that of the sting of the insect, which takes the form of the point of a bayonet stabbing her in the arm. The intense pain results in hallucinations, such as the ferocious tigers (taken from a Barnum & Bailey circus poster) leaping from the mouth of a fish (similar to that in Bosch's *Temptation of St. Anthony*, today in the Museu Nacional de Arte Antiga, Lisbon), which in turn has sprung from a pomegranate. In the background is an elephant with an obelisk, a deformation of the sculpture of an elephant bearing an obelisk on its back by Gian Lorenzo Bernini in Rome's Piazza della Minerva.

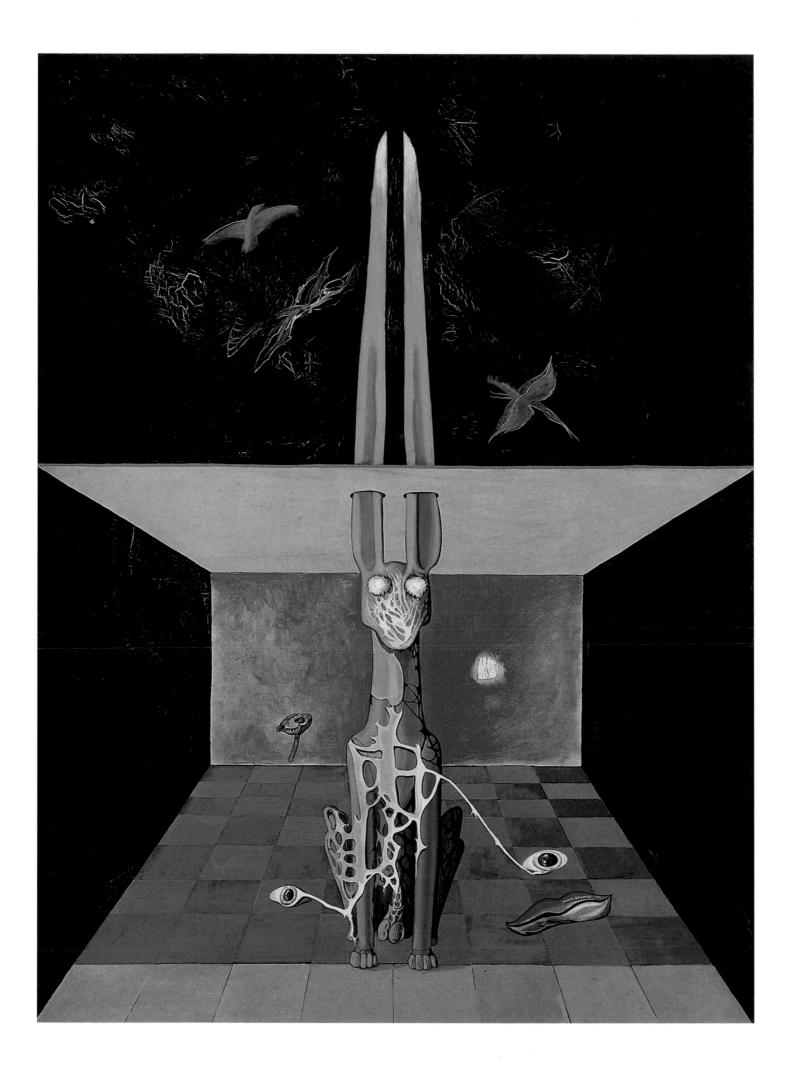

■ VICTOR BRAUNER
The Prestiges of the Air
1934, oil on canvas
130 x 96.5 cm
Private collection

The Romanian painter and sculptor Brauner arrived in Paris in 1930 and met Yves Tanguy and Alberto Giacometti, who introduced him to the Surrealist group. In particular, he followed the examples of Max Ernst, Paul Klee, and Giorgio de Chirico. This painting was exhibited at his first one-man show, held in 1934 at the Pierre Loeb gallery; Breton wrote the introduction to the catalogue. This canvas reveals first of all the influence of the artist's father, a believer in spiritualism who gave his son a lasting passion for the exotic and the occult. A second relevant aspect is the theme of metamorphosis. The figures in Brauner's paintings tend to be bizarre creatures similar to ritual totems that blend animal, mineral, vegetal, and human components. His fantasy universe is populated by nightmares, phantoms, specters, and mysterious figures of arcane symbolism; the meaning is often obscure and indecipherable.

ÓSCAR DOMÍNGUEZ,
REMEDIO VARO,
ESTEBAN FRANCÉS
Exquisite Corpse
1935, collage
27.3 x 20 cm
Private collection

The "exquisite corpse" is a typical expression of the concept of "automatism" in Surrealist art, according to which the painter must avoid the intentional intervention of reason and instead give free rein to his unconscious. The procedure involves a group of artists making a text or picture phrase by phrase or image by image, each contributing his part without knowing what the others have done in such a way that the sum of the parts is thoroughly accidental and irrational. In this work three Spanish painters used the technique of collage, invented by the Cubists and the Futurists. They amused themselves in placing together images that were very different, deliberately strange, ambiguous, and mysterious, thus challenging the viewer to find a connection among the various parts and give a unitary sense of the whole. The first owner of this work was the painter Marcel Jean, author, in 1935, of another *Exquisite Cadaver*, made together with three artists and today held in the Museum of Modern Art, New York.

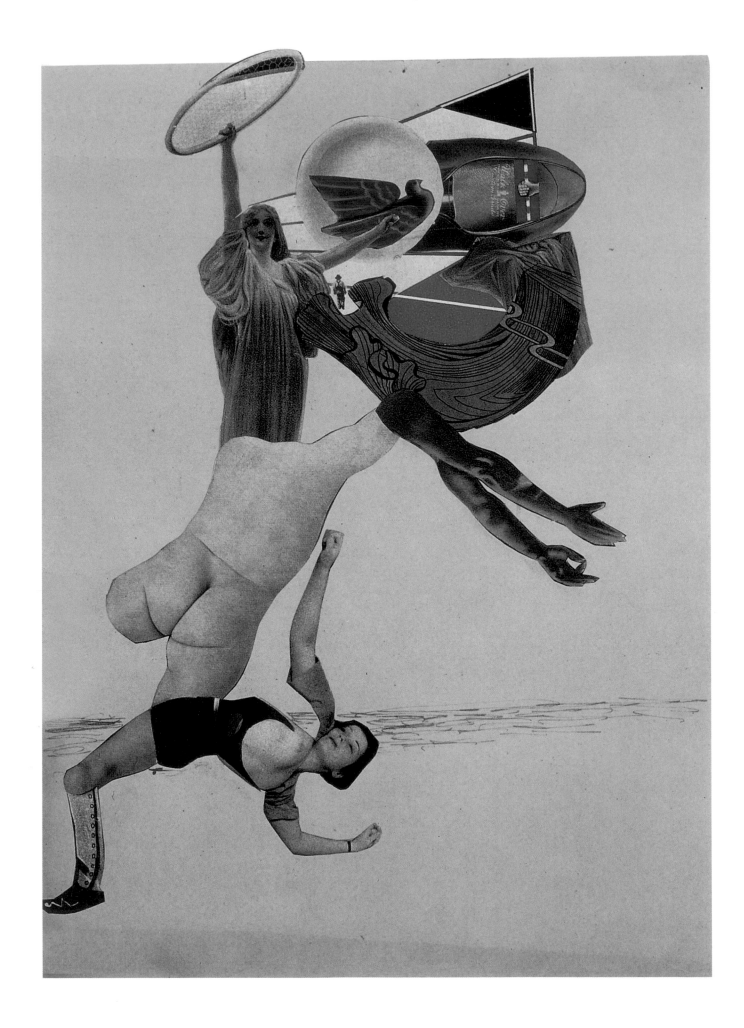

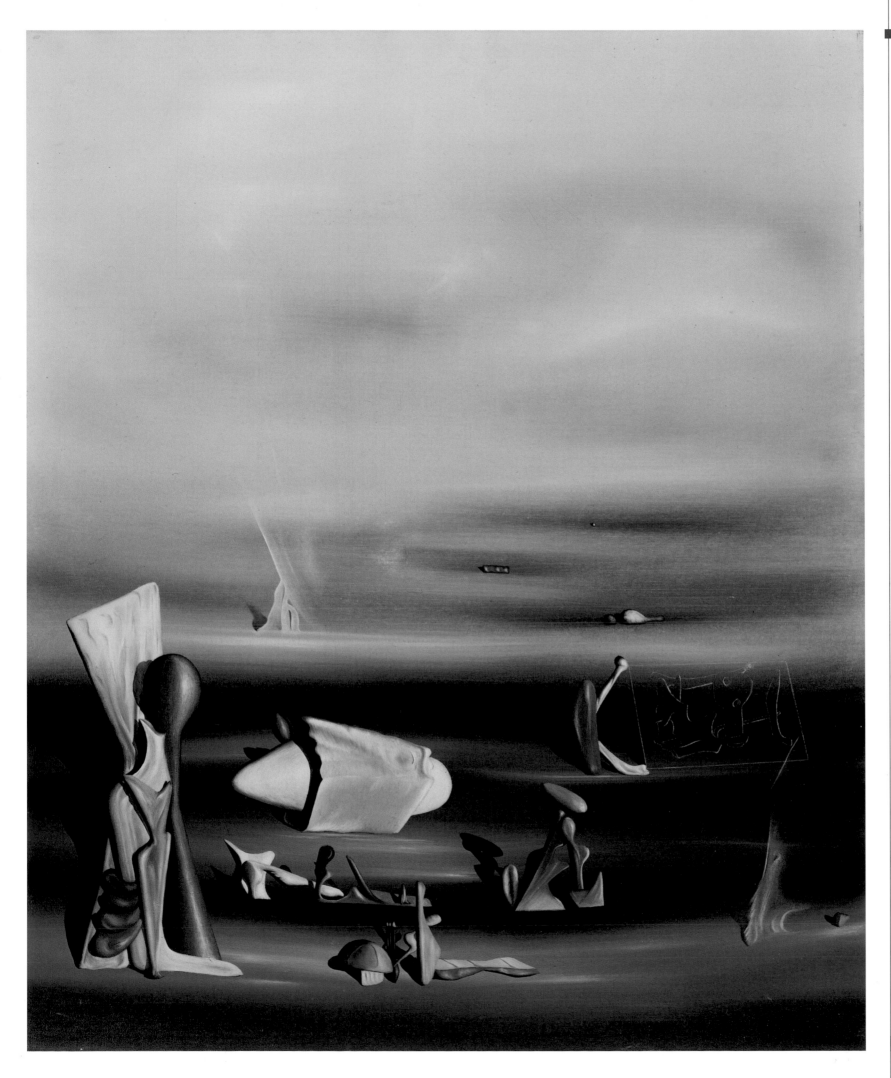

YVES TANGUY
Construct, Destroy
1940, oil on canvas
71 x 58.5 cm
Galleria
Internazionale
d'Arte Moderna di
Ca' Pesaro, Venice

Tanguy joined the
Surrealist movement
in 1925 and the
following year began
painting his famous
"psychoanalytic
landscapes,"
suggested by the
Metaphysical
paintings by de
Chirico. The desolate
desert setting makes
one think of other
planets, populated
by strange beings
vaguely biomorphic,
mysterious, and
disturbing. Their
nature and meaning
remain deliberately
obscure; the title,
instead of clarifying
the sense of the
composition, only
further disorients and
confuses the viewer.
These are not actual
places, situations, or
objects (although the
artist sometimes
includes references to
childhood memories
of landscapes); the
reference is explicitly
to the unconscious
world of dreams. The
use of intense, cold
colors gives the
scene the sensation
of extreme and
oppressive silence,
of indifference
and solitude.

JOAN MIRÓ
Nude
1926, oil on canvas
92 x 73.6 cm
Philadelphia Museum
of Art, Louise and
Walter Arensberg
Collection,
Philadelphia

In 1926 Miró
collaborated with
Max Ernst on the
scenery for *Romeo
and Juliet* performed
by the Ballets Russes
of Serge Diaghilev
and spent several
months at Montroig,
in Tarragona, Spain,
during which he
made "fantastic
landscapes" and
other compositions,
including this one.
Gifted with a fervid
imagination, he
simplified reality to
its minimal terms
and transformed it
into spectacular
symbolic images,
in which the design
and colors lose their
descriptive capacity
and acquire an
evocative power
similar to that of
poetry and music.
In a letter to Michel
Leiris of August, 10,
1924, Miró wrote,
"Surrealism frees the
unconscious, exalts
desire, gives greater
power to art . . .
I painted as in a
dream, in the most
complete freedom."

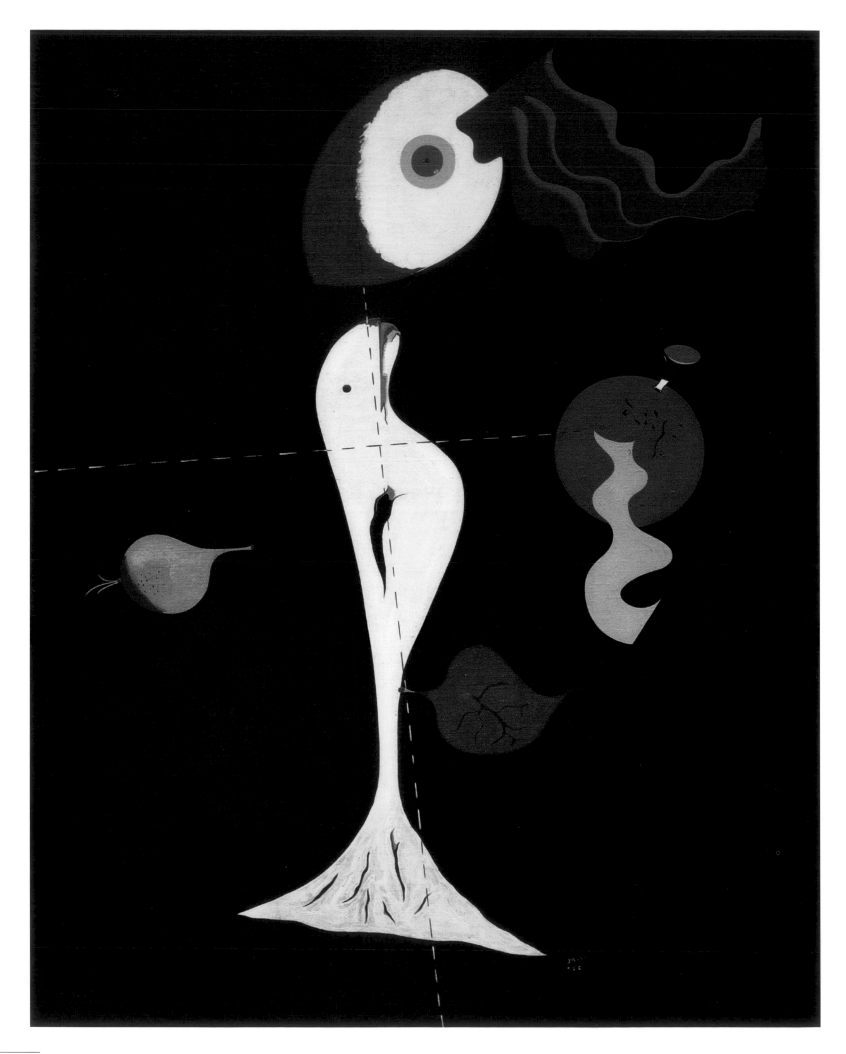

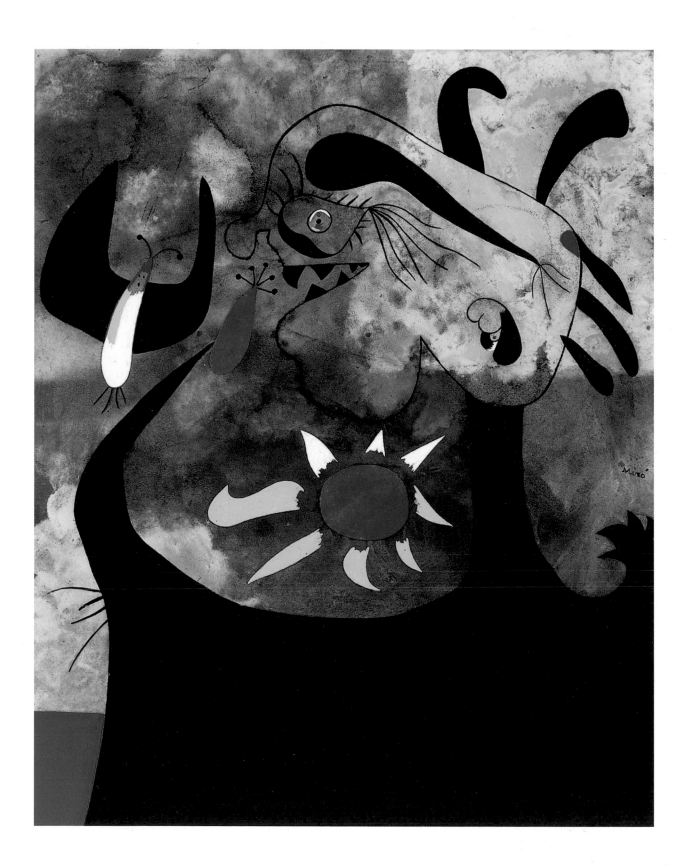

■ JOAN MIRÓ
Woman Tormented by the Sun Who Recites Poems Melted into the Geometric Shapes of the Musical Flight of a Bat Born on the Sea
1939, oil and gouache on paper
40.7 x 33 cm
Private collection

At the outbreak of the Spanish civil war Miró took refuge in France, where he continued his painting and his political activities (for example, the *Aidez l'Espagne* poster). Like Tanguy, he created his own fantasy universe inhabited by bizarre, vaguely biomorphic creatures; his work, however, is characterized by bright and lively colors and by an amused and happy atmosphere, sometimes ironic, sometimes satirical. A many-faceted and versatile artist, Miró blended citations from Old Masters with children's drawings, alternating figurative and abstract elements, put grotesque and violent visions together with those delicate and intensely lyric, and played on chromatic contrasts and the union of opposites. The work reproduced here reveals the poetics of Breton, with whom Miró collaborated in the 1940s on the popular series of *Constellations*.

HANS BELLMER
A Thousand Girls
1939, oil on panel
48.5 x 30 cm
Private collection

In 1938, after the
death of his first
wife, Marguerite,
Bellmer moved from
Berlin to Paris, where
he was welcomed by
his friends Paul Eluard
and André Breton,
who introduced him
to Max Ernst, Man
Ray, Jean Arp, Marcel
Duchamp, and Yves
Tanguy. During those
years Bellmer was
working on a series
of female figures
whose bodies, as
in this work, were
composed of
numerous anatomical
details, often
repeated several
times and shown
from different points
of view. Bellmer freely
drew his inspiration
from the works of
Giuseppe Arcimboldi,
active in the 16th
century and famous
for this kind of
illusionistic painting,
both fantastic and
highly detailed.
Bellmer explored
what he called
the "physical
unconscious,"
which consisted
of the arbitrary
decomposition and
recomposition of the
images a man thinks
of when imagining
his own body or that
of a woman, the
object of his desire.

■ PAUL DELVAUX
Sleeping Venus
1944, oil on canvas
173 x 199 cm
Tate Gallery, London

Delvaux joined the Surrealist movement in 1935. His paintings show the influence of the dreamy atmospheres of Magritte and the Metaphysical compositions of de Chirico. This scene is set in an imprecise ancient city, perhaps a site in Magna Graecia. In the foreground is the sleeping Venus who gives the painting its title. Observing her serene and relaxed face the viewer becomes aware that the goddess is completely unaware of what is happening around her, the meaning of which is difficult to assess. The artist has located a skeleton and a woman in modern dress to the left of the canvas; to the right and in the background are nude women, apparently suffering sorrow and desperation. The scene is deliberately enigmatic, obscure, and without hints offering a solution. It is up to each viewer to free his or her imagination so as to give an identity to the figures and a meaning to their actions.

The history of Italy between the world wars was marked by the birth of Fascism and the creation of a dictatorial regime led by Benito Mussolini. Italian intellectuals and artists lost their independence in the face of this political power, which sought to control every aspect of their expression. In June 1925, on a proposal from Giovanni Gentile, minister of public education, the National Fascist Institute of Culture was founded; work started that same year on the *Enciclopedia Italiana*, while in 1926 the Reale Accademia d'Italia was created for the purpose of directing and controlling all intellectual activity while suffocating every form of

Mario Sironi,
Urban Landscape,
circa 1920,
oil on canvas,
44 x 60 cm;
Pinacoteca di Brera,
Collezione Jesi, Milan

never undertook a united repressive action against the members of the artistic avant-garde, and the control of artists was left to the discretion of individual officials, who applied the rules in a more or less rigid manner. In many magazines, such as *Critica Fascista* and *Gerarchia*, the cultural debate was relatively open to criticism and contrary opinion, and articles not perfectly in line with the official directives were sometimes printed. The fact remains, however, that in a short time the fine arts union, directed by Cipriano Efisio Oppo, had a monopoly on the major exhibitions in both public and private spaces. Between 1927 and 1939 it directly supervised the

Art in Italy between

dissent. In exchange for loyalty to the regime, academy members received a high salary and enjoyed many privileges; the most famous members included Gabriele D'Annunzio, Filippo Tommaso Marinetti, Luigi Pirandello, Guglielmo Marconi, Ottorino Respighi, Adolfo Wildt, Felice Carena, and Marcello Piacentini. Between 1928 and 1931 the structure of the Confederazione Nazionale dei Sindacati Fascisti was reworked and the Confederazione dei Professionisti e degli Artisti was created. In order to exhibit works, an artist had to be a member of this guild, and guild membership required membership in the national Fascist party as well as proof of "good moral and political conduct." Unlike what happened in Germany, the Fascist regime

Mario Mafai,
Models in the Studio,
1940, oil on canvas,
165 x 126 cm;
Pinacoteca di Brera,
Milan

mounting of more than three hundred shows. In 1926 Antonio Maraini replaced Vittorio Pica as the general secretary of the Venice Biennale, the most prestigious and famous art show in Italy at the international level, which in 1928 was transformed into a state-run institution, financed and controlled from Rome. Giuseppe Volpi di Misurata was made president, and a determinant role was played in the directing council by Margherita Sarfatti, a rich Milanese who was one of the leading cultural personalities in Italy during the period and was also involved in a love affair with Mussolini. Two other prestigious institutions during those years were the Triennale of Milan and the Quadriennale of Rome. The first was planned in 1919 and was inaugurated by Mussolini in 1923; originally called the International Biennale of Decorative Arts, with headquarters in Monza, in 1930 it was renamed the International Triennale of Decorative and Modern Industrial Arts. In 1933 it was moved to Milan with the new name of International Triennale of Decorative and Modern Industrial Arts and Modern Architecture. Its executive council boasted such leading lights as Mario Sironi, Carlo Carrà, and Margherita Sarfatti. The Quadriennale of Rome was created in

December 1928 to be the leading exhibition of Italian national art and was inaugurated by Mussolini in 1931. The selection commission was directed by Cipriano Efisio Oppo and included among its members Felice Carena, Ferruccio Ferrazzi, Giorgio Morandi, Adolfo Wildt, and Aldo Carpi. In the second half of the 1920s and early 1930s the most widespread art movement in Italy was the Novecento Italiano, which, thanks to the special relationship between Mussolini and Margherita Sarfatti, sought (in vain) recognition as the official art of the regime. The Novecento was based on ideas drawn from European avant-garde movements of the opening of the century, first

sculpture, architecture, and the decorative arts. Early in the 1930s Margherita Sarfatti gradually lost her sway over Mussolini, and the Fascist regime assumed an increasingly rigid and intolerant attitude toward the arts. Examples of this are the attacks that Roberto Farinacci unleashed in 1929 at the Novecento group and the directives emanated by Galeazzo Ciano in 1933, with the later institution of the Ministry of the Press and Propaganda (renamed Ministry of Popular Culture in 1937), which imitated the methods employed by Joseph Goebbels in Germany. Lavish prizes were offered to get artists to adhere to the party line, such as the Cremona Prize,

the World Wars

among them Futurism, but at the same time it reflected the cultural climate of the time in Europe, characterized by faith in realism and the *rappel a l'ordre*—the call for a "return to order"—understood as the defense of artistic traditions against the iconoclastic and nihilistic fury of the Dadaists. The original nucleus of the Novecento group was composed of seven painters: Anselmo Bucci, Leonardo Dudreville, Achille Funi, Gian Emilio Malerba, Piero Marussig, Ubaldo Oppi, and Mario Sironi, all habitual visitors to the gallery of Lino Pesaro in Milan. In the 1924 Venice Biennale Margherita Sarfatti succeeded in having a hall reserved for the members of the group, which enjoyed its period of greatest development between the first and second edition of the Mostra d'Arte del Novecento Italiano, held in Milan in 1926 and 1929. Many Italian artists joined the movement, some out of sincere belief, some for convenience, all of them faithful to it to a greater or lesser degree. Their numbers enriched it with new experiences and ideas, not only in painting but in

instituted by Farinacci in 1939, which can be taken as symbolic of the efforts of the central authority to control artistic life in Italy. To win the prize artists had to make paintings on certain fixed subjects, such as "Listening to a speech by Il Duce on the radio," "the battle for wheat," or "the new Europe emerging out of bloodshed." In that same year, however, Giuseppe Bottai, minister of national education, created the Bergamo Prize, which numbered among its jurors Cornelio Di Marzio, Achille Funi, Felice Casorati, and Giulio Carlo Argan, and in which the most important artists of the period took part, seeing this event as their major opportunity to freely express their art. There was also the Corrente movement, which between 1938 and 1941 struggled to renew Italian culture in light of international experiences. The defeat of Italy in World War II marked the end of the Fascist regime: Giovanni Gentile, president of the academy in 1943, was killed by partisans on April 15, 1944; Marinetti died on December 2 of the same year.

Midday
(Meriggio)
1922–23,
oil on panel
120 x 130 cm
Civico Museo
Revoltella, Galleria
d'Arte Moderna,
Trieste

At the end of World
War I Casorati moved
to Turin, where he
became one of the
leaders of that city's
cultural life. This
panel was first
presented at the
fourteenth Biennale
of Venice, at which
Casorati was given a
hall to himself. The
Museo Revoltella of
Trieste bought the
work for 20,000 lira.
In the introductory
text of the catalog,
Lionello Venturi called
attention to the
innovative style:
"Look at *Midday* and
you will see in the
figure seen from
behind, in the
slippers, in the hat,
a consistency of
volume that is the
same as the depth
of the color. All the
forms are perfectly
solid, firmly immersed
in the atmosphere."
In particular Casorati
sought to obtain a
balance among the
masses and in the
distribution of light,
so as to create a
composition
apparently simple,
severe, and orderly
but in reality highly
complex.

■ FELICE CASORATI
Silvana Cenni
1922,
tempera on canvas
205 x 105 cm
Private collection

This painting was first exhibited, under the title *Giovanna*, at Buenos Aires in 1923; it was then exhibited at the Carnegie Institute of Pittsburgh in 1924, Philadelphia in 1925, and Leipzig in 1929, not being shown in Italy until the twenty-sixth Venice Biennale in 1952. The work, which depicts an imaginary figure—for which one of Casorati's students, Nella Marchesini, posed—immediately found itself at the center of a heated critical debate. On one side was Piero Gobetti, who called it "a defective painting, broken by too many imbalances"; on the other was Lionello Venturi, for whom the work "assumes the appearance of particular gravity and dignity, the result of its perfectly organic construction, while at the same time it suggests sweetness through the delicacy with which the shadows are illuminated." Many critics later took note of the woman's austere and solemn—almost monumental—pose, her collected and meditative air, and the work's references to classical art, beginning with the works of Piero della Francesca.

The Daughters of Lot
1919, oil on canvas
110 x 80 cm
Ludwig Museum,
Cologne (in deposit
at the Museo d'Arte
Moderna e
Contemporanea,
MART, Rovereto)

After his experiences
with Futurism and
Metaphysical art,
Carrà contributed to
the magazine *Valori
Plastici*, founded by
Mario Broglio, and
became one of the
outstanding
proponents of the so-
called "return to
order," which was
expressed in
figurative painting
with classical,
traditional layouts.
During this period
Carrà devoted close
attention to classical
Italian art, in
particular Giotto and
the 15th-century
masters, as he
revealed in his
"Discourse on Giotto
and Paolo Uccello,"
published in *La Voce*
in 1916. This painting
was presented at the
third Rome Biennale
in 1925. Certain
elements recall the
climate of
Metaphysical art, such
as the building in the
background, the
flooring, and most of
all the stately poses
of the two women.
Their gestures are
deliberately obscure,
and aside from the
title, nothing offers
help in identifying
them and attributing
a precise meaning to
their actions.

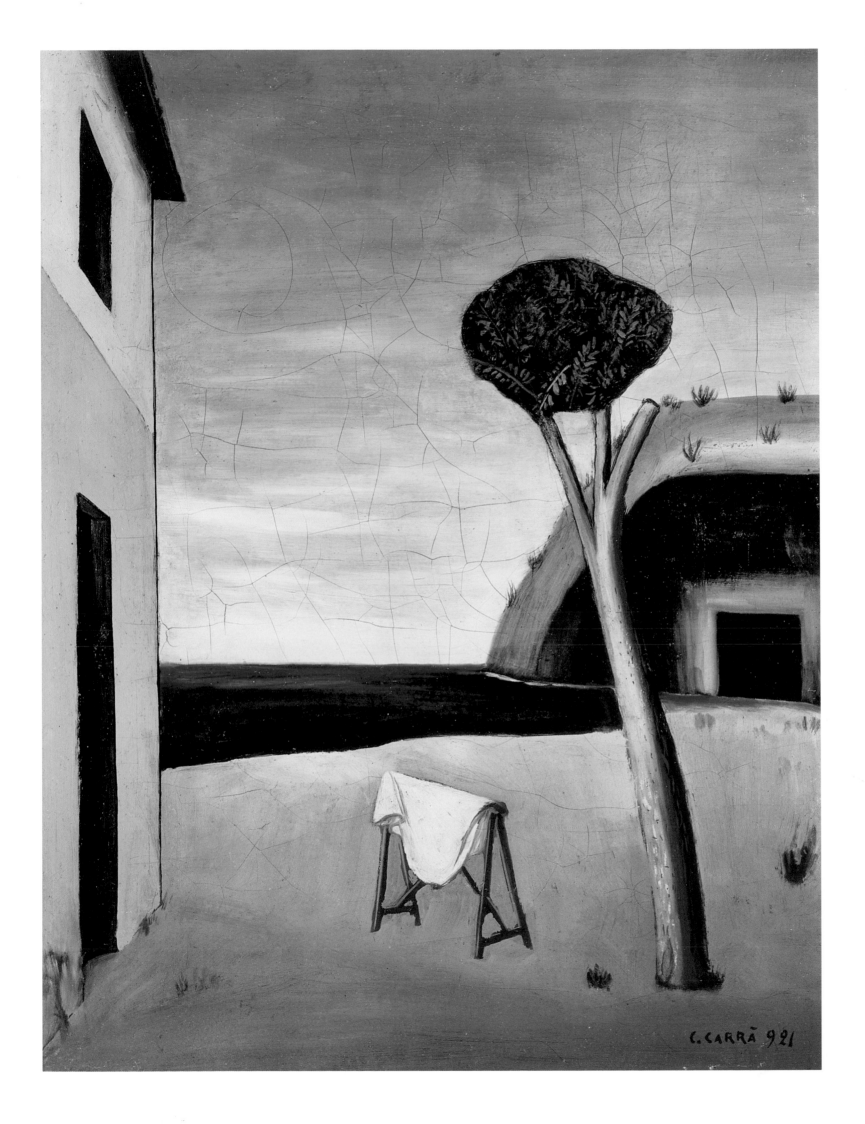

CARLO CARRÀ
Pine by the Sea
1921, oil on canvas
68 x 52.5 cm
Private collection

Subtle reminders of Carrà's Metaphysical period show up in this canvas, beginning with its atmosphere of silence and solitude. The white cloth draped over the sawhorse, reminiscent of a winding sheet, and the square opening to the right, which recalls the opening to an ancient tomb, could be taken as symbolic allusions to the mystery of death and resurrection. Carrà made numerous landscapes during the early 1920s, most of all in Valsesia and Garfagnana, reworking in a personal way the formal simplifications of Cézanne. Here he applies the organization of space theorized by the masters of the early Renaissance: the solid and dense structure of the pine in the foreground infuses a reassuring sense, while the presence of the house to the left and the hill to the right can be seen as the expression of the artist's desire to find peace and inner calm in nature. In 1925 Wilhelm Worringer dedicated an essay to this painting entitled *Wissen und Leben* ("To Know and to Live"), in which he presented this work as an example of a new and harmonious balance between artist and subject.

FILIPPO DE PISIS
Composition with Mortar, Shells, and Fish
1925, oil on panel
53 x 70 cm
Private collection

This painting was among the last de Pisis made in Rome, shortly before his stay in Paris. The particular atmosphere that animates the entire composition and the placement in the foreground of such a variety of objects recall the Metaphysical works by de Chirico, Savinio, and Carrà, but the use of color and the firm design already denote a mature personal style.

GIORGIO MORANDI
Still Life with Bottles
1929, oil on canvas
40 x 53 cm
Private collection

After his brief Metaphysical period, Morandi returned to his own very personal style, working almost in isolation and apparently outside the cultural debate taking place around him. He made several series of landscapes at Grizzana and Roffeno, vases of flowers, and still lifes in which he revealed his rigorous, methodical, almost maniacal attention to the relationships among individual objects, their masses and colors, and the effects of light on their surfaces.

Art in Italy between the World Wars

■ GIORGIO DE CHIRICO
Gladiators at Rest
1928, oil on canvas
183 x 123 cm
Private collection

This painting was exhibited, *hors concours*, at the second edition of the Bergamo Prize, in 1940, together with *Room of the Gladiators*, made in 1927 (private collection); the two canvases were part of the collection of Léonce Rosenberg and decorated the Hall des Gladiateurs in his Parisian home, known as the Maison Dorée. The nearly three hundred paintings de Chirico made in Paris between 1925 and 1930 mark a turning point in his career; he gradually abandoned Metaphysical notions, joined and then broke with the Surrealists, and finally discovered classical art, creating a series of works inspired by classical, historical, and mythological themes, such as horses running along the seashore and gladiators. The standing figure in this canvas recalls the faceless mannequins of the Metaphysical period, while the sculptural form of the seated gladiator makes an explicit reference to Renaissance painting.

SCIPIONE
Piazza Navonna
1930, oil on panel
80 x 82 cm
Galleria Nazionale
d'Arte Moderna, Rome

Scipione was one of
the promoters of the
"Roman school"—also
known as the "Via
Cavour school"—
together with Mario
Mafai and Antonietta
Raphaël Mafai, the
sculptor Marino
Mazzacurati, and
several critics and
writers, among them
Giuseppe Ungaretti.
These artists drew
inspiration for their
works from themes
of baroque culture
but at the same time
used warm, intense
colors similar to those
of the Expressionists.

MARIO SIRONI
**Classical Composition
with Colosseum**
1934, oil on panel
54 x 69 cm
Private collection

On January 11, 1920,
together with
Dudreville, Funi,
and Russolo, Sironi
published the
"Manifesto against All
Returns in Painting";
during the coming
years he was among
the founders of the
Novecento group, and
in 1933 he published
the "Manifesto of
Mural Painting." In
his works of the
1930s he abandoned
his Futurist and
Metaphysical efforts
to adopt an archaic
and classical style in
which the forms are
simplified and the
subjects freely drawn
from myth and
ancient history.

Art in Italy between the World Wars

■ CARLO LEVI
Figure of a Woman
1934, oil on canvas
54 x 64.5 cm
Raccolta d'Arte
Contemporanea
Alberto della Ragione,
Florence

Having earned a
degree in medicine,
Levi began to paint
under the guidance of
Felice Casorati, and in
1929 took part in the
"Six Painters of Turin"
show, which was in
opposition to the
Novecento group. A
Jew and a member of
the clandestine
antifascist movement,
Levi was arrested in
the spring of 1934
and, in May 1935,
was condemned to
two years of exile in
Lucania, as evoked
in his famous novel
*Christ Stopped at
Eboli*, first published
in 1945.

■ GIUSEPPE MIGNECO
**Shepherds of
the Island**
1940, oil on canvas
70 x 90 cm
Galleria Nazionale
d'Arte Moderna, Rome

This painting,
presented for the
Bergamo Prize and
bought by the
minister of national
education in 1941,
testifies to the
Expressionist style
of Migneco, one of
the exponents of the
artistic movement
Corrente. Active
between 1938 and
1941, this movement
sought to avoid the
isolation of Italian
culture and aspired
to greater openness
to ideas from
international avant-
garde movements.

FORTUNATO DEPERO
The Magician's House
(A Medianic-mechanic Vision of My Atelier)
1920, oil on canvas
150 x 260 cm
Private collection

This canvas presents the interior of the Casa d'Arte Depero at Rovereto, a small artisan's workshop in which the painter, aided by his wife, Rosetta Amadori, and several workers designed and made household object:, tapestries, intarsia, pillows, furniture, toys, and advertising posters. These products were characterized by geometric designs, lively colors, and rich decoration composed of plant and animal motifs, as well as mannequins, automatons, robots, and other strongly stylized figures.

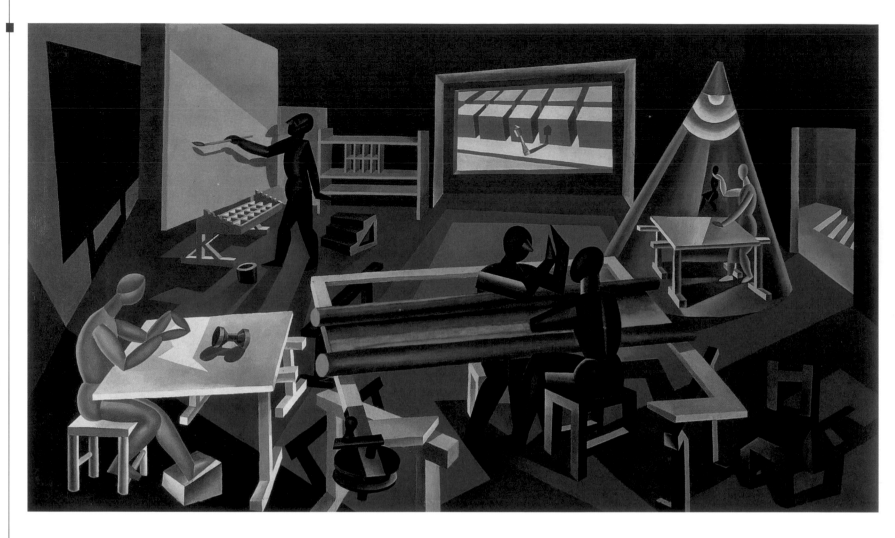

ENRICO PRAMPOLINI
Cosmic Apparition of the Aerodynamic Being
1935, oil on canvas
190 x 190 cm
Private collection

September 22, 1929, saw publication of the "Manifesto of Futurist Aeropainting." The aeropainter developed the formal decomposition already experimented with in the 1910s, approaching abstraction. "Every aeropainting simultaneously contains the double movement of the airplane and that of the hand of the painter moving the pen, brush, or palette knife. We will soon arrive at a new plastic extraterrestrial spirituality."

In Italy abstract painting initially came into being thanks to several artists with Futurist backgrounds, such as Enrico Prampolini, Osvaldo Peruzzi, Cesare Andreoni, Bruno Munari, and the architect Alberto Sartoris. This close relationship is reflected in the fact that Futurist and abstract painters often exhibited together in the editions of the Rome Quadriennale, the Venice Biennale, or at other exhibits in public and private galleries. Many abstract painters were to be found in the 1930s in the Galleria del Milione at Milan; they contributed to the magazines *Valori Primordiali*, founded in 1938 by Franco Ciliberti, *Origini*, and *Quadrante*. Among the leading exponents of abstractionism in Italy were Osvaldo Licini, Atanasio Soldati, Carla Badiali, Manlio Rho, and Mario Radice. Radice developed his artistic style in close contact with the Rationalist architects Cesare Cattaneo and Giuseppe Terragni.

MASSIMO CAMPIGLI
**Mother and
Daughter**
1940, oil on canvas
84 x 58 cm
Galleria Nazionale
d'Arte Moderna, Rome

In 1928, the year in
which he took part in
the Venice Biennale,
Campigli visited the
Villa Giulia Museum in
Rome and was struck
by the Etruscan relics.
During the 1930s he
was the subject of
various exhibitions in
New York, Paris, and
Milan; at the same
time he worked on
various large-scale
projects, such as the
fresco for the fifth
Milan Triennale
(destroyed), the work
Do Not Kill for the
Courts of Justice in
Milan, and a huge
decorative mural for
the atrium of the
University of Padua,
made between 1939
and 1940. During the
same years Campigli
began to employ a
deliberately archaic
and primitive style,
with pale colors and
a simplified design.
His female figures,
set against neutral
backgrounds,
gradually assumed
the classical hourglass
shape, with their
increasingly narrow
waists showing off
their shoulders and
hips. Their facial
features were
reduced to a few
geometric elements,
so that they seem
expressionless, devoid
of personality.

Art in Italy between the World Wars

■ Renato Guttuso
Crucifixion
1941, oil on canvas
200 x 200 cm
Galleria Nazionale
d'Arte Moderna, Rome

Guttuso presented
this canvas at the
fourth edition of the
Bergamo Prize,
winning the second
prize of 25,000 lira.
The painting made a
powerful impression,
and many critics
expressed their
serious reservations,
reproaching Guttuso
for the audacity of
certain stylistic
choices and for the
complicated and
disorderly
organization of the
masses. For example,
Pietro Torriano called
the work "a mixture
of Futurism, Cubism,
and Expressionism . . .
such that the
combination seems
forced, giving the
painting a hybrid
feel." Guttuso's
treatment of the
religious subject
provoked a scandal in
more conservative
religious circles: he
was labeled a *pictor
diabolicus*, the creator
of an immoral and
blasphemous work.
The archbishop
Adriano Bernareggi
was asked to
intervene and have
the canvas removed
from the exhibit, but
he did no more than
to ask the organizers
to present the work in
a discreet, not overly
explicit way.

In an essay published in 1919 the critic Wilhelm Worringer addressed the situation of modern art in Germany, lamenting in particular the crisis of Expressionism, which in his view was proving itself incapable of finding new sources of inspiration. In the spring of that year, almost in response to Worringer, Walter Gropius founded the Bauhaus in Weimar with the purpose of revolutionizing the style and language of the arts. The four-page flyer presenting the new school was illustrated with a woodcut by Lyonel Feininger entitled *Cathedral*. The image of a cathedral represented the ideal, earlier followed by the exponents of Romanticism, of the close cooperation among all the disciplines in the creation of a total work of art. A city's cathedral was seen as the perfect example of that cooperation, since construction of a cathedral required all the arts of an entire city, with

George Grosz,
The Funeral; Dedicated to Oskar Panizza,
1917–18, oil on canvas,
140 x 110 cm;
Staatsgalerie,
Stuttgart

synthesis. Among the first to be hired as teachers were the painters Max Thedy, Lyonel Feininger, Johannes Itten, and Otto Frölich, the engraver Walther Klemm, the sculptor Richard Engelmann, the sculptor-engraver Gerhard Marcks, and Wilhelm Köhler, director of the Weimar Museum. Paul Klee joined the school in 1920, Oskar Schlemmer in 1921, Wassily Kandinsky in 1922, and the next year László Moholy-Nagy. The theoretical courses were organized without too much difficulty, but setting up the artisan workshops met with numerous obstacles, first of all

Art in Germany between

A group of students and teachers of the Bauhaus in Weimar in a photograph from circa 1921–23

contributions from more or less everyone: architects, painters, sculptors, and artists from goldsmiths to carpenters, weavers to masons, in addition to a host of laborers. This ambitious, utopian desire to create a community of artists capable of expressing the ideals and sentiments of an entire people in a unitary manner was partially motivated by the distress that many Germans felt as a result of Germany's defeat in World War I, with the consequent end of the empire and the inability of the Weimar Republic to resolve the nation's many problems. Gropius also drew inspiration from the ideals that had animated the Arts and Crafts Movement in England in the second half of the 19th century, among the first such movements to claim equal dignity for the decorative arts. Gropius chose the term *Bauhaus* by uniting the words *bauen* ("to build") and *haus* ("house"), to make clear the concrete aspect of artistic construction. Lessons in the Bauhaus were given in two buildings designed by Henry van de Velde and used before World War I by the school of artisan arts and the academy of fine arts of which the Bauhaus was meant to be a

the difficulty of securing the necessary funds. There was also friction among the teachers because of differing philosophical, aesthetic, and political ideas. On August 5, 1923, an exhibition opened at Weimar in which Bauhaus students and teachers presented some of their works to the public. Among the most interesting was the experimental "Haus am Horn" designed by Georg Muche. Although the show enjoyed good results, the school's problems did not diminish, and in the first months of 1925 it had to move to Dessau, south of Berlin. Gropius himself designed the new buildings, which rank among the most successful examples of

architecture of the 1920s. Six workshops were set up at Dessau: weaving, metalwork, mural painting, graphics and advertising (directed by Herbert Bayer), carpentry (directed by Marcel Breuer), and a plastics laboratory; Kandinsky and Klee gave courses in painting. In 1927 the Swiss Hannes Meyer was nominated director of the new architecture section. On February 4, 1928, however, perhaps worn down by internal bickering and the continuous attempts by political factions to interfere with the school, Gropius quit as director of the Bauhaus; he was replaced by Hannes Meyer, who made a radical change in the programs and the hours. However, his interest in Marxist philosophy attracted the antipathy of conservative groups, in particular the Nazis, who by the end of the 1920s were gathering more and more support, gaining power throughout the German nation. Financial problems and political pressure put increasing limits on the school's freedom.

orders of the regime; those who did not accept were forced into silence or sought refuge outside the borders of Germany. The canvases of dissidents were removed from public museums, sold to foreigners, or burned during propagandistic displays. In 1937 the Haus der Deutschen Kunst mounted a show of works pleasing to the Nazi regime and to Hitler himself; during the same period a show was opened in Munich of 640 works by 112 artists called "Entartete Kunst," meaning "degenerate art": the aim was that of deriding and humiliating the rebellious painters not aligned with official culture. The public preferred the "degenerate artists," and that show was visited by more than 2 million people.

the World Wars

Gradually its structure changed as did even the spirit that had animated it during its first years of life. In August 1930 Meyer was obliged to quit as director, his place being taken by the architect Ludwig Mies van der Rohe. In 1932 the Nazi party won a majority in Saxony-Anhalt and in the city council of Dessau. On August 22 of that year, following an inspection by the mayor of Dessau, Fritz Hesse, and by the first minister of the Land, the Nazi Freyberg (accompanied by Paul Schultze-Naumburg, who in those years directed the cultural politics of Hitler's party), the city council voted to close the school. Mies van der Rohe moved to Berlin with a few students and teachers, including Wassily Kandinsky, Hinnerk Scheper, and Josef Albers. On March 11, 1933, Joseph Goebbels was named head of the ministry of popular culture and propaganda: His aim was that of giving a voice only to art faithful to the new regime while eliminating every form of dissent. In April the halls of the school were seized by the Gestapo, and the Bauhaus was definitively closed. In the following years German artists had to submit to the

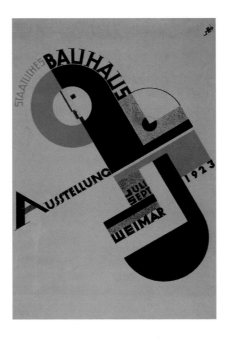

Many of the artists in the show were members of the Neue Sachlichkeit ("New Objectivity") movement, one of the most interesting trends in painting in the 1930s. The definition was used for the first time in 1925 as the title of a show mounted by Gustav Friedrich Hartlaud at the Kunsthalle in Mannheim. The group's common denominator was its faithful adherence to figurative painting and the critical eye it cast on German society, which the artists denounced for its hypocrisy, corruption, and vices, which attracted the open hostility of the Nazis.

GEORGE GROSZ
Metropolis (Berlin)
1916–17,
oil on canvas
100 x 102 cm
Museo Thyssen-
Bornemisza, Madrid

The original idea
behind this painting
was four drawings
that Grosz made in
1915 for the portfolio
entitled *Big City*, the
dominant theme of
which was the
frenetic life in
modern metropolises.
The style of the work
recalls the Futurists,
but whereas they
exalted the dynamic
life of the city and
every form of
technological
progress, Grosz took a
quite negative view of
the crowds inhabiting
large urban centers.
In his opinion, the
individual loses his
identity in such
crowds and is
transformed into a
cog in the service
of the financial and
political powers. This
work is pervaded by a
sense of anguish and
by an apocalyptic
atmosphere
emphasized by dark,
violent colors. The
dominant color is
blood red,
transforming the
scene into a dramatic
infernal procession.
The canvas also seeks
to depict the German
middle class as vile,
corrupt, hedonistic,
and unable to resolve
the problems that
gripped the nation
following its defeat
in World War I.

Art in Germany between the World Wars

■ GEORGE GROSZ
Pillars of Society
1926, oil on canvas
200 x 108 cm
Staatliche Museen,
Neue Nationalgalerie,
Berlin

The title, taken from
an 1877 play by
Henrik Ibsen, is
ironic, since the work
denounces the evils
of Germany in the
immediate postwar
period. The figure in
the middle foreground
is a lawyer, a militant
in the Corpsbruder, a
pro-Nazi business
association; he has no
ears, and his face is
marked by a wound
from a duel; in his
hands he holds a beer
stein and a sword,
while a soldier on
horseback rises from
his topless head: an
incarnation of his
warlike schemes. To
the left is a journalist
that resembles Alfred
Hugenberg,
nicknamed "The
Spider." He wears
a bedpan as hat,
symbolic of his
mental instability. To
the right is a socialist
deputy bearing the
slogan *"Sozialismus
ist Arbeit"* ("Socialism
is work"); his head
is topped by a
smoking lump of
indeterminate,
repulsive matter.
Visible in the
background are
groups of soldiers and
a priest who gives his
blessing with eyes
closed, so as not to
see what is going on
in front of him.

MAX BECKMANN
Night
1918–19,
oil on canvas
133 x 154 cm
Kunstammlung
Nordrhein-Westfalen,
Düsseldorf

In 1914, at the outbreak of World War I, Beckmann volunteered for the medical corps; he was discharged a year later, suffering from a serious nervous breakdown. This painting can be read as an allegory of the evil and the violence he had witnessed and that had profoundly disturbed him. The domestic peace of a family about to eat a meal is shattered by criminals who steal, torture, and kill. Using a crude and immediate realism, a nervous line, and vivid colors, Beckmann presents a crazed humanity turned brutally inhuman by hatred, as these men take sadistic relish in torturing the weak. The compositional structure recalls the scenes of martyrdom in classical art, but while in those works evil and pain are defeated or at least attenuated by faith in God, here the painter presents a thoroughly pessimistic vision of life, without the hint of escape.

Art in Germany between the World Wars

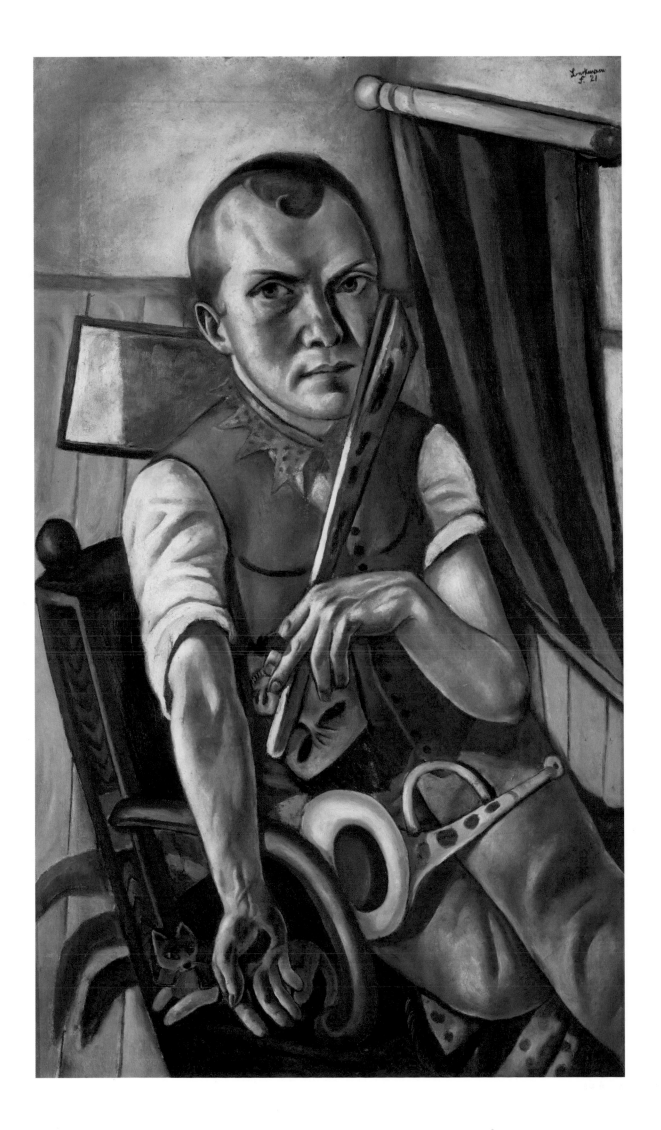

■ MAX BECKMANN
Self-portrait as a Clown
1921, oil on canvas
100 x 59 cm
Von der Heydt-Museum, Wuppertal

This painting is one of the numerous self-portraits Beckmann made during his career. Like all the members of the New Objectivity movement, Beckmann looked on reality in a neutral and disenchanted manner. He does nothing to embellish the scene or to make himself more appealing or attractive. On the contrary, in this canvas he openly displays the existential crisis that beset him, the feelings of frustration, discontent, and self-pity that tormented him. The sad artist, victim of a profound moral crisis, seems to have lost all hope and belief. He extends his right arm in a sign of surrender; he no longer believes he can perform the role of spiritual guide. He presents himself in the worn clothing of a clown unable to do his work, meaning to give pleasure. Even the disturbed perspective with which the painter presents the room—which recalls the interiors by van Gogh—testifies to his disconsolate state of mind.

LYONEL FEININGER
Lady in Mauve
1922, oil on canvas
100 x 80 cm
Museo Thyssen-
Bornemisza, Madrid

At the beginning of
his career Feininger
worked as an
illustrator, drawing
caricatures and
vignettes for various
magazines and
making brilliant
use of a rapid and
succinct line. He
was influenced by
the works of the
Cubists and the
Futurists, from whom
he learned to deform
the proportions of
figures and objects
so as to obtain
decidedly unusual
spatial effects with
great visual impact.
This canvas is
immediately notable
for its daring and at
the same time
refined use of line;
the buildings in the
background are
arranged like
theatrical curtains,
almost completely
without depth, thus
concentrating the
viewer's attention
on the woman in the
foreground. The very
low point of view lets
the artist make the
figure more graceful
and dynamic. The
colors of her dress
contrast with the
background, while
the elaborate
headdress crowns her
face like the halo of
an icon, giving her
an exotic and
sophisticated look.

Born in New York, Feininger often took walks along the Hudson River and was fascinated by its many ships and boats, particularly the sailboats. In 1924 he spent the summer at Deep on the Baltic Sea, often returning there over the following years. There he could dedicate himself to the subject of the sea and ships, which he depicted in many paintings over the arc of his long and successful career, both in Germany and after his return to the Untied States. While revealing Feininger's debt to Cubism and Futurism, these canvases also show his application of the teaching of the Bauhaus. The sailboats move rapidly and lightly across an unreal space on the edge of dreams and the imagination. The almost geometric simplicity of the lines is brought to life by the delicately colored sails, the refined alterations in tone, and the urgent rhythms that create an alluring atmosphere.

PAUL KLEE
Senecio (Old Man)
1922, oil on gauze
mounted on panel
40.5 x 38 cm
Kunstmuseum, Klee
Foundation, Basel

The period he spent
teaching at the
Bauhaus, from 1920
to 1931, represented
the highpoint of
Klee's career. It
was a formative
experience that
permitted him to
compare himself to
and compete with
other strong
personalities, taking
part in long and
profitable discussions
on pictorial technique
and the concept of
art itself. The
composition here
reveals Klee's ability
to transform reality
into a poetic world
of fables and dreams.
Klee was
experimenting with
the possibility of
portraying objects
and people in a way
approaching pure
geometric forms—
the circle, triangle,
square—enlivened by
luminous colors, at
times dense, at times
nearly transparent.
The Latin term *senecio*
that gives this work
its name can mean
"old man" but also
refers to a genus of
composite plants
(with disklike
flowers), establishing
a subtle metaphore
with the man
depicted.

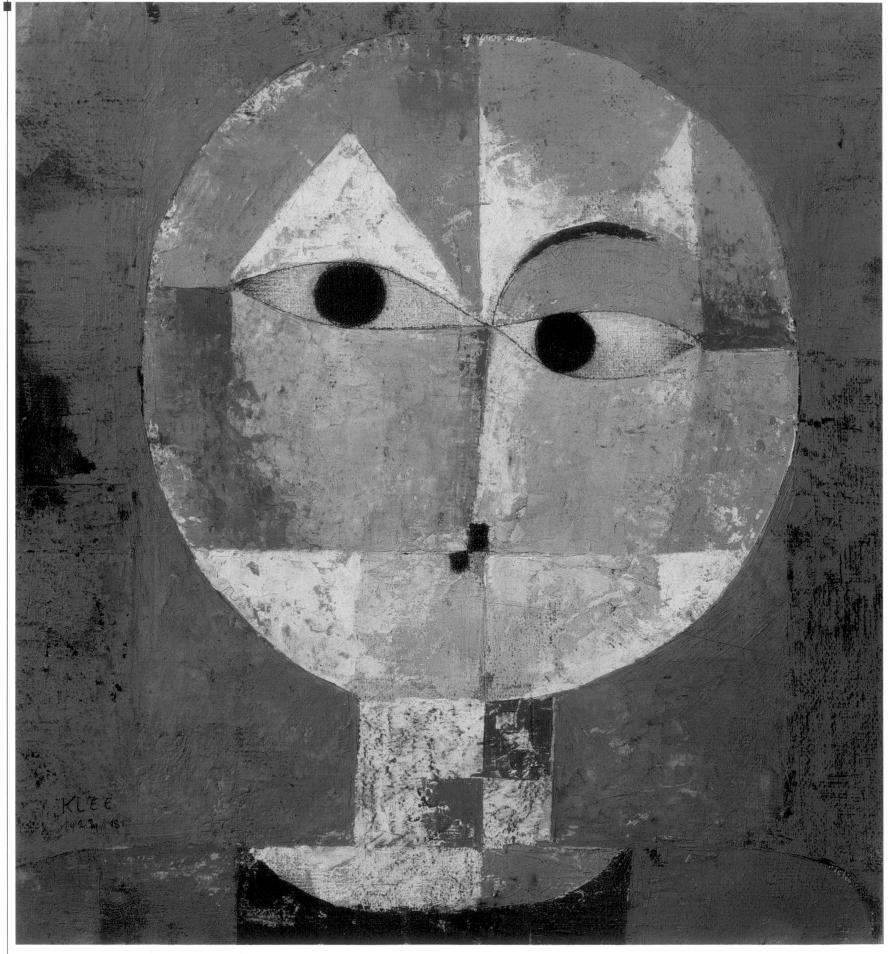

Art in Germany between the World Wars

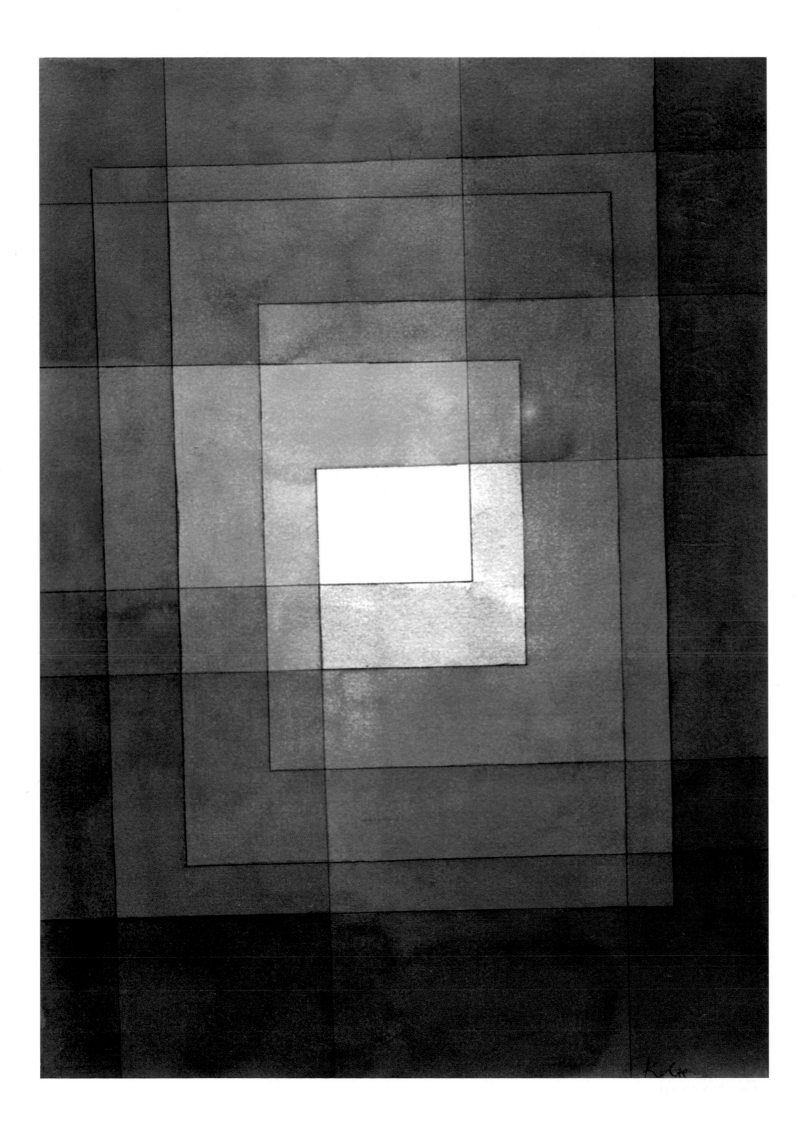

PAUL KLEE
**Polyphony Framing
White**
1930, pen and
watercolor on paper
mounted on cardboard
33.3 x 24.5 cm
Kunstmuseum, Bern

In 1925, when the
Bauhaus moved from
Weimar to Dessau,
Klee and his wife, the
pianist Lily Stumpf,
found themselves
living together with
Wassily Kandinsky
and his wife, Nina
Andreevskaia, in a
small two-family
house reserved for
teachers. The close
proximity of
Kandinsky and their
friendship had an
influence of Klee's
art, moving him more
and more toward
geometric
abstraction. An
example is this
watercolor, the title
of which testifies to
Klee's passion for
music. The forms
are simplified and
reduced to an
irregular series of
variously colored
rectangles, while the
bright tones and the
careful application
of light give the
entire composition
grace and rhythm. In
1931 Klee left the
Bauhaus and accepted
the chair of painting
at the Düsseldorf
Academy; he stayed
there two years, until
he was fired by the
Nazis, who were
hostile to his art,
which they judged
"degenerate."

WASSILY KANDINSKY
On White II
1923, oil on canvas
105 x 98 cm
Musée National d'Art
Moderne, Centre
Georges Pompidou,
Paris

At Weimar, where he
began teaching in
the spring of 1922,
Kandinsky took part
in long conversations
with the other
Bauhaus teachers that
helped him to clarify
and define both his
technique and his
artistic vision. The
school's creative
climate and its
powerful charge of
artistic enthusiasm
and fervor had an
affect on Kandinsky.
During the following
years he applied
greater discipline to
his abstract style.
The lines, which
previously had ranged
freely over the
pictorial space, were
now returned to
elementary geometric
forms (straight lines,
angles, circles,
triangles, polygons);
the colors were no
longer spots arranged
according to a lyric
and poetic criteria,
but were applied in
accordance with
complex rational
balances that
Kandinsky took
care to establish.
The pale background
eliminates every
reference to reality
and makes possible
the accentuated
optical effects of
the figures in the
foreground.

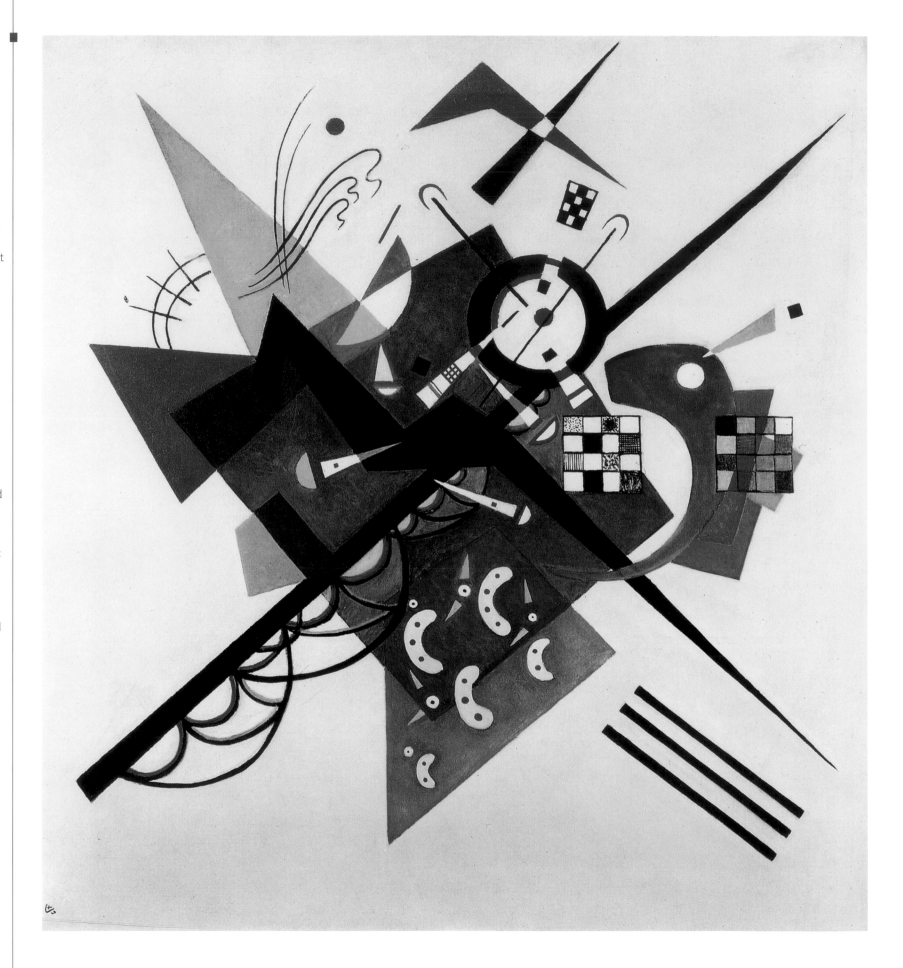

Art in Germany between the World Wars

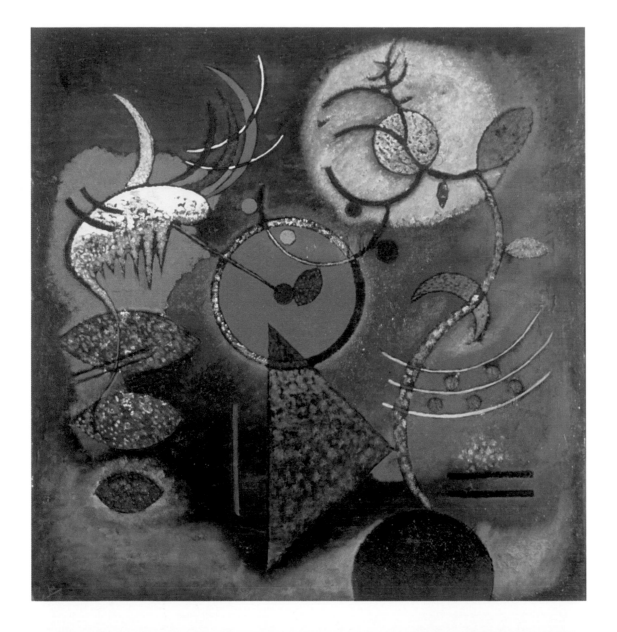

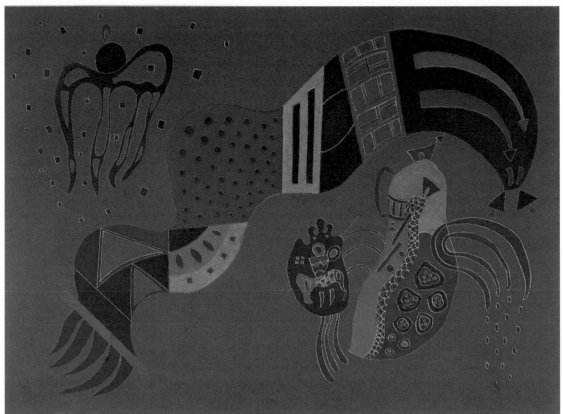

WASSILY KANDINSKY
Calm
1926, oil on panel
48.3 x 46.3 cm
Solomon R.
Guggenheim Museum,
New York

WASSILY KANDINSKY
Moderate Rush
1944, oil on
cardboard
42 x 58 cm
Musée National d'Art
Moderne, Centre
Georges Pompidou,
Paris

After his move to
Dessau in 1925,
Kandinsky added
new elements to his
abstract geometrics
and began to enrich
his compositions with
figures vaguely
assimilable to the
plant and animal
world. This change
became even more
radical after his move
to France in the
1930s. In 1926, when
he made the first of
the paintings shown
here, he published
one of his most
important works,
*Point and Line to
Plane*, in which he
clarified his concept
of pictorial space and
gave the theoretical
bases of his style.
Compared to the
works made at
Weimar, this painting
has quieter tones and
a more articulated
design; the pictorial
application has
become denser and
has a slower and more
careful rhythm. The
second painting,
made in the year of
his death, is an
example of his last
works, with their
constant balance
between abstract
and figurative
suggestions.

CHRISTIAN SCHAD
Portrait of an Englishwoman (Mrs. Lillian Kennard)
1926, oil on canvas
57 x 46 cm
Private collection

During his stay in Italy between 1920 and 1925, Schad studied the works of classical masters, most especially Raphael. He then decided to abandon his earlier style, inspired first by Futurism and Cubism, then by abstract art, to return to a figurative style. Over the coming years he specialized in portraits. Schad's portraits are characterized by a highly meticulous realism, so accurate in even the smallest detail that they seem static, cold, and impersonal. Schad stands out from the members of the Blaue Reiter, who sought to represent the world filtered through their feelings and emotions; he instead created a sharp detachment, including the emotional, between himself and his sitters. He did nothing to embellish them or make them more appealing and shows them instead in an objective manner as though they were gazing into a mirror: the image is a faithful, even pitiless, copy of reality.

CHRISTIAN SCHAD
Sonja
1928, oil on canvas
90 x 60 cm
Staatliche Museen,
Neue Nationalgalerie,
Berlin

In this portrait Schad presents an accurate reconstruction of the atmosphere of tragic decadence that suffocated Germany during the years of the Weimar Republic, on the eve of the advent of Nazism. The setting is an expensive restaurant, as can be deduced from the clothes of the figures and the ice bucket with champagne. The subject is a liberated woman who can afford to pass time in night spots and to smoke in public. Her calm, slightly empty expression reveals a personality with a proud and willful character. The viewer cannot see if she is alone or in company; Schad presents her from a slightly raised point of view, putting the spectator in the position of a waiter about to take her order or of her host, taking his seat in front of her. The style is typical of the realism of the New Objectivity movement: the flat, cold colors communicate a detached and impersonal sensibility.

OTTO DIX
**Metropolis
(left panel of
triptych)**
1927–28, mixed
media on panel
181 x 101 cm
Galerie der Stadt,
Stuttgart

In 1927 Dix was given
a chair at the Dresden
Art Academy and thus
was able to dedicate
more of his time to
painting. This panel
is the left section of
a triptych depicting,
with pitiless sarcasm,
the evils of German
society in the Weimar
years. The setting of
the scene is a
cobblestone street; a
pair of war veterans,
one of them
mutilated, looks with
a mixture of hatred
and desire at several
prostitutes on their
way to a bordello. The
prostitutes address
them with the cold
eyes of disdain. In
this way Dix makes
clear his opinion of a
nation in which vice
and corruption have
the upper hand over
feelings of solidarity
or compassion for the
weak, the abandoned,
and the deprived. In
the central panel Dix
presents a festive
dance set in an
opulent parlor, and
in the right-side
panel he shows a
group of women,
likely high-priced
prostitutes, ignoring
a mutilated veteran
begging for alms.

■ OTTO DIX
**The Seven
Deadly Sins**
1933, mixed media
on panel
179 x 120 cm
Staatliche Kunsthalle,
Karlsruhe

In this large allegory Dix presents personifications of sins, making more or less explicit references to the German society of his time. The crouching old woman in the immediate foreground is an incarnation of Avarice; the dwarf riding her is symbolic of Envy (Dix added the Hitler-style mustache after 1945). Death with the scythe represents Sloth, the horned devil Anger, and the woman Lust. In the background are two grotesque masks, Pride, with its face shaped like buttocks, and Gluttony, a baby wearing a funny hat. Barely legible writing on the wall repeats a line from Nietzsche's *Thus Spoke Zarathustra:* "The deserts grow: woe to him who harbors deserts!" In the year he made this painting Dix was fired from his post at the Dresden Art Academy and had to withdraw to Lake Constance, where he dedicated himself to landscape painting.

After four years of war, with at least 10 million dead and more than twice that number wounded, Europe went through two decades with a new political arrangement. Four empires were gone—the Russian, German, Austro-Hungarian, and Ottoman—many borders had been redrawn, and new states had come into being. The 1920s and 1930s were a period of great creative ferment as well as profound anxiety, both for individuals and entire societies. Despite the peace treaties, or perhaps precisely because of them, the tensions that had caused World War I had not been resolved and had instead created the conditions that would lead to another, even more destructive, conflict. The interwar years were a period of scientific discoveries and the application of new technologies, with progress made in medicine and the growing use of radio, telephone,

Exposition des Arts Décoratifs et Industriels Moderne, which opened in Paris on April 28, 1925, and was open to the public for nearly six months; this event provided the definitive crowning of Art Deco in all its forms, and marked the point of its greatest worldwide popularity. Thanks to the growing facility of exchange and travel, increasingly rapid means of communication, greater movement of ideas and news, novelties spread rapidly throughout Europe and across the ocean. In general, cultural and artistic life reflected an emotional climate characterized on one hand

Art in Europe between

automobile, airplane, and films; factors that revolutionized daily life.

Paris maintained its role as the chosen city for intellectuals and artists, the center of Western culture, and the capital of fashion and entertainment. After the wartime years of restraints, theaters, music halls, nightspots, and cafés reopened. It was the French capital that saw the birth or official consecration of new dance styles and new hairstyles, works of music, cocktails, the rules of proper attire, and the manners of polite society. The nights of Montparnasse and its mythical locales, such as Le Dôme, Le Select, and La Coupole, soon entered the collective imagination as an enchanted realm where everything was possible and where the most outrageous fantasies became reality. Standing out among the period's many events was the

by a spirit of rebellion against rules and a profound yearning for change and freedom of expression, while on the other hand there was a desire for discipline and order united with a longing to return to the teaching of the greats of the past with their faithfulness to objective reality. This was the climate in which Dada spread, seeking to destroy every form of traditional art in the name of a new method of artistic expression, loosed from the tight bonds of logic and dedicated to the free expression of the subconscious. A similar attitude was adopted by the Surrealists. For them art could no

longer limit itself to the depiction of objects and persons or the repetition of events more or less familiar, going no farther than the surface of things; they wanted to transcend the appearance of reality to reach its most authentic essence and explore the still mysterious depths of the human subconscious. During these same interwar decades abstract painters defined the methods used to erase every reference to objective reality. Their paintings turned increasingly to music as a source of inspiration; they intended to use colors in the same way that music uses notes, to express sentiments and pure emotion.

At the same time, groups and movements arose across Europe, varying in their size and organization, determined to oppose the avant-garde and defend the values and traditions of Western art, through adherence to the figurative themes and style of the past. This was the position taken by the artists who

masterpieces by Velázquez, Holbein, Poussin, and Courbet. Picasso himself confessed to Maurice Raynal: "You can't invent every day." With the outbreak of the Spanish civil war his ties to the social and political realities of the time grew stronger and led him to make *Guernica*, a perfect synthesis of Cubism and classicism.

Equally meaningful was the experience of Henri Matisse. During the years of World War I he had been drawn to the formal simplifications of Cubism and had applied what he called *"l'esprit de géometrie"* in his work. Between 1919 and 1929 he dedicated

■ Pablo Picasso, *The Dream*, 1932, oil on canvas, 130 x 97 cm; Collection of Mr. and Mrs. Victor Ganz, New York

the World Wars

belonged to the Novecento (Italy) and New Objectivity (Germany) groups. Critics have noted a parallel between this demand for a "return to order" and the birth of political regimes that supported similar values (Fascism in Italy, Nazism in Germany). There were also the "Realistic Manifesto," dictated in 1920 by the brothers Naum Gabo (pseudonym of Naum Pevsner) and Antoine Pevsner (who supported the birth of Constructivism), and the Socialist Realism of the Soviet Union of Stalin. Even in European countries with democratic governments the cultural climate was drawn to a more or less conservative move toward the "neo-classical." A particularly emblematic example is that of Pablo Picasso, one of the leading exponents of Cubism. In 1917 he spent two months in Rome and while there contributed to the Ballets Russes of Serge Diaghilev, designing the scenery for *Parade*. He visited Naples, Pompeii, and Florence and was enormously impressed by direct experience of the works of classical artists. While continuing to make the Cubist works desired by collectors and art dealers, Picasso also made compositions in which he returned to the figurative tradition, approaching a classical monumentality, and he paid homage, not without a certain irony, to

himself to the theme of odalisques, making roughly fifty canvases that communicate a serene and vital sensuality and that rework in a modern style the famous examples by Delacroix, Ingres, and Renoir.

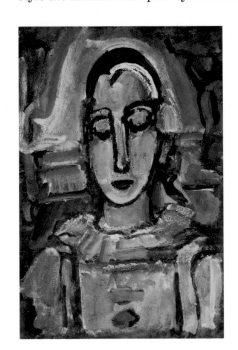

The many expressions of European artists between the two world wars present a state of mind in crisis and uncertainty, the result of the dawning awareness that Europe could no longer consider itself the center of the world, not only as a result of discovery and reevaluation of other civilizations— Asian, African, Oceanic—but also due to the burgeoning economic, political, and cultural power of the United States, which turned the tables after World War II, putting the New World above the Old.

■ Georges Rouault, *Pierrot*, 1938, oil on paper mounted on canvas, 101 x 67 cm; private collection

CONSTANT PERMEKE
The Black Bread
1923, oil on canvas
50 x 70 cm
Musée d'Art
Contemporain, Ghent

The style Permeke adopted in the works of his maturity was based primarily on an Expressionistic use of colors—here dominated by brown and yellow tones; with a spare, almost essential design: strong forms, massive and almost sculptural; and sharp, strongly contrasting shadows. His compositions communicate to the viewer an almost religious gravity and urge the viewer to share the emotions of the figures epicted. Heedless of avant-garde experiments, Permeke drew inspiration from the scenes of daily life in the great masters of Flemish painting. Like Vincent van Gogh in his Dutch period, Permeke felt spiritually close to the life of the peasants, the fishermen, the poor. In his paintings he sought to convey a profound sense of their human condition while at the same time participating in it with a troubled and moved soul.

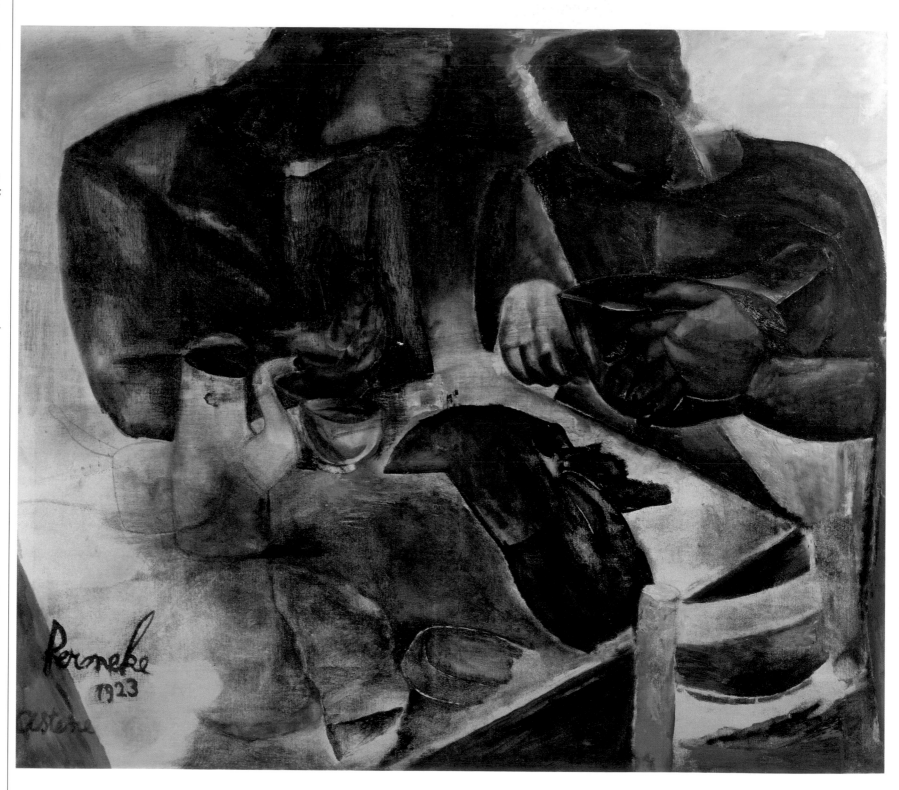

Art in Europe between the World Wars

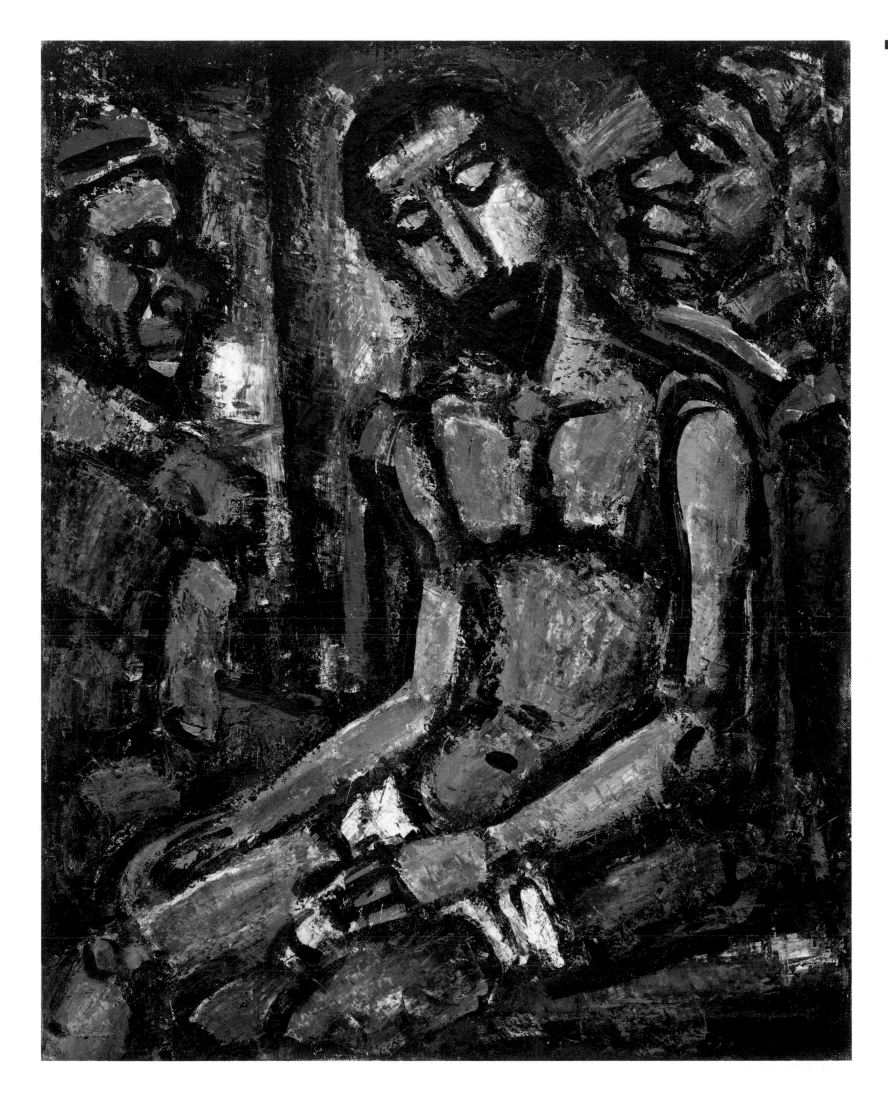

■ GEORGES ROUAULT
Christ Mocked by Soldiers
1932, oil on canvas
92 x 72 cm
Museum of Modern
Art, New York

Rouault's art reveals a profound spiritual tension and a sincere and deeply felt discovery of religious values, based on the Catholic existentialism of the philosopher Jacques Maritain, whom Rouault met in 1911. His attitude is similar to that adopted in literature by Georges Bernanos; both proclaim the presence of evil, both physical and moral, for which humans seek explanation and from which they seek relief in faith in God. This painting presents a good example of Rouault's bare and immediate style. He found his models as much in the Expressionists and the Fauves as in the archaic language of the Middle Ages, which he probably assimilated as a boy while serving as apprentice to a restorer of stained glass. This is one of his many creations from the years between the two world wars; his other outstanding works include the dramatic series of the *Miserere*, the *Fleurs du Mal*, and *Les Réincarnations du Père Ubu*.

TAMARA DE LEMPICKA
Andromeda
1927–28,
oil on canvas
99 x 65 cm
Private collection

Nudes were one of Lempicka's favorite subjects, and the example given here reveals the stylistic sources from which she drew her inspiration. Having emigrated to Paris in 1918, she became a student of Maurice Denis, from whom she learned the use of warm, intense tonalities, and André Lhote, who introduced her to the formal decompositions of Cubism, here evident in the urban view in the background. At the same time she followed the example of the masters of the Italian Renaissance, whose works she had seen during trips to Italy, and she also adopted the plastic solidity of the nudes by Jean-Auguste-Dominique Ingres, in particular their appearance, both ethereal and powerfully sensual. The subject of this canvas is from Ovid's *Metamorphoses*: The chained young girl is awaiting her savior, but if one looks closely she seems far stronger and dangerous than the sea monster Perseus had to defeat before loosing her bonds.

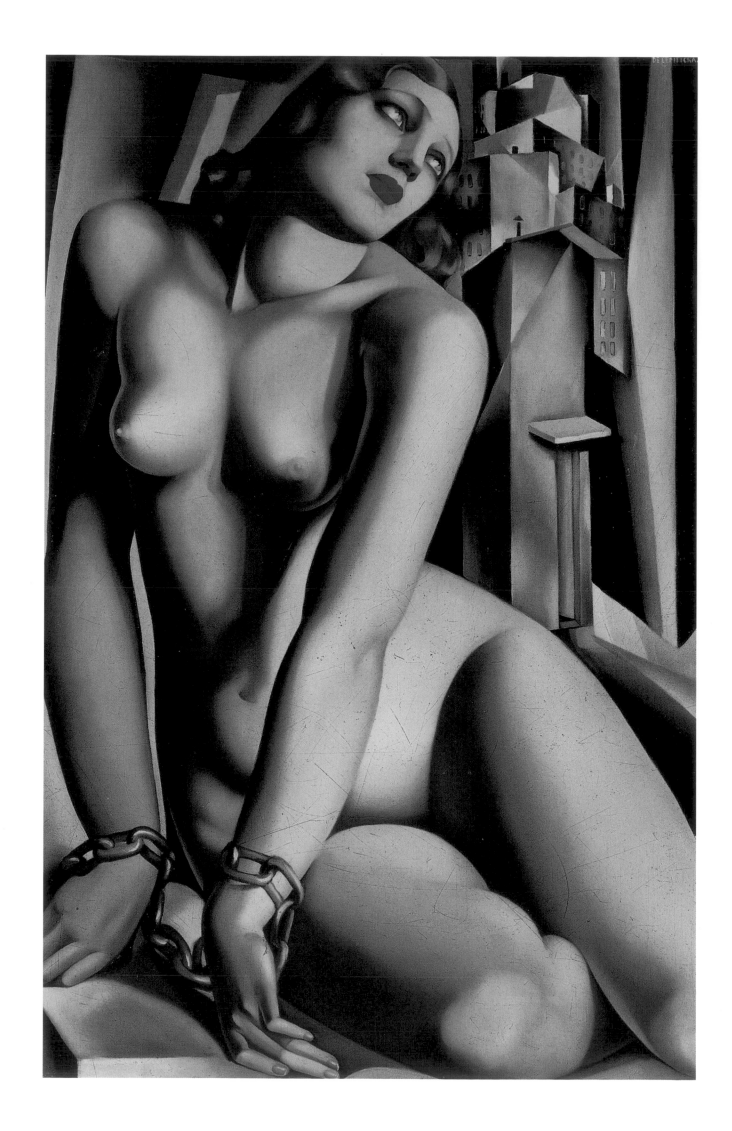

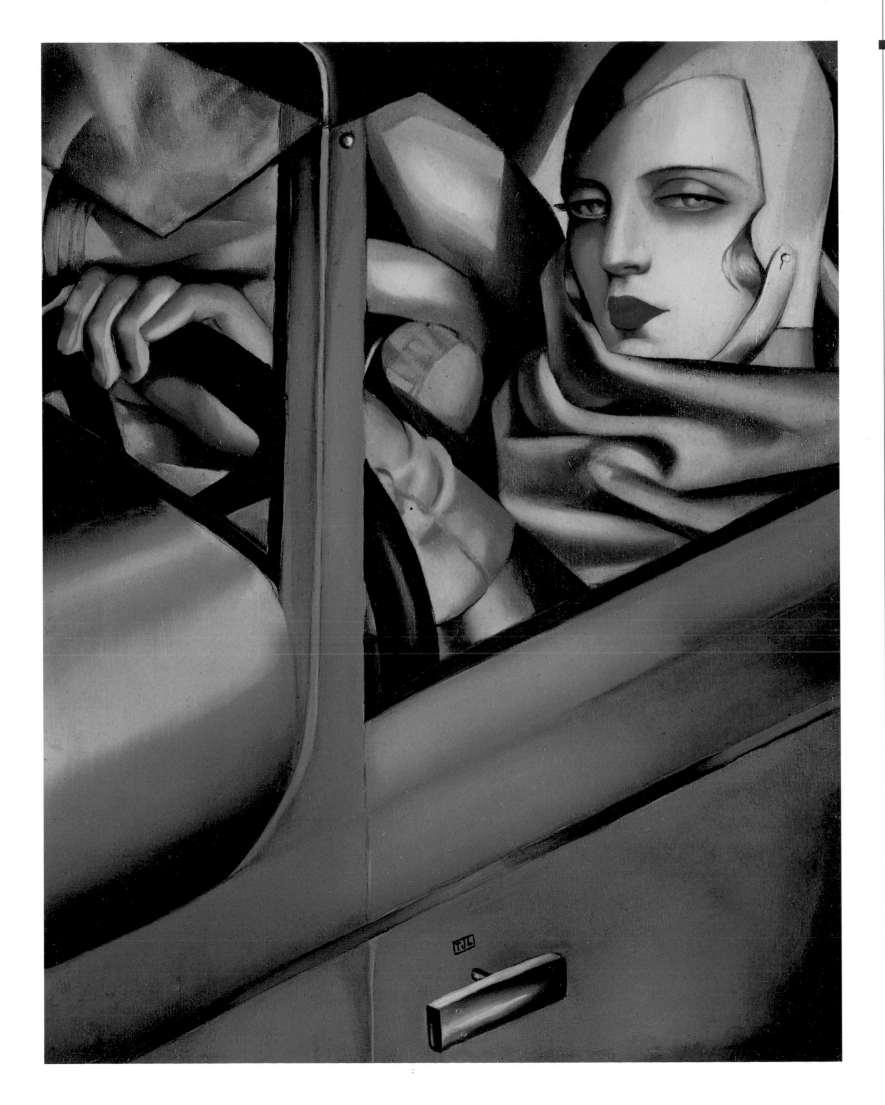

■ TAMARA DE LEMPICKA
Self-portrait (Tamara in the Green Bugatti)
1929, oil on panel
35 x 26 cm
Private collection

This painting was commissioned from Lempicka for the cover of the German fashion magazine *Die Dame*. It very quickly became so popular, that it is often considered emblematic of the interwar decades. The painter, who in reality drove a yellow Renault, shows herself at the wheel of a Bugatti, the symbol par excellence of luxury and speed. She wears a sporty helmet-hat and a pair of elegant doeskin gloves; the scarf at her neck, the same color as her hat, hides her dress, which one can imagine only recently acquired from a leading Parisian couturier. It is the image of a modern emancipated woman, as the feminist movements of the period might have imagined her: independent, free from male domination, strong and willful, in control of her destiny much as she is fully in control of the powerful mechanical vehicle. At the same time, however, she has lost none of her femininity; indeed, her look, emphasized by the bright red lipstick and eye makeup, is intense and seductive.

HENRI MATISSE
**Decorative Figure
on an Ornamental
Ground**
1925–26,
oil on canvas
130 x 98 cm
Musée National d'Art
Moderne, Centre
George Pompidou,
Paris

Among the many
odalisques Matisse
painted during the
1920s this is the
most geometric. Here,
he simplifies the
human figure so that
it approaches the
extreme linearity of
elementary forms.
The woman's body is
arranged like a
pyramid and her face
is a simple oval line,
repeated in the eyes
and mouth. By
contrast, the
wallpaper in the
background and the
rugs on the floor are
characterized by a
rich and complex
decoration, with
bright colors and
elaborate designs. In
his apartment at Nice
Matisse had arranged
a large wooden easel
on which he hung
fabrics and multicolor
rugs in a bizarre
mixture of styles,
Oriental and Western,
and he used them as
source material for
his paintings. The
almost baroque
superabundance of
these decorative
elements seems to
suffocate and
completely absorb the
human figure, making
it lose its material
consistency.

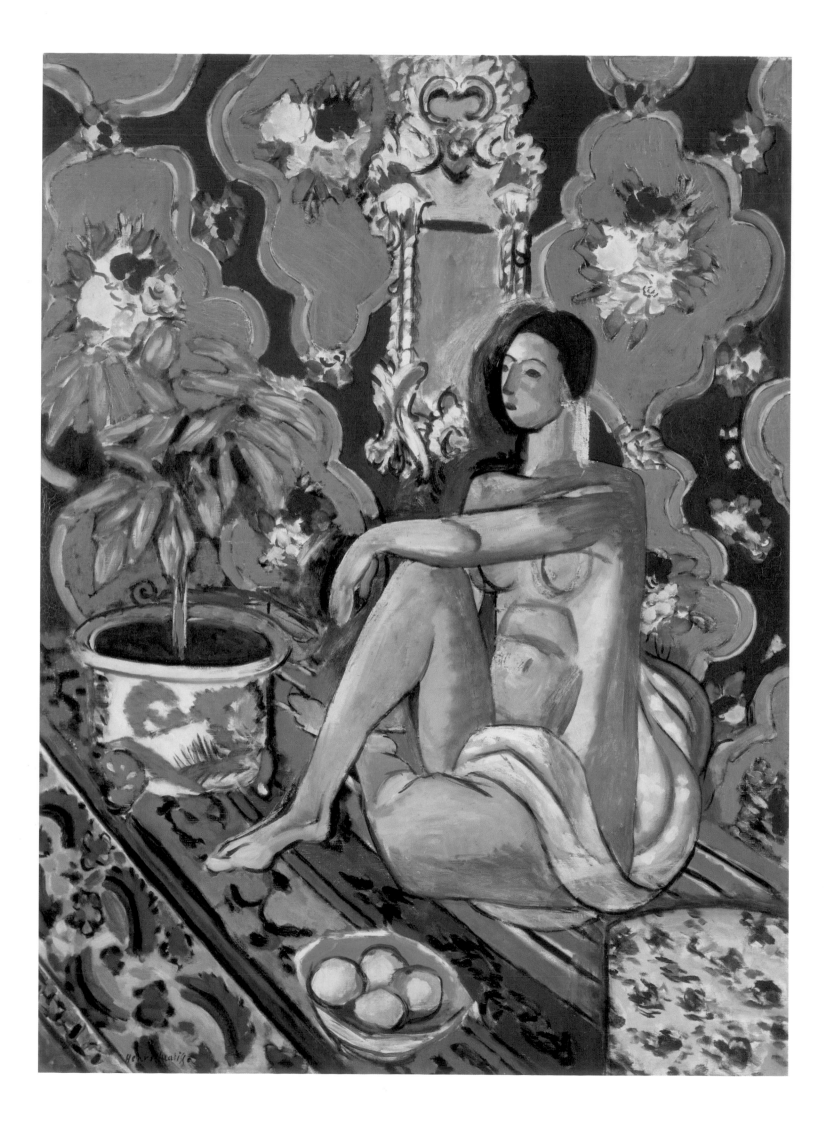

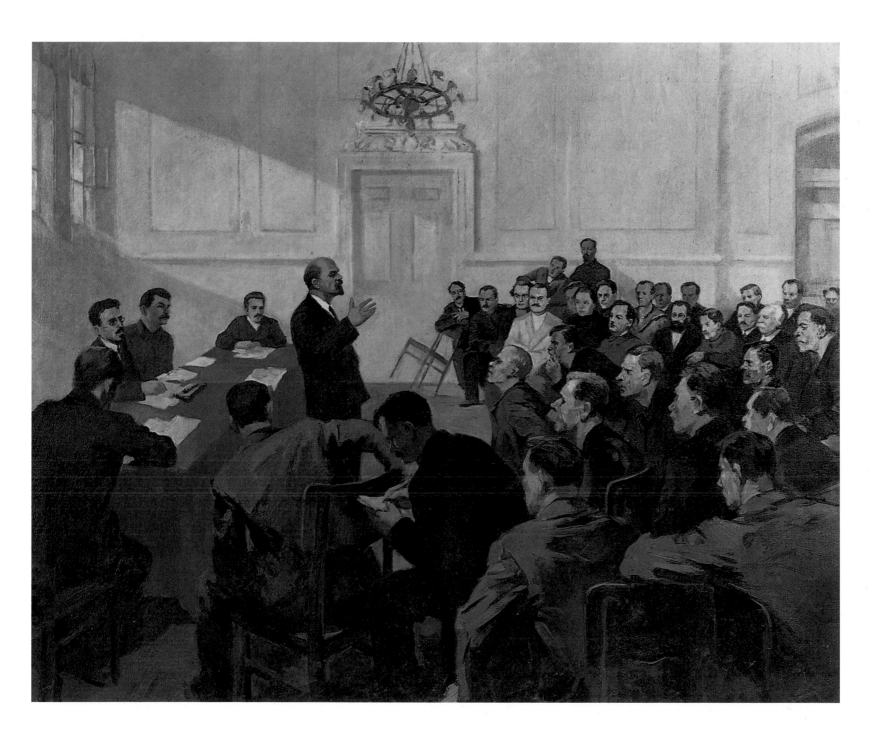

■ NIKOLAI SEMIONOV
10th Congress of the Russian Communist Party, March 1921
1936, oil on canvas
150 x 185 cm
Private collection

In this painting Semionov celebrates an episode of the Russian Revolution. Aside from Lenin, several other political and cultural leaders of those years can be recognized in this work, including Gorky, Malinovsky, Sverdlov, Krylenko, Voroshilov, Zinoviev, and Stalin. Semionov followed Stalin's orders and remained faithful to the principles of Social Realism; he ignored the stylistic revolutions of the exponents of the various avant-gardes and draws his inspiration from the Wanderers (*Peredvidzniki*), the itinerant exhibiting society of the second half of the 19th century whose members painted historical episodes and scenes of Russian daily life. Semionov paid particular attention to the different expressions on the faces of the figures: All are concentrating on the words of Lenin, standing at the center of the composition, his pose calm but determined. The room is illuminated by rays of sunlight that enter through a window and wrap a kind of secular halo around the orator and his listeners.

PABLO PICASSO
Women Running on the Beach

1922, gouache
on plywood
34 x 42.5 cm
Musée Picasso, Paris

Picasso made this painting during a summer visit to Dinard, in Brittany. In it he abandoned the formal decompositions of Cubism and followed the "return to order" of the years immediately following World War I, drawing his inspiration from the classical tradition of monumental art. Here he presents two women running on the beach, holding hands, their fluid and powerful gestures more like a dance step than a run. The landscape and clothing of the women do not make it possible to attribute a spatial or temporal setting to the work; this could be a scene from today or from ancient Greece. In 1924 the subject of the painting was enlarged and used as the curtain for performances of Diaghilev's *Le Train Bleu*, with libretto by Jean Cocteau, choreography by Bronislava Nijinska, costumes by Coco Chanel, scenery by Henri Laurens, and music by Darius Milhaud.

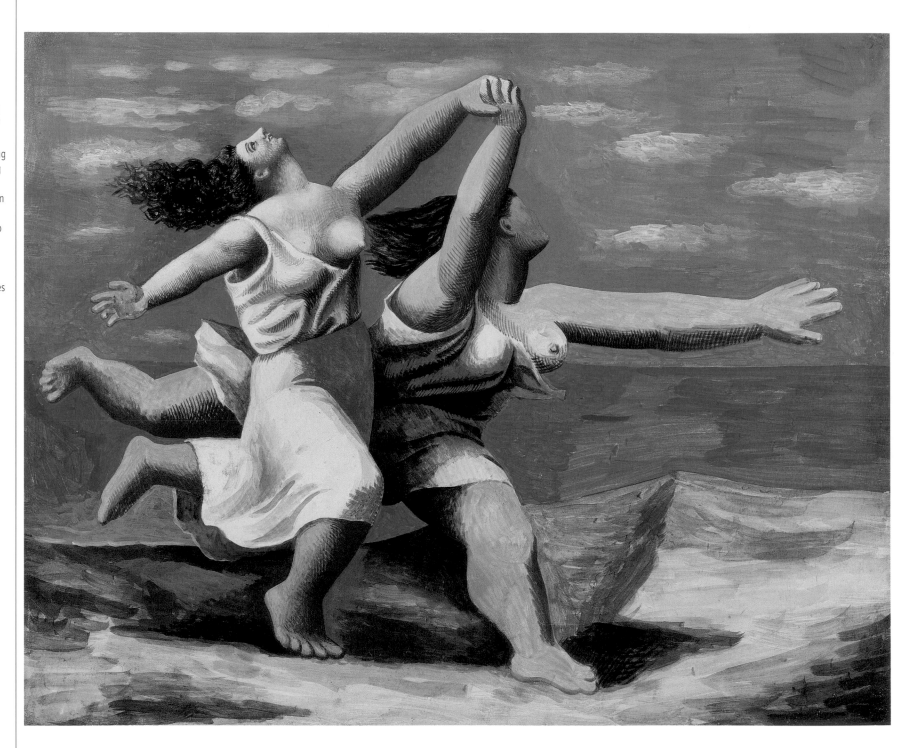

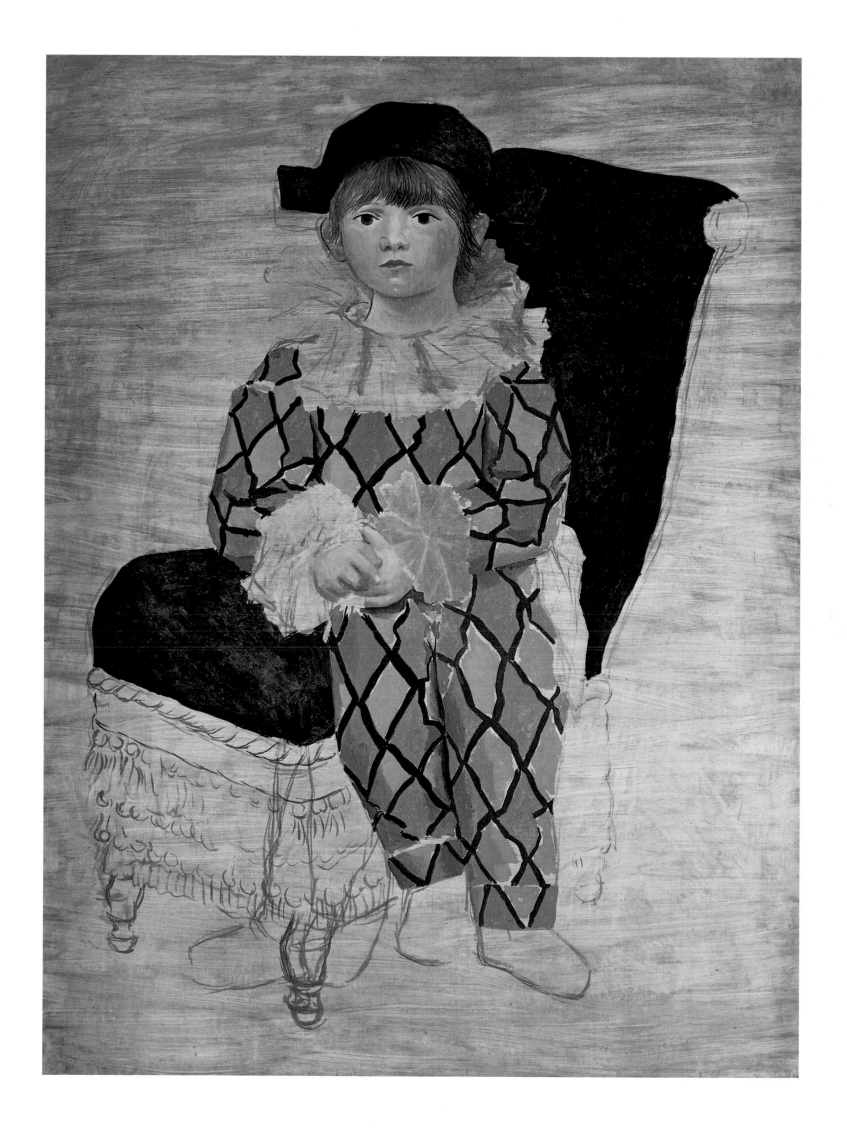

■ PABLO PICASSO
**Paulo Dressed
as Harlequin**
1924, oil on canvas
139 x 97.5 cm
Musée Picasso, Paris

On July 12, 1918, Picasso married Olga Koklova, a ballerina from the Diaghilev company, for which Picasso had designed costumes and scenery for the ballet *Parade*. On February 4, 1921, their son Paulo was born, of whom Picasso made many portraits, alone or with his mother. This canvas, deliberately left unfinished, testifies to the "classical" period of Picasso's production. He can be seen to have abandoned the daring stylistic experiments of his Cubist works to return to the style of the great masters of the past, whose works he had seen during his stay in Italy. At the same time he also drew on some of his youthful works, including those of the so-called blue and rose periods, but now with a far different state of mind, more serene and optimistic, and with a great awareness of his expressive abilities. The colors are less aggressive, and the line is far softer, most of all in the features of the boy's face, which is fascinating because of its emotional intensity.

PABLO PICASSO
Guernica
1937,
tempera on canvas
354 x 782 cm
Museo Reina Sofia,
Madrid

After World War I
Cubism no longer
presented a unitary
movement, for every
artist carried on his
own personal
exploration. Picasso
too experimented
with other artistic
forms. He traveled
to Italy and worked
for the Ballets Russes
of Serge Diaghilev,
met the Futurists,
discovered classical
painting, and
permitted himself
a "return to the
classics" in which
he gave his personal
interpretation of the
figurative tradition.
In January 1937 the
Spanish government,
in exile because of
the civil war,
commissioned him
to make a mural to
decorate the Spanish
pavilion at the
Universal Exposition
in Paris. Three months
later, while Picasso
was working on
preparatory drawings,
German airplanes
bombed Guernica,
the oldest city in
the Basque Provinces.
In response to the
terrible reports of
the attack, Picasso
radically altered the
layout of his work
and on May 1 began
painting this large
canvas, completing it
in a few weeks.

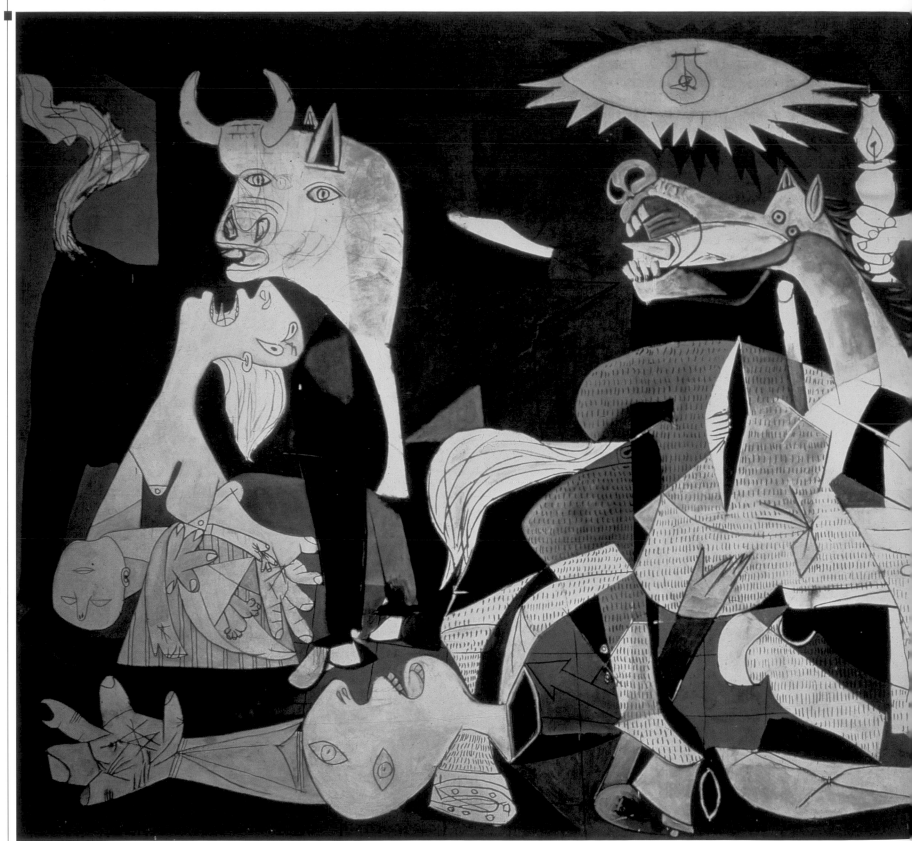

Art in Europe between the World Wars

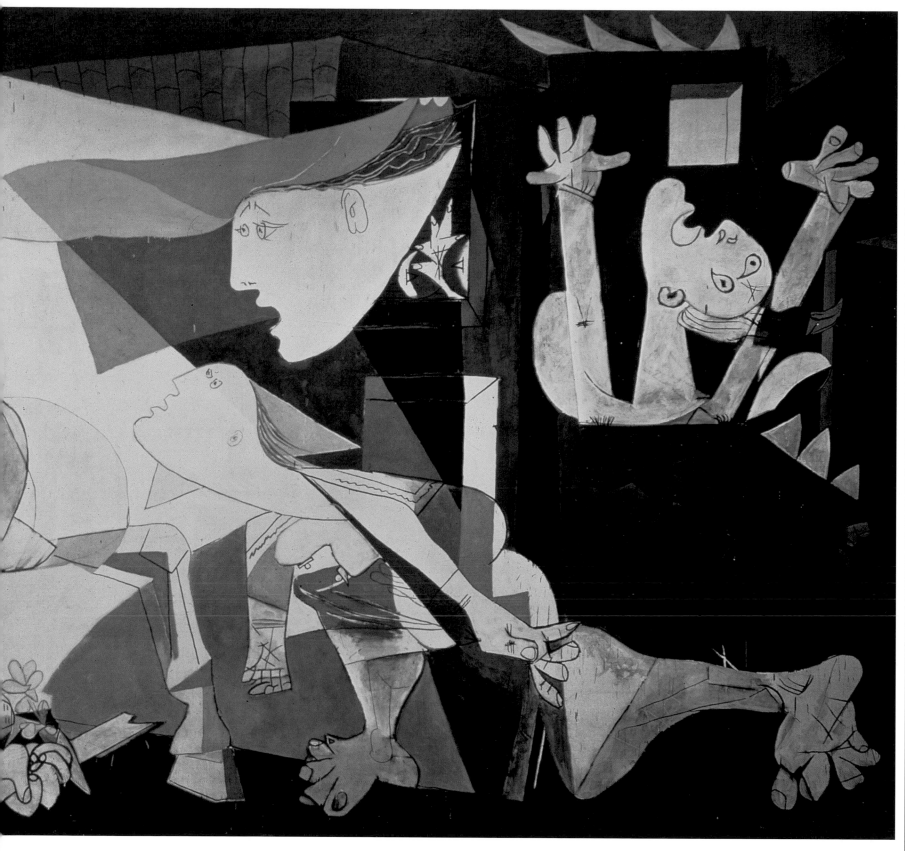

Pushing the formal
decompositions of
Cubism to their
limits, he created
a powerful antiwar
allegory, a heartfelt
denouncement of all
forms of gratuitous
violence, against
injustice and cruelty.
Some of the figures
are drawn from a
1935 etching called
Minotauromachie
and are closely
related to the world
of bullfighting,
emblematic of
Spain. This somber
lamentation over a
dead matador, which
recalls the medieval
depositions of Christ,
represents Picasso's
lamentation for an
entire nation, brutally
stricken, and becomes
the symbol itself of
universal grief in
the face of violence
and death. The
great variety of
widely differing
interpretations that
critics have given the
numerous symbolic
figures in the work
reflects the variety
and richness of
Picasso's creative
inspiration and
make the painting
one of the great
masterpieces of
the century.

hen the 20th century began, the art and culture of the United States were still based on 19th-century European models. Two institutions located in New York City, the Society of American Artists and the National Academy of Design, held a monopoly on the artistic training of young artists, who were judged by critics in annual shows structured very much like the Parisian Salons. After the Impressionist work of John Singer Sargent, Mary Cassatt, and James McNeill Whistler, the first autonomous and original pictorial expression was that of the group known as the Eight after their first (and only) group show, held in February 1908 at the Macbeth Gallery in New York. Also known as the New York realists, there were in fact eight of them: Arthur B. Davies, William J. Glackens, Ernest Lawson, George Luks, Maurice Prendergast, Everett Shinn, John Sloan, and Robert Henri, the leader of the group. Despite the clear stylistic differences among them, these artists were grouped together by critics because of their common desire to go against the traditional teaching of the art academies and to depict the reality of their lives. Thus their paintings present crowded city avenues, the luxury of the well-to-do sections of town, and the misery of the poor areas inhabited by immigrants. There are scenes of men at work, of sporting events, of coffee houses and bars, train stations, theaters, and dancehalls. Although these artists were familiar with classical art and many had taken trips to learn more in Europe, they did not look to the masters of the past for their inspiration and turned instead to the black-and-white images of such photographers as Alfred Stieglitz, Edward Steichen, Alvin Langdon Coburn, and Clarence White. In the scenes they

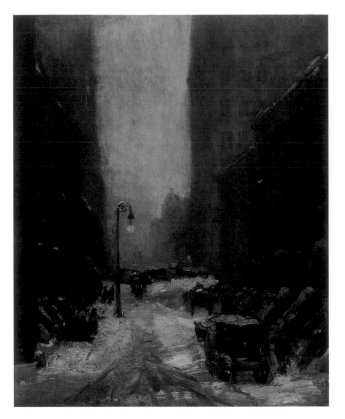

Robert Henri, *Snow in New York*, 1902, oil on canvas, 81.2 x 65.3 cm; National Gallery of Art, Washington, D.C.

painted they sought to be immediate and direct, objective and impartial, concrete and simple; they tried not to take sides and tried not to let cultural or aesthetic precepts affect them, even at the risk of hurting the feelings of critics, who called them ironically the Apostles of Ugly and the Ashcan school.

A second important step in the formation of art in the United States was taken by the Armory Show, an exhibition that opened on February 17, 1913, at the Armory of the 69th Regiment of Infantry and then moved to Chicago and Boston. More than a thousand works by more than three hundred artists were presented, and despite some important absences (Modigliani and the Futurists), it was the first large show of European avant-garde works, uniting Impressionists, Symbolists, Pointillists, Fauves, Expressionists, and Cubists. The event attracted a throng of visitors, in part because of a large-scale newspaper campaign in which the American artists were compared and contrasted with their European counterparts. The show presented plenty of reasons for astonishment, scandal, and polemic, but from then on American critics and collectors began changing their aesthetic vision. Direct ties between European and American artists were also presented in the shows at Alfred Stieglitz's gallery at 291 Fifth Avenue, known as the 291 Gallery or just 291; it was active from 1905 to 1917. The many exhibitions of contemporary art mounted there include the first Dada experience of Marcel Duchamp, Francis Picabia, and May Ray in 1915. After World War I the members of the movement known as Precisionism rose to the fore, led by Charles Demuth and Charles Sheeler, who sought to rework figurative realism. The 1920s were a period of strong economic and cultural growth: new museums were opened along with new private galleries where collectors competed for works by emerging talents. The Wall Street collapse in 1929 and the years of the Great Depression did not stop the creativity of America's artists, who formed various movements, grouped under the name American Scene or American Wave, and presented their works to the public and critics in shows in Chicago, Pittsburgh, and New York between 1930 and 1932. Among the diverse artistic expressions were the Realism of Edward Hopper and Charles

William J. Glackens, *Nude with Apple*, 1910, oil on canvas, 99.1 x 121.9 cm; Brooklyn Museum, New York

Burchfield, the Regionalism of Thomas Hart Benton, Grant Wood, and John Steuart Curry, the Urban Realism of Reginald Marsh, and the Social Realism of Ben Shahn, Philip Evergood, and William Gropper. Many of these artists were able to paint because of help from the government. To alleviate in part the effects of the 1929 crisis President Roosevelt promoted the Works Progress Administration. In the following years, between 1933 and 1943, following the example of what had been done in Mexico during the 1920s, the Public Works of Art Project was instituted, along with the Treasury Relief Art

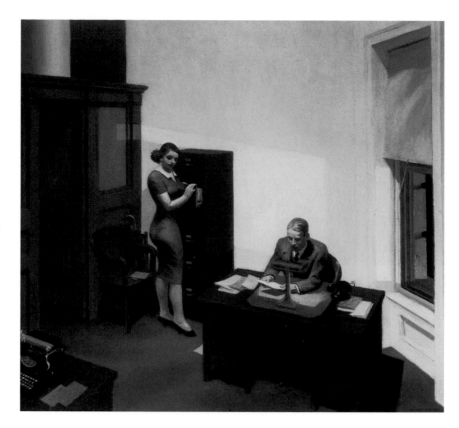

collaboration with several art dealers, to publicize the John Ford film *The Long Voyage Home*, based on the stories of Eugene O'Neill. In 1940 Grant Wood and eight other painters were invited to visit the movie set and make paintings of important scenes, creating an interesting comparison between the two art forms.

Throughout the first half of the 20th century American artists and intellectuals sought to free themselves from European domination, but only after World War II did the situation change, with the students becoming the masters.

Art in the United States

Project and the Federal Art Project, directed by Holger Cahill. Thanks to these projects, 883 paintings had been commissioned by 1936, along with 469 sculptures, 259 prints, and 955 murals in major public buildings, such as schools, post offices, libraries, and social centers in cities but also in remote towns. Hundreds of artists were involved and subsidized. While they drew inspiration from European art as well as from the Mexican art of David Alfaro Siqueiros, José Clemente Orozco, and Diego Rivera, they also sought to create a language and style all their own. Some of these artists celebrated the progress of industry and the growth of cities. Some presented the life and work of farmers, immune to the "vices" of the cities and ever faithful to the traditions and moral and spiritual values of their fathers; some looked with nostalgia on the past and sought there the roots of their culture and the most genuine national values. With few exceptions they rejected abstract art and followed a more or less objective realism. They also drew inspiration from photography, increasingly used in illustrated magazines, as well as from the cinema, which in those same decades was attracting a vast following. Related to this was the idea concocted by Hollywood producer Walter Wanger, in

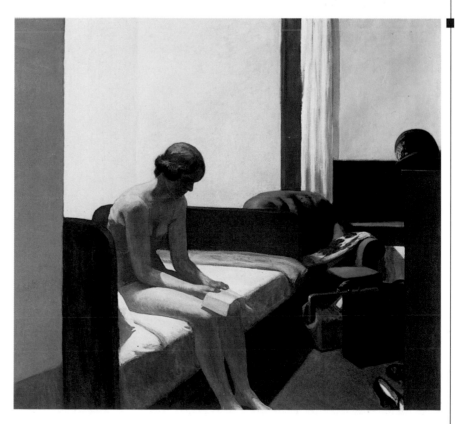

FREDERIC
REMINGTON
The Outlier
1909, oil on canvas
101.9 x 69.2 cm
Brooklyn Museum,
New York

A painter and sculptor
of enormous popular
success, Remington
was the bard of the
West, the epic story
of the American
frontier and the
settling of the
country. This painting
was among his last,
made during the last
year of his life, and in
it he seems to show
an awareness that the
stories presented in
his canvases, in a
sharp and meticulous
realism, were moving
away from current
events into legends.
The last uprisings of
Native Americans,
such as Geronimo's
uprising and Wounded
Knee, had long since
become history. In a
wild and harsh
landscape,
illuminated by the
last rays of the
setting sun (with its
clear symbolism) a
sole Indian warrior
stands guard, useless
sentry against a
victorious enemy.
His expression may
be proud and
unconquered, but he
knows that his world,
where his ancestors
lived for millennia,
is destined to be
destroyed by the
new civilization.

Art in the United States

■ GEORGE LUKS
The Wrestlers
1905, oil on canvas
122.5 x 168.3 cm
Museum of Fine Arts,
Boston

After studies at the
Pennsylvania Academy
of Fine Arts, Luks
took a long trip to
Germany, France, and
England to study the
works of the masters
of the past. In his
paintings, which
present aspects of
daily life, he revealed
extraordinary skill at
design, as evident
here in the perfect
anatomical rendering
of the wrestlers.
Equally skilled are
the different facial
expressions of the
two figures and the
contrast between
their strongly
illuminated bodies
and the almost
black background.

■ ROBERT HENRI
Gertrude
Vanderbilt Whitney
1916, oil on canvas,
127 x 182.9 cm
Whitney Museum
of American Art,
New York

Learned, refined,
and with a strong
personality, Gertrude
Vanderbilt Whitney
was a leading
connoisseur of art
and was herself an
artist. Heir to a rich
dynasty, she bought
the works of young
artists, following
their careers and
financing several
exhibitions and
above all opening
the Whitney Studio
in New York, which
would become one of
the greatest museums
of modern art.

WILLIAM GLACKENS
At Mouquin's
1905, oil on canvas
121.9 x 99.1 cm
Art Institute of
Chicago

After studying at the Pennsylvania Academy of Fine Arts, Glackens became an illustrator for leading American newspapers and magazines. The layout and style of this painting recall canvases on similar subjects by the French Impressionists, works that Glackens had seen during a trip to Paris in 1895. In particular, Glackens was strongly influenced by the works of Pierre-Auguste Renoir, with their soft lines and great luminosity, creating pleasant, relaxed atmospheres. Mouquin's was an elegant New York restaurant, a popular meeting place for members of high society but also visited by intellectuals, journalists, and artists, including several from the Eight. The man presented here, in the company of an aristocrat friend, is James Moore, an art collector and one of the first to appreciate the work of the Eight.

■ EVERETT SHINN
**The Orchestra Pit,
Old Proctor's Fifth
Avenue Theater**
circa 1906, oil
on canvas
44.6 x 49.5 cm
Arthur G. Altschul
Collection, New York

This painting, one of the many Shinn made of the world of the theater, shows clear influence of the Impressionists, most particularly *Orchestra of the Opéra*, painted by Edgar Degas in 1868–69 (Musée d'Orsay, Paris). In both works the artist chose an unusual angle, with the orchestra in the foreground and the dancers on stage relegated to a small background area. Shinn opted for an even lower and closer point of view, such that nearly one-third of the work is occupied by the red curtain dividing the orchestra pit from the audience. A second difference is that while in the Degas painting only the arms and legs of the dancers are visible, here three dancers can be seen nearly full-figure; one of them, her expression surprised and curious, leans forward and seems to look directly at the artist busy portraying her.

JOHN SLOAN
Hairdresser's Window
1907, oil on canvas
81 x 66 cm
Wadsworth Atheneum,
Hartford, Connecticut

Over his long,
successful career,
Sloan was painter,
illustrator, etcher,
and teacher. He took
part in the show of
the Eight at the
Macbeth Gallery and
in the Armory Show,
becoming one of the
masters of American
art. His favorite
subjects were urban
scenes, primarily in
the working-class
areas of New York,
in which he hoped to
show "the happiness
and the misery of
daily life." In this
work, based on rapid
brushstrokes and a
limited range of
colors, he draws the
viewer's attention to
the passersby who
pause to observe the
quiet work of a
hairdresser. The
clothes on the various
figures and the
writing on the signs,
left indefinite,
establish that this is
a working-class area;
these aspects also
demonstrate that
Sloan far preferred
direct and immediate
realism to the
elaborate decorations
of academic painting.

■ GEORGE BELLOWS
Stag at Sharkey's
1909, oil on canvas
92 x 122.6 cm
Cleveland Museum of
Art, Cleveland, Ohio

Between 1900 and 1911 organized boxing matches were illegal in New York, but clandestine matches were held in private clubs, such as Tom Sharkey's, where those who could afford the admission price could also place illegal bets. The center of this painting is taken up by the pair of entangled boxers and by the referee, checking to make sure no fouls are committed while also keeping out of the way of the violent match. Bellows showed great skill in designing the bodies of the two men, perfectly rendering the sense of force, agility, and power; he puts them in an intense, pale light, making them stand out against the dark background with the seated spectators. Most of the spectators are unrecognizable shapes, but in those few faces that can be seen Bellows revealed acute insight, making their expressions reveal their attitudes toward the progress of the fight.

GEORGIA O'KEEFFE
Street, New York, I
1926, oil on canvas
122 x 76 cm
Private collection

O'Keeffe made this composition two years after her marriage to Alfred Stieglitz, one of America's leading photographers. Stieglitz had a profound influence on her style. In fact, there are close ties between his urban views and O'Keeffe's radical formal decompositions in which she tranforms New York buildings into abstract geometric forms.

GEORGIA O'KEEFFE
Summer Days
1936, oil on canvas
91.4 x 76.2 cm
Whitney Museum of American Art, New York

Beginning in 1929 O'Keeffe spent summers in Santa Fe, New Mexico, and in 1949 she moved there permanently. In this painting she united the major themes of her last works. Above appears an animal skull stripped clean of its flesh, similar to a sacred African mask; in the center are flowers, to which she attributed profound allegorical meaning; below is a barren desert landscape, imbued with magical and spiritual values.

Jimson weed (*Datura stramonium*) is a poisonous plant of the nightshade family that grows in the desert regions of New Mexico, O'Keeffe's adopted homeland. Its white flowers, with large, irregular, funnel-shaped corollas, open between March and November in the cool of the evening, but cannot stand the heat of the day. "I saw my first Jimson weed sticking out between two steps on a stairway at Puye Pueblo. For many years they grew near my house at Abiguiu," wrote the painter. "One moonlit night at the ranch I counted one hundred twenty-five." In this canvas she shows her intense love of nature and at the same time invites the viewer to go beyond mere appearance to see the secrets of the soul, through the profound symbolism of her work, with its subtle erotic allusions.

CHARLES DEMUTH
My Egypt
1927, oil on panel
90.8 x 76.2 cm
Whitney Museum
of American Art,
New York

Demuth studied at
the Julian Academy
in Paris, where he
came in contact with
Cubists and Futurists.
On his return to
America he took a
passionate interest
in architecture and
photography. In
the 1920s, together
with Charles Sheeler,
he gave life to
Precisionism, also
called "Cubist
Realism," which
anticipated many of
the techniques later
adopted by pop art
and hyperrealism.
Most of Demuth's
works depict the
industrial city
of Lancaster,
Pennsylvania, where
he was born and was
forced to spend most
of his life because of
a serious form of
diabetes. In the
panel shown here
the surface is
marked off by
geometric lines that
cross not only the
buildings but the
sky and that serve
the same rhythmic
and dynamic function
as Futurist force-
lines. As indicated
by the title, Demuth
wished to compare
these enormous
grain elevators to
the towering
architecture of
ancient to
reveal that they
produce the same
emotional effect.

■ CHARLES SHEELER
American Interior
1934, oil on canvas
76.2 cm x 82. 6 cm
Yale University Art
Gallery, New Haven,
Connecticut

A native of
Philadelphia, Sheeler
applied the principles
of Precisionism not
only to industrial
views but also to a
series of interiors,
including the example
shown here, which
presents his home in
South Salem. Unlike
Charles Demuth, who
learned from the
Cubists and the
Futurists to
decompose buildings
and arrange them
across planes without
depth, Sheeler
remained faithful to
reality and drew
inspiration from
photography, which
he studied for many
years, at the same
time that he was
studying painting.
The point of view
chosen permitted him
to show off his skill
at design and his
precision in rendering
details. The
arrangement of the
objects seems
accidental but is the
result of repeated
studies on the
interrelationships
among the masses.
The distribution of
the shadows was also
carefully studied and
accurately follows
classical rules, which
Sheeler learned at the
Pennsylvania Academy
of Fine Arts and by
studying classical
masters during years
spent in Europe.

EDWARD HOPPER
Lighthouse Hill
1927, oil on canvas
71.8 x 100.3 cm
Dallas Museum of
Art, Dallas, Texas

Standing out among
the many works that
Hopper dedicated to
coastal views is his
series of lighthouses,
works characterized
by the use of strong
light in sharp contrast
to broad areas of
shadow. This canvas
is divided in two
horizontal bands, the
sky and the ground,
which oppose the
vertical thrust of the
house and the
cylindrical volume of
the lighthouse. The
point of view Hopper
chose is so low that
the ocean cannot be
seen, but the viewer
senses its presence
on the far side of
the hill. The desolate
landscape and the
absence of human
figures give the scene
an alienated and
uneasy atmosphere
that has been
compared to that of
certain Metaphysical
compositions by
Giorgio de Chirico. In
deciding to depict a
lighthouse, almost
always located in an
isolated and hard-to-
reach site, Hopper
was expressing one
of his favorite
themes, that of
solitude and the lack
of communication
that afflicts modern
society.

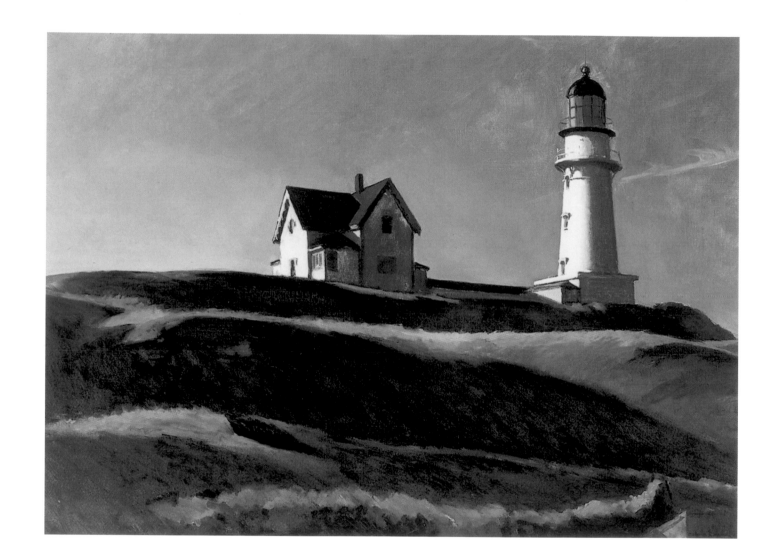

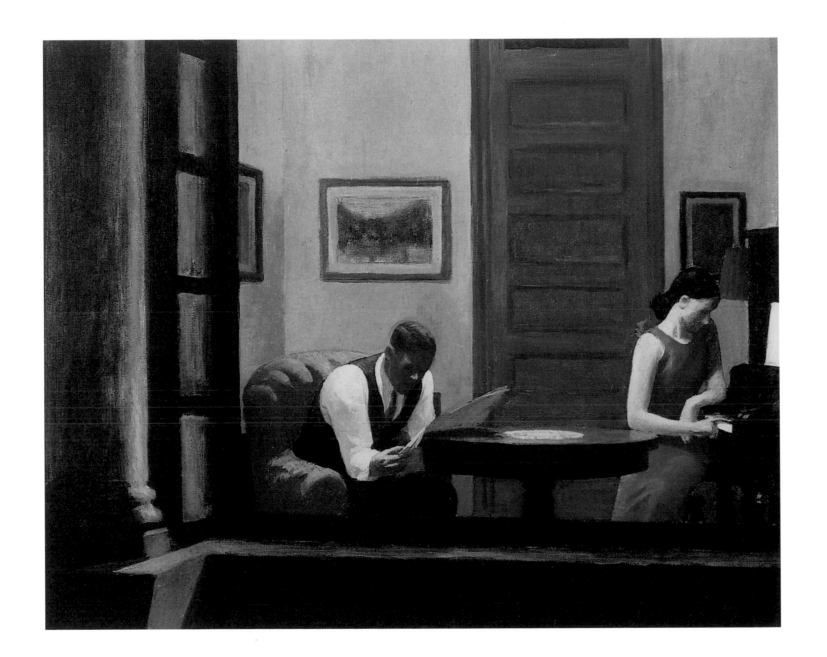

■ EDWARD HOPPER
Room in New York
1932, oil on canvas
73.5 x 91.5 cm
Sheldon Memorial Art
Gallery, University of
Nebraska, Lincoln

As he often did,
Hopper here presents
figures seen through
a window, forcing the
viewer to violate the
intimacy of their
domestic life. The
faces of the two
figures are not
defined, nor are the
furnishings of their
home, indications of
the depersonalization
of modern mass
society. The man is
busy reading a
newspaper, which he
seems to use as an
excuse for turning
away from his
companion, perhaps
to avoid continuing a
difficult conversation.
She is tapping out
notes on the piano,
but the position of
her left arm and most
of all her legs,
directed toward the
table, make clear that
she is not actively
playing the
instrument; instead
she seems absorbed in
her own thoughts as
though seeking the
right words and the
courage to face the
man seated across
from her. No other
elements explain who
these people are and
why they find
themselves in this
situation; Hopper
structures the scene
like a still from a
motion picture and
challenges the viewer
to use his or her
imagination to
reconstruct the event.

EDWARD HOPPER
Nighthawks
1942, oil on canvas
84.1 x 152.4
Art Institute of
Chicago

Hopper said he got
the original idea for
his painting from
the view of diners
in a restaurant on
Greenwich Avenue
in New York; the
work has become
an icon of solitude
and the lack of
communication in
large American cities.
Lost in their separate
thoughts and
completely detached
and indifferent to one
another, the four
figures seem to have
stepped out of one
of many Hollywood
films from those
years, or from a
story by Hemingway,
whom Hopper knew
and admired.

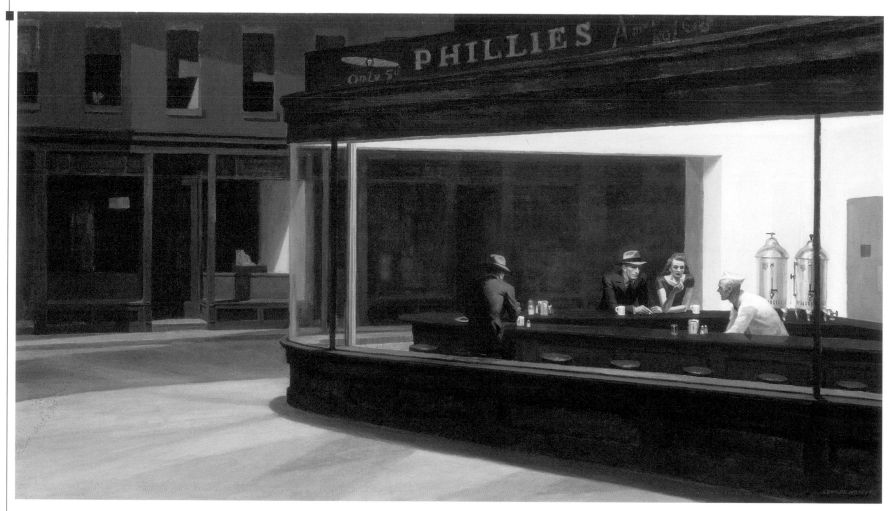

EDWARD HOPPER
Gas
1940, oil on canvas
66.7 x 102.2 cm
Museum of Modern
Art, New York

If the gas station
represents
civilization, the
forest on the other
side of the street is
symbolic of nature,
wild and
uncontaminated.
The sky is still pale,
but the artificial
illumination in the
station indicates
that night is coming,
making the man at
the pumps, one of
the many silent and
solitary figures in
Hopper's paintings,
seem even more
alone.

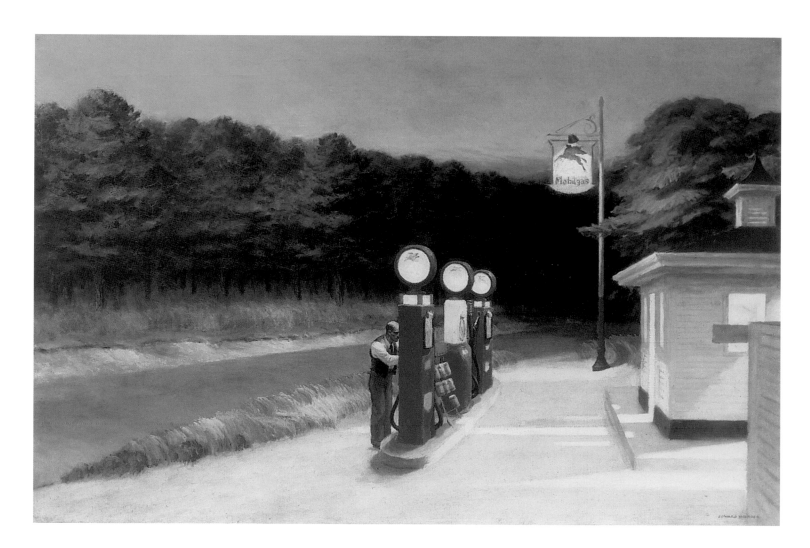

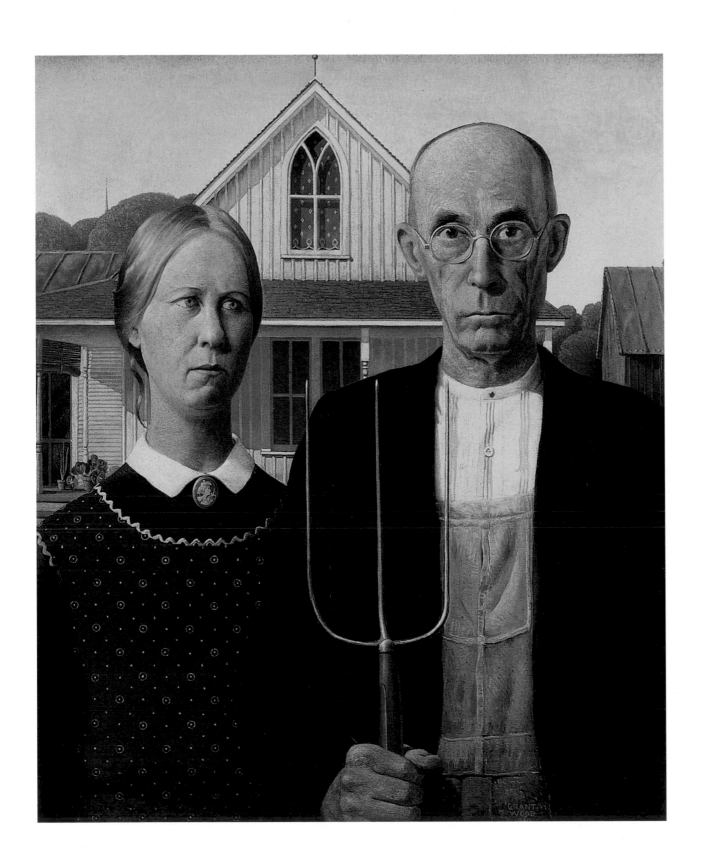

■ GRANT WOOD
American Gothic
1930, oil on
composition board
74.3 x 62.4 cm
Art Institute of
Chicago

This is one of the
most famous and
popular American
images, both symbol
and synthesis of
American art during
the first half of the
20th century.
Standing in front of
their farmhouse are
two Midwestern
farmers; as models
Wood used his sister
Nan and his dentist,
Byron H. McKeeby.
The man holds a
pitchfork; indeed he
grasps it with
determination almost
like a scepter, symbol
of his work and his
power. He stares out
at the viewer with a
severe and proud
expression. Whether
the woman beside and
slightly behind him is
his daughter or wife
is not clear. Both
wear their Sunday
best with a sober and
austere elegance.
Wood wanted to
contrast the economic
and moral crisis of
America's cities—
struck by the
Depression and
inhabited by
gangsters that made
fun of Prohibition—
with the moral
rectitude of rural
society, where it was
still possible to
encounter the original
spirit of the first
colonists.

BEN SHAHN
**The Passion of Sacco
and Vanzetti**
1931–32, tempera
on canvas
214.6 x 121.9 cm
Whitney Museum
of American Art,
New York

This is one of the
many paintings that
Shahn, the
Lithuanian-born
leader of Social
Realism in the United
States, dedicated to
the story of Sacco
and Vanzetti. In
1921 Nicola Sacco
and Bartolomeo
Vanzetti were arrested
and tried for robbery
and murder. Although
the case against them
did not seem
convincing, the two
Italian-American
anarchists were found
guilty and were
sentenced to death.
Despite strong
protests and appeals
in their favor, they
were executed in
1927 by electric chair.
Shahn here depicts
the funeral, the final
moment in the tragic
tale. He makes clear
his position in favor
of the two men
not only in the
expressions on
the three men
accompanying the
coffins but most of all
by putting white lilies
in the men's hands,
the flower that often
appears in classical
religious paintings in
the hands of martyr
saints as symbol of
purity and innocence.

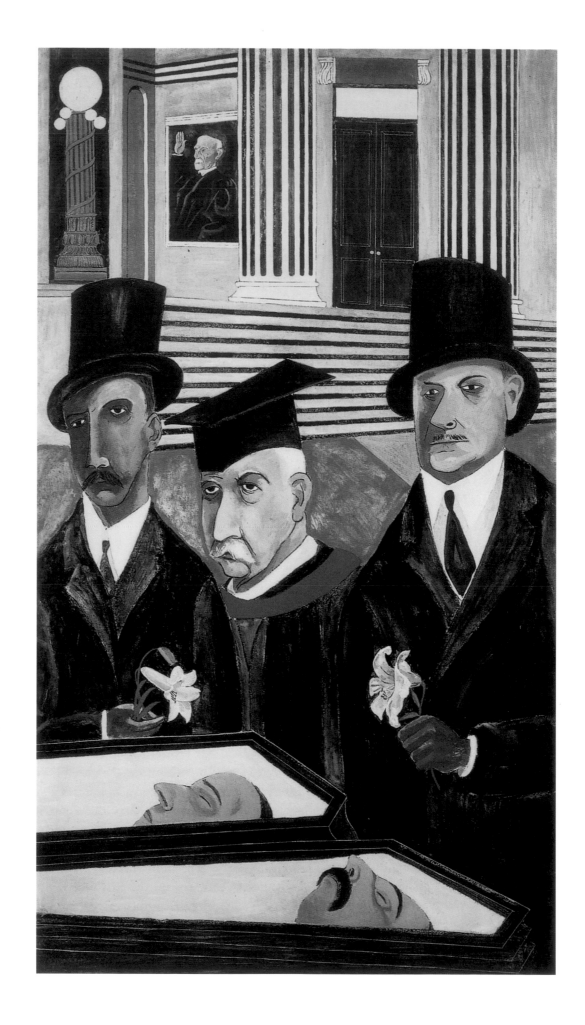

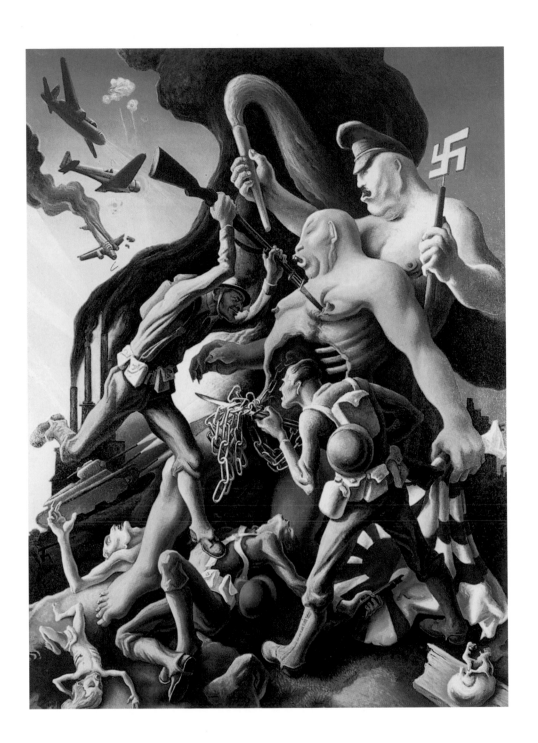

■ THOMAS HART
BENTON
**The Year of Peril:
Exterminate!**
1942, tempera and oil
on canvas
250.2 x 189.2 cm
State Historical
Society of Missouri,
Columbia, Missouri

After the Japanese
attack on Pearl Harbor
the United States
entered World War II,
but much of the
American population,
only recently
liberated from the
dark years of the
Depression following
the collapse of the
stock market in 1929,
was hostile to the
new conflict and did
not understand the
reasons for the
sacrifice. For this
reason Benton made a
series of six large
canvases entitled *The
Year of Peril* in which
he sought to convince
his compatriots of the
need to intervene to
defend the ideals of
democracy against
the threat of
totalitarianism.
American soldiers are
shown fighting two
monstrous and
deformed beings, one
easily recognized by
the Japanese flag he
grasps, the other by
the Nazi emblem and
vague resemblance to
Hitler. The scene of
battle in the
background, the
stricken bodies, and
the skull in the
foreground
accentuate the
scene's drama.

At the beginning of the 20th century the cultural training and careers of Latin American artists were still in the hands of art academies. The Academy of San Carlos, founded in Mexico City in 1785, and the public and private schools that had arisen in the first decades of the 19th century at Rio de Janeiro, Buenos Aires, Havana, Lima, and several minor centers controlled and directed exhibition activity, the style of the artists, and the taste of collectors. For the most part the teachers drew on the classical tradition, although some demonstrated an awareness of new trends. Scholarships and grants made it possible for the most promising students to travel to Europe, and art academies sometimes invited European artists to come and give classes and seminars. The popularity of art magazines and the increased distribution of illustrated books made possible awareness of events in the art world even in the most remote areas.

The first important cultural movement to involve both the figurative arts and literature was called Modernismo and spread elements of Art Nouveau, Symbolism, Naturalism, and Impressionism, to which can be added nostalgic flights across time (for example, the rediscovery of European medieval art) and space (with the continuous citations of models from Asia, most of all those Chinese and Japanese). Among the best-known exponents of this movement were the Mexicans Roberto Montenegro, Alberto Fuster, and Julio Ruelas, the Argentine Emilio Pettoruti, the Venezuelan Armando Reverón, and the Brazilians José Ferraz de Almeida Júnior, Lasar Segall, and Tarsila. Tarsila's

Diego Rivera, *Flower Seller*, 1942, oil on masonite, 122 x 122 cm; private collection

David Alfaro Siqueiros, *Peasant*, 1935, pyroxyline on masonite, 87.6 x 76 cm; private collection

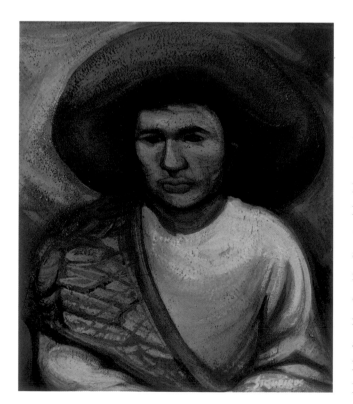

The leading exponents of Latin American art in the 19th century included the Uruguayan José Manuel Blanes, who spent many years in Italy; the Argentine Eduardo Sívori, a student of Puvis de Chavannes; the Colombian Andrés de Santa María, the best interpreter of the Impressionist style; and the Puerto Rican Francisco Oller, who drew inspiration from Courbet and Cézanne. These artists succeeded in creating personal and original syntheses of the millenary traditions of the pre-Columbian civilizations, the cultures of Spain and Portugal—spread over the Americas during three centuries of colonial rule—and ideas from European art, both ancient and modern. In this way they prepared the way for a new generation of artists receptive to the avant-garde ideas and revolutionary ferment that characterized the first half of the 20th century.

production was influenced by her time in Paris, where she took part in the cultural life and associated with other artists, among them Léger and Brancusi.

At the same time a second approach was being developed, one that could be called "indigenism" and that was promoted by artists who were socially and politically engaged. With their work they denounced the evils of contemporary society and fought the injustice and inequalities to which they and their compatriots were victim, most of all the natives, descendents and heirs of the ancient pre-Columbian civilizations. The Mexican Revolution of 1910–20, led by Pancho Villa and Emiliano Zapata, which

put an end to the regime of Porfirio Díaz, stimulated young intellectuals and artists to seek new expressive forms. The so-called *época heroica* in Mexican art is marked by numerous important personalities, such as Fernando Leal, Jean Charlot, Ramón Alva de la Canal, and Fermín Revueltas, but most of all there are *"los tres grandes del renacimiento muralista"*: Diego Rivera, José Clemente Orozco, and David Alfaro Siqueiros. Thanks to the patronage of the minister of education José Vasconcelos, they made large frescoes celebrating the values of the Revolution while evoking Mexican history and tradition. In the first murals that he made for the Escuela Nacional Preparatoria and for the Escuela de Agricoltura of

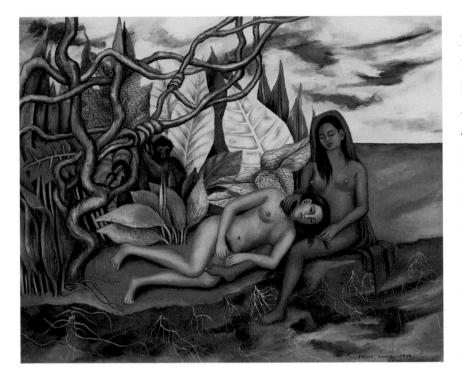

1933 Rivera made murals for the Pacific Stock Exchange in San Francisco and Rockefeller Center in New York, influencing young American artists, among them Jackson Pollock, who in 1936 took part in the activity of the Experimental Workshop, directed by Siqueiros in Manhattan. Equal political and social dedication, although with less strident tones, can be found in many works by the Brazilians Emiliano Cavalcanti and Candido Portinari, who worked to depict aspects of the lives of people of different social classes and different racial groups, with a particular sympathy for the poorer classes and for the difficult but dignified lives in the shantytowns known as *favelas*. In the 1930s Constructivism

Frida Kahlo, *Two Nudes in the Jungle (Mother Earth)*, 1939, oil on metal, 25.1 x 30.2 cm; private collection

Latin America

Chapingo, Rivera distanced himself from the Cubist style he had learned in Paris and drew inspiration instead from what he had seen in Italy, in particular Byzantine and Renaissance art. Equally important were the murals for the Secretaría de Educación Pública, made in Mexico City between 1929 and 1930 in which Rivera repeated and reinterpreted the forms of classical art. Orozco too made his debut with murals at the Escuela Nacional Preparatoria between 1923 and 1926, in which he matured a solid and monumental style, with a sharp design and expressive use of colors, as also seen in the paintings on canvas he made during the 1930s and in the illustrations he made for the book by the Mexican novelist Mariano Azuela *Los de Abajo* (translated in English as *The Underdogs*). Equally aggressive and dramatic were the creations by Siqueiros, who concentrated on the theme of the revolt of the proletarian classes against every kind of oppression and injustice.

The fame of *los tres grandes* soon reached the United States. In 1930 Orozco painted *Prometheus* at Pomona College in Claremont, California, and made a mural at the New School for Social Research in New York; in

became widespread, creating its own forms (both figurative and abstract), beginning with a rigorously geometric base. The most important exponents were the Uruguayans Joaquín Torres García and Rafael Barradas, aside from the members of the Arte Madí and Arte Concreto-Invención groups, and later the Neo-Concreto group and the Venezuelan Jesús Rafael Soto. The next decade saw the spread of the Surrealist movement, inaugurated at the Exposición Internacional del Surrealismo, held in January 1940 at the Galería de Arte Mexicano in Mexico City and organized by André Breton, the Austrian painter Wolfgang Paalen, and the Peruvian poet César Moro. The best-known followers of Surrealism were the Chilean Roberto Matta, an ingenious creator of oneiric images, and the Cuban Wilfredo Lam, whose paintings, influenced by the magical rites of pagan religions, explore the most inaccessible mysteries of the subconscious.

Frida Kahlo presents a separate case, for although she exhibited at the 1940 show and took part in other Surrealist exhibitions, she always refused to be included in the movement and created her own style, which resists all categorization.

DIEGO RIVERA
Zapatista Landscape (Guerilla Warfare)
1915, oil on canvas
145 x 125 cm
Museo Nacional de Arte Moderno, Mexico City

Between 1913 and 1921 Rivera made about two hundred Cubist paintings: urban landscapes, still lifes, and portraits, such as those of Jacques Lipchitz and the literary critic Ramón Gómez de la Serna. In this work he sought to celebrate the Mexican Revolution by way of various symbolic objects presented against a landscape background that recalls the mountains of his country. There is a sombrero, a rifle, and a poncho (a Zacatecas serape), loaned to him by the writer Martín Luis Guzman. Rivera painted an Aztec symbol on the sombrero as though seeking to establish ties with pre-Columbian civilizations and as if he saw the Zapatista revolt as revenge for colonial oppression. These objects are fragmented as in the style of the works by Picasso, Braque, and Gris, which Rivera could have seen during his stay in Paris. On the back of the canvas is another painting, made about two years earlier, depicting a *Woman at the Well*.

JOSÉ CLEMENTE
OROZCO
Emiliano Zapata
1930, oil on canvas
178.4 x 122.6 cm
Chicago Art Institute

Emiliano Zapata is a
mythical figure in the
Mexican revolutionary
imagination. With his
cry "land and liberty,"
he fought to bring
about radical agrarian
reforms to ease the
miserable conditions
of the peasant. In the
foreground of this
canvas are kneeling
farmers, symbolic of
the oppressed people;
behind them are two
armed men. The
figure of Zapata
seems drawn from
a medieval painting
of a saint: his face
is crowned by the
sombrero, similar
to a halo, while the
knife pointing to
his eye recalls his
assassination-
martyrdom, which
occurred in 1919,
when he was only
forty, at the orders
of General Venustiano
Carranza. Orozco
made this painting
during his self-
imposed exile in the
United States,
following the
disturbances caused
by his mural paintings
in Mexico City. He
sold this painting to
the actor Vincent
Price to pay for his
trip to New York from
California, where he
had gone to make
several murals.

Creation
(detail)
1922–23,
mixed media,
encaustic and collage
with gold inserts
Escuela Nacional
Preparatoria,
Mexico City

Creation is the first
mural Rivera made
for the school's
main hall (later
transformed into a
theater), and it
reveals his experience
in Europe in contact
with works of classical
art (Byzantine
mosaics and medieval
and Renaissance
frescoes) and modern
art (from Cézanne to
the Cubists). This
image is a detail of
the fresco in which
Eve can be seen,
depicted as a mestiza
surrounded by
allegories of Dance,
Music, Song, and
Drama. To the right
side Adam appears,
also portrayed as a
mestizo and
surrounded by a
series of women that
stand for Fables,
Knowledge, Erotic
Poetry, Tradition,
Tragedy, Prudence,
Justice, and Strength,
Temperance, and
Science. In the
decades following,
Rivera made numerous
murals dedicated to
pre-Columbian
civilizations as well
as to the subject of
contemporary politics
seen from the point
of view of the
working-class
struggle against
injustice and
oppression.

DAVID ALFARO
SIQUEIROS
Victim of Fascism
1945, pyroxyline
on cellotex
368.5 x 246.5 cm
Palacio de Bellas
Artes, Mexico City

The Art Nouveau–style
Palacio de Bellas
Artes in Mexico City
was begun in 1904
on the ruins of the
convent of Santa
Isabel; the dictator
Porfirio Díaz wanted
it built in time to be
inaugurated on the
celebration of the
centennial of Mexican
independence.
Because of serious
structural problems,
caused by the
instability of the
ground, the work
went on for more
than thirty years.
The second and third
floors of the building
hold mural paintings
by Rivera, Orozco,
Tamayo, and
Siqueiros, among
others. This painting
is the right panel of
a triptych, the central
panel of which
presents *The New
Democracy* while the
left panel shows
Victims of War. In
this large-scale work
Siqueiros celebrated
the end of World War
II, the fall of Nazism
and Fascism, and the
return to democracy.
The symbolic figure
portrayed with his
hands tied and back
marked by lashes,
recalls scenes of
martyrdom in
medieval art.

XUL SOLAR
National Holiday
1925, watercolor and
pen on paper
28 x 38 cm
Private collection

In his paintings
Xul Solar applies in
a personal way the
decompositions and
formal simplifications
of the Futurists and
Cubists, whose works
he saw during the
years he spent in
Europe. His figures
move freely across
an unreal space,
without depth and
freed of the laws of
perspective and
physics. Thanks to
the use of color, he
created a fantasy
universe similar
to reality but
transformed into a
lyrical and highly
evocative dimension.

PEDRO FIGARI
Dance on the Patio
circa 1930,
oil on panel
99 x 119.5 cm
Private collection

Influenced by the
French Post-
Impressionists, most
especially Bonnard
and Vuillard, Figari
loved to present
scenes of the daily
life of Uruguay, using
a simple style full of
poetry and lively and
delicate tonalities.
The scene is set
in a quiet night
illuminated by the
full moon; the viewer
is transported to a
patio where a pair of
guitarists plays
dances for a group of
peasants wearing the
kind of traditional
clothes worn on
festive occasions.

The artists of Latin America

■ RUFINO TAMAYO
Still life with Foot
1928, oil on canvas
58.1 x 51 cm
Private collection

While maintaining solid and enduring ties to Mexico's popular traditional, Tamayo always paid close attention to the ideas and creations of the avant-gardes in Europe and the United States. In this canvas, the most important example from his youthful production, he reveals that he already possessed notable skill in drawing, in organizing masses, and in the use of color. The painting also reveals the influence of the Metaphysical works of de Chirico, on which it was clearly based. Tamayo assembled a variety of different objects, including playing cards, scissors, and the sculpture of a foot that gives the work its title. These objects are located atop a table near an open window through which can be seen a hot-air balloon. The meaning is deliberately obscure, as though Tamayo were challenging the viewer to decipher the images and come up with an interpretation.

EMILIO PETTORUTI
Singer
1934, oil on canvas
81 x 60 cm
Private collection

From 1930 to 1947 Pettoruti directed the Museo Provincial de Bellas Artes in La Plata, the city of his birth. During that seventeen-year period he actively worked to introduce avant-garde ideas, particularly those of Futurism and Cubism, to Argentina. He met opposition from most of the country's critics and academics, hardly receptive to innovation, who accused him of seeking to destroy the nation's traditional art. This painting was presented at the Tercer Salón de Arte, held at La Plata in August 1932. One clearly notes the typical decomposition of forms into two-dimensional geometric elements that is the most obvious trait of Cubism. The subject of the work was inspired by similar compositions by Picasso and Gris, works that Pettoruti may well have seen during a brief visit to Paris.

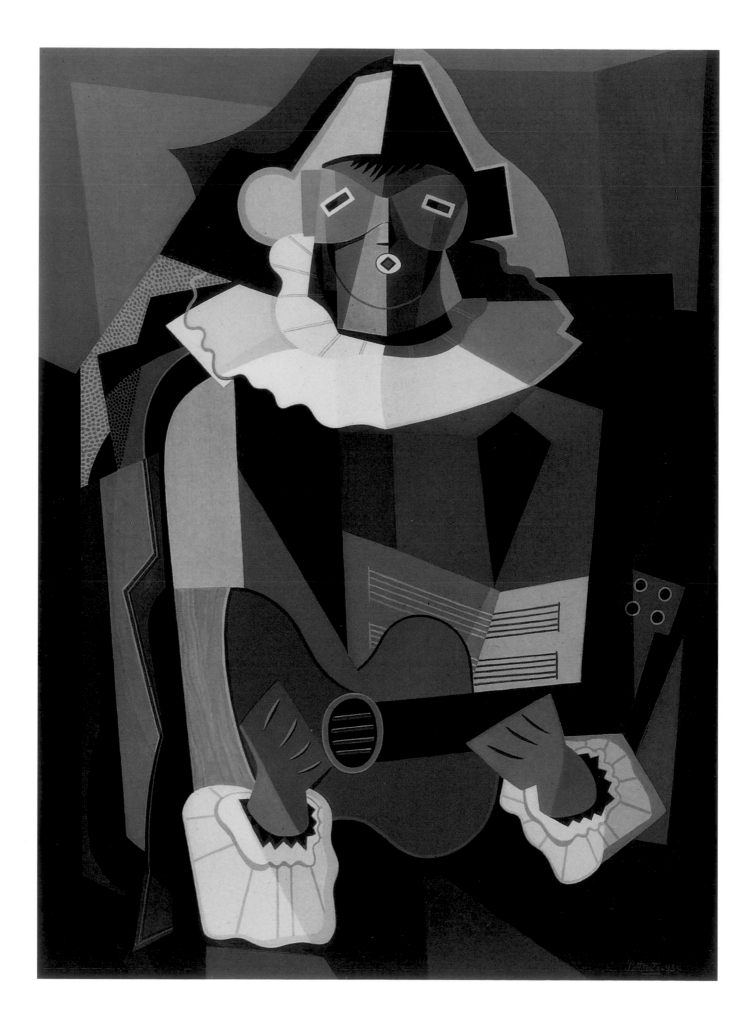

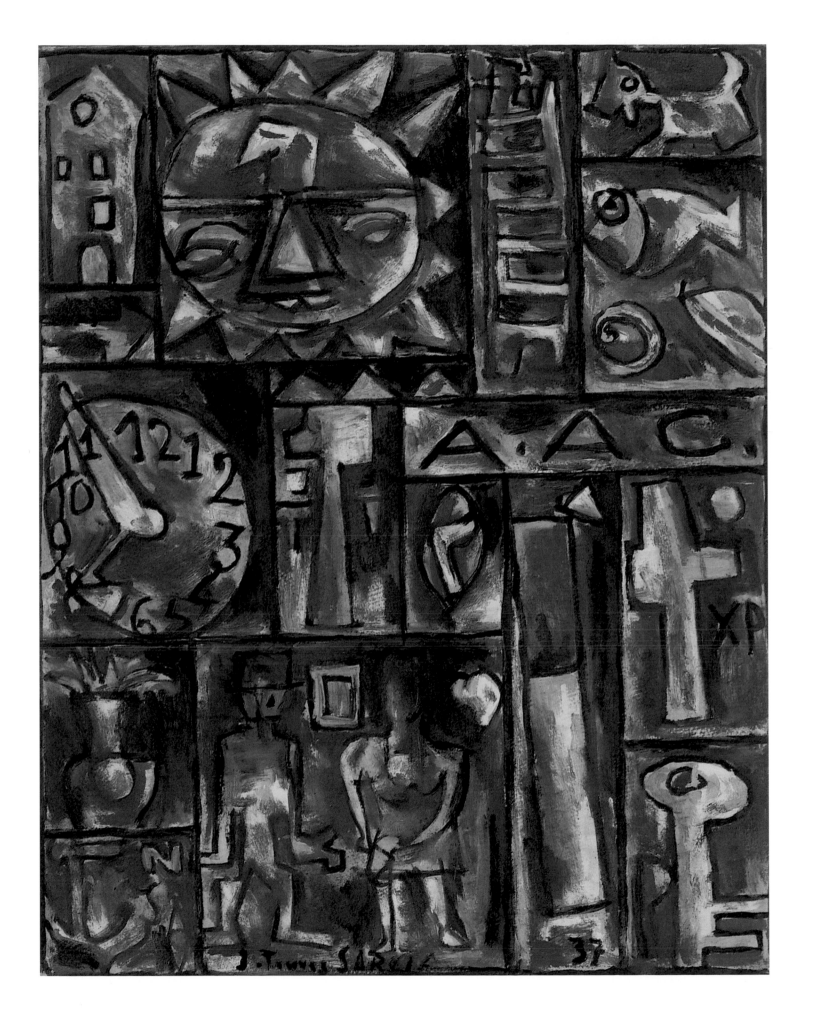

■ JOAQUÍN TORRES
GARCÍA
**Constructivist
Composition with
Deformed Objects**
1937, oil on masonite
52 x 41.2 cm
Private collection

Beginning in 1929,
when he was among
the founders of the
Cercle et Carré
group, Torres
García developed
his particular
Constructivist style,
which applies
geometric proportions
in a systematic
manner. In his
writings of the 1930s
he often referred to
the "golden section,"
a mathematical
formula according to
which he organized
and distributed lines
and masses. In this
painting he made use
of a few essential
colors and simplified
the shapes of the
objects, reducing
them to their
symbolic values. Some
of these objects often
appear in his works
and are related to his
vision of life. In
particular there is the
sun, which represents
the cosmos; the clock,
related to the eternal
passage of time; the
fish, which stands for
nature; and the
anchor, which Torres
García saw as
symbolic of hope.
At the bottom are
a stylized man and
woman, behind them
a small square
(rationality) and
a heart (the
sentiments).

FRIDA KAHLO
Souvenir
1937, oil on canvas
40 x 28.5 cm
Private collection

In this painting, with its complex symbols, much like the dreamlike visions of Surrealism, Kahlo is pierced by a lance ridden by two tiny cupids; her heart has literally been torn from her chest and lies on the ground, its blood flowing into the sea. The sadness of this painting may be connected to her discovery of the relationship between her husband, Diego Rivera, and her sister, Cristina, which had begun two years earlier. Kahlo depicts herself with one foot solidly rooted to the earth while the other has become a ship, perhaps indicating her desire to seek her fortune outside her country. To her sides are two sets of clothes, one in Western style, the other traditionally Mexican, emblematic of Kahlo's two souls as the daughter of a Hungarian Jew who emigrated from Germany and a Mexican mestiza.

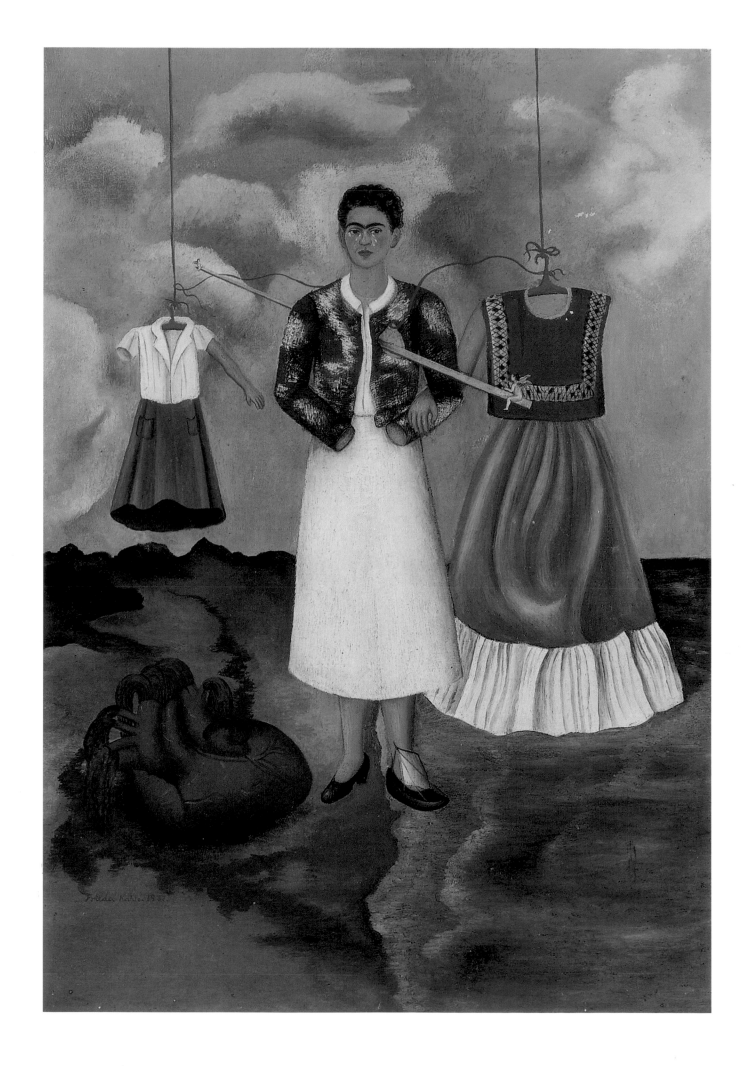

The artists of Latin America

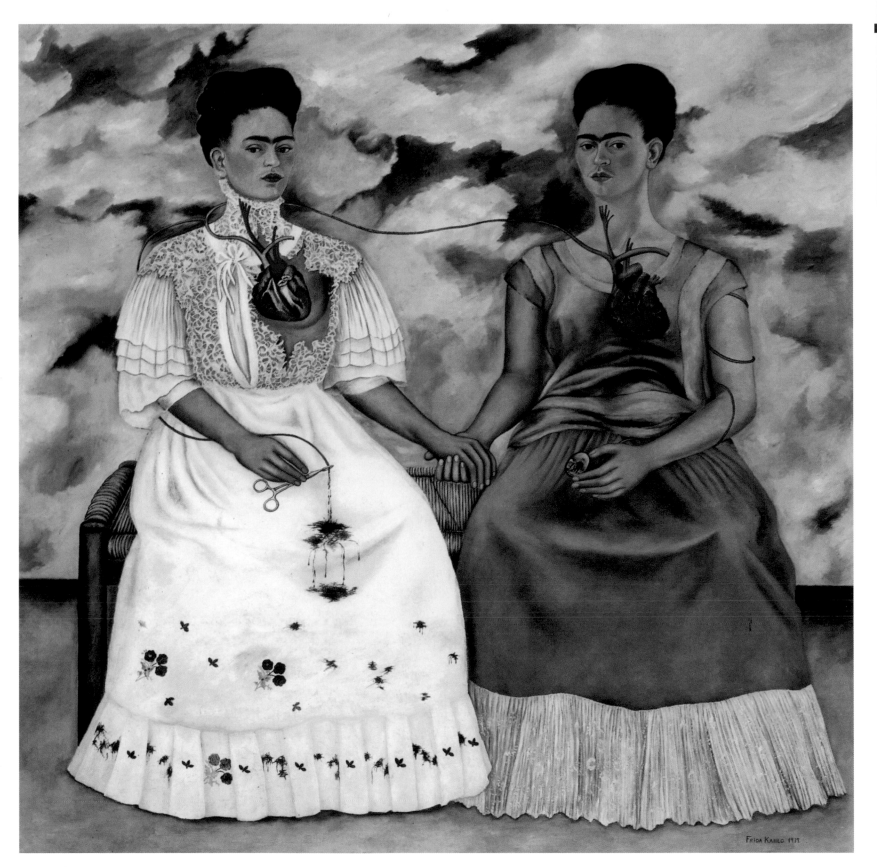

■ FRIDA KAHLO
**Las Dos Fridas
(The Two Fridas)**
1939, oil on canvas
173 x 173 cm
Museo Nacional de
Arte Moderno,
Mexico City

Kahlo's art is closely
related to her
personal life. She
made this painting
shortly after
returning to Mexico
from Paris; it was
made in response to
the request for a
divorce from her
husband, Diego
Rivera. Kahlo presents
herself doubled: one
Frida wears a native
Mexican costume and
holds a small
medallion showing
the child Diego; the
other wears Western
clothes. The two
women are joined by
a vein running heart
to heart. One Frida is
healthy because she
is loved; the other is
sick because of the
separation. The Frida
in white holds
a blood clamp with
which she stops the
flow of blood that has
stained her dress. The
sky behind the two
Fridas is filling with
dense clouds,
threatening a storm.
With this complex
vision Kahlo depicted
her pain at the loss
of the man she loved
and at the same time
she presented her
attempt to find
consolation and
comfort in herself.

rom the earliest civilizations until the end of the 19th century, sculpture had an established identity and served a precise social role. Most sculpture was public and monumental and served a celebratory function related to religion or political power. Sculpture was designed to be complementary to an architectural structure, such as a temple or palace, a city square, or a garden. Over the course of the first half of the 20th century avant-garde movements wrought radical changes in the language, materials, and subjects of three-dimensional art, giving the discipline a completely different aspect. In seeking the origins of modern sculpture, critics usually select certain leaders of Impressionism, such as Edgar Degas and Auguste Renoir, who proved themselves highly creative in this field, although the role they played was by no means comparable to their importance in the history of painting. More important contributions were made by Auguste Rodin and Medardo Rosso. Rodin closely studied the masters of the past, in particular Michelangelo, and made use of a new and original language and technique far removed from all academic rules, just as the Impressionist painters were doing during the same years. Among his immediate successors were Aristide Maillol, Antoine Bourdelle, and Charles Despiau. Medardo Rosso, friend of Degas and Zola, had a more intimist and subjective vision and made small-scale works using fragile materials like wax, which he shaped with great poetic sensitivity. His works had an effect on the Futurists, who took many of his intuitions to their extreme conclusions.

Auguste Rodin, *Head of Lady Sackville,* 1914–15, marble 76.1 x 109 x 63.5 cm; private collection

The figure of Henri Matisse stands out among the exponents of Post-Impressionism. He made his sculptural debut in 1899 with a copy of the *Jaguar Devouring a Hare* by Antoine Louis Barye. Between 1900 and 1903 he made his first human figure, *The Slave,* which repeated the theme of the *Walking Man* by Rodin, but presented it in a very different manner, giving more space to the linear development. Over the following decades Matisse made numerous sculptures, such as the three versions of the *Nude Lying Down* (1907–29) or the four works entitled *Back* (1909–29), in which he

Amedeo Modigliani, *Head of a Woman,* 1912, sandstone, 58 x 12 x 16 cm; Musée National d'Art Moderne, Centre Georges Pompidou, Paris

experimented with new solutions similar to what he was doing at that time in painting and engraving. Equally important was the work of Ernst Barlach, who transferred some of the themes typical of Expressionism to three dimensions.

The great revolution in modern sculpture resulted from the encounter between the innovations in the paintings by Cézanne, who suggested the use of simple and elementary geometric forms, and the forms of non-European art (the so-called primitive sculpture), which had already inspired Gauguin in his wooden statues, exhibited in the retrospective show held in the Salon d'Automne in Paris in 1906. Among the first artists to achieve this synthesis was Amedeo Modigliani, who dedicated equal passion to the study of the art of ancient Egypt and the study of African tribal statues. Those same statues provided inspiration to Constantin Brancusi and to exponents of Cubism, in particular Pablo Picasso. Picasso made his first experiments in 1907; his style acquired greater security in the *Woman's Head* of 1909 and reached full awareness in the *Glass of Absinthe* of 1914. In the course of his long career he often returned to sculpture, using the most disparate materials, from those traditional, such as bronze and ceramics, to those more unusual, which he assembled to create three-dimensional collages that were still having influence

on sculptors after World War II. The Cubist efforts directed at the fragmentation of forms proceeded parallel to those made in the same years by the Italian Futurists, in particular Umberto Boccioni. On April 11, 1912, he published the "Technical Manifesto of Futurist Sculpture." Among the principal points of his proclamation was the affirmation that "the aim of sculpture is the abstract reconstruction of the planes and volumes that determine form, not their figurative value." Indeed, "sculpture cannot make its goal the episodic reconstruction of reality." It was necessary, Boccioni claimed, "to destroy the pretended nobility, entirely literary and traditional, of marble and bronze and to deny squarely that one must use a single material for a sculptural ensemble. The sculptor can use twenty different materials, or even more, in a single work, provided the plastic emotion requires it. Here is a modest sample of these materials: glass,

base of almost all the avant-garde movements of the century, beginning with the exponents of Russian Constructivism—and first among them Tatlin, one of the pioneers of abstract sculpture—and continuing on with Dadaism and Surrealism. It was during those same years that the technique of collage came into increasingly widespread use, leading to a gradual dissolution of the solid line between painting and sculpture, with works that were partly sculpted and partly painted and thus located in a middle-ground between the two disciplines. There is then the problem presented by the readymades of Marcel Duchamp, which raise serous questions concerning the very concept of sculpture.

In the period between the two world wars the efforts in this field moved in a variety of directions. Some artists returned to the traditions of the past in the name of the so-called return to order, leading to

Sculpture

wood, cardboard, cement, iron, horsehair, leather, cloth, mirrors, electric lights, etc." These two objectives, to free sculpture from the imitation of reality and to use any materials in its creation, were at the

a renewed faithfulness to objective reality. Far from holding back the avant-garde movements related to Surrealism and to the various forms of abstract art, this conservative and reactionary stance only stimulated them to take further steps in their experimentation. Two trends can be identified within these expressions—sometimes opposed, sometimes blended and practiced at the same time by the same artist—and these trends can be seen as the two "poles" that form the name of one of the many groups that arose in those years: Cercle et Carré ("Circle and Square"). The first trend preferred curving lines and explored biomorphic, organic forms and their ties to surrounding space (the works of Jean Arp, for example); the second preferred straight lines, used elementary geometric figures, and explored the relationships between light and surfaces or the balances among masses (such as in the creations by El Lissitzky, László Moholy-Nagy, Georges Vantongerloo, Jacques Lipchitz, and Henri Laurens). During those same years other artists destined for later success, among them Alberto Giacometti, Marino Marini, Alexander Calder, and Henry Moore, presented their first works.

This work was
commissioned from
Rodin on August 16,
1880, by Edmond
Turquet, under-
secretary of fine arts,
who intended to place
it in a new museum
dedicated to the
decorative arts. The
building was never
built, and Rodin
spent the rest of his
life working on the
large structure,
which became a kind
of ongoing work in
progress. Drawing
inspiration from
Michelangelo, Rodin
created a monumental
meditation on death,
pain, and damnation.
In 1887 he began
exhibiting sculptures
from the door, cast
separately or
assembled in new
combinations, such
as *The Thinker, The
Prodigal Son, Fugit
Amor, Crouching
Woman,* and *The Kiss.*
In 1900 he presented
a plaster model of
the gates, without
the projecting parts
and still largely
incomplete. Upon
his death, in 1917,
the work was still
not finished. In
1925, bronze casts,
including the one
shown here, were
made on the basis
of the last plaster
versions and the
remaining drawings.

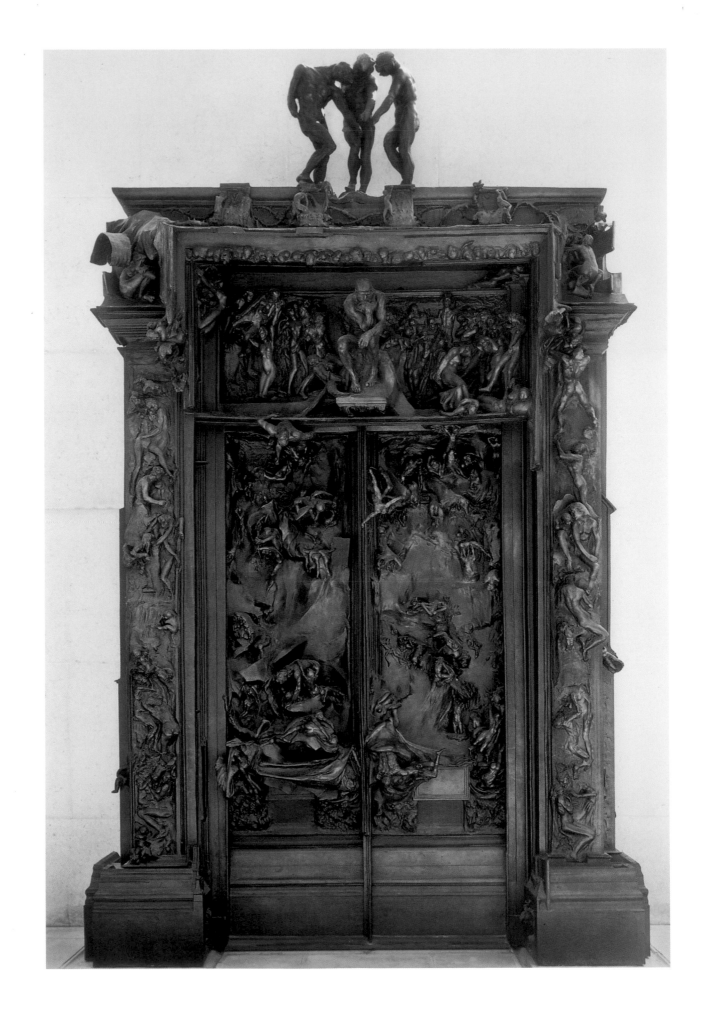

■ MEDARDO ROSSO
The Concierge
circa 1920, wax
37.5 x 30 x 16 cm
Private collection

The original plaster model, today in the Museo Medardo Rosso in Barzio, near Lake Como, was made in 1883, the year in which Rosso was expelled from the Brera Academy in Milan for disciplinary reasons. Already in this work one can note his turning away from the classical tradition in search of new, more open expressive forms. He depicts Orsola, the concierge of his house; he defines the features of her face in an accurate manner, but there is a sweet affection in the way he brings to light the signs of advancing age. At the same time he models the surfaces of the bust so as to most effectively render the effects of light and shadow, approachinq the works being made during the same period by the Impressionists. In 1920 Rosso exhibited this statue at the Mostra d'Arte Sacra in Venice, altering its title to *St. Orsola*; that same year he began making wax replicas, including the one shown here.

CONSTANTIN
BRANCUSI
The Kiss
1907, stone
28 x 26 x 21.5 cm
Kunsthalle, Hamburg

With this famous
statue Brancusi
began the long
process of formal
simplification that
led him close to
abstractionism. It is
also one of the first
works that he made
directly in stone,
without the use of a
preliminary clay
model. Brancusi was
probably inspired by
The Kiss, one of
Rodin's most famous
statues, but the
classical theme of
the pair of lovers is
presented here in a
completely different
way. Brancusi did not
seek his models in
the tradition of
Western art and
turned instead to
non-European models,
in particular those
from Africa, which he
saw and studied in
the ethnographic
museums of Paris. The
bodies of the figures
are transformed into
two masses with
elementary, almost
geometric, forms.
At the same time,
however, the forms
communicate a strong
and fascinating
emotional force, for
which reason the
statue is today
considered a universal
icon of the love
between a man
and a woman.

■ CONSTANTIN
BRANCUSI
**Mademoiselle
Pogany II**
1920–25, bronze
height 43.8 cm
Private collection

Margit Pogany was a
Hungarian art student
whom Brancusi met
in December 1910 in
Paris and invited her
to pose for him, in his
studio at 54, Rue du
Montparnasse. When
she returned to
Hungary early in
1911, Brancusi
destroyed the clay
models he had made
in her presence,
preserving only
several drawings,
which he reworked
and simplified a few
months later.
Brancusi concentrated
on the girl's hair, her
large eyes, and one
of her two arms held
near her chin,
reducing all these
elements to the most
minimal terms, to the
limits of abstraction.
The first version of
the work dates to
1912; between 1920
and 1925 he made a
second version in
stone and several
bronze casts,
including the one
shown here, sold at
auction in New York
on May 14, 1997, for
nearly $7 million. In
1931 Brancusi used
the same portrait to
make a further,
more radical,
simplification.

PABLO PICASSO
**Woman's Head
(Fernande)**
1909, bronze
40.5 x 23, x 26 cm
Musée Picasso, Paris

Fernande Olivier was
the pseudonym of
Amélie Lang
(1881–1966). Early in
the century she was a
model and dreamed of
becoming a painter;
in 1904 she met
Picasso and began an
affair with him that
lasted until 1912. In
the summer of 1909
she and Picasso went
to Horat de Ebro,
where he made
numerous portraits
of her. On his return
to Paris, he made a
model in clay and two
in plaster, from which
he made the bronze
cast shown here. This
was a fundamental
work in Cubist
sculpture, having
an influence there
similar to the
influence of
Demoiselles d'Avignon
(see page 74) on
painting. Fernande's
face is fragmented
and recomposed
following the theories
of Cubism, with a
careful alternation of
straight and curved
lines to control the
reflection of light.
This multiplication
of planes meant the
elimination of the
single point of view,
so important to
classical sculpture,
replaced by a new,
more dynamic vision
of reality.

■ PABLO PICASSO
Glass of Absinthe
1914, painted
bronze with silver
sugar strainer
height 21.5 cm
Private collection

■ PABLO PICASSO
Glass of Absinthe
1914, painted bronze
with silver sugar
strainer
Staatliche Museen,
Museum Berggruen,
Berlin

Absinthe, already the
subject of several
famous paintings by
Impressionists, was a
popular drink among
the Parisian working
class as well as among
artists. A green
liqueur distilled from
wormwood and such
aromatics as anise
and mint, it was
known for its bitter
taste, its hallucinatory
aspect, and its
deleterious effect on
habitual drinkers. The
sculptures shown here
include the detail of
the sugar strainer
through which the
absinthe was poured
to diminish its bitter
flavor. Picasso was
inspired by a bronze
made in 1913 by
Umberto Boccioni
entitled *Development
of a Bottle in Space*,
in which the spiraling
form of a bottle is
sectioned so as to
make visible not only
its exterior but
interior. The works
shown here are two
of six bronzes, made
from a wax model
commissioned from
Picasso by Daniel-
Henry Kahnweiler;
Picasso personally
painted each of them.
He kept one for
himself and sold the
other five to gallery
owners, who
presented them at
auction at the Hôtel
Drouot in Paris on
June 13 and 14, 1921.

HENRI MATISSE
La Serpentine
1909, bronze
height 55.9 cm
Private collection

Matisse made this
sculpture in his new
studio at Issy-les-
Moulineaux in the fall
of 1909 while he was
busy painting the two
large panels of *Music*
and *Dance* (see page
68), commissioned
by Sergei Shchukin.
He did not use a
model but drew
inspiration from a
photo he found in
the magazine *Mes
Modèles*. The
photographer Edward
Steichen took a series
of famous snapshots
showing Matisse at
work on the clay
model; those
photographs and the
preparatory drawings
reveal that the
original idea for the
statue was far more
realistic in style; only
later did Matisse
decide to elongate it
and make it thinner,
making the body of
the girl more lithe
and light. Ten bronze
casts and a proof
were made of the
statue; the first was
cast by Costenoble in
1910; the others were
made in the Valsuani
foundry between 1929
and 1953 and are
almost all held by
major museums.

■ ALEXANDER
ARCHIPENKO
Flat Torso
1914, marble
38.5 x 9 x 4 cm
Staatsgalerie,
Stuttgart

Archipenko was
among the leaders
in the European
avant-garde
movements during
the first decades of
the century. A tireless
experimenter in both
the language and
techniques of art, he
assembled a wide
variety of materials,
such as wood, glass,
and metal, and used
them to create
increasingly daring
figures. His earliest
works were based on
reality, but they later
moved away from it,
approaching pure
abstract forms. The
marble sculpture
shown here, one of
the most important
works from his
Parisian period,
represents an
important step in
the process of the
gradual simplification
and liberation of
lines, no longer tied
to the representation
of reality. The smooth
surfaces are a mirror
of Archipenko's
compositional rigor,
for he eliminated
every superfluous
decorative element
to capture the pure
sense of the human
body. At the same
time he eliminated
weight and density
from the masses,
which became fluid
and light in space,
with extreme grace
and elegance.

UMBERTO BOCCIONI
**Unique Forms of
Continuity in Space**
1913, bronze
126 x 89 x 40 cm
Civico Museo d'Arte
Contemporanea, Milan

During his short life
Boccioni made
slightly more than ten
sculptures, in plaster
or assembled from a
variety of materials.
Almost all have been
destroyed since
Boccioni left them in
the courtyard of his
studio in Milan when
he left for the war.
The piece shown here
is one of the three
statues by Boccioni of
which the plaster
original has survived
(Museu de Arte, São
Paulo), from which
several bronze casts
were made in 1931.
In this work Boccioni
wanted to visually
depict the energy of
movement, a basic
theme of Futurist
aesthetics. Boccioni
depicted a man intent
on the force of
striding forward; the
muscular masses of
his body contort,
swell, and surge into
the surrounding
space. The bronze
itself seems to melt in
a fluid and harmonic
movement of full and
empty spaces, areas
of light and shadow,
in an unstable and
precarious balance.

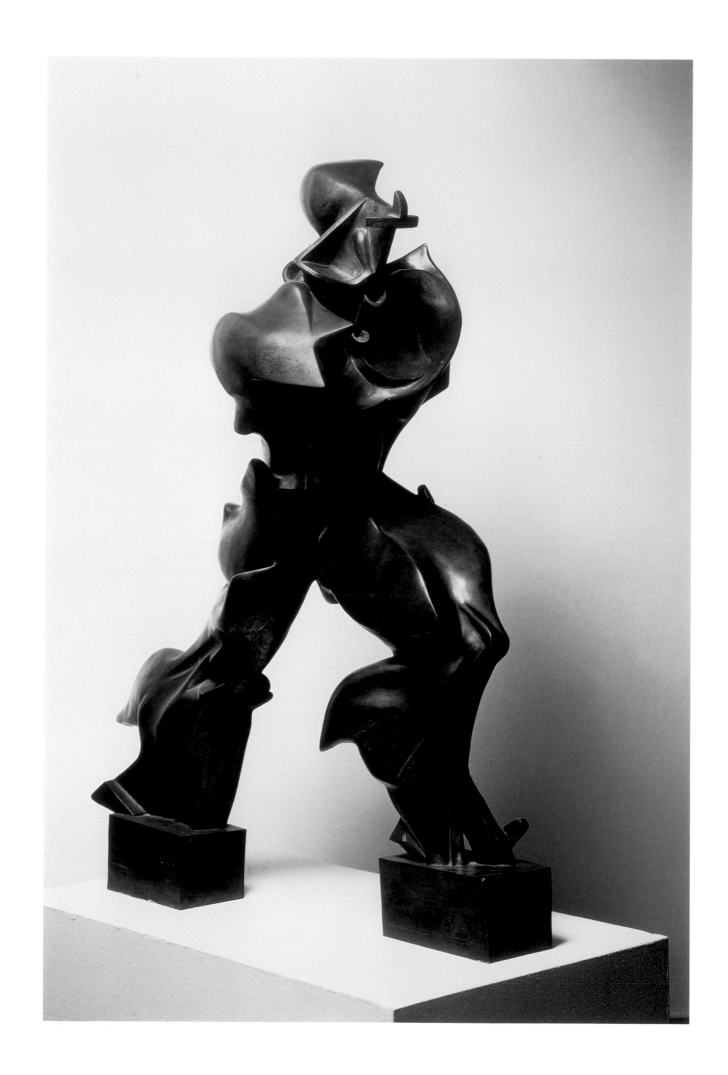

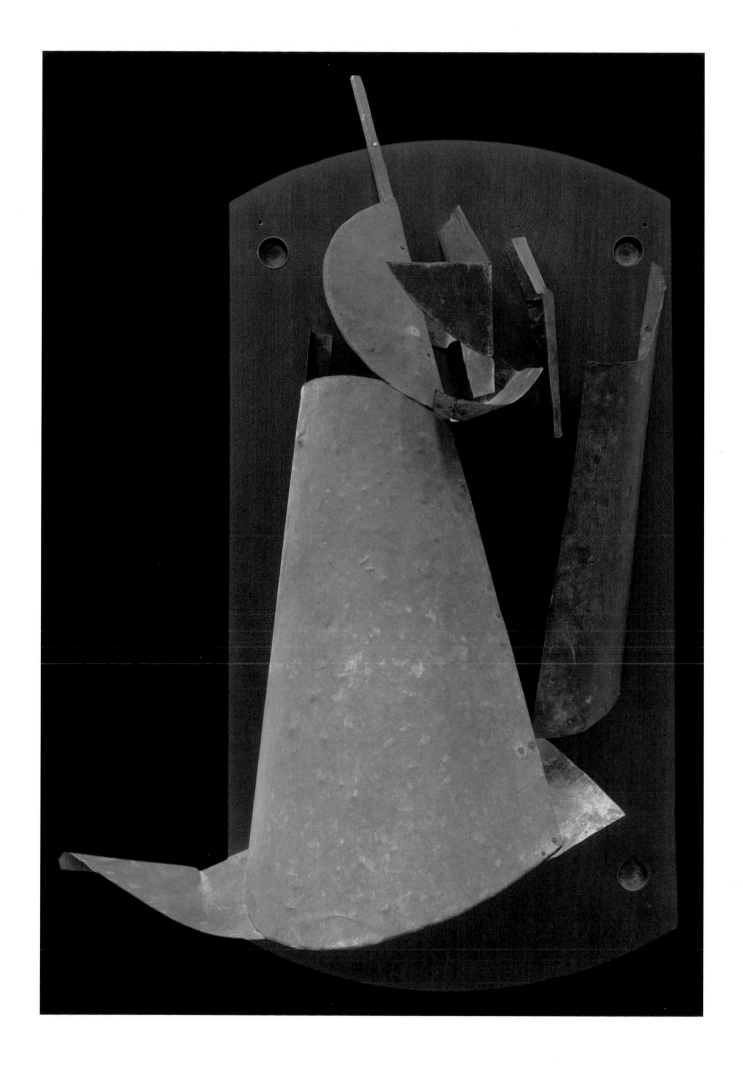

■ VLADIMIR TATLIN
Counterrelief
1916,
wood and metal
100 x 64 x 27 cm
Tretyakov Gallery,
Moscow

In 1913 Tatlin went
to Paris where he
associated with
avant-garde artists,
in particular Pablo
Picasso. Tatlin was
impressed particularly
by a series of reliefs
Picasso had made in
iron, wood, and
cardboard. On his
return to Russia he
decided to made
similar sculptures.
Whereas Picasso had
remained attentive to
the representation,
albeit deformed, of
objects of daily use
(guitars, glasses, and
such), Tatlin decided
to free himself from
every reference to
reality to create
thoroughly abstract
works. He was thus
one of the first to
conceive of sculpture
no longer as a more-
or-less faithful
imitation of the real
world but as a free
construction in which
materials are used on
the basis of their
plastic qualities,
their reciprocal
relationships, and
their ability to reflect
or capture light. Other
Russian artists were
to follow his example,
outstanding among
them Alexander
Rodchenko, Kazimir
Malevich, and the
brothers Naum Gabo
and Antoine Pevsner.

ERNST BARLACH
Flute Player
1936, bronze
height 59 cm
Private collection

The original idea for
this sculpture, a
masterpiece from the
artist's mature period
and a typical example
of his Expressionist
style, was a drawing
made between 1919
and 1920 and today
preserved in the Ernst
Barlach Haus in
Hamburg. In 1936
Barlach created two
wooden models and
one in plaster, used
as the model for
casting the bronze
shown here, made in
various examples in
the Hermann Noack
foundry (active in
Berlin since 1897).
The subject is a young
shepherd; he wears
his simple hat pulled
down nearly to his
closed eyes and is
wrapped in a heavy
cloak that leaves only
his legs, hands, and
face free. His pose
and expression make
clear that he is
completely rapt in his
music; the position of
his body, in particular
that of his legs,
seems to accord with
the flute's sweet
harmonies. The simple
lines and limited
gestures display an
unaffected and
intimate style that
seeks to express
spiritual values.

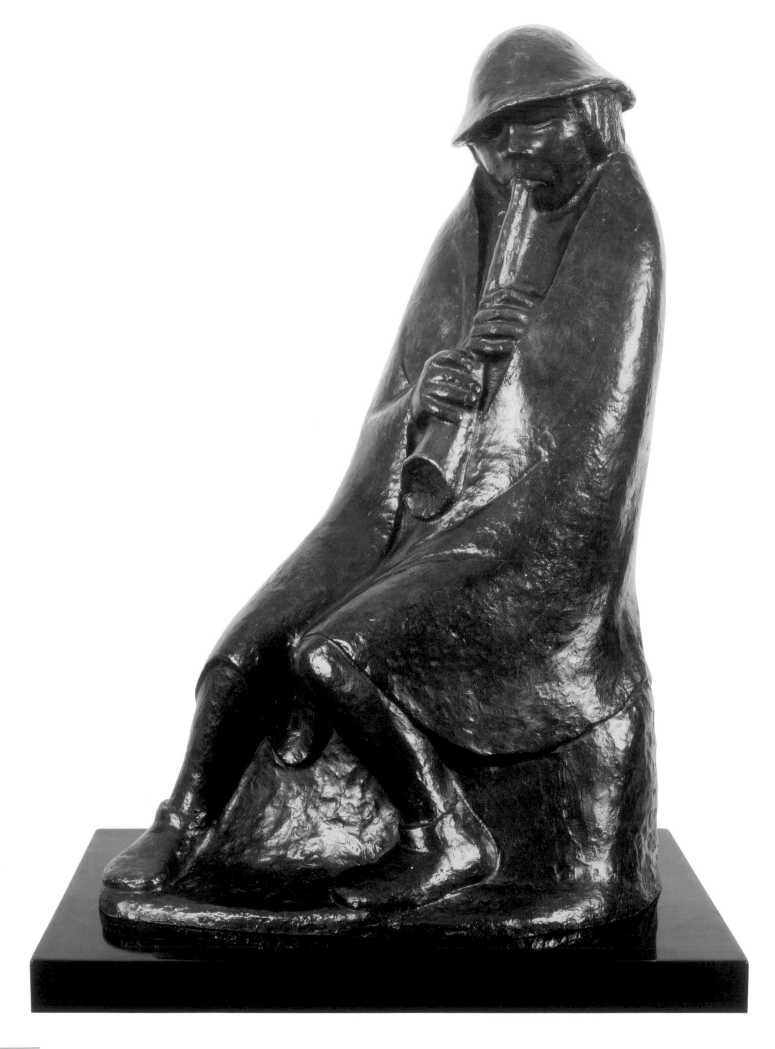

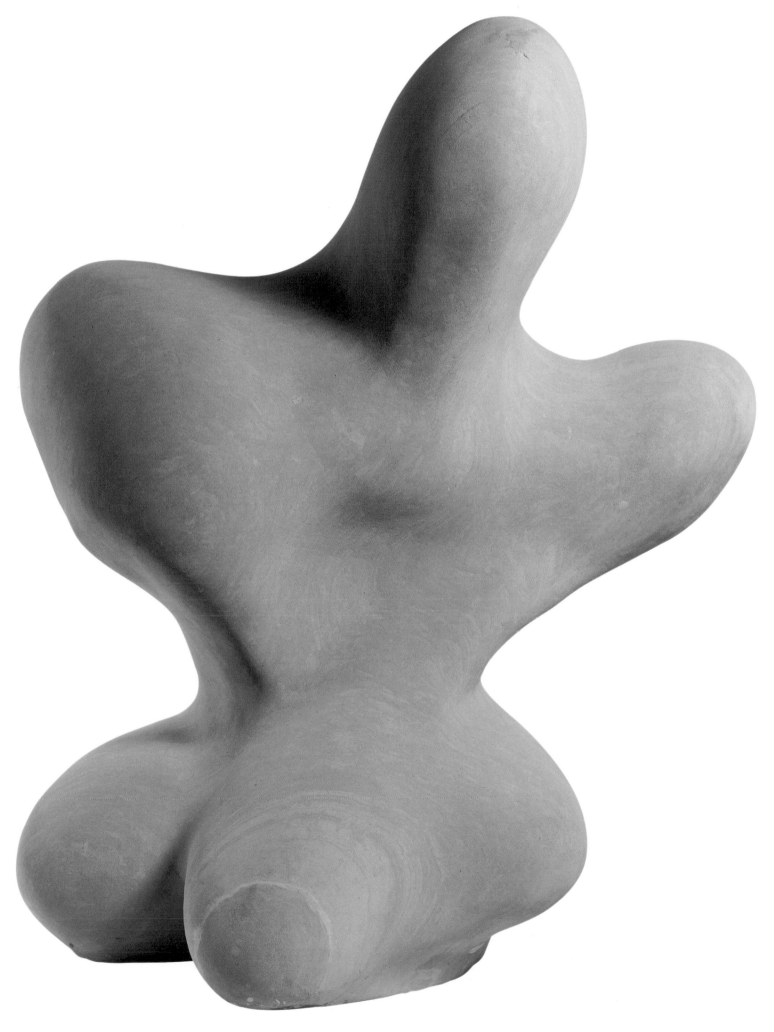

■ JEAN ARP
Giant Seed
1937, stone
162 x 125 x 77 cm
Musée National
d'Art Moderne,
Centre Georges
Pompidou, Paris

Over the course of
the 1930s, after
having rounded off
his training with his
Dadaist and Surrealist
experiences, Arp
concentrated on
sculpture and made
what he called his
"cosmic forms." In
1937, the year in
which he carved this
statue, he joined the
Swiss Allianz group
of painters and
sculptors, founded in
Zurich by Max Bill and
Leo Leuppi; he also
exhibited works at the
Putzel Gallery in San
Francisco, receiving
high praise from
critics. For Arp it
was a crucial year,
for he reached full
expressive maturity
in works of great
compositional
breadth. Arp further
developed the
subject of symbolic
biomorphic forms that
he had experimented
with in two-
dimensional reliefs in
the 1910s and 1920s;
these forms now
assumed new values
and greater spatial
impact. In this
sculpture one notes
the harmony of the
sinuous lines and
the smooth surfaces,
which constitute
the dominant
characteristic of
Arp's later works.

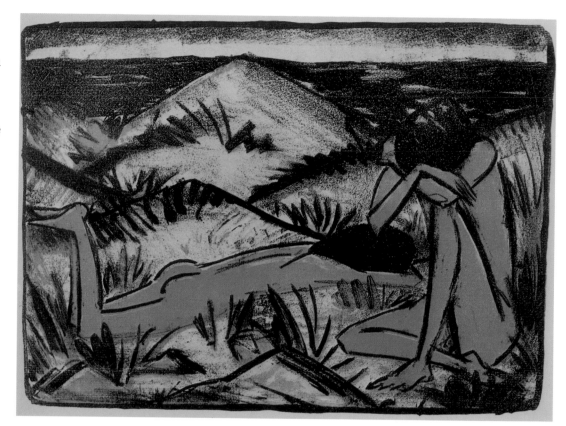

Between the end of the 19th century and the first decades of the 20th, art prints went through enormous development, going through a truly radical evolution. The quantitative and qualitative progress of the typographical industry made possible a dramatic increase in production while also reducing costs, making prints available to a far larger public. New and old publishers, including Ambroise Vollard, Fernand Mourlot, and Daniel-Henry Kahnweiler, followed by Albert Skira, Stratis Eleftheriadis—best known as Tériade—and Adrien Maeght oversaw the publication of richly illustrated editions on which the leading artists worked, heirs to the heritage of Gustave Doré, William Blake, Honoré Daumier, and William Hogarth. Important support was provided by magazines, both specialized and generic, from *L'Illustration* to *Harper's Bazaar*, from *Le Minotaure* to *Verve*, from *La Revue Blanche* to *La Révolution Surréaliste* and many others, which presented innovative and revolutionary graphic works. Though some were short-lived and ran up against censure or financial problems, these publications performed a fundamental role in the diffusion of new works or art, stimulating cultural debate and favoring discussion among artists, critics, and collectors.

The production of posters and the advertising materials that industries and commercial enterprises employed to draw attention to their products was equally conspicuous during this period, so much so that it forms a separate subject. In most cases, these were low-quality works designed only to inform potential buyers or to attract their attention, but there were also cases of the felicitous collaboration between businessmen and artists with outcomes of great prestige and value.

Thanks to progress made in the field of photography, the reproduction of works of art no longer required the use of engravings. For many centuries great artists as well as ranks of skilled but anonymous artisans had labored over copper plates to make possible the reproduction of paintings and fresco cycles so as to make them available for the pleasure and edification of the many people who could not afford to undertake long and difficult trips to and across Europe. Abandoning the use of

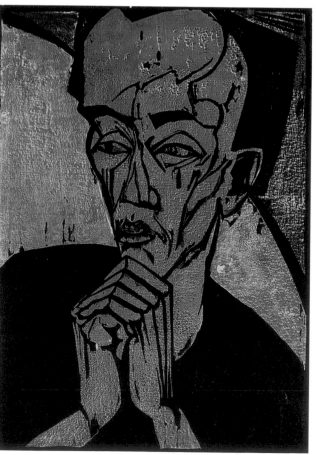

engravings for the reproduction and "translation" of works of art freed artists to made use of the process in the creation of original works.

Over the span of a few years the custom arose of limiting the print runs of such works to only a few dozen copies, each of which would be numbered and signed in pencil by the artist, who would then "strike out" the plate, making it impossible for the printing of further "illegal" copies. Furthermore, the artists themselves, increasingly freed of the control of art academies, enjoyed greater expressive freedom. In general they still studied and admired the works of the great masters of the past, from Albrecht Dürer to Rembrandt, from Giovanni Battista Piranesi to Francisco Goya, but for inspiration they were more likely to turn to the Japanese prints that were becoming increasingly available all across Europe. Over the course of the decades specialized organizations came into being, such as the Société des Peintres

Otto Mueller,
Girls in a Sand Dune, One Sitting, One Lying Down,
1920, lithograph,
29.7 x 39.2 cm

Erich Heckel,
Male Portrait,
1919, woodcut,
46 x 32.7 cm

Graveurs, Les Peintres Graveurs Indépendants, La Jeune Gravure Contemporaine, the Comité National de la Gravure in France, or the Society of Wood Engravers in England. The members of the various pictorial movements active at the end of the 19th century, referred to in general as Post-Impressionists, made use of the printmaking process as a means of study, as a step in the preparation of paintings, and finally as a discipline unto itself. Following the example of the Impressionists, they looked at the reality in which they lived and at the same time sought a more immediate and direct relationship with nature. This can be seen in both their crowded and highly animated urban views as well as in their landscapes, in which they showed great attention to lyrical values. Each of these artists, according to personal taste and manual dexterity, preferred a certain technique: from woodcuts to engraving to etching and aquatints, from

Max Beckmann, who denounced the horrors of war and stripped bare the ills of German society during the decades between the two world wars.

There are then the dreamlike visions of Wassily Kandinsky and Paul Klee, parallel to the Cubist efforts of Braque and Picasso and the Suprematist works of Kazimir Malevich and related to the experimentation that would lead to abstract art. Among the other artists whose works put them in the foreground of this category were the Germans Lovis Corinth and Max Slevogt, the Russian Marc Chagall, creator of famous series

■ Fernand Léger,
The Vase,
1927 lithograph,
53.5 x 43.4 cm

Art prints

silk-screen printing to lithography. Some, for example Art Nouveau artists, preferred designs with elaborate lines, refined and elegant to the point of virtuosic; they tended to prefer delicate tints with soft tones to emphasize the evocative values of their compositions. Others, including the Nabis, Maurice de Vlaminck, Raoul Dufy, Henri Matisse, and the Fauves, concentrated their attention on the rhythm of the colors, on their force and energy. Their example was taken to its extreme consequences by the Expressionists, who attributed a great importance to graphics. They looked to the artists of the Berlin and Vienna Secessions, studied the works of Gustav Klimt and Oskar Kokoschka, along with the innovative graphics of the magazines *Pan* and *Ver Sacrum*. The members of Die Brücke ("The Bridge")—Erich Heckel, Karl Schmidt-Rottluff, Ernst Ludwig Kirchner, Max Pechstein, Emil Nolde, and Otto Mueller—used a dry and stark language. They sought strong contrasts, clear and aggressive graphics, and references to non-European cultures, in particular those Indian, African, and from the islands of the Pacific, in the wake of the woodcuts by Paul Gauguin. Even more pungent and corrosive were the prints by Käthe Kollwitz, Otto Dix, George Grosz, and

of illustrations—including those for *The Fables of La Fontaine* and for the Bible—the Americans Thomas Hart Benton, John Sloan, Edward Hopper, and George Bellows—the last-named known for his scenes of boxing matches—the Scottish D. Y. Cameron, creator of more than 450 etchings, the French André Dunoyer de Segonzac, Jean-Louis Forain, and Georges Rouault, whose masterpiece, the series of about sixty prints entitled *Miserere*, presents an intense and deeply felt meditation on human life. The Italian artists best known for activity in this field include Umberto Boccioni, Carlo Carrà, Giorgio de Chirico, Lorenzo Viani, Benvenuto Disertori, Luigi Bartolini, and Giorgio Morandi.

■ Giorgio de Chirico,
illustration for the
Calligrammes by
Guillaume Apollinaire,
1930, lithograph,
15.9 x 15.8 cm

PABLO PICASSO
The Frugal Meal
1904, etching
46.2 x 38 cm

In his long and
successful career
Picasso used a wide
range of artistic
techniques and,
thanks to his
extraordinary
versatility and
inexhaustible
creativity, he made
more than two
thousand graphic
works. Among the
most famous of
these are his thirty
etchings for Ovid's
Metamorphoses, made
in 1931, and the so-
called *Vollard Suite*
(made for Ambroise
Vollard), composed
of a hundred etchings
made between 1933
and 1937. In 1899
Picasso had made
his first engraving,
entitled *El Zurdo*,
under the guidance
of the engraver
Ricardo Canals. *The
Frugal Meal* was
Picasso's second
etching, made shortly
after his move to
Paris in 1904, and
was printed in about
thirty examples by
Eugène Delâtre. This
etching is one of the
most important works
of the blue period,
both in terms of its
style and its subject,
the portrait of a
young couple,
perhaps laborers,
seated before their
meager dinner: a
scene of great
expressive force
and pathos.

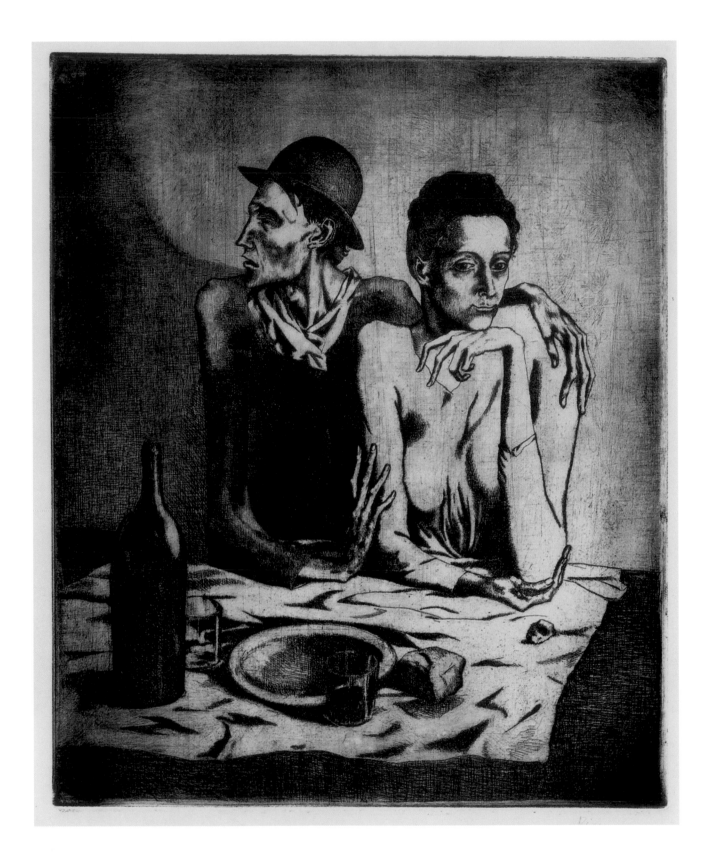

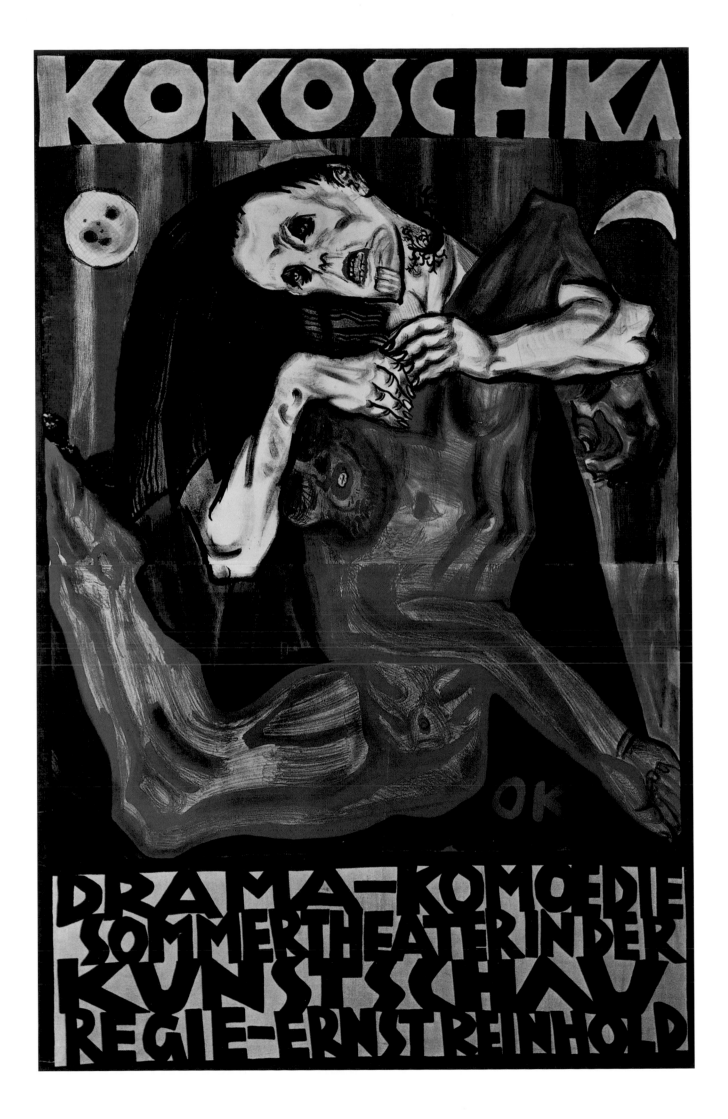

■ OSKAR KOKOSCHKA
Pity
1908, lithograph,
122 x 79.5 cm

In the first show of
the Kunstschau, the
exhibit of the new
group of artists led
by Gustav Klimt,
Kokoschka, then
twenty-two,
presented many
drawings and various
lithographs. He also
staged several of his
literary works in the
open-air theater
located a short
distance from the
exhibition rooms
with the paintings.
This colored
lithograph is one of
the posters he made
to announce the
performances of
*Mörder, Hoffnung der
Frauen* ("Murderer,
Hope of Women"),
the first of the five
theatrical pieces,
considered one of the
finest examples of
Expressionist theater.
With its structure
based on that of
Greek tragedy (two
actors and a chorus),
the work deals with
the conflict between
men and women,
presented as
irreconcilable
enemies. The poster
aroused strong
reactions, most of
them negative, and
caused a sensation
and a scandal
because of the
heavily dramatic
presentation of the
figures, the extremely
simplified and
distorted design,
the sharp chromatic
contrasts, and the
unconventional
use of text.

EMIL NOLDE
Dancer
1913, lithograph
52.8 x 68.7 cm

In 1913 Nolde
rented an apartment
in Flensburg, in
northern Germany,
where he oversaw the
printing of a dozen-
odd color lithographs,
including this one.
He wrote that "The
dancer, the last of the
sheets, expresses all
my passion and joy."
He emphasized the
dynamism and agility
of the dancer, an
Australian named
Saheret, presented
in the midst of a
frenetic dance, both
wild and primitive.

ERNST LUDWIG
KIRCHNER
Russian Dancers
1909, lithograph
32.7 x 38.5 cm

Between 1908 and
1909 Kirchner
attended various
theaters in Dresden,
including the Central
Theater, the Eldorado,
the Flora, and the
Victory Salon. On
September 10, 1909,
he sent a postcard
to Erich Heckel at
Dangast, reporting
that he had admired
the dancers in the
court theater of
St. Petersburg. He
added a drawing in
pen and pastel very
similar to this work,
which depicts Olga
Preobrajenska and
Georges Kiatschik,
dancers with that
company.

Art prints

■ Edvard Munch
Girls on the Bridge
1918–20,
woodcut and
lithograph
50 x 42.5 cm

This engraving
repeats, reversed, a
painting that Munch
made around 1899
(Nasjonalgalleriet,
Oslo) and that he
later redid with slight
variations. The
setting of the scene
is Aasgaardstrand,
Norway, where Munch
usually spent the
summer months.
Although the
presentation seems
perfectly natural, as
is so often the case
in Munch's works
he embedded
elements alluding
to the themes of
expectation, hope,
and death. Seen from
behind, the girls seem
absorbed in their
thoughts while
looking down at the
reflections of the
houses and trees on
the water. Munch
offers no way to
identify the figures
nor to clarify the
meaning of their
actions. Instead he
requires the viewer
to see beyond surface
appearance, and to
ponder its possible
meaning. The style is
nervous, spare, and
essential; the lines
left by the burin are
clearly visible and
seem to tear the
space, emphasizing
the sharp chromatic
contrasts.

**Study for
"Malepartus"**
1919, lithographic
pencil on paper
67.5 x 46 cm

This is a preparatory
drawing for the
eighth lithograph in
the series of ten
prints entitled *Die
Hölle* ("Hell")
published by
Neumann of Berlin in
1919. Malepartus was
a bar in Frankfurt that
took its name from a
site in *Reineke Fuchs*
("Reynard the Fox"),
a work by Wolfgang
Goethe. Beckmann's
intention is declaredly
polemical and
reflects in part his
experiences during
those months in
Berlin: He wants to
denounce the
irresponsible behavior
of Germany's upper
class, which thought
only of amusements
and the satisfaction
of its baser instincts,
showing no concern
whatsoever for the
dire financial,
political, and social
problems afflicting
the country in the
period following
World War I. To make
his position clearer,
Beckmann uses a
fast and nervous line,
sharp and easily
understandable,
particularly trenchant
in the caricatural
deformations and
psychological
characterizations
of the figures.

Dix made this lithograph (sixty-five copies) in 1923, shortly before starting work on the fifty etchings in the series *War*. In this work, his dramatic and desperate tones give way to biting sarcasm against the ills afflicting Germany. On the one hand, Dix still had in his eyes the images of death, hunger, and desolation of World War I and the immediate postwar period; on the other, he wanted to denounce the nation's loss of moral values, which in his opinion was more serious than the military defeat and the financial crisis. The subject of this print is one of the many examples of this degeneracy, a woman made-up in a showy and vulgar manner, with the false smile typical of those who make their living tricking and exploiting others. The bright colors and the spare, essential design emphasize the grotesque and caricatural figure of the woman, presented as an allegory of corruption and vice.

Tightrope Walker
1923, lithograph
44 x 27 cm

This lithograph, printed in black and pink, was inserted in the book *Kunst der Gegenwart* ("Art of the Present"), published in 1923 by Piper of Munich. Two printings were made of this image, one of 80 copies on Japon paper and one of 220 copies on normal paper. Klee reduces reality to its essential elements and then transfers those elements to a highly evocative but unreal atmosphere. Here Klee identifies himself with the tightrope walker, moving in precarious balance along a narrow rope suspended through a void, halfway between the world and the sky, between reality and fantasy, between all ties to daily life and the absolute freedom of artistic creativity. Both the painter and the tightrope walker perform in front of a public, trying to make something that requires long months (or years) of study, dedication, and sacrifice look easy. Both must amuse people and make them dream, make them experience emotions and transport them to an unreal world, the world of art and poetry.

■ WASSILY KANDINSKY
Orange
1923, lithograph
38.2 x 40.5 cm

Kandinsky's graphic works (a total of more than two hundred) keep step with his evolution as a painter and often provided a testing ground where he experimented with new expressive ideas. When he made this work he had only recently moved to Germany following the invitation from Walter Gropius to teach at the Bauhaus in Weimar. This lithograph testifies to the geometric phase of Kandinsky's aesthetic ideas, which he expressed in the theoretical work *Point and Line to Plane*, published in 1926. The pictorial surface has completely lost any sense of depth and is occupied by geometric forms, regular and irregular, including triangles and circles at the center and a chessboard in the upper left corner. The variously colored figures are arranged in an apparently random order that in reality responds to the intimate requirements of the artist, a sort of language of the soul that the viewer is invited to decipher.

This famous
lithograph, of which
fifty numbered copies
were made along
with fourteen proofs,
indicates Matisse's
extraordinary gifts as
a draftsman. Between
1922 and 1925 he
returned several times
to the orientalist
theme of the
odalisque, which he
had grown fond of
after trips to Morocco
and Algeria, making
works with different
techniques. The
model for this work
was Henriette
Derricarrère, whom
Matisse met at Nice
in 1920 in the
Studios de la
Victorine, where she
was dancing for a
film. He was struck
by her statuesque
form and intensely
expressive face,
with features at
once delicate and
strong. He asked
her to pose for him
for many paintings
and graphic works.
During the next years
Matisse preferred to
concentrate on the
rhythm of colors, as
demonstrated by the
splendid images in
Jazz, a 142-page
book with twenty
large illustrations,
published by Tériade
in 1947.

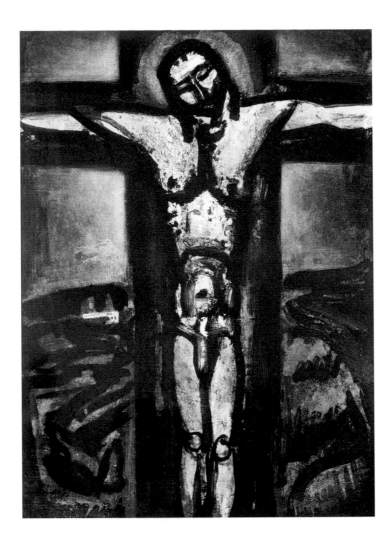

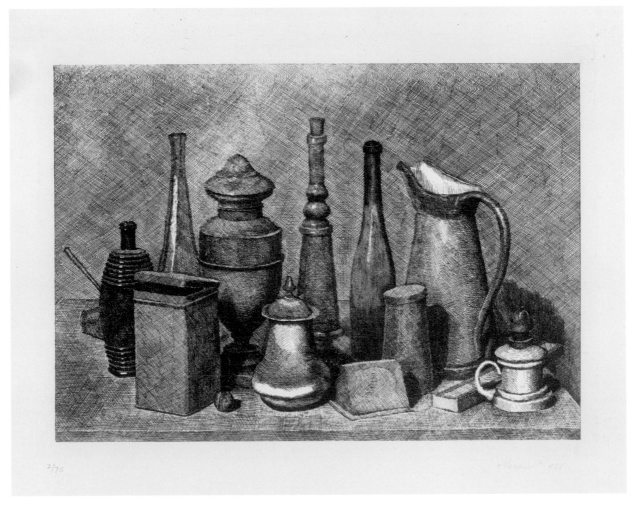

■ GEORGES ROUAULT
Christ Crucified
plate no. 20 of the
series *Miserere*,
1926–48
etching
58.3 x 41.5 cm

Rouault's graphic
production occupies
a large part of his
artistic activity. A
good example is the
fourteen panels for
Les Fleurs du Mal of
1927, the seventeen
etchings for the
*Circus of the Shooting
Star* of 1938, the
seventeen panels of
the *Passion* of 1929,
and the fifty-eight
etchings of the
Miserere. In these
Rouault made use of
a sharp line, with
strong contours that
express profound
spiritual tension.

■ GIORGIO MORANDI
**Large Still Life
with the Lamp
to the Right**
1928, etching
25.2 x 34.4 cm

Over the arc of more
than forty years
Morandi made a little
more than 130
etchings depicting
landscapes, seashells,
vases of flowers
(especially zinnias),
and portraits, but
most of all still lifes
with vases, bottles,
boxes, and other
ordinary objects. This
etching, of which
seventy-five copies
were made, is notable
for the masterful
contrasts of hatching
and the exquisite
balance achieved
among the various
masses.

D uring the 19th century, the industrial revolution caused a radical transformation of daily life and almost completely redesigned the appearance of cities. In the face of these rapid and uncontrolled developments, city planners and architects sought to identify society's new needs in terms of work and entertainment and the use and organization of public and private spaces. They also addressed the need to protect lasting quality and aesthetic values from the onslaught of the mass production of increasingly identical products dominated by the principles of cost and functionality. Science and technology offered new ductile and strong materials, available in large quantities and at increasingly low prices, thus making possible the creation of structures that until then would have been unthinkable. At the middle of the century the Crystal Palace, which Joseph Paxton designed between 1850 and 1851 for the Universal Exhibition in London, awakened wonder; this large structure was composed entirely of prefabricated metal-and-glass modules. It was immediately dubbed the Parthenon of the Industrial Revolution, although it remained standing far less time than its illustrious predecessor: It was destroyed by fire in 1936. In 1889, amid enthusiasm and criticism, the Eiffel Tower was unveiled, centerpiece of the Universal Exhibition in Paris and emblem of a new age of iron construction, already theorized by the French architect and writer Eugène-Emmanuel Viollet-le-Duc in his *Entretiens sur l'Architecture* ("Discourses on Architecture") in 1863. Between 1892 and 1893 Victor Horta designed the Hotel Tassel in Brussels, the first civil building of a certain importance to make large-scale use of iron.

In 1895 Otto Wagner published *Moderne Architektur*, in which he called on his colleagues to join in a common effort to elaborate a new style to keep up with the times. The members of the Vienna Secession can be said to have answered his call when they expressed their aesthetic vision in the Secession Building by Joseph Maria Olbrich. Between 1905 and 1911 Josef Hoffmann oversaw the construction of Palais Stoclet in Brussels in which he put into practice the teachings of Wagner and the leaders of the Secession. No less important was the birth in Munich, in October 1907, of the Deutscher Werkbund, an association formed by industrialists, members of the avant-garde, architects, and critics. There was then the work of Peter Behrens, Walter Gropius, and Bruno Taut. In the same years the modernist movement took form in Barcelona, with its greatest expression in the architecture of Antoní Gaudí, who proved himself capable of harmonizing new and never-tried construction techniques with the rich and elaborate decorations that were the fruit of his ingenious imagination. At the same time in Holland a state law of 1901 designed to coordinate the creation of new residential zones stimulated the activity of a group of architects who contributed to the magazine *Wendingen* and came to be grouped as the Amsterdam School. They put into practice the teaching of Hendrik Petrus Berlage, designer of the Stock Exchange in Amsterdam and point of contact between Europe and America.

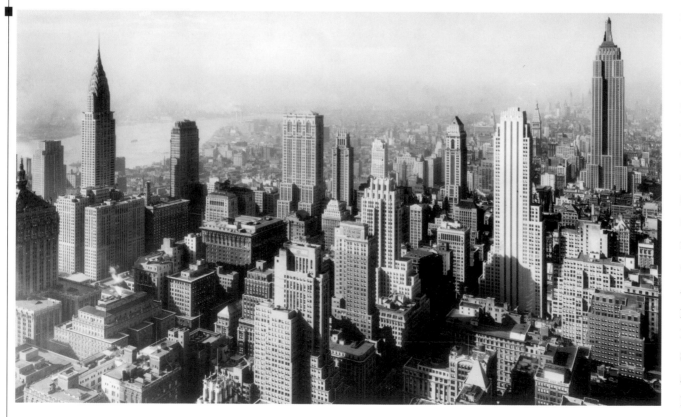

The enormous industrial and urban growth in the United States placed it among the avant-garde in this field, and indeed within the passage of only a few decades the United States ranked among the recognized world leaders in terms of modern architecture. The disastrous Chicago fire of 1871 destroyed much of the center of the city, transforming it into a gigantic worksite while also making it a testing ground for experimentation. The high cost of land led architects to explore the possibilities of height: The new steel-frame structures permitted reduction in the width and weight of load-bearing walls, while the perfection of mechanical elevators favored the creations of the architects of the Chicago School. In 1885 William Le Baron Jenny designed the Home Insurance Building, ten floors with a steel-frame structure; in 1889 John Wellborn Root designed the eighteen-floor Monadnock

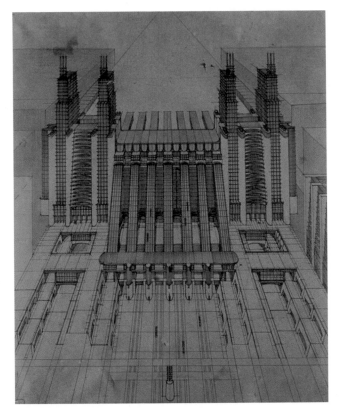

generation can and must rebuild every living space from the top down, thus destroying what is old or inadequate to its needs. Among the outstanding expressions of the twenty years from 1919 to 1939 was the Russian Constructivism promoted by Vladimir Tatlin, the Vesnin brothers, Konstantin Mel'nikov, Ilia Golosov, El Lissitzky, and Moisei Ginzburg. Even more important was the Bauhaus, the school founded by Walter Gropius and active from 1919 to 1933, when it was closed by the Nazis. The Rationalist principles promoted by its teachers and the effort to create

Architecture

Building, at the time the highest masonry-structure building in the world; in 1895 Charles B. Atwood and Daniel Burnham designed the Reliance Building, a fifteen-floor structure that was the first use of an entirely steel support structure. Frank Lloyd Wright was the unquestioned leading genius among American architects of this period. During his long and prolific career he developed the theme of "organic" architecture, with which he simplified and reorganized living spaces, taking his ideas from the forms of nature.

In Italy there was the "Manifesto of Futurist Architecture," written in 1914 by Antonio Sant'Elia (who died in World War I at the age of twenty-eight). Sant'Elia made designs for future cities in which the innovative and dynamic principles of the Futurist movement were given their fullest application. The large-scale industrial and urbanistic developments following World War I stimulated the creativity of architects. Loved or hated, cities grew in height and width; great metropolises with millions of inhabitants began coming into existence. Entire city districts were knocked down to make room for new public and private spaces. The conviction began to slowly take root that each

a greater harmony among the arts and industry had an enormous and widespread effect on the artistic outlook of an entire generation. New trends in architecture were presented and discussed at the meetings of the Congrès International d'Architecture Moderne (CIAM), the first of which was held at Château de la Sarraz in Switzerland from June 25 to 29, 1928, attended by many of the leading architects of the world, including Gropius, Le Corbusier, and Rietveld. In 1932 Philip Johnson and the historian Henry-Russell Hitchcock wrote the text for a catalog to accompany a show at the Museum of Modern Art in New York. Entitled *The International Style: Architecture since 1922*, it was long considered an authoritative work.

ANTONÍ GAUDÍ
Sagrada Familia
begun 1883
Barcelona

A solitary and isolated artist, Gaudí dedicated almost all his life to this, his masterpiece, a church that is still not completed. It is an ingenious and fantastic revisitation of the Neo-Gothic style, full of mystical-Christian symbols. Gaudí began work in 1883 on a commission from the Asociación Espiritual de Devotos de San José, formed in 1866. Taking inspiration from Art Nouveau and Cubism, Gaudí erected four tapering towers that recall termites' nests or sand castles; his original design called for eighteen of these towers, in memory of the twelve apostles, the four evangelists, the Virgin Mary, and (the highest) Jesus Christ. The towers are crowned by geometric spires covered with brightly colored ceramics. The building was partially damaged during the Spanish civil war; work began again in 1940 under the guidance of the architects Francesc Quintana, Puig Boada, and Lluís Garí, while Josep Maria Subirachs made sculptures for its several façades.

Architecture

■ OTTO WAGNER
Karlsplatz Pavilion
1898–1901
Vienna

In 1890 Wagner
was engaged to
coordinate a plan
for enlarging the
city of Vienna. In
particular he
designed the
structure for subway
stations, including
this splendid pavilion.
It is dressed in
Carrara marble and
embellished with rich
decorations in green-
painted ironwork
destined to have a
great influence on
the members of
the Secession.

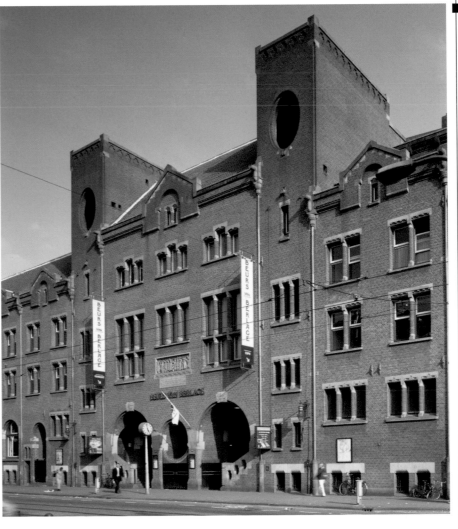

■ HENDRIK PETRUS
BERLAGE
Stock Exchange
1898–1903
Amsterdam

Berlage's Stock
Exchange is
characterized by
sweeping horizontal
development and a
notable sense of
volumetric extension.
It is composed of
three main halls:
the Commodities
Exchange, the Grain
Exchange, and the
Stock Exchange.
There are also smaller
spaces designed to
serve as offices. The
bare brick walls and
the elements in white
stone set in the walls
and carved with
allegorical figures
give the palace a
solemn and
monumental image.

VICTOR HORTA
**Museum of Fine
Arts Concert Hall**
1920–28
Brussels

During the 1920s,
after making several
innovative and
revolutionary works
faithful to the spirit
of Art Nouveau,
Horta returned to
creations more
respectful of
tradition, such as
the monumental
hall to host the
Museum of Fine Arts
in Brussels. Shown
here is the vast
concert hall, with its
elegantly fluid lines.

ADOLF LOOS
**Goldman & Salatsch
Building**
1910–12
Vienna

An argumentative
innovator, Loos
dedicated all his life
to the promotion of
a radical change in
the way of conceiving
architecture. As he
wrote in his essay
*Ornament und
Vebrechen* ("Ornament
and Crime"), his goal
was that of creating
simple, elementary
lines by abolishing
every type of
useless decoration.
Commissioned by the
clothier Goldman &
Salatsch, the building
located in the historic
Michaelerplatz
opposite the Hofburg
is considered one of
the first examples of
modern architecture.

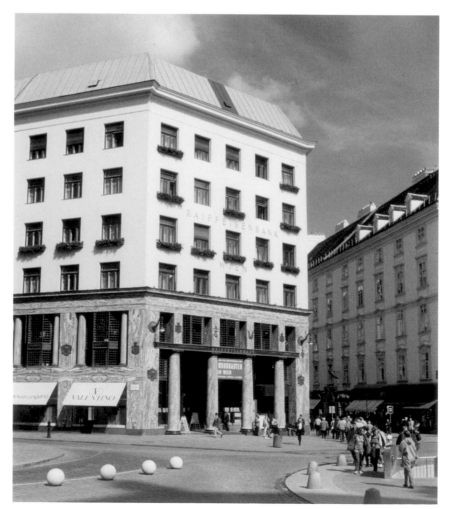

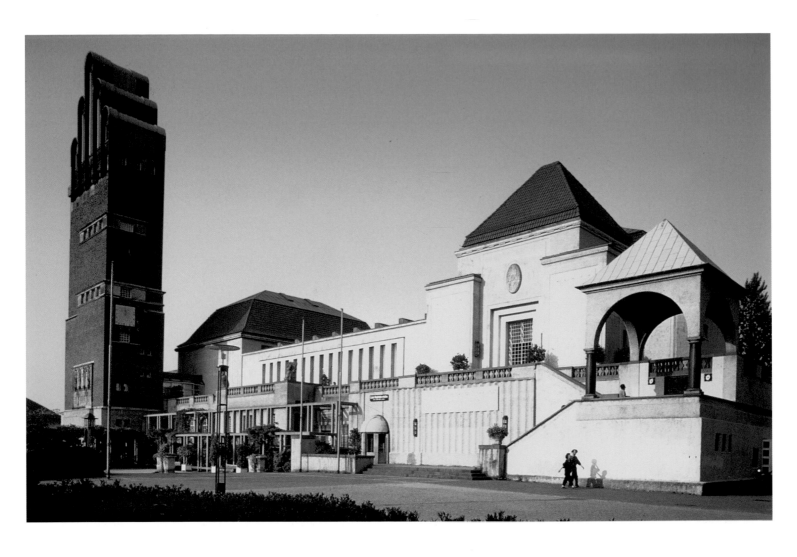

■ Joseph Maria
Olbrich
**Exhibition Hall of
Mathildenhohe**
1906–08
Darmstadt

In 1898 the grand
duke of Hesse, Ernst
Ludwig, in an attempt
to elevate the quality
of local artisan work,
followed the ideas of
the English Arts and
Crafts Movement and
promoted the birth
of Mathildenhohe, a
colony of artists and
artisans on a hill near
Darmstadt. Joseph
Maria Olbrich, already
having created the
Secession Building in
Vienna, was invited
to design the homes,
studios, gardens,
internal furnishings,
and this large
building, made to
display the works of
art produced.

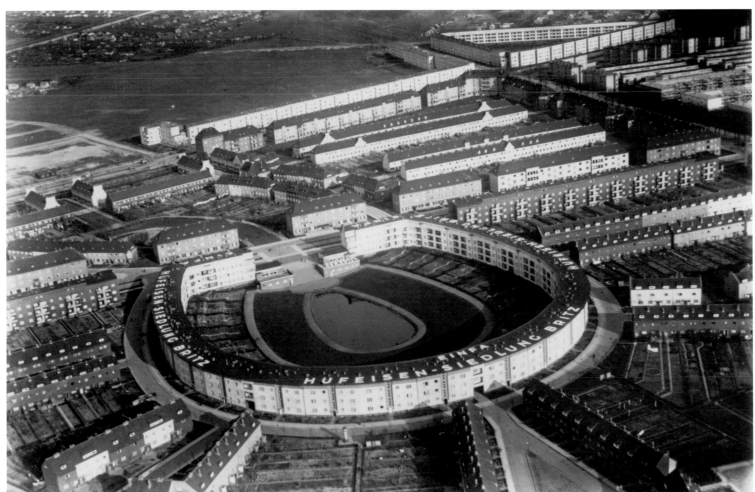

■ Bruno Taut
**Hufeisen-siedlung
Britz**
1931
Berlin

In 1924 Taut began
work on numerous
important urban
designs in Berlin,
including the Onkel
Toms Hütte,
southwest of the
city, and the
Hufeisen-siedlung
Britz to the south,
a housing complex
named for its singular
horseshoe shape
surrounding an
artificial lake.
Together with Martin
Wagner, Taut was
involved in the
creation of a new
concept of "people's"
housing, with simple
and functional lines,
that was to have a
great influence in the
coming decades.

PETER BEHRENS
AEG Turbine Factory
1907–08
Berlin

Beginning in 1907
Behrens designed
five buildings for
AEG, including this
turbine factory on
Huttenstrasse in
Berlin. Its stylish,
innovative shape
became the model
for industrial
architecture both
in Germany and
elsewhere. The large
glass walls of its
facade serve to give
light to the interior
and also to lighten
the heavy structure
of horizontal
masonry bands.

ERICH MENDELSOHN
Einstein Tower
1920–21
Potsdam

During the 1920s
and 1930s this
building was used
as an observatory
and center for
scientific research;
in particular it was
used for study of
the deviations of
cosmic rays that is
the basis of Einstein's
theory of relativity.
With its daring,
almost sculptural
lines, the tower is
today considered
the masterpiece of
German Expressionist
architecture.

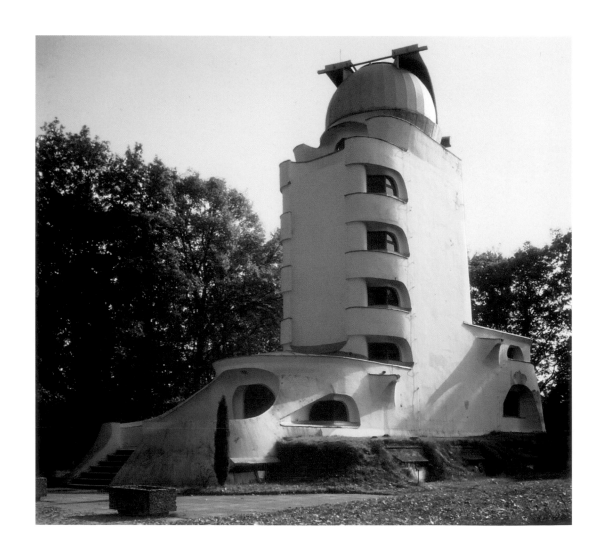

Hoffmann was commissioned to make this palace by the banker and industrialist Adolf Stoclet, and he worked on it in collaboration with Gustav Klimt, who designed the wall mosaics in the dining room. The building has an asymmetrical structure, although it is well proportioned in its balance and alternation of empty and full spaces. It is composed of a series of cubes and parallelepipeds that culminate in the large central tower topped by allegorical statues made by Franz Metzner. These are four male figures bearing cornucopias, symbol of abundance. The dome that tops the tower is an explicit reference to Olbrich's Secession Building. The facsades are dressed in white marble framed by a geometric molding made of gilt copper; this molding serves the double purpose of giving the home a sense of rhythm and movement and of evoking the luxury and magnificence of the patrician homes of the Renaissance.

WALTER GROPIUS
Bauhaus
1925–26
Dessau

The transfer of the
Bauhaus from
Weimar to Dessau
gave Gropius the
chance to design a
new building, more
commodious and
functional, but most
of all a complete
expression and a
concrete application
of the school's
aesthetic principles.
Gropius designed a
group of rigidly
geometric buildings
to house the
classrooms and
workshops,
laboratories and
auditorium, the
dining hall and
dormitories connected
by covered hallways
designed to house
administrative offices.

WALTER GROPIUS
**Bauhaus Teachers'
Housing; the
Home of Klee and
Kandinsky**
1926–28
Dessau

Near the school in
Dessau, in the area
of a park, Gropius
designed a group
of homes with an
innovative design
in line with his
Rationalist-geometric
thinking for teachers
at the school; a
single-family house,
destined for himself
as director, and three
two-family houses,
such as that shown,
in which Klee and
Kandinsky lived. The
furniture and details
of the homes were
designed by Fritz
Scheibler, Josef
Albers, Marcel Breuer,
Marianne Brandt, Carl
Jacob Jucker, Wilhelm
Wagenfeld, and other
Bauhaus designers.

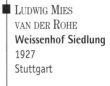

LUDWIG MIES
VAN DER ROHE
Weissenhof Siedlung
1927
Stuttgart

During the 1927
Stuttgart Exhibition
Mies van der Rohe
was in charge of
coordinating the
work on an
experimental city
quarter for which
he asked the
collaboration of
fifteen of Europe's
leading architects.
Ten were German:
Peter Behrens,
Richard Döcker,
Walter Gropius,
Ludwig Hilberseimer,
Hans Poelzig, Adolf
Rading, Hans
Scharoun, Adolf G.
Schneck, and Bruno
and Max Taut. Mies
van der Rohe laid
out the complex,
established the
general rules, and
designed the main
prototype.

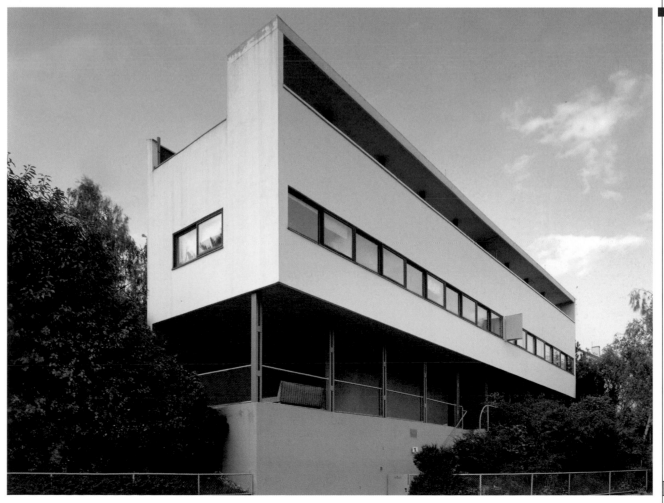

LE CORBUSIER
Weissenhof Siedlung
1927
Stuttgart

Five non-German
architects participated
in Mies van der Rohe's
project: the Belgian
Victor Bourgeois, the
Dutch Mart Stam and
Jacobus Johannes
Oud, the Austrian
Josef Frank, and
the French-Swiss
Le Corbusier. In his
building, Le Corbusier
applied the five
elements that he
had already used
experimentally in
the "Domino" houses
of 1914 and in the
Espirit Nouveau
pavilion built for the
1925 Paris Exposition:
pilotis (support
columns), the roof
garden, open interior
plan, ribbon winds,
and the free facade.

KONSTANTIN
STEPANOVIC
MEL'NIKOV
**Rusakov Workers'
Club**
1927–29
Moscow

From 1927 to 1929
Mel'nikov worked on
the design for his
own home studio and
on seven workers'
clubs, of which he
made six, including
this one. The club has
a striking "toothed-
wheel" structure with
a triangular layout,
the main axis of
which runs diagonally
to the street. Various
expedients make
possible different
uses for the interior.
These include
retractable wheeled
partitions that can
cut off one or more of
the three projecting
auditoriums from the
main auditorium and
two side halls.

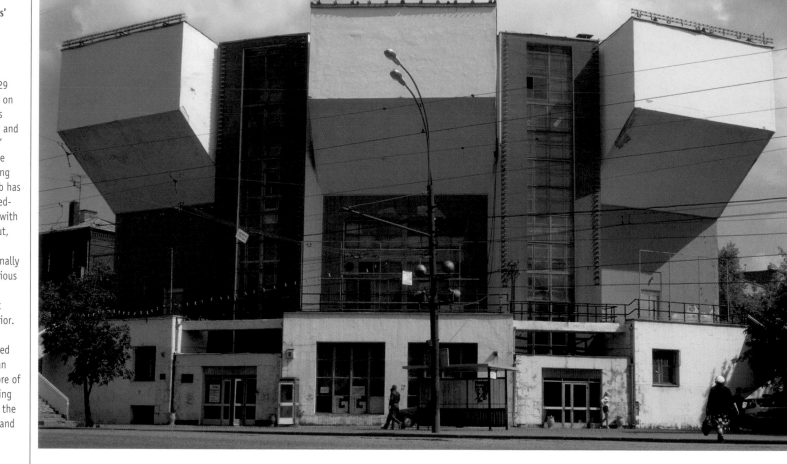

ALVAR AALTO
Library
1927–35
Viipuri

On December 6, 1917,
Finland became
independent of Russia
and began a vast
program of urbanistic
reorganization, in
which Aalto
participated. Aalto
drew inspiration from
the design by the
Swedish architect Erik
Gunnar Asplund for
the City Library of
Stockholm, and
reworked it in this
famous building in
which he dedicated
particular attention to
the questions of light
and noise. The library
is composed of two
bodies, one for the
storage and reading
of books, the other
for the offices and
conference room.

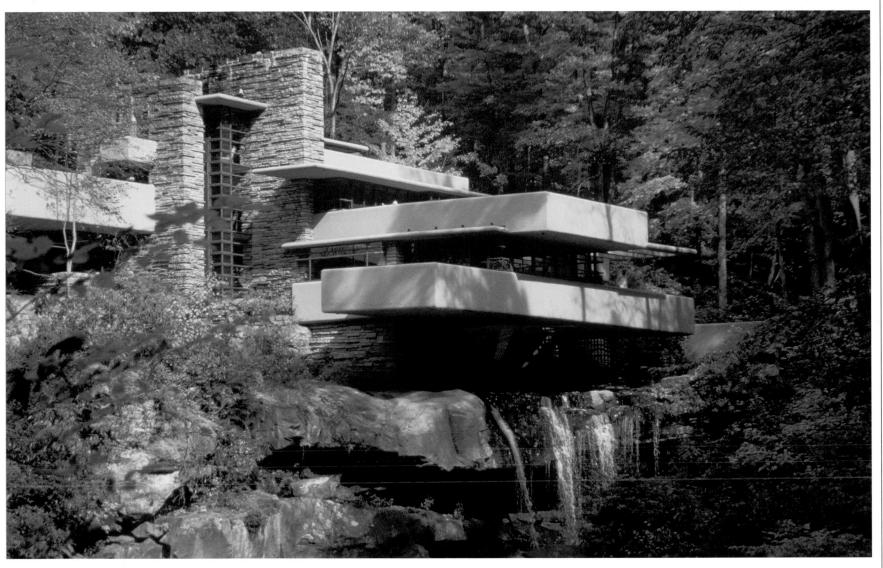

■ FRANK LLOYD
WRIGHT
Fallingwater
1936–39
Bear Run,
Pennsylvania

This home, one of
the most famous
works of 20th-century
architecture, was
commissioned to
Wright when he was
seventy by Edgar
Kaufmann, a wealthy
businessman who
had made his fortune
from a chain of
stores. Located
about 62 miles from
Pittsburgh, the home
represents the best
example of Wright's
efforts to
harmoniously embed
a building in a natural
setting. Wright
located the home in a
wooded area directly
above the course of a
stream. The vertical
body is made of bare
stone and solidly
anchored to the rock
of the hillside;
inserted in it is a
series of projecting
cement terraces that
extend into space
toward the waterfall,
challenging the laws
of gravity. Between
2000 and 2002 the
house underwent a
radical restoration
and restructuring of
the cement parts,
which had been
compromised by the
infiltration of water.

With its 60-story height of 791 feet, the Woolworth Building was the tallest in the world until 1929, when it was surpassed by the Chrysler Building, designed by William van Alen and 1,033 feet high. During the inauguration ceremonies, attended by President Woodrow Wilson, the building was illuminated with 80,000 bulbs. The most modern inventions were employed in its construction, although it also involved the large-scale use of terracotta, and the vaguely Neo-Gothic decorations of its facade and most of its interiors—with the abundant use of marble, bronze, and mosaics—helped earn it the nickname "cathedral of commerce." It was commissioned by Frank W. Woolworth, owner of the chain of low-cost "five and dime" stores; to build it he spent $13.5 million. Today his office on the twenty-fifth floor has been transformed into a small private museum.

RICHMOND H.
SHREVE, WILLIAM
LAMB, ARTHUR
LOOMIS HARMON

**Empire State
Building**
1929–31
New York

This building is built
atop the location of
the first Waldorf
Astoria Hotel; the
excavations began a
few weeks before the
collapse of the New
York stock market in
October 1929 and the
inauguration took
place on May 1, 1931.
With its 1,250 feet
over 102 floors the
Empire State Building,
made by the design
studio Shreve, Lamb
& Harmon, held the
world record for
height until 1954.
Its surface is nearly
2,152,782 square
feet; its construction
required 57,000 tons
of steel. The
structure, which
narrows upward in a
series of set-backs,
recall ancient
ziggurats, but in fact,
the shape is a result
of laws introduced in
1916 that required
gradual narrowing of
building facade to
permit sunlight to
reach the streets and
lower floors of the
city. With its
characteristic Art
Deco style, the
building soon entered
the collective
imagination, as
indicated by its
1933 appearance in
the most famous
scenes in the movie
King Kong.

MARCELLO
PIACENTINI
**Palace of the
Rettorato**
1932–35
Rome

The design of the
new headquarters
of the university of
Rome was entrusted
to Piacentini with
the collaboration
of several other
architects, including
Gio Ponti and
Giovanni Michelucci.
Made of travertine,
the Palace of the
Rettorato repeats the
outlines of ancient
Roman architecture
as filtered through
the Vienna Secession.
Standing in front of
the building is a
sculpture by Arturo
Martini depicting
Minerva, goddess of
wisdom.

GIOVANNI
MICHELUCCI
**Santa Maria Novella
Train Station**
1932–35
Florence

A jury composed of
Marinetti, Ojetti, and
Piacentini entrusted
design of the Santa
Maria Novella Train
Station—among the
best examples of
Italian Rationalist
architecture—to
the "Tuscan group"
composed of
Michelucci and
several students,
among them Nello
Baroni, Italo
Gamberini, Sarre
Guarnieri, Leonardo
Lusanna, and Pier
Niccolò Berardi.
The building was
inaugurated on
October 28, 1935,
anniversary of the
Fascist revolution.

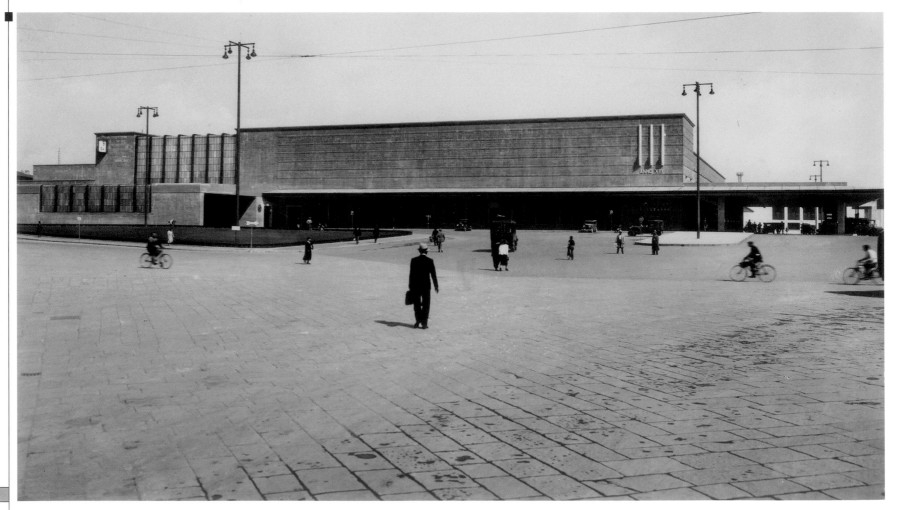

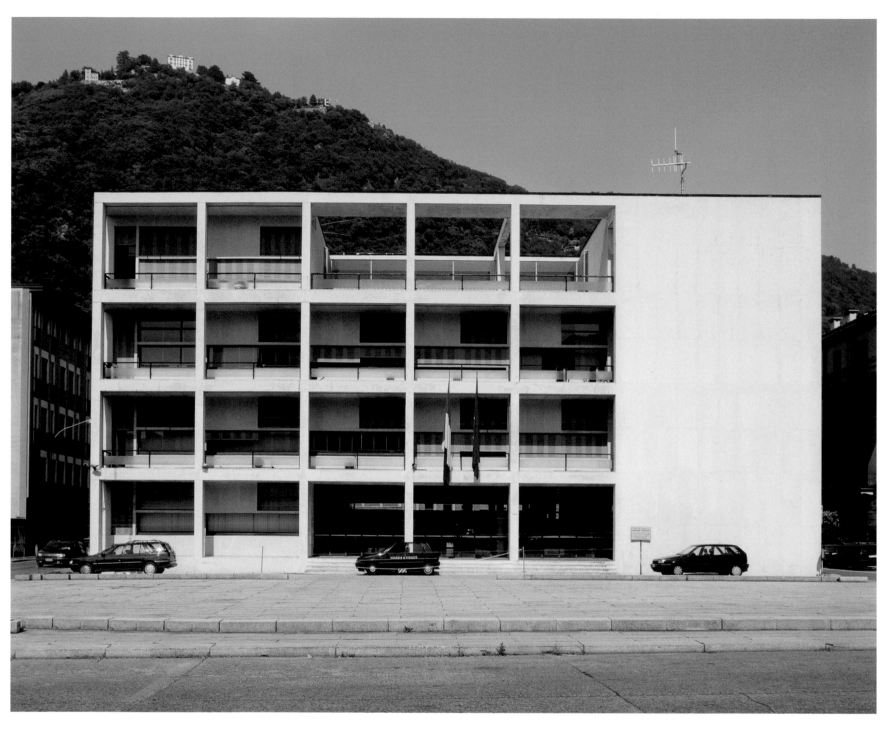

To paraphrase one of Mussolini's maxims, one can say that Italian architecture during the Fascist period was revolutionary or reactionary according to the circumstance. Along with Neo-Classical buildings designed to celebrate and revive the pomp of imperial Rome, the regime gave space to new Rationalist trends, with results that displayed high levels of quality. With the Casa del Fascio, Terragni developed the theme of the cube and articulated the full and empty spaces to give rhythm and movement to the entire structure. He eliminated all ornament and used extremely simple and linear forms. Other important architects active during the period include Giovanni Michelucci, creator of the Santa Maria Novella Train Station in Florence (see page 336), Pierluigi Nervi, who made the Giovanni Berta Stadium in Florence in 1930–32, and Luigi Piccinato, who in 1933–34 designed the plan for the new city of Sabaudia, built in the reclaimed Pontine Marshes.

During the early years of the 20th century the leading country in terms of industrial design was Germany, which had been experiencing strong economic growth. The magazine *Jugend* ("Youth"), founded in Munich in 1896 by Georg Hirth, gave its name to Jugendstil, the German version of Art Nouveau. In the same year the architect Hermann Muthesius was sent to London as cultural attaché to the German embassy with the aim of studying English architecture and developments in the applied arts, most of all the Arts and Crafts Movement. In 1897 the Vereinigte Werkstätten für Kunst und Handwerk ("United Workshops for Art and Craftwork") was created, with contributions from architects, graphic artists, and designers. In 1903 the architect Josef Hoffmann and the painter Kolo Moser, with funding from the banker Fritz Wärndorfer, created the Wiener Werkstätte ("Viennese Workshop"), which operated in the fields of painting and sculpture, architecture, and the decorative arts.

spread of similar movements, such as the Design and Industries Association in Britain (1915) and the Comité Central des Arts Appliqués in France (1916). Without doubt the most important factor in Europe in terms of design in the twenty-year period between the world wars was the Bauhaus, the school founded by Walter Gropius with the purpose of giving equal dignity to the visual arts and the decorative arts; most of all, it sought to teach arts and crafts in a way that would exploit the advances made in industrial technology. This goal was attempted, though not always successfully, by joining the teaching of theories to lessons in the technical and practical aspects of the arts. An important goal of the school was the creation of prototypes that could be produced for sale. Such sales offered the school a means of covering its considerable expenses, for it received little by way of state support, and its students did not have the means to pay. Even so, the driving force behind the school remained the aesthetic concepts of its founders, who

Design and the

In Munich in October 1907, Hermann Muthesius created the Deutscher Werkbund, an association designed to improve the quality of German industrial production. It was joined by men of differing background and training; politicians, industrialists, writers, critics, artists, and architects. By 1910 it had 731 members, 360 of whom were artists. One of the principal practical applications of the ideas promoted by the Werkbund was related to AEG (Allgemeine Elektrizitäts-Gesellschaft), the Berlin electricity-supply company. In 1907 the company named Peter Behrens its artistic consultant. He designed advertising graphics, furnishings and fixtures, as well as five industrial plants, including the AEG Turbine Factory (see page 328). The Werkbund spread to Austria after 1910, to Switzerland (1913), and then Sweden (1917); it also inspired the formation and

attributed equal value to the design of an object and its construction. In that way they applied the principles of the Arbeitschule ("Work School") movement, according to which one learns by doing, not reading, as expressed in the slogan *Arbeitschule gegen Buchschule* ("work school versus book school").

The evolution of design in Germany influenced the Scandinavian schools. In general the artists in Scandinavian countries, drawing inspiration from their age-old cultural traditions, took designs used by the ancient Vikings, for example, and reworked them in a modern style. They too sought further to reconcile artisan crafts with industrial production and, because of its local abundance, showed a marked preference for wood. Among the most important designers were Alvar Aalto, Kaare Klint, Tapio Wirkkala,

Arne Jacobsen, Børge Mogensen, Bruno Mathsson, and Finn Juhl. The many and various trends that arose in France during these same decades had as their starting point the Société des Artistes-Décorateurs (founded in 1907), which organized yearly exhibition salons that achieved a synthesis in the Exposition Internationale des Arts Décoratifs et Industriels Modernes in Paris in 1925. That major show, a true celebration of Art Deco, presented a union of technological and scientific innovations with artistic avant-garde movements, such as Cubism, Futurism, and abstract art. Areas of Europe renowned since ancient times for certain artisan productions, such as Toulouse, Limoges, Nîmes, Lille, and Reims, saw their basic models reworked by a new generation of artists and artisans. The many personalities of importance in this movement included Emile Gallé, Georges de Feure, Francis Jourdain, Emile-Jacques Ruhlmann, René Lalique, Erté (Romain de Tirtoff), Louis Süe and André Mare, Paul Poiret,

since the 1920s in the United States the definition used—and still predominant today—was Industrial Design. By the 1930s the profession of designer had been institutionalized, the title referring to the person with the task of conferring artistic qualities on mass-produced industrial products. This was partially a result of the large-scale widespread industrial growth of the United States, which reached its apex in the 1930s; it also resulted from the arrival in the United States of many of Europe's leading architects and designers, fleeing Nazi persecution. An outstanding phenomenon of this new field was streamlining, a design theory used initially only in the making of ships and airplanes but later given widespread application in the design of objects of daily use. Another important development was the show "Modern Architecture: International Exhibition," held at the Museum of Modern Art in New York, with its catalog written by Henry-Russell Hitchcock and Philip

Raymond Loewy, *Coldspot "Super Six" Refrigerator*, made by Sears Roebuck & Co., 1934

applied arts

Gabrielle Coco Chanel, and Le Corbusier (Charles-Edouard Jeanneret). Aside from variations resulting from individual takes on the style, Art Deco was characterized by geometric simplifications, zigzagging and sleek curvilinear forms, the use of costly materials with elegant and sophisticated decorations, and the production of luxury items affordable only to the wealthy but desired of by all.

The theoreticians in Germany spoke of *Kunstgewerbe*, meaning "industrial art;" those in France talked about *Art Décoratif*, meaning "decorative art;" but

Johnson. The exhibition's title recalled that of a 1925 book by Gropius, *International Architektur*. American designers like Charles and Ray Eames, Norman Bel Geddes, and Raymond Loewy took ideas from European movements—from Arts and Crafts to Liberty, from the Secession to Biedermeier—and applied them to the new requirements of low-cost mass production, with practicality and functionality given preference over aesthetic appeal. In Italy many important figures were active in the design and creation of glass, ceramics, furniture, and fittings, although this was almost always within the limits of an artisan craft with only limited production capabilities because of Italy's slow industrial development. One can speak of design in Italy in the modern sense of the term only at the end of the 1930s, if not after World War II.

Le Corbusier, *Chaise Longue*, 1928 (Cassina reissue, 1964), chrome-plated tubular steel and animal hide, 56.4 x 160 cm

EMILE GALLÉ
**Three Vases and
a Bowl**
early 20th century,
glass paste with
etched decoration
of floral motifs
Private collection

Emile Gallé was among
the leading innovators
in the field of the
decorative arts, both
in terms of the use of
materials and the
design of his
creations. Beginning
in the last decade of
the 19th century Gallé
joined the creation of
art pieces in ceramic
and glass with lower-
priced "industrial"
production. As he
stated in 1889, "I
wanted to make art
more accessible so
as to prepare a less
restricted number of
people for the use of
more elaborate works."

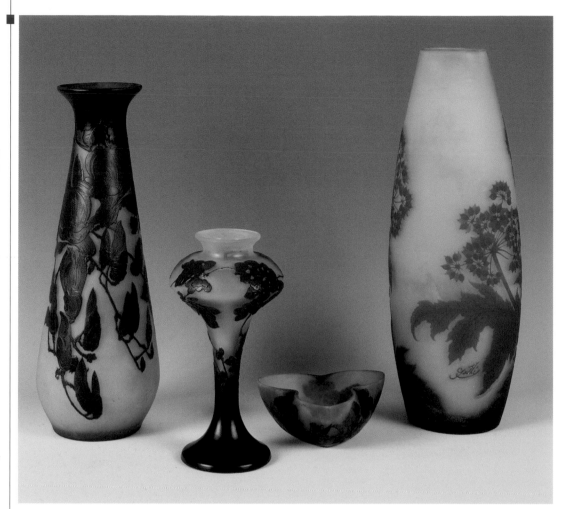

RENÉ LALIQUE
**Oiseau de Feu
("Firebird") Lamp**
circa 1930
crystal and bronze
height 43.5 cm

This lamp was one of
the most successful
creations of the
French company
between 1922 and
1945. In this model
the fan-shaped crystal
portion bears relief
decoration of a
mythological figure
with spread wings;
the bronze cube base
also bears relief
decoration of stylized
winged figures.

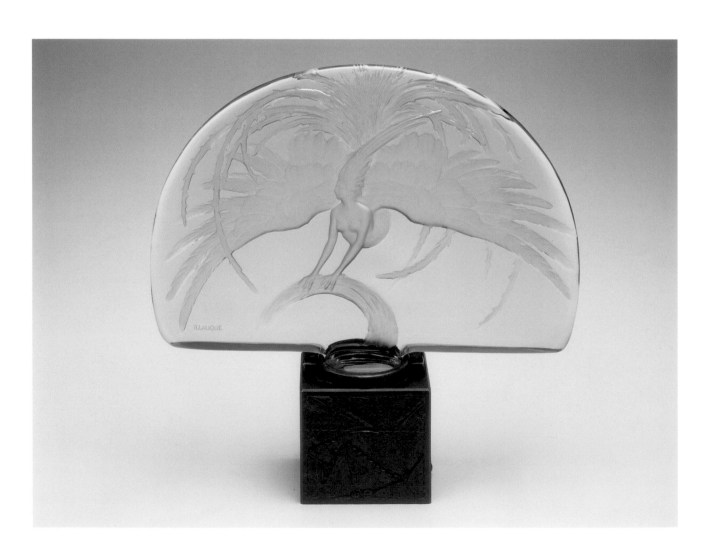

Design and the applied arts

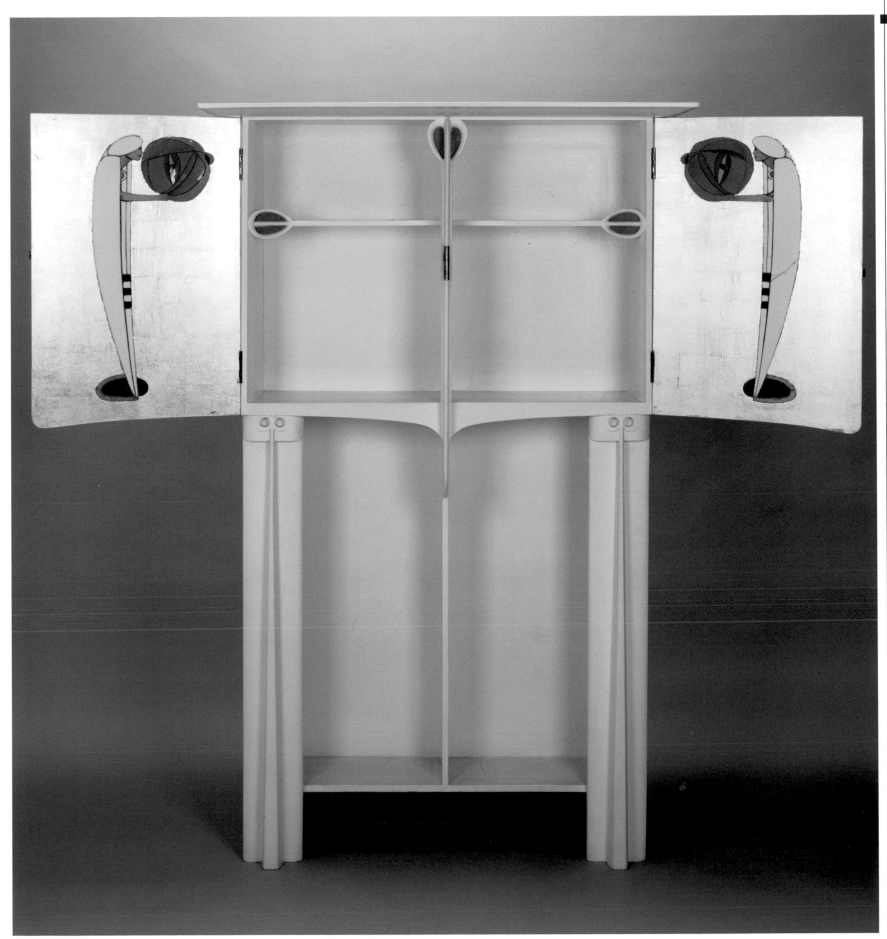

■ CHARLES RENNIE
MACKINTOSH
Cabinet
1902, painted wood
154.3 x 99.3 x 39.7 cm
Fine Art Society,
London

The Scottish architect
is also famous as a
designer of furniture,
much of which is
still in production.
Influenced by Art
Nouveau and the
geometric purity of
modernism, in a few
decades he became
Britain's most
original architect and
designer. He sought
to create an elegant
style through the
production of pieces
that were unique—or
were made in a very
limited number of
examples—for which
he carefully chose the
design and materials
so as to distinguish
them from the uniform
impersonality of
industrial mass
production. This is
one of the examples
made for the home
at 14 Kingsborough
Gardens, Glasgow.
Inside each of the two
wings of this cabinet
is an elegant
decoration with a
stylized female figure.
The figures hold the
"weeping rose," one of
Mackintosh's favorite
motifs, which he first
designed in 1900 for
the desk of the
musician Michael Diak.

JOSEF HOFFMANN
Rocking Chair
circa 1905–10,
frame in bent
beechwood, seat and
back in Vienna straw
65 x 106 x 107 cm
Private collection

Hoffmann was one
of the believers in
"total" works of art,
both in architecture
and in industrial
design. The figures
and objects he
designed are
characterized by an
extreme formal
cleanliness and by
the absence of
decoration. He loved
clear and simple lines
and sought the ideal
match of materials,
always working
toward the sense of
purity that results
from an ideal
synthesis between
an object's function
and its beautiful
appearance.

GERRIT RIETVELD
Red Blue Chair
1918 (Cassina reissue,
1973),
painted beechwood
65.5 x 88 x 83 cm

Rietveld designed a
first version of this
chair in 1917 in
unpainted oak; the
following year he
decided to paint it
in primary colors:
red, yellow, and blue.
In doing so he was
applying to the
decorative arts the
principles of the
Neo-Plasticism of
Piet Mondrian and
Theo van Doesburg,
and echoing the De
Stijl movement,
which he joined
that same year.

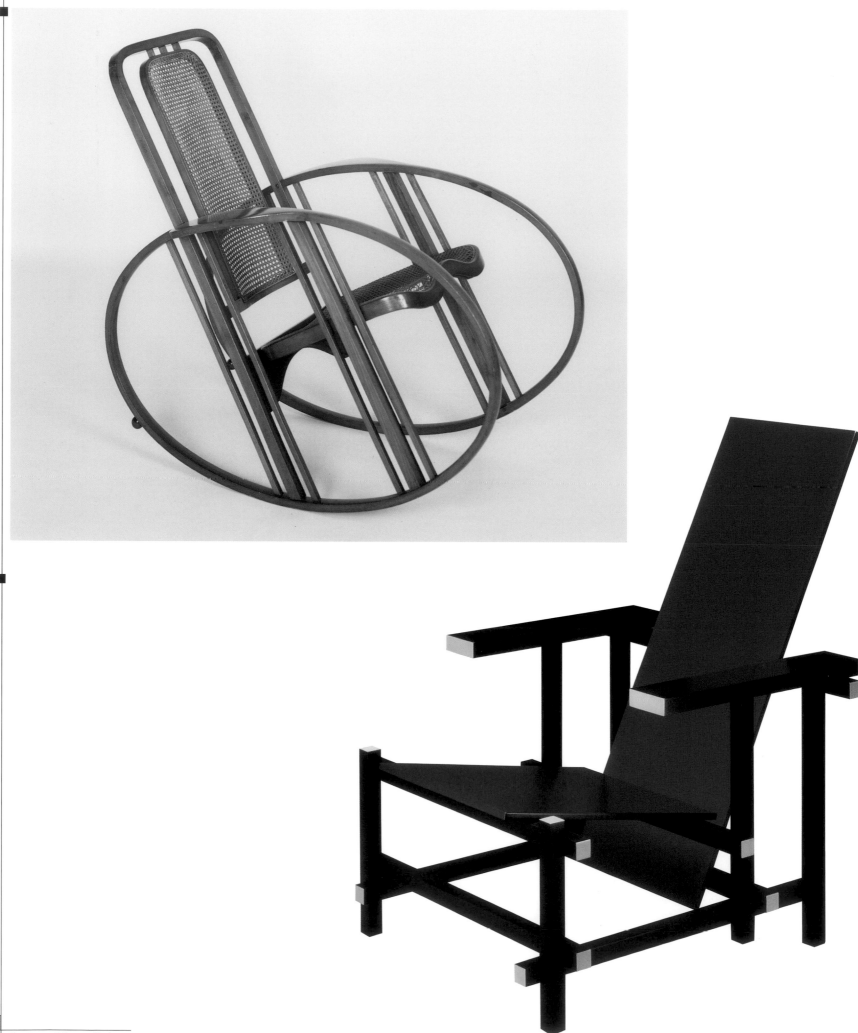

Design and the applied arts

PETER BEHRENS
Electric Kettle
1909,
metal and wood

This is one of the electric kettles that Behrens designed for AEG. Its design reveals that he had abandoned the sinuous and refined lines of the Jugendstil and Art Nouveau that he had adopted early in his career to use instead a functional geometric style that was nonetheless equally elegant.

MARIANNE BRANDT
Teapot
circa 1924,
brass and wood
7.3 x 16.1 x 10.6 cm

Brandt was one of Moholy-Nagy's students at the Bauhaus; from him she learned to simplify forms and to use elementary geometric figures. This teapot, designed around 1924, was made in different versions in different materials between 1925 and 1929, including one in silver, one in bronze and wood, and one in tombac and wood.

LUDWIG MIES
VAN DER ROHE
**"MR" Armchair
(Weissenhof)**
1927 (Knoll
reissue, 1964),
chrome tubular steel
and leather
48 x 79 x 74 cm

This is one of the
many models of
cantilevered chairs,
made of a single steel
tube bent to create a
frame that does not
require rear support.
This model repeats a
design by the Dutch
architect Mart Stam
of 1924; it draws
inspiration from a
rocking chair by the
Austrian furniture-
maker Michael Thonet
for the addition of
the two tubes that
act as arms. The
prototype was first
presented in the
Weissenhof
experimental
apartment buildings
that Mies van der
Rohe designed in a
suburb of Stuttgart
in 1927.

MARCEL BREUER
Wassily Chair
1925 (Gavina
reissue, 1960)
chrome tubular steel
and leather
78 x 72 x 69 cm

The B3 chair, baptized
the "Wassily" in the
1960s, was among
the furniture designed
for the Bauhaus
building at Dessau.
Breuer was one of the
first designers to use
tubular steel covered
in fabric or leather
to create simple,
functional structures,
lightweight and
strong, practical
and elegant.

Design and the applied arts

■ ALVAR AALTO
Tea Cart No. 98
(Artek, 1935–36)
birchwood

Like almost all
Scandinavian
designers, Aalto
preferred to use
wood, a material
abundantly available
in his homeland. The
lines of this tea cart
are dynamic and at
the same time
harmonious, a result
of the abolition of
right angles in favor
of rounded curves.
The monochromatic
spokeless wheels
contribute to the soft
effect. The shelves of
the cart can also be
dressed in black
linoleum or white
laminate.

■ ALVAR AALTO
Chair 41 ("Paimio")
circa 1933
(Artek, 1935)
wood
66 x 61 x 87.6 cm

This chair was
admired for both
its comfort and its
elegance. Its name
refers to the
sanatorium Aalto
designed in the
Finnish city of
Paimio. In addition
to the buildings
that compose the
sanatorium, made for
tuberculosis patients,
he also designed all
the fixtures and the
furniture, including
this chair. The
elasticity of the
back of the chair is
designed to make
breathing easier.

GIO PONTI
Plates
1924–25, porcelain
decorated in blue
and gold
diameter 32.3 cm
Private collection

These two display
plates were designed
by Ponti during the
years in which he
was artistic director
of the Richard Ginori
factory in Sesto
Fiorentino, for which
he reworked the
entire production
line. The plate on the
left is decorated with
the "Attività Gentili"
motif; that on the
right presents "Amore
dell'Antichità." Both
plates show a
geometric structure
combined with the
use of classical forms,
a style that Ponti
successfully
developed further
in the following
decades.

ALFREDO RAVASCO
Paperweight
1920s–1930s
agate, silver, and
precious stones
height 12 cm
Private collection

The square, stepped
base is made of agate
decorated by masks
in embossed silver;
aligned cabochon
sapphires flow out
of the mouths of
the masks in a
simulation of water.
The structure is
topped by a basket
holding fruit made of
cabochon or faceted
sapphires, rubies, and
emeralds; the basket
is supported by four
fully round silver
caryatids. The object
shows Ravasco's
passion for geometric
forms and his
preference for
brightly colored
precious stones.

NAPOLEONE
MARTINUZZI
**Vase designed for
Venini**
circa 1928–30
black blown
glass with silver
iridescence, neck
and applied
serpentine handles
decorated in red
height 25.5 cm
Private collection

NAPOLEONE
MARTINUZZI
**Vase designed for
Venini**
circa 1928–30
salmon pink
"pulegosi" glass
with spherical
body and neck with
serpentine decoration
height 29 cm
Private collection

In Venice the art of
glassmaking had been
handed down over the
centuries from father
to son, master to
student, regulated by
severe laws (including
the penalty of death)
and confined to the
narrow space of the
island of Murano.
During the early
decades of the 20th
century, the glass
masters reworked their
models, assimilating
ideas from the artistic
avant-garde
movements. Among
the best known
glassmakers were
Venini & Co., Artisti
Barovier, Barovier &
Co., S.A.I.A.R. Ferro
Toso, Fratelli Toso,
Barovier & Toso,
Cenedese & Co., and
Seguso Vetri d'Arte.
Many outstanding
artists worked for these
houses, including
Guido Balsamo-Stella,
Alfredo Barbini, Fulvio
Bianconi, Tommaso
Buzzi, Dino Martens,
Napoleone Martinuzzi,
Flavio Poli, Giulio Radi,
Carlo Scarpa, and
Vittorio Zecchin.

MARCELLO
PIACENTINI
Bedroom furniture
circa 1928,
fruit-tree wood
Private collection

Aside from his
intense activity as
an architect and city
planner, Piacentini
designed furniture
and objects in which
he united classical
elements to modern
ones, inspired by the
Secession and Art
Deco. The bedroom
furniture shown
here is typical of
the monumental
triumphalism that
found favor among
the leading lights of
Fascism, a style of
which Piacentini was
a leading interpreter.
Included is a bed,
chest with mirror,
closet, and two
chairs. Each piece is
dominated by pairs
of dramatic fasces, large
enough in the bed to
accommodate bedside
tables. This furniture
was probably made by
the Bega company of
Bologna, which
during those same
months was busy
making the furniture
for the Palace of
Justice in Messina,
one of Piacentini's
best-known works.
Who ordered the
furniture is unknown,
but it seems to have
been conceived as
a gift to Benito
Mussolini. In the end,
he refused to accept
it because its
manufacturer was
using it as a
publicity gimmick.

Design and the applied arts

■ HENRY FORD
Model T
("Tin Lizzie")
1908

This car was one of the numerous variants of the famous Model T, nicknamed Tin Lizzie. It is an economical car made to be affordable thus reduced to the essentials, but with a use of materials and a style that made the car lightweight and at the same time strong, comfortable, and practical, easy to use and maintain. Thanks to assembly-line production, the cost of the car went from $850 to only $260. Between 1908 and 1927 Ford sold 15 million.

■ Stanley Woods on a Moto Guzzi 498 in a race on the Isle of Man
1935
National Motor Museum, Beaulieu

Carlo Guzzi founded the Società Anonima Moto Guzzi in 1921 and in that same year made the first of his famous motorcycles, the Moto Guzzi Tipo Normale, innovative in design and solidly built with trustworthy mechanical parts. In 1930 he designed a motorcycle with a four-cylinder supercharged motor for races; a few years later he made a bicylindrical with rear suspension that won the Tourist Trophy in 1935.

From its initial appearance, following Joseph Nicéphore Niepce's early experiments (he made the first paper negative in 1816) and the daguerreotypes of Louis Daguerre (who made his procedure public on January 7, 1839), photography has been the subject of great attention, both in relation to to other arts and as an art form in and of itself. A few lamented its widespread adoption, including French painter Paul Delaroche, who foresaw the death of his art, rendered obsolete by the new invention, and both Charles Baudelaire and Emile Zola, who castigated contemporary painters for doing nothing but imitating the work of photographers. In contrast to these were the many artists who made use of photography in their own art, such as Eugène Delacroix, who saw it as an indispensable tool for achieving a perfect imitation of reality; Jean-Auguste-Dominique Ingres, one of the first to use it for portraits; and Camille Corot, who collected more than three hundred photographic prints in his studio, mostly landscapes. The admission of several photographers to the 1859 Paris Salon marked the first important official recognition of the new discipline among the fine arts. Aside from the Barbizon painters, the Impressionists often drew inspiration from photography. It was no accident that the Impressionists' first group show, which ran from April 15 to May 15, 1874, was held at 35, Boulevard des Capucines in the studio of Gaspard-Félix Tournachon, better known as Nadar, one of the first great photographers of the 19th century. Nadar himself, who began his career as a caricaturist for the magazines *Charivari* and *Le Rire*, and who was a regular at the Café Guerbois, meeting place of the Impressionists, was among the first to claim artistic dignity for his photographic creations, in particular his scenes of contemporary life and his famous aerial views of Paris (taken from a balloon). In 1889 the French capital was the site of the first world congress of photography. The topics discussed included photography's role and its ranking among the other artistic disciplines. In 1891 Gabriel Lippman, professor at the Sorbonne, perfected a complex process for making color photographs,

which won him the Nobel Prize for physics in 1908. The last decades of the century saw the growing popularity of Pictorialism, a photography style based on a particular treatment used to create photographic prints with soft, shaded tones similar to the art of the Impressionists. Pictorialism spread thanks to the English Linked Ring group and the French Photo Club de Paris. In 1902 Alfred Stieglitz founded the Photo-Secession movement, which claimed full artistic dignity for photography, and the next year he began the magazine *Camera Work*, which became a true forge of great talent. In 1907 the Lumière brothers, inventors of the Cinématographe camera-projector, presented their Autochrome system for color photography. Over the first decade of the 20th century the industry not only improved the quality of photographic plates but made cameras increasingly lightweight, easy to use, and inexpensive, thus increasing the number of fans of the new art. At the same time the points of contact (and also of friction) between photographers and exponents of avant-garde art movements increased. In 1912, for example, at the Picchetti hall in Rome, Anton Giulio and Arturo Bragaglia presented the concepts of "Futurist Photodynamism." On September 27, 1913, however, a manifesto was published, signed by Boccioni, Balla, Carrà, Russolo, Severini, and Soffici in which (showing little foresight), the six artists separated themselves from Bragaglia,

to study human movement. There were also the photographic works of Christian Schad, Lásló Moholy-Nagy, John Heartfield, Hannah Höch, Max Ernst, Hans Bellmer, El Lissitzky, and Alexander Rodchenko. Even more important was the role performed by Man Ray. In 1921 the American artist, friend of Alfred Stieglitz, moved to Paris, and a few months later made his first "rayographs," a kind of photographic readymade. These were images obtained on photosensitive materials without the use of either lens or camera and without the mediation of a negative; they were made by putting the object in direct contact with the emulsion liquid. Photography earned its final recognition as an art form in the decades between the two world wars. This happened as a result of the growing popularity and diffusion of illustrated magazines, the opening of specialized galleries, the mounting of specific exhibitions, and the birth of collecting, first among an elite few but gradually among a more vast public. Many figures achieved outstanding fame for their activity as photographers, including Ansel Adams (1902–1984), author of twenty-four books on America's national parks; Cecil Beaton (1904–1980), who specialized in portraits; Gyula Halász, known by the pseudonym Brassai (1899–1984), author of the famous book *Paris de*

declaring, "Warning. Given the general ignorance in matters of art, we Futurist painters declare that everything referred to as 'photodynamic' has to do exclusively with photography. Such purely photographic

Photography

researches have nothing to do with the plastic dynamism invented by us nor with any form of dynamic research in the fields of painting, sculpture, or architecture." Not until 1931 did the "Manifesto of Futurist Photography" appear, signed by Filippo Tommaso Marinetti and Tato, pseudonym of Guglielmo Sansoni (1896–1974). The two artists presented their principles in sixteen points, ending their thesis by affirming that "all these researches have the aim of further erasing the borders between the photographic science and pure art and thus automatically favoring their development in the fields of physics, chemistry, and war." The Dadaists and Surrealists often made use of photography, beginning with Marcel Duchamp, who made the painting *Nude Descending a Staircase* (see page 81) by reworking a series of photographs taken by Etienne-Jules Marey

Nuit in 1932; Robert Capa (1913–1954), one of the most famous war correspondents; Henri Cartier-Bresson (1908–2004); Robert Doisneau (1912–1994); Alfred Eisenstaedt (1898–1995); Edward Weston (1886–1958); and Tina Modotti (1896–1942). Also important was the Farm Security Administration (FSA), a U.S. government agency set up during the Great Depression. The agency engaged many photographers to document the conditions in rural areas, and the result was impressive: In eight years they took more than 270,000 images.

MARCEL DUCHAMP,
HENRI-PIERRE ROCHÉ
Multiple Portraits
1917, photographic
print
8.7 x 14 cm
Private collection

This photo was taken
in August 1917 while
Duchamp, Roché, and
Francis Picabia were
at New York's Coney
Island amusement
park. Made using an
arrangement of
mirrors inclined at 60
degrees, this image,
a photographic
readymade, is one of
the first important
examples of the use
of photography by
exponents of the
Dada movement.

ALFRED STIEGLITZ
**Georgia with a
Cow Skull**
1931, photographic
print
Private collection

Stieglitz made many
portraits of his wife,
the painter Georgia
O'Keeffe, and their
friends, including
Ellen Koeniger. In
this photograph
O'Keeffe holds a cow
skull, an image that
often appears in her
paintings. By way of
the attentive play
of light, Stieglitz
emphasizes her
emotions as she
stares out at the
camera, not in the
least intimidated by
its presence.

■ ROBERT CAPA
**Death of a
Republican Soldier**
1936, photographic
print
16 x 20 cm
Private collection

This photograph has
become an enduring
icon of the heroic
sacrifice of those who
die fighting for
freedom against any
form of dictatorship.
The falling soldier has
been identified as
Federico Borrell
García, called Taino,
killed during the
Spanish civil war, on
the Cerro Muriano
front, on September
5, 1936. For decades,
the authenticity of
this image has been
the subject of heated
debate: Is it a true
snapshot of war or a
posed photograph?
Capa himself provided
differing and
contradictory versions
of the episode, none
of which could be
proven in an
incontrovertible way.
Some historians
consider the question
of little importance
since it does not
change the symbolic
value and the
conceptual message
of the image. Others
see it as essential
for photography to
differentiate itself
from the other visual
arts precisely because
of its innate ability
to document reality
and historical truth
without manipulation
or arbitrary
reconstructions.

Man Ray moved to Paris in 1921 and opened a photographic studio in Montparnasse. He made fashion pictures and photographic portraits of painters, sculptors, poets, dancers, models, and personalities from high society that were published in leading magazines of the time, such as *Vanity Fair, Vogue,* and *Harper's Bazaar*. At the same time he did not overlook Dadaist and Surrealist experiments, such as this photograph, first published in Number 13 of the magazine *Litérature,* in June 1924. In this famous image, a blend of sensuality and conceptualism, Man Ray posed Alice Prin, known as Kiki (see page 120), his model and lover for nearly six years. The title is a French idiom that means "hobby," but it is also an explicit reference to the seen-from-behind nudes by Jean-Auguste-Dominique Ingres. The shape of the woman is identified with that of the musical instrument by means of the typical *f*-holes in the sound-box of a violin.

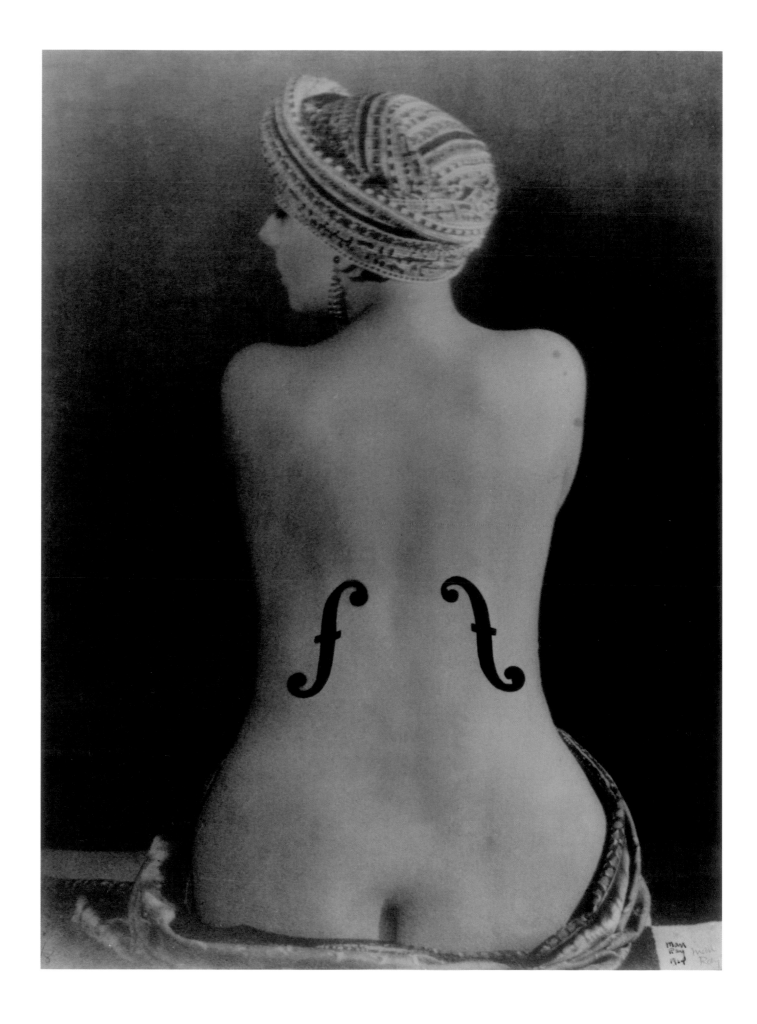

■ HENRI
CARTIER-BRESSON
Henri Matisse
1944, photographic
print,
12 x 18 cm
Private collection

Henri Cartier-Bresson
was one of the
leading photographers
of the 20th century,
among the first to
transform photo-
journalism into art.
As a youth he was
drawn to design and
painting, and in 1966
these subjects again
became his
predominant
interests. In his
photographs he
reveals a "humanistic"
concept of reality, so
much that he is
considered more a
classicist than an
experimenter. He
compared his activity
to that of a fisherman
who spots the right
moment to capture
a fish, or that of
an archer, who
eliminates all other
awareness to
concentrate on the
target, with which
he creates a sort of
mystical relationship.
In this famous
portrait Cartier-
Bresson enters into
a sort of spiritual
communion with the
great painter and
works to show us the
man's soul and art;
he pays particular
attention to the
delicate balances
among the figures
and the other objects
in the area, arranged
so as to create a
visual harmony, as
if these were the
elements of a
Matisse painting.

TINA MODOTTI
Woman of
Tehuantepec
circa 1927,
photographic print
25 x 20 cm
Private collection

Modotti became
interested in the
culture and art of
Latin America during
a stay in San
Francisco, from 1913
to 1922. Her first
husband, the painter
and poet Roubaix de
l'Abrie Richey (Robo),
visited Mexico in
1922, but fell sick
with smallpox and
died before she could
reach him. In 1923,
together with the
photographer Edward
Weston, of whom she
became model,
collaborator, and
lover, Modotti set
herself up for several
years in Mexico City,
where she associated
with artists and
intellectuals,
including Diego
Rivera, Frida Kahlo,
David Alfaro
Siqueiros, and José
Clemente Orozco. In
Mexico she dedicated
herself with equal
passion to politics
and to photography,
portraying the life
and habits of the
people with sincere
emotional
involvement. Her
bare, essential style
led her to seek a
kind of direct
and immediate
communication in
which the political
message she hoped
to convey becomes
evident.

■ EDWARD WESTON
Tina on the Azotea
1924 or 1925,
photographic print
7.4 x 9.1 cm
Private collection

■ EDWARD WESTON
Tina on the Azotea
1924, photographic
print
9.1 x 7.4 cm
Private collection

Weston's encounter with Tina Modotti marked a radical turn in the art of both of them. In the three years spent in Mexico Weston took his creativity in a new direction and achieved full expressive maturity. As the result of contact with numerous artists and intellectuals, he gradually abandoned the Pictorialism and asymmetrical design of his early portraits to adopt a personal, original style. He increasingly simplified his still lifes and landscapes, moving them toward abstraction. In his series of nudes he revealed his debt to the muralists Rivera, Orozco, and Siqueiros, drawing on their heroic, monumental figures. In these photographs one notes an increased sureness in the distribution of light, which gives the woman's body a statuary reality and at the same time also a strong charge of sensual eroticism.

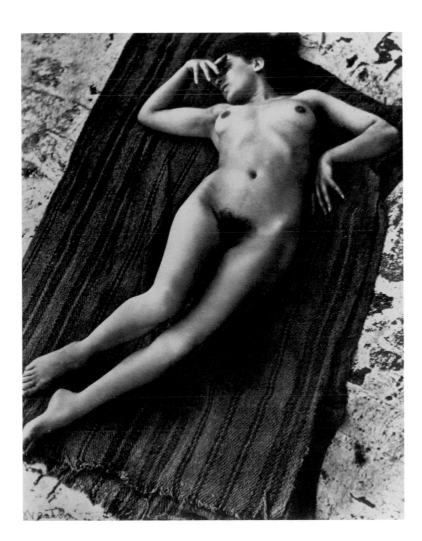

B y no means were motion pictures the invention of one individual—instead, they resulted from decades of scientific investigation and experiments in the fields of optics, chemistry, and mechanics. At their heart, movies are based on a visual illusion—known for centuries—called the persistence of vision, meaning the retention of an image on the retina so that it remains visible after its actual disappearance. People had long dreamed of being able to reproduce realistic movement, but only in the 19th century did the necessary scientific and mechanical means become available. Among the many to study these phenomena were Joseph Plateau (who investigated the principle of persistence of vision), Simon R. von Stampfer, William G. Horner, Franz von Uchatius, Eadweard Muybridge, Emile Reynaud (whose Théâtre Optique showed animated films from 1892 to 1900), Thomas Alva Edison (his Edison Vitascope dates to 1896), and the Lumière brothers, Auguste and Louis, who gave the cinema what many see as its birthday: December 28, 1895, when they astonished Paris with their Cinématographe. As had happened nearly half a century earlier with photography, even at the very beginning people saw that the new invention promised more than the mere recording and reproduction of reality and that it could be used to communicate ideas and emotions, and could therefore be considered a means for creating art, similar to painting, sculpture, and the other artistic disciplines. The first film school was in France, and the technical evolution of moviemaking was aided by the presence of ingenious figures. The first of these was Georges Méliès, actor, designer, art director, but most of all director and producer of hundreds of film, including *A Trip to the Moon* (1902), *Le Royaume des Fées* (1903), *An Impossible Voyage* (1904), and *The Conquest of the Pole* (1912). No less important

were the animation pioneer Emile Cohl, creator of the first regular cartoon character, Fantoche; the writer-director Max Linder; the director René Clair; and the director Jean Renoir, son of the Impressionist painter Pierre-Auguste, whose best-known films include *The Little Match Girl* (1928), an adaptation of a Hans Christian Andersen fairytale; *Grand Illusion* (1937), set during World War I; and *The Human Beast* (1938), based on a Zola novel. In Italy motion pictures

came into being in the first decades of the century. In 1904 Film Ambrosio was founded in Turin, Italy's first film studio; in 1905 Alberini and Santoni built a studio in Rome that became Cines the next year and was active until 1937, when Cinecittà replaced it. Backed by an age-old cultural tradition, the Italian producers made feature films based on ancient history, with grandiose crowd scenes shot outdoors, from *Quo Vadis?* (1912), a worldwide box-office hit directed by Enrico Guazzoni, to the three-hour *Cabiria* (1914), inspired by the Punic Wars and directed by Giovanni Pastrone with subtitles by Gabriele D'Annunzio and music by Ildebrando Pizzetti. There were also realist films, such as *Sperduti nel Buio* (1914), directed by Nino Martoglio, with its violence and dark tones, and such popular fare as the fantasy series starring the mysterious character Za-la-Mort, created and directed by Emilio Ghione. Other important early films include *Ashes* (1916), based on the novel by Grazia Deledda, directed by Febo Mari, and starring Eleonora Duse in her only film role, and *Pantera di Neve* (1919) and *La Rosa* (1921), based on original stories by Luigi Pirandello directed by Arnaldo Fratelli. After World War I Italian filmmaking went through a long period of crisis, although important films were made, such as those by Alessandro Blasetti, Mario Camerini, Carmine Gallone, Augusto Genina, Mario Soldati—

with *Old-Fashioned World* (1941) and *Malombra* (1942)—and Luchino Visconti, a former assistant to Jean Renoir. In 1932 the international film exhibition of Venice was instituted, the first such exhibition of its kind, destined to help spread motion pictures through the world. In terms of both quantity and quality, the world leader in filmmaking soon became the United States, where the first studios in Hollywood, California, date to 1907. Hollywood soon controlled the world market for films thanks to its perfection of the technique and the skills of its designers, directors, and actors, who took over every genre, from

■ Cecil B. DeMille, *The Squaw Man* (1931)

school of filmmaking arose in Russia, before and after the Revolution, with numerous adaptations of the works of Tolstoy, Chekhov, Gogol, Pushkin, and Dostoyevsky. Examples are *Mother* (1926), based on the novel by Maxim Gorky and directed by Vsevolod Pudovkin, and the films by Alexander Petrovich Dovzhenko and Sergei Eisenstein, first among them *Potemkin* (1925). Filmmaking also reached high levels in Germany, where its birth was largely influenced by Expressionist painting, as is clear in such famous films as *The Cabinet of Dr. Caligari* (1919), directed by Robert Wiene, *Metropolis* (1927) by

Motion pictures

comedies to tragedies. The Americans created their own film language and imposed it on the world. It is a language based on rapid, crisp editing, straightforward storytelling, the predominance given action over dialogue, a maniacal attention to technical detail, clear and sharp images, and acting that is dramatically expressive without lapsing into the melodramatic. A short list of the outstanding artists who made contributions to the early years of American filmmaking includes D. W. Griffith, Thomas H. Ince, Cecil B. DeMille, Mack Sennett, Charlie Chaplin, Douglas Fairbanks, Buster Keaton, Erich von Stroheim, Joseph von Sternberg, John Ford, Walt Disney, and Orson Welles. Another important

Fritz Lang, *Waxworks* (1924) by Paul Leni, and *Nosferatu the Vampire* (1922) by F. W. Murnau. The advent of the Nazis brought an end to expressive freedom. The Scandinavian school produced several outstanding figures during the first decades of the century, including the Swede Victor Sjöström (Seastrom), the Finn Mauritz Stiller, and the Danes Benjamin Christensen and Carl Theodor Dreyer, the latter famous for *The Passion of Joan of Arc* (1928), *Vampire* (1929), and *Day of Wrath* (1943). Spain is represented by the works of the director Luis Buñuel, a friend of Salvador Dalí, with whom he made *An Andalusian Dog* (1928) and *The Golden Age* (1930), film adaptations of Surrealist notions.

■ John Ford, *Stagecoach* (1939)

The story is set during World War I: two French officers, the aristocrat Captain De Boeldieu (Pierre Fresnay) and Lieutenant Maréchal (Jean Gabin), of humble origins, are shot down during a reconnaissance flight and taken prisoner by Captain Von Rauffenstein (Erich von Stroheim, at the center in the photo). Sent to a prison camp in Germany they meet other French, Russian, and English soldiers. After various attempts to escape they are put in an old castle. Maréchal succeeds in escaping, together with another prisoner, a Jew named Rosenthal (Marcel Dalio), thanks to De Boeldieu's sacrifice, who is killed by the German captain. Worn out by hunger and cold, the two fugitives take refuge with a peasant of Württemberg, whose husband and brothers have all been killed in the war; after a few weeks they leave, heading for the Swiss frontier. Masterfully directed and acted, the film presents moments of extraordinary tension; at the same time, it confronts important social issues and renounces war. The war the film was intended to prevent began two years after its release.

■ Piero Fosco
Cabiria
1914
Original poster

Cabiria is considered the grandfather of all "costume epics." Its technical innovations included the first traveling shots, taken from a dolly, a wheeled platform on which a camera can be mounted; vast historical sets; and crowd scenes, all of which had an influence on movies for decades to come. The film was presented at the same time at both the Teatro Vittorio Emanuele in Turin and the Teatro Lirico in Milan on April 18, 1914. It enjoyed enormous success both in Italy and abroad; in Paris it was shown for six months (230 times) and in New York for a year. Set during the Second Punic War and freely drawn from the novel *Cartagine in Fiamme* by Emilio Salgari, it tells the story of Cabiria, a young Greek who flees an eruption of Etna, is taken prisoner by pirates, and is sold as a slave in Carthage. Just as she is about to be sacrificed to the god Moloch, she is saved by Fulvius Axilla, a Roman patrician, with assistance from the Herculean-bodied slave Maciste, played by Bartolomeo Pagano, a former dockworker from Genoa.

The son of music-hall performers, Charles Spencer Chaplin joined the Fred Karno company at the age of seventeen. During a tour of the United States he was noticed by Mack Sennett, who signed him for his Keystone company. Chaplin made 35 films for Keystone between 1913 and 1915, steadily evolving the character he became famous for, the endearing vagabond with the bowler, tight jacket, baggy pants, black mustache, and cane known as the Little Tramp, after the movie of that title (1915). Over the coming years Chaplin was involved in intense activity as an actor and director, becoming famous throughout the world. In 1918 he signed a $1 million contract with First National; in 1919, in partnership with Mary Pickford, Douglas Fairbanks, and D. W. Griffith, he formed United Artists, for which he made such masterpieces as *The Gold Rush* (1925), *City Lights* (1931), *Modern Times* (1936), *The Great Dictator* (1940), and *Monsieur Verdoux* (1947). In 1952 he left the United States to move to Vevey, Switzerland, where he died on December 25, 1977.

This film was first
shown in Berlin on
March 2, 1920,
meeting immediate
and vast critical and
public acclaim. The
screenplay by Carl
Mayer was based on
an idea from Czech
writer Hans Janowitz.
Hermann Warm and
Walter Röhrig did the
art direction, building
and painting sets that
follow the spirit of
Expressionism. The
costumes were
designed by Walter
Reimann. Werner
Krauss plays the
part of the enigmatic
Dr. Caligari; Conrad
Veidt is Cesare, the
sleepwalking
cadaverous assistant
who commits crimes
at the doctor's
bidding. Lil Dagover
is Jane, girlfriend of
Franz, the student
who unmasks Caligari.
It is a nightmarish
tale in which crimes,
abductions, and
various strange and
unreal situations
follow one another
until the final twist in
which it is revealed
that Franz is a patient
in a mental hospital
and that the entire
story has been the
fruit of his obsession.
The film's dark
atmosphere of terror
seems an effort to
exorcise Germany's
deep anguish
following its military
defeat in World War I.

This film is unanimously judged one of the great masterpieces of the silents. The story, based on a screenplay by Nina Agadzhanova Sutko, is set in Czarist Russia during the 1905 Russo-Japanese War. The crew of the battleship *Potemkin*, unhappy with rotten food, rebels against their officers, throwing them into the sea and raising the red flag of revolution. The battleship then moves toward the harbor of Odessa, where it is welcomed by festive crowds. Cossacks are also there, however, and they open fire on the unarmed citizens (shown here is the famous scene of a baby carriage rolling down the Odessa stairs). The *Potemkin* must flee, pursued by a fleet sent to oppose it, but the crews of the Czarist ships refuse to fire on their compatriots, and the battleship avoids being encircled and takes refuge in a Rumanian port.

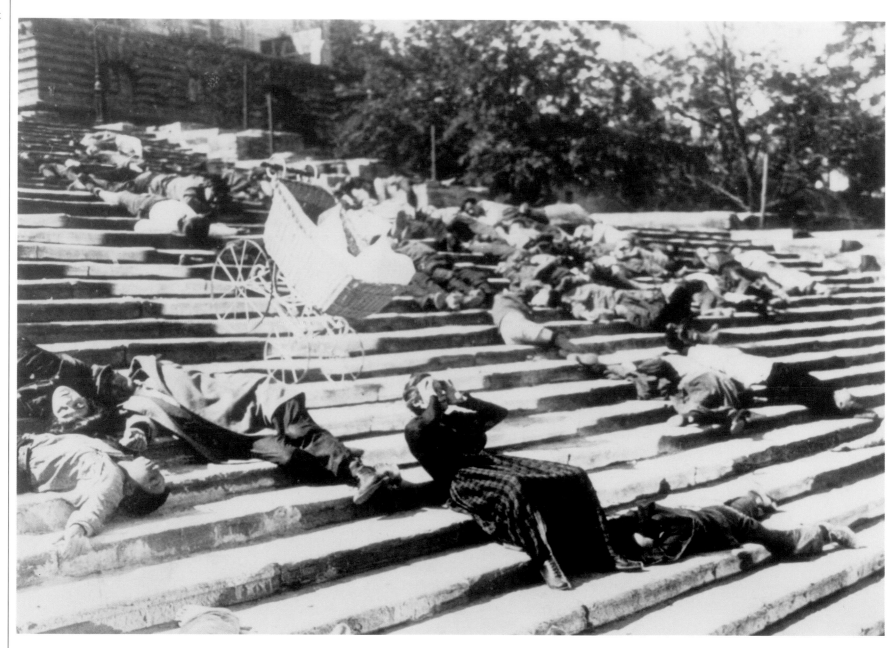

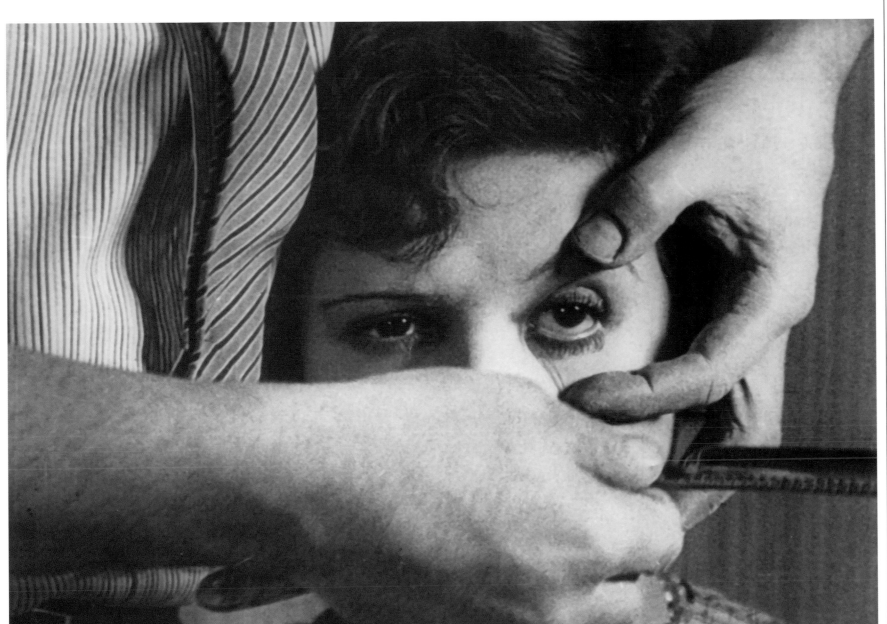

Although in many ways quite different (the first is silent and runs seventeen minutes, the second has sound and lasts an hour), *An Andalusian Dog* and *The Golden Age* (1930) perfectly express the Surrealist spirit, abandoning rationality and reality to give free rein to the unconscious and dreams. A notable aspect of both films is the total absence of an overall narrative or logical meaning, beginning with the titles, which seem to have no direct relationship to the events presented. Buñuel and Dalí (who collaborated in the planning of both films) seem to amuse themselves by disorienting and disturbing the audience with bizarre and morbid scenes, with incessant and more or less explicit allusions to violence, antireligious sentiments, and erotic imagery. Various scenes have become famous, such as the opening sequence in which a woman's eye presented in close-up is sliced by a razor, or the scene of a hand covered by ants, a recurrent image in Dalí's paintings.

1900–45 Events,

1900 World population is about 1.5 billion.
July 29, Humbert I, king of Italy, is assassinated.
Sigmund Freud publishes *The Interpretation of Dreams*.
Max Planck formulates the quantum theory of physics.
Universal Exposition in Paris, April 15 to November 12.

1901 Queen Victoria dies.
The Boxer Uprising ends with the Peace of Peking.
U.S. President McKinley is assassinated and succeeded by Theodore Roosevelt.
Marconi transmits the first transatlantic telegraph message.
Thomas Mann, *Buddenbrooks*; Anton Chekhov, *Three Sisters*.

1902 Cuba becomes independent from Spain.
End of the Boer War.
Alfred Stieglitz founds the Photo-Secession group.
Debussy composes *Pélleas et Mélisande*.
Joseph Conrad, *Heart of Darkness*.

1903 Wright brothers' first flight.
Death of Pope Leo XIII, replaced by Pius X.
Panama wins independence from Colombia.
Memorial exhibition of Gauguin at the Salon d'Automne.

1904 Russo-Japanese War begins over control of Korea and Manchuria; it ends in 1905 with Japan's victory.
France and Great Britain form the Entente Cordiale.
Giacomo Puccini, *Madame Butterfly*.
George M. Cohan, *Give My Regards to Broadway*.

1910 Death of Edward VII of England, succeeded by George V.
Revolution in Mexico.
Herwarth Walden founds *Der Sturm*.
First abstract watercolors by Wassily Kandinsky.
Bertrand Russell and A. N. Whitehead begin publication of the *Principia Mathematica* (to conclude in 1913).

1911 Italy declares war on Turkey and conquers Libya.
Vincenzo Peruggia steals the *Mona Lisa* from the Louvre (it was returned in 1913).
Maria Curie is awarded the Nobel Prize for chemistry.
Birth of Der Blaue Reiter at Munich.

1912 The *Titanic* sinks during its maiden voyage.
International exhibition of the Sonderbund at Cologne.
Wassily Kandinsky, *Concerning the Spiritual in Art*.
Igor Stravinsky composes the music to *Petrouchka*.
Enrico Guazzoni, *Quo Vadis*.

1913 Guillaume Apollinaire, *Alcools*.
Charles Ives, *Holiday Symphony* and *The Fourth of July*.
Marcel Proust begins publishing, at his own expense, *Remembrance of Things Past*.
Armory Show in New York.
Edmund Husserl, *Ideas for a Pure Phenomenology*.
D.H. Lawrence, *Sons and Lovers*.

1914 Archduke Ferdinand is assassinated at Sarajevo, beginning World War I.
Death of Pope Pius X, replaced by Benedict XV.
Opening of the Panama Canal.
James Joyce, *Dubliners*.
George Bernard Shaw, *Pygmalion*.

1920 Hitler presents his party at Munich.
Mexican president Carranza is deposed; Alvaro Obregón becomes the new president.
The Treaty of Sèvres ends the Ottoman Empire.

1921 Foundation of the Italian Communist party at Leghorn.
Adolf Hitler becomes president of the German Nationalsocialist party.
Rudolph Valentino stars in *The Sheikh*.

1922 Death of Pope Benedict XV, replaced by Pius XI.
In Italy, Fascists march on Rome; Mussolini is named head of the Italian government.
The first Soviet Congress in Moscow institutes the USSR.
James Joyce, *Ulysses*.
Ludwig Wittgenstein, *Tractus Logico-Philosophicus*.

1923 French and Belgian troops occupy the Ruhr to force Germany to pay its reparations.
Bauhaus exhibition at Weimar.
November 3, Hitler attempts a coup in Munich and is imprisoned.

1924 Italy annexes Fiume.
In Italy, the Fascist party wins elections thanks to electoral riggings and intimidations; the socialist deputy Giacomo Matteotti is assassinated by Fascists.
Death of Lenin; hostility between Stalin and Trotsky for control of power.
André Breton, *Manifeste du Surréalisme*.

1930 Germany's Nazi party wins 107 seats in elections becoming the country's second party.
Haile Selassie becomes emperor of Ethiopia
Robert Musil begins publication of *The Man without Qualities*.
The first World Cup Soccer games; Uruguay defeats Argentina for the title.

1931 Alfonso XIII of Spain abdicates and a republic is proclaimed.
Paul Doumer is elected president of France.
Japan occupies Manchuria.

1932 Paul von Hindenburg is elected president of Germany; Adolf Hitler and the Nazi party obtain a majority in the elections.
In India Gandhi begins his first hunger strike in prison.
Franklin D. Roosevelt is elected president of the United States.
The Bauhaus moves to Berlin.

1933 Adolf Hitler is named chancellor of Germany; the Reichstag in Berlin is destroyed by fire; Hitler is given full power in March.
The Bauhaus is closed.
Publication of the magazine *Minotaure* begins in France.

1934 "The Night of the Long Knives," June 30, in Germany: the SS kill Ernst Rohm and many members of the SA; on August 2 Hitler assumes the position of head of state.
Mao Tse-tung begins the Long March of the Red Army in China.
George Eliot, *Murder in the Cathedral*.

1940 June 10, Italy enters the war against France.
Germany and the USSR sign a nonaggression pact.
Charlie Chaplin, *The Great Dictator*.

1941 German and Italian troops invade Yugoslavia and Greece.
June 21, Germany declares war on the USSR.
December 7, the Japanese attack the naval base at Pearl Harbor, bringing the United States into the world war.

1942 The Italian-German offensive in Egypt is stopped at El Alamein.
American troops land in Morocco and Algeria; Italian and German troops occupy French Tunisia.
In November the Battle of Stalingrad begins.
Enrico Fermi creates the first self-sustaining chain reaction in uranium.

1943 End of the Battle of Stalingrad with the surrender of von Paulus and his army.
On July 10 American forces invade Sicily; on July 25 Mussolini is forced to withdraw; on September 8 General Badoglio signs an armistice with the Allies; the republic of Salò comes into being. On October 13 Italy declares war on Germany.

1944 June 6, D-Day landings of Allied troops in France.
August 25, Allied troops enter Paris.
Italy's King Victor Emmanuel III abdicates in favor of his son Humbert II.
First performance of *The Glass Menagerie* by Tennessee Williams.

1900–45 Events, artists, works

1905 Revolutionary activity at in Russia; the crew of the *Potemkin* mutinies.
Foundation of Die Brücke group in Dresden.
The Salon d'Automne of Paris and creation of "Les Fauves."
Einstein's Theory of Relativity.
E. M. Forster, *Where Angels Fear to Tread*.

1906 Finland is the first European country to give the vote to women.
San Francisco earthquake.
Giosuè Carducci wins the Nobel Prize for literature.
Deaths of Cézanne and Ibsen.

1907 Rudyard Kipling wins the Nobel Prize for literature.
Cézanne retrospective at the Salon d'Automne in Paris.
Creation of the Deutscher Werkbund in Munich.
Picasso, *Demoiselles d'Avignon*.
Great Britain, France, and Russia form the Triple Entente.

1908 Bulgaria obtains independence from the Ottoman Empire.
The Eight hold their show at the Macbeth Gallery in New York.
Worst earthquake in Europe (Sicily) kills 75,000.
General Motors in founded; Ford creates the Model T.

1909 Arnold Schoenberg composes 12-tone works.
Neue Künstlervereinigung is founded in Munich.
On February 20 Filippo Tommaso Marinetti publishes his "Manifesto del Futurismo."
Guglielmo Marconi is awarded the Nobel Prize for physics.

1915 On May 7 a German submarine sinks the English ship *Lusitania*; on May 24 Italy enters the war alongside France and Great Britain.
Germans use poison gas at Ypres.
Edgar Lee Masters, *Spoon River Anthology*.

1916 Battles of Verdun, the Somme.
Franz Kafka, *Metamorphosis*.
Albert Einstein elaborates his General Theory of Relativity.
Hugo Ball founds the Cabaret Voltaire in Zurich; birth of Daddism.

1917 On March 15 the czar of Russia abdicates.
The United States declares war on Germany.
Austrian-German offensive at Caporetto against Italy.
November 7, the Communist Revolution begins in Russia.
Death of Buffalo Bill.

1918 The "Spanish" influenza pandemic begins.
November 4, armistice between Austria and Italy.
November 9, Germany's Kaiser Wilhelm II abdicates.
November 11, Armistice ends World War I.

1919 Treaty of Versailles at Paris; founding of the League of Nations.
Mussolini establishes a Fascist society.
Gabriele D'Annunzio occupies the city of Fiume.
Birth of the Weimar Republic in Germany.
Walter Gropius founds the Bauhaus.
Chaplin, Pickford, Fairbanks, and Griffith establish United Artists.

artists, works

1925 Hitler, *Mein Kampf*.
G.F. Hartlaub organizes the "Neue Sachlichkeit" show in Mannheim.
Exposition International des Arts Décoratifs et Industriels Modernes in Paris: Art Deco.
The Bauhaus moves to Dessau.
F. Scott Fitzgerald, *The Great Gatsby*.
Sergei Eisenstein, *Potemkin*.
Charlie Chaplin, *The Gold Rush*.

1926 The British Empire becomes a commonwealth.
"Mostra d'Arte del Novecento Italiano" in Milan.
Grazia Deledda wins the Nobel Prize for literature.
Fritz Lang, *Metropolis*.

1927 Execution in the United States of the anarchists Nicola Sacco and Bartolomeo Vanzetti.
The Academy of Motion Picture Arts and Sciences is founded.
Charles Lindbergh flies solo nonstop from New York to Paris.
Introduction of sound to films with *The Jazz Singer*, directed by Alan Crosland.

1928 Herbert Hoover elected president of the United States.
Bertolt Brecht, *The Three-Penny Opera*.
D.H. Lawrence, *Lady Chatterley's Lover*.
Alexander Fleming discovers penicillin.

1929 Pope Pius XI signs the Lateran Treaty with Italy.
U.S. Stock Market crash begins Great Depression.
St. Valentine Day's Massacre: Al Capone eliminates the Bugsy Moran gang.
Graf Zeppelin makes round-the-world flight.
Ernest Hemingway, *A Farewell to Arms*.

1935 October 3, Italy invades Ethiopia.
President Roosevelt begins the second phase of the New Deal, a reform plan begun in 1933.
Anti-Semitic legislation (the "Nuremberg Laws") take hold in Germany.

1936 Italian king Victor Emmanuel III takes the title of emperor of Ethiopia.
Civil war begins in Spain.
Mussolini and Hitler form the Rome-Berlin Axis and support General Franco in Spain.
In Great Britain Edward VIII abdicates to marry Wallis Simpson; he is succeeded by George VI.

1937 On April 26 German planes bomb Guernica; Pablo Picasso paints *Guernica*.
On December 3 Japanese troops enter the Chinese city of Nanking, beginning the "rape of Nanking," and setting off the war between China and Japan (1937–45).
In Munich the "Degenerate Art" show is held, visited by more than 1 million people.

1938 On March 12 German troops occupy Austria.
Anti-Semitic persecutions grow fiercer in Germany, and the first "laws for the defense of the race" are enacted in Italy.
Jean-Paul Sartre, *Nausea*.

1939 Germany invades Czechoslovakia.
Franco's troops occupy Madrid.
Hitler annexes Bohemia and Moravia; Slovakia is given nominal independence as a satellite state.
The Italian army invades Albania
On September 1 Germany invades Poland, beginning World War II.
On September 3 Great Britain and France declare war on Germany.
Pius XII is elected.

1945 Death of President Roosevelt, succeeded by Harry Truman.
On April 25 Turin and Milan are liberated from the Nazi occupation.
On April 28 Mussolini is killed; on April 30 Hitler commits suicide.
Germany surrenders on May 8.
On August 6 an atomic bomb is dropped on Hiroshima; on August 9 on Nagasaki.
The Nuremberg Trials against Nazi criminals begins.

References

Biographies
•
Bibliography
•
Index of names and places
•
Photographic sources

Biographies

ALVAR AALTO
(Kuortane, 1898–Helsinki, 1976)

Aalto earned his diploma in architecture from the Helsinki Polytechnic in 1921 and opened his first studio in Jyvaskyla, in 1923; in 1924 he married the architect Aino Marsio, who died in 1949. In 1927 he won the competition for the Southwestern Finland Agricultural Cooperative buildings in Turku and moved there. Between 1931 and 1933 he designed the Paimo Sanatorium; in 1935 he completed work on the Viipuri Library, considered his masterpiece. In that same year he founded the Artek company to produce and distribute his furniture designs. From 1946 to 1948 he taught at MIT; on his return to Finland he settled in Helsinki, working on important public commissions. From 1963 to 1968 he was president of the Finland Academy.

ANSEL ADAMS
(San Francisco, 1920–Carmel, 1984)

Adams took his first photographs in 1916 during a vacation in Yosemite National Park. He began studying piano and not until 1930, following an encounter with Paul Strand, did he dedicate himself full time to photography. In 1928 he married Virginia Best. In 1931 he exhibited sixty photographs at the Smithsonian Institute; the next year he was among the founders of the f.64 Group, and in 1933 he opened a gallery in San Francisco. In 1946 he founded the Department of Photography at the California School of Fine Arts in San Francisco. A landscape photographer, he spent much of his life in America's national parks, to which he dedicated more than twenty-four books.

ALEXANDER ARCHIPENKO
(Kiev, 1887–New York, 1964)

Archipenko enrolled in the Kiev School of Art in 1902, but was expelled in 1905 for criticizing the teaching methods. In 1906 he went to Moscow and two years later to Montparnasse, the artists' quarter of Paris. He began exhibiting his sculptures at the Salon des Indépendants and the Salon d'Automne. In 1912 he was among the founders of the Section d'Or, and he exhibited four sculptures and five drawings in the 1913 Armory Show in New York. During World War I he took refuge at Cimiez, in the home of a friend. In 1921 he married Angelica Bruno-Schmitz and moved to Berlin; two years later he moved to New York, where he opened a school of art. He became a U.S. citizen in 1928 and taught and exhibited his sculpture in various U.S. cities.

JEAN (HANS) ARP
(Strasbourg, 1887–Basel, 1966)

Alsace was part of Germany when Arp was born, for which reason he was baptized Hans; following World War I the region passed to France, changing his name to Jean. He studied at the Weimar Academy and the Académie Julian in Paris. In 1912 he contributed to the Blaue Reiter; a short time later he moved to Paris, where he met Apollinaire, Picasso, and Modigliani. He met Sophie Tauber in 1915 and married her in 1922. In 1916 he joined Dada; in 1925 he exhibited at the Pierre gallery in Paris together with the Surrealists. Between 1929 and 1930 he participated in the Cercle et Carré and Abstration-Création groups. In 1943 his wife died; in 1959 he married Marguerite Hagenbach. In 1954 he won the international prize for sculpture at the Venice Biennale.

LÉON BAKST
(St. Petersburg, 1866–Paris, 1924)

After studies at the St. Petersburg Academy Bakst began a career as an illustrator. After travels throughout Europe he returned to Russia, making a name for himself for his book illustrations and portraits. In 1908, together with Aleksander Benois and Serge Diaghilev, he founded *Mir Iskussiva* ("The World of Art"). In 1902–03 he began designing costumes and theatrical scenery. In 1906 he taught drawing at the Yelizaveta Zvantseva private art school, where Marc Chagall was among his pupils. In 1909 he worked with Diaghilev and was among the founders of the Ballets Russes, becoming its artistic. His most famous works include those for the ballets *Schéhérazade* and *L'Après-midi d'un faune*. In 1912, because of his Jewish origins, he had to leave Russia and moved to France.

GIACOMO BALLA
(Turin, 1871–Rome, 1958)

Balla studied at the night school of drawing at the Turin Academy. In 1895 he moved with his mother to Rome, where he painted portraits and landscapes in a style near that of Pointillism and he exhibited at the shows of the Società degli Amatori e Cultori. In 1910, with Boccioni, Severini, Carrà, and Russolo he signed the "Technical Manifesto of Futurist Painting," of which he was one of the leaders. After World War I he became involved in films, the theater, and the applied arts. In the 1930s he moved away from the Futurists and approached figurative painting, helped by his Futurist-named painter-daughters, Elica ("Propeller") and Luce ("Light").

ERNST BARLACH
(Wedel, 1870–Rostock, 1938)

Ballach studied at the Hamburg School of Arts and Crafts, at the Dresden Academy, and the Académie Julian in Paris. He contributed drawings to the magazines *Jugend* and *Simplicissimus*, wrote dramatic works, and proved himself skilled at

ceramics and woodcuts. In 1906 he went to Jarkiv in Russia and from then on drew inspiration from the popular traditions of northern Europe. During the 1920s he moved to Güstrow, where he discovered his calling as a sculptor, most of all in bronze and wood. His success was affirmed by a one-man show in 1933 at the Paul Cassier gallery in Berlin. Because of Nazis persecution, he spent the last years of his life in solitude, and many of his works were destroyed.

CECIL BEATON
(London, 1904–Broad Chalke, 1980)

Beaton began his involvement in photography when still a child; after studies at Cambridge University he held his first photography show in London in 1926, winning contracts with the magazines *Vogue, Vanity Fair*, and *Harper's Bazaar*, for which he worked until the middle of the 1940s. During the 1930s he took many photographs of Hollywood actresses; in 1937 he was named court photographer to Britain's royal family and during World War II he was photographer of the British Ministry of Information. He also worked as a stage and costume designer. In 1958 he won an Oscar for the costumes in the film *Gigi* and in 1964 for Audrey Hepburn's costumes in *My Fair Lady*. In 1954 he published *The Glass of Fashion*. Queen Elizabeth II knighted him in 1972.

MAX BECKMANN
(Leipzig, 1884–New York, 1950)

Beckmann studied at the Weimar Academy of Art from 1900 to 1903; he visited Paris, Amsterdam, Geneva, and Berlin; in Berlin he took part in the Secession exhibit. In 1906 he married Minna Tube. In 1913 Paul Cassirer mounted the first one-man show of his works. In 1914 he enlisted in the medical corps, but was discharged in 1915 for nervous exhaustion. In 1925 he divorced and married Mathilde von Kaulbah, nicknamed Quappi; in the same year he was granted a chair at the Stadesliche Kunstinstitut of Frankfurt; in 1926 exhibited for the first time in the United States, at the J.B. Neumann Gallery. In 1933 he was fired from his teaching post and put on the list of "degenerate" artists; in 1937 he left Germany and lived and exhibited in London, Paris, and Amsterdam. He 1947 he went to the United States, where he taught and was the subject of numerous shows.

PETER BEHRENS
(Hamburg, 1868–Berlin, 1940)

In 1889 Behrens got his diploma from the Karlsruhe Art School. He taught architecture in Darmstadt from 1900 to 1901, and from 1903 to 1907 directed the Düsseldorf Art Academy. In 1907 he joined the Deutscher Werkbund and was called by Emil Rathenau to serve as design consultant for AEG, the German electricity-supply company, where he worked until 1914. He oversaw the design of advertising art, general office objects, and five factory buildings, including the Turbine Factory in Berlin. After 1922 he taught at Düsseldorf, Vienna, and Berlin.

HANS BELLMER
(Katowice, 1902–Paris, 1975)

Although his father, an engineer, hoped he would take up technical studies, Bellmer was drawn to advertising graphics, industrial design, and art. He met Otto Dix and George Grosz and followed the activity of the Dadaists and Surrealists, who effected his production as painter and sculptor. In 1927 he married and opened an advertising agency in Berlin. In 1938, to escape Nazi persecution, he moved to Paris, where he joined the Surrealist movement. Between 1937 and 1965 he was involved in the various phases of the creation of *Die Puppe*, an articulated doll-mannequin made of a variety of materials.

GEORGE BELLOWS
(Columbus, Ohio, 1882–New York, 1925)

Bellows studied at Ohio State University from 1901 to 1904, contributing illustrations to student magazines and playing on the baseball team. In 1904 he left the university to study art in New York, where he became a student of Robert Henri. In 1908 he took part in the show of the Eight at the Macbeth Gallery in New York, in 1909 he entered the National Academy of Design, and the next year he taught at the Art Students League of New York; he was also among the founders of the Society of Independent Artists.

THOMAS HART BENTON
(Neosho, Missouri, 1889–Kansas City, Missouri, 1975)

Benton studied at the Corcoran School of Art in Washington, D.C., and at the Art Institute of Chicago. He visited Paris between 1908 and 1911, attending the Académie Julian and becoming enamored of Cezanne, Matisse, and the Cubists. During the 1920s he made numerous paintings in which he depicted scenes of American life; he designed a series of sixty-four large murals dedicated to the history of the United States, but completed only sixteen. In 1935 he became director of the City Art Institute and School of Design of Kansas City. He wrote two autobiographies, *An Artist in America* (1937) and *An American in Art* (1969).

HENDRIK PETRUS BERLAGE
(Amsterdam, 1856–The Hague, 1934)

Between 1875 and 1878 Berlage studied at Zurich under the guidance of the students of Gottfiend Sempre. He traveled in Germany, Austria, and Italy worked with Petrus Cuypers and on his return to Amsterdam. In 1883 he took part in the competition for the Amsterdam Stock Exchange, which he completed in 1903. In 1901 he was commissioned to direct an urban plan for Amsterdam South. In 1910 he published the book *Art and Society*, in which he expressed his ideas of an ideal urban society. In 1913 he began working for the Kröller Müller family and moved to The Hague, where he made friends with Ludwig Mies van der Rohe and collaborated on the main museum.

UMBERTO BOCCIONI
(Reggio Calabria, 1882–Sorte,1916)

Having graduated from the Technical Institute in 1901 Boccioni moved to Rome, where he studied graphics and attended the Scuola Libera di Nudo at the Academy of Fine Arts and studied literature and journalism on his own. In 1902 he visited Paris and saw Impressionist and Post-Impressionist painting firsthand; in 1906 he went to Russia; in the winter between 1906 and 1907 he took courses in life drawing at the Venice Academy. In 1908 he moved with his mother and sister to Milan, where he had his initial contact with the founding nucleus of the Futurism, in particular his spiritual guide, Marinetti. In 1910 he signed the "Manifesto of Futurist Painting" and took part in the group's exhibits. In the fall of 1911 he was in Paris, where he met Severini, Apollinaire, and Picasso. In 1912 he attended the Futurist exhibit at the Berheim-Jeune gallery in Paris, also presented in London, Berlin, and Brussels. From 1912 to 1914 he contributed to the magazine *Lacerba*. At the outbreak of World War I he was among the most ardent interventionists; he volunteered for service and died in 1916 after a fall from a horse.

GIOVANNI BOLDINI
(Ferrara, 1842–Paris, 1931)

Boldini got his first lessons in painting from his father, Antonio, former student of Mindari in Rome. In 1862 he spent a period of study in Florence and attended the academy and the Café Michelangelo, habitual meeting place of the Macchiaioli. In 1867 he went to Paris, during the Universal Exhibition; in 1870 he went to London; the following years, after a brief stay in Italy, he moved to Paris, where he remained almost without interruption until his death. He signed a contract with Goupil and began to exhibit at the Salon; within a few years he had gained great fame as a portraitist and had gathered a large clientele of well-to-do middle-class and aristocratic ladies, as well as celebrities from the world of entertainment. In 1914, with the outbreak of World War I, he moved first to London, then to Nice. He returned to Paris in 1918 and the next year was honored with the Legion of Honor. In 1926 he met Emilia Cardona, thirty years old, who became his wife in 1929.

CONSTANTIN BRANCUSI
(Pestisani Gorj, 1876–Paris, 1957)

Brancusi studied at the Kraków School of Arts and Crafts and from 1898 to 1901 at the Bucharest Academy. After working for several years in Vienna and Munich, in 1904 he moved to Paris and the following year enrolled in the Ecole des Beaux-Arts. He met Auguste Rodin, visited his studio, and became passionate about African art. In 1907 he made *The Kiss*, followed by other sculptures in which he increasingly simplified the forms, approaching abstraction, as in the *Heads*, in the three versions of the portrait of Mademoiselle Pogany, in the *Bird in Space* series and in *The Fish*. In 1908 he met Matisse, Modigliani, Léger, and

Duchamp. He took part in the 1913 Armory Show in New York, showing five works. During World War I he worked on wood sculpture, with his personal interpretation of primitive art, exploring formal simplifications and coming nearer to abstractionism. In 1952 he became a French citizen.

MARIANNE BRANDT
(Chemnitz, 1893–Kirchberg, 1983)

Brandt studied painting and sculpture at Weimar from 1911 to 1917; in 1924 she enrolled in the Bauhaus painting class, where she studied under Moholy-Nagy; the following year, when the school moved to Dessau, she designed many metal objects for its kitchen. During the next two years she designed lamps; in 1929 she worked with Walter Gropius at Berlin. From 1949 to 1954 she taught at the Academy of Fine Arts in Dresden and the Berlin Academy of Applied Arts, dedicating herself to painting, weaving, and photography.

GEORGES BRAQUE
(Argenteuil, 1882–Paris, 1963)

In 1890 Braque moved with his family to Le Havre, where he took night courses at the Ecole des Beaux-Arts and met Dufy and Friesz. In 1900 he married in Paris and after military service enrolled in the Académie Humbert; he moved away from the Impressionist style, which he had followed in his first works, approaching the works of the Fauves. He stayed in L'Estaque, frequented Matisse, Derain, and Vlaminck, drew inspiration from Cézanne, and met Apollinaire, who introduced him to Picasso, with whom he created various phases in Cubism. In 1912 he took part in the Blaue Reiter show and the "Sonderbund" show in Cologne. After World War I he signed a contract with Léonce and Paul Rosenberg. Over the next decades he exhibited with success in major

international shows; he returned to representational art, most of all in a series of still lifes, experimented various pictorial techniques, and worked in graphics, theatrical scenery, and sculpture.

VICTOR BRAUNER
(Piatra Neamt, Moldavia, 1903–Paris, 1966)

Brauner studied at the evangelical school in Braila from 1916 to 1918, then in 1921 attended the Bucharest School of Fine Arts. In 1924 he had his first one-man show in the Mozart Gallery in Bucharest; his first works were inspired by Cézanne and the Expressionists. He moved to Paris in 1930 and associated with Giacometti and Tanguy, who introduced him to other members of Surrealism, which he joined after 1933. In 1934 he exhibited at the Pierre gallery in Paris, but with little success. Between 1935 and 1938 he lived in Bucharest. In 1938 he lost an eye in a fight; during World War II he lived in southern France and Switzerland. In 1948 he returned to Paris and in 1947 took part in the Exhibition Internationale du Surréalisme at the Maeght Gallery. In the paintings of his later decades he used forms and symbols drawn from a variety of sources.

MARCEL BREUER
(Pecs, 1902–New York, 1981)

Thanks to a scholarship Breuer attended the Vienna Academy; unhappy with the teaching, which he considered obsolete, he moved to the Bauhaus in Weimar, studying there between 1920 and 1924. In 1925 Gropius made him director of the furniture workshop at the school in Dessau. In 1928 he left the Bauhaus to open an architecture studio in Berlin. In 1935, to escape Nazi persecution, he moved to London; in 1937 he moved to the United States, where he was reunited with Gropius and with

whom he opened a studio (active until 1941) and thanks to whom taught at the School of Design of Harvard University. In 1946 he moved to New York.

LUIS BUÑUEL
(Calanda, Spain, 1900–Mexico City, 1983)

Buñuel studied with the Jesuits at Saragossa before taking courses in literature and philosophy at the University of Madrid, where he met Federico Garcia Lorca and Salvador Dalí. In 1924 he got a degree in literature and the next year married Jeanne Rucar. He moved to Paris, where he associated with the Surrealists. With Dalí he made the short film *An Andalusian Dog* and *The Golden Age*, both of which provoked scandal and strong responses. In 1939 he emigrated to the United States and worked at the Museum of Modern Art and did dubbing. In 1940 he moved to Mexico, becoming a Mexican citizen in 1948. Over the following hears he made numerous films, including *Viridiana* (1961), which won the Palma d'Ora at the Cannes Festival. He made *Belle de Jour* (1967), which won the Leon d'Oro at the Venice Festival. In 1970 he returned to Spain and made *Tristana*, followed by *The Discreet Charms of the Bourgeoisie* (1972) and *That Obscure Object of Desire* (1977).

MASSIMO CAMPIGLI (Max Ihlenfeld)
(Berlin, 1895–Saint-Tropez, 1971)

In 1899 he moved with his mother, Anna Paolina Ihlenfeld, and his grandmother to Settignano, near Florence. He studied in Milan and in 1914 wrote his first articles for *Lacerba*, adopting the pseudonym Massimo Campigli; after World War I he worked in Paris as correspondent for *Corriere della Sera* and became an Italian citizen. He frequented

Italian painters living in Paris (de Chirico, Savinio, Tozzi, Severini, de Pisis, and Paresce), with whom he formed the group known as the Sette di Parigi ("Parisian Seven"). In 1923 he mounted his first one-man show at the Bragaglia Gallery in Rome; he took part in the two shows of the Italian Novecento group between 1926 and 1929, the year in which he also exhibited at the Jeanne Bucher gallery in Paris, beginning a long, successful career. From 1949 on he alternated living in Paris with long stays in Rome, Milan, and Saint-Tropez.

ROBERT CAPA
(Budapest, 1913–Thai-Binh, 1954)

Capa studied political science at the University of Berlin and studied photography on his own. He began working for the *Deutscher Photodienst* in 1932, and in 1933 moved to Paris. His photographs of the Spanish civil war earned him international fame. Over the next decades he worked as a war correspondent throughout the world—China, Italy, France, Germany, Israel—and was killed in Indochina by the explosion of a land mine.

CARLO CARRÀ
(Quargnento, 1881–Milan, 1966)

Carrà began his career as a decorator in Valenza; in 1895 he moved to Milan, where he became involved in the gallery of Vittore Grubicy de Dragon and the Divisionist painters. He visited Paris, where he contributed decorations to pavilions for the 1900 Universal Exhibition, and London, where he visited avant-garde settings; in 1906 he enrolled at the Brera Academy, a student of Cesare Tallone. In 1910 he joined the Futurists and took part in all the group's major shows. In 1915 he developed the aesthetic of *antigrazioso*, inspired by

the paintings of Henry Rousseau and 14th-century Tuscan artists. In Ferrara in 1916 he met de Chirico, Savinio, and de Pisis, with whom he gave life to Metaphysical art. Later, together with the magazine *Valori Plastici* and the Novecento movement, he returned to a more traditional style, faithful to realism, as demonstrated by the landscapes he made at Moneglia, Forte dei Marmi, in Valesia, and in the Tuscan Apennines.

HENRI CARTIER-BRESSON
(Chanteloup, 1908–Paris, 2004)

Cartier-Bresson was originally drawn to painting, studying with an uncle and then under Jacques-Emile Blanche and André Lhote; he associated with the Surrealists. He moved to photography in the 1930s, and in 1931 took a long trip through France, Spain, Italy, and Mexico, documenting what he saw with photographs taken with a Leica. In 1932 he held his first show in the Julien Levy gallery and in 1933 took important photos in Spain. In 1935 the worked for the film industry in the United States together with Paul Strand; on his return to France he continued working in film with Jean Renoir and Jacques Becker. In 1947, together with Robert Capa, David "Chim" Seymour, George Rodger, and William Vandiverst he founded Magnum Photos, which became the most important photo agency in the world. In the following decades he made reportage throughout the world and took photo portraits of the leading cultural and political personalities of the world.

FELICE CASORATI
(Novara, 1883–Turin, 1963)

Casorati spent his youth between Milan, Reggio Emilia, Sassari, and Padua, earning a law degree in the last-named in 1906. He made his debut at the 1907 Venice Biennale with

Portrait of a Woman, a picture of his sister Elvira. He lived in Naples between 1908 and 1911 and in Verona from 1911 to 1915. After World War I he moved to Turin. In 1924 he exhibited at the Venice Biennale and took part in two editions of the Novecento show (1926 and 1929); he was also involved in interior design and the applied arts, making costumes and theatrical scenery. In 1930 he married Daphne Maugham; in 1938 he won the painting prize at the Venice Biennale and obtained various recognitions at shows in Paris, Pittsburgh, and San Francisco.

MARC CHAGALL
(Vitebsk, 1887–Saint-Paul-de-Vence, 1985)

After art studies at St. Petersburg, Chagall moved to Paris in 1910, where he met the leading avant-garde artists. At the outbreak of World War I he was in Russia; while at Vitebsk during the Revolution he obtained several official commissions of a cultural character. In 1922 he left Russia and went first to Berlin, then to Paris. During World War II he took refuge in the United States, where he began to make theatrical scenery and costumes; in 1948 he went to Vence on the Côte d'Azur, where he made engravings, stained-glass, mosaics, and ceramics, using these art forms to spread a biblical message.

CHARLIE CHAPLIN
(London, 1889–Vevey, 1977)

The son of music-hall entertainers, Chaplin was performing at a young age; when eight he was the member of a troupe of child dancers, the Eight Lancashire Lads. At age seventeen he joined the Fred Karno Company, and it was with a troupe of that company that he arrived in the United States. Mack Sennett took note of him in 1913 and signed him to a contract with his Keystone company, and

within a few years Chaplin had become famous, a fame sealed by *The Tramp* (1915). In 1919 he was among the founders of United Artists. In 1925 he made *The Gold Rush*, which some see as his masterpiece. Other films of that period include *City Lights* (1931), *Modern Times* (1936), and *The Great Dictator* (1940). In 1952, because of his presumed sympathies for Communism, he left the United States and took up residence in Switzerland. In 1972 he was awarded an Oscar for his career. He married four times and had eleven children.

TULLIO CRALI
(Igalo, 1910–Milan, 2000)

Crali attended the Technical Institute of Gorizia; interested in art from his childhood, he made paintings that he signed with the pseudonym Balzo Fiamma. In 1929 he joined Futurism. In 1930 he designed Futurist architecture and associated with the members of the group, among them Cangiullo, Janelli, Dormal, Farfa, and Fillia. In 1932 he got a degree from the Venice Academy; he presented his works at the first exhibition of the Italian Futurist Aeropainters in Paris; he made advertising signs and sketches of Futurist clothing. In 1933 he took part in the Futurist exhibition of motion-picture-scenery design in Rome. Over the following years he exhibited several times at the Rome Quadriennale and the Venice Biennale. Between 1950 and 1958 he taught in an Italian high school in Paris. From 1962 to 1966 he moved to Cairo, where he taught at the Italian School of Art. On his return to Italy he moved to Milan, where he worked as a painter.

SALVADOR DALÍ
(Figureres, 1904–1989)

Second son of a notary, Dali studied at the Madrid School of Fine Arts, where he made friends with Garcia

Lorca and Luis Buñuel. In 1928 he moved to Paris and met Picasso, Miró, and most of all Breton and Eluard, thanks to whom he joined Surrealism. In 1929 he met Gala (Helena Deluvina Diakinoff), wife of Eluard, who became his model, lover, and wife in a civil rite in 1934. In 1933 he exhibited at the Julien Levy Gallery in New York, obtaining a favorable response from American critics and collectors. The next year he argued with the other exponents of the Surrealist movement (from which he was expulsed in 1940), who rebuked him for his lack of political involvement. In 1935 he explained his "paranoid-critical" method in the essay *Conquest of the Irrational*. In 1940 he went to the United States and met with great success, writing, painting, and working in the cinema and theater. In 1941 he was the subject of a series of shows in New York and other American cities. In 1948 he returned to Spain and went to Port Lligat. He began a series of works with religious subjects. Over the next decades he carried on his stylistic experiments with space, hyperrealism, and optical art.

GIORGIO DE CHIRICO
(Vólos, 1888–Rome, 1978)

Born in Greece to Italian parents, de Chirico moved to Munich in 1906, where he encountered the philosophy of Nietzsche, Schopenhauer, and Weininger and the late-Romantic painting of Arnold Bocklin and Max Klinger. In 1911 he went to Paris, where he became friends with Paul Valéry and Guillaume Apollinaire. At Ferrara in 1916 he met Carlo Carrà, with whom he created Metaphysical painting, which repeated and enlarged upon themes he had already presented in works made in France. He contributed to the magazine *Valori Plastici* and was among the leading supporters of the return to the classical figurative tradition. In

1925 he returned to Paris and associated with the Surrealists, breaking with them (not without disputes and polemics) to follow his own route, characterized by a personal reworking of myths and ancient history. He worked on various pictorial cycles in which his creativity gradually diminished, replaced by a refined and self-celebratory mannerism.

ROBERT DELAUNAY
(Paris, 1885–Montpellier, 1941)

Delaunay did not receive any sort of regular artistic training; from 1902 to 1905 he worked in a studio making theatrical decorations. In 1904 he exhibited his first paintings at the Salon des Indépendants, works inspired by the Impressionists, Gauguin, and Cézanne. In 1909 he adopted a style closer to Cubism and made his famous series of *The Eiffel Tower*, *Notre-Dame*, and *Saint Séverin*. In 1910 he met Léger and married Sonia, destined to have an important influence on his artistic evolution toward geometric abstractionism. Between 1932 and 1934 he was a member of the Abstraction-Création group, and he later painted abstract works, including the series of *Rhythms without End*; he experimented with the use of such materials as plaster, sand, sugar, and cement and made large decorative panels.

SONIA DELAUNAY-TERK (Sarah Stern)
(Odessa, 1885–Paris, 1979)

Orphaned at the age of five, she spent her infancy in St. Petersburg with her maternal uncle, the lawyer Henri Terk. She studied at Karlsruhe, Germany, moving to Paris in 1905, where she attended the Académie de la Palette and married gallery owner Wilhelm Uhde. In 1910 she divorced Uhde and married the painter Robert Delaunay, with whom she associated

with Cubist, Dada, and Surrealists artists and elaborated a style of geometric abstract painting that Apollinaire dubbed Orphic, hence "Orphism." In addition to painting she made theatrical scenery and worked in the decorative arts, attributing equal artistic dignity to all these activities. She designed interior furnishings and clothing; she opened a fashion house in Madrid, Barcelona, Bilboa, and, in 1924, in Paris, together with Jacques Heim.

PAUL DELVAUX
(Antheit, 1897–Furnes, 1994)

Son of a lawyer in the Brussels court of appeals, Delvaux studied architecture and painting in that city's academy. In the 1920s he painted marine scenes in a Post-Impressionist style, later moving closer to Expressionism, but in 1934 he was struck by the works of Giorgio de Chirico, and beginning in 1935 he adopted the style and poetic sensibilities of Surrealist painting. In 1938 he participated in the International Exhibition of Surrealism in Paris and in 1940 he exhibited in Mexico. In 1945 he was the subject of an important one-person show that made him known to the public at large; he was also present at the Venice Biennale in 1948 and 1954. In 1969 the Musée des Arts Décoratifs in Paris dedicated a vast retrospective show to him.

CECIL B. DE MILLE
(Ashfield, Massachusetts, 1881–Los Angeles, 1959)

Drawn to the theater in his youth, with his older brother William he founded the De Mille Play Company. In 1913 he became involved in moviemaking and with Samuel Goldwyn and Jesse L. Lasky founded the Jesse L. Lasky Feature Play Company, the future Paramount. Among the more than one hundred

films he directed, mostly westerns or biblical epics, he made two versions of *The Ten Commandments* (1923 and 1956), *The Plainsman* (1937), *Northwest Mounted Police* (1940), *Reap the Wild Wind* (1942), and *The Greatest Show on Earth* (1952).

CHARLES DEMUTH
(Lancaster, Pennsylvania, 1883–1935)

Demuth studied at the Pennsylvania Academy of Fine Arts. He visited Paris for the first time in 1907 and was struck by Cubist paintings; he returned to Paris from 1912 to 1914 to study at the Académie Julian. In 1915 he held his first one-man show, at the Daniel Gallery in New York; in the 1920s he exhibited at the 291 Gallery of Alfred Stieglitz and became one of the most important exponents of the Precisionist style, also called "Cubist Realism."

FORTUNATO DEPERO
(Fondo, 1892–Rovereto, 1960)

In December 1913 Depero arrived in Rome, where he met Balla and gallery owner Giuseppe Sprovieri. In 1914 he took part in the Futurist exhibition in Rome, and on March 11, 1915, together with Balla, he signed the "Manifesto of the Futurist Reconstruction of the Universe." In 1916 he signed a contract with Diaghilev for the staging of *Le Chant du Rossignol*, based on the Andersen fairytale, with music by Stravinsky. In 1918 he and Gilbert Clavel staged the so-called Balli Plastici. In 1919 he began making furniture, decorative art objects, tapestries, and advertising images. In 1925 he took part in the Exhibition Internationale des Arts Décoratifs in Paris. In 1927 he published the "bolted" book *Depero-Futurista*. In 1928 he visited New York and in the 1930s took part in exhibits mounted by the Fascist ministry controlling fine arts.

FILIPPO DE PISIS
(Ferrara, 1896–Milan, 1956)

Between 1916 and 1919 de Pisis was in Ferrara, together with de Chirico, Savinio, and Carrà; while studying literature and philosophy at the University of Bologna he met Morandi. In 1919 he moved to Rome and dedicated himself full time to painting: he was in contact with the members of the magazine *Valori Plastici* and made friends with Armando Spadini and was influenced by Futurist and Metaphysical painting. In 1925 he moved to Paris, where he had his first one-man exhibit, in 1926, in the Galerie au Sacre du Printemps. He took part in the two exhibits of the Novecento group, in 1926 and 1929, and was a member of the "Italians in Paris" group. During the 1930s he visited England several times. At the outbreak of World War II he returned to Italy, first to Milan, then Venice. Because of a mental illness he spent his last years in a rest home at Brugherio.

ANDRÉ DERAIN
(Chatou, 1880–Garches, 1954)

In 1898 Derain enrolled in the Académie Eugène Carrière, where he met Matisse, Puy, Marquet, and Vlaminck, with whom he exhibited at the Salon d'Automne in 1905. After 1906 he associated with Braque and Picasso. Together with them he studied non-European cultures and followed with interest the birth of Cubism, the style of which he approached. In 1911 he distanced himself from the activities of avant-garde groups, and between 1919 and 1921 he wrote a short treatise, which remained unpublished, called *De pictura rerum*, in which he proposed a return to realism in painting and drew inspiration from the great masters of the past, from the art of imperial Rome to that of Caravaggio.

OTTO DIX
(Untermhaus, 1891–Singen, 1969)

From 1909 to 1914 Dix studied at the Dresden School of Applied Arts. In 1913 he visited Austria and Italy and was influenced by Futurism. He volunteered for service in World War I and expressed his horror at his experiences in a series of drawings and paintings. He approached the Dada movement, but preferred to remain within German Expressionism. With Grosz and other artists he created the New Objectivity movement. In 1926 he had a personal show at the Neumann-Nierendorf in Berlin; in 1927 he was nominated professor at the Dresden Art Academy, and in 1931 he became a member of the Prussian Academy of Arts in Berlin. During the period of Nazism his works were considered "degenerate art." Fired from his teaching post and prohibited from exhibiting his works in public, he withdrew to Hemmenhofen on Lake Constance, where he made landscapes and works with religious themes.

THEO VAN DOESBURG
(Utrecht, 1883–Davos, 1931)

Van Doesburg had his first show in 1908 at The Hague; he was also active in poetry and art criticism. After military service, between 1914 and 1916, he moved to Leiden and collaborated with the architects Oud and Wils. In 1917 he was among the founders of the magazine *De Stijl* and the art group of the same name. In 1922 he taught at the Bauhaus in Weimar and joined the Dada movement, contributing to the magazine *Mécano* with Kurt Schwitters, Jean Arp, and Tristan Tzara. In 1924 the Landesmuseum of Weimar dedicated a one-man show to him. In 1925 he published the manifesto of Elementarism, in which he presented his new theories. He

took part in the birth of the magazine *Art Concret*, the organ of the Paris group of that name, and was among the leading exponents of the Abstraction-Création movement.

ÓSCAR DOMÍNGUEZ
(La Laguna, Tenerife, 1906–Paris, 1957)

In 1927 Domínguez visited Paris for the first time and came in contact with the exponents of Surrealism. In 1929 he made *Dream*, his first Surrealist work, and in 1933 he had his first one-man show in Tenerife, with paintings showing the influence of Magritte and Dalí. In 1934 he moved to Paris and experimented with new techniques, both in painting and sculpture, together with Breton, Ernst, Tanguy, Matta, and Picasso.

KEES VAN DONGEN
(Delfshaven, 1877–Monte Carlo, 1968)

Van Dongen studies at the Fine Arts Academy in Rotterdam; in July 1897, after a trip to the United States, he moved to Paris. In 1904 he had his first solo show thanks help from the art dealer Ambroise Vollard. He came in contact with the Fauves, with whom he participated in the Salon d'Automne in 1905. He also saw works by the artists of Die Brücke as well as by Picasso, from whom he drew inspiration for the works of his maturity. After World War I he alternated period in Paris with long stays on the Côte d'Azur. In 1957 he moved to the principality of Monaco, where he developed his style, very similar to Expressionism, full of light and colors with learned and refined suggestions.

GERARDO DOTTORI
(Perugia, 1884–1977)

In 1910 Dottori contributed to the Florentine magazine *La Difesa*

dell'Arte, and two years later he joined the Futurist movement. He abandoned the Symbolist and Divisionist style of his early works and adopted a plastic dynamism not without suggestions of abstraction inspired by Balla. During World War I he wrote "words-in-freedom" under the pseudonym G. Voglio. From the 1920s to the 1940s he was present in almost all the major Futurist shows. He signed the "Manifesto of Futurist Aeropainting" in 1929 and founded the newspaper *Griffa!* in Perugia.

MARCEL DUCHAMP
(Blainville, 1887–Neuilly-sur-Seine, 1968)

Duchamp studied painting in Rouen, then from 1904 to 1905 at the Académie Julian in Paris. He published humoristic drawings in the magazines *Courrier Français* and *Le Rire*. He began exhibiting in 1908 at the Salon des Indépendants and the Salon d'Automne. He met Picabia and in 1911 moved toward Futurism and Cubism. He famously exhibited *Nude Descending a Staircase No. 2* at the 1913 Armory Show in New York; during that same year he signed the *Bicycle Wheel*, his first readymade. Between 1915 and 1923 he designed the *Large Glass* and made other readymades. Beginning in 1925 he concentrated on chess and took part in numerous professional competitions. In later decades he slowed his artistic production but continued to associate with members of the Dada and Surrealist groups, having a great influence on them.

RAOUL DUFY
(Le Havre, 1877–Forcalquier, 1953)

In 1897 Dufy took courses from Charles Lhuillier at the Ecole des Beaux-Arts in Le Havre, where he met Friesz and Braque. In 1900, thanks to a grant, he went to Paris, where he studied at the Academy of Fine Arts;

the next year he exhibited for the first time at the Salon. His first paintings showed the influence of the Impressionism of Boudin, but he then followed the style of the Fauves, then the Cubists, and then he was struck by the large retrospective show dedicated to Cézanne in 1907. In 1911 he married Eugénie-Emilienne Brisson; he set up his atelier in Montmartre, and took numerous trips, most of all to the Côte d'Azur, attracted by the warm Mediterranean light, which glows from his canvases and from his numerous illustrations for books and magazines.

SERGEI MIKHAILOVICH EISENSTEIN
(Riga, 1898–Moscow, 1948)

Eisenstein first worked in the theater as an actor, stage designer, and director, and only in 1924 did he turn to the cinema. He began teaching at GIK, the state film school, in 1928; in 1930 he was invited to Hollywood, where he met Chaplin and Disney. In 1932 he worked in Moscow for the Sojuzkino studio. In 1939 he received the Lenin Prize; in 1940 he became artistic director of Mosfilmstudios; in 1946 he received the Stalin Prize, and the following year he was made director of the Cinematographic Department at the Institute of Art History and the Academy of Science. His most famous works include *Potemkin* (1925), *Ten Days That Shook the World* (1928), and *Alexander Nevsky* (1937).

MAX ERNST
(Bruhl, 1891–Paris, 1976)

Ernst studied philosophy, psychiatry, and art history at the University of Bonn; in 1912 he founded the Das Junge Rheinland group together with August Macke. In 1918 he married Luise Strauss. The next year he started a Dada group, called W/3 West Stupida and edited the magazines *Der Ventilator* and *Bulletin D*; he also

organized the first Dada exhibit in Cologne. He visited Paris in 1920 and moved there in 1922. He became friends with Breton and Eluard and joined the Surrealists. In 1927 he married Marie-Berthe Aurenche. In 1938, following disputes with Breton, he left the Surrealist movement and moved to near Avignon along with the painter Leonora Carrington. Between 1941 and 1953 he lived in the United States. He worked with Breton and Duchamp, founded the Surrealist magazine *VVV*, and married another two times, to Peggy Guggenheim in 1941 and Dorothea Tanning in 1946. In 1953 he returned to Paris, where he mounted numerous retrospective exhibits.

ALEXANDRA EXTER
(Belostok, today Bialystok, 1882–Fontenay-aux-Roses, 1949)

Exter studied art at Kiev from 1901 to 1907 and the next year married Nikolai Exter. She associated with the leading Russian painters, writers, and musicians and traveled, both inside Russia and elsewhere, most of all Paris, where she had her first exhibit in 1912. In 1916 she converted to abstractionism and in the same year began to draw stage scenery and theatrical costumes, winning international recognition. In 1920 she left Kiev and moved to Moscow, where she married the actor Gregari Nekrasov. In 1921 she joined the Constructivist movement. In 1924 she moved to France and taught drawing and scenography at the Modern Academy opened by Léger in Paris.

LYONEL FEININGER
(New York, 1871–1956)

Feininger's father was a German violinist who had emigrated to the United states; his mother was a singer. In 1887 he was sent to Germany to continue his musical education, but was drawn instead to art and attended

the academies of Hamburg and Berlin. In 1894 he began a prolific career as an illustrator, caricaturist, and cartoonist for German, French, and American magazines. He also painted, influenced by Cubism, and associated with the members of the Die Brücke and Der Blaue Reiter groups. In 1917 he held his first one-man show in the Der Sturm gallery in Berlin. In 1919 he met Gropius, who made him director of the engraving workshop at the Bauhaus. He followed the school to Dessau and Berlin, but in 1937 had to leave Germany and return to New York, where he was the subject of many exhibits, including a retrospective at the Museum of Modern Art in 1944.

GEORGES DE FEURE
(Paris, 1868–1928)

Son of a Dutch architect and a Belgian mother, he began his career as a designer of advertising posters. As a painter he made works full of symbolic and allegorical references, inspired by the poetry of Charles Baudelaire, and exhibited at the Salon de la Rose + Croix. Among his most famous creations are the works he made for the S. Bing pavilion at the Universal Exhibition in Paris in 1900, considered masterpieces of Art Nouveau. He also worked with success in decorative arts and as a designer of costumes and stage scenery.

PEDRO FIGARI
(Montevideo, 1861–1938)

Figari studied law and in 1886 began working as a defense lawyer; in 1893 he founded the periodical *El Deber*. He began painting in the last decade of the 19th century; in 1912 he published the essay *Arte, Estética, Ideal*. He made two trips to France, in 1913 and from 1925 to 1933. On his return to Montevideo he was named art counselor to the ministry of

public education and began depicting the life and traditions of his people, with paintings showing work in the fields, gauchos on the pampas, religious ceremonies, and festivals.

HENRY FORD
(Greenfield, Michigan, 1863–Dearborn, Michigan, 1947)

The son of Irish immigrants, Ford worked for the Edison Illuminating Company of Detroit. He built his first automobile, the Quadricycle, in 1896, and with $28,000 in capital founded the Ford Motor Company in June 1903. In 1908 he designed the Model T, destined for enormous success. For the construction of his cars in the factory at Highland Park, Detroit, Ford introduced the use of the assembly line. Over the span of a few years, the time required to assemble a Model T went from 12 1/2 hours to 1 1/2 hours; by 1915 Ford was manufacturing 1 million cars a year. Ford went on to design the Model A and the V8, in 1932. In 1941, after twelve years of research, Ford made the prototype of a car with a biodegradable body made of plastic and hemp fiber, the Hemp Body Car. In 1945 he left the direction of the company.

JOHN FORD
(Cape Elizabeth, Maine, 1895–Palm Desert, California, 1973)

Ford was born into a family with Irish origins and was drawn to motion pictures when still young; he worked as an actor and stuntman in films directed by his brother and began his activity as a director in 1917 with a series of short westerns. In 1924 he directed the *Iron Horse*; by the time sound arrived he had reached his full artistic maturity, as he demonstrated in a series of highly successful films. The 137 films he made over his long career include *Stagecoach* (1939), *The Grapes of Wrath* (1940), *My*

Darling Clementine (1946), *Fort Apache* (1948), *The Quiet Man* (1952), and *The Searchers* (1956).

PIERO FOSCO (Giovanni Pastrone)
(Asti, 1882–Turin, 1959)

As a boy Fosco played the violin and after earning his diploma in accounting he worked in Turin for an importer of French films. He became involved in the cinema, and in 1908 became director of Itala film, a production house destined to perform a fundamental role in the birth of Italian cinema. A true revolutionary in the techniques of film directing, his many films include *La Mashera di Ferro* (1909), *Lucia di Lammermoor* (1910), and his masterpiece, *Cabiria* (1914), with subtitles by Gabriele D'Annunzio and music by Ildebrando Pizzetti.

ESTEBAN FRANCÉS
(Port-Bou, 1914–United States, 1976)

After studies in Spain, Francés moved to Paris in 1937, where he associated with the Surrealists; his stylistic innovations include the technique of *grattage automatique*, the pictorial equivalent of automatic writing, which consisted in covering a surface with layers of paint in different colors and then scratching a design with a razor, thus revealing unpredictable colors. At the outbreak of World War II Francés went to the United States.

OTHON FRIESZ
(Le Havre, 1879–Paris, 1949)

Friesz studied at Le Havre and, with Dufy and Braques, painted landscapes at Trouville and Honfleur. He moved to Paris in 1898 and followed the style of the Impressionists; he met Matisse, Rouault, and Marquet and other exponents of the Fauvist movement, which he joined in 1905. Between 1909 and 1912 he traveled to Munich (with

Dufy) and to Portugal, and Belgium. From 1914 until his death he lived at 73, Rue Notre-Dame des Champs in Paris, where he occupied the studio that had belonged to William-Adolphe Bouguereau and spent his vacations at Cap-Brun, near Toulon, where he bought a house in 1923.

EMILE GALLÉ
(Nancy, 1846–1904)

Gallé studied at Nancy and between 1862 and 1866 took courses in mineralogy at Weimar; he specialized in glass making and woodwork. In 1875 he married Henriette Grimm; in 1883 he opened an atelier that produced ceramics, glass, and art objects in wood. Over the following years he participated regularly in international exhibitions and opened branch offices in Paris, Frankfurt, and London.

ANTONÍ GAUDÍ Y CORNET
(Reus, 1852–Barcelona, 1926)

The last of five children born into a humble family of boiler makers, Gaudí studied at the Barcelona Architecture School. In 1878 he opened a studio in Barcelona, where he made his first work, the Casa Vicens. In 1882 he met the industrialist Güell y Bacigalupi who became his sponsor. In 1883 he began designing the Sagrada Familia, to which he would dedicate his entire life. In 1901 he was given an award by Barcelona for the Casa Calvet. Among his most important works were the Casa Batlló, the Güell Park, and the Casa Milà in Barcelona. In 1910 he won enormous success at the exhibition of the Societé Generale des Beaux-Arts of Paris. A deeply religions man, he was nicknamed "God's architect." He is buried in the crypt of the Sagrada Familia and in 1999, on the initiative of Cardinal Ricard María Carles Gordo, the process of his beatification began.

CASS GILBERT
(Zanesville, Ohio, 1859–Brockenhurst, 1934)

Gilbert studied architect under William R. Ware at the Massachusetts Institute of Technology. He traveled through Europe in 1880 and on his return worked first for McKim, Mead & White and then, from 1884 to 1892, with James Knox Taylor, with whom he designed numerous private homes, churches, and public buildings. In 1887 he married Julia T. Finch. In 1899 he moved to New York to work on the Broadway-Chambers Building. Over the next three decades he became one of America's most innovative architects, with works that changed the face of American cities, with the Customs House (1901–07), the Union Club (1902), and the Woolworth Building (1910–13). Gilbert was among the founders of the Architectural League of New York, serving as its president from 1913 to 1914.

WILLIAM J. GLACKENS
(Philadelphia, 1870–New York, 1938)

Glackens worked as an illustrator for various periodicals in Philadelphia and studied painting at the Pennsylvania Academy of Fine Arts. In 1883 he met Robert Henri and went to Paris in 1895. On his return to America he became an illustrator for the *New York Herald*, *Saturday Evening Post*, and *New York World*. In 1898 he was sent to Cuba to make illustrations of the Spanish-American War. In 1908 he took part in the show of the Eight at the Macbeth Gallery in New York. During the last years of his life he devoted himself full time to painting and made several more trips to Paris, where he exhibited with success.

ALBERT GLEIZES
(Paris, 1881–Avignon, 1953)

Gleizes first learned art from his

father, an interior designer, from whom he learned the strict geometric forms he later adopted in his Cubist works. He exhibited at the Salon d'Automne and the Salon des Indépendants. In 1911 he abandoned the Impressionist style of his youthful works to move toward Cubism, becoming one of the leading exponents of that style. In 1912 he and Jean Metzinger published the essay *Du Cubisme*. He took part in the activity of the Section d'Or group. He was among the leading artists at the 1913 Armory Show in New York, and between 1915 and 1919 lived in the United States. In 1927 he founded the artistic-agricultural commune of Moly-Sabata at Sablons, which was involved in religion as well as art. In 1931 he joined the Abstraction-Création group; he illustrated books and made mural decorations; in 1932 he published *L'Homocentrisme ou Retour de l'homme chrétian* and *La forme et L'histoire*.

JOHN WILLIAM GODWARD
(London, 1861–1922)

Godward's artistic training was strongly influenced by the classicism of Laurens Alma-Tadema, and he is included among the painters of the so-called Marble School. His favorite subjects were romantic young women dressed in clothing similar to that worn in ancient Greece and imperial Rome. Between 1887 and 1905 he took part regularly in the annual shows of the Royal Academy of London; in 1912 he went to Rome for further study. After World War I he was unable to adapt his style to the changing taste of collectors and feeling excluded and rejected he committed suicide.

NATALIA GONCHAROVA
(Negaevo, 1881–Paris, 1962)

Goncharova studied at the Moscow college of painting, sculpture, and

architecture, where she met Mikhail Larionov; they married in 1905 and together took part in several exhibits, in close contact with the Russian avant-garde. She exhibited at the Salon d'Automne in Paris for the first time in 1906; 1909 she was among the founders of the Jack of Diamonds group. In 1912 she was invited to the second exhibit of the Blaue Reiter in Munich, and in 1913 she and Larionov wrote the "Manifesto of Rayists and Futurists." She moved to Geneva and then to Paris, where she collaborated with Diaghilev, designing stage scenery and costumes.

JUAN GRIS
(Madrid, 1887–Boulogne-sur-Seine, 1927)

After studies at the Escuela de Artes y Manufacturas in Madrid, Gris began working as an illustrator for *Blanco y Negro*, *Madrid Comico*, and *Alma America*. In 1904 he studied painting as a student of José Maria Carbonero. In 1906 he moved to Paris, taking up residence in the Bateau Lavoir and working in close contact with Picasso and Braque, together with whom he gave birth to Cubism. In 1908 he met the art dealer Daniel-Henry Kahnweiler and signed a contract with him in 1912. In 1914 he began experimenting with the technique of collage and *papiers collés*. In 1916 he sold several paintings to the art dealer Léonce Rosenberg, and in 1917 signed a three-year contract with him. In 1920 he made a new contract with Kahnweiler. In 1922 he moved to Boulogne-sur-Seine and drew stage settings and costumes for the Ballets Russes of Diaghilev.

WALTER GROPIUS
(Berlin, 1883–Boston, 1969)

Gropius studied architecture in Munich and Berlin; between 1908 and 1910 he collaborated with Peter Behrens and in 1910 with Adolf Meyer; in 1911 he designed the Fagus Works at Alfeld-an-der-Leine and in 1914 the Werkbund pavilion in Cologne. In 1919 he founded the Staatliches Bauhaus in Weimar, serving as its director until April 1928. He then moved to London and between 1934 and 1937 worked with Maxwell Fry. He moved to the United States in 1938 and began teaching at Harvard University. He opened a studio and worked with Marcel Breuer and then with the TAC group.

GEORGE GROSZ
(Berlin, 1893–1959)

Grosz first studied at the Dresden Academy as a student of Richard Müller, then at the Berlin School of Decorative Arts under Emil Orlik. He served as a volunteer in World War I, after which he approached the Berlin Dada movement and was among the first exponents of the New Objectivity group. In 1919 he had his first one-man show, at the gallery of Hans Goltz in Munich. He founded the magazine *Die Pleite* and collaborated with Wieland Herzfelde's Malik-Verlag, which published collections of his satirical drawings. The tone of his works and his political activities attracted the condemnation of the Nazis, and he was included among the "degenerate" artists. In 1933 he fled to the United States, where he taught at the Art Students League of New York; he later became a U.S. citizen. In 1959, shortly before his death, he returned to Germany and was named a member of the Berlin Academy of Fine Arts.

RENATO GUTTUSO
(Bagheria, 1912–Rome, 1987)

Guttuso learned to paint by visiting the workshop of Emilio Murdolo, a decorator of Sicilian carts, and the studios of Domenico Quattrociocchi and the minor Futurist Pippo Rizzo. In 1929 he made his debut at the second exhibit of the Sicilian Sindacato Artistico and in 1931 was admitted to the first Rome Quadriennale. In 1932 and 1934 his paintings were included in the collective shows that the Galleria del Milione dedicated to Sicilian painters. At first he made friends with the artists of the "Roman school," later moving to the exponents of the Corrente group, which he joined in 1940. In that same year he joined the Communist party; he took part in the Resistance World War II and was a leading figure in Italian culure in the immediate postwar period. He was among the founders of the Fronte Nuovo for the Arts, which promoted realistic painting that is socially and politically involved. In 1975 he was elected senator.

CARLO GUZZI
(Milan, 1889–Lecco, 1964)

After technical studies he worked at Isotta Fraschini Motori; during World War I he was involved in the design of hydroplane motors and met Giorgio Parodi and Giovanni Revelli. In 1921, together with Parodi, he founded the Società Anonima Moto Guzzi, with headquarters at Mandello sul Lario; its eagle symbol is an homage to Revelli, who died in a plane accident. In that same year he designed the Moto Guzzi Tipo Normale, the first of many popular motorcycles.

MARSDEN HARTLEY
(Lewiston, Maine, 1877–Ellsworth, Maine, 1943)

Hartley studied at the Art Institute of Cleveland and the Chase School in New York; in 1907 he had his first exhibit, at the 291 Gallery of Alfred Stieglitz, and he took part in the 1913 Armory Show. He traveled to Europe several times, coming in contact with various exponents of the avant-garde. Between 1926 and 1934 he lived and worked in Aix-en-Provence, New Mexico, and Bavaria. He is considered one of the leaders of American art between the two world wars and one of the precursors of Abstract Expressionism.

RAOUL HAUSMANN
(Vienna, 1886–Limoges, 1971)

In 1900 Hausmann's family moved to Berlin, where he met Erich Heckel and Ludwig Meidner. In 1912 he contributed to the magazine Der Sturm, in 1914 he was part of the Die Aktion group, and in 1916 he was among the founders of the Die Freie Strasse group, with Grosz and Mehring. In 1918 he was among the founders of the Berlin Dada movement and directed the magazine Club Dada. In 1933 he left Germany for France, where he continued his activity as a painter, writer, and photographer.

ERICH HECKEL
(Döebeln, 1883–Radolfzell, 1970)

From 1897 to 1904 Heckel attended the Realgymnasium in Chemnitz, where he met Schmidt-Rottluff, who convinced him to abandon poetry and turn instead to painting. Between 1904 and 1905 he studied architecture at Dresden, where he met Kirchner and Bleyl, with whom he founded the Die Brücke group. In the spring of 1909 he visited Italy; he spent the summer at Moritzburg with Kirchner and the fall with Schmidt-Rottluff at Dangast. In 1918 he moved to Berlin; he joined the Novembergruppe and the politically active Arbeitsrat für Kunst. The Nazis included him among the "degenerate" artists and prohibited him from exhibiting and painting. From 1941 to 1943 he moved to Carinthia. He then went to Hemmenhofen, on Lake Constance, and from 1949 until his death he taught at the Karlsruhe Academy.

ROBERT HENRI
(Cincinnati, Ohio, 1865–New York, 1929)

In 1886 Henri enrolled in the Pennsylvania Academy of Fine Arts in Philadelphia; he went to Paris in 1888 and studied at the Académie Julian. He traveled to Italy in 1890, and on his return to Philadelphia taught painting at the School of Design for Women. His studio became a meeting place for artists, laying the basis for the Eight. In 1895 he returned to Paris, remaining there until 1900, when he moved to New York. In 1908 he traveled to Spain to study the painting of Goya and Velázquez. He organized the first exhibition of the Eight, at the Macbeth Gallery. In 1923 he published *The Art Spirit*, in which he presented his artistic vision.

FERDINAND HODLER
(Bern, 1853–Geneva, 1918)

Hodler studied in the workshop of the landscape painter Ferdinand Sommer at Thun and was a student of Barthélemy Menn at the Ecole des Beaux-Arts in Geneva from 1872 to 1877. In 1881 he rented an atelier in Geneva; he was to live in Geneva until his death, and it was there, in 1885, that he had his first one-man show, at the Cercle des Beaux-Arts. In 1889 he married Bertha Stucki, whom he divorced in 1891, the year in which he became a member of the Société Nationale des Artistes Français. In 1892 he took part in the first Salon de la Rose + Croix in Paris. In 1898 he married Berthe Jacques and made friends with Cuno Amiet. In 1900 he became a member of the Berlin Secession and an honorary member of the Vienna Secession; he also won a gold medal at the Universal Exhibition in Paris. In 1905 he visited Italy and exhibited with Klimt at the Berlin Secession. In 1917 he was the subject of a large retrospective show at the Kunstaus in Zurich.

JOSEF HOFFMANN
(Pirnitz, Moravia, 1870–Vienna, 1956)

Architect and designer, Hoffmann studied architecture at the Academy of Fine Arts in Vienna, where he was a student of Karl Hasenauer and Otto Wagner. In 1895 he won the Prix de Rome and went to Italy. An outstanding member of the Vienna Secession he contributed to the magazine *Ver Sacrum*. In 1903 he was among the founders of the Wiener Werkstätte; from 1905 to 1911 he worked on the Palais Stoclet in Brussels with Gustav Klimt. In 1910 he oversaw construction of the Austrian pavilion for the Universal Exhibition in Rome; in 1925, together with Peter Behrens, he designed the Austrian pavilion for the Paris Exhibition. He taught at the Kunstgewerbeschule in Vienna until 1936.

EDWARD HOPPER
(Nyack, New York, 1882–New York, 1967)

Hopper studied art in New York from 1900 to 1906, including classes with Robert Henri, and worked in advertising illustration. Between 1906 and 1910 he made three trips to Europe, during which he made watercolors, etchings, and paintings. He first exhibited his paintings in 1908 in a group show at the former Harmonie Club building in New York. He had one painting in the 1913 Armory Show and was invited to participate in the Venice Biennale in 1922. In 1933 the Museum of Modern Art held a retrospective of his work, as did the Whitney Museum of American Art in 1964.

VICTOR HORTA
(Ghent, 1861–Brussels, 1947)

In 1878, after studies at the Academy of Fine Arts in Ghent, Horta moved to Paris for several years. On his return to Belgium he studied with Alphonse Balat at the Brussels Academy and won the Godecharle prize. At the age of twenty-five he designed his first buildings in Ghent; in a short time he became one of the most representative and innovative exponents of Art Nouveau, using new construction techniques and applying his rich, elaborate decorations in iron and glass. Among his most famous creations are the Hotel Tassel (1893), the Hotel Solvay (1985), the Maison du Peuple in Brussels (1896–99), and the A l'Innovation store (1901). After 1903 he returned to a more traditional and classical style that he used in the design of such monumental works as the Tournai Museum of Fine Arts (1903–28), the Brugmann Hospital (1912–24), and the Brussels Museum of Fine Arts (1920–28).

MARCEL JANCO
(Bucharest, 1895–Tel Aviv, 1984)

Janco studied architecture in Zurich; in 1916 he associated with the artists at the Cabaret Voltaire and was among the leaders in the Dada movement. He worked in both painting and etching and designed posters and illustrated books for Tristan Tzara. In 1918 he collaborated in the activity of the Neue Leben group of Basel. In 1920 he returned to Rumania. He took part in the leading avant-garde exhibitions in Bucharest and was among the animators of the Contimporanui group. In 1920 he took refuge in Tel Aviv, where he founded the New Horizons group and continued his activity as painter, illustrator, writer, and architect. In 1953 he founded the Ein Hod artist community in the ancient Arabian village of Carmel. In 1967 he was awarded the National Grand Prix of Israel.

ALEXEI JAWLENSKY
(Torschok, 1864–Wiesbaden, 1941)

Son of a Russian aristocrat and landowner, Jawlensky studied at the Military School in Moscow and in 1884 became an officer in Moscow's Imperial Guard. In 1889 he enrolled in the St. Petersburg Academy; in 1896 he moved to Munich, where he continued his art studies. He exhibited for the first time in 1902 at the Berlin Secession, then in 1903 at the Munich Secession and in 1905 again in Berlin. Between 1903 and 1906 he made three trips to Paris, where he saw the art of Gauguin and Matisse. Between 1907 and 1909 he spent the summer months at Murnau together with Kandinsky and Gabriele Münter. In 1912 he joined the Blaue Reiter and took part in the group's activities. He spent World War I in Switzerland, after which he, Kandinsky, Klee, and Feininger founded the Blue Four, and as part of that group he exhibited in Germany and the United States. In 1927 the first symptoms of the arthritis that was to slow his painting appeared, and by 1938 it had become paralysis, preventing him from painting.

FRIDA KAHLO
(Coyoacán, Mexico City, 1907–1954)

Kahlo's father was a Hungarian Jew who had emigrated from Germany; her mother was a mestiza. At six she fell ill with polio; on September 17, 1925, she was involved in a bus accident that resulted in a serious lesion to her spinal cord and many other factures that gave her serious physical and psychological problems throughout her life. During her long convalescence she painted, drawing inspiration from the folk art of Mexican ex-votos. She associated with the photographer Tina Modotti and the painter Diego Rivera, sharing their political outlook; she married Rivera on August 21, 1929. In 1938 she went to Paris, where she met Duchamp, Kandinsky, Picasso, and the Surrealists, all of whom praised her

style even though she refused to be included in their movement. In 1939 she was divorced from Rivera and married again the next year.

WASSILY KANDINSKY
(Moscow, 1866–Neuilly-sur-Seine, 1944)

Kandinsky studied law at Moscow but at age thirty abandoned a promising career as a lawyer to go to Munich, where he attended the art academy. Dividing his time between Paris and Berlin, between 1901 and 1904 he led the Phalanx group. Early in his career he was influenced by the style of Matisse and the Fauves; he then moved to Expressionism and was among the leading exponents of the Blaue Reiter. At the same time he carried on theoretical studies (expressed in the essay *Concerning the Spiritual in Art*, published in 1912) and painted his first abstract works. He returned to Russia in 1918 and was named professor of the State Art Laboratories. In 1921 he returned to Germany and the next year began teaching at the Bauhaus, where he directed the mural painting workshop and studied theories of form. When the Nazis rose to power in 1933 and closed the Bauhaus, Kandinsky went to France, where he expanded his exploration of abstractionism, joining geometric shapes to new biomorphic forms.

FERNAND KHNOPFF
(Grembergen-lez-Termonde, 1858–Brussels, 1921)

Khnopff first studied law but abandoned it to dedicate himself to painting. He studied with Mellery at the Brussels Academy and with Jules Lefebvre in Paris, where he was influenced by the works of Delacroix and Moreau. In 1891 he began making frequent trips to England, where he studied Pre-Raphaelite painting and met the Maquet family, in particular

the three sisters Elsie, Lilly, and Nancy, whom he portrayed in several paintings. He made friends with the Symbolist painter Emile Verhaeren and associated with several art groups related to Symbolism, thanks to which he enlarged the themes of his works. He was awarded silver medals at the Universal Exhibitions in Paris in 1889 and 1900 and in that of Munich in 1905.

ERNST LUDWIG KIRCHNER
(Aschaffenburg, 1880–Frauenkirch, 1938)

Kirchner studied architecture at Dresden but then decided to become a painter. In 1905 he was among the founders of Die Brücke. In 1910 he joined the Neue Secession in Berlin; the next year he moved to Berlin and associated with the members of the Blaue Reiter. For health reasons he was excused service during World War I and went to Davos, Switzerland, where he began another movement, called Rot-Blau. In 1931 he was named a member of the Berlin Academy, and in 1933 he was put in charge of the decorations of the Folkwang Museum in Essen. A few months later, however, the Nazis put him on the list of "degenerate" artists and the post was denied him; he fell into a depression and committed suicide.

MOÏSE KISLING
(Kraków, 1891–Sanary-sur-Mer, 1953)

Kisling studied at the Kraków School of Fine Arts, where he was a student of Joseph Pankiewicz; in 1910 he went to Paris, where he made friends with Modigliani, Braque, Soutine, Max Jacob, and André Salmon. In 1912 Juan Gris gave him his atelier in the Bateau Lavoir; that same year he spent the summer at Céret with Picasso and Gris and exhibited for the first time at the Salon d'Automne in Paris. In 1913 he presented three

paintings at the Salon des Indépendants. On August 21, 1917, he married Renée Gros; in 1919 he had his first one-man show, at the Druet gallery in Paris. In 1924 he became a French citizen, but during World War II he went to the United States. He lived in California and exhibited with success in New York, and Washington, D.C.

PAUL KLEE
(Münchenbuchsee, 1879–Muralto, 1940)

Klee finished his studies at Bern and Munich, a student of Franz von Stuck. He traveled in Italy and France and in 1910 had his first one-man show at the Kunstmuseum in Bern. In 1911 he joined the Blaue Reiter and took part in that group's second show, in 1912. In 1913 he was among the founders of the Neue Secession of Munich. In 1919 he was discharged from the army and signed a three-year contract with the art dealer Hans Goltz, making it possible for him to dedicate himself to painting full time. In 1920 he accepted the invitation of Gropius to teach at the Bauhaus, where he directed the workshop of binding and glass painting. In 1927 he also began teaching a course in painting. In 1924, together with Kandinsky, Feininger, and Jawlensky he founded the Blue Four. In 1931 he was given the chair in painting at the Düsseldorf Academy, but two years later, with the advent of the Nazis, he was dismissed from the post. Put on the list of "degenerate" artists, he took refuge in Switzerland, remaining there the rest of his life.

GUSTAV KLIMT
(Baumgarten, 1862–Vienna, 1918)

In 1876 Klimt enrolled in the Vienna School of Applied Arts; in 1879 he was a student of Hans Makart. With his brother Ernst and painter friend Franz Matsch he founded the

Künstlerkompanie in 1883, which received important public and private commissions, including the decoration of the Burgtheater, Kunsthistorisches Museum, and the palace of the industrialist Nikolaus Dumba. In 1897 he was among the founders of the Vienna Secession and was nominated its president. In 1903 he traveled to Italy and visited Venice and Ravenna, where he was impressed by the Byzantine mosaics. In 1905, he and another eighteen artists left the Secession to found a group called Kunstschau or "Klimt group," which exhibited in 1908 and 1909. Between 1905 and 1911 he worked on the decorations in the Palais Stoclet in Brussels. Between 1912 and 1917 he made portraits, landscapes, and allegorical compositions.

IVAN KLYUN
(Bolshiye Gorky, 1870/73–Moscow, 1942/43)

Klyun worked as a librarian and studied design; he took courses in painting at Warsaw, Kiev, and Moscow. Influenced by Malevich, he began exhibiting in 1910 and took part in the shows of various groups, including the Union of Youth (1913–14), 0.10 (with Cubist and abstract sculpture), Tramway V (1915), and World of Art (1917), which reflects his adhesion to Suprematism. During the last years of his life he returned to realistic painting, following the directives of Communist officialdom.

OSKAR KOKOSCHKA
(Pöchlarn, 1883–Montreux, 1980)

Kokoschka studied at the Vienna School of Decorative Arts, where he was influenced by the Secession, Klimt, and Schiele. He worked as an illustrator, wrote theatrical works, and in 1908 exhibited in the Kunstschau show. He later met the Fauve painters and members of Die Brücke; he

contributed to the avant-garde magazine *Der Sturm* and the shows of the Blaue Reiter, maturing his Expressionist style. After World War I he taught at the Dresden Academy until 1924. Persecuted by the Nazis he moved to Prague in 1934, then to London, and finally to Switzerland, where he made his last works, animated by a tragic and bitter sensibility.

FRIEDRICH KÖNIG
(Vienna, 1857–1941)

König studied at the Kunstgewerbeschule and the Vienna Academy, then moved to Munich. He began his career as a book illustrator, making woodcuts. He contributed to the magazine *Ver Sacrum* and was among the founders of the Vienna Secession in 1897. He made paintings, engravings, and decorative arts. In 1904 he began participating in the leading international shows, including the International Exhibition of Fine Arts in Rome in 1911.

FRANTISEK KUPKA
(Opocno, 1871–Puteaux, 1957)

From 1889 to 1892 Kupka studied at the Prague Academy, dedicating himself to historical and patriotic themes. In 1892 he enrolled at the Vienna Academy, beginning to depict allegorical and symbolic subjects. In 1894 he exhibited at the Kunstverein in Vienna; in 1896 he went to Paris, where he attended the Académie Julian and the Ecole des Beaux-Arts; he worked as a book illustrator, poster artist, and cartoonist for magazines; in 1906 he moved to Puteaux, on the edge of Paris, and exhibited at the Salon d'Automne. Impressed by the Futurists he moved to abstractionism between 1910 and 1911, exploring the relationships between music and painting, colors and movement. In 1921 he held a one-man show at the Povolosky gallery in

Paris. In 1931 he was among the founders of the Abstraction-Création movement. In 1936 he took part in the "Cubist and Abstract Art" show at the Museum of Modern Art in New York.

RENÉ-JULES LALIQUE
(Ay, 1860–Paris, 1945)

Lalique studied design with Justin-Marie Lequien; in 1876 he began working as an apprentice for the jeweler Louis Aucoc and took classes at the Ecole des Arts Décoratifs in Paris. Between 1878 and 1880 he studied in London; on his return to France he dedicated himself to jewelry design. In 1884 he created Lalique & Varenne; two years later he married Marie-Louise Lambert. In 1892 he began to include glass in his creations. In 1894 he began designing jewelry for Sarah Bernhardt and for S. Bing's Maison de l'Art Nouveau. In 1900 he took part in the Universal Exhibition in Paris, where he awakened a great interest. On July 8, 1902, he married Augustine-Alice Ledru. In 1909 he developed his glass production, with new avant-garde techniques. In the 1920s and 1930s he reached the height of his international success.

WILFREDO LAM
(Sagua la Grande, Cuba, 1902–Paris, 1982)

Son of a mulatto mother and Chinese father, Lam was drawn to art when still a child. He attended the Havana School of Fine Arts and exhibited at the Salon of the Association of Painters and Sculptors. In 1923 he moved to Spain, to Madrid and then Barcelona; during the civil war he fought with the Republicans, but in 1938 he was forced to go to Paris, where he met Picasso. The next year he met Breton and joined the Surrealist movement. He returned to Cuba in 1941, remaining there until 1952, when he settled in Paris. In his

paintings the myths of ancient civilizations appear in fantastical and Surreal interpretations.

FRITZ LANG
(Vienna, 1890–Beverly Hills, 1976)

Lang studied architecture at the Technische Hochschule in Vienna, then from 1913 to 1914 he studied painting in Munich and Paris. He served in the Austrian army in World War I and was discharged after being wounded four times. During his convalescence he became interested in the performing arts. He soon became a screenwriter and bit player and then director, first for UFA and then with his own company. In 1920 he met the writer and actress Thea von Harbou; they married in 1922, and with her he wrote his best-known films: *Dr. Mabuse* (1922), *Die Nibelungen* (1924), *Metropolis* (1927), and *M* (1931). When the Nazis took power Lang moved to France and then the United States, where he signed a contract with MGM and made a new series of successful films, including *Fury* (1936), *You Only Live Once* (1937), *Scarlet Street* (1945), and *The Big Heat* (1953).

MIKHAIL LARIONOV
(Tyraspol, 1881–Fontenay-aux-Roses, 1964)

Larionov studied at the Moscow College of Painting, Sculpture, and Architecture, where he met Natalia Goncharova (whom he married in 1955); with her he founded the Jack of Diamonds group in 1909 and published the "Manifesto of Rayists and Futurists" in 1913. In 1914 he met Marinetti, then visiting Moscow, and became interested in Futurism. After World War I he moved to France, where he worked in stage design and continued his experiments in painting, which slowed only after 1946, following the partial paralysis of his right shoulder.

MARIE LAURENCIN
(Paris, 1885–1956)

While studying at the Académie Humbert in Paris, Laurencin met Georges Braque. She exhibited for the first time, at the Salon des Indépendants, in 1907, the year she met Picasso and the others artists who visited his studio in the Bateau Lavoir in Montparnasse. In 1912 she had her first personal show, with Robert Delaunay, in the Galerie Barbazanges in Paris and took part in the decorations of the Maison Cubiste at the Salon d'Automne. She married Otto von Wätjen in 1914 and was divorced from him in 1921. After World War I she enjoyed increasing success with her female portraits; she also designed costumes and stage scenery, first for Diaghilev's Ballets Russes and then for the Comédie Française and, after World War II, for the Compagnie des Champs Elisées.

LE CORBUSIER
(Charles-Edouard Jeanneret)
(La Chaux-de-Fonds, 1887–Cap Martin, 1965)

Le Corbusier studied engraving at the School of Applied Arts in his native city, and traveled in Europe between 1904 and 1914. He worked in the studio of Peter Behrens and met Walter Gropius and Mies van der Rohe. In 1917 he settled in Paris and two years later founded the magazine *L'Esprit Nouveau*, of which 28 issues were printed, running to 1925. In 1922 he opened a studio with his cousin Pierre Jeanneret and Charlotte Perriand. In 1930 he married Yvonne Gallis. In 1942 he began his studies on the Modulor, a composite of harmonic dimensions based on the human scale and universally applicable in architecture and mechanics. Over the following decades he worked in architecture and city planning. In 1955 the Chapel of Notre-Dame-du-Haut at Ronchamp, which he designed, was inaugurated.

FERNAND LÉGER
(Argentan, 1881–Gif-sur-Yvette, 1955)

Léger studied in Paris at the School of Decorative Arts, the School of Fine Arts, and the Académie Julian. His work was first inspired by Cézanne, then the Fauves. By way of gallery owner Daniel-Henry Kahnweiler he met Braque and Picasso, who drew him toward Cubism, which he interpreted in an original and personal way. He took part in the 1913 Armory Show in New York. After World War I he dedicated his work to the world of work and industry and inserted mechanical forms in his paintings. He met Le Corbusier, Theo van Doesburg, and Mondrian. In 1925 he had his first one-man show in the United States, at the Anderson Gallery in New York. During his last years he returned to the human form in the famous series of *Constructors* and in *Circus*. In 1952 he married Nadia Khodossievitch.

TAMARA DE LEMPICKA
(Tamara Gorska)
(Warsaw, 1898–Cuernavaca, 1980)

Lempicka discovered her passion for art during a trip to Italy with her maternal grandmother in 1911. In 1914 she abandoned her studies and moved to St. Petersburg to her aunt Stefa Janseen; there she met the young lawyer Tadeusz Lempicki, whom she married in 1916. They moved to Paris, and in 1920 she gave birth to a daughter, Kizette. She attended the Académie de la Grande Chaumière and took lessons from Maurice Denis and André Lhote. In 1922 she took part in the Salon d'Automne. In 1925 she went to Italy, exhibited her works in Milan, and met Gabriele D'Annunzio. In 1928 she divorced and became involved with Baron Raoul Kuffner, whom she married in 1933; in 1939 she moved to the United States, where she continued to exhibit with varying success.

CARLO LEVI
(Turin, 1902–Rome, 1975)

Levi got a degree in medicine in Turin and from 1924 to 1928 worked as an assistant in a clinic at the University of Turin. He began painting under the guidance of Felice Casorati and exhibited in 1929 in the "Six Painters of Turin" show. During the 1920s he was part of Piero Gobetti's Rivoluzione Liberale group; he later joined the clandestine anti-Fascist group Justice and Liberty. Arrested in 1934, he was sentenced to two years of exile in the province of Matera; in 1939 he went to France and published his most famous novel, *Christ Stopped at Eboli*, in 1945. His other books include *Of Fear and Freedom* (1946), *The Watch* (1950), *Words Are Stones* (1955), and *The Future Has an Ancient Heart* (1956). In 1963 and 1968 he was elected to the Italian Senate.

WILHELM LIST
(Vienna, 1864–1918)

After studies with Christian Griepenkerl at the Vienna Academy from 1885 to 1889, List continued his education at the Munich Academy. He then attended the studio of Bouguereau in Paris. Together with Klimt he was one of the founders of the Vienna Secession, of which he was a member from 1899 to 1905; he then joined Klimt's Kunstschau group, exhibiting with the group in 1908 and 1909. He painted landscapes, portraits, still lifes, and mythological scenes of a Symbolist inspiration; he illustrated several texts by Rilke and contributed to the magazine *Ver Sacrum*.

RAYMOND LOEWY
(Paris, 1893–Munich, 1986)

Loewy got a degree in engineering in 1918 and moved to the United States the next year. He worked as a window dresser and fashion illustrator for *Vogue, Harper's Bazaar,* and *Vanity Fair*. In 1929 he opened an industrial design studio; in 1934 he designed the Cold Spot refrigerator for Sears Roebuck. In 1937 he related his experiences with the Pennsylvania Railroad Company in the book *The New Vision Locomotive*. From 1938 to 1963 he worked for Studebaker. In 1949 he founded the Raymond Loewy Corporation.

ADOLF LOOS
(Brno, Moravia, 1870–Kalksburg, 1933)

After studying at the Dresden Polytechnic Loos went to the United States in 1893; on his return to Vienna he began his professional career as an interior designer and architect, taking a stance openly against his colleagues in the Vienna Secession. He founded the magazine *Das Andere*; in 1906 he opened a school of architecture and published various texts, including *Spoken into a Void, Ornament and Crime* (1908) and *Architektur* (1910). The most important of his works as architect include the office building on the Michaelerplatz (1910), the Corner House (1921), the Moller House (1927), and the revolutionary Tristan Tzara House (1926).

GEORGE LUKS
(Williamsport, Pennsylvania, 1867–New York, 1933)

Luks studied at the Pennsylvania Academy of Fine Arts and in 1885 took a trip to Europe, where he studied in the academies of Düsseldorf, Munich, Paris, and London. After nearly ten years he returned to the United States and began working as a magazine illustrator while painting. Between 1896 and 1897 he worked for the *New York World*, and in 1898, during the Spanish-American War, the *Evening Bulletin* sent him to Cuba as a correspondent. In 1908 he took part in the show of the Eight at the Macbeth Gallery in New York and exhibited in the 1913 Armory Show. He taught at the Art Students League in New York and opened his own art school.

AUGUST MACKE
(Meschede, 1887–Perthes, 1914)

Macke studied at the Düsseldorf Academy from 1904 to 1906; between 1907 and 1909 he visited Paris three times and came in contact with the avant-garde painting movements. In Berlin he took lessons from Lovis Corinth, considered one of the precursors of Expressionism. In 1910 he made friends with Franz Marc and went to Paris with him in 1912. He was among the leaders of the Blaue Reiter and participated in the group's shows and in other group exhibits in Germany, attracting the attention of critics and collectors. In 1914 he visited Tunisia with Klee; in that year, with the outbreak of Word War I, he was conscripted and sent to the front, where he died at age twenty-seven.

CHARLES RENNIE MACKINTOSH
(Glasgow, 1868–London, 1928)

The first of eleven children of a policeman, Mackintosh studied design and painting at the Glasgow School of Art and worked in the architecture studio of John Hutchinson. After a trip to Italy in 1891 he designed furniture and housewares for a group called The Four, composed of Margaret MacDonald, whom he married in 1900; his sister-in-law Frances MacDonald; and her husband, Herbert McNair. In 1896 they gave their first exhibit with the London Arts and Crafts Exhibition Society and won the contest for the design of the new Glasgow School of Art; in 1900 they exhibited with success in Vienna, and did the same two years later in Turin, then in Dresden, Moscow, and Berlin. They designed both the building and furnishings for the four tea rooms of

the Willow Tea Rooms of Miss Cranston in Glasgow.

MARIO MAFAI
(Rome, 1902–1965)

Mafai studied at the Scuola di Nudo in Rome's Academy and met Antonietta Raphaël and Scipione, with whom he formed the "Roman school." In the fall of 1930 he exhibited with Scipione in the Rome gallery of Pier Maria Bardi; the next year he took part in the first Rome Quadriennale; he took part in several Venice Biennales and in 1937 was the subject of an important one-man show at Laetitia Pecci Blunt's Cometa gallery. He made the series of *Demolitions*, works with violent colors depicting the urbanistic destruction wrought in Rome by Fascist city planners. Because of the racial laws his companion, Raphaël, of Jewish origin, had to move to Genoa. In 1940 he exhibited in Milan for the first time, at the Barbaroux gallery, and presented the painting *Models in the Studio* for the Bergamo Prize, winning the first prize of 25,000 lira. After World War II he continued his activity, expanding on the themes of his earlier works.

ALBERTO MAGNELLI
(Florence, 1888–Meudon, 1971)

Magnelli began painting in 1907 and in 1911 became involved in Florentine Futurism. In 1914 he went to Paris together with the Futurist poet Aldo Palazzeschi. During the winter between 1914 and 1915 he converted to abstract art. In 1918 he made the series *Lyrical Explosions*. Between 1919 and 1922 he traveled in France, Germany, Switzerland, and Austria. In 1925 he visited Paris, where he associated with Picasso, and in 1931 he moved to Paris. In 1933 he met Kandinsky, who had moved to Paris following the closing of the Bauhaus, and Susi Gerson, who became his wife. In 1934 he exhibited in the Pierre Loeb gallery and made the definite passage to abstraction. In 1950 he was given a personal room at the Venice Biennale. In 1955 he won the first prize for foreign painting at the São Paulo Biennale in Brazil. He moved to Meudon, near Paris, in 1959.

RENÉ MAGRITTE
(Lessines, 1898–Schaerbeek, 1967)

In 1912 Magritte's mother, Adeline, committed suicide, throwing herself in the Sambre River; with his father and two brothers he moved to Charleroi. In 1916 he enrolled in the Fine Arts Academy of Brussels. In 1922 he married Georgette Berger. He began his career designing advertisements and wallpaper. In 1923 he was struck by the works of de Chirico and began to associate with the Belgian Surrealists. In 1927 he had his first one-man show, at the Le Centaure gallery in Brussels. In 1929 he and his wife went to Cadaqués together with Paul and Gala Eluard; in 1940 they moved to Carcassonne in southern France. Over the coming years Magritte made several trips, including to Ischia and Rome in 1965, and exhibited his works in major international galleries, both public and private.

KAZIMIR MALEVICH
(Kiev, 1878–Leningrad, 1935)

In 1895 Malevich studied at the Kiev Art School; in 1904 he moved to Moscow, where he studied at the private Rerberg academy and came in contact with representatives of pictorial avant-gardes, with whom he exhibited his first works, in a Post-Impressionist style. In 1912 he moved toward Cubism and Futurism, which he synthesized and moved beyond, creating his own style, which he called Suprematism. In 1924 he exhibited at the Salon des Indépendants in Paris. During the Russian Revolution he carried on intense public, political, and artistic activity. Following Stalin's condemnation of abstract art, he was accused of failing to adhere to Socialist Realism; he was isolated and in 1930 was imprisoned for two months.

HENRI MANGUIN
(Paris, 1874–Saint-Tropez, 1949)

In 1896 Manguin attended the atelier of Gustave Moreau, where he made friends with Henri Matisse, Albert Marquet, and Charles Camoin. In 1902 he exhibited for the first time at the Salon des Indépendants and in 1905 he took part with the members of the Fauvist group at the Salon d'Automne; in 1908 he worked at the Académie Ranson together with Marquet, with whom he took a trip to Naples in 1909. During those same years he discovered Provence and Saint-Tropez, where he met Signac and developed his experiments on color and light.

MAN RAY (Emmanuel Radnitzky)
(Philadelphia, 1890–Paris, 1976)

In 1906 Man Ray abandoned architecture studies to turn to painting. He held various jobs (newspaper vendor, engraver, layout artist, designer) and took evening courses in design. In 1907 he met the photographer Alfred Stieglitz, who taught him the secrets of photography. In 1914 he married Donna Loupov and painted Cubist-inspired paintings. In 1915 he met Marcel Duchamp and Picabia; in that same year he began using a camera in his work. In 1921 he moved to Paris, becoming one of the outstanding exponents of Dadaism, beginning his rayographs, and working in photography at a professional level. After 1924 he approached Surrealism and increased his activity as a photographer, with fashion photos and experimental avant-garde creations, to which he added activity in film. Between 1940 and 1945 he lived in the United States, where he married Juliet Browner in 1946.

FRANZ MARC
(Munich, 1880–Verdun, 1916)

Marc learned to paint from his father, Wilhelm, creator of religious works. Having decided to follow a religious calling he studied theology, but then in 1899 he enrolled in the faculty of philosophy at the University of Munich. In 1900 he left off philosophical studies and entered the Munich Art Academy. In 1903 and again in 1907 he went to Paris, where he saw the works of van Gogh, Gauguin, and the Fauves. In 1907 he married Maria Schnürr, but they divorced the next year. In 1910 he signed his first contract with the art dealer Bernhard Koehler; he left Munich and moved to the nearby town of Sindelsdorf. He met Macke, Jawlensky, Kandinsky, and Münter, with whom he adhered at first to the Neue Künstlervereinigung of Munich and then gave life to the Blaue Reiter. He returned to Paris in 1912, and the next year married Maria Franck; Robert Delaunay moved his style toward Cubism. In August 1914 he volunteered and was killed at Verdun by the explosion of a grenade.

FILIPPO TOMMASO MARINETTI
(Alexandria, 1876–Bellagio, 1944)

In 1902 Marinetti published his first book of poetry, *La Conquete des Étoiles*; in 1905 he founded the magazine *Poesia*. On February 20, 1909, he published in *Le Figaro*, the "Founding and Manifesto of Futurism," followed, in 1912, by the "Technical Manifesto of Futurist Literature." In 1914 he went to Russia for a series of meetings, during which he came in contact with the members of the avant-garde. In the same year the published the novel *Zang Tumb*

Tumb. He organized and led marches in favor of Italy's intervention in World War I and was decorated with two medals for valor. In 1923 he married Benedetta Cappa, with whom he had three daughters. In 1919 he joined the Fascist party and became a leading cultural figure of Fascist Italy, the regime's poet, faithful to Mussolini; in 1936 he went to eastern Africa as a volunteer and in 1942 took part in the campaign in Russia.

NAPOLEONE MARTINUZZI
(Murano, 1892–Venice, 1977)

Born into a family of glassmakers, Martinuzzi attended the workshops of ceramists, gold workers, and sculptors. He studied at the Fine Arts Academy in Venice and then in Rome. In 1925 he became artistic director of the Venini glassworks, for which he designed new works that were innovative in terms of their shape and materials (as in the "pulegoso" glass). In 1932, with the engineer Francesco Zecchin, he founded Zecchin-Martinuzzi Vetri Artistici e Mosaici, specializing in glass sculptures. In 1934 the company closed and Martinuzzi continued his activity as a sculptor and designer for other glassmaking companies, including Seguso and Cenedese. He regularly exhibited at the Milan Triennale, the Venice Biennale, and the Rome Quadriennale.

HENRI MATISSE
(Cateau-Cambresis, 1869–Nice, 1954)

Matisse studied law in Paris and worked in a law office, abandoning it to dedicate himself to painting. He attended the Académie Carrière, the Ecole des Beaux-Arts, the atelier of Gustave Moreau, and courses at the Ecole des Arts Décoratifs. In his first works he drew inspiration from the Impressionists and experimented with the style of the Pointillists; after studying the works of van Gogh and Gauguin he created the style that came to be called Fauve following the group's first exhibit at the Salon d'Automne in 1905. After approaching Cubist geometries, he made the series of Odalisques in which he returned to a figural classicism. He also worked in sculpture and book illustrations for Skira and completed his experiments with the *papiers découpés*, splendid collages that he made in his last years. Between 1948 and 1951 he volunteered to decorate the chapel of the rosary for the Dominican nuns of Vence, considered his spiritual testament.

EDGAR MAXENCE
(Nantes, 1871–La Bernerie-en-Retz, 1954)

Student of Gustave Moreau and Jules-Elie Delaunay, Maxence exhibited regularly at Paris's Salon des Artistes Français. In 1900 he won a gold medal at the Universal Exhibition in Paris and was awarded the Legion of Honor. He painted portraits, landscapes, still lifes, allegorical figures, and mythological scenes similar in style to the work of the Symbolists. Between 1895 and 1897 he exhibited at the Salon de la Rose + Croix.

GEORGES MÉLIÉS
(Paris, 1861–1938)

Son of a wealthy footwear manufacturer, Méliés studied painting with Gustave Moreau. He moved to London, where he worked in the Egyptian Hall theater; on his return to France he worked as a conjurer and illusionist in the Robert Houdin theater and studied photography. In 1895 he was enthralled by the motion-pictures projected by the Lumière brothers; he bought the necessary equipment, set up a studio in an attic at Montreuil, and began making films. Between 1896 and 1914 he made 531 films of lengths ranging from one to forty minutes; he is considered the father of special effects (from multiple exposures to dissolves) and was one of the first to experiment in the use of colors, directly handpainting the film. In 1913 his company, Star Film, went bankrupt and for several years he returned to working as a magician; in 1931 he was awarded the Legion of Honor.

ERICH MENDELSOHN
(Allenstein, now Olsztyn, Poland, 1887–San Francisco, 1953)

Mendelsohn studied architecture in Berlin and Munich, where he associated with the artists of the Blaue Reiter. In 1920 he published a series of drawings in the magazine *Wendingen* and made the Einstein Tower at Potsdam, a masterpiece of Expressionist architecture. From 1921 to 1923 he worked in Holland; in 1924 he went to the United States, where he met Frank Lloyd Wright. The next year he was invited to the Soviet Union. Beginning in 1925 he worked on important commissions in Nuremberg, Stuttgart, Chemnitz, and Berlin, winning international fame. With the advent of Nazism he had to leave Germany and worked in London and Palestine. In 1941 he moved to New York, and in 1945 to San Francisco, where he dedicated his last years to working on Jewish community centers.

JEAN METZINGER
(Nantes, 1883–Paris, 1956)

In 1903 Metzinger moved to Paris to study art; he met Robert Delaunay, Max Jacob, and Guillaume Apollinaire, who introduced him to Braque and Picasso. In 1910 he exhibited for the first time at the Salon des Indépendants and wrote several articles for the magazine *Pan*. In 1911 his works were presented in Hall XLI of the Salon des Indépendants, the official presentation of Cubist painting, of which he was among the most representative examples. In 1912 he and Gleizes wrote the essay *Du Cubisme*. He was among the founders of the Section d'Or group and exhibited at the Galerie de la Boëtie in Paris together with other Cubists. After World War I he settled in Paris and took part in numerous personal and group shows in France and elsewhere.

GIOVANNI MICHELUCCI
(Pistoia, 1891–Fiesole, 1990)

Michelucci received his degree in 1911 from the architecture college of Florence. In 1914 he became a professor of architectural design. During the 1920s he taught evening courses at the Institute of Art in Rome and the architecture college in Florence (becoming director of the architecture faculty in 1936). In 1948 he taught city-planning techniques at the engineering school of Bologna. Among his most important works is the Santa Maria Novella Train Station in Florence, the church of San Giovanni Battista on the Autostrada del Sole near Florence, and the headquarters of the Monte dei Paschi of Siena at Colle Val d'Elsa.

LUDWIG MIES VAN DER ROHE
(Aachen, 1886–Chicago, 1969)

Mies van der Rohe worked in his father's workshop as a stonecutter; from 1905 to 1907 he attended the studio of Bruno Paul in Berlin and from 1908 to 1911 that of Peter Behrens, where he met Le Corbusier and Gropius. From 1921 to 1924 he created four designs for glass-and-steel skyscrapers. In 1927 he coordinated the work on the Weissenhof Siedlung, an experimental quarter in Stuttgart. He was director of the Bauhaus from 1930 until the Nazis closed it in 1933. In 1937 he moved to the United

States and directed the faculty of architecture at the Illinois Institute of Technology in Chicago and applied his "less is more" principle to fundamental building types.

GIUSEPPE MIGNECO
(Messina, 1908–Milan, 1997)

Migneco spent his childhood at Ponteschiavo, where his father was station-master and his mother taught elementary school. After studies at Messina he moved to Milan to take courses in medicine, but turned instead to painting. He contributed illustrations to the *Corriere dei Piccoli* and made advertising art for a necktie manufacturer. During the 1930s he met Birolli, de Grada, Sassu, and the other artists with whom he gave life to the Corrente group. In 1940 he had his first one-man show, at the Genova gallery of Stefano Cairola; in 1942 he presented the painting *Lizard Hunters* at the Bergamo Prize. In the years following World War II he was a leader of the Neo-Realist movement, with works dedicated to the reality of Sicily characterized by intense colors similar to the style of van Gogh and the Expressionists.

JOAN MIRÒ
(Montroig, 1893–Palma de Mallorca, 1983)

Son of a ceramist, Mirò studied at the art school of Francisco Galí in Barcelona. He made his debut as a figurative painter, similar in style to the Fauves. In 1919 he visited Paris and saw the Cubism of Picasso; in 1924 he joined the Surrealist group led by Breton. During the 1930s in addition to paintings he made lithographs, collages, and three-dimensional works in wood, iron, and assembled objects. In 1940 he began the series of *Constellations*, with an approach to abstraction. After World War II his paintings showed the influence of the informal artists of the

United States. During his last decades he worked in monumental bronze sculpture, ceramics, illustrated books, and theatrical design.

AMEDEO MODIGLIANI
(Leghorn, 1884–Paris, 1920)

Modigliani was forced to end his classic studies in 1898 because of a serious lung condition. He began attending the studio of Guglielmo Micheli, a student of Giovanni Fattori. In September 1900 he again suffered a lung infection, and during his convalescence he went to Naples, Rome, Florence, and Venice, where he took courses at the academy. Early in 1906 he moved to Paris; the next year he joined the Société des Artistes Indépendants, exhibiting six paintings there in 1908. He met Constantin Brancusi, who got him involved in sculpture, and his first collector and patron, Paul Alexandre. In 1914 he became involved with Beatrice Hastings, the art dealer Léopold Zborowski, and Paul Guillaume. In 1917 he began his relationship with Jeanne Hébuterne, with whom he had a daughter, and who commited suicide following his death.

TINA MODOTTI
(Udine, 1896–Mexico City, 1942)

In 1913 Modotti moved to San Francisco, where she worked in a textile factory. In 1915 she married the painter and poet Roubaix de l'Abrie Richey (Robo). In 1921 she met the photographer Edward Weston, with whom she took a short trip to Mexico; in 1923 she moved to Mexico City and began activity as a photographer. She worked for various newspapers and was involved in intense political activity for the Communist party. In 1930 she was expelled from Mexico; she lived in Germany, then the Soviet Union, where she continued her political involvement. In 1936, with the

outbreak of the Spanish civil war, she volunteered for the Red Cross service in Spain; in 1939 she returned to Mexico together with Vittorio Vidali.

LÁSZLÓ MOHOLY-NAGY
(Bácsborsód, 1895–Chicago, 1946)

In 1913 Moholy-Nagy was studying law at the University of Budapest; wounded in World War I, he founded the MA artistic group during his convalescence as well as the literary magazine Jelenkor. In 1919 he got his law degree and moved to Vienna; in 1920 he went to Berlin, where he made photograms and collages in the Dada style. In 1921 he met El Lissitzky and joined Constructivism; in the same year he went to Paris. In 1922 Herwarth Walden organized the first one-man show of his work at the Der Sturm gallery in Berlin. In 1923 he began teaching at the Bauhaus, first at Weimar, then at Dessau; he worked in photography, theatrical scenery, and film. In 1934, because of Nazi persecution, he moved to Amsterdam and the next year to London, where he worked as a designer for various companies and contributed to films. In 1937 he was named director of the New Bauhaus in Chicago, which had a short life. He remained in the United States until his death; in 1941 he was part of the American Abstract Artists group, and in 1944 he became a U.S. citizen.

PIET MONDRIAN
(Amersfoort, 1872–New York, 1944)

Mondrian began painting landscapes in Holland, inspired by the Impressionists and the Fauves; in 1912 he moved to Paris, where he saw Cubism, which he made use of in his compositions. In 1917 he began to design the first rectangles in pure colors on a white background, a style he was to rework throughout his life. In 1918 he signed the De Stijl manifesto, was the founder and guide

of the "Neo-Plastic" group, and continued to write essays and theoretical articles. In 1940 he left Paris for New York, where he made various works, including *New York City* and *Broadway Boogie Woogie*.

GIORGIO MORANDI
(Bologna, 1890–1964)

Morandi studied at the Bologna Academy from 1907 to 1913. He came in contact with the Futurists and Metaphysical painting; he contributed to the magazine Valori Plastici and took part in the shows of the Novcecento group in 1926 and 1929, although in a background manner given his timid and reserved character. During the 1930s he began concentrating on still lifes, applying a methodical and rigorous attention allowing him to create a synthesis between Realism and Chardin and the formal simplifications of Cézanne. Aside from painting he was constantly involved in graphic art and from 1930 to 1956 held the chair in engraving at the Bologna Academy of Fine Arts.

GUSTAVE-ADOLPHE MOSSA
(Nice, 1883–1971)

Son of the painter Alexis Mossa, Mossa began his activity as a watercolorist. He later moved to painting with a style approaching that of Beardsley and Burne-Jones: he painted classic scenes, fantastic and symbolic visions. He exhibited in Nice, Paris, and Buenos Aires; in 1926 he replaced his father as conservator at the Musée Jules Chéret in Nice.

ALPHONSE MUCHA
(Ivancice, 1860–Prague, 1939)

In 1879 Mucha moved to Vienna, where he worked in the theatrical workshop of Kautsky-Brioschi-Burckardt; in 1882 he went to Mikulov, where he earned his living as a portraitist. In 1884, thanks to the

interest of Count Khuen Belassi, he entered the Munich Academy. In 1888 he moved to Paris and studied at the Académies Julian and Colarossi. He worked as an illustrator for several magazines and books, designed posters, and made numerous decorative panels. In 1900 he received a silver medal at the Universal Exhibition in Paris. He took numerous trip to the United States; on February 10, 1906 he married Maria Chytilova. In 1910 he was the guest of Count Jérôme Collorado-Mannsfeld in the Castle of Zbiroh, near Prague, where he made the canvases of the Slav Epic.

OTTO MUELLER
(Liebau, 1874–Breslau, 1930)

From 1890 to 1894 Mueller worked in lithography at Görlitz; he then studied at the Dresden and Munich academies; in Munich he attended the atelier of Franz von Stuck. From 1899 to 1908 he traveled in Italy, Switzerland, and Germany. He met Kirchner, Schmidt-Rottluff, and Heckel and in 1910 joined the Die Brücke group. He volunteered for service in World War I and was wounded in a lung in 1916. In 1919 he became a professor at the Breslau Academy, a post he occupied until his death. In 1937 the Nazis removed his works from German museums and displayed several in the show dedicated to "degenerate" art.

EDVARD MUNCH
(Løten, 1863–Ekely, 1944)

In 1880 Munch left scientific studies to dedicate himself to painting at the Royal School of Design in Oslo. He took many trips to France, Italy, and Germany that permitted him to enlarge his awareness and come in contact with many other artists, in particular the Impressionists. The tragic sense of life and death that he assimilated from Scandinavian

literature made him one of the leading interpreters of Expressionism, and his works had a notable influence on 20th-century art. His artistic production began to slow in 1908, the result of nervous disorders.

GABRIELE MÜNTER
(Berlin, 1877–Murnau, 1962)

Münter studied design at Düsseldorf; being female she could not attend the academy so she took courses in painting in Munich, at the Künstlerinnenvereins, and the Union of Woman Artists. She attended the Phalanx group, where she met Kandinsky, becoming his pupil and then his companion for many years. Together they took long trips in Europe and she completed her pictorial training in Murnau, in 1908. Between 1907 and 1909 she exhibited Paris, at the Salon des Indépendants and the Salon d'Automne. In 1909 she was among the founders of the Neue Künstlervereinigung group, and in 1911 she participated in the activities of the Blaue Reiter. In 1913 Herwarth Walden, owner of the Der Sturm gallery in Berlin, mounted the first one-person show of her work. In 1914 she began to distance herself from Kandinsky, separating with him finally in 1916. She took several trips to Scandinavian countries, Italy, and France. In 1931 she settled in Murnau together with the philosopher and historian Johannes Eichner; she continued to paint, developing and enlarging the themes of Expressionism.

EMIL NOLDE (Emil Hansen)
(Nolde, 1867–Seebüll, 1956)

Nolde worked as an apprentice and wood carver in Munich and Karlsruhe, where he took courses at the Kunstgewerbeschule. In 1891 he taught at the Kunstgewerbeschule of Saint Gall in Switzerland. In 1898 he moved to Munich, where he studied at

the private school of Friedrich Fehr. After a trip to Copenhagen, where he met and married Ada Vilstrup, in 1902 he returned to Berlin and changed his name from Hansen to Nolde, after his birthplace. In 1905 he had his first one-man show, in the gallery of Ernst Arnoldi in Dresden. In 1906 he joined the Brücke group, becoming one of its leading exponents. In 1912 he took part in the second show of the Blaue Reiter and the "Sonderbund" show in Cologne. In 1913 he took a long trip to New Guinea. In 1926 he moved to Seebüll. The Nazis included him among the "degenerate" artists and prevented him from exhibiting and painting. In 1946 his wife died, and in 1948 he married Jolanthe Erdmann.

GEORGIA O'KEEFFE
(Sun Prairie, Wisconsin, 1887–Santa Fe, 1986)

In the spring of 1916 O'Keeffe began making the first abstract charcoal drawings, which were noticed by Alfred Stieglitz, photographer, art dealer, and her future husband. He presented them in his 291 Gallery in New York, which made her known in the artistic environments in the United States. In addition to abstract paintings O'Keeffe began painting landscapes and still lifes, which earned her a solid international name. In 1929 she began spending time in New Mexico, moving there in 1949. Her works became enriched with new motifs related to the dry and wild landscape and the traditional elements of the local culture.

JOSEPH MARIA OLBRICH
(Troppau, Silesia, 1867–Düsseldorf, 1908)

From 1890 to 1893 Olbrich studied at the Vienna Academy; he traveled to Italy and Tunisia and entered the studio of Otto Wagner, working under him for five years. In 1897, together with Klimt, Hoffmann, and other

artists, he founded the Vienna Secession, for which he designed the Secession Building. Ernst Ludwig, grande duke of Hesse-Darmstadt, entrusted him with the design of the buildings for the Darmstadt artists' community. In 1907 he was among the leading exponents of the Deutscher Werkbund; in 1908 he worked in Düsseldorf on the construction of the Tietz department store.

JOSÉ CLEMENTE OROZCO
(Zapotlán el Grande, 1883–Mexico City, 1949)

Orozco studied at the Mexico City Academy and attended the studio of the engraver José Guadalupe Posada. In 1922 he made his first murals, collaborating with Rivera and Siqueiros on decorations in the Escuela Nacional Preparatoria. Over the five next years he decorated the walls of other public buildings in Mexico City and Oriziba. From 1927 to 1932 he worked in the United States, in California, New York, and New Hampshire. On his return to Mexico, in 1934, he continued his activity as a painter with vast fresco cycles dedicated to the history of his people.

MAX PECHSTEIN
(Eckersbach, 1881–Berlin, 1955)

In 1900 Pechstein studied at the Dresden School of Decorative Arts, a student of Otto Gussmann, then he studied at the Dresden Academy, winning the State of Saxony prize, comparable to the French Prix de Rome. He was one of the five founders of Die Brücke. In 1907 he took his first of three trips to Italy, where he was primarily interested in Etruscan art and the mosaics of Ravenna, and he spent nine months in Paris, where he came in contact with the Fauves. In 1908 he settled in Berlin and became associated with both the Secession and the Blaue Reiter; in 1910 he joined the New

Secession, serving as its president for a certain period. In 1914 he took a trip to Oceania, to the island of Palau in New Guinea. In 1917 he was among the promoters of the Novembergruppe and the Arbeitsrat für Kunst; the advent of the Nazis meant he had to quit his activity as a teacher and painter. Only after the war was he able to return to his chair at the Berlin Academy, which he held until his death.

CONSTANT PERMEKE
(Antwerp, 1886–Ostend, 1952)

Permeke studied at the Bruges Academy and the Ghent Academy; he settled his studio at Ostend and at Laethem-Saint-Martin, where he approached the style of the Impressionists. In 1914, after being severely wounded in the war, he was evacuated to England where he began to paint laborers and ordinary people. On his return to Ostend he made the series dedicated to fisherfolk and sailors. In 1929 he settled at Jabbeke, near Bruges. Beginning in 1935 he also worked in sculpture, mainly female nudes and monumental figures. In 1951 he was given a large retrospective show in Antwerp.

EMILIO PETTORUTI
(La Plata, 1892–Paris, 1971)

Pettoruti studied at the La Plata Academy; in 1913 he went to Italy, where he met Marinetti, who introduced him to Futurist aesthetics. In 1916 he had his first one-man show, at the Gonelli gallery in Florence; in 1916 he was in Rome, where he made friends with Soffici, Carrà, de Chirico, and other artists. In 1921 he was in Munich and two years later exhibited in the Der Sturm gallery in Berlin. During a short tip to Paris he met Gris and Severini. On his return to Argentina he continued his artistic experimentation, and in October 1924 exhibited at the Salón

Witcomb in Buenos Aires. He later participated in shows and sought to make avant-garde art better known in his homeland.

MARCELLO PIACENTINI
(Rome, 1881–1960)

Architect and city planner, Piacentini won the contest for the reworking of the center of Bergamo, which was applied in 1927. In 1910 he designed the Italian pavilion for the World Exhibition in Brussels and in 1915–17 the Corso Cinema in Rome. He was the greatest exponent of the monumental triumphalism that was so pleasing to Italy's Fascist leaders. As general commissioner of architecture, he oversaw the arrangement of the E 42 Exhibition in Rome from 1938 to 1942. In 1941 he began the demolition of the neighborhoods around St. Peter's in Rome to make way for the Via della Conciliazione.

FRANCIS PICABIA
(Paris, 1879–1953)

From 1895 to 1897 Picabia attended the Ecole des Arts Décoratifs in Paris; he was then the student of Albert Charles Wallet, Ferdinand Humbert, and Fernand Cormon. In 1903 he debuted with works inspired by Impressionism at the Salon des Indépendants and at the Salon d'Automne. In 1905 he had his first one-man show, at the Haussmann gallery; in 1908 he discovered Fauvist painting; in 1912 he worked out a personal synthesis between Fauvism and Cubism and over the following years he approached abstract art. He was friends with both Apollinaire and Duchamp. He participated in the 1913 Armory Show in New York, and Alfred Stieglitz gave him a one-man show in his 291 Gallery. He then became one of the leaders of the Dada and Surrealist groups. While living in Barcelona in 1916–17 he published the first volume of his

poetry and the magazine 391, an imitation of Stieglitz's 291. During the 1930s he associated with Gertrude Stein; after World War II he continued his activities as writer, polemicist, and painter, with works approaching abstractionism.

PABLO PICASSO
(Malaga, 1881–Mougins, 1973)

Picasso began his artistic training under the guidance of his father, a design teacher; he studied at the La Guarda School of La Coruña, at the La Lonja Escuela de Bellas Artes in Barcelona, and at the Academia Real de San Fernando in Madrid. In Barcelona he attended the artistic settings of Modernismo, in particular the café Els Quatre Gats. Between 1900 and 1902 he made three trips to Paris and painted the works of his so-called blue period. In April 1904 he moved to Paris, living in the famous Bateau Lavoir on Montmartre, where he lived until October 1909. During those years he began his rose period, between 1905 and 1906; he discovered African art, and together with Georges Braque created Cubism, based on a radical fragmentation of forms. In 1917 he traveled to Italy along with Diaghilev's Ballets Russes; he studied classical art and learned the style of the classics and faithfulness to reality. The Spanish civil war brought him to a social and political awareness that found its greatest expression in *Guernica*. After World War II he was tireless in his experimentation in various directions and his work was unanimously considered the symbol itself of 20th-century art.

GIO PONTI
(Milan, 1891–1979)

In 1921 Ponti got a degree in architecture from the Milan Polytechnic; from 1923 to 1938 he was artistic director of Richard Ginori. In 1922 he opened a studio

with the architects Fiocchi and Lancia and later Fornaroli and Soncini. In 1927 he was part of the artistic council of the Monza Biennale and founded the Labirinto group. During the 1930s he made designs for Fontana Arte. In 1928 he founded the magazine *Domus*; in 1941 he created the periodical *Stile*. He was active as architect, designer of furniture, ceramics, and fabrics, scenery designer, and painter. He developed his activity in more directions, from ship furnishings to the Pirelli Tower in Milan; he worked to support the Association for Industrial Design and was among the organizers of the Compasso d'Oro contest promoted by La Rinascente.

LYUBOV' POPOVA
(Moscow, 1889–1924)

Popova studied under Stanislav Zhukovsky in 1907 and with Konstantin Yuon and Ivan Dudin in 1908. In 1912 she met Tatlin; in the same year she visited Paris, where she studied with Henri Le Fauconnier, Jean Metzinger, and André Dunoyer de Segonzac. She went to France again in 1913, and also Italy, where she came in contact with Futurism. Between 1913 and 1915 she approached also Cubism and exhibited in the leading shows of the Russian avant-garde. In 1916 she joined the Suprematist group; she taught at the Svomas and Vkhutemas schools. Over the next decade she worked in painting, porcelain, and literature; she designed fabrics, clothes, costumes, and theatrical stage sets.

ENRICO PRAMPOLINI
(Modena, 1894–Rome, 1956)

Prampolini enrolled in Rome's Fine Arts Academy in 1912, but left to study with Balla and the other Futurists. In 1912 he exhibited his first Futurist works in a group show at the

Frattini gallery in Rome; in 1914 he took part in the first international Futurist show, at the Sprovieri gallery in Rome. In 1915 he published the text *Pittura pura; contributo per l'arte astratta*. In 1916 he worked on the stage settings for the film Thais by Anton Giulio Bragaglia; he met Tristan Tzara and took part in the Dada show in Zurich. In 1920 he worked as scene designer for the Teatro del Colore of Achille Ricciardi. In the 1920s he took part in the Futurist exhibitions in various European cities. In 1925 he moved to Paris and joined the Futurist aeropainters. In 1939 he presented several panels at the Universal Exhibition in San Francisco and in New York. After World War II he increased his experiments and enriched his works toward abstract and Cubist elements.

MARIO RADICE
(Como, 1900–1987)

Between 1912 and 1918 Radice took art lessons from Achille Zambelli and Pietro Clerici. After World War I he abandoned veterinary studies to devote himself full time to painting. He met Manlio Rho and Giuseppe Terragni; in 1927 he exhibited in Como on the occasion of the show commemorating the centennial of the death of Alessandro Volta. He met Léger in Paris, contributed to the magazine *Quadrante*, and associated with other artists who exhibited in the Galleria del Milione in Milan. Between 1933 and 1936 he made the decorations for the Casa del Popolo by Terragni in Como; eight large frescoes and two walls with polychrome bas-reliefs, also painted in fresco. During the later 1930s he worked on projects with the architect Cesare Cattaneo and exhibited at the Rome Quadriennale, the Venice Biennale, and in various group shows of abstract artists. In 1946 he was involved in the foundation of M.A.C. ("Movimento Arte Concreta").

ALFREDO RAVASCO
(Genoa, 1873–Ghiffa, 1958)

Ravasco did his apprenticeship with his father, Giacomo Ravasco, a Genoese goldsmith who went into business in Milan in 1873 with his own workshop. Ravasco took courses at the Artisan School of the Brera Academy and began working in the goldsmith shop of Eugenio Belloso. He made his debut at the International Exhibition in Milan in 1906; he associated with the intellectuals and artists active in Milan, including Gio Ponti, who directed him toward new artistic expressions that he presented at the first Decorative Arts Show in Milan in 1919 and at other international exhibitions. Ravasco was also active as a teacher (beginning in 1903 at the Humanitarian in Milan and from 1928 at ISIA in Monza); in 1925 he directed the Scuola del Corallo in Torre di Greco. In 1942 his Milan workshop was destroyed by Allied bombing. At the end of his life he donated all his possessions and creations to the Orphanage for Girls of the Stella di Milan.

FREDERIC REMINGTON
(Canton, New York, 1861–Ridgefield, Connecticut, 1909)

After studies at Yale University he began working as a illustrator for *Harper's Weekly*, *Century Illustrated Magazine*, and *Collier's*. In 1884 he married Eva Caten and studied at the Art Students League in New York. In 1898, during the Spanish-American War, he went to Cuba as a war correspondent. He made illustrations, sculptures, and paintings of life in the American West, with cowboys, Indians, pioneers, and cavalrymen. His works became widespread and popular classics, contributing to the myth of the West.

JEAN RENOIR
(Paris, 1894–Beverly Hills, 1979)

Second son of the Impressionist Auguste Renoir, in 1920 Jean Renoir married Andrée Heuchling, one of his father's models (and later a films actress under the name Catherine Hessling). Renoir began working as a ceramist but was drawn to the cinema and in 1924 directed his first film, *La Fille de l'Eau*, starring his wife and his older brother, Pierre. In 1931 he made *La Chienne*, one of the first great sound movies, with Michel Simon. Renoir's films over the next years used a realistic style with a social consciousness and political stance close to the ideas of the Popular Front. These included *Grand Illusion* (1937), *The Human Beast* (1938), and *The Rules of the Game* (1939). Renoir moved to the United States in 1940 and made several successful films. When he returned to Europe in the 1950s he made more films and was active in television, the theater, and literature. In 1970 he moved back to California.

GERRIT RIETVELD
(Utrecht, 1888–1964)

Rietveld began his training in his father's woodworking shop; in 1906 he attended classes in archcitectural design given by P. J.C. Klaarhamer. In 1918 he joined the De Stijl group. In 1920 he furnished the Hartog office at Maarssen and the G.Z.C. jewelry shop in Amsterdam; in 1924 he worked in the Schröder House at Utrecht. During the 1930s he was influenced by Rationalism, as is clear in the row houses he designed for the Werkbund exhibition in Vienna (1930–32). Over the next twenty years he was involved in abstract themes with the extreme simplification of planes, as in the Dutch pavilion at the Venice Biennale (1954), the furnishings of the UNESCO building in Paris (1958), and the Zonnehorf Museum in Amsterdam (1959).

DIEGO RIVERA
(Guanajuato, 1886–Mexico City, 1957)

From 1896 to 1905 Rivera attended the San Carlos Academy in Mexico City; thanks to a grant he was able to go to Europe for the first time from 1907 to 1909; he stayed in Spain and Paris, where he studied classical art in museums and saw avant-garde art. In 1911 he took a second trip to Paris, where he made friends with Léger, Robert and Sonia Delaunay, Modigliani, Chagall, Gris, and Picasso, who moved him toward Cubism. In 1913 he made his first Cubist works, which he exhibited at the Salon d'Automne and the Berthe Weill gallery. In 1920 he went to Italy and was struck by the Byzantine mosaics and the works of the Middle Ages and Renaissance. On his return to Mexico he visited the Mayan ruins in Yucatan. In 1922 the Mexican government commissioned him to make a large fresco in the Escuela Nacional Preparatoria; this was the first of a long series of murals made in Mexico and in the United States. Politically involved, Rivera, along with Breton, signed a manifesto in favor of revolutionary art in 1939.

ALEXANDER RODCHENKO
(St. Petersburg, 1891–Moscow, 1956)

Rodchenko studied at the Kazan Art Institute, where he met Varvara Fedorovna Stepanova. In 1916 he exhibited for the first time in Moscow, at the "Magazin" show mounted by Tatlin. He was an active participant in Russian cultural life after the Communist Revolution, occupying various important posts. His painting and his sculpture first reflected ideas from Cubism and Futurism; they later approached Suprematism and Constructivism. After 1921 he was involved in advertising design and experimental

photography: portraits, architectural details, and objects taken from various angles. He also designed scenery and costumes for movies and plays as well as furniture.

AUGUSTE RODIN
(Paris, 1840–Meudon, 1917)

Rodin began painting at the age of ten and until 1857 was a student at the Ecole Spéciale de Dessin et de Mathématiques; he took art courses with Lecocq de Boisbaudran, and modeling with Jean-Baptiste Carpeaux, and from the painter Jean-Hilaire Belloc. He tried and failed three times to be admitted to the Ecole des Beaux-Arts. In 1864 he entered the studio of the sculptor Albert Carrier-Belleuse. From 1871 to 1877 he lived in Brussels, where he made the caryatids of the exchange building and the frieze on the academy. In 1875 he visited Italy, where he was struck by the works of Michelangelo. In 1876 he sculpted *The Age of Bronze* and from 1879 to 1882 he worked in Sèvres ceramics. In 1880 the French government commissioned him to make a monumental door for the Museum of Decorative Arts being constructed in Paris. He worked on this large work all his life and drew inspiration from it for almost all his other works.

OTTONE ROSAI
(Florence, 1895–Ivrea, 1957)

Rosai studied at the Institute of Decorative Arts and the Institute of Fine Arts in Florence. In 1913 he took part in the show of engravings made by the students of the Institute of Fine Arts. He became friends with Soffici, Carrà, and Severini and took part in several Futurist shows, in particular the Esposizione Libera Futurista held in Rome in 1914 and the National Futurist Exhibition in 1919. After the war he exhibited in Florence, Rome, Milan, at the Venice

Biennales, and had a one-man show at the gallery in Palazzo Ferroni in Florence in 1932. In 1933 he signed the "Realist Manifesto," exalting Fascist culture, with Alberto Luchini, Gioacchino Contri, Romano Bilenchi, and Alfio Del Guericio. In 1939 he taught figure drawing in the arts high school of Florence and in 1942 he was given a chair in that city's academy.

MEDARO ROSSO
(Turin, 1858–Milan, 1928)

Rosso made his debut in 1880, participating in the contest for a monument to Garibaldi with a design that associated him with the antiacademic climate of the Lombard Scapigliatura movement. In 1882 he entered the Brera Academy in Milan, but was expelled in 1883 for indiscipline. In 1884 he took a short trip to Paris and then moved there in 1889. There he met Count Armando Doria, who became his patron, and associated with Emile Zola and Edmond de Goncourt. He was fascinated by Impressionist painting, which he sought to translate in his sculptures in plaster, wax, and bronze. Sometime after 1893 he made friends with Auguste Rodin, who stimulated him and encouraged his artistic work. In 1903 he exhibited at the show of the Vienna Secession. In those same years he approached the thematics of the Symbolists, suggested to him by the Dutch painter Etha Fles. He followed the activities of the Futurists with interest and in 1923 was nominated chief counselor of plastic arts.

GEORGES ROUAULT
(Paris, 1871–1958)

Of humble origins, Rouault took evening classes at the Paris School of Decorative Arts and worked for a restorer of stained glass. In 1891 he enrolled in the Ecole des Beaux-Arts;

his teacher was Gustave Moreau and his fellow students included Matisse, Marquet, and Manguin. He took part in the Fauves group at first, but later followed his own course. After 1910 he began some of his best-known series, such as the *Prostitutes*, *Judges*, and *Clowns*. In 1911 he met the philosopher Jacques Maritain, who moved him toward religious themes, as is clear in the famous Miserere series of engravings. Also famous were his illustrations for *Les Fleurs du Mal* and in *Les Réincarnations du Père Ubu*.

SANTIAGO RUSIÑOL
(Barcelona, 1861–Aranjuez, 1931)

Rusiñol studied with Tomas Moragas; he spent much time in Paris, where he was influenced by the painting of Whistler and the Impressionists and by Japanese prints. He studied at the Académie Gervex and in 1997 settled at Montmartre together with other Spanish painters, among them Miguel Utrillo, Ramon Casas, and Zuloaga. In 1894 he retuned to Barcelona and became one of the major landscape artists of the period. He participated in the Modernist movement and was among the founders of the Els Quatre Gats, the habitual meeting place of avant-garde artists, among them Picasso and Nonell. Rusiñol was an art critic and poet and was active in the theater.

LUIGI RUSSOLO
(Portogruaro, 1885–Cerro di Laveno, 1947)

Russolo's father, Domenico, was the organist in the cathedral of Portogruaro; his older brothers Giovanni and Antonio graduated from the Milan Conservatory. Russolo began studying music, then turned to painting and engraving. In 1909 he debuted at the annual "White and Black" show held by Milan's Famiglia Artistica, exhibiting

Symbolist etchings. He met Boccioni, joined Futurism, and took part in many of the group's shows, painting his best-known works. On March 11, 1913, he published the manifesto "The Art of Noises," in which he expressed Futurist theories of music. From then on he abandoned painting to work exclusively in music. He contributed to the magazine Lacerba, composed pieces of music, and invented instruments that he called Noise Intoners (Rumblers, Roarers, Exploders, Crashers, etc.). In 1916 he published the book *The Art of Noises*.

ALBERTO SAVINIO (Andrea de Chirico)
(Athens, 1891–Rome, 1952)

Younger brother of Giorgio de Chirico, Andrea studied piano at the Athens Conservatory. After his father's death, in 1905, he moved to Munich, where he continued his musical studies. In 1911 he went to Paris, where he associated with Apollinaire and other intellectuals, musicians, and artists. At the outbreak of World War I he moved to Ferrara, together with his brother. There they came in contact with de Pisis, Carrà, the Florentine cultural setting (Soffici and Papini), and Zurich Dadaism (Tristan Tzara). In 1917 he was sent as interpreter to Salonika on the Macedonian front; between 1918 and 1922 he contributed to the magazine *Valori Plastici*. He lived in Rome, where he married the theater actress Maria Morino and worked in the field of music as a pianist, orchestra director, and composer for the theater and ballet. In 1926 he went to Paris and worked full time in painting, drawing inspiration from the Surrealists; he held his first show at the Jacques Bernheim gallery, presented by Jean Cocteau. In 1935 he moved to Rome, where he wrote and explored the fantasy themes of his painting; he was also involved in mural painting and the applied arts.

CHRISTIAN SCHAD
(Miesbach, 1894–Stuttgart, 1982)

Schad studied at the Munich Academy; between 1913 and 1921 he made numerous woodcuts published by the most influential literary magazines, among them *Die Aktion* of Berlin, *Die weissen Blätter* of Leipzig, and *Sirlus* of Zurich. In those same years he associated with the exponents of the Dadaist movement and was influenced first by Futurism, then by Cubism, then by abstraction. In 1918, in Geneva, he experimented with a technique similar to that of photography, making works he called schadographs. From 1920 to 1925 he lived in Italy, in Rome, where he met Evola, Prampolini, and other artists and visited the Casa d'Arte Bragaglia. In 1925 he moved to Vienna and two years later exhibited his new creations at the Würthle gallery; in these he returned to representational art, following the style of New Objectivity. After World War II he took numerous trips in Europe and took part in the major international exhibitions.

EGON SCHIELE
(Tulln, 1890–Vienna, 1918)

A precocious talent, at sixteen Schiele was admitted to the Vienna Academy. He met Gustav Klimt, who encouraged him and influenced his first works. In 1900 he exhibited in Klimt's Kunstschau. With several friends he founded the Neukunstgruppe ("New Art Group") and was elected its president. Such was the scandal awakened by his erotic drawings that he was arrested and tried. In 1915 he enlisted and was sent to the garrison of Prague; on June 17 he married Edith Harms, who gave new vigor to his creativity. In 1916 he was in Vienna and in 1918 he took part in a show of the Vienna Secession.

KARL SCHMIDT-ROTTLUFF
(Rottluff, 1884–Berlin, 1976)

In 1902 Schmidt met Heckel, with whom he associated in the Vulkan literary circle. He then moved to Dresden to study architecture. He was among the founders of the Die Brücke group. In 1905, to distinguish himself from other artists with the same, quite ordinary last name (Schmidt), he added to it the name of his birthplace (Rottluff). After 1913 he met Feininger and was drawn to Cubist painting; he was also influenced by the works of Munch and by African art. After World War I he traveled to Italy and France. In 1931 he was elected a member of the Berlin Academy. The Nazis included him among the "degenerate" artists: he was expelled from the academy, was no longer permitted to exhibit or paint, and his works were confiscated. From 1947 to 1954 he taught at the Hochschule für Bildende Künste in Berlin and was among the founders of the Brücke Museum.

KURT SCHWITTERS
(Hanover, 1877–Ambleside, 1948)

Schwitters studied at the Dresden Academy; he worked as a designer, architect, typographer, writer, and painter. He was originally drawn to Cubism, but then met Arp and Hausmann and became one of the leading exponents of Dada. His principal work, *Merzbau*, consisted of a variety of disparate objects that he assembled, or "constructed," in a variety of ways, most of them accidental. In 1923 he founded the magazine *Merz*. In 1927 he created the Ring Neuer Werbegestalter, with Cesar Domela, László Moholy-Nagy, and Friedrich Vordemberge-Gildewart. To escape Nazi persecution, in 1937 he moved first to Norway and then to England.

SCIPIONE (Gino Bonichi)
(Macerata, 1904–Arco, 1933)

In 1909 Scipione moved to Rome, where he attended the Scuola di Nudo at the Academy. In 1927 he exhibited in the Bragaglia gallery and the next year at the Doria gallery, along with Mario Mafai, Antonietta Raphaël, Gisberto Ceracchini, and Giuseppe Capogrossi, with whom he created the "Via Cavour School," also called the Roman School. Over the period of his short life he created powerfully emotional works in which he blended his passion for baroque art with the bright chromatics of Expressionism.

NIKOLAI SEMIONOV
(St. Petersburg, 1892–Moscow, 1958)

Semionov studied at the Repin Institute of Art in St. Petersburg, where he learned to follow the 19th-century tradition. During the Russian Revolution he took part in political and cultural activity. In the 1920s he began making portraits, historical scenes, and works with social themes, becoming one of the Soviet government's official painters.

GINO SEVERINI
(Cortona, 1883–Paris, 1966)

Severini studied at the technical schools of Cortona before moving to Rome in 1899. He met Boccioni and Balla in 1901 and made his debut in Divisionism. In 1906 he moved to Paris, where he came in contact with Modigliani and Max Jacob. In 1910 he signed the first "Manifesto of Futurist Painting" and became one of the principal members of the movement. In 1913 he had a one-man show at the Marlborough Gallery in London and then at the Der Sturm gallery in Berlin. In 1916 he exhibited together with Picasso and approached Cubism. In the 1920s he followed the style of the Novecento Italiano group

and made representational, realistic works, but he abandoned this in the 1940s to return to Futurist and Cubist compositions, giving special attention to geometric abstraction.

BEN SHAHN
(Kovno, Lithuania, 1989–New York, 1969)

In 1906 Shahn moved to New York, where from 1913 to 1917 he worked as an apprentice lithographer and took art courses. From 1919 to 1922 he studied at the National Academy of Design; between 1924 and 1929 he took several trips to Europe, where he was struck by the works of George Grosz and Otto Dix. On his return to the United States he made paintings with social and political themes in a graphic style. In 1933 he worked with Diego Rivera on a mural for the RCA Building in Rockefeller Center, but it was destroyed before being completed because it included a portrait of Lenin. He made murals financed by the Federal Art Project and was active in photography. Together with his wife, Bernarda Brysen, he made several works for post offices in the Bronx in 1938–39.

CHARLES SHEELER
(Philadelphia, 1883–Dobbs Ferry, New York, 1965)

Sheeler studied at the Philadelphia School of Industrial Art, then from 1903 to 1906 at the Pennsylvania Academy of Fine arts, a student of William Merritt Chase. Over the next seven years he made several trips to Europe, to England, Holland, Spain, and Italy, where he was impressed by the frescoes of Piero della Francesca in Arezzo. In Paris he studied the works of Cézanne, Matisse, and the Cubists. He exhibited six works in the 1913 Armory Show in New York and moved to New York in 1919, where he was active in photography as well as painting.

EVERETT SHINN
(Woodstown, New Jersey, 1876 – New York, 1953)

From 1888 to 1890 Shinn studied industrial design at the Spring Garden School in Philadelphia; in 1893 he worked as an illustrator for several magazines and took courses at the Pennsylvania Academy of Fine Arts, where he met Henri, Sloan, Glackens, and Luks. In 1897 he moved to New York and worked as a painter and illustrator. In 1908 he took part in the show of the Eight at the Macbeth Gallery in New York; over the following years he taught at the Art Students League in New York. Between 1917 and 1923 he worked as the art director on several films in Hollywood.

DAVID ALFARO SIQUEIROS
(Santa Rosalia, Chihuahua, 1896–Cuernavaca, 1974)

Siqueiros studied at the San Carlos Academy in Mexico City; he enlisted and as a captain, in 1919, was sent to Europe to serve in embassies in Spain, Italy, and France, where he studied classical art and visited the meeting places of the artistic avant-gardes. In Paris he became friends with Diego Rivera, with whom he made the frescoes in the Escuela Nacional Preparatoria in Mexico City. Between 1936 and 1938 he fought in Spain as an officer in the republican army. He later made large mural cycles in Mexico and the United States, where he also gave lessons and had a great influence on young American artists.

MARIO SIRONI
(Sassari, 1885–Milan, 1961)

In 1903 Sironi quit his engineering studies to attend the Academy of Fine Arts in Rome, where he met Balla, Boccioni, and Severini. Late in 1913 he joined Futurism, and after World War I he went through a brief period of Metaphysical art. He was among the founders of the Novecento Italiano group and was one of the major supporters of the return to the figurative tradition. During the 1930s he worked to elaborate an aesthetic approach for the Fascist regime, writing critical essays and mounting shows and other cultural events. Aside from painting, he made frescoes, mosaics, bas-reliefs, and was involved in scenery design and architecture. After 1943 he concentrated on easel painting, with increasingly dark tones.

JOHN SLOAN
(Lock Haven, Pennsylvania, 1871–Hanover, New Hampshire, 1951)

At five Sloan moved to Philadelphia, where he attended courses at the Academy; he made illustrations for magazines and studied painting under Robert Henri. In 1904 he went to New York and exhibited in the National Arts Club. In 1908 he took part in the show of the Eight at the Macbeth Gallery; in 1910 he joined the Socialist party and worked for several Socialist newspapers, including *The Masses*, of which he was director from 1912 to 1916. He exhibited in the 1913 Armory Show in New York; in 1916 he began teaching in the Art Students League. In 1939 he published the book *Gist of Art*.

ARDENGO SOFFICI
(Rignano sull'Arno, 1879–Forte dei Marmi, 1964)

In the spring of 1893 Soffici moved with his family to Florence, where he worked in a law office. In 1903, following the death of his father, he went to Paris with several other painters. He worked as a magazine illustrator and met Papini, Picasso, and Apollinaire. In 1907 he moved to Poggio a Caiano, although he often made trips back to Paris. In 1908 he worked for *La Voce*; together with Papini he founded the magazine *Lacerba*, to which nearly all the Futurist artists contributed. He volunteered for service in World War I, was wounded twice, and was decorated. During the 1920s he joined Fascism and contributed to *Popolo d'Italia*; in his painting he followed the style of the Tuscan 15th century and created the aesthetic vision of *Valori Plastici* and *Novecento*.

CHAÏM SOUTINE
(Smilovitchi, 1893–Paris, 1943)

The tenth of eleven children born to a poor Jewish family, Soutine studied design at Minsk in 1907 and in 1910 attended the Vilnius Academy. In 1911 he went to Paris, where he made friends with Chagall and Modigliani, who presented him to the art dealer Léopold Zborowski. After World War I Soutine summered in Céret and Cagnes; he made still lifes, landscapes, compositions with animal carcasses inspired by Rembrandt, and most famously the series of portraits of ushers, pastry chefs, choir boys, and other young men, presented with pitiless realism in a style near that of Expressionism. In 1927 he had a one-man show at the Bing gallery in Paris; over the next decade he worked on the major themes of his production, primarily portraits.

ALFRED STIEGLITZ
(Hoboken, New Jersey, 1864–New York, 1946)

Stieglitz got his training in Germany, at the Realgymnasium in Karlsruhe and the Polytechnic Institute in Berlin; he took courses in mechanical engineering at the University of Berlin and lessons in photography from Hermann Wilhelm Vogel. In 1890 he returned to the United States and dedicated himself full time to photography. In 1893 he directed the magazine *The American Photographer*; in 1902 he founded the Photo-Secession Group; in 1903 he created the magazine Camera Work; and in 1905, together with Edward Steichen, he opened the Little Galleries of the Photo-Secession, later known as "291," where he worked in photography, avant-garde painting, literature, philosophy, and music. In 1924 he married the painter Georgia O'Keeffe.

RUFINO TAMAYO
(Oaxaca, 1899–Mexico City, 1991)

Orphaned at twelve, Tamayo lived with an aunt who directed him to commercial studies. In 1915 he began taking art lessons, and he left school in 1917 to work full time on painting. In 1925 he had his first exhibit, at the Weyhe Gallery in New York; in 1932 he made frescoes in the Escuela Nacional de Musica in Mexico City. In 1936 he moved to the United States. He participated in numerous shows in America and Europe and received various commissions to decorate public buildings, such as the UNESCO building in Paris (1958). In 1964 he returned to Mexico City.

YVES TANGUY
(Paris, 1900–Woodbury, Connecticut, 1955)

Tanguy spent his childhood at Locronan, in Brittany, the place where his family was from, and was impressed by the region's landscapes. In 1918 he joined the merchant marine and made several trips to Africa, South America, and England. During military service at Lunéville in 1920 he met the poet Jacques Prévert. He began painting, self-taught, at age twenty-three, impressed by de Chirico's Metaphysical works. In December 1925 he met Breton and joined the Surrealist group, soon becoming one

of its most expressive members. His style was already defined in 1927, when he had his first solo show at the Galerie Surréaliste in Paris, where he presented the oneiric atmospheres of his landscapes populated by strange and disturbing plastic forms. In 1939 Tanguy met the painter Kay Sage and they traveled to the American Southwest; they married in 1940 and settled in Woodbury, Connecticut; he became a U.S. citizen in 1948. A retrospective of his work was held at the Museum of Modern Art in New York after his death.

VLADIMIR TATLIN
(Kharkiv, 1885–Novodevichy, 1953)

From 1902 to 1903 Tatlin studied at the Moscow College of Painting, Sculpture, and Architecture and from 1904 to 1910 at the Penza School of Art; in 1912 he exhibited with Larionov, Goncharova, Chagall, and Malevich in the Donkey's Tail show. Between 1908 and 1911 he associated with the Burliuk brothers and Mikhail Larionov, who introduced him to Futurist art. In 1913 he visited Paris and was influenced by the art of Picasso. Not long after that, together with Alexander Rodchenko, he created Constructivism, one of the leading avant-garde movements in Russia. In 1919 he designed the great monument to the Communist Third International. After the Revolution he worked for the new government. He taught in Leningrad, Kiev, and Moscow and worked in painting, architecture, industrial design, ceramics, sculpture, theatrical scenery, and music.

BRUNO TAUT
(Königsberg, 1880–Istanbul, 1938)

Taut studied architecture at Königsberg and Berlin; in 1904 he joined the studio of Theodor Fischer in Stuttgart; in 1910 he opened a studio in Berlin. After World War I he became one of the leading avant-garde designers; he made many buildings and had an important impact on theory with numerous essays, including *Alpine Architektur* (1919). In 1921 he worked at Magdeburg; from 1924 he was busy on important urbanistic projects (Onkel Toms Hütte and the Hufeisen-siedlung Britz). With the advent of the Nazis, in 1933, he left Germany to work in Russia, Japan, and finally Turkey.

GIUSEPPE TERRAGNI
(Meda, 1904–Como, 1943)

Terragni earned his diploma in architecture in 1926 and with Libera, Figini, Pollini, Frette, Larco, and Rava formed Gruppo 7; he took part in the first (1928) and second (1931) shows of Rational architecture in Rome and the exposition of Rational architecture in Florence in 1932, where he stood apart as one of the most creative personalities. His works include three buildings in Como: the Novocomun residential complex (1927–28), the Casa del Fascio (1933–36), and the Sant'Elia nursery school (1936–37). In 1941 he was sent to the Russian front; he was so ill on his return, both physically and mentally, that after a brief period of convalescence he suddenly died, perhaps a suicide.

JAN TOOROP
(Poerworedjo, 1858–The Hague, 1928)

Born on the island of Java to Norwegian and Oriental parents, Toorop moved to Holland and in 1880 enrolled in the Amsterdam Academy. From 1882 to 1886 he lived in Brussels; he studied at the Academy and associated with the artists of Les XX, with whom he exhibited between 1885 and 1893. In 1886 he married the Englishwoman Annie Hall. He became one of the leaders of Art Nouveau, most of all by way of his advertising art, including posters. In his paintings social themes alternate with allegorical and symbolic references. In 1905 he converted to Catholicism and made several works with religious subjects.

JOAQUÍN TORRES GARCÍA
(Montevideo, 1874–1949)

In 1891 Torres García moved with his family to Spain and in 1892 settled at Barcelona, where he attended the Academy of Fine Arts and the Baixas Academy. In 1909 he married Manolita Piña de Rubiés. He traveled in Belgium, France, and Italy; in 1920 he went to New York, where he spent two years. In 1930 he met Mondrian, van Doesburg, and Seuphor and participated in the Cercle et Carré group and elaborated the principles of Constructivist painting, which he further developed after his return to Uruguay, in 1934. In Uruguay he founded the Arte Constructivo association and in 1944 published the essay *Universalismo Constructivo*.

LOUIS VALTAT
(Dieppe, 1869–Paris, 1952)

Son of a rich family of shopowners, Valtat was admitted to the Ecole des Beaux-Arts in Paris in 1887 and took lessons with Boulanger, Lefebvre, and Harpignies. He also took courses at the Académie Julian, where he met Bonnard and Vuilland, who invited him to the Café Volpini, popular with Nabis painters, thanks to whom he abandoned the Pointillist style of his early years. In 1895, with Toulouse-Lautrec and Albert André he designed the stage settings for the opera *Chariots de Terre Cuites*, presented at the Paris Opéra. He traveled to England, Spain, Italy, and Algeria. In 1905 he exhibited at the Salon d'Automne together with other Fauvist painters. He had several personal shows at the Parisian galleries of Vollard and Druet. In later years he painted primarily landscapes in Brittany and Normandy, along with seascapes, nudes, and still lifes. He also made engravings.

REMEDIOS VARO
(Anglés, 1908–Mexico City, 1963)

Daughter of a hydraulic engineer, Varo studied at the San Fernando Academy in Madrid; in 1930 she married Gerardo Lizarraga, a fellow student at the academy. They lived in Paris for a year and then went to Barcelona, where they worked designing advertising posters. In 1935 she separated from her husband; she associated with avant-garde intellectuals and artists, most of all Surrealists; she was among the founders of the Logicophobe group. Following the Spanish civil war, she moved to Paris, where she met Breton. At the outbreak of World War II she moved to Mexico, and in 1947 she went to Venezuela. She married Walter Gruen in 1952. In 1956 she had her first solo exhibit.

MAURICE DE VLAMINCK
(Paris, 1876–Rueil-la-Gadelière, 1958)

In 1892 Vlaminck settled at Chatou; he studied violin and was involved in bicycle racing until an illness forced him to give it up in 1896. In 1900 he met André Derain, forming a life-long friendship. Vlaminck had a brief career as an author, writing two novels. It was in 1901, when he visited the show that gallery owner Bernheim-Jeune had dedicated to van Gogh, that Vlaminck discovered his calling as a painter. He met Matisse, who invited him to exhibit with the Fauves at the Salon d'Automne in 1905. In 1906 he had his first one-man show, mounted by Ambroise Vollard. After 1910 he studied the works of Cézanne and paid attention to the formal decompositions of the

Cubists. At the end of World War I he left Paris to live in the country, where he made landscapes influenced by Expressionism. In his last works he used darker colors in works with disturbing and dramatic atmospheres.

FRIEDRICH VORDEMBERGE-GILDEWART
(Osnabrück, 1899–Ulm, 1962)

In 1919 Vordemberge-Gildewart moved to Hanover to study architecture and sculpture. In 1919 he made his first abstract relief. From the beginning of his pictorial career he was in contact with Kurt Schwitters, Jean Arp, and Theo van Doesburg, with whom he participated in the activity of the De Stijl group. In 1927 he was among the founders of the Die Abstrakten Hannover group; in 1929 he had his first solo show, at the Povolozky gallery in Paris. He joined the Abstraction-Création group in 1932 and moved to Berlin in 1936, but Nazi persecution forced him to take refuge first to Switzerland and then in Amsterdam. After the war he taught a course in visual communication at Ulm.

OTTO WAGNER
(Penzing, Austria, 1841–Vienna, 1918)

Wagner studied at the Vienna Academy and in 1863 became an architect. In that same year he married Josephine Domhart, with whom he had three children; in 1881 he married Louise Stiffel, with whom he had three more. In 1894 he was named chief consultant for building in Vienna, and was given the chair in architecture at the Vienna Academy. In 1899 he joined the Vienna Secession, founded two years earlier by several of his students. He became one of the movement's most important exponents.

EDWARD WESTON
(Highland Park, Illinois, 1886–Carmel, California, 1958)

When he was sixteen, Weston received a camera from his father as a gift: a Kodak Bullseye # 2. He had his first photographic show, at the Art Institute of Chicago, in 1903. In 1908 he moved to California and was among the founders of the Camera Pictorialists of Los Angeles. In 1909 he married Flora May Chandler. His photographs were published in many magazines, including *American Photography*, *Photo Era*, and *Photo Miniature*. In 1921 he met Tina Modotti, who became his model, collaborator, and lover, and with whom he took a brief trip to Mexico. He was part of the f.64 Group, which had a large influence on the formation of an entire generation of photographers. In 1937 he was the first photographer to be awarded a Guggenheim Fellowship. Struck with Parkinson's disease, he gradually diminished his activity, which he passed on to his two sons, Brett (1911–1993) and Cole (1919–2003).

ROBERT WIENE
(Breslau, 1873–Paris, 1938)

Son of an actor, Wiene worked at the Lessing Theater in Berlin; he then worked in filmmaking as a screenwriter and director, for Sascha Film in Vienna and Bioscop and Messter Film in Berlin. His most famous films are *The Cabinet of Dr. Caligari* (1919), considered the masterpiece of Expressionist cinema; *Genuine* (1920), *The Hands of Orlac* (1924), *Der Rosenkavalier* (1926), and his last film, *Ultimatum* (1938).

GRANT WOOD
(Anamosa, Iowa, 1892–Cedar Rapids, Iowa, 1942)

Between 1910 and 1911 Wood

studied at the Minneapolis School of Design; he worked as a designer and took courses at Iowa State University and the Art Institute of Chicago. In 1920 he traveled to Europe and in 1923 enrolled in Paris's Académie Julian. He also went to Italy, Germany, and Holland. In 1934 he was made the state director for Iowa of the Public Works of Art Project and taught at the University of Iowa. Until 1928 he painted views, landscapes, and portraits in an Impressionist style; he later adopted a more realistic and precise style. His painting is included as part of the American Scene, along with that of Thomas Hart Benton and John Steuart Curry.

FRANK LLOYD WRIGHT
(Richland Center, Wisconsin, 1867–Phoenix, Arizona, 1959)

In 1885 Wright enrolled in the engineering school of Madison, Wisconsin, and worked as a designer in the studio of Allen D. Conver. In 1887 he moved to Chicago and joined the studio of Adler & Sullivan. In 1893 he began independent activity. Between 1889 and 1909 he designed his series of so-called prairie houses. Between 1909 and 1911 he took a long trip to Europe, while from 1916 to 1922 he worked at the Imperial Hotel in Tokyo. In 1932 he participated in the show of contemporary architecture at the Museum of Modern Art and met Le Corbusier, Mies van der Rohe, and other European architects. He made his most famous works during the second half of the 1930s, including Fallingwater. Over the next decade he developed the theme of the Usonian Houses, designed Broadacre City, The Illinois (a mile-high skyscraper), and between 1946 and 1959 designed the Guggenheim Museum in New York, a synthesis of his interest in the use of curved lines in architecture.

XUL SOLAR
(Oscar Augustín Alejandro Schulz Solari)
(San Fernando, 1887–Tigre, 1963)

Son of an Italian mother and German father, Xul Solar studied architecture in Buenos Aires and traveled to England, France, Italy, and Germany, where he began to painting and was interested in the occult sciences and techniques of meditation. In 1924 he returned to Argentina, where he joined the Martin Fierro group composed of young Modernist painters and writers; he also made friends with Jorge Luis Borges and created a fantasy universe, full of poetry and imagination, with geometric forms and lively colors in delicate tones.

Bibliography

The art of the first half of the 20th century has been the subject of a vast literature, in terms of both general works and those dedicated to individual artists. So many books have been written on the subject that the pages of this volume would not suffice to present a list of only the titles of the works. The books presented here include works that are generally recognized to be of fundamental importance to the subject—works that will include further bibliographical information—along with a few texts of more specialized interest.

Amaya, Mario. *Art Nouveau*. London: Studio Vista, 1966.

Apollonio, Umbro. *Fauves and Cubists*. New York: Crown, 1960.

Apollonio, Umbro, ed. *Futurist Manifestos*. Translated by Robert Brain et al. Boston: MFA Publications, 2001.

Arnheim, Rudolf. *Picasso's Guernica, the Genesis of a Painting*. Berkeley: University of California Press, 1962.

Arwas, Victor. *Alphonse Mucha, Master of Art Nouveau*. New York: St. Martin's Press, 1985.

Banham, Rayner. *Theory and Design in the First Machine Age*. London: Architectural Press, 1960.

Barr, Alfred H., Jr. (ed). *Fantastic Art, Dada, Surrealism*. New York: Museum of Modern Art; distributed by Simon and Schuster, 1947.

Bayer, Herbert, Gropius, Walter, and Gropius, Ise. *Bauhaus, 1919–1928*. New York: C.T. Branford Co., 1952.

Brettell, Richard R. *Modern Art, 1851–1929*. Oxford and New York: Oxford University Press, 1999.

Buffet-Challié, Laurence. *The Art Nouveau Style*. Translated by Geoffrey Williams. New York: Rizzoli, 1982.

Carrà, Massimo (ed.). *Metaphysical Art*. Translated by Caroline Tisdall. New York: Praeger Publishers, 1971.

Chase, Edward T. *The Etchings of the French Impressionists and Their Contemporaries*. New York: Crown Publishers, 1946.

Chilvers, Ian. *A Dictionary of Twentieth-Century Art*. Oxford, New York: Oxford University Press, 1998.

Cocteau, Jean. *Modigliani*. Translated by F. A. McFarland. London: Zwemmer, 1950.

Cogniat, Raymond. *French Painting at the Time of the Impressionists*. Translated by Lucy Norton. New York: Hyperion Press, 1951.

Cooper, Douglas. *The Cubist Epoch*. New York: Phaidon, 1970.

Cooper, Douglas. *Picasso Theater*. New York: Harry N. Abrams, 1987.

Cork, Richard. *Vorticism and Abstract Art in the First Machine Age*. Berkeley: University of California Press, 1976.

Cottington, David. *Cubism*. Cambridge, New York: Cambridge University Press, 1998.

Cottington, David. *Modern Art: A Very Short Introduction*. Oxford, New York: Oxford University Press, 2005.

Crepaldi, Gabriele. *The Impressionists*. Translated by Jay Hyams. New York: Barnes & Noble Books, 2002.

Crespelle, Jean Paul. *The Fauves*. Translated by Anita Brookner. Greenwich, Conn.: New York Graphic Society, 1962.

Droste, Magdalena, et al. *Bauhaus Archive Berlin*. Translated by Helen Adkins. Berlin: Museumspädagogischer Dienst, 1999.

Duncan, Alastair. *Art Nouveau*. London: Thames and Hudson, 1994.

Faerna, José Maria. *Kandinsky*. Translated by Alberto Curotto. New York: Cameo/Abrams, 1996.

Fry, Edward F. *Cubism*. Translated by Jonathan Griffin. London: Thames and Hudson, 1966.

Fry, Roger. *Cézanne: A Study of His Development*. University of Chicago Press, 1989.

Glancey, Jonathan. *The Story of Architecture*. London, New York: Dorling Kindersley, 2000.

Golding, John. *Boccioni's Unique Forms of Continuity in Space*. Newcastle upon Tyne: University of Newcastle upon Tyne, 1972.

Golding, John. *Cubism, A History and an Analysis, 1907–14*. New York: G. Wittenborn, 1959.

Gray, Camilla. *The Russian Experiment in Art, 1863–1922*. New York: Thames and Hudson, 1986.

Gubler, Jacques. *ABC 1924–1928: Avant-garde and Radical Architecture*. Milan: Electa, 1994.

Hamilton, Alastair. *The Appeal of Fascism*. London. 1971.

Hamilton, George Heard. *19th and 20th Century Art*. New York: Harry N. Abrams, 1970.

Hamilton, George Heard. *Painting and Sculpture in Europe, 1880–1940*. Baltimore: Penguin Books, 1967.

Herbert, Barry. *German Expressionism: Die Brücke and Der Blaue Reiter*. London: Jupiter Books, 1983.

Hilton, Tim. *Picasso*. London: Thames and Hudson, 1975.

Howard, Jeremy. *Art Nouveau: International and National Styles in Europe*. Manchester, New York: Manchester University Press; distributed in the USA by St. Martin's Press, 1996.

Huici, Fernando. *Klimt*. Translated by Sarah Hilditch. New York: Arch Cape Press, 1989.

Humphreys, Richard. *Futurism*. London: Tate Gallery, 1999.

Jaffé, H.L.C. *De Stijl, 1917–1931*. Cambridge, Mass.: Belknap Press, 1986.

Joll, James. *Intellectuals in Politics: Blum, Rathenau, Marinetti*. London: Weidenfeld and Nicolson, 1960.

Kahnweiler, Daniel-Henry. *My Galleries and Painters*. Translated by Helen Weaver. New York: Viking Press, 1971.

Kandinsky, Wassily. *Concerning the Spiritual in Art*. Translated by M.T.H. Sadler. New York: Dover Publications, 1977.

Kaplan, Patricia, and Susan Manso, eds. *Major European Art Movements, 1900–1945*. New York: E. P. Dutton, 1977.

Katz, Ephraim. *The Film Encyclopedia*. New York: G.P. Putnam's Sons, 1979.

Klein, Mason, ed. *Modigliani: Beyond the Myth*. New Haven: Yale University Press, 2004.

Langui, Emile. *50 Years of Modern Art*. London: Thames and Hudson, 1959.

Le Corbusier. *The Decorative Art of Today*. Translated by James I. Dunnett. Cambridge, Mass.: MIT Press, 1987.

Lista, Giovanni. *Futurism*. Translated by Charles Lynn Clark. New York: Universe Books, 1986.

Malevich, Kazimir. *Essays on Art*. 2 vols. Translated by Xenia Glowackacki-Prus and Arnold McMillin. New York: G. Wittenboin Publishers, 1971.

Marchetti, Francesca Castria, ed. *American Painting*. Translated by Jay Hyams. New York: Watson-Guptill, 2002.

Martin, Marianne W. *Futurist Art and Theory, 1909–15*. Oxford: Clarendon Press, 1968.

Meyers, Jeffrey. *Modigliani: A Life*. Orlando: Harcourt, 2006.

Muller, Joseph-Emile. *Fauvism*. Translated by Shirley E. Jones. New York: Praeger, 1967.

Nochlin, Linda. *Realism*. Harmondsworth: Penguin, 1971.

Olivier, Fernande. *Picasso and His Friends*. Translated by Jane Miller. New York: Appleton-Century, 1965.

Overy, Paul. *De Stijl*. London: Thames and Hudson, 1991.

Parsons, Thomas, and Iain Gale. *Post-Impressionism: The Rise of Modern Art*. London: Studio Editions, 1992.

Penrose, Roland. *Man Ray*. Boston: New York Graphic Society, 1975.

Penrose, Roland. *Picasso: His Life and Work*. Berkeley: University of California Press, 1981.

Reade, Brian. *Art Nouveau and Alphonse Mucha*. London, 1963.

Rewald, John. *Cézanne: A Biography*. New York: Harry N. Abrams, 1986.

Richardson, John. *A Life of Picasso*. New York: Random House, 1996.

Rosenblum, Robert. *Cubism and Twentieth-Century Art*. Englewood Cliffs, N.J.: Prentice-Hall, 1976.

Rosenblum, Robert. *Nineteenth-century Art*. New York: Harry N. Abrams, 1984.

Rubin, William S. *Dada and Surrealist Art*. New York: Harry N. Abrams, 1969.

Rubin, William S. (ed.). *Pablo Picasso, A Retrospective*. New York: Museum of Art; Boston: distributed by New York Graphic Society, 1980.

Rubin, William S. (ed.). *Picassso in the Collection of the Museum of Modern Art*. New York: Museum of Modern Art; distributed by New York Graphic Society, Greenwich, Conn., 1972.

Rubin William S. *"Primitivism" in Twentieth-Century Art*. New York: Museum of Modern Art, 1984.

Sabartés, Jaime. *Picasso, An Intimate Portrait*. Translated by Angel Flores. New York: Prentice-Hall, 1948.

Sembach, Klaus-Jürgen. *Art Nouveau: Utopia, Reconciling the Irreconcilable*. Translated by Charity Scott Stokes. Köln, London: Taschen, 2000.

Shapiro, Theda. *Painters and Politics: The European Avant-Garde and Society, 1900–1925*. New York: Elsevier, 1976.

Stein, Gertrude. *Autobiography of Alice B. Toklas*. New York: The Literary Guild, 1933.

Tisdall, Caroline, and Angelo Bozzolla. *Futurism*. London: Thames and Hudson, 1977.

Vollard, Ambroise. *Cézanne*. New York: Dover Press, 1984.

Whitfield, Sarah. *Fauvism*. New York: Thames and Hudson, 1991.

Wingler, Hans Maria. *The Bauhaus: Weimar, Dessau, Berlin, Chicago*. Translated by Wolfgang Jabs and Basil Gilbert. Cambridge, Mass.: MIT Press, 1969.

Index of names and places

Numbers in *italics* refer to illustration captions (the name of the artist or the location of the work)

Aalto, Alvar, *332*, 338, *345*, 369
Aarau, *28*, *153*
Adams, Ansel, *351*, 369
Adrian-Nilsson, Gösta, 87
Aix-en-Provence, 72, 168
Albers, Josef, 239, 330
Aleichem, Sholom, 111
Alexandre, Jean, 116, 118
Alexandre, Paul, 116, 118, 130
Allegheny, 55
Almeida Júnior, José Ferraz de, 284
Alsen, island of, 144, 147, 151
Alva de la Canal, Ramon, 285
Amiet, Cuno, 138, 139
Amsterdam, 106, 322, *325*
Andreoni, Cesare, 235
Anthéor, 61
Apollinaire, Guillaume, 45, 72, 73, 98, 116, 124, 169, 176, 184, 185, 194, 206, 216
Aragon, Louis, 206, 207
Archipenko, Alexander, *305*, 369
Arcimboldi, Giuseppe, 222
Argan, Giulio Carlo, 225
Arp, Jean (Hans), 194, 222, 297, *309*, 369
Atwood, Charles B., 323

Baargeld, Johannes Theodor, 194
Badiali, Carla, 235
Baj, Enrico, 195
Bakst, Léon, 102, *112*, 369
Ball, Hugo, 194
Balla, Giacomo, 29, *86*, *91*, *92*, *93*, 169, 350, 369
Balsamo-Stella, Guido, 347
Barbini, Alfredo, 347
Barcelona, 22, 30, 44, 45, 49, 74, 80, 81, 137, 322, *324*
Barlach, Ernst, 296, *308*, 369
Barnes, Albert C., 124, 187
Baroni, Nello, 336
Barradas, Rafael, 87, 285
Bartolini, Luigi, 311
Barye, Antoine Louis, 296
Basel, *43*, *246*
Baudelaire, Charles, 64, 350
Baum, Paul, 154
Bayer, Herbert, 239
Bear Run (Penn.), *333*
Beaton, Cecil, 29, *351*, 370
Beaulieu, *349*
Bechtejeff, Vladimir von, 154
Beckmann, Max, *242*, *243*, *316*, 370
Behrens, Peter, 322, *328*, 331, 338, *343*, 370
Bel Geddes, Norman, 339
Bellmer, Hans, *222*, 351, 370
Bellows, George, *273*, 311, 370
Benois, Alexandre, 102
Benton, Thomas Hart, 266, *283*, 311, 370
Benvenuti, Benvenuto, 116
Beardi, Pier Niccolò, 336
Bergson, Henri, 86, 168
Berlage, Hendrik Petrus, 322, *325*, 370
Berlin, 33, 35, 42, *44*, *63*, 94, *132*, *133*, 134, *135*, 138, 139, *142*, *144*, *145*, 147, *148*, *149*, 153, 154, 155, 156, 161, *166*, 194, 204, *211*, 222, 239, *241*, *251*, *303*, 308, 316, *327*, *328*, 363
Bern, 17, *78*, *181*, *247*
Bernareggi, Adriano, 237

Bernini, Gian Lorenzo, 215
Besant, Annie, 155
Bianconi, Fulvio, 347
Bienert, Fritz, 178
Bill, Max, 309
Bing, S(iegfried), 22
Blake, William, 310
Blanes, José Manuel, 284
Blasetti, Alessandro, 358
Blavatsky, Helena Petrovna, 155
Bleyl, Fritz, 138
Bloch, Albert, 154
Bloch-Bauer, Adele, 36
Boccioni, Umberto, *16*, 82, 86, *87*, *88*, *89*, *90*, 92, 94, 95, 297, 303, *306*, 311, 350, 370
Böcklin, Arnold, 184
Boldini, Giovanni, 17, *23*, *29*, 371
Bologna, 184, 348
Bonn, 208
Bonnard, Pierre, 290
Bonsons, Jaume Andreu, 44
Borisov-Musatov, Viktor, 102
Borrel, García Federico, 353
Bossì, Erma, 154
Boston, 266, *269*
Bottai, Giuseppe, 225
Bourdelle, Antoine, 296
Bragaglia, Anton Giulio, 87, 350
Bragaglia, Arturo, 350
Bragaglia, Carlo Ludovico, 87
Brancusi, Constantin, 17, 116, 129, 130, 284, 296, *297*, *300*, *301*, 371
Brandt, Marianne, 330, *343*, 371
Braque, Georges, 56, 58, *61*, *72*, 73, 76, *78*, *79*, 82, 84, 154, 286, 311, 371
Brassaï (Gyula Halász), 351
Brauner, Victor, *217*, 371
Breton, André, 129, 137, 195, 206, 207, 208, 213, 216, 221, 222, 285
Breuer, Marcel, 239, 330, *344*, 371
Broglio, Mario, 186, 187, 228
Brussels, *24*, 33, 37, 80, 94, 150, 210, 322, *325*, *329*
Bucci, Anselmo, 116, 225
Bucharest, 32
Buenos Aires, 227, 284
Buffalo (N.Y.), *20*, 150
Buñuel, Luis, 207, 359, *365*, 371
Burchfield, Charles, 266
Burlyuk, David, 87, 102, 154
Burlyuk, Vladimir, 102, 154
Burnham, Daniel, 323
Burty Haviland, Frank, 130
Buzzi, Paolo, 101
Buzzi, Tommaso, 347

Cabanel, Alexandre, 215
Cagnes-sur-Mer, 117
Cahill, Holger, 266
Calder, Alexander, 297
Camerini, Mario, 358
Cameron, D(avid) Y(oung), 311
Camoin, Charles, 56
Campendonk, Heinrich, 154, 155
Campigli, Massimo (Max Ihlenfeld), *225*, *236*, 371
Canals, Ricardo, 312
Capa, Robert, 351, *353*, 372
Carena, Felice, 224, 225
Carlsund, Otto G., 169
Carpi, Aldo, 225
Carrà, Carlo, 86, 87, 92, *94*, *95*, *131*, *184*, *189*, *190*, 193, 224, *228*, *229*, 230, 311, 350, 372

Carranza, Benustiano, 287
Cartier-Bresson, Henri, 351, *355*, 372
Casagemas, Charles, 44, 45, 48, 50
Casas, Ramon, 22
Casati Stampa, Camillo, 29
Casati Stampa, Luisa (Amman), 29
Casella, Alfredo, 100
Casorati, Felice, 225, *226*, *227*, 233, 372
Cassatt, Mary, 20, 266
Cassirer, Paul, 139
Castel, Jean, 185
Cattaneo, Cesare, 235
Cavalcanti, Emiliano, 285
Cendrars, Blaise, 83, 117, 194
Cerro Muriano, 353
Cézanne, Paul, 17, 46, 54, 58, 64, 65, 72, 74, 78, 85, 99, 116, 118, 126, 129, 162, 168, 184, 229, 284, 288, 296
Chagall, Bella (Rosenfeld), 110
Chagall, Marc, *102*, *108*, *109*, *110*, *111*, 121, 311, 372
Chanel, Coco (Gabriele), 262, 339
Chapingo, 285
Chaplin, Charlie, 359, *362*, 372
Charlot, Jean, 285
Chemnitz, 138
Chicago, *73*, 266, *270*, *280*, *281*, 287, *322*
Christensen, Benjamin, 359
Christy, Henry, 128
Ciano, Galeazzo, 225
Claire, René, 358
Claremont, 285
Cleveland (Ohio), *50*, *273*
Cocteau, Jean, 29, 120, 201, 262
Cohl, Emile, 358
Collioure, 56, 59, 68, 71, 84
Cologne, *138*, 139, 154, 194, *228*, 338
Columbia (Mo.), 283
Como, *235*, *323*, *337*
Constable, John, 184
Corinth, Lovis, 311
Corot, Camille, 350
Côte d'Azur, 61, 62
Courbet, Gustave, 17, 85, 184, 255, 284
Crali, Tullio, *101*, 372
Curry, John Steuart, 266

Dagover, Lil, 363
Daguerre, Louis Jacques Mande, 21, 350
Dalí, Gala (Galina Dyakonova), 212, 215
Dalí, Salvador, *6–7*, 17, 30, *206*, 207, *212*, *213*, *214*, *215*, 359, 365, 373
Dallas (Tex.), *278*
Dangast, 144, 146, 314
D'Annunzio, Gabriele, 29, 86, 224, 358
Darmstadt, *199*, *327*
Daumier, Honoré, 310
Davies, Arthur B., 266
Debschitz, Wilhelm von, 138
Debussy, Claude, 168
De Chirico, Giorgio, *19*, 124, 184, *185*, *186*, *187*, *188*, 189, 190, 191, 192, 193, 208, 210, 216, *217*, 219, 223, 230, *231*, *278*, 291, *311*, 373
Deep, 245
Degas, Edgar, 17, 21, 46, 54, 87, 89, 148, 271, 296
Delacroix, Eugène, 128, 165, 255, 350
Delaroche, Paul, 350
Delâtre, Eugène, 45, 312
Delaunay, Elie, 25
Delaunay, Robert, 73, *83*, 154, 160, 165, 169, 373
Delaunay-Terk, Sonia (Sarah Stern), 73, *83*,

169, 373
Delmarle, Felix, 87
Delvaux, Paul, *207, 223*, 373
De Mille, Cecil B., *359*, 373
Demuth, Charles, 266, *276*, 277, 373
Denis, Maurice, 258
Depero, Fortunato, 92, *100, 234*, 373
De Pisis, Filippo, 184, 185, *192, 230*, 374
Derain, André, *56, 59*, 72, 116, 124, *129*, 154, 374
Derricarrère, Henriette, 320
Despiau, Charles, 296
Diaghilev, Serge, 100, 102, 112, 220, 255, 264
Diak, Michael, 341
Díaz, Porfirio, 285, 289
Di Marzio, Cornelio, 225
Dinard, 262
Disertori, Benvenuto, 311
Disney, Walt, 359
Dix, Otto, 194, *239, 252, 253*, 311, *317*, 374
Döcker, Richard, 331
Dodo (Doris Grosse), 140
Doesburg, Theo van, 169, 178, *182*, 342, 391
Doisneau, Robert, 351
Domínguez, Óscar, *218*, 374
Dongen, Kees van, 29, 45, 52, 56, *57, 62*, 116, 138, 148, 154, 391
Doré, Gustave, 310
Dortmund, *19*
Dottori, Gerardo, *101*, 374
Doucet, Henri, 116
Dovzhenko, Alexander Petrovich, 359
Dresden, 22, 33, 134, 138, 139, 141, 147, 164, 178, 194, 252, 253, 314
Dreyer, Carl Theodor, 359
Drouard, Maurice, 116
Dubuffet, Jean, 195
Duchamp, Marcel, 19, 21, 73, *81*, 194, *195, 196, 197, 198, 199*, 200, 207, 222, 266, 297, 351, *352*, 374
Dudreville, Leonardo, 225, 232
Dufy, Raoul, 56, 58, *63*, 311, 374
Dünaberg, 172
Dunoyer de Segonzac, André, 73, 311
Durand-Ruel, Paul, 20
Düren, *139*
Dürer, Albrecht, 143, 310
Duse, Eleonora, 358
Düsseldorf, 91, *116*, 164, *207, 242*, 247

Eames, Charles, 339
Eames, Ray, 339
Efros, Abram, 111
Einstein, Albert, 328
Einstein, Carl, 129
Eisenstaedt, Alfred, 351
Eisenstein, Sergei Mikhailovich, *364*, 374
El Lissitzky, 297, 323, 351
Eluard, Paul, 207, 208, 212, 222
Engelman, Richard, 238
Ensor, James, 132, 138
Erbslöh, Adolph, 154
Ernst, Max, 120, 137, 194, 195, *202, 206, 208, 209*, 210, 217, 220, 222, 351, 375
Exter, Alexandra, 103, *112*, 115, 375
Erté (Romain de Tirtoff), 339
Essen, *139*
Evergood, Philip, 267

Fagus, Félicien, 44
Fairbanks, Douglas, 359, 362
Farinacci, Roberto, 225

Fattori, Giovanni, 116
Feininger, Lyonel, *17*, 167, 169, 178, 181, 238, *244, 245*, 375
Ferrara, 184, 185, 186, 187, 188, 189, 190, 216
Ferrazzi, Ferruccio, 225
Feure, Georges de, *27*, 339, 373
Figari, Pedro, *290*, 375
Flensburg, 147, 314
Florence, 28, 99, 116, 176, 184, 185, *233*, 255, *336, 337*
Folgore, Luciano, 101
Forain, Jean-Louis, 311
Ford, Henry, *349*, 375
Ford, John, 267, *359*, 375
Fosco, Piero (Giovanni Pastrone), 358, *361*, 375
Foujita, Tsuguharu, 117, 120
Francés, Esteban, *218*, 375
Fratelli, Arnaldo, 358
Fresnay, Pierre, 360
Freud, Sigmund, 138, 206, 208, 214
Friedrich, Caspar David, 184
Friesz, Othon, 56, *58*, 375
Frölich, Otto, 238
Fry, Roger, 67
Funi, Achille, 225, 232
Fuster, Alberto, 284

Gabin, Jean, 360
Gabo, Naum (Naum Pevsner), 103, 255, 307
Gallé, Emile, 339, *340*, 376
Gallen-Kallela, Akseli, 138
Gallone, Carmine, 358
Gamberini, Italo, 336
Gargallo, Laure, 50
Garí, Lluís, 324
Gaudí y Cornet, Antoni, 322, *324*, 376
Gauguin, Paul, 18, 39, 45, 59, 114, 129, 134, 138, 150, 168, 296, 311
Geneva, *120, 180, 206*
Genina, Augusto, 358
Gentile, Giovanni, 224, 225
Gerbig, Alexander, 149
Geronimo, 268
Ghiglia, Oscar, 116
Ghione, Emilio, 358
Giacometti, Alberto, 217, 297
Ghent, *207, 256*
Gilbert, Cass, *334*, 376
Ginori, Richard, 346
Ginzburg, Moisei, 323
Girieud, Pierre, 154
Glackens, William J., *266, 270*, 376
Glarner, Fritz, 179
Gleizes, Albert, 71, 73, *80*, 85, 376
Gobetti, Piero, 227
Godward, John William, *26*, 376
Goebbels, Joseph, 225, 239
Golosov, Ilia, 323
Gómez de la Serna, Ramón, 286
Goncharova, Natalia, 87, 102, *103, 104*, 169, 376
Goodwin, Philip L., 187
Gosol, 45, 54, 55
Govoni, Corrado, 184
Goya, Francisco, 44, 310
Granovsky, Alexei, 111
Griffith, D.W., 359, 362
Gris, Juan, 71, *84*, 286, 292, 376
Gropius, Walter, 19, 43, 238, 239, 319, 322, 323, *330*, 331, *338*, 377
Gropper, William, 267
Grosz, George, 194, *238, 240, 241*, 377
Grünewaldd, Matthias, 143, 150

Guarnieri, Sarre, 336
Guazzoni, Enrico, 358
Guernica, 264
Guillaume, Paul, 117, 124, 129, 131, 185, 186
Guro, Yelena, 102
Guttuso, Renato, *237*, 377
Guzman, Martín Luis, 286
Guzzi, Carlo, 349, 377

Hamburg, 132, 147, 194, *300*, 308
Hanover, 183, 194, 205
Harmon, Arthur Loomis, *335*
Hartford (Conn.), *272*
Hartlaub, Gustav Friedrich, 239
Hartley, Marsden, *136*, 377
Hastings, Beatrice, 117, 119
Hausmann, Raoul, 194, *204*, 377
Havana, 284
Heartfield, John, 351
Hébuterne, Jeanne, 117, 126, 127
Heckel, Erich, 138, 139, 144, *146, 147*, 153, 161, *310*, 311, 314, 377
Hélion, Jean, 169
Hemingway, Ernest, 120, 280
Henri, Robert, *266, 269*, 377
Hervé, Julien-Auguste, 139
Hilberseimer, Ludwig, 331
Hiroshige, Ando, 128
Hirth, George, 338
Hitchcock, Henry-Russell, 323, 339
Hitler, Adolf, 238, 253, 283
Höch, Hannah, 351
Hodler, Ferdinand, 17, 27, *28*, 377
Hofer, Karl, 154
Hoffmann, Josef, 33, 322, *329*, 338, *342*, 378
Hogarth, William, 310
Holbein, Hans, 255
Hollywood, 21, 267, 280, 359
Holtzman, Harry, 179
Honfleur, 58
Hopper, Edward, *10–11*, 20, 266, *267, 278, 279, 280*, 311, 378
Horner, William G., 358
Horta, Victor, 322, *326*, 378
Horta de Ebro, 44, 76, 302
Hugenberg, Alfred, 241
Hülsenbeck, Richard, 194, 204

Ibsen, Henrik, 138, 241
Ince, Thomas H., 359
Ingres, Jean-Auguste-Dominique, 255, 258, 350, 354
Itten, Johannes, 238

Jacob, Max, 44, 45, 72, 117, 194
Jacobsen, Arne, 338
Janco, Marcel, *194*, 378
Janowitz, Hans, 363
Java, 24
Jawlensky, Alexei, 56, 102, 154, 155, 164, 166, 167, 169, 181, 378
Jean, Marcel, 218
Jenney, William Le Baron, 323
Johns, Jasper, 195
Johnson, Philip, 323, 339
Jourdain, Francis, 339
Jucker, Carl Jacob, 330
Juhl, Finn, 339

Kahlo, Frida, *20, 285, 294, 295*, 356, 378
Kahnweiler, Daniel-Henry, 45, 62, 72, 73, 76, 77, 84, 303, 310
Kandinsky, Wassily, *2–3, 18*, 56, 102, 104,

114, 135, 136, 138, *154*, 155, *156, 157, 158, 159*, 160, 163, 164, 166, 167, 168, *169, 170, 171, 172, 173*, 176, 178, 181, 238, 239, 247, *248, 249*, 311, *319*, 330, 378
Kann, Alphonse, 80
Kanoldt, Alexander, 154
Kansas City, *132*
Karlsruhe, 253
Karno, Fred, 362
Kaufmann, Edgar, 333
Keaton, Buster, 359
Khlebnikov, Velimir, 102
Khnopff, Fernand, *24*, 379
Kierkegaard, Søren, 138, 168
Kiesler, Frederick, 207
Kiki (Alice Ernestine Prin), 120, 354
Kircher, Athanasius, 128
Kirchner, Ernst Ludwig, *12, 138, 139, 140, 141, 142, 143*, 153, 161, 163, 311, *314*, 379
Kisling, Moïse, *120*, 124, 379
Klee, Paul, *128*, 129, *135*, 155, 163, *165*, 167, *168*, 169, 178, *180, 181*, 217, 238, 239, *246, 247*, 311, *318*, 330, 379
Klemm, Walther, 238
Klimt, Gustav, 18, 22, 27, *32, 33, 34, 35, 36, 37, 38*, 39, 41, 311, 313, 329, 379
Klinger, Max, 33, 184
Klint, Kaare, 338
Klyun, Ivan, *114, 115*, 379
Koenig, Hertha, 52
Koeniger, Ellen, 352
Kogan, Moisey, 154
Köhler, Wilhelm, 238
Koklova, Olga, 263
Kokoschka, Oskar, 18, *33, 42, 43*, 311, *313*, 379
Koller, Hugo, 41
Kollwitz, Käthe, 311
König, Friedrich, 22, 379
Kraków, 120, 125
Krauss, Werner, 363
Kruchonykh, Alexei, 102
Kubin, Alfred, 154, 155
Kubista, Bohumil, 138
Künzelsau, *210*
Kupka, František
, *174, 175*, 379

La Fresnaye, Roger de, 73
Lalique, René-Jules, 339, *340*, 380
Lam, Wilfredo, *129*, 137, 285, 380
Lamb, William, *335*
Lancaster, 276
Lang, Fritz, *358*, 359, 380
La Plata, 292
Larionov, Mikhail, 87, 102, *105*, 155, 169, 380
Lasker-Schüler, Else, 160
Laurencin, Marie, *72*, 380
Laurens, Henri, 262, 297
Lautréamont, Comte de (Isidore Ducasse), 206
Lawson, Ernest, 266
Leadbeater, Charles, 155
Leal, Fernando, 285
Leck, Bart van der, 169
Le Corbusier, 323, *331, 339*, 380
Lederer, August, 33
Le Fauconnier, Henri, 73, 115, 154, 155
Léger, Fernand, 72, 73, *82*, 129, 284, *311*, 380
Leghorn (Livorno), 116
Leiden, 132, 169

Index of names and places

Leipzig, *152*, 194, 227
Leiris, Michel, 220
Lejeune, Emile, 117
Lempicka, Tamara de, 17, *258*, *259*, 380
Leni, Paul, 359
Lenin, Vladimir, 261
Leonardo da Vinci, 197
L'Estaque, 59, 61, 72, 78
Leuppi, Leo, 309
Levi, Carlo, *233*, 381
Lévi-Strauss, Claude, 137
Lewis, Wyndham, 87
Leysin, 42
Lhote, André, 73, 258
Liberty, Arthur Lasenby, 22
Licini, Osvaldo, 235
Lima, 284
Lincoln (Nebr.), *279*
Linder, Max, 358
Lipchitz, Jacques, 121, 286, 297
Lippman, Gabriel, 350
List, Wilhelm, *27*, 381
Livorno (Leghorn), 116
Loeb, Pierre, 206, 217
Loewy, Raymond, *339*, 381
London, 18, 22, 67, 87, 94, 112, 128, 169, 179, 207, *223*, 322, 338, *341*
Longhi, Roberto, 185
Loos, Adolf, 42, *326*, 381
Löwenstein, Arthur, 91
Ludwigshafen am Rhein, *175*
Luks, George, *266*, *269*, 381
Lumière, Auguste, 22, 350, 358
Lumière, Louis, 22, 350, 358
Lusanna, Leonardo, 336

Macke, August, 136, 154, *155*, *162*, *163*, 165, 180, 381
Mackintosh, Charles Rennie, 22, *341*, 381
Mac Orlan, Pierre, 45
Madrid, *17*, 21, 44, *56*, 137, *141*, 146, *151*, *161*, *163*, *202*, *215*, 240, 244, *264*, *267*
Maeght, Adrien, 310
Mafai, Antonietta Raphaël, 232
Mafai, Mario, *224*, 232, 381
Magnelli, Alberto, *176*, 383
Magritte, René, *21*, *207*, *210*, *211*, 223, 382
Mahler, Alma, 43
Maillol, Aristide, 56, 296
Malaga, 44
Malerba, Gian Emilio, 225
Malevich, Kazimir, *18*, 102, *103*, *106*, *107*, 113, 114, 115, 169, 177, 307, 311, 382
Malipiero, Gianfrancesco, 100
Mañach, Pedro, 44
Manet, Edouard, 17
Manguin, Henri, *56*, *60*, 382
Mannheim, 35
Man Ray, 20, 29, 120, 194, *195*, 200, *203*, 206, 222, *266*, *350*, 351, *354*, 382
Maraini, Antonio, 224
Marc, Franz, *154*, 155, *160*, *161*, 163, 176, 382
Marchesini, Nella, 227
Marcks, Gerhard, 238
Marconi, Guglielmo, 224
Mare, André, 339
Marey, Etienne-Jules, 81, 87, 91, 351
Mari, Febo, 358
Marinetti, Filippo Tommaso, *86*, 87, 96, 99, 101, 102, 106, 224, 225, 336, 351, 382
Marini, Marino, 297
Maritain, Jacques, 257
Marquet, Albert, 56
Marsan, Eugène, 45

Marsh, Reginald, 267
Martens, Dino, 347
Martini, Alberto, 29
Martini, Arturo, 336
Martinuzzi, Napoleone, *347*, 382
Martoglio, Nino, 358
Marussig, Piero, 225
Maslon, Samuel H., 186
Masson, André, 206
Mathsson, Bruno, 338
Matisse, Amélie (Parayre), 56, 67
Matisse, Henri, 18, 45, 56, 57, 58, 59, *64*, *65*, *66*, *67*, *68*, 69, *70*, *71*, 72, 73, 75, 84, 102, 114, 117, 124, 128, 129, 138, 144, 148, 157, 166, 176, 255, *260*, 296, *304*, 311, *320*, 355, 383
Matisse, Pierre, 71, 186
Matsch, Franz, 32
Matta, Sebastian, 129, 285
Maxence, Edgar, *25*, 383
Mayakovsky, Vladimir, 87, 102, 103
Mayer, Carl, 363
Mazzacurati, Marino, 232
Méliès, Georges, *358*, 383
Mellingstedt, 147
Mel'nikov, Konstantin Stepanovic, 323, *332*
Mendelsohn, Erich, *328*, 383
Mercereau, Alexandre, 73
Messina, 348
Metzinger, Jean, 71, 73, *85*, 115, 383
Metzner, Franz, 329
Mexico City, 207, 284, 285, *286*, 287, *288*, *289*, 295
Meyer, Hannes, 239
Michelangelo Buonarroti, 28, 298
Micheli, Giovanni, *336*, 337, 383
Mies van der Rohe, Ludwig, 239, *331*, 344, 383
Migneco, Giuseppe, *233*, 383
Milan, *16*, *61*, *86*, *87*, *89*, *91*, *92*, 94, *95*, *97*, *98*, *99*, *119*, *120*, *124*, *128*, *169*, *184*, *185*, *189*, *190*, *191*, *192*, *193*, *216*, *224*, 225, *235*, 236, 299, 306, 361
Milhaud, Darius, 201, 262
Milwaukee (Wisc.), *164*
Minneapolis (Minn.), *186*, *267*
Mir, Joaquim, 23
Miró, Joan, *20*, 30, 129, 206, 220, 221, 384
Modigliani, Amedeo, *4–5*, 18, 20, 45, *116*, *117*, *118*, *119*, *120*, *121*, *122*, 123, *124*, *125*, *126*, *127*, 129, *130*, 266, *296*, 384
Modotti, Tina, 20, 351, *356*, 357, 384
Mohensen, Børge, 338
Moholy-Nagy, László, *177*, 238, 297, 351, 384
Moilliet, Louis, 165, 180
Mönchengladbach, *147*
Mondrian, Piet, *168*, 169, *178*, *179*, 182, 183, 342, 384
Monet, Claude, 17, 168
Montenegro, Roberto, 284
Montesquiou-Fezensac, Joseph de, 42
Montesquiou-Fezensac, Victoire de, 42
Montroig, 220
Monza, 224
Moore, Henry, 297
Moore, James, 270
Morandi, Giorgio, 184, *185*, *191*, *192*, 225, *230*, 311, *321*, 384
Moreau, Gustave, 25, 56
Moreau, Luc-Albert, 73
Morice, Charles, 72
Moro, César, 285
Morozov, Ivan, 46, 57, 60, 77, 102
Morris, William, 22

Moscow, *46*, *51*, *60*, 67, 68, *70*, *73*, *77*, *102*, *103*, *104*, 109, *111*, 112, 115, *131*, 156, 159, *307*, *332*
Moser, Kolo, 338
Mossa, Gustave-Adolphe, *22*, 384
Mourlot, Fernand, 310
Mucha, Alphonse, *23*, *31*, 384
Muche, Georg, 238
Mueller, Otto, 138, 139, *152*, *153*, *310*, 311, 384
Munari, Bruno, 235
Munch, Edvard, 42, 138, 141, *315*, 385
Munich, 22, *39*, 49, 102, 104, 136, 138, *154*, *155*, 156, *157*, 158, *159*, 164, 168, *170*, 178, 184, 216, 239, 318, 322, 338
Münter, Gabriele, 154, *155*, 157, 158, *164*, 168, 385
Murnau, 157, 164, 172
Murnau, Friedrich Wilhelm, 359
Mussolini, Benito, 224, 225, 337, 348
Muthesius, Hermann, 338
Muybridge, Eadweard, 21, 81, 87, 91, 358

Nadar (Gaspard-Félix Tournachon), 21, 350
Naples, 116, 255
Natali, Renato, 116
Nervi, Pierluigi, 337
Neuzil, Wally, 40
Nevinson, Christopher, 87
New Haven (Conn.), *277*
Newman, Barnett, 129
New York, *18*, 20, 48, 51, 53, *55*, *71*, *74*, *79*, 81, 82, *83*, 89, *94*, *126*, 136, *137*, *154*, 155, 169, *179*, 187, 194, *195*, 198, 200, 207, *212*, 214, 218, 236, 245, *249*, *255*, *257*, *266*, *268*, *269*, 270, *271*, 272, *274*, *276*, *280*, *282*, 285, 287, 301, *322*, 323, *334*, *335*, 339, 352, 361
Nice, 117, 260, 320
Niemeyer, Wilhelm, 144
Niépce, Joseph Nicéphore, 350
Nietzsche, Friedrich, 138, 168, 184, 187, 253
Noack, Hermann, 308
Nolde Emil, *19*, *132*, *133*, 138, 144, *150*, *151*, 311, *314*, 385
Nölken, Franz, 138
Nonell, Isidre, 22, 44
Novgorod, *105*

Oberlin (Ohio), *143*
Obrist, Hermann, 138
O'Keeffe, Georgia, *274*, *275*, 352, 385
Olbrich, Joseph Maria, 32, 322, *327*, 385
Olivier, Fernande, 45, 75, 76, 302
Oller, Francisco, 284
O'Neill, Eugene, 267
Oppi, Ubaldo, 225
Oppo, Cipriano Efisio, 224, 225
Orozco, José Clemente, 20, 267, 285, *287*, 289, 356, 357, 385
Ostend, 132
Osterholz, 147
Ottawa, *34*
Otterlo, *24*, 27
Ovid, 258, 312

Paalen, Wolfgang, 285
Padua, 236
Pagano, Bartolomeo, 361
Paimio, 345
Palau, 134
Pallarés, Manuel, 44
Palucca, Gret, 178
Papini, Giovanni, 184

Paris, 17, 18, 20, 21, 22, 24, *25*, 27, 32, 34, 44, 45, 46, 47, 49, 55, 56, *57*, 60, 61, 62, 63, *64*, *65*, 69, *72*, 73, 76, 80, 81, 84, 87, 94, 95, *96*, 98, 102, 105, 109, 115, *116*, 117, 118, 119, 120, *121*, 122, 125, 128, 129, 131, 137, 148, 156, 160, 162, *165*, 166, 168, *169*, *171*, *173*, 174, 175, 176, 184, 185, 186, 197, 200, *201*, 203, 204, 206, 207, 208, 212, 215, 216, 217, 222, 230, 231, 236, *248*, *249*, *254*, *258*, *260*, *262*, *263*, 264, 270, 271, 276, 284, 285, 286, 292, 295, *296*, *298*, 301, *302*, 303, 307, *309*, 312, 322, 331, 339, 350, 351, 354, 358, 361
Pasadena (Calif.), *167*
Patani, Osvaldo, 127
Paxton, Joseph, 322
Pearl Harbor, 283
Pechstein, Max, *134*, 138, *139*, *148*, *149*, 161, 311, 385
Péret, Benjamin, 207
Permeke, Constant, *256*, 385
Peruzzi, Osvaldo, 235
Pesaro, Lino, 225
Peschka, Anton, 41
Petipa, Marius, 112
Pettoruti, Emilio, 284, *292*, 386
Pevsner, Antoine, 103, *254*, 255, 307
Philadelphia, *81*, *196*, 197, *198*, *213*, 220, 227, 277
Piacentini, Marcello, 224, *336*, 348, 386
Pica, Vittorio, 224
Picabia, Francis, 116, 169, 194, 195, *200*, *201*, 210, 266, 352, 386
Picart, Alfred, 22
Picasso, Pablo, *8–9*, 18, 19, 20, *21*, 30, 44, *45*, *46*, *47*, *48*, *49*, *50*, *51*, *52*, *53*, *54*, *55*, 57, 72, *73*, *74*, *75*, *76*, *77*, 78, 82, 84, 90, 102, 116, 117, *128*, 129, 131, 154, 176, 209, *254*, *255*, *262*, *263*, *264*, 265, 286, 292, 296, *297*, *302*, *303*, 307, 311, *312*, 386
Picasso, Paul, 263
Piccinato, Luigi, 337
Pickford, Mary, 362
Pietrasanta, 116
Pieve di Cento, 184
Pigorini, Luigi, 128
Pirandello, Luigi, 224, 358
Piranesi, Giovanni Battista, 310
Pissarro, Camille, 17
Pittsburgh, 227, 266, 333
Pizzetti, Ildebrando, 358
Plateau, Joseph, 358
Poelzig, Hans, 331
Pogany, Margit, 301
Poiret, Paul, 339
Poli, Flavio, 347
Pollock, Jackson, 129, 285
Ponti, Gio, 336, *346*, 386
Popova, Lyubov', 103, *115*, 386
Portinari, Candido, 285
Port Lligat, 212, 215
Potsdam, *328*
Poussin, Nicolas, 255
Prague, *31*, 73, *174*, *175*, 194, 204
Prampolini, Enrico, *234*, 235, 386
Pratella, Francesco Balilla, 101
Prendergast, Maurice, 266
Price, Vincent, 287
Pudovkin, Vsevolod, 359
Puig Boada, Isidre, 324
Puig i Cadafalch, Josep, 44
Punin, Nikolay, 103

Index of names and places

Puteaux, 174
Puy, Jean, 56, 70
Puye, Pueblo, 275

Quintana, Francesc, 324

Radi, Giulio, 347
Radice, Mario, *235*, 386
Rading, Adolf, 331
Raimondi, Giuseppe, 184, 191
Raleigh, *136*
Ranger, Walter, 267
Rank, Otto, 214
Rapallo, 164, 168
Rauschenberg, Robert, 195
Ravasco, Alfredo, *346*, 387
Ravegnani, Giuseppe, 184
Raynal, Maurice, 71, 255
Redon, Odilon, 24, 53
Reimann, Walter, 363
Remington, Frederic, *268*, 387
Renoir, Jean, 358, 359, *360*, 387
Renoir, Pierre-Auguste, 17, 255, 270, 296, 358
Respighi, Ottorino, 224
Reverdy, Pierre, 211
Reverón, Armando, 284
Revueltas, Fermin, 285
Reynaud, Emile, 358
Rho, Manlio, 235
Richter, Hans, 194
Rietveld, Gerrit, 323, *342*, 387
Rilke, Rainer Maria, 52
Rivera, Diego, 17, 20, 117, 267, *284*, 285, *286*, *288*, 289, 294, 295, 356, 357, 387
Roche, Henri-Pierre, *352*
Rodchenko, Alexander, 103, *113*, 307, *350*, 351, 387
Rodin, Auguste, 32, *296*, *298*, 300, 387
Röhring, Walter, 363
Rome, 26, *29*, *35*, 90, 92, 99, 100, 116, 128, *168*, *184*, 185, 215, 224, 225, 228, 230, *232*, *233*, 235, *236*, *237*, 255, *336*, 337, 350, 358
Romiti, Gino, 116
Roosevelt, Franklin D., 266
Root, John Wellborn, 323
Rosai, Ottone, *99*, 388
Rosenberg, Léonce, 231
Rosso, Medardo, 296, *299*, 388
Rotella, Mimmo, 195
Rothschild, Herbert, 178
Rothschild, Nannette, 178
Rothko, Mark, 129
Rotterdam, 91
Rouault, Georges, 56, 154, *255*, *257*, 311, *321*, 388
Rouen, *118*, 196
Rousseau, Henri, 154
Rovereto, *228*, 234
Rozanova, Olga, 115
Ruelas, Julio, 284
Ruhlmann, Emile-Jacques, 339
Rusiñol, Santiago, *22*, *30*, 388
Russolo, Luigi, 86, 87, 92, 94, *96*, 232, 350, 388

Saarbrücken, *162*
Sabartés, 44
Sabaudia, 337
Sacco, Nicola, 282
Saint Louis (Mo.), *208*
Saint-Tropez, 60, 64
Salmon, André, 45, 117
San Francisco, 57, 84, 309, 356

São Paulo, *117*, 306
St. Petersburg, *44*, *45*, *47*, *49*, *57*, *61*, *63*, *66*, *67*, *68*, *75*, *76*, *83*, 102, *103*, *104*, *106*, *107*, *109*, *110*, *158*, *172*, 314
Santa Fe, 274
Santa María, Andrés de, 284
Sant'Elia, Antonio, *323*
Sarfatti, Margherita, 224, 225
Sargent, John Singer, 20, 266
Sarraz, Château de la, 323
Sartoris, Alberto, 235
Satie, Erik, 194
Savinio, Alberto (Andrea de Chirico), 184, 185, 187, *216*, 230, 388
Scarpa, Carlo, 347
Schad, Christian, *250*, *251*, 351, 388
Schapire, Rosa, 144
Scharoun, Hans, 331
Scheibler, Fritz, 330
Scheper, Hinnerk, 239
Schiaparelli, Elsa, 207
Schiefler, Gustav, 147, 151
Schiele, Egon, 18, *33*, *39*, *40*, *41*, 389
Schiele, Gertrude, 41
Schlemmer, Oskar, 238
Schmidt, Joost, *239*
Schmidt-Rottluff, Karl, 138, 139, *144*, *145*, 146, 311, 389
Schneck, Adolf G., 331
Schnitzler, Arthur, 36
Schoenberg, Arnold, 154, 155, 168, 170
Schopenhauer, Arthur, 184
Schwitters, Kurt, 194, *205*, 389
Scipione (Gino Bonichi), *232*, 389
Seebüll, *150*, 151
Segall, Lasar, 284
Segantini, Giovanni, 86
Semionov, Nikolai, *261*, 389
Sennett, Mack, 358, 362
Serov, Valentin, 102
Sesto Fiorentino, 346
Seuphor, Michel, 169
Seurat, Georges, 64, 163
Severini, Gino, 82, 86, 87, 92, 94, 95, *97*, 116, 117, 124, 311, 350, 389
Shahn, Ben, 267, *282*, 389
Sharkey, Tom, 273
Shchukin, Sergei, 51, 57, 66, 67, 68, 69, 75, 102, 304
Sheeler, Charles, 266, 276, *277*, 389
Shinn, Everett, 266, *271*, 389
Shreve, Richmond H., *335*
Signac, Paul, 56, 60, 64
Siqueiros, David Alfaro, 20, 267, *284*, 285, *289*, 356, 357, 389
Sironi, Mario, *193*, *224*, 225, *232*, 390
Sívori, Eduardo, 284
Sjöström, Victor, 359
Skira, Albert, 310
Slevogt, Max, 311
Sloan, John, 266, *272*, 311, 390
Smilovitchi, 121
Soffici, Ardengo, 87, *98*, 99, 184, 189, 311, 350, 390
Soldati, Atanasio, 235
Soldati, Mario, 358
Soler, Benet, 44, 49
Solingen, *133*
Soto, Ángel Fernández de, 44, 45
Soto, Jesús Rafael, 285
Soupault, Philippe, 206
Soutine, Chaïm, 120, *121*, 124, 390
Speyr, Magherita, 91
Spoerri, Arman, 195
Spoerri, Christo, 195

Spoerri, Daniel, 195
Staffelsee (lake), 164
Stalin, Joseph, 103, 255, 261
Stam, Martin, 344
Stampfer, Simon R. von, 358
Steichen, Edward, 266, 304
Stein, Gertrude, 45, 55, 57, 72
Stein, Leo, 45, 55, 57
Stella, Joseph, 87
Stepanova, Varvara, 103
Sternberg, Joseph von, 359
Stieglitz, Alfred, 194, 200, 266, 274, 350, 351, *352*, 390
Stiller, Mauritz, 359
Stockholm, *42*, *82*, *129*, *199*
Stoclet, Adolf, 33, 329
Stravinsky, Igor, 112
Strindberg, August, 138
Stroheim, Erich von, 360
Stuck, Franz von, 156
Stuttgart, *121*, *160*, *185*, *195*, *238*, *239*, *245*, *252*, *305*, 331, 344
Subirachs, Josep Maria, 324
Süe, Louis, 339

Tairov, Alexander, 112
Tamayo, Rufino, 289, *291*, 390
Tanguy, Yves, 206, 217, *219*, 221, 222, 390
Tarsila, 284
Tatlin, Vladimir, 87, *102*, 103, 113, 114, 115, 297, *307*, *323*, 391
Tato (Guglielmo Sansoni), 351
Taut, Bruno, 322, *327*, 331, 391
Taut, Max, 331
Tchaikovsky, Peter Ilyich, 112
Tériade (Stratis Eleftheriadis), 310
Terragni, Giuseppe, 235, *337*, 391
Thedy, Max, 238
Tibertelli, Ernesta, 184
Toorop, Jan, *24*, 27, 391
Torres García, Joaquín, 169, 285, *293*, 391
Torriano, Pietro, 237
Toulouse-Lautrec, Henri de, 47, 54, 118, 139
Trieste, *226*
Trouville, 58
Tula, *18*
Turin, 226, 233, 358, 361
Turner, Joseph Mallord William, 184
Turquet, Edmond, 298
Tutundjian, Leon, 169
Tzara, Tristan, 194, 195, 200

Uchatius, Franz von, 358
Udal'tsova, Nadezhda, 115
Uhde, Wilhelm, 77
Ungaretti, Giuseppe, 232
Utenwarf, 151

Valtat, Louis, 56, *61*, 391
Van Alen, William, 334
Van Gogh, Vincent, 18, 42, 128, 138, 141, 144, 146, 150, 256
Vantongerloo, Georges, 169, 297
Vanzetti, Bartolomeo, 282
Varo, Remedios, *218*, 391
Vauxcelles, Louis, 56, 72, 139
Veidt, Conrad, 363
Velázquez, Diego Rodríguez de Silva, 255
Velde, Henry van de, 169
Venice, *19*, *21*, 33, *38*, *85*, *90*, *108*, 116, 129, *182*, *219*, 224, 225, 226, 227, 235, 236, 299, 347
Venturi, Lionell, 226, 225
Vesnin, Alexander, 323

Vesnin, Viktor, 323
Vevey, 363
Viani, Lorenzo, 311
Viareggio, 93
Vidal, Sebastián Junyer, 44, 45
Vienna, 27, *32*, *33*, *34*, 35, *36*, *37*, *38*, *40*, *41*, 138, *325*, *326*, 327
Viipuri, *332*
Villon, Jacques, 73
Viollet-le-Duc, Eugène-Emmanuel, 322
Visconti, Luchino, 359
Vitebsk, 108, 110
Vlaminck, Maurice de, 56, *57*, *63*, 72, 116, 154, 311, 392
Vollard, Ambroise, 45, 46, 56, 63, 77, 90, 310, 312
Volpi di Misurata, Giuseppe, 224
Vordemberge-Gildewart, Friedrich, *183*, 392
Vrubel', Mikhail, 102
Vuillard, Edouard, 290

Wagenfeld, Wilhelm, 330
Wagner, Martin, 327
Wagner, Otto, 322, *325*, 392
Walden, Herwarth, 154
Warm, Hermann, 363
Wärndorfer, Fritz, 338
Wadsworth, Edward, 87
Washington, D.C., *52*, *128*, *178*, *266*
Weill, Berthe, 117, 123
Weimar, 135, 238, 247, 248, 249, 251, 252, 319, 330
Wells, Orson, 359
Werefkin, Marianne, 154, 155, 164
Werfel, Franz, 43
Weston, Edward, 351, 356, *357*, 392
Whistler, James Abbott McNeill, 20, 266
White, Clarence, 266
Whitney, Betsey Cushing, 53
Whitney, John Hay, 53
Wildt, Adolfo, 224, 225
Wiegels, Karl Wilhelm, 45
Wiene, Robert, *363*, 392
Wirkkala, Tapio, 338
Wolfskehl, Karl, 155
Wood, Grant, 266, 267, *281*, 392
Woods, Stanley, 349
Woolworth, Frank W., 334
Worringer, Wilhelm, 229, 238
Wounded Knee, 268
Wright, Frank Lloyd, 322, 323, *333*, 392
Wuppertal, *88*, *243*

Xul Solar, *290*, 390

Zapata, Emiliano, 285, 287
Zborowski, Léopold, 117, 121, 122, 125
Zecchin, Vittorio, 347
Zijl, Lambertus, 138
Zola, Emile, 296, 350, 358
Zurich, 27, *156*, 158, 185, 194, 200, 204, 309

Index of names and places

Photographic sources